DUMBARTON OAKS STUDIES XLIX

BASTIONS OF THE CROSS

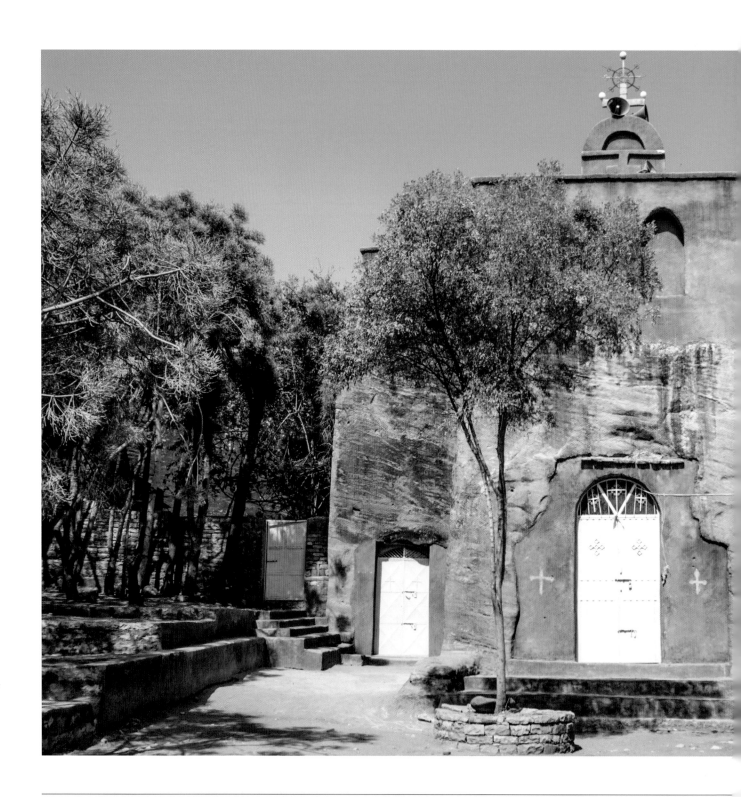

BASTIONS
OF THE CROSS

Medieval Rock-Cut
Cruciform Churches of
Tigray, Ethiopia

Mikael Muehlbauer

DUMBARTON OAKS RESEARCH LIBRARY AND COLLECTION | WASHINGTON, DC

ISBN 978-0-88402-497-2

LIBRARY OF CONGRESS CATALOGING-IN-PUBLICATION DATA

NAMES: Muehlbauer, Mikael, author.

TITLE: Bastions of the cross : medieval rock-cut cruciform churches of Tigray, Ethiopia / Mikael Muehlbauer.

OTHER TITLES: Dumbarton Oaks studies ; 49.

DESCRIPTION: Washington, D.C. Dumbarton Oaks Research Library and Collection, [2023] | Series: Dumbarton Oaks studies ; [xlix] | Originally presented as the author's thesis (Ph.D.)—Columbia University, 2020. | Includes bibliographical references and index. | Summary: "In the late eleventh century, Ethiopian masons hewed great cruciform churches out of mountains in the eastern highlands of Tigray, Ethiopia's northernmost province. Hitherto unparalleled in scale, these monuments were royal foundations, instruments of political centralization and re-Christianization that anticipated the great thirteenth-century churches at Lalibela. Bastions of the Cross, the first monograph devoted to the subject, examines the cruciform churches of Abreha wa-Atsbeha, Wuqro Cherqos, and Mika'el Amba and connects them to one of the great architectural movements of the Middle Ages: the millennial revival of the early Byzantine aisled, cruciform church. These were also the first to incorporate vaulting, and uniquely did so in the service of a centralized spatial hierarchy. It was through resuscitated pilgrimage networks that Ethiopian craftsmen revisited architectural types abandoned since Late Antiquity, while Islamic mercantile channels brought precious textiles from South Asia that inspired trans-material conceptions of architectural space. This study reveals the eleventh century, in contrast to its popular reputation as a 'dark age,' to be a forgotten watershed in the architectural history of Ethiopia and Eastern Christianity"—Provided by publisher.

IDENTIFIERS: LCCN 2023020033 | ISBN 9780884024972 (hardcover)

SUBJECTS: LCSH: Church architecture—Ethiopia—Tigray Region. |Architecture, Byzantine—Ethiopia—Tigray Region. | Church buildings—Ethiopia—Tigray Region. | Cave churches—Ethiopia—Tigray Region. | Tigray Region (Ethiopia—Antiquities).

CLASSIFICATION: LCC NA6086.2.T54 M84 2023 | DDC 726.50963—dc23/eng/20230602

LC record available at https://lccn.loc.gov/2023020033

FRONTISPIECE: Wuqro Cherqos, facade, Tigray, Ethiopia. Photograph by author.

CONTENTS

List of Figures vii

Preface xi

Note on Transliteration and Dating xv

INTRODUCTION 1

1. MEDIEVAL ARCHITECTURE IN TIGRAY, ETHIOPIA 27

2. CHURCHES IN THE MAKING 79

3. INVENTING LATE ANTIQUITY IN MEDIEVAL ETHIOPIA 135

4. MEDIEVAL ETHIOPIA IN THE INDIAN OCEAN WORLD SYSTEM 165

CONCLUSION: A LOCAL LEGACY 191

Abbreviations 207

Bibliography 209

General Index 231

FIGURES

1. San Marco, southeast transept elevation 2
2. Abreha wa-Atsbeha, interior viewed from the northeast lateral aisle 3
3. Abreha wa-Atsbeha, 1:100 scale plan 5
4. Wuqro Cherqos, 1:100 scale plan 6
5. Mika'el Amba, 1:100 scale plan 7
6. Modern Ethiopia with political zones 8
7. Mountain range near Addigrat 9
8. Map of East Africa, Egypt, and the Red Sea area 10
9. Aksum Stele Park, toppled stele 13
10. Beta Emmanuel 14
11. "Maryam Corou" ground plan and elevation, Wuqro Cherqos 19
12. "Plan of Rock-Cut Church at Dongolo," Wuqro Cherqos 20
13. "Rock-Cut Church at Dongolo," elevation, Wuqro Cherqos 21
14. "Plan of the Excavated Church of Abha Os Gaba, or Abhahasuba," Abreha wa-Atsbeha 22
15. Dungur "Palace," south porch foundation 28
16. Diagram of Aksumite wall structure 29
17. Agula Cherqos, measured ground plan 30
18. Maryam Nazret, Aksumite spolia piers 31
19. Aksumite "Corinthian" capital 31
20. "East Church," measured ground plan 32
21. Proconnesian marble and assorted alabaster chancel fragments 33
22. Cathedral of Sanaa, hypothetical reconstruction 34
23. Dabra Dammo, measured ground plan 36
24. Dabra Dammo, west portal elevation 37
25. Dabra Dammo, narthex ceiling 37
26. Zarama Giyorgis, reconstructed ground plan 38
27. Zarama Giyorgis, nave ceiling 39
28. Zarama Giyorgis, aisle coffer 40
29. Abba Garima II, "Sanctuary of Light" parchment folio 41
30. Degum Selassie, North Church, ground plan 42
31. Degum Selassie, North Church, nave view 43
32. Degum Selassie, round shaft, southeast corner of the apse 44
33. Abba Garima I, parchment folio 45
34. Maryam Baraqit, east elevation 47
35. Hawzen Takla Haymanot, nave elevation 48
36. Yohannes Matmaq, measured ground plan 50
37. Yohannes Matmaq, north nave colonnade (pre-restoration) 51
38. Yohannes Matmaq, outer rail post 51
39. Yohannes Matmaq, nave ceiling 52

40. Maryam Nazret, east foundation 54

41. Maryam Nazret, southernmost chamber, east wall and dome 55

42. Dabra Salam Mika'el, measured ground plan 56

43. Dabra Salam Mika'el, nave arcade and south aisle 57

44. Dabra Salam Mika'el, Majestas Domini 58

45. Cherqos Agabo, east elevation 59

46. Plan of Maryam Qorqor 60

47. Maryam Qorqor, north wall 62

48. Maryam Qiat, south portal door, north portal door 63

49. Maryam Qiat, nave elevation 64

50. Plans: (a) Iyasus Gwahegot, measured ground plan, (b) Yemrehanna Krestos, ground plan 65

51. Iyasus Gwahegot, north nave arcade 66

52. Maryam Dabra Tseyon, measured ground plan 68

53. Maryam Dabra Tseyon, north facade 69

54. Maryam Dabra Tseyon, northeast choir bays viewed from the nave 70

55. Maryam Dabra Tseyon, blind arcade detail 70

56. Maryam Wuqro, south facade 71

57. Maryam Wuqro, throne in the narthex 72

58. Maryam Wuqro, monolithic altar ciborium 73

59. Abuna Yemata Guh, mural painting showing Saint Yemata on horseback 74

60. Medhana Alam, nave elevation 76

61. Rock-hewn house, exterior elevation 77

62. Bodrum Camii (Myrelaion), measured ground plan 81

63. Abreha wa-Atsbeha, viewed from the market square 82

64. Abreha wa-Atsbeha, south transept elevation 84

65. Abreha wa-Atsbeha, south transept elevation 84

66. Abreha wa-Atsbeha, exochamber facade 86

67. Abreha wa-Atsbeha, facade 87

68. Abreha wa-Atsbeha, nave ceiling 88

69. Abreha wa-Atsbeha, west lateral bays of the north transept 88

70. Abreha wa-Atsbeha, north transept vault 89

71. Abreha wa-Atsbeha, south transept vault 90

72. Abreha wa-Atsbeha, crossing space and choir dome 91

73. Abreha wa-Atsbeha, choir dome 92

74. Abreha wa-Atsbeha, bema and chancel as seen in 1971 92

75. Abreha wa-Atsbeha, barrel vault over the altar 93

76. Abreha wa-Atsbeha, apse conch 94

77. Abreha wa-Atsbeha, apse synthronon and niche 94

78. Abreha wa-Atsbeha, south pastophoria, dome and drum detail 95

79. Abreha wa-Atsbeha, north pastophoria 95

80. Abreha wa-Atsbeha, sculpted crosses 96

81. Mika'el Amba Monastic Complex viewed from afar 97

82. Mika'el Amba, *tukul* foundation 98

83. Mika'el Amba, facade 99

84. Mika'el Amba, center portal, chancel arch detail 100

85. Mika'el Amba, facade 100

86. Mika'el Amba, north transept 101

87. Mika'el Amba, narthex ceiling 102

88. Mika'el Amba, door to the nave 102

89. Mika'el Amba, south transept vault 103

90. Mikaʾel Amba, south exochamber 104

91. Mikaʾel Amba, nave vault and crossing 105

92. Mikaʾel Amba, north transept 106

93. Mikaʾel Amba, eastern lateral aisle 107

94. Mikaʾel Amba, choir 107

95. Mikaʾel Amba, apse 108

96. Mikaʾel Amba, sculpted crosses 109

97. Mikaʾel Amba, south chancel 111

98. Wuqro Cherqos Monastic Complex 112

99. Wuqro Cherqos, facade 114

100. Wuqro Cherqos, facade 114

101. Wuqro Cherqos, narthex ceiling 115

102. Wuqro Cherqos, narthex southwest wall 116

103. Wuqro Cherqos, nave vaults 117

104. Wuqro Cherqos, west end 118

105. Wuqro Cherqos, north transept 119

106. Wuqro Cherqos, south transept 120

107. Wuqro Cherqos, choir dome 121

108. Wuqro Cherqos, pre-2006 restoration chancel holes 122

109. Wuqro Cherqos, apse conch 123

110. Wuqro Cherqos, south pastophoria ceiling 126

111. Mikaʾel Amba, survey post hole, north courtyard
 wall immediately north of the north transept arm 128

112. Mikaʾel Amba, painting detail, northwest wall 130

113. Monastery of St. Antony on the Red Sea, Majestas Domini,
 Chapel of the Four Animals, apse fresco 130

114. Wuqro Cherqos, triumphal arch 138

115. Abu Mena, measured ground plan, fifth- to sixth-century phase 140

116. Church of the Holy Apostles, hypothetical ground plan 142

117. Panagia Ekatontapiliani, Great Church, interior elevation 143

118. Hagia Irene, Synthronon 145

119. Bethlehem, barrel-vaulted cross arms and crossing dome 148

120. Mausoleum of Galla Placidia, north vault 149

121. Bab al-Nasr (Gate of Victory) 150

122. Deir al-Surian, nave and west end 151

123. Deir al-Surian, sanctuary dome 152

124. Qus tomb tower, pumpkin dome 153

125. Fatimid wood panel 154

126. Unidentified Aksumite cruciform drum pillar 156

127. Funerary stele with ankh (looped cross) featuring a human face at the center 157

128. Red Monastery, pediment detail 158

129. Deir al-Surian, wooden sanctuary screen 159

130. Kalenderhane Camii (Theotokos Kyriotissa[?]) 161

131. Basilica of St. Sernin 162

132. Islamic textile scraps from the sacristy of Dabra Dammo 169

133. Stepped cross motif 172

134. Red and white textile fragment 173

135. Masjid-i Tārākhāna, minaret detail 175

136. Abreha wa-Atsbeha, transept vaults 177

137. Schematic of uncircumscribed crosses in Abreha wa-Atsbeha 178

138. The Courtauld Handbag 179
139. Abreha wa-Atsbeha, north lateral aisle 180
140. Textile fragment with diamond shapes and quatrefoils 180
141. Stepped cross textile 181
142. Interlace braid motif 181
143. Qubba Imām al-Dūr, bastion detail 182
144. Textile fragment with alternating Xs and rosettes 183
145. Textile with "checkerboard" pattern 183
146. Zavareh Jami Mosque (Masjid-i Jāmiʿ-i Zavārah), herringbone brickwork 184
147. Monastery church of St. Macarius, "old door" immured in the central haykal screen 184
148. Abreha wa-Atsbeha, dome ornament 186
149. Textile fragment with arches and stylized plants (stylized tree) 186
150. Deir al-Surian, apse stucco detail 187
151. Wooden ciborium from the Hanging Church 188
152. Abreha wa-Atsbeha, narthex south wall 194
153. Beta Emmanuel, nave vault 196
154. Beta Maryam, south arcade spandrel 197
155. Beta Giyorgis, west facade 198
156. Beta Giyorgis, nave and north transept ceiling 200
157. Bethlehem, nave ceiling 201
158. Wuqro Cherqos, southeast lateral support pier, capital detail 203
159. Maryam Dabra Tseyon, hewn processional cross, northeast pier 205

PREFACE

MY LAST VISIT TO TIGRAY, ETHIOPIA, IN January 2020, was a brief and happy trip. I was there for two weeks, just prior to my dissertation defense, having been invited to join the second season of excavations at Maryam Nazret by the Franco-Ethiopian "super team" of Marie-Laure Derat (CNRS), François-Xavier Fauvelle (Collège de France), and Hiluf Berhe (Mekelle University). The excavation was thrilling, and in addition to reconnecting with an elderly farmer I had known for years, I looked forward to future seasons of excavation and independent fieldwork. Yves Gleize, the team's forensic archaeologist, and I had even planned a joint excursion to Tigrayan churches for the following June. In short, I was optimistic about continuing my research in what seemed to be a stable northern Ethiopia.

That year, however, was calamitous. First, a rare locust plague in Ethiopia caused crop loss and famine-like conditions, then the global COVID-19 pandemic depleted the once vibrant tourist industry, while lockdowns strained supply chains and exacerbated food shortages. Finally, from 3 November 2020 to 3 November 2022, the regional government of Tigray and the federal government of Ethiopia became embroiled in a devastating civil war. Although a ceasefire has been negotiated as I review this manuscript (March 2023), over one hundred thousand lives were lost,[1] millions were displaced, and more still are in starvation conditions.[2] Indeed, some of

those individuals to whom my work is indebted, and who are thanked in the pages to follow, are feared dead.[3] Historic sites have been targets, and many of the living, breathing ecclesiastic and monastic centers discussed below may be unrecognizable as the smoke clears.[4]

That said, despite this necessary preface, the book in hand, written as these horrors unfolded, is not a postmortem; I have intentionally kept discussions of the war and its effects to a minimum in order to reflect what was until recent times a burgeoning and hopeful place. Likewise, accounts of contemporary society are as I saw them prior to the war—to be read in the context of a happier future.

This book is based on my identically titled doctoral dissertation, defended at the Department of Art History and Archaeology at Columbia University on 31 January 2020, and rewritten twice, first in 2021 as a Core Lecturer at Columbia University and again in 2022 as an American Council of Learned Societies Fellow. For their role in making this book a reality, I thank Colin Whiting, Nikolaos Kontogiannis, Kathy Sparkes, Ioli Kalavrezou, Peri Bearman, and the entire publication team at Dumbarton Oaks. Colin Whiting

1 This is a somewhat conservative estimate. Jan Nyssen of Ghent University suggests that the loss of life is closer to five hundred thousand.

2 United Nations, "OCHA Ethiopia Situation Report," Situation Report, 22 July 2022. I thank Desta Haileselassie Hagos and Gebrekirstos Gebremeskel of https://tghat.com as well as Jan Nyssen and his "Tigray Digest" listserv for their regular updates about the wartime situation.

3 I have refrained from mentioning their rumored passing until official notice is given.

4 H. Abrha Abay, "Tigray's Ancient Rock-Hewn Churches Are under Threat: Why It Matters," *The Conversation* (blog), 3 May 2022, https://theconversation.com/tigrays-ancient-rock-hewn-churches-are-under-threat-why-it-matters-182026; H. Abrha Abay, "Ethiopia's War in Tigray Risks Wiping Out Centuries of the World's History," *The Conversation* (blog), 29 March 2022, https://theconversation.com/ethiopias-war-in-tigray-risks-wiping-out-centuries-of-the-worlds-history-179829. The eleven hewn churches at Lalibela (Amhara region) were largely spared, according to the recent report of A. Belados and T. Tribe, "The World Heritage Site of Lalibela and Environs: Current Situation," *ICMA News* (Spring 2022): 25–26, https://www.medievalart.org/pastnewsletters.

understood the importance of my project from the beginning, and as an editor consistently challenged and encouraged me to be the best writer I could be. Kathy Sparkes designed the cover of my dreams, while Peri Bearman polished the rough edges of my prose and ensured my Arabic transliterations were accurate. Likewise, without the constructive criticisms of the two anonymous peer reviewers, this manuscript would not have achieved its present version.

Stephen Murray, my doctoral advisor at Columbia, was crucial for this project in every way. As well as being a generous reader and mentor, he was, from the beginning, committed to a geographically diverse Middle Ages and bravely advocated for me and my field of study. It was from him that I learned medieval architecture and *Bauforschung*, and my conclusions reached in this monograph are products of the archaeological method he taught me. This project also benefited from the advice and mentorship of my other faculty advisors at Columbia, Vidya Dehejia, Holger Klein, and Avinoam Shalem. Their respective expertise in Indian, Byzantine, and Islamic art and architecture enriched and contextualized my study immensely. Robert Ousterhout (University of Pennsylvania), my external committee member, likewise brought in-depth knowledge of rupestrian architecture.

While working on this project I benefited from the advice, friendship, or encouragement of many, including Bailey Barnard (Nebraska Wesleyan University), Ruth Barnes (Yale), Alebachew Belay (Debre Berhan University), Elizabeth Bolman (Case Western Reserve), Hannah Borenstein (University of Chicago), Claire Bosc-Tiessé (INHA-CNRS), Peter Brown (Princeton), Gina Buckley (University of Algarve), Isabella Chavez (Fine Arts Museum, San Francisco), Emogene Cataldo (Columbia), David Cardona (Gersh Academy), Stephanie Caruso (Art Institute of Chicago), Sasson Chahanovich (Heidelberg University), Elisa Daniele (UCLA), Walter Denny (University of Massachusetts), Mario di Salvo (Fondation Carlo Leone), Claire Dillon (Columbia), Heather Ecker (Dallas Museum of Art), Kelsey Eldridge (Harvard), Judson Emerick (Pomona), Alexander Ekserdijian (Yale), Tiffany Floyd (University of North Texas), Matthew Gillman (Rockefeller University), Alasdair

Grant (Hamburg University), Navina Haidar (Metropolitan Museum of Art), Timothy Insoll (University of Exeter), Gregor Kalas (University of Tennessee), Steven Kaplan (Hebrew University), Carol Krinsky (NYU), Sumru Krody (Textile Museum), Stephen Leccese (Fordham), Álvaro Luís Lima (University of Florida), Christina Maranci (Harvard), Ignacio Montoya (University of Nevada), Irene Morrison-Moncure (NYU Gallatin), Luca Palozzi (Università di Pisa), Alina Payne (Villa I Tatti), Daniel Ralston (The National Gallery, London), Kristina Richardson (University of Virginia), Héléna Rochard (INHA, Paris), David Russell (*New York Post*), Raymond Silverman (University of Michigan), Jochen Sokoly (Virginia Commonwealth University), Anna Stavrakopoulou (Aristotle University, Thessaloniki), Alexis Wang (Binghamton University), Anaïs Wion (CNRS), and Yu Shen and Yimeng Teng (Charlottesville, VA/Los Angeles, CA). Warren Woodfin (Queens College, CUNY) first introduced me to Byzantium as an undergraduate and is the reason I entered academia. Martina Ambu (ERC HornEast Project) has been an interlocutor for all things Ethiopia. James Nati (then of Yale Divinity School) taught me Geʿez, and my friend Felege-Selam Yirga (University of Tennessee), in whose Knoxville office I wrote much of Chapter 3, helped me retain it. Marie-Laure Derat (CNRS), my advocate and role model, published groundbreaking works to which this book is indebted, and invited me to Paris to present my material in front of the greatest *éthiopisant(e)s*. Father Emmanuel Fritsch (Lyon), whose liturgical dating criterion is so important, has been a dear friend and generous colleague, who shared his fieldwork photos with me and read my dissertation. Michael Gervers (University of Toronto) supplied crucial photos. Henry Louis Gates Jr., of the Hutchins Center for African and African American Research (Harvard), ensured that my fieldwork was funded. Claude Lepage (Sorbonne) invited me into his (and Manijeh Torfeh-Perrot's) Paris home, discussed Ethiopian architecture with me for eight hours, and kindly allowed my reproduction of several images. Herman Bennett (CUNY Graduate Center), Irene Morrison-Moncure (NYU Gallatin), and Ignacio Montoya (University of Nevada), then of the Pipeline fellowship at the CUNY Graduate

Center, made academia a reality for me. Wolbert Smidt (Mekelle University) shared his hard drive and unpublished work on oral history with me. The bones of Chapter 4 were written in Thelma Thomas's (NYU IFA) seminar class. Abebe Tessema (Avery Library, Columbia) facilitated and encouraged my work at the greatest library. For all things technology and photography related, Gabriel Rodriguez and the Media Center at Columbia University have been an enormous help, lending me camera equipment on more than one occasion.

Financially, this project was supported by a number of institutions. Columbia University's Graduate School of Arts and Sciences funded five years of my graduate education, culminating in a happy and productive sixth year as a junior fellow in Byzantine Studies at Dumbarton Oaks. As a Wallace Fellow at Villa I Tatti (Harvard), I was able to spend a delightful semester in Italy. In 2022 I was awarded an ACLS fellowship, which granted me the financial resources, and thus the time, to write the final draft of this monograph. Fieldwork in Ethiopia, Egypt, and Greece, as well as my participation in several international conferences, were largely funded by fieldwork subventions from the Hutchins Center for African and African American Research at Harvard University. Extra archival work in Italy was funded by the Cesare Barbieri Foundation at Trinity College. Final edits to the text were made in Cairo as a postdoctoral fellow at the American Research Center in Egypt while writing my next book, *Inventing Late Antiquity in Fatimid Egypt*.

Research in Ethiopia was enabled through the generosity and assistance of a number of individuals and institutions. Yonas Desta, formerly of the Authority for Research and Conservation of Cultural Heritage in Addis Ababa, gave me permission to photograph objects in storage as well as archival materials, and the current director, Abebaw Ayalew, generously transferred reproduction rights. Nebyat Tekelle and Dawit Kebede,

then at the Tigray Culture and Tourism Bureau, provided logistical support as well as permission letters. Access to sites would have been impossible without these guides, drivers, and regional tourism officers: Abraham (Wuqro), Haftom (Hawzen), Haile Selassie (Wuqro), Hailey Weldegarima (Megab), Kidane (Wuqro), Kiros (Wuqro), Manbara (Hawzen), Nega (Mekelle), and Yemane (Wuqro). In Lalibela and Lasta, I had the good fortune of working with Fikru Woldegiyorgis, who consistently went above and beyond to get me access to monuments and materials. The kind staffs at the Dibora Hotel (Wuqro), Moringa Hotel (Mekelle), and Geralta Lodge (Hawzen) kept me fed during my long stays and made fieldwork a pleasure. In Addis Ababa I had the good fortune of an affiliation with the French Research Center under the enlightened stewardship of Thomas Guindeuil, Amélie Chekroun, and Clement Ménard.

Fieldwork in Egypt was facilitated (and later funded) through the American Research Center in Egypt, particularly through the hard work of Helmy Samir, Djodi Deutsch, Yasmin el Shazly, and most of all, Mary Sadek and Ahmed Hassan. Archival work in Italy was facilitated by archivists Patrizia Pampana (Società Geografica Italiana, Rome), Paola Cagiano (Accademia dei Lincei, Rome), Paola Busonero (Ministero degli Affari Esteri, Rome), Roberto Ferrari (AREF Brescia), Lia Corna (Museo delle Storie, Bergamo), and Senna Luciano (Touring Club Italiano, Milan).

Last but not least I thank my family. My mother Esther and late father Eric, in whose Queens, NY, home I wrote this book, my late grandmother Leah, my late uncle Thomas, and my siblings Evan, Sarah, and Stefan—all of whom supported my academic pursuits even as they took me frequently away. Finally, thank you to my partner, Binxin Xie, who, in addition to being there from the beginning, worked with me to produce the professional to-scale ground plans found throughout the volume.

NOTE ON TRANSLITERATION AND DATING

FOR ETHIOPIC NAMES AND PLACES I USE either common English usage (i.e., Lalibela, Mekelle) or, for more uncommon names, the spelling of the *Encyclopaedia Aethiopica* (with simplified orthography). At the first instance of each Ethiopic word or name, I provide full transliteration in parentheses following the system used in the *Encyclopaedia Aethiopica*. Arabic proper names, italicized terms, and bibliographic information are transliterated according to the method used by the *International Journal of Middle Eastern Studies*; Arabic dynasties (e.g., Fatimids, Sulayhids) and place names follow common English usage.

All dates are CE, unless specifically noted.

INTRODUCTION

A Parallel History: Post-Aksumite Tigray and the Venetian Republic in the Eleventh Century

Take two churches from the second half of the eleventh century, the basilica of San Marco (St. Mark's) built in Venice in 1063 (Fig. 1) and the church of Abreha wa-Atsbeha (Abrəha wä-Aṣbəḥa, Fig. 2) built in Ethiopia's northernmost province around the same time. Notwithstanding their main purpose as places of worship, these buildings could scarcely be more different. San Marco is one of the most visited and accessible churches in Europe; its fabulous cosmatesque floor cracks under the weight of five million tourists per annum. By contrast, Abreha wa-Atsbeha, hewn into living sandstone, is situated in a particularly rural village in eastern Tigray (Təgray) province. Even as one of the most visited tourist destinations in the region prior to the Tigray War, the civil war that enveloped the region from 2020 to 2022, Abreha wa-Atsbeha received, at most, a few thousand visitors a year.

Indeed, it would be nearly impossible to find a Byzantine art historian unfamiliar with Venice's great church, yet quite unusual to find one aware of Abreha wa-Atsbeha.[1] Built by different

societies and located thousands of kilometers apart, it may surprise the reader to find that both churches are quite similar. This is not because of any contact between the artisans or the societies that built them, but because of their similar ideological underpinnings: both regional powers looked toward sixth-century Byzantium to understand their eleventh-century circumstances.

The story of San Marco is well known. Built on the western fringe of the Byzantine Empire, St. Mark's was a royal monument, commissioned by the upstart mercantile dukes (doges) of the Venetian Republic. Newly enriched by the trade in exotic cloths and spices between the Levant and the Adriatic,[2] in 1063 the doge Domenico Carini set about having a monument constructed to better house the relics of St. Mark the apostle (allegedly taken from Egypt in the ninth century). The existing church was rebuilt with an aisled cruciform layout, an ideologically loaded form, mirroring the Justinianic Church of the Holy Apostles in Constantinople.[3] The

1 Roger Stalley, the great art historian of early medieval Ireland, was well aware of it, however; see his review of R. Plant, *Architecture of the Tigre, Ethiopia*, in *NEAS* 10.1 (1988): 99–101.

2 D. Jacoby, "Venetian Commercial Expansion in the Eastern Mediterranean, 8th–11th Centuries," in *Byzantine Trade, 4th–12th Centuries: The Archaeology of Local, Regional and International Exchange. Papers of the Thirty-Eighth Spring Symposium of Byzantine Studies, St. John's College, University of Oxford, March 2004*, ed. M. M. Mango (Farnham, UK, 2009), 371–91.

3 T. Papacostas, "The Medieval Progeny of the Holy Apostles: Trails of Architectural Imitation across the Mediterranean,"

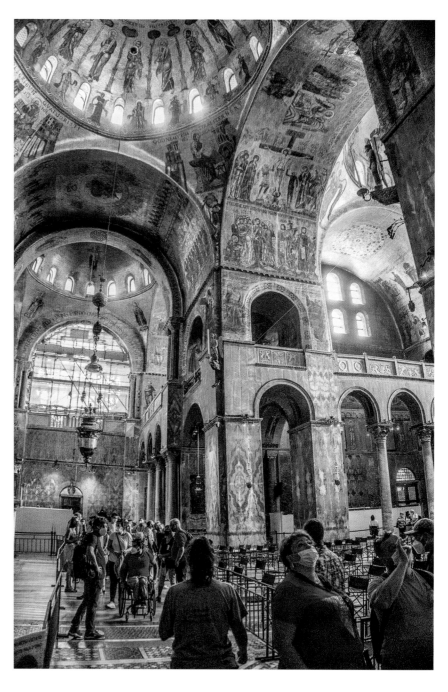

Figure 1.
San Marco, southeast
transept elevation,
Venice, Italy, 1063.
Photograph by author.

fabric, however, was local—Venetian bricks were erected concentrically over formwork rather than pitched (corbeled with successively inclined bricks, in the Middle Byzantine manner), and the high altar was moved from the crossing to the apse in the occidental style of axial worship.[4]

Nonetheless, the message was clear: the relics of the apostle Mark were to be displayed here, just like those of the holy apostles were displayed in

in *The Byzantine World*, ed. P. Stephenson (London, 2010), 386–405.

4 R. G. Ousterhout, *Eastern Medieval Architecture: The Building Traditions of Byzantium and Neighboring Lands*, Onassis Series

in Hellenic Culture (New York, 2019), 516. On Byzantine dome construction, see R. Ousterhout, *Master Builders of Byzantium* (Princeton, 1999), 230–33; E. Rabasa-Díaz et al., "Geographic and Chronological Extent of Brick Vaults by Slices," in *History of Construction Cultures: Proceedings of the 7th International Congress on Construction History (7ICCH 2021), July 12–16, 2021, Lisbon, Portugal*, vol. 1, ed. J. Mascarenhas-Mateus and A. P. Pires (London, 2021), 126–33, at 126–28.

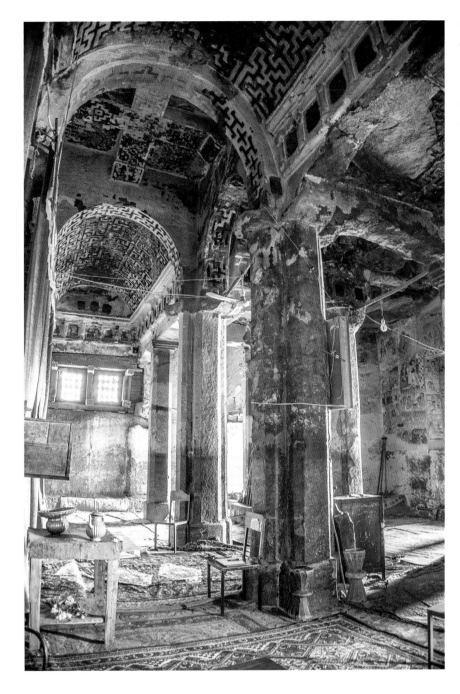

Figure 2.
Abreha wa-Atsbeha,
interior viewed from
the northeast lateral
aisle, town of Abreha
wa-Atsbeha, Tigray,
Ethiopia. Photograph
by author.

the imperial mausoleum in Constantinople.[5] In emulation of the ecumenical style of the neighboring Byzantines, the church was extensively mosaicked; after the sack of Constantinople during the Fourth Crusade, in 1204, as if by a

magnetic force, its façade became an open-air vitrine of plundered imperial spolia.[6]

The story of Abreha wa-Atsbeha is similar, albeit less precise, and will be reconstructed here briefly (for further details, see Chaps. 2–4). Built

5 F. Barry, "*Disiecta Membra*: Ranieri Zeno, the Imitation of Constantinople, the *Spolia* Style, and Justice at San Marco," in *San Marco, Byzantium, and the Myths of Venice*, ed. H. Maguire and R. S. Nelson (Washington, DC, 2010), 7–62, at 7.

6 On the mosaics, see O. Demus, *The Mosaics of San Marco in Venice*, 2 vols. in 4 (Chicago, 1984). On the use of spolia, see Barry, "*Disiecta Membra.*" On the "spolia style" of Venetian reliquaries, see H. A. Klein, "Refashioning Byzantium in Venice, ca. 1200–1400," in Maguire and Nelson, *San Marco, Byzantium*, 193–226.

on the southernmost fringe of the Ismaili Fatimid caliphate (r. 909–1171) in northern Ethiopia, it was, like San Marco, most likely a royal monument, built by mercantile elites (Ḥaṣani), that is, petty kings or chieftains who ruled northern Ethiopia following the collapse of the late antique Aksumite state. Enriched by trade with the Fatimids in enslaved people, salt, pelts, and civet musk, the reigning Hatsani built this church (alongside two related churches: Wuqro Cherqos [Wəqro Čerqos] and Mika'el Amba) in the late eleventh century as a new Christian center. Like San Marco, Abreha wa-Atsbeha was built as an aisled cruciform church, albeit entirely refracted through local (as well as Fatimid Egyptian) building traditions.[7] And, like San Marco, it was an ideologically loaded building, although Abreha wa-Atsbeha only began housing relics as of the seventeenth or eighteenth century. Just as Byzantine (or Byzantinizing) mosaics cladded the fabric of San Marco, exotic cloth patterns, styled after the liturgical textiles imported into Ethiopia via the Indian Ocean trade, adorned Abreha wa-Atsbeha.

But unlike the swampy lagoons of the Adriatic, Tigray was in Justinian's time (r. 527–565) an early epicenter of Christian building. Christian Aksumite elites were in direct dialogue with Constantinople, and it was from northern Ethiopia, lorded over by the Aksumite Empire (ca. 100–600), that the sixth-century Byzantines bought their eastern goods (silks and spices) and sent Proconnesian marble screens on the imperial fisc.

Although the specifics behind the date, form, and function of Abreha wa-Atsbeha will be spelled out below, these two monuments present a remarkably similar history, despite being constructed on opposite ends of the Byzantine world. The architecture of post-Aksumite Tigray and that of the early Venetian Republic was ultimately that of aspirational middlemen—brokers and suppliers of goods on the peripheries of world empires who nursed larger ambitions. Although neither polity was a superpower when it built

its eleventh-century masterpieces (both powers would need to wait for the thirteenth century for that), we find here shared evidence of an aspirational worldview expressed through architecture.[8] In both cases, elites looked back to sixth-century Byzantium (real or imagined) to articulate their burgeoning spiritual and economic power. Aisled cruciform churches were the lens through which they did it.

Suffice it to say therefore that the underappreciated architecture of northern Ethiopia should be considered at once familiar and new to scholars of Byzantine art and architecture. By opening up the remarkable churches of Tigray to wider audiences, and in a comparative perspective, I hope to model new possibilities for a more inclusive study of the Eastern Christian world.

<center>+₊+</center>

This is the first monograph to treat three closely linked buildings in the region of Tigray, Ethiopia: the churches Abreha wa-Atsbeha (Fig. 3), Wuqro Cherqos (Fig. 4), and Mika'el Amba (Fig. 5). Despite having been identified as a set as early as the 1940s, these monuments remain largely undocumented, undated, and little known outside the field of Ethiopian Studies. However, as I will suggest, they should be understood as some of the most important monuments from the Middle Ages.[9] They were a millennial revival, the first and only localization of Early Byzantine aisled cruciform churches in Ethiopia, the first churches there to incorporate vaulting, and the only monuments to do so in the service of centralized spatial hierarchy. Such construction projects were revolutionary, reversing a trend of otherwise

7 But see, however, the use of Islamic architectural motifs in the later, thirteenth-century phase at San Marco: T. Dale, "Cultural Hybridity in Medieval Venice: Reinventing the East at San Marco after the Fourth Crusade," in Maguire and Nelson, *San Marco, Byzantium,* 151–91.

8 For ideological underpinnings of the Venetian Republic, see D. Pincus, "Venice and the Two Romes: Byzantium and Rome as a Double Heritage in Venetian Cultural Politics," *Artibus et Historiae* 13.26 (1992): 101–14.

9 How to periodize the era between ca. 400 and 1500 in non-Western contexts is hotly debated. Though I have chosen to employ the term "medieval," this is not universally accepted. On the periodization of Ethiopian history, see S. Kaplan, "The Periodization of Ethiopian History: Reflections, Questions, and Some Modest Suggestions," *History in Africa,* forthcoming. See also for analogous issues in the Islamicate world (in which Medieval Ethiopia may also be bracketed), D. M. Varisco, "Making 'Medieval' Islam Meaningful," *Medieval Encounters* 13 (2007): 385–412. Cf. T. Bauer, *Warum es kein islamisches Mittelalter gab: Das Erbe der Antike und der Orient* (Munich, 2018).

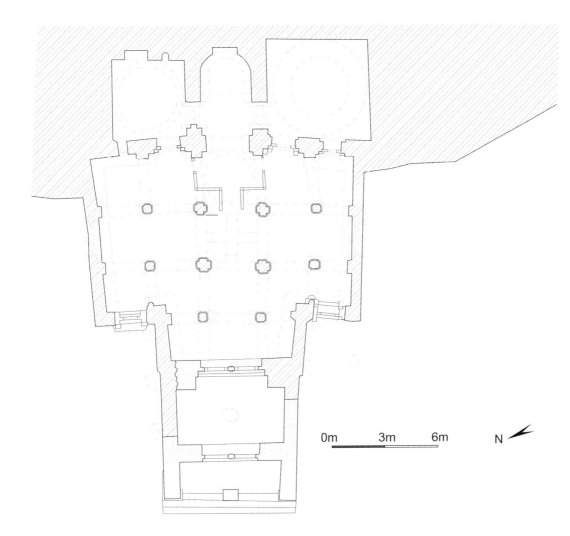

Figure 3.
Abreha wa-Atsbeha,
1:100 scale plan, Tigray,
Ethiopia. Plan by
author and Binxin Xie,
redrawn and modified
after C. Lepage, "Une
origine possible des
églises monolithiques
de l'Éthiopie ancienne,"
*Comptes rendus des
séances de l'Académie
des Inscriptions et Belles-
Lettres* 141.1 (1997): 205.

0m 3m 6m N

small-scale and conservative hypogean architecture in the region in favor of large, innovative, and modular buildings. Built in the late eleventh century, their local construction connected with what was happening elsewhere around the globe. Ethiopian masons called upon time-tested rock-cutting techniques and used their skills to carve innovative churches in rock on an unparalleled scale. Resuscitated pilgrimage networks brought Ethiopian Christians to far-flung locales such as Constantinople and Asia Minor, while participation in Islamic mercantile channels brought precious textiles from South Asia into Ethiopia. Pilgrimage networks allowed artisans to revisit architectural types abandoned for five hundred years, while imported cloths inspired transmaterial conceptions of architectural space. For a millennium the churches were vessels for a changing liturgy as well as new forms of popular piety. Although built in what has been popularly

termed a "dark age," these structures reveal that the eleventh century in northern Ethiopia was in fact vibrant and international. Byzantinists, take note: the great Ethiopian cruciform churches of the first millennium may be profitably compared with contemporaneous architectural movements in the Eastern Mediterranean and beyond.

Based on exhaustive site study and fieldwork in Ethiopia and Egypt between 2016 and 2019 as well as archival work in Ethiopia, Italy, and the United States, my study attempts, largely in the absence of written sources, to date and contextualize the buildings in both the history of Ethiopia and the broader history of Eastern Mediterranean architecture. All of my work in Tigray was completed under the oversight of the Tigray Cultural and Tourism Bureau in Mekelle (Mäqäla), then led by Dawit Kebede. The bureau supplied me with ground transportation and licensed guides to facilitate access and

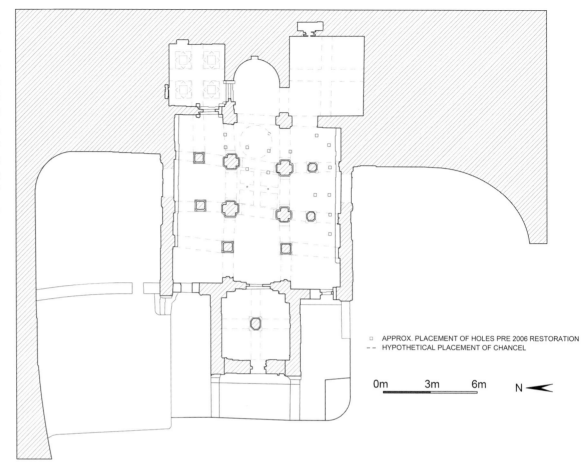

Figure 4.
Wuqro Cherqos, 1:100 scale plan, Wuqro, Tigray, Ethiopia. Plan by author and Binxin Xie, redrawn and modified after J. Gire and R. Schneider, "Etude des églises rupestres du Tigré: Premiers résultats de la mission 1970," *Abbay* 1 (1970): pl. 7.

☐ APPROX. PLACEMENT OF HOLES PRE 2006 RESTORATION
-- HYPOTHETICAL PLACEMENT OF CHANCEL

0m 3m 6m N◄

serve as translators. As these churches are active places of worship and under parish jurisdiction, I was not permitted to excavate or procure samples (for carbon-14 dating). My affiliation with the bureau as well as respect for the clergy (and regular attendance at the liturgy) granted me free rein to survey the building interiors, including photographing areas that were off-limits to laity (see Chap. 2), and treasury collections. All measurements and documentation were made using a handheld laser and are my own work (unless otherwise noted). Oral testimony, which flavors much of the monograph, was in all cases not solicited but volunteered, usually because of the sheer amount of time I spent at these various churches.

In my text I advance three interlinked conclusions about the buildings. The first concerns the date. I locate these churches in the late eleventh century, with a shared groundbreaking and system of patronage between 1000 and 1150 (more specifically, 1089–1094). The second reevaluates

the building types. Long identified as "cross-in-square" churches, I illustrate how this typological connection with Middle Byzantium is misleading. Rather, I suggest that the churches are local reinventions of earlier established, aisled cruciform basilicas, here called Tigrayan cruciform churches. Third, having established a shared eleventh-century date, I find that these monuments were the products of northern Ethiopian Christian elites (early Zagwe?), who were closely aligned with the Shi'i Fatimid caliphate. Their ground plans and use of vaulting presented a shared memory of late antiquity (ca. 350–700), of both the distant past and of monuments encountered anew by the mechanism of pilgrimage. They exhibited both a continuation of local building traditions and select adaptations of forms from Fatimid Egypt and coastal South Asia. Tigrayan cruciform churches, for all their uniqueness, may in fact be understood as an experimental form of prestige architecture from early medieval Ethiopia.

APPROX. 55 METERS AWAY

0m 3m 6m N

Figure 5.
Mika'el Amba, 1:100
scale plan, Atsbi,
Tigray, Ethiopia.
Plan by author and
Binxin Xie; redrawn
and modified
after Z. Thiessen,
*Yemrehannä Krestos
Church: Documenting
Cultural Heritage in
Ethiopia* (Stockholm,
2010), 21.

Defining Tigray and Ethiopia

The province Tigray (Fig. 6) is the northern-most part of the Federal Democratic Republic of Ethiopia in Eastern Africa. It is a small region, with the Danakil Depression (the opening of the east African rift to the Red Sea) on its east, and the Takkaze (Täkkäze) River on its south and west. Eastern Tigray is highland, defined by jagged escarpments of semi-arid sandstone massifs (Fig. 7), while western Tigray is a lowland plain.[10] The economy there, by and large, is one of subsistence agriculture. The high altitude and consistent rainy season have allowed a perpetual cultivation of cereals, mostly teff (indigenous to Ethiopia), as well as livestock husbandry, such as zebu (Asiatic cattle), donkeys, and fat-tailed sheep. The people of Tigray are overwhelmingly Orthodox Christian and practice a distinct form of Christianity present in the region since the fourth century. Indeed, it remains a Christian center to the present day (Fig. 8), with a veritable repository of churches, including a large number of hypogea. Recent estimates number at least two hundred such churches in Tigray, which are hewn out of sheltered mesas (locally called in the singular, *amba*).[11]

10 P. Billi, *Landscapes and Landforms of Ethiopia* (Dordrecht, 2015); Y. Abul-Haggag, *A Contribution to the Physiography of Northern Ethiopia* (London, 1961).

11 Tsegray Hagos, "Breathtaking Rock-Hewn Churches in Eastern Tigray," *The Ethiopian Herald*, 16 February 2018, sec. Technology, https://web.archive.org/web/20180706001143/ http://www.ethpress.gov.et/herald/index.php/technology/ item/10942-breathtaking-rock-hewn-churches-in-eastern-tigray.

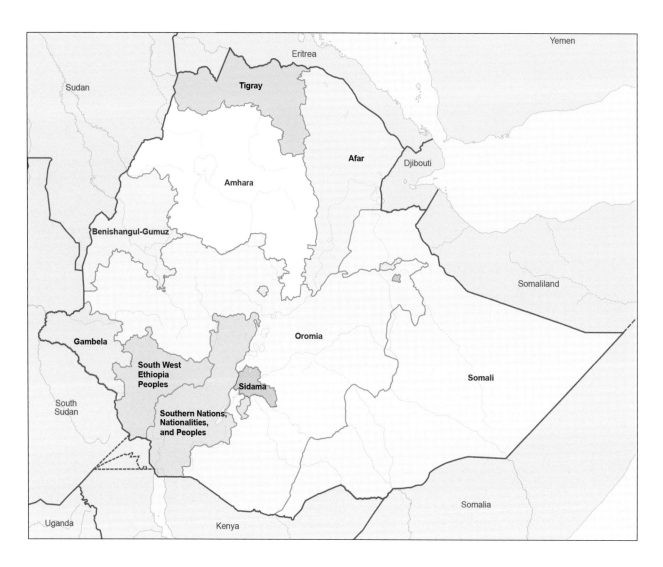

Figure 6.
Modern Ethiopia
with political
zones. Map by
NordNordWest,
with modifications
by author, courtesy
of Wikimedia
Commons.

This is only one region of the Federal Democratic Republic of Ethiopia, however (see Fig. 6), which is the largest country in the Horn of Africa and has the second-largest population on the continent after Nigeria. Although the Tigray and Amhara regions, in the north and center of the country respectively, bear a number of cohesive cultural and geographic similarities, the federal state as it exists today is near unparalleled in its diversity. The Ethiopian rift valley (Danakil Depression), a land of sulfurous fumes and lava flows, sizzles under daily temperatures above 30°C, while snowfall graces the peaks of the adjacent Semien Mountain range (~4500 m, in the central highlands).[12] In the Gambella province, to the far

southwest, one finds equatorial jungles and banana plantations; in the far east, nomadic cattle herders ply the Somali region's desert-like landscape. The federal state bearing the name Ethiopia is inherently unwieldy, having only existed for thirty years. Ethiopia's fractured shape is a somewhat recent product of the wars of conquest by Menelik (Mənilək) II, a profoundly influential Ethiopian emperor of the late nineteenth and early twentieth centuries (r. 1889–1913).[13]

Despite my standard use of the term Ethiopia to describe the historical Christian civilizations of the horn of Africa, this name is somewhat misleading. It is derived from the Greek *Αἰθιοπία*

12 F. Barberi et al., "Evolution of the Danakil Depression (Afar, Ethiopia) in Light of Radiometric Age Determinations," *Journal of Geology* 80.6 (1972): 720–29.

13 R. Caulk, *"Between the Jaws of Hyenas": A Diplomatic History of Ethiopia, 1876–1896,* ed. B. Zewde (Wiesbaden, 2002); S. Rubenson, *The Survival of Ethiopian Independence* (London, 1976).

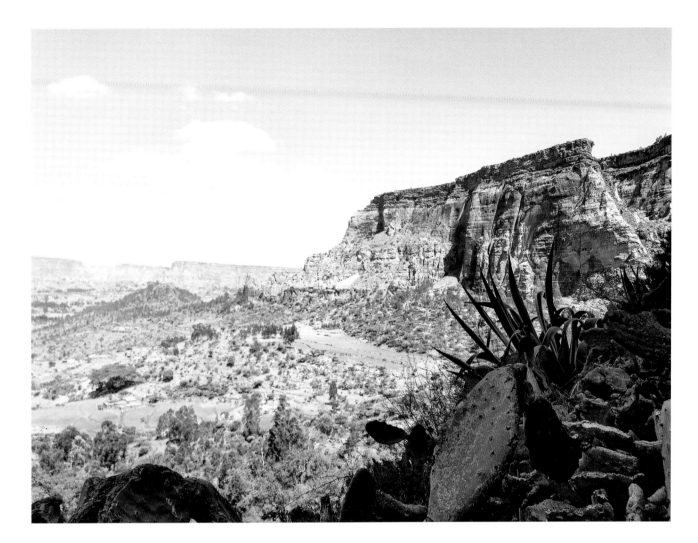

or "Land of the Burned-Face People," which was used to refer to all of Africa south of the Sahara as well as India.[14] The name Abyssinia is likely familiar to some readers—it was used as a general geographic designation for the country until around 1950, when it was abandoned (partially initiated by the reigning emperor, Haile Selassie [Ḥaylä Śəllase], r. 1930–1974) in favor of the more inclusive Ethiopia.[15] The term Abyssinia is the Anglicization of Habesha (ሐበሻ, *Ḥabäša*), which in both the Tigrayan language (Tigrinya, Təgrəñña) and Amharic is how the Orthodox Christian highland peoples of Ethiopia refer to themselves. In the Amhara and Tigray regions, the Habesha are generally characterized by their shared practice of (Miaphysite) Orthodox Christianity, use of Semitic languages, and abstinence from consuming "unclean animals," in an analogous manner to Jewish and Muslim prohibitions.[16] With few exceptions, these Semitic-speaking peoples from the north and central highlands ruled Ethiopia up to the swearing-in of Prime Minister Abiy Ahmed, an ethnic Oromo from the southern highlands,

Figure 7.
Mountain range near Addigrat, Tigray, Ethiopia. Photograph by author.

14 P. Schneider, *L'Éthiopie et l'Inde: Interférences et confusions aux extrémités du monde antique (VIIIᵉ siècle avant J.-C.– VIᵉ siècle après J.-C.)*, Collection de l'École française de Rome 335 (Rome, 2004); A. Bekerie, "Ethiopica: Some Historical Reflections on the Origin of the Word Ethiopia," *International Journal of Ethiopian Studies* 1.2 (2004): 110–21; J. Sorenson, "History and Identity in the Horn of Africa," *Dialectical Anthropology* 17.3 (1992): 227–52.

15 W. L. Belcher, *Abyssinia's Samuel Johnson: Ethiopian Thought in the Making of an English Author* (New York, 2012), 23–41.

16 T. Guindeuil, "What Do Christians (Not) Eat: Food Taboos and the Ethiopian Christian Community (13th–18th Centuries)," *AÉ* 29 (2014): 59–82; T. Guindeuil, "Alimentation, cuisine et ordre social dans le royaume d'Éthiopie (XIIᵉ–XIXᵉ siècle)" (PhD diss, Sorbonne University–Paris 1, 2012).

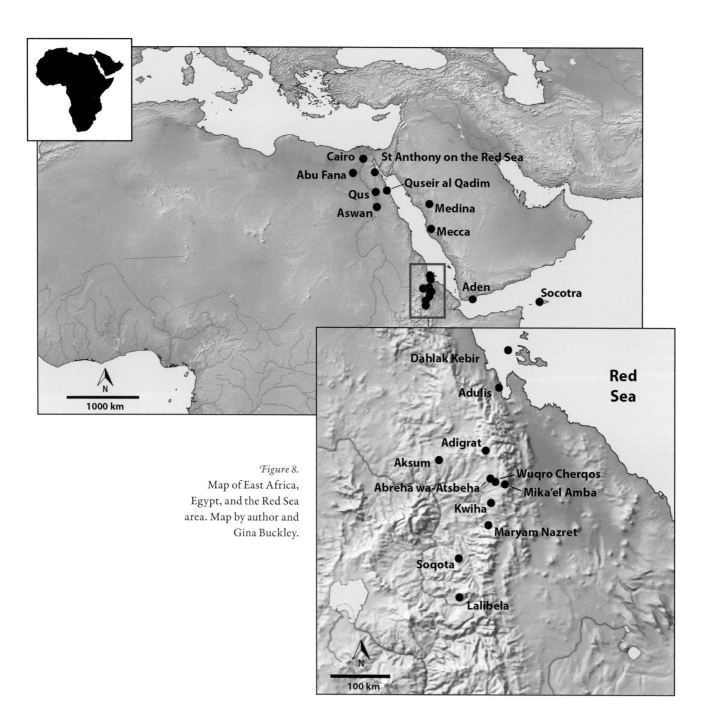

Figure 8.
Map of East Africa,
Egypt, and the Red Sea
area. Map by author and
Gina Buckley.

in 2018.[17] Despite the fact that the Habesha are a minority in the modern federal state, since the European Enlightenment the field of Ethiopian Studies has maintained its Christian, highland

focus.[18] Without as yet a sea change in the foci of this now-burgeoning field, for the purposes of this study "Abyssinia" may as well be used.

17 O. Mubangizi, "Dr. Abiy Ahmed's Ethiopia: Anatomy of an African Enigmatic Polity," *Pambazuka News*, 15 May 2018, https://www.pambazuka.org/node/99007. For the critique of such ethnic boundaries in the study of modern Ethiopian history, see B. J. Yates, "Ethnicity as a Hindrance for Understanding Ethiopian History: An Argument Against an Ethnic Late Nineteenth Century," *History in Africa* 44 (2017): 101–31.

18 In terms of art history, the only survey text so far that challenges this paradigm is R. A. Silverman, ed., *Ethiopia: Traditions of Creativity* (East Lansing, MI, 1999). For the historiographical critique of this emphasis, see M. Kebede, "Eurocentrism and Ethiopian Historiography: Deconstructing Semitization," *International Journal of Ethiopian Studies* 1.1 (2003): 1–19.

A Brief History of Ethiopian Civilization and Christianity

The Ethiopian highlands, with a climate favorable to draft animals and crop cultivation, were long home to advanced agriculture and centralized state structures (see Table 1).[19] Although the South Arabian cultural impact has long been overstated, alongside autochthonous lithic tools and pottery, we find, from the first millennium BCE, several examples of well-preserved South Arabian materials in Tigray as well.[20] Around the first century, Tigray was the heartland of the so-called Aksumite Empire, based around a capital city in the west Tigrayan highlands (Aksum) and a Red Sea port at Adulis (now in Eritrea).[21] Though comparatively little is known about this civilization, largely due to a lack of archaeological study, it was a powerful trading empire (or a confederacy of city-states), and was noted as such in the annals of its neighbors.[22] Taking advantage of the Ethiopian highlands' access to the Red Sea, the Aksumite Empire supplied the Roman Empire with elephant ivory and salt from the Danakil Depression as well as frankincense and

myrrh.[23] Most importantly, however, Aksum was an international broker. The highlands' proximity to the Red Sea allowed it to impose tariffs on spices and silk from India en route to the Mediterranean, a practice it supported with the local minting of coins.[24] Territorially, the Aksumite Empire was generally restricted to Tigray and Eritrea, although there were several moments in its history when it occupied areas as far afield as the Nile valley and Arabia.[25] The largest freestanding monoliths of the antique world were erected under the Aksumites as well, sculpted with discrete stories so as to resemble

19 D. W. Phillipson, *Foundations of an African Civilisation: Aksum and the Northern Horn, 1000 BC–AD 1300* (Woodbridge, UK, 2012), 9–44.

20 R. Fattovich, "Aksum and the Habashat: State and Ethnicity in Ancient Northern Ethiopia and Eritrea," Working Papers in African Studies 228 (Boston, 2000), 1–24. On the Almaqah temples of Yeha, and the more recently discovered foundation near Wuqro, see C. J. Robin and A. de Maigret, "Le Grand Temple de Yeha (Tigray, Éthiopie), après la première campagne de fouilles de la Mission française (1998)," *CRAI* 142.3 (1998): 737–98; P. Wolf and U. Nowotnick, "The Almaqah Temple of Meqaber Ga'ewa near Wuqro (Tigray, Ethiopia)," *PSAS* 40 (2009): 367–80.

21 For introductions to Aksumite civilization, see Phillipson, *Foundations of an African Civilisation*, 47–207; S. C. Munro-Hay, *Aksum: An African Civilization of Late Antiquity* (Edinburgh, 1991); P. Piovanelli, "Reconstructing the Social and Cultural History of the Aksumite Kingdom: Some Methodological Reflections," in *Inside and Out: Interactions between Rome and the Peoples on the Arabian and Egyptian Frontiers in Late Antiquity*, ed. J. H. F. Dijkstra and G. Fisher (Leuven, 2014), 331–52.

22 Munro-Hay, *Aksum*, 166–80. Indeed, given the material culture evidence from "Aksumite" cities such as Adulis, Anza, and Matara, the case could be made that there was instead a loose confederation of northern Ethiopian city-states; see M.-L. Derat, *L'énigme d'une dynastie sainte et usurpatrice dans le royaume chrétien d'Éthiopie du XIe au XIIIe siècle* (Turnhout, 2018), 89, esp. n. 16. See also M. Wendowski and H. Ziegert, "Aksum at the Transition to Christianity," *AÉ* 19 (2003): 215–30.

23 S. Munro-Hay, "The Foreign Trade of the Aksumite Port of Adulis," *Azania: Archaeological Research in Africa* 17.1 (1982): 107–25; H. S. Woldekiros, "The Route Most Traveled: The Afar Salt Trail, North Ethiopia," *Chungara: Revista de Antropología Chilena* 51.1 (2019): 95–110; L. Sernicola and L. Phillipson, "Aksum's Regional Trade: New Evidence from Archaeological Survey," *Azania: Archaeological Research in Africa* 46.2 (2011): 190–204; N. Groom, *Frankincense and Myrrh: A Study of the Arabian Incense Trade* (London, 1981). Close to the salt flats of the Danakil, in contemporary Eritrea, Aksumite inscriptions have been found from the sixth or seventh century; see C. Conti Rossini, "Documenti per l'archeologia eritrea nella bassa Valle dei Barca," *RRAL*, ser. 5, 12.4 (1903): 139–50.

24 See W. H. Schoff, trans., *The Periplus of the Erythraean Sea: Travel and Trade in the Indian Ocean by a Merchant of the First Century* (New York, 1912) (for the Greek critical edition, B. Fabricius, ed., *Arriani Alexandrini periplus maris erythraei* [Dresden, 1849]); for a sixth-century account of Red Sea trade, see J. M. McCrindle, trans., *The Christian Topography of Cosmas Indicopleustes* (repr. New York, 2010). A scan of the manuscript on which the translation is based can be found on the Vatican Library website: https://digi.vatlib.it/view/MSS_Vat.gr.699. In the cave of Hoq in Socotra, an island off the Indian Ocean coast of Yemen, are preserved a number of inscriptions from India traders in late antiquity, including Aksumite inscriptions in Ge'ez; see I. Strauch, *Foreign Sailors on Socotra: The Inscriptions and Drawings from the Cave Hoq* (Bremen, 2012); I. Strauch and M. D. Bukharin, "Indian Inscriptions from the Cave Ḥōq on Suquṭrā (Yemen)," *Annali: Università degli studi di Napoli "L'Orientale"* 64 (2004): 121–38; A. de Saxcé, "Trade and Cross-Cultural Contacts in Sri Lanka and South India during Late Antiquity (6th–10th Centuries)," *Heritage: Journal of Multidisciplinary Studies in Archaeology* 4 (2016): 121–59. For coins, see W. Hahn and R. Keck, *Münzgeschichte der Akßumitenkönige in der Spätantike*, Veröffentlichungen des Instituts für Numismatik und Geldgeschichte der Universität Wien 21 (Vienna, 2020). On Byzantium and the India trade, see most recently R. Darley, "Seen from across the Sea: India in the Byzantine Worldview," in *Global Byzantium: Papers from the Fiftieth Spring Symposium of Byzantine Studies*, ed. L. Brubaker, R. Darley, and D. Reynolds (Abingdon, UK, 2022), 9–38.

25 For relations with South Arabia and Nubia, see G. Hatke, *Aksum and Nubia: Warfare, Commerce, and Political Fictions in Ancient Northeast Africa* (New York, 2013); M. 'A. Bāfaqīh, *L'unification du Yémen antique: La lutte entre Saba', Ḥimyar et le Ḥaḍramawt du Ier au IIIème siècle de l'ère chrétienne* (Paris, 1990).

Table 1. Chronological Overview

DATE RANGE	STATE STRUCTURE
1000 BCE to 100 CE[1]	Pre-Aksumite Society (possibly D'mt?)
100 to 600/700	The Aksumite Empire
700 to 1100	Hatsani States (Post-Aksumite/Early Zagwe?)
1100 to 1270	Zagwe Dynasty
1270 to 1974	"Solomonic" Empire

1 All date ranges are approximate and not universally accepted, aside from the relatively securely dated "Solomonic" dynasty.

great towers.[26] Although now collapsed due to its precarious shape (Fig. 9)—or intentionally toppled in the medieval period—the largest of these was originally some 30 meters tall.[27] For tombs, the Aksumites hewed chambers out of the sandstone bedrock (or they were plastered with grit to appear rock-hewn).[28] Victories and other salient events were declared with public texts, written in a variety of languages including Geʿez (Gəʿəz or Classical Ethiopic, the language of the Aksumite Empire), Greek, Pseudo-South Arabian, and South Arabian.[29]

Most important for the region's later history was the religious conversion of the Aksumite emperors. An ally of Byzantium, some of the country's elites were Christianized in the fourth century, eventually in the Miaphysite doctrine, probably due to affiliations with Alexandria and the then-non-Chalcedonian Byzantine state under Emperor Anastasius (though the specifics of this conversion narrative are imprecise).[30]

Ethiopian Christianity fell under the Alexandrian patriarchate until 1959, when it was granted autocephaly, although the mother church's ecclesiastical and cultural influence varied over time.[31] Given the general absence of material-culture remains for early Christianity in Aksum, scholars, most importantly Wolfgang Hahn, have looked to coinage to support the fourth-century conversion. While the crescent and star were previously used as religious insignia on Aksumite coins, they were replaced by a Greek cross after the reign of Ezana in the mid-fourth century.[32] On the basis of this, and the presence of ecclesiastical remains only in urban centers, it appears that Christianity was a top-down phenomenon, perhaps only superficially embraced by the court for the purposes of trade.

Aksum reached its relative zenith during the sixth century. Byzantium, which at the time was waging a war with Persia over the maritime silk route, found a close ally in its Aksumite coreligionists against the Persian-aligned Himyarites in Yemen.[33] However, due to circumstances not yet

26 D. W. Phillipson, ed., *The Monuments of Aksum: An Illustrated Account* (Addis Ababa, 1997), 11–43.

27 For the most recent research on the subject, see B. Poissonnier, "The Giant Stelae of Aksum in the Light of the 1999 Excavations," *P@lethnology* 4 (2012): 49–86.

28 D. W. Phillipson, *Archaeology at Aksum, Ethiopia, 1993–7*, 2 vols. (London, 2000), 1:165–79, 2:425–31; J. Tipper, "The Tomb of the Brick Arches: Structure and Stratigraphy," in ibid., 1:31–57.

29 É. Bernand, A. J. Drewes, and R. Schneider, *Recueil des inscriptions de l'Éthiopie des périodes pré-axoumite et axoumite*, 3 vols. in 4 (Paris and Wiesbaden, 1991–2019); A. Bausi, M. J. Harrower, and I. A. Dumitru, "The Gəʿəz Inscriptions from Beta Samāʿti (Beta Samati)," *BO* 77.1 (2020): 34–56.

30 The conversion of Ethiopia is typically ascribed a semi-legendary origin, where a Christian named Frumentius (Abba Salāma) was shipwrecked and enslaved by the Aksumite court, but eventually converted the reigning Aksumite king Ezana to Christianity. This origin story should, however, be

taken with caution. The best overview of Aksumite conversion is H. Brakmann, *Τὸ παρὰ τοῖς βαρβάροις ἔργον θεῖον: Die Einwurzelung der Kirche im spätantiken Reich von Aksum* (Bonn, 1994).

31 H. Erlich, "Identity and Church: Ethiopian–Egyptian Dialogue, 1924–59," *IJMES* 32.1 (2000): 23–46. Often a relationship with Syria-Palestine is argued in literature on Ethiopian Christianity, but there appears to be little evidence for this. See P. Marrassini, "Some Considerations on the Problem of the 'Syriac Influences' on Aksumite Ethiopia," *JES* 23 (1990): 35–46.

32 W. Hahn, "Symbols of Pagan and Christian Worship on Aksumite Coins: Remarks to the History of Religions in Ethiopia as Documented by Its Coinage," *Nubica et Aethiopica* 4/5 (1999): 431–54.

33 G. W. Bowersock, *The Throne of Adulis: Red Sea Wars on the Eve of Islam* (New York, 2013). See also A. Berger, ed.

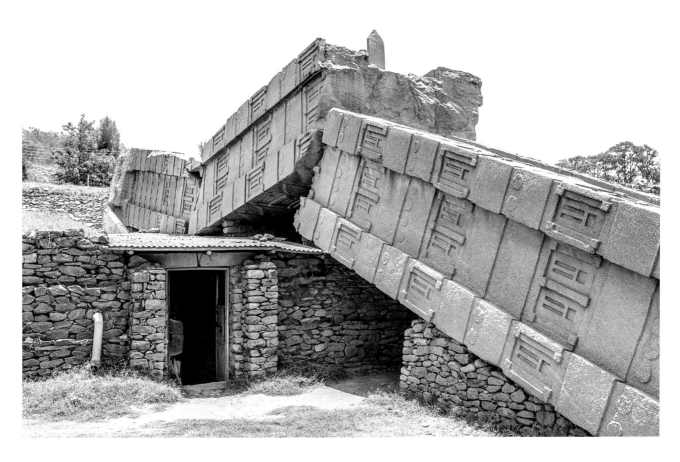

fully understood, Aksum declined or collapsed in the succeeding century. Although earlier scholars contended that the empire continued until the tenth century, recently excavated archaeological evidence shows an abrupt abandonment of sites in the early 600s,[34] and points to multiple causes. A catastrophic submerging of the port at Adulis as well as soil degradation and deforestation appear the likely culprits, though the Justinianic plague certainly played a role.[35] Following the

collapse of Aksum, limited archaeology and scarce sources suggest, however, that an agrarian, Christian society, centered in the eastern Tigray province, survived the fall.[36] The Hatsani Daniel

and trans., *Life and Works of Saint Gregentios, Archbishop of Taphar* (Berlin, 2006). Fear of a resurgent Ethiopia also played a major role in later Egyptian Muslim eschatological texts; see S. Bouderbala, "Al-Ḥabasha in Miṣr and the End of the World: Early Islamic Egyptian Apocalypse Narratives Related to Abyssinia," *NEAS* 19.1 (2019): 9–22.

34 For accounts of Aksum continuing until the tenth century, see S. Hable Sellassie, "The Problem of Gudit," *JES* 10.1 (1972): 113–24; S. Hable Sellassie, *Ancient and Medieval Ethiopian History to 1270* (Addis Ababa, 1972), 159–237. For a synthetic account of the abandonment of Aksumite sites, see N. Finneran, *The Archaeology of Ethiopia* (Abdington, UK, 2007), 211–14.

35 K. A. Bard et al., "The Environmental History of Tigray (Northern Ethiopia) in the Middle and Late Holocene: A Preliminary Outline," *African Archaeological Review* 17.2

(2000): 65–86; K. W. Butzer, "Rise and Fall of Axum, Ethiopia: A Geo-Archaeological Interpretation," *American Antiquity* 46.3 (1981): 471–95; K. W. Butzer and G. H. Endfield, "Critical Perspectives on Historical Collapse," *PNAS* 109.10 (2012): 3628–31; R. Fattovich et al., *The Aksum Archaeological Area: A Preliminary Assessment* (Naples, 2000), 16–17. Y. Gebre Selasse, "Plague as a Possible Factor for the Decline and Collapse of the Aksumite Empire: A New Interpretation," *ITYOPIS, Northeast African Journal of Social Sciences and Humanities* 1 (2011): 36–61.

36 A. C. D'Andrea et al., "The Pre-Aksumite and Aksumite Settlement of NE Tigrai, Ethiopia," *Journal of Field Archaeology* 33.2 (2008): 151–76, at 156, 158, 169; F. Anfray, "Nouveaux sites antiques," *JES* 11.2 (1973): 13–27; Munro-Hay, *Aksum*, 81–89; S. C. Munro-Hay, *Ethiopia and Alexandria: The Metropolitan Episcopacy of Ethiopia*, vol. 1, Bibliotheca Nubica et Aethiopica 5 (Warsaw, 1997), 101–7; M. Kropp, "La corne orientale de l'Afrique chez les géographes arabes," *Bulletin des études africaines* 17–18 (1992): 161–97. Jacques Mercier and Claude Lepage reconstruct some sort of post-Aksumite state in Tigray, which derived its income from the Danakil salt trade, from the many ecclesiastical remains that may date from this early period; C. Lepage and J. Mercier, *Les églises historiques du Tigray: Art éthiopen / The Ancient Churches of Tigrai: Ethiopian Art*, trans.

Figure 9.
Aksum Stele Park, toppled stele (with modern doorway to visit tomb below), Aksum, Tigray, Ethiopia. Photograph by author.

Figure 10.
Beta Emmanuel,
Lalibela, Lasta,
Ethiopia.
Photograph
by author.

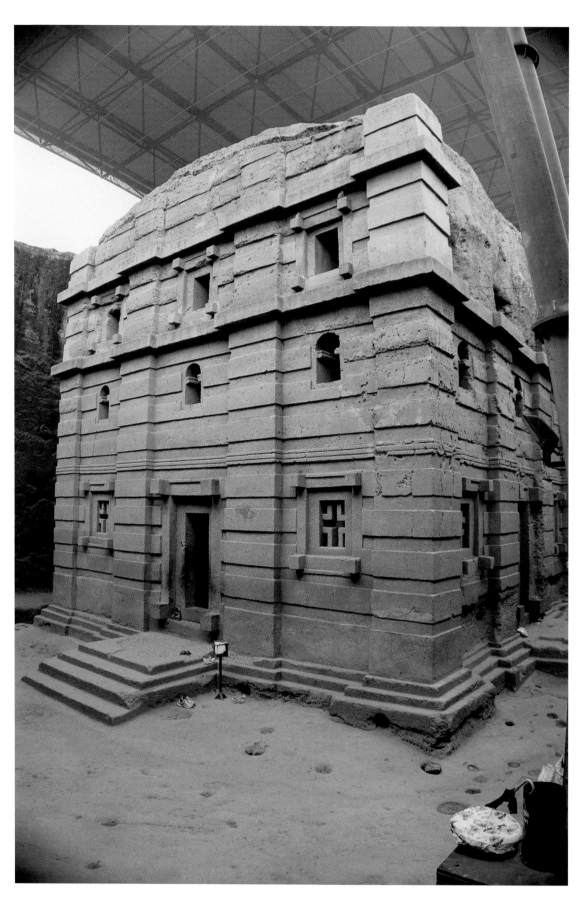

(*Ḥaṣani Dan'əl*; *Ḥaṣani* = warlord?) inscription, a rare example of post-Aksumite monumental epigraphy (tenth century?), paints a dire, if vague, picture of civil war and unrest in the region.[37] Written to commemorate the conquests of a local warlord, with the title *Hatsani*, the text also evidences post-Aksumite titulature, which would come into prominence under the Zagwe dynasty in the twelfth century.[38] That said, Islam also took root then, mostly in the Dahlak archipelago, a group of coral islands off the Eritrean coast, but also in highland Tigray.[39] Arabic-inscribed headstones make up the majority of written records in situ from the early Middle Ages in Ethiopia.[40]

Only slightly better understood than the immediate post-Aksumite era is the so-called Zagwe dynasty, which governed parts of Ethiopia prior to 1270. Although lauded for its architectural production in the central highlands at Lalibela (Lalibäla; Fig. 10), this group remains quite obscure.[41] Aside from some securely dateable grants of land from the twelfth and thirteenth centuries, barely anything is known of what or whom the Zagwe governed, although it appears they directly controlled Lasta in northern Amhara as well as some of Tigray.[42] Long

treated as a dynasty of usurpers, the Zagwe emulated Aksumite kingship, and used Geʿez for ecclesiastical matters.[43] The Coptic patriarchs in Egypt legitimized their rule, and this period saw close relations between Ethiopia and Egypt: delegations, craftsmen, and building materials were regularly sent between Cairo and the Ethiopian highlands.[44] In large part due to the work of the historian Marie-Laure Derat, the Zagwe period can even be understood to be a watershed for Christianity in Ethiopia, a point to which I will return (see Chaps. 1 and 3).

Following the overthrow of the Zagwe dynasty in 1270, a better-documented dynasty claiming legitimacy from King Solomon took control of the Ethiopian highlands.[45] Though not all "Solomonic" rulers were themselves from this lineage, some iteration of this empire continued (more or less) until the Communist revolution in 1974. That said, for much of Ethiopian history, its society was extremely localized and diverse, with centralized imperial powers being the exception to the rule.[46]

Scholarship

Generally speaking, the field of Ethiopian Studies moves slowly and is impeded by a number of factors, such as an uncertain placement in area studies as well as a general lack of accessibility to source materials (both primary and secondary).[47]

S. Williams and C. Wiener (Paris, 2005), 31–105; C. Lepage, "Entre Aksum et Lalibela : Les églises du sud-est du Tigray (IXᵉ–XIIᵉ s.) en Éthiopie," *CRAI* 150.1 (2006): 9–39.

37 M-L Derat, *L'énigme*, 108–13; Gebre Selasse, "Plague," 43–44; F.-X. Fauvelle, *The Golden Rhinoceros: Histories of the African Middle Ages*, trans. T. Tice (Princeton, 2018), 89–93.

38 Derat, *L'énigme*, 108–13.

39 G. Lusini, "Christians and Moslems in Eastern Tigray up to the XIV C.," *Studi magrebini* 25 (1993–1997): 245–52.

40 As of 2022, sites of Muslim habitation are being studied by the European Research Council-funded HornEast project; see https://horneast.hypotheses.org/.

41 See C. Bosc-Tiessé and M.-L. Derat, eds., *Lalibela: Site rupestre chrétien d'Éthiopie* (Toulouse, 2019); C. Bosc-Tiessé and M.-L. Derat, "Lalibela, un site rupestre dans la longue durée: Histoire, archéologie et patrimonialisation," in *Patrimoine mondial de l'UNESCO: Enjeux et opportunités* (Paris, 2019), 77–115.

42 On the territories controlled by the Zagwe, see M.-L. Derat, "Les donations du roi Lālibalā: Éléments pour une géographie du royaume chrétien d'Éthiopie au tournant du XIIᵉ et du XIIIᵉ siècle," *AÉ* 25 (2010): 19–42; M. Muehlbauer, "A Rock-Hewn Yəmrəhannä Krəstos? An Investigation into Possible 'Northern' Zagʷe Churches near ʿAddigrat, Təgray," *Aethiopica* 23 (2020): 31–56. On the dynasty and its legacy, see M.-L. Derat, *L'énigme*; M.-L. Derat, "Before the Solomonids: Crisis, Renaissance and the Emergence of the Zagʷe Dynasty (Seventh–Thirteenth Centuries)," in *A Companion to Medieval Ethiopia and Eritrea*, ed. S. Kelly (Leiden, 2020), 31–56. See

also the informative review of Derat's *L'énigme* by A. Bausi, "The Enigma of a Medieval Ethiopian Dynasty of Saints and Usurpers," *Orientalistische Literaturzeitung* 113.6 (2018): 439–47.

43 In addition to the inscriptions mentioned, of particular interest is a Nubian-language document from Qasr Ibrim (Qaṣr Ibrīm), Nubia, dated 1186, which refers to the Zagwe dynasty in Ethiopia as "Aksumite"; Derat, *L'énigme*, 179.

44 M. Gobezie Worku, "The Church of Yimrhane Kristos: An Archaeological Investigation" (PhD diss., Lund University, 2018), 34–40.

45 The best overview of "Solomonic" Ethiopian history is M.-L. Derat, *Le domaine des rois éthiopiens (1270–1527): Espace, pouvoir et monachisme* (Paris, 2003). However, Derat now suggests that kingly descent from Solomon was originally a Zagwe idea; Derat, *L'énigme*, 157–60.

46 D. Crummey, *Land and Society in the Christian Kingdom of Ethiopia: From the Thirteenth to the Twentieth Century* (Urbana, IL, 2000).

47 For an in-depth historiographic overview, see S. Uhlig, "Ethiopian Studies," in *EAe* 2:433–38. In a preliminary "state of the field" article in 1964, the lack of widespread reading

In North America, the region is occasionally grouped with studies of Byzantium, although specialists have often overlooked Ethiopia in favor of other, more immediately accessible eastern Christian regions, such as Armenia and Georgia.[48] Moreover, scholars of Christian Egypt are largely ignorant of Ethiopia despite the two regions having shared a church for a millennium.

Although European scholars and orientalists were interested in the study of Ethiopian languages and literature from as early as the fifteenth century, the relatively infrequent contact with Ethiopia during the Enlightenment largely prevented its study from becoming a full-fledged part of the Western academy.[49] Within Ethiopia, however, we find autochthonous historical studies. The richest is Andemta (*Andəmta*), a tradition of textual commentary (largely of religious literature), which has thrived in monastic scriptoria and religious schools since medieval times.[50] Moreover, Ethiopian sovereigns took an interest in archaeology. Under Emperor Menelik II in the late nineteenth century, we find the royal invocation of Ethiopia's ancient heritage used as a bulwark against European colonial incursions—an

ideological use of cultural heritage paralleling that of the contemporary Greek kingdom.[51]

The development of the field in the West took place, by and large, in the late nineteenth and early twentieth centuries. The British Maqdala (Mäqdäla) expedition against Ethiopia in 1868 ended with the looting of the royal library of Tewodros II (Theodore, r. 1855–1868) and the formation of one of Europe's oldest collections of Ethiopian manuscripts, now in the British Library.[52] Interest in Aksumite heritage culminated in the Deutsche Aksum-Expedition (1906), an imperial German archaeological expedition, undertaken with the blessings of the Ethiopian Empire, to the antique capital of Aksum (which yielded extraordinarily valuable finds for the study of antique Ethiopia).[53] The colonial occupation of Ethiopia by fascist Italy (1936–1941) was also a watershed. As in French-occupied Maghreb, orientalists were the handmaidens of colonialism—their unfettered access to materials through imperial domination resulted in major, equivocal, strides in Ethiopian studies. Carlo Conti Rossini and Enrico Cerulli, veritable giants in the field, were both colonial administrators.[54] Indeed, throughout this monograph the attentive reader will find numerous citations of foundational figures in Ethiopian studies, including Antonio Mordini (the head of the Italian ethnographic service) and Alessandro Augusto Monti della Corte (of the Pontificio Istituto Archeologia Cristiana), whose

by scholars was lamented by David Buxton; D. R. Buxton, "Ethiopian Medieval Architecture: The Present State of Studies," *Journal of Semitic Studies* 9.1 (1964): 239–44.

48 See, however, the not-unproblematic M. Evangelatou, *A Contextual Reading of Ethiopian Crosses through Form and Ritual: Kaleidoscopes of Meaning*, Gorgias Eastern Christian Studies 49 (Piscataway, NJ, 2018); and J. Gnisci's review of it in *Aethiopica* 23 (2020): 256–68.

49 But see, however, M. Salvatore and J. De Lorenzi, "An Ethiopian Scholar in Tridentine Rome: Täsfa Ṣeyon and the Birth of Orientalism," *Itinerario* 45.1 (2021): 17–46; C. Bosc-Tiessé, "Ethiopian Manuscripts in Old Regime France and the Collection of the French National Library," *RSE* 6 (2022): 153–94.

50 For Andemta commentaries, see M. Alehegne, *The Ethiopian Commentary on the Book of Genesis: Critical Edition and Translation*, Äthiopistische Forschungen 73 (Wiesbaden, 2011); K.-S. An, *An Ethiopian Reading of the Bible: Biblical Interpretation of the Ethiopian Orthodox Tewahido Church* (Eugene, Or, 2015). Furthermore, in the south of Ethiopia, oral history (*argaa-dhageettii* in Oromo) has been shown to preserve historical events from at least six hundred years prior. See C. Oba-Smidt, *The Oral Chronicle of the Boorana in Southern Ethiopia: Modes of Construction and Preservation of History among People without Writing*, trans. R. Prior and J. Watt, Northeast African History, Orality and Heritage 4 (Zurich, 2016). For academic publications in Ethiopian languages, see B. Tafla, "Production of Historical Works in Ethiopia and Eritrea: Some Notes on the State of Recent Publications 1991–97," *Aethiopica* 1 (1998): 176–206.

51 A. G. Zena, "Archaeology, Politics and Nationalism in Nineteenth- and Early Twentieth-Century Ethiopia: The Use of Archaeology to Consolidate Monarchical Power," *Azania: Archaeological Research in Africa* 53.3 (2018): 398–416; Y. Hamilakis, *The Nation and Its Ruins: Antiquity, Archaeology, and National Imagination in Greece* (New York, 2007).

52 S. Ancel and D. Nosnitsin, "On the History of the Library of Mäqdäla: New Findings," *Aethiopica* 17 (2014): 90–95.

53 E. Littmann et al., *Deutsche Aksum-Expedition*, 4 vols. (Berlin, 1913). See also B. Hirsch and F.-X. Fauvelle-Aymar, "Aksum après Aksum: Royauté, archéologie et herméneutique chrétienne de Ménélik II (r. 1865–1913) à Zär'a Ya'qob (r. 1434–1468)," *AÉ* 17 (2001): 59–109.

54 G. Dore, "Carlo Conti Rossini in Eritrea tra ricerca scientifica e prassi coloniale (1899–1903)," in *Linguistic, Oriental and Ethiopian Studies in Memory of Paolo Marrassini*, ed. A. Bausi, A. Gori, and G. Lusini (Wiesbaden, 2014), 321–42; K. Mallette, *European Modernity and the Arab Mediterranean: Toward a New Philology and a Counter-Orientalism* (Philadelphia, 2010), 132–61.

academic reputations were built during the occupation's regime.[55] As with the looted library from Maqdala, the legacy of the Italian occupation is housed in rare books libraries all around Italy.[56]

After the restoration of the emperor Haile Selassie in 1941, a postwar "modernization" of the empire was ushered in.[57] In addition to fancy high-rises in the capital of Addis Ababa, the emperor initiated a program of Western-style study of the country's history based at the Ethiopian Studies Institute at Addis Ababa University.[58] Foreigners were invited to tour the country,[59] while a generation of Ethiopian scholars, including Sergew Hable Selasse, Getatchew Haile, and Taddesse Tamrat, brought academic rigor to subjects hitherto reserved for churchmen.[60] That said, the emperor was also a despot, and while the imperial fisc funded aerial photography of monuments and lavish ceremonies, the agrarian base suffered in silence.[61] Invariably, popular discontent led to revolution, and from 1974 to 1989 Ethiopia received most of its aid and support from the Soviet bloc. Although scholars from Ethiopia maintained their presence in the field, Western academic interest declined in that period, though several foundational works were written by Russian scholars.[62] From the early 1990s to 2020, the study of Ethiopia again shifted to the West, largely to Europe but also North America.

Scholars now have the good fortune of having a number of specialist journals on the subject: *Journal of Ethiopian Studies* (Institute of Ethiopian Studies, Addis Ababa), *Annales d'Éthiopie* (French Center for Ethiopian Studies, Addis Ababa), *Rassegna di studi etiopici* (University of Naples "L'Orientale"), *Northeast African Studies* (Michigan State University), and *Aethiopica* (Hamburg University). Despite this luxury, the study of Ethiopia's history within Ethiopia, in addition to broader socioeconomic issues, is severely limited by a lack of accessibility to publications, especially those written in languages other than English.[63] Indeed, some of the most important historiography is written in French, German, and Italian, and is thus inaccessible to young scholars within the country.[64]

As for disciplines, the architectural history of Ethiopia has on the whole largely been skewed in favor of Lalibela and the Lasta region in the central highlands, which received comprehensive archaeological and scholarly treatment during the Italian occupation.[65] Tigrayan churches, by

55 Antonio Mordini, who will be cited frequently due to his intensive documentation of sites in Tigray, is an interesting figure in this regard. In a letter from 14 April 1940, he professes a milquetoast interest in colonialism: "non ho nessuna intenzione di darmi alla carriera coloniale...." Letters from Mordini to Carlo Conti Rossini from Asmara dated 14 April 1940, 18 April 1940, and 10 May 1940, held in the Carlo Conti Rossini Archivio (Busta 10) of the Accademia dei Lincei, indicate nevertheless that Mordini was regularly sent, on initiative of Conti Rossini, to document places of interest, particularly Aksumite inscriptions. See also A. Mordini, "Stato attuale delle ricerche etnografiche (cultura materiale) nell'A.O.I.," in *Atti del terzo Congresso di studi coloniali, Firenze–Roma, 12–17 aprile 1937–XV*, vol. 6, *V. sezione: Etnografica-filologica-sociologica*, Centro di studi coloniali, Istituto coloniale fascista, 9 vols. (Florence, 1937), 149–59; A. A. Monti della Corte, *Lalibelà, le chiese ipogee e monolitiche e gli altri monumenti medievali del Lasta* (Rome, 1940); A. A. Monti della Corte, *I castelli di Gondar* (Rome, 1938).

56 See, for example, F. Sicilia, *I manoscritti etiopici di Antonio Mordini alla Biblioteca Palatina* (Genoa, 1995).

57 A. Levin, "Haile Selassie's Imperial Modernity: Expatriate Architects and the Shaping of Addis Ababa," *JSAH* 75.4 (2016): 447–68.

58 B. Zewde, "A Century of Ethiopian Historiography," *JES* 33.2 (2000): 1–26, at 8–9.

59 H. S. Lewis, "Anthropology In Ethiopia, 1950s–2016: A Participant's View," in *Seeking Out Wise Old Men: Six Decades of Ethiopian Studies at the Frobenius Institute Revisited*, ed. S. Dinslage and S. Thubauville, Studien zur Kulturkunde 131 (Berlin, 2017), 27–46, at 30.

60 Getatchew Haile writes of a "conspiracy" by the history department faculty at Addis Ababa University to rewrite the history of Ethiopia, which resulted in the foundational histories by scholars Sergew Hable Selassie and Taddesse Tamrat; G. Haile, "In Memoriam Taddesse Tamrat (1935–2013)," *Aethiopica* 16 (2013): 212–19, at 214. The resulting monographs were the above-cited Hable Sellassie, *Ancient and Medieval Ethiopian History* (n. 34), and T. Tamrat, *Church and State in Ethiopia 1270–1527* (Oxford, 1972).

61 E. J. Keller, "Drought, War, and the Politics of Famine in Ethiopia and Eritrea," *Journal of Modern African Studies* 30.4 (1992): 609–24, at 610–11.

62 For examples of Soviet interest in Ethiopia, see I. M. Kobishchanov, *Axum*, trans. J. W. Michels (University Park, PA, 1979); S. B. Chernetsov, *Efiopskaia feodal'naia monarkhiia v XIII–XVI vv.* (Moscow, 1982); S. B. Chernetsov, *Efiopskaia feodal'naia monarkhiia v XVII veke* (Moscow, 1990).

63 See, however, the Amharic-language text, D. Ayenachew, *Selomonawyan: A History of the Political Administration of Ethiopia (1270–1529)* (Addis Ababa, 2021).

64 The recently published reference work, *A Companion to Medieval Ethiopia and Eritrea* (ed. S. Kelly [Leiden, 2020]), will hopefully correct this deficiency in the near future, as it makes available in English a synthesis of much of the superb Ethiopianist scholarship written in French and Italian.

65 Monti della Corte, *Lalibelà*.

contrast, were almost wholly unknown outside of their parish communities until 1966, when Fr. Tewalde Medhin Joseph, an Ethiopian Catholic priest based in Addigrat, read aloud the names of 120 largely unknown rock-cut churches at the Third International Conference of Ethiopian Studies in 1966.[66]

The subjects of this monograph—Abreha wa-Atsbeha, Wuqro Cherqos, and Mika'el Amba—while significantly neglected, are exceptional, however; they have been known to the outside world for more than one hundred years. Wuqro Cherqos, connected to a major north–south caravan route, was first visited by Francisco Alvares, a Portuguese chaplain in the early sixteenth century, who among other things, noted its fine workmanship and three-aisled plan.[67] French naval officer, amateur naturalist, and antiquarian Théophile Lefebvre followed in the 1840s, and recorded an imaginative version of the church's ground plan and elevation in a subsequent publication (Fig. 11).[68] Some of the participants in the punitive 1868 Maqdala expedition against King Tewodros visited the church, including William Simpson, an accomplished draftsman and war correspondent, best known for his serial documentation during the Crimean War.[69] Largely unknown to scholars today, Simpson's writings are still quite useful. Not only did he draft a largely accurate plan of Wuqro Cherqos (Fig. 12), along with elevation drawings (Fig. 13), but he

also placed it in a historical context.[70] The first of many to compare it with the architecture of Byzantium, Simpson wrote that it was "so exactly [Byzantine] . . . that we may almost take it for granted that it was erected under the superintendence of a Greek architect."[71] Wuqro Cherqos was so well known by the twentieth century that it was mentioned as an attraction in the second tourist guide to Ethiopia, published during the Italian occupation.[72]

Abreha wa-Atsbeha, only slightly less accessible than Wuqro Cherqos, received its first documented European visitors at the turn of the nineteenth century—British explorers Henry Salt and George Annesley.[73] Annesley's laudable travelogue detailed, among other things, the church's state of conservation, and accounted for several lost features, including a full wooden chancel and a column that leaked holy water. Upon the journey's end, they drafted a provisional ground plan based on what they had seen (Fig. 14).[74]

Finally, Mika'el Amba, the most isolated of the three churches, was first visited by the "Church Missionary Society," an Anglican proselyting group, in 1842, though it was formally described only in the twentieth century by Beatrice Playne, a British muralist and architect.[75] She was the first to visit all three churches and, recognizing their formal similarities, declared them all to be

66 T. Joseph, "Introduction générale aux églises monolithes du Tigrai," in *Proceedings of the Third International Conference of Ethiopian Studies, Addis Ababa 1966*, 2 vols. (Addis Ababa, 1969), 1:83–98. Later republished in Amharic as T. Josief, *Betigrie Teklay Gezat yemigenyu bewqer yeteseru abyate kerstyanat* (Addis Ababa, 1970).

67 D. W. Phillipson, *Ancient Churches of Ethiopia: Fourth–Fourteenth Centuries* (New Haven, 2009), 94; F. Alvares, *The Prester John of the Indies: A True Relation of the Lands of the Prester John, Being the Narrative of the Portuguese Embassy to Ethiopia in 1520*, rev. trans. and ed. C. F. Beckingham and G. W. B. Huntingford, 2 vols. (Cambridge, 1961), 1:176–77. On the town, see W. Smidt, "Dängolo," in *EAe* 2:87–88.

68 T. Lefebvre, *Voyage en Abyssinie exécuté pendant les années 1839, 1840, 1841, 1842, 1843*, 6 vols. (Paris, 1845–51), 3:426 and pl. 52.

69 W. Simpson, *The Autobiography of William Simpson, R. I. (Crimean Simpson)*, ed. G. Eyre-Todd (London, 1903). See also M. Muehlbauer, "From Stone to Dust: The Life of the Kufic Inscribed Frieze of Wuqro Cherqos in Tigray, Ethiopia," *Muqarnas* 38 (2021): 1–34.

70 W. Simpson, "Abyssinian Church Architecture," in *Papers Read at the Royal Institute of British Architects: Session 1868–69* (London, 1869), 234–46, at 238–41; W. Simpson, "Abyssinian Church Architecture: Part II, Rock-Cut Churches," *The Architectural Review* 4 (1898): 9–16, at 16. Simpson also noted that the church was filled with refuse.

71 Simpson, "Abyssinian Church Architecture," 239–40.

72 *Guida dell'Africa orientale italiana* (Milan, 1939), 300. The first tourist guide is arguably A. Zervos, *L'empire d'Éthiopie: Le miroir de l'Éthiopie moderne, 1906–1936* (Alexandria, 1936).

73 G. Annesley, *Voyages and Travels to India, Ceylon, the Red Sea, Abyssinia, and Egypt: In the Years 1802, 1803, 1804, 1805, and 1806*, 3 vols. (London, 1809), 3:27.

74 Annesley, *Voyages and Travels*, 27–29. Along with Wuqro Cherqos, it was visited by certain members of the Maqdala expedition; W. Simpson, "An Artist's Jottings in Abyssinia," *Good Words* 9 (1868): 605–13, at 612.

75 C. W. Isenberg and J. L. Krapf, *Journals of the Rev. Messrs. Isenberg and Krapf, Missionaries of the Church Missionary Society: Detailing Their Proceedings in the Kingdom of Shoa, and Journeys in Other Parts of Abyssinia, in the Years 1839, 1840, 1841, and 1842* (London, 1843), 510.

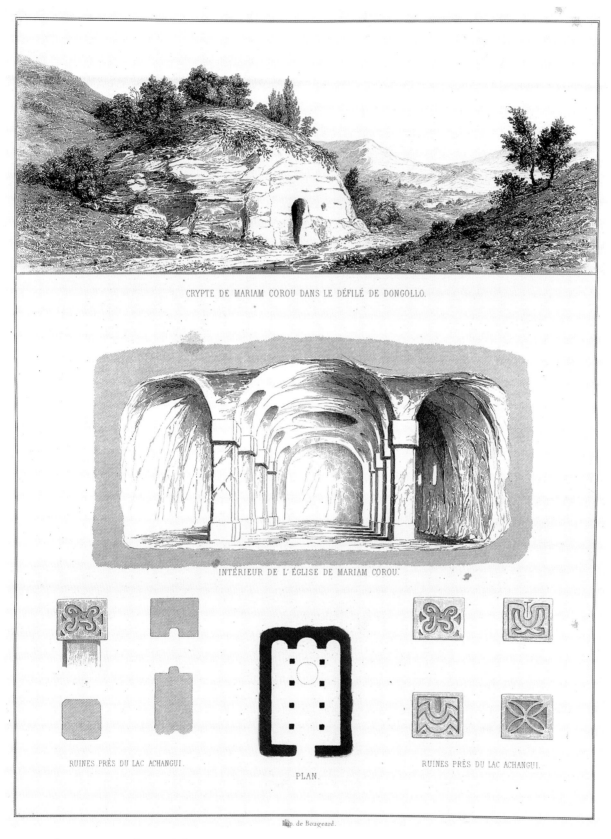

CRYPTE DE MARIAM COROU DANS LE DÉFILÉ DE DONGOLLO.

INTÉRIEUR DE L'ÉGLISE DE MARIAM COROU.

RUINES PRÈS DU LAC ACHANGUI.

PLAN.

RUINES PRÈS DU LAC ACHANGUI.

Imp. de Bougeard.

Figure 11. "Maryam Corou" ground plan and elevation, Wuqro Cherqos, Tigray, Ethiopia.
Painting from T. Lefebvre, *Voyage en Abyssinie [...]* (Paris, 1845–51), 3:pl. 52.

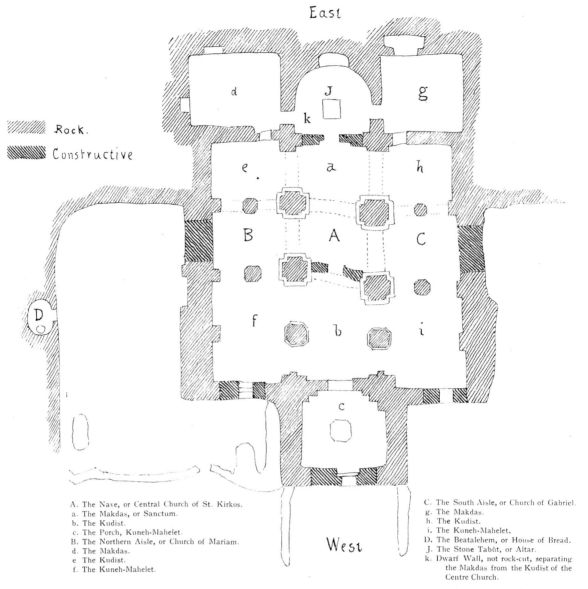

East

West

A. The Nave, or Central Church of St. Kirkos.
a. The Makdas, or Sanctum.
b. The Kudist.
c. The Porch, Kuneh-Mahelet.
B. The Northern Aisle, or Church of Mariam.
d. The Makdas.
e. The Kudist.
f. The Kuneh-Mahelet.

C. The South Aisle, or Church of Gabriel.
g. The Makdas.
h. The Kudist.
i. The Kuneh-Mahelet.
D. The Beatalehem, or House of Bread.
J. The Stone Tabût, or Altar.
k. Dwarf Wall, not rock-cut, separating
 the Makdas from the Kudist of the
 Centre Church.

PLAN OF ROCK-CUT CHURCH AT DONGOLO.
DRAWN BY WILLIAM SIMPSON.

Figure 12. "Plan of Rock-Cut Church at Dongolo," Wuqro Cherqos, Tigray, Ethiopia. Painting from W. Simpson, "Abyssinian Church Architecture: Part II, Rock-Cut Churches," *The Architectural Review* 4 (1898): 9.

produced in a single campaign, a pathbreaking opinion also held by the present author.[76]

Post-occupation Ethiopia yielded a number of important studies and aspirations for further work. Roger Sauter, a Swiss schoolteacher, was the

first to undertake a catalogue of the churches; he published an annotated bibliography, typology, and working list of monuments in 1963 (which he updated in 1976).[77] Antonio Mordini, for his

76 B. Playne, *St. George for Ethiopia* (London, 1954), 73–80. On the three churches, she wrote: "My own belief is that Cherkos at Wughuro is a copy of Abraha Atzbaha and that Mikael Ambo is a still later effort on the same plan" (pp. 82, 187–88).

77 R. Sauter, "Où en est notre connaissance des églises rupestres d'Éthiopie," *AÉ* 5 (1963): 235–92, at 235–37, 256–57; R. Sauter, "Églises rupestres au Tigré," *AÉ* 10 (1976): 157–75. He also advanced the idea that rock cutting came from pre-Christian cultic practices, a trope that would be repeated in the historiography until very recently; Sauter, "Où en est notre

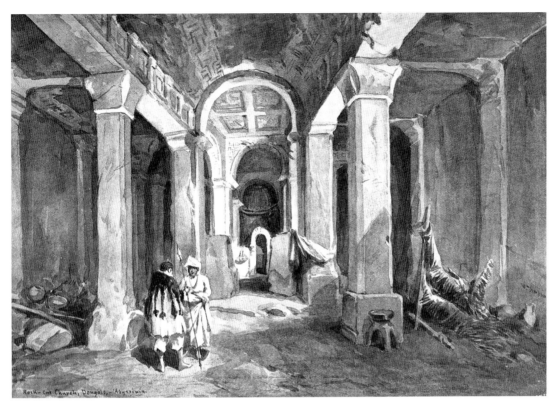

Figure 13.
"Rock-Cut Church
at Dongolo,"
elevation, Wuqro
Cherqos, Tigray,
Ethiopia. Painting
from W. Simpson,
"Abyssinian Church
Architecture:
Part II, Rock-Cut
Churches," *The
Architectural
Review* 4 (1898): 12.

part, proposed a research program to comprehensively study and document ancient churches.[78] At the same time, Jean Doresse, a French Copticist and Byzantinist based in Beirut, visited a few rock-hewn churches in this period, including Abreha wa-Atsbeha and Wuqro Cherqos, and was among the first to integrate the study of Ethiopian Christianity with Byzantium.[79]

Following Fr. Tewalde Medhin's 1966 address, there was a flurry of interest in the rock-hewn churches of Tigray. In 1971, David Buxton, an entomologist by training, who had previously assisted with the restoration of the nearby monastery of Dabra Dammo (Däbrä Dammo), along with Antonio Mordini and Derek Matthews, published the first attempted chronology of rock-hewn churches in Tigray.[80] He included full architectural descriptions of Abreha wa-Atsbeha, Wuqro Cherqos, and Mika'el Amba. Noting their formal similarities and shared plan, Buxton placed them within the same general building program, separate from the construction of basilicas.[81] Buxton was also the first to typologize their unique form. Despite naming them after Middle Byzantine cross-in-square

connaissance," 235; C. Conti-Rossini, "Appunti sulla lingua awiyă del Denghelà," *Giornale della Società Asiatica Italiana* 18 (1905): 103–94, at 116–17. Later, Francis Anfray, a French archaeologist of antique Ethiopia, further subdivided church constructions into six categories, including rock-hewn and free-standing churches, and assembled a working list of some 197 monuments of historical significance; F. Anfray, "Des églises et des grottes rupestres," *AÉ* 13.1 (1985): 7–34.

78 A. Mordini, "L'architecture religieuse chrétienne dans l'Éthiopie du Moyen Age: Un programme de recherches," *Cahiers d'études africaines* 2.5 (1961): 166–71. For an early synthesis by Mordini (when in the service of fascist Italy), see Mordini, "Stato attuale."

79 J. Doresse, "Nouvelles recherches sur les relations entre l'Égypte copte et l'Éthiopie: XIIᵉ–XIIIᵉ siècles," *CRAI* 114.3 (1970): 557–66; J. Doresse, *L'empire du Prêtre-Jean*, 2 vols. (Paris, 1957), 1:61–71, 79–80.

80 D. Buxton, "The Rock-Hewn and Other Medieval Churches of Tigré Province, Ethiopia," *Archaeologia* 103 (1971): 33–100. He also published on churches in Tigray following upon his work with the British Council in Ethiopia from 1946–49; see D. Buxton, "The Christian Antiquities of Northern Ethiopia," *Archaeologia* 92 (1947): 1–42; D. Buxton, *Travels in Ethiopia* (London, 1949), 191–200. For the history of the restoration of Dabra Dammo, see T. B. Libanos, "Däbrä Damo," in *EAe* 2:19. My transliteration of Dabra Dammo, with a doubled consonant, follows that proposed in A. Bausi, "'Däbrä Dammo', Not 'Däbrä Damo'," *Géolinguistique* 20 (2020), http://journals.openedition.org/geolinguistique/1918.

81 Buxton, "Rock-Hewn and Other Medieval Churches," 42–43; D. Buxton, *The Abyssinians* (New York, 1970), 106–8.

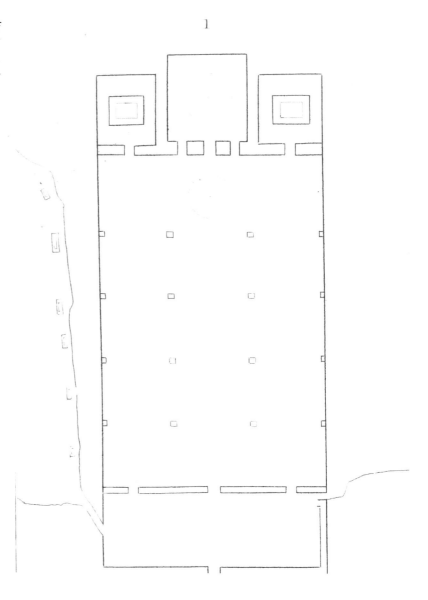

churches (see Chap. 2), Buxton described them as aisled cruciform churches, and ultimately placed them within an eleventh-century to early twelfth-century timeframe.[82]

Other intrepid foreigners visited the churches in the late 1960s (some were sponsored by the Ethiopian emperor, Haile Selassie), including Ruth Plant, Marilyn Heldman, George Gerster, Ivy Pearce, Otto Jäger, and Otto Dale.[83] Ruth

Plant, a trained architect, is notable for her definitive study of the churches she examined in this period, which she sketched and for which she also drafted her own ground plans.[84] Just prior to the fall of the Ethiopian monarchy, an Oxford University–led survey expedition rapidly

82 Buxton, "Rock-Hewn and Other Medieval Churches," 48.

83 R. Plant, "Rock-Hewn Churches of the Tigre Province (with Additional Churches by David Buxton)," *EO* 13.3 (1970): 157-268; R. Plant, "Notes on 17 Newly-Discovered Rock-Hewn Churches of Tigre," *EO* 16.1 (1973): 36–53; I. Pearce, "Pearce's Pilgrimage to the Rock-Hewn Churches of Tigre," *EO* 11.2

(1968): 77–120; O. Dale, "The Rock-Hewn Churches of Tigre," *EO* 11.2 (1968): 121–57; O. A. Jäger and I. Pearce, *Antiquities of North Ethiopia: A Guide*, 2nd ed. (Stuttgart, 1974), 103–50; G. Gerster, *Churches in Rock: Early Christian Art in Ethiopia*, trans. R. Hosking (New York, 1970), 131–35; F. Altheim and R. Stiehl, "Chronologie der altäthiopischen kirchlichen Kunst," *Klio* 53 (1971): 361–68.

84 R. Plant, *Architecture of the Tigre, Ethiopia* (Worcester, UK, 1985).

documented a number of rock-hewn churches and inventoried treasury collections.[85]

The most important group to travel through Tigray in this period, however, was French, under the aegis of the Centre national de la recherche scientifique (CNRS). From 1970 to 1975, the CNRS sponsored several missions to northern Ethiopia, which included scholars who would go on to have distinguished careers in the field: Byzantine art historian Claude Lepage (a former student of André Grabar and a specialist in Palaiologan-era ornament), professional architect and surveyor Jean Gire, and Roger Schneider, a professor based at Addis Ababa University.[86] Gire and Schneider produced a corpus of professional and well-drawn architectural plans, while Lepage began his forty-year career as a result of these missions.[87] Claude Lepage is a giant in the field, and readers of the present volume will see his name cited often in the footnotes.

Lepage pioneered the application of modern art-historical methods, taken from Byzantine art studies, to a region that was then the domain of dilettantish travel writings. Aside from his major contributions to the study of mural paintings and manuscript illuminations, Lepage revolutionized the study of medieval churches, using their liturgical furnishings as a means to date them.[88] Lepage noted the use of bemas and chancels (or the representation of them in evidential signs) in certain churches in Tigray, whereby he dated them to an earlier period, since the liturgical layout parallels that of early Christian templon screens in the Mediterranean.[89] Grouping them with certain stylistic criteria (and alleged funerary functions), Lepage reconstructed and temporalized the built environment of early medieval Ethiopia to a degree unmatched by scholars since.[90] He compellingly argued that Abreha wa-Atsbeha, Wuqro Cherqos, and Mika'el Amba were a coherent set of churches, produced between the tenth and twelfth centuries, and suggested, like Playne, that Abreha wa-Atsbeha was the first.[91]

Immediately after the deposition of Emperor Selassie, few foreign scholars outside of the Soviet Union were permitted to do fieldwork there,[92] but for one scholar, Michael Gervers, it coincided with the beginning of a longstanding interest in Ethiopia. He has since published widely on rock-hewn churches; his most recent project is an ethnographic study of contemporary hewn churches in north and central Ethiopia.[93]

When fieldwork was again possible (1990–2020), scholarship on the rock-hewn churches of Ethiopia increased at a steady pace, with major publications in recent decades by the likes of Emmanuel Fritsch, David Phillipson, and Mengistu Gobezie Worku. Emmanuel Fritsch, a French priest who was based in Ethiopia for close

85 B. Juel-Jensen and G. Rowell, eds., *Rock-Hewn Churches of Eastern Tigray: An Account of the Oxford University Expedition to Ethiopia, 1974* (Oxford, 1975).

86 C. Lepage, "Les ornements peints de l'église de Visoko Decani: Description et analyse des motifs recherches sur l'histoire et l'origine des ornements" (PhD diss., University of Nancy, 1967); C. Lepage, "L'ornementation végétale fantastique et le pseudo-réalisme dans la peinture byzantine," *CahArch* 19 (1969): 191–211. Roger Schneider, who specialized in epigraphy, lived in Ethiopia from 1956 until his death in 2002. His archive has since been donated to the Institute of Ethiopian Studies in Addis Ababa; see M.-L. Derat, "Les archives Roger Schneider (1917–2002) au centre Walda Masqal (Institute of Ethiopian Studies, Addis Abeba)," *AÉ* 26 (2011): 291–302.

87 J. Gire and R. Schneider, "Etude des églises rupestres du Tigré: Premiers résultats de la mission 1970," *Abbay* 1 (1970): 73–79. See also the synthesis of Lepage's early missions, in C. Lepage, "Le premier art chrétien d'Éthiopie," *Les Dossiers de l'Archéologie* 8 (1975): 34–79.

88 C. Lepage, "Premières recherches sur les installations liturgiques des anciennes églises d'Éthiopie," *CNRS, Travaux de la RCP* 230 (1972): 77–114.

89 Lepage, "Premières recherches," 78–89.

90 Lepage and Mercier, *Les églises historiques*, 31–105; Lepage, "Entre Aksum et Lalibela." See also C. Lepage, "Bilan des recherches sur l'art médiéval d'Éthiopie: Quelques résultats historiques," in *Proceedings of the Eighth International Conference of Ethiopian Studies, University of Addis Ababa, 1984*, ed. T. Beyene, 2 vols. (Addis Ababa, 1988–89), 2:47–55.

91 Lepage and Mercier, *Les églises historiques*, 71–91.

92 Unfortunately, Russian has proven to be somewhat of an entrenched linguistic barrier for the integration of Soviet-era scholarship on Ethiopia into the broader historiography. For a partial survey of these published works, see M. L. Volpe, "An Annotated Bibliography of Ethiopian Literature in Russian," *RSE* 32 (1988): 171–93.

93 For his initial theory that hewn churches were meant to parallel Christ's birth and resurrection, see M. Gervers, "The Mediterranean Context of the Rock-Cut Churches of Ethiopia," in Beyene, *Proceedings of the Eighth International Conference*, 1:171–83; R. Pankhurst, "Caves in Ethiopian History, with a Survey of Cave Sites in the Environs of Addis Ababa," *Ethiopia Observer* 16 (1973): 15–34. Gervers is most valued, however, for his outreach efforts; he created a searchable open-use database of thousands of fieldwork photographs from Ethiopia (http://ethiopia.deeds.utoronto.ca) and founded an Ethiopian Studies Institute at the University of Toronto.

to thirty years, brought an academic rigor from his intensive study of Ethiopian Orthodox and Egyptian Coptic liturgies to the study of ancient churches in Ethiopia.[94] Fritsch expanded upon Lepage's method of "liturgical dating" by establishing firm chronological parameters based on liturgical changes specific to the Coptic church (of which Ethiopian Orthodoxy was a part), whereby he was able to assign a mid-twelfth-century date to Tigrayan cruciform churches (see Chap. 2).[95]

David Phillipson, who led excavations at Aksum in the early 1990s, published on the country's medieval monuments in a magisterial survey, *Ancient Churches of Ethiopia*.[96] Phillipson sought to fully ground Ethiopian monuments in the Aksumite past and, indeed, significantly pushed the date of the triad of Tigrayan cruciform churches back to the eighth to tenth century, by virtue of their stylistic affinities with Aksumite monuments.[97] Following Phillipson, his student Niall Finneran advanced the idea that Aksumite-derived articulation was a means of asserting a legacy of stability in the uncertain period of the early Middle Ages.[98] More recently, architect Mario Di Salvo published a survey of Ethiopian

basilicas, but his conclusions largely echo earlier scholarship.[99]

New possibilities for the study of Ethiopian architecture (writ large) were introduced in 2018 with the appearance of Mengistu Gobezie Worku's doctoral dissertation.[100] His study of the church of Yemrehanna Krestos (Yəmrəḥannä Krəstos) in the Amhara region incorporated scientific tests of the church's wood revetments through accelerator mass spectronomy (AMS) carbon-14 dating. As well as confirming a medieval date for the church, Gobezie Worku also modeled how scientific testing could be used alongside stylistic criteria to date churches.[101]

Ethiopia, Egypt, and Byzantium: The Question of "Influence"

The concept of "cultural influence," as it was once used in art-historical scholarship, is largely without merit today.[102] That the monuments I will discuss (apart from Maryam Nazret, see Chap. 1) were thoroughly local endeavors and material testaments to the country's rich architectural heritage is, to my mind, unquestionable. Yet the (English-language) study of Ethiopian art remains dogged by this question, especially when its monuments are compared with others in the Eastern Mediterranean, such as in Byzantium and Egypt. We find in early work, for example, unfounded observations (e.g., William Simpson's "Greek architect," who was supposedly behind Wuqro Cherqos) that are predicated on the belief that fine ecclesiastical architecture could not be produced locally.[103] Race has played a significant

94 E. Fritsch and M. Gervers, "*Pastophoria* and Altars: Interaction in Ethiopian Liturgy and Church Architecture," *Aethiopica* 10 (2007): 7–51; E. Fritsch, "The Altar in the Ethiopian Church: History, Forms and Meanings," in *Inquiries into Eastern Christian Worship: Selected Papers of the Second International Congress of the Society of Oriental Liturgy, Rome, 17–21 September 2008*, ed. B. Groen, S. Hawkes-Teeples, and S. Alexopoulos, Eastern Christian Studies 12 (Leuven, 2012), 443–510; E. Fritsch, "Liturgie et architecture ecclésiastique éthiopiennes," *Journal of Eastern Christian Studies* 64.1–2 (2012): 91–125. See also M. Gervers and E. Fritsch, "Rock-Hewn Churches and Churches-in-Caves," in *EAe* 4:400–404.

95 E. Fritsch, "New Reflections on the Image of Late Antique and Medieval Ethiopian Liturgy," in *Liturgy's Imagined Past/s: Methodologies and Materials in the Writing of Liturgical History Today*, ed. T. Berger and B. D. Spinks (Collegeville, MN, 2016), 39–92; E. Balicka-Witakowska, "Mika'el Amba," in *EAe* 3:959–61; E. Balicka-Witakowska, "Sära Abraha wä-Aṣbäḥa," in *EAe* 4:628–30.

96 Phillipson, *Ancient Churches of Ethiopia*. See also D. W. Phillipson, "The Aksumite Roots of Medieval Ethiopia," *Azania: Archaeological Research in Africa* 39.1 (2004): 77–89; Phillipson, *Foundations of an African Civilisation*. Inaccuracies in *Ancient Churches of Ethiopia* are pointed out in E. Fritsch's review, in *AÉ* 25 (2010): 307–17.

97 Phillipson, *Ancient Churches of Ethiopia*, 92–98, 183–91.

98 Finneran, *Archaeology of Ethiopia*.

99 M. Di Salvo, *The Basilicas of Ethiopia: An Architectural History* (London, 2017). Seemingly unaware that there was originally a hewn narthex in the church of Abreha wa-Atsbeha, Di Salvo argues that the lack of a narthex made it "imperfect," and it was therefore "corrected" in the churches of Wuqro Cherqos and Mika'el Amba. He also connects the cushion capitals in Wuqro Cherqos with the Lalibela complex, and posits a thirteenth-century date for its construction; Di Salvo, *Basilicas of Ethiopia*, 80–83.

100 Gobezie Worku, "Church of Yimrhane Kristos."

101 See, however, Muehlbauer, "Rock-Hewn Yəmrəḥannä Krəstos?," 35–36.

102 For the best critique of this concept, see M. Baxandall, *Patterns of Intention: On the Historical Explanation of Pictures* (New Haven, 1985), 58–62.

103 Simpson, "Abyssinian Church Architecture," 39–40.

role in this, as have colonial legacies, which result in a problematic historiography that parallels other African art-historical contexts.[104] In the study of Ethiopian illuminated manuscripts, and to a lesser extent architecture, the assumed influence of Egyptian or Byzantine models has often taken precedent over autochthonous input, and, in response, certain scholars have now taken up the admirable charge to "Ethiopianize" or "Africanize" the field of study.[105]

Although the field has a long way to go in terms of rebalancing the historiography (as do even those who purport to do so), there are also political stakes to this, especially when discussing the Ethiopian Orthodox church's historical relations with the see of Alexandria. In today's rapidly shifting political landscape, the contemporary states of Ethiopia and Egypt face a very worrisome future.[106] Despite historic links between Ethiopian Orthodoxy and the Coptic church,[107] it is no surprise that we often find this long-standing relationship ignored[108] or cast in an adversarial light[109] in English-language scholarship. This view likely sounds particularly strange to those whom this history claims to valorize. Most Ethiopian Orthodox ecclesiastics I spoke to in Tigray and Amhara valued the historic relations with the Coptic church, and

in some cases even ascribed Egyptian origins to clearly local liturgical furnishings, as a marker of prestige and connectedness.

I believe that to regard Ethiopian architecture as developing in isolation is as problematic as suggesting it was entirely derivative.[110] This monograph, which focuses on monuments that incorporated architectural iconography as well as artistic forms from the wider world, does not ignore their autochthonous conceptions. In considering the architectural productions of early medieval Tigray from a global perspective, my study is both a corrective, calling for the inclusion of these monuments into broader debates in medieval art, and a plea for further study and preservation of the architecture of this overlooked part of the world.

Structure

This book is divided into four chapters and a conclusion. The first chapter, entitled "Medieval Architecture in Tigray, Ethiopia," provides an architectural survey of northern Ethiopia's monuments (ca. 400–1500). Though by no means exhaustive, the chosen chronology provides both a corpus to work with and temporal parameters for dating Tigrayan churches writ large. Moreover, my survey also provides a broad regional and religious context within which to understand my subject churches, and their unique architecture.

In Chapter 2, entitled "Churches in the Making," I provide comprehensive documentation and surveying of the architectural fabric of my subject churches as well as a proposed dating and typology. Although most of my documentation comes from firsthand observation, I also illustrate their (recent) restoration histories as gleaned through archival documentation. My dating, which I consider the most important part of the book, locates the church foundings in the

104 E. W. Giorgis, *Modernist Art in Ethiopia*, New African Histories (Athens, OH, 2019), 30–36. For the legacy of Leo Froebenius on the study of Nigeria's Ile-Ife bronzes, see R. Abiodun, *Yoruba Art and Language: Seeking the African in African Art* (New York, 2014), 207–10.

105 J. Gnisci, "Constructing Kingship in Early Solomonic Ethiopia: The David and Solomon Portraits in the Juel-Jensen Psalter," *ArtB* 102.4 (2020): 7–36, at 9–10; Phillipson, *Ancient Churches of Ethiopia*, xi. Nearly forty years ago, an Ethiopian scholar, Seyoum Wolde, critiqued the field of Ethiopian art from this perspective, yet his contribution is uncredited in these recent, better publicized, critiques; S. Wolde, "The Profile of Writings on Ethiopian Medieval Christian Art," in Beyene, *Proceedings of the Eighth International Conference*, 2:165–71.

106 S. Milas, *Sharing the Nile: Egypt, Ethiopia and the Geo-Politics of Water* (London, 2013), 168–76.

107 See, most recently, M. Ambu, "Du texte à la communauté: Relations et échanges entre l'Égypte copte et les réseaux monastiques éthiopiens (XIIIᵉ–XVIᵉ siècle)" (PhD diss., Panthéon-Sorbonne University, 2022).

108 See, for example, Phillipson, *Ancient Churches of Ethiopia*, 24.

109 E. Tibebe and T. W. Giorgis, "The Ethiopian Orthodox Church: Theology, Doctrines, Traditions, and Practices," in *The Routledge Handbook of African Theology*, ed. E. K. Bongmba (London, 2020), 265–79, at 274.

110 See the balanced discussion in J. Mercier and C. Lepage, *Lalibela, Wonder of Ethiopia: The Monolithic Churches and Their Treasures* (London, 2012), 253–55. In David Phillipson's discussion of the lost (fourth- to sixth-century) five-aisled cathedral of Aksum, for example, no mention was made of Constantine, whereas the Constantinian connotations of this Aksumite building were, in fact, a profound statement of Aksum's place in the world vis-à-vis the Roman Empire; see A. Manzo's review of Phillipson's *Ancient Churches of Ethiopia*, *RSE* 4 (2012): 275–83, at 280–81.

late eleventh century, with a terminus ante quem of 1150. Broadly speaking, in my discussion of the three individual rock-hewn monuments, I suggest that these churches should be conceived of as multiphase endeavors rather than a single "great campaign."

Chapter 3, "Inventing Late Antiquity in Medieval Ethiopia," presents both the meaning and context behind the unique architecture of Tigrayan cruciform churches. I propose that these monuments were a type of revival architecture—a local reinvention and evocation of sixth-century Justinianic aisled cruciform churches, engineered with then-revolutionary vaulting. I suggest that these churches were wholly the product of the late eleventh century, when the elites of East Tigray once again became involved in overseas trade via an alliance with the Fatimid caliphate.

The fourth chapter, "Medieval Ethiopia in the Indian Ocean World System," examines the role of Indian Ocean textiles in medieval Ethiopia and in the decoration of Tigrayan cruciform churches. I contend that the characteristic ornamental programs of Abreha wa-Atsbeha and Wuqro Cherqos were drawn from Indian,

Egyptian, and even Armenian liturgical cloths, which were introduced into northern Ethiopia through Fatimid mercantile channels. This program of architectural ornament, which formally resembles the revetments of contemporaneous Seljuk buildings (in Iran and Anatolia), was, I suggest, a parallel development, which in both Tigrayan and Seljuk societies came about from similar textile sources. As well as illustrating the origins of these architectural ornaments, my study highlights the global implications of South Asian textiles traversing the medieval Silk Road.

My concluding chapter, "A Local Legacy," examines the multifaceted afterlife of Tigrayan cruciform churches within Ethiopia and offers a framework for their future study within the canon of Byzantine architecture. In introducing later evocations of the architecture as well as the oral traditions surrounding these monuments, I underscore their local significance within Ethiopian architectural history. The concluding chapter demonstrates how these eleventh-century monuments have taken on new meaning since they were hewn, as loci for popular piety and wellsprings of autochthonous architectural inspiration.

CHAPTER 1

MEDIEVAL ARCHITECTURE IN TIGRAY, ETHIOPIA

T IGRAY IS HOME TO AT LEAST TWO hundred rock-hewn churches as well as a living tradition of hypogean architecture. The purpose of this chapter is to provide the reader with an architectural context, the broader history of the region's architecture, so as to better situate these monuments. Although generally unknown to scholars of Byzantine architecture, the medieval churches of Tigray, stemming from the fourth century, present a fascinating architectural history that parallels the development of the church basilica in the Mediterranean. As with the hewn architecture of Byzantine Cappadocia, the hypogean churches of Tigray are an autochthonous development, a natural result of the economy and relative ease of the rock medium, especially in a territory long associated with scarcity of wood.[1] In all cases, hewn architecture tends to imitate freestanding architecture, while—especially in the later Middle Ages— moving beyond it, utilizing imaginative, sculptural, and idiosyncratic articulation particular to the rupestrian medium.

Here I present a chronological selection of churches, from the first churches of late antiquity (ca. 350–700) to the large-scale monastic architecture of the late Middle Ages

(1300–1500), and conclude with a look at the continuity of practices in the modern day. Generally speaking, certain trends are apparent, such as the localization of Byzantine forms in late antiquity, a reliance on rock-cut architecture after the collapse of the Aksumite Empire, and an increase in scale and architectural creativity after the late medieval growth of monastic confederations. As nearly every church surveyed in this chapter is a basilica, the biaxial, aisled cruciform conceptions behind Abreha wa-Atsbeha, Wuqro Cherqos, and Mikaʾel Amba, the subjects of my study, should be understood as a singular moment in Ethiopia's architectural history. Considered within the context of the churches surveyed in this chapter, the particular veneration of these three monuments into the present day is unsurprising.

Early Christian Churches, 300–700

ARCHAEOLOGICAL FOUNDATIONS

Any attempted chronology of churches in medieval Ethiopia must invariably begin with the late antique architecture of the Aksumite Empire.[2]

1 R. G. Ousterhout, *Visualizing Community: Art, Material Culture, and Settlement in Byzantine Cappadocia*, DOS 46 (Washington, DC, 2017), 23–24.

2 For a broad overview of Aksumite churches, see D. W. Phillipson, *Ancient Churches of Ethiopia: Fourth–Fourteenth Centuries* (New Haven, 2009), 1–63; C. Giostra, "La diffusione del Cristianesimo lungo il Mar Rosso alla luce dell'archeologia: La città-porto di Adulis e il regno di Aksum," *RACr* 93 (2017): 249–313. For comprehensive, albeit significantly dated,

27

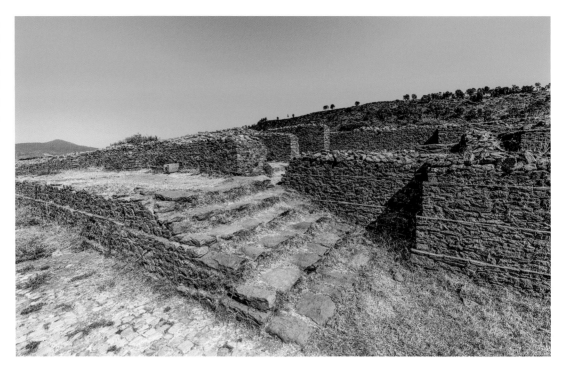

In many ways, church foundation during the Aksumite period can be seen as mirroring the better understood development of Christian architecture in the Mediterranean. Much as Christians adapted the form of Roman meeting halls into the church basilica following Constantine's conversion, so too did Aksumite Christians recast local architectural forms for ecclesiastical use.[3] Here Aksumite "palaces"—large rectangular buildings with stepped foundations and corner rooms, the ruins of which are found all over Tigray (Fig. 15) and Eritrea—formed the basis for the Ethiopian basilica.[4]

Though these buildings were, strictly speaking, not always palaces, they were designed for elite use and engineered with a building technique common across the Red Sea basin called "half timbering" (Fig. 16). Half timbering involved the layering of ashlar or, more commonly, dressed rubble with heavy timbers, which were often bonded to a rubble core through wooden binders.[5] When the binders projected through the facing materials, the exposed ends were often rounded (commonly known as "monkey heads") and used as a decorative flourish, while registers of wood courses were occasionally dovetailed, using metal clamps.[6] Though the palaces were constructed with a post-and-lintel system, they were also raised atop stepped foundations of cyclopean masonry, or compacted

inventories of Aksumite sites in Tigray and Eritrea, with good bibliography, see E. Godet, "Répertoire de sites pré-axoumites et axoumites du Tigré (Éthiopie)," *Abbay* 8 (1977): 19–58; E. Godet, "Répertoire de sites pré-axoumites et axoumites d'Éthiopie du Nord, IIe partie: Érythrée," *Abbay* 11 (1980–82): 73–113.

3 On the basilica form, see A. Nünnerich-Asmus, *Basilika und Portikus: Die Architektur der Säulenhallen als Ausdruck gewandelter Urbanität in später Republik und früher Kaiserzeit*, Arbeiten zur Archäologie 13 (Cologne, 1994). On church construction under Constantine, see M. J. Johnson, "Architecture of Empire," in *The Cambridge Companion to the Age of Constantine*, ed. N. Lenski (New York, 2006), 278–97.

4 For a chronology of these so-called palaces, see D. W. Phillipson, "Changing Settlement Patterns in Northern Ethiopia: An Archaeological Survey Evaluated," *Azania: Archaeological Research in Africa* 43 (2008): 133–45. The fullest excavation of one of these "palaces" was Dungur (Dəngur) near Aksum; see F. Anfray, *Le site de Dongour Axoum, Ethiopie:*

Recherches archéologiques, Archaeology as History 3 (Hamburg, 2012).

5 D. Buxton and D. Matthews, "The Reconstruction of Vanished Aksumite Buildings," *RSE* 25 (1971–72): 53–77; B. Lindahl, *Architectural History of Ethiopia in Pictures* (Addis Ababa, 1970), 23–25. Images recording a *chaîne opératoire* of building half-timbered structures is recorded in *Deutsche Aksum-Expedition*, vol. 2, *Ältere Denkmäler nordabessiniens*, ed. D. Krencker (Berlin, 1913), 7–10.

6 C. Lepage and J. Mercier, *Les églises historiques du Tigray: Art éthiopen / The Ancient Churches of Tigrai: Ethiopian Art*, trans. S. Williams and C. Wiener (Paris, 2005), 62.

Figure 16.
Diagram of Aksumite wall structure. Drawn by Derek Matthews, from D. Buxton and D. Matthews, "The Reconstruction of Vanished Aksumite Buildings," *RSE* 25 (1971–72): fig. 1, courtesy of *RSE*.

rubble. The largest palace, Taʾaka Maryam, near Aksum, occupied a space of 120 by 80 meters.

As a phenomenon, Christianity began among the elite in Aksumite society, and prestigious architecture became the basis for an Aksumite basilica-type church there. This is clearly the case with the early ecclesiastical structures found inland, such as the foundations of Agula Cherqos (Agulaʿ Čerqos) near Wuqro (Fig. 17), and the newly discovered, unconfirmed fourth-century church at Beta Samati (Betä Semati).[7] Both of

7 F. Anfray, "Notes archéologiques," *AÉ* 8 (1970): 31–56, at 39–40; Phillipson, *Ancient Churches of Ethiopia*, 48–49;

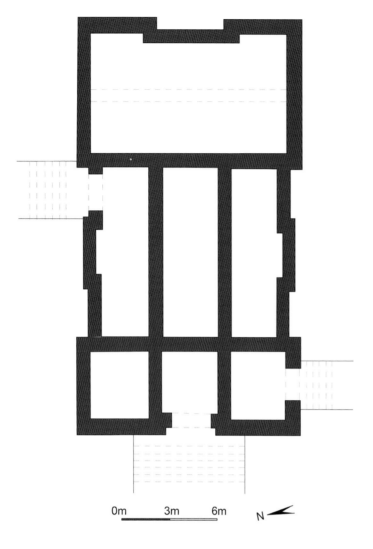

localized forms of acanthus leaves were sculpted to create classicizing, pseudo-Corinthian capitals (Fig. 19).[9]

This architectural taxonomy shifts in areas with frequent Mediterranean contact, however. Here conched apses were introduced, notably at coastal Adulis (as at the 25-meter long "British Museum" cathedral) and at the inland metropolises Matara (Mäṭära) and Aksum (church of Arbaetu Ensesa [Arbaʿətu Ǝnsəsa]).[10] Moreover, the Aksumites localized a type of cruciform baptismal font, common to Coastal Asia minor and the Levant (as at the church of St. John in Ephesus), for use in the pastophoria or in separate areas to the immediate east of churches (Fig. 20).[11]

0m 3m 6m N

Figure 17. Agula Cherqos, measured ground plan, near Wuqro, Tigray, Ethiopia. Plan by author and Binxin Xie, redrawn and modified after F. Anfray, "Notes archéologiques," *AÉ* 8 (1970): 40, fig. 22.

these buildings are superficially indistinguishable from secular palaces; they consist of a stepped platform with a multipiered hall set within, sided on its quadrants with corner rooms (which in their ground plans resemble "towers"). Aksumite piers, whether in secular or religious settings, were almost always monolithic—square profiled with chamfered edges and crowned with cushion or stepped capitals (Fig. 18).[8] On occasion,

M. J. Harrower et al., "Beta Samati: Discovery and Excavation of an Aksumite Town," *Antiquity* 93.372 (2019): 1534–52.

8 M. Gaudiello and P. A. Yule, eds., *Mifsas Bahri: A Late Aksumite Frontier Community in the Mountains of Southern*

Tigray. Survey, Excavation and Analysis, 2013–16, BAR International Series 2839 (Oxford, 2017), 236–44.

9 L. Ricci and R. Fattovich, "Scavi archeologici nella zona di Aksum. B. Bieta Giyorgis," *RSE* 31 (1987): 123–97, at 166–67, pls. 154–62.

10 For Adulis, see G. Castiglia, "Between Aksum and Byzantium: The Rise of Early Christianity in the Horn of Africa. Sources and New Archaeological Data," *Vetera Christianorum* 57 (2020): 85–105; G. Castiglia, "La cristianizzazione di Adulis (Eritrea) e del regno Aksumita: Nuovi dati dal Corno d'Africa d'età tardo antica," *Rendiconti della Pontificia Accademia di Archeologia* 91 (2020): 91–127; G. Castiglia et al., "For an Archaeology of Religious Identity in Adulis (Eritrea) and the Horn of Africa: Sources, Architecture, and Recent Archaeological Excavations," *Journal of African Archaeology* 19 (2021): 25–56. On the first church at Adulis, see S. Massa, "La prima chiesa di Adulis: Le origini della cristianità nel Corno d'Africa alla luce delle testimonianze archeologiche," *RACr* 93 (2017): 411–55. For Matara, see F. Anfray, "Matara: The Archaeological Investigation of a City of Ancient Eritrea," *P@lethnology* 4 (2012): 11–48; F. Anfray, "Deux villes axoumites: Adoulis et Matara," in *Atti del IV Congresso Internazionale di Studi Etiopici*, 2 vols. (Rome, 1974), 1:745–65; F. Anfray, "Maṭarā," *AÉ* 7 (1967): 33–88. For Arbaetu Ensesa in Aksum, see Tekle Hagos, "Archaeological Excavations at the Church of Arbaetu Ensesa, Aksum, Ethiopia, 2006–2007," *AÉ* 26 (2011): 79–98. For comparanda, see the late antique North African examples in I. Gui, N. Duval, and J.-P. Caillet, *Basiliques chrétiennes d'Afrique du Nord (inventaire et typologie)*, vol. 1, *Inventaire de l'Algérie*, Série Antiqué 129 (Paris, 1992).

11 M. Muehlbauer, "The Disappearance of the Ethiopian Baptismal Font," in *Baptême et baptistères: Regards croisés sur l'initiation chrétienne e ntre Antiquité Tardive et Moyen Âge. Actes du colloque international d'études, Sorbonne Université, Paris, 12–13 novembre 2020*, ed. B. Caseau, V. Michel, and L. Orlandi, Biblioteca di Archeologia e Storia dell'Arte 1 (Milan, 2023), 92–107. For this type of cruciform font as a Byzantine imperial symbol, see M. Falla Castelfranchi, *Βαπτιστήρια: Intorno ai più noti battisteri dell'Oriente*, Quaderni dell'Istituto di Archeologia e Storia Antica 1 (Rome, 1980). On the baptismal font at Ephesus, see M. Büyükkolancı, "Zwei neugefundene Bauten der Johannes-Kirche von Ephesos: Baptisterium und

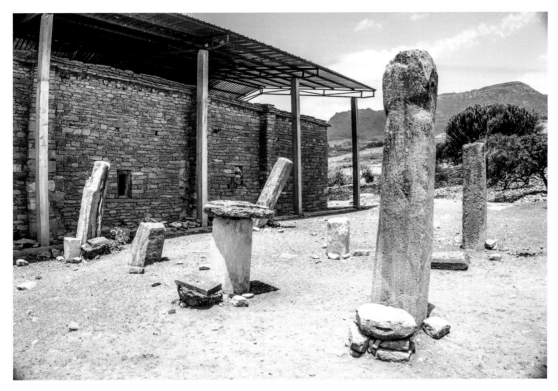

Figure 18. Maryam Nazret, Aksumite spolia piers, Addi Awona, Tigray, Ethiopia. Photograph by author.

Figure 19. Aksumite "Corinthian" capital, photographed in storage, Ethiopian National Museum, Addis Ababa, Ethiopia. Photograph by author.

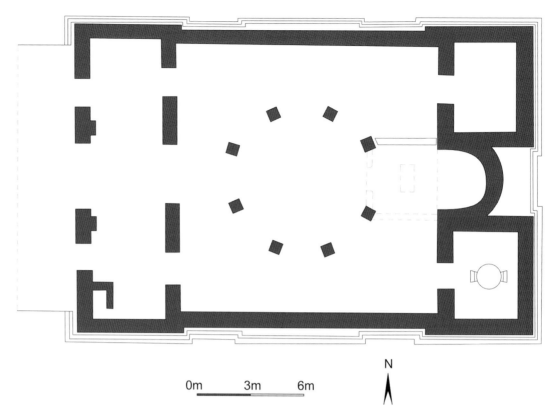

0m 3m 6m

N

Figure 20. "East Church," measured ground plan, Adulis, Eritrea, sixth century. Plan by author and Binxin Xie, redrawn and modified after C. Giostra, "La diffusione del Cristianesimo lungo il Mar Rosso alla luce dell'archeologia: La città-porto di Adulis e il regno di Aksum," *RACr* 93 (2017): 278, fig. 19a.

Liturgically, Aksumite churches follow a format consistent with Early Byzantine churches, that of the prothesis rite or "old ordo." The eucharistic gifts were prepared on a table and subsequently carried to the high altar (the Great Entrance or the Entrance of the Mysteries).[12] Often the sacraments were prepared in a subsidiary space, an enlarged side room to the north or south of the sanctuary (this is especially visible in the ground plans of Dabra Dammo and the basilica at Matara). In front of the altar was a low barrier or chancel, with a projecting porch (*solea*). Without exception, surviving Aksumite

screens are Byzantine imports (Fig. 21), namely, Proconnesian marble slabs and posts (although smaller bits of alabaster and other hardstones suggest a greater diversity).[13] The occasional Greek mason's mark suggests that these furnishings, exported to Adulis during the peak of Aksumite–Byzantine collaboration in the sixth century, arrived prefabricated from imperial workshops in Constantinople, perhaps in return for Aksumite

Skeuophylakion," in A. Thiel, *Die Johanneskirche in Ephesos*, Spätantike–Frühes Christentum–Byzanz 6 (Wiesbaden, 2005), 66–84.

12 E. Fritsch and M. Gervers, "Pastophoria and Altars: Interaction in Ethiopian Liturgy and Church Architecture," *Aethiopica* 10 (2007): 7–51, at 12–13. On the Great Entrance in Byzantine worship, see R. F. Taft and S. Parenti, *Il Grande Ingresso: Edizione italiana rivista, ampliata e aggiornata*, Analekta kryptopherrēs 10 (Grottaferrata, Italy, 2014).

13 M. E. Heldman, "Early Byzantine Sculptural Fragments from Adulis," in *Études éthiopiennes: Actes de la X^e conférence internationale des études éthiopiennes, Paris, 24–28 août 1988*, ed. C. Lepage (Paris, 1994), 239–52; S. C. Munro-Hay, "The British Museum Excavations at Adulis, 1868," *Antiquaries Journal* 69 (1989): 43–52; F. Anfray, "Le Musée archéologique d'Asmara," *RSE* 21 (1965): 5–15, at 10–11. For the origins of this type of chancel layout, see T. F. Mathews, "An Early Roman Chancel Arrangement and Its Liturgical Functions," *RACr* 38 (1962): 73–95. For late antique liturgical layouts more broadly, see N. Duval, "Les installations liturgiques dans les églises paléochrétiennes," *Hortus Artium Medievalium* 5 (1999): 7–30. On the export of precious stones, see J.-P. Sodini, "Le commerce des marbres à l'époque protobyzantine," in *Hommes et richesses dans l'Empire byzantin*, vol. 1, *IV^e–VII^e siècle* (Paris, 1989), 163–86.

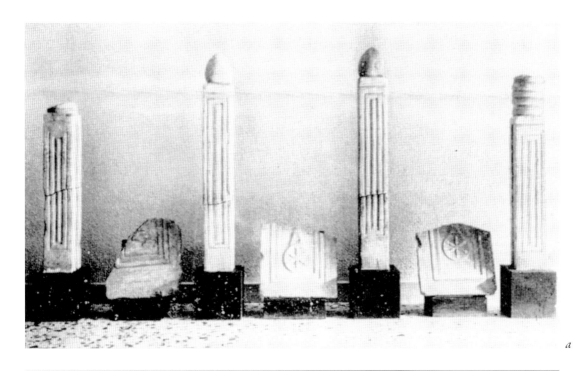

a

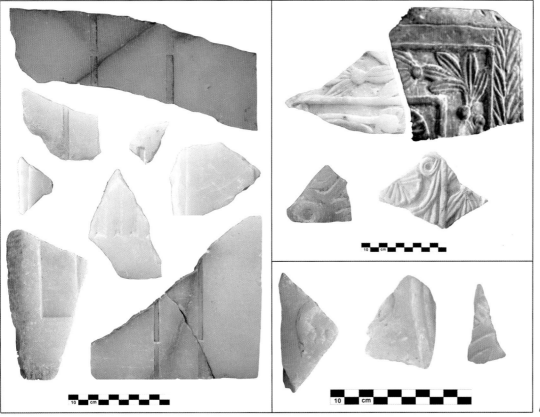

b

Figure 21. Proconnesian marble and assorted alabaster chancel fragments recovered from Adulis, Eritrea: (a) currently held in the Archaeological Museum of Asmara, Eritrea; (b) excavated from the "British Museum Cathedral." Photographs by Francis Anfray and Matteo Pola; (a) F. Anfray, "Le Musée archéologique d'Asmara," *RSE* 21 (1965): pl. V:8, courtesy of *RSE*; (b) © Pontificio Istituto di Archeologia Cristiana/Matteo Pola, courtesy of Gabriele Castiglia.

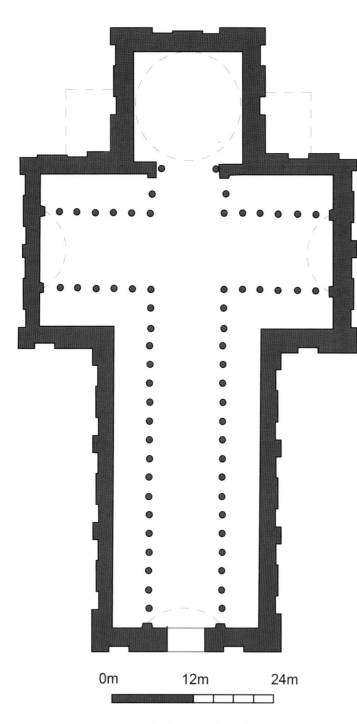

0m 12m 24m

Figure 22. Cathedral of Sanaa, hypothetical reconstruction, Sanaa, Yemen, sixth century. Plan by author and Binxin Xie, redrawn and modified after B. Finster and J. Schmidt, "Die Kirche des Abraha in Ṣanʿāʾ," in *Arabia Felix: Beiträge zur Sprache und Kultur des vorislamischen Arabien. Festschrift Walter W. Müller zum 60. Geburtstag,* ed. N. Nebes (Wiesbaden, 1994), 82.

ivory.[14] When measured against contemporaneous Byzantine shipwreck finds in Italy (Marzamemi) and coastal Syria (Amrit), these marble components are the furthest archaeology-attested point in Justinian's maritime network.[15]

In the sixth century, Aksumite churches exhibited a wide range of formal diversity beyond that of simple basilicas, undoubtedly owing to Aksum's international reach. The east church at Adulis (see Fig. 20), despite occupying a basilican footprint, had a centralized core replete with an ambulatory (perhaps originally domed).[16] Likewise, a cruciform (perhaps aisled-cruciform), apsed church on the Beta Giyorgis (Betä Giyorgis) hill in the city of Aksum was partly excavated.[17] The cathedral of Aksum, St. Mary of Zion (Aksum Tseyon [Aksum Ṣəyon], now rebuilt as a modern church) was originally a five-aisled basilica, and likely conceived in dialogue with the episcopal iconography of Constantine's main church projects.[18]

14 Massa, "La prima chiesa," 436–37. On the possible Aksumite provenance of Byzantine ivory, see D. W. Phillipson, "Aksum: An African Civilisation in Its World Contexts," *Proceedings of the British Academy* 111 (2001): 23–59, at 36–38; D. W. Phillipson, *Foundations of an African Civilisation: Aksum and the Northern Horn, 1000 BC–AD 1300* (Woodbridge, UK, 2012), 200–201.

15 D. W. Phillipson, *Foundations of an African Civilisation: Aksum and the Northern Horn, 1000 BC–AD 1300* (Woodbridge, UK, 2012), 199. See also R. K. Pedersen, "The Byzantine-Aksumite Period Shipwreck at Black Assarca Island, Eritrea," *Azania: Archaeological Research in Africa* 43.1 (2008): 77–94. On the Marzamemi shipwreck, see J. Leidwanger, E. S. Greene, and A. Donnelly, "The Sixth-Century CE Shipwreck at Marzamemi," *AJA* 125.2 (2021): 283–317; J. Leidwanger, "New Investigations of the 6th-C. A.D. 'Church Wreck' at Marzamemi, Sicily," *JRA* 31 (2018): 339–56. On the related shipwreck finds at Amrit in coastal Syria, see M. Dennert and S. Westphalen, "Säulen aus Konstantinopel: Ein Schiffsfund im antiken Hafen von Amrit," *Damaszener Mitteilungen* 14 (2004): 183–97.

16 C. Giostra and S. Massa, "Dal Mediterraneo al Mar Rosso: La cristianizzazione della città-porto di Adulis e la diffusione di modelli e manufatti bizantini," *Hortus Artium Medievalium* 22 (2016): 92–109, at 101–7.

17 L. Ricci and R. Fattovich, "Scavi archeologici nella zona di Aksum. B. Bieta Giyorgis," *RSE* 31 (1987): 123–97.

18 M. Muehlbauer, "An African 'Constantine' in the Twelfth Century: The Architecture of the Early Zagwe Dynasty and Egyptian Episcopal Authority," *Gesta* 62.2 (forthcoming, 2023). As the episcopal see of the Ethiopian Orthodox Church, Aksum Tseyon has not been comprehensively examined, though a sounding made in the 1950s exposed a foundation dating to the Aksumite period; see H. de Contenson, "Les fouilles à Axoum en 1958: Rapport préliminaire," *AÉ* 5 (1963): 3–40. For

Perhaps the most elaborate Aksumite church was the sixth-century cathedral of Sanaa (known as al-Qalīs < Gk. ἐκκλησία; Fig. 22),[19] built in occupied South Arabia during the Ethiopian occupation of Himyar.[20] Jointly erected by the Aksumite regent Abreha and the Byzantine emperor Justinian, the cathedral is known only from the description given by the early Muslim historian ʿAbd al-Walīd al-Azraqī (d. 865) and remains unexcavated.[21] Like the church at Beta Giyorgis hill in Aksum, the cathedral is described as a cruciform basilica (perhaps aisled), built in the prevailing Aksumite style of half timbering, though vaulted in the Byzantine fashion and mosaicked with a starry sky, like that in the tomb of Galla Placidia in Ravenna (and its Carolingian imitations).[22] Predictably, this richly adorned

cathedral was swiftly spoliated after the Muslim conquest. Its mosaics, book-matched marble revetments, columns, and foliate capitals were redeployed in the Kaaba (684 version) and the Great Mosque of Sanaa.[23]

STANDING CHURCHES

Though our knowledge of Aksumite architecture is largely limited to excavated foundations, there are two standing churches that, while heavily reconstituted as they stand, may have origins in late antiquity.

The first is Dabra Dammo, a monastery church reputed to date from the sixth century. It is perhaps the best-studied church in Ethiopia outside of those in the central highlands, though its building chronology is controversial.[24] A major complicating factor was the invasive 1948 restoration undertaken by architect Derek Matthews (on behalf of the reigning emperor, Haile Selassie), which heavily altered its appearance and is responsible (among other things) for its characteristically flat roof.[25] That said, rare documentary evidence provides the monastery church with a terminus ante quem of the thirteenth century.[26]

Built atop a flat-topped mesa, and only accessible via a leather pulley, Dabra Dammo is somewhat isolated, despite its active monastic community. The main church is a rectangular, three-aisled basilica, some 20 meters long and 9 meters wide,

a synthesis of reconstruction attempts, see Phillipson, *Ancient Churches of Ethiopia*, 37–40.

19 Because the building was described with cubit measurements (sing. *dhirāʿ*; see n. 21 below), I have scaled the groundplan according to the average cubit measurement recorded in the Tulunid-era (868–905) Cairo Nilometer: 54 cm per; W. Popper, *The Cairo Nilometer: Studies in Ibn Taghrī Birdī's Chronicles of Egypt* (Berkeley, CA, 1951), 102–5.

20 See, most recently, W. Daum, "Abraha's Cathedral: Change and Continuity of a Sacred Place," in *South Arabian Long-Distance Trade in Antiquity: "Out of Arabia"*, ed. G. Hatke and R. Ruzicka (Newcastle upon Tyne, 2021), 245–59. See also C. J. Robin, "La Grande Église d'Abraha à Ṣanʿāʾ: Quelques remarques sur son emplacement, ses dimensions et sa date," in *Interrelations between the Peoples of the Near East and Byzantium in Pre-Islamic Times*, ed. V. Christides, Semitica Antiqua 3 (Cordoba, 2015), 105–29; B. Finster and J. Schmidt, "Die Kirche des Abraha in Ṣanʿāʾ," in *Arabia Felix: Beiträge zur Sprache und Kultur des vorislamischen Arabien. Festschrift Walter W. Müller zum 60. Geburtstag*, ed. N. Nebes (Wiesbaden, 1994), 67–86. For South Arabian architecture in late antiquity more generally, see B. Finster, "The Material Culture of Pre- and Early Islamic Arabia," in *A Companion to Islamic Art and Architecture*, ed. F. B. Flood and G. Necipoğlu, 2 vols. (Hoboken, NJ, 2017), 1:61–88; C. Darles, "Typologie des sanctuaires de l'Arabie du Sud antique: Tentative pour une nouvelle classification," *PSAS* 44 (2014): 121–38.

21 For al-Azraqī's description, see his *Akhbār Makka wa-mā jāʾa fīhā min al-āthār*, ed. ʿA. ʿA. Ibn Duhaysh, 2 vols., (Mecca, 2003), 1:213–16. Even its location is disputed. In contemporary Sanaa, a circular pit is regarded as the foundation, though al-Azraqī directly contradicts this, as pointed out in W. Daum, "Ṣanʿāʾ: The Origins of Abrahah's Cathedral and the Great Mosque. A Water Sanctuary of the Old Arabian Religion," *PSAS* 48 (2018): 67–74, at 72.

22 Finster and Schmidt, "Die Kirche des Abraha," 72; E. Swift and A. Alwis, "The Role of Late Antique Art in Early Christian Worship: A Reconsideration of the Iconography of the 'Starry Sky' in the 'Mausoleum' of Galla Placidia," *Papers of the BSR* 78 (2010): 193–217, 352–54; G. Mackie, "Abstract and Vegetal

Design in the San Zeno Chapel, Rome: The Ornamental Setting of an Early Medieval Funerary Programme," *Papers of the BSR* 63 (1995): 159–82, at 174–75.

23 B. Finster, "Zu einigen Spolien in der Freitagsmoschee von Ṣanʿāʾ [sic]," *ZDMG*, Suppl. 4 (1980): 492–500; B. Leal, "The Abbasid Mosaic Tradition and the Great Mosque of Damascus," *Muqarnas* 37 (2020): 29–62, at 31; M. Guidetti, "The Byzantine Heritage in the *Dār al-Islām*: Churches and Mosques in al-Ruha between the Sixth and Twelfth Centuries," *Muqarnas* 26 (2009): 1–36, at 9.

24 D. Matthews and A. Mordini, "The Monastery of Debra Damo, Ethiopia," *Archaeologia* 97 (1959): 1–58; D. H. Matthews, "The Restoration of the Monastery Church of Debra Damo, Ethiopia," *Antiquity* 23.92 (1949): 188–200. See the rebuildings propsed by Lepage and Mercier, *Les églises historiques*, 38–45.

25 Matthews, "Restoration of the Monastery Church."

26 While the church foundation is likely earlier, literary mentions of the monastery of Dabra Dammo begin to appear in the thirteenth century; see S. C. Munro-Hay, "Saintly Shadows," in *Afrikas Horn: Akten der Ersten Internationalen Littmann-Konferenz*, ed. W. Raunig and S. Wenig, Meroitica 22 (Wiesbaden, 2005), 137–68, at 154–56.

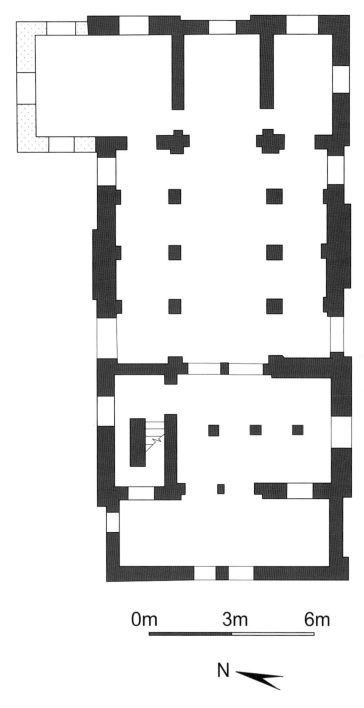

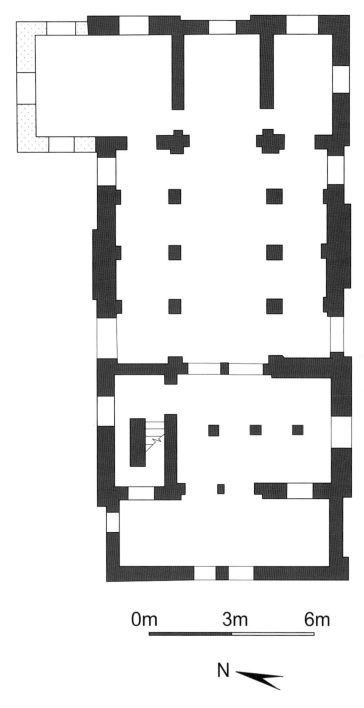

0m 3m 6m

N

Figure 23. Dabra Dammo, measured ground plan, Tigray, Ethiopia. Plan by author and Binxin Xie, redrawn and modified after D. Matthews and A. Mordini, "The Monastery of Debra Damo, Ethiopia," *Archaeologia* 97 (1959): fig. 3.

with an enlarged northeast chamber (Fig. 23).[27] Set atop a platform of stone steps, the fabric is half-timbered, with even courses of wood bosses, lending the church the appearance of a "textbook" Aksumite-style building.[28] Of clear late antique origin are the monolithic pillars that carry the nave and embellish the central portal (Fig. 24).[29]

Multiple wood elements in the church—namely, the nave entablature and triumphal arch—may be from medieval reconstructions. There the channeled strapwork and ornament are most similar to examples from the twelfth century (namely, at Mika'el Amba, discussed in Chap. 2), pointing to at least one medieval restoration phase. Moreover, the coffered narthex ceiling, long ascribed to late antiquity on the basis of its iconographic program (recently suggested by Jacques Mercier to be spolia from an Aksumite palace; Fig. 25), may just as well be located in a more contemporary, Fatimid decorative repertoire, perhaps even redeployed from a screen.[30]

The second is Zarama Giyorgis (Zärema Giyorgis), a rarely visited parish church near Atsbi (Aṣbi) in East Tigray, which may also be an Aksumite foundation (Fig. 26). This church is unique among Ethiopian buildings in that it was subject to a full survey and radiocarbon dating in early 1973 by Claude Lepage. While the

27 Per the published mensuration of Derek Matthews, who also possibly enlarged the church (illustrated on my ground plan). Including the side chamber, the monastery church is 12 meters wide.

28 Given the fact that half-timbered churches were still produced in Tigray into the twentieth century, dating churches just on their building fabric is unreliable, as was highlighted by David Buxton in his 1964 state of the field; D. R. Buxton, "Ethiopian Medieval Architecture: The Present State of Studies," *Journal of Semitic Studies* 9.1 (1964): 239–44, at 241–42.

29 As noted during the restoration works, however, they may be exogenous; Matthews, "Restoration of the Monastery Church," 193.

30 Certain loose coffers were taken to the Colonial Museum in Rome; see A. Mordini, undated "Folder 78," in Carlo Conti Rossini Archivio (Busta 11), Accademia dei Lincei, Rome; A. Mordini, "Uno sconosciuto capolavoro dell'arte etiopica: Il soffitto di Dabra Dammò," *Antichità viva* 1.8 (1962): 29–36; A. Mordini, "Il soffitto del secondo vestibolo dell'Endā Abuna Aragāwi in Dabra Dāmmó," *RSE* 6.1 (1947): 29–35; J. Mercier, *Art of Ethiopia: From the Origins to the Golden Century* (Paris, 2021), 44–45. See, for example, the illuminating comparisons offered with regard to Islamicate decoration, in Krencker, *Deutsche Aksum-Expedition*, 2:175–80, 182–94. David Phillipson suggested that the coffers were from a screen; Phillipson, *Ancient Churches of Ethiopia*, 59.

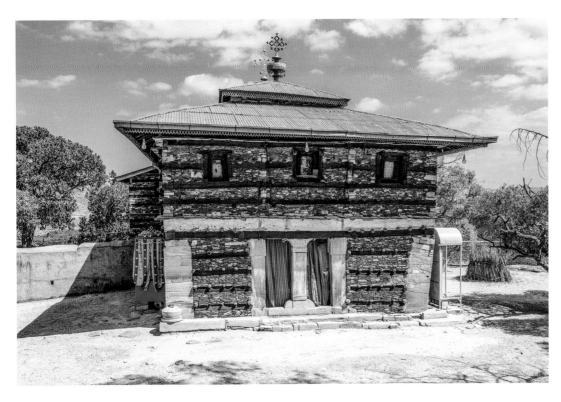

Figure 24.
Dabra Dammo, west
portal elevation, Tigray,
Ethiopia. Photograph
by Alexander Savin,
Wikimedia Commons.

Figure 25.
Dabra Dammo, narthex
ceiling, Tigray, Ethiopia.
Photograph by Michael
Gervers, from Mazgaba
Seelat, http://ethiopia.
deeds.utoronto.ca/,
MG-2005.088:031.

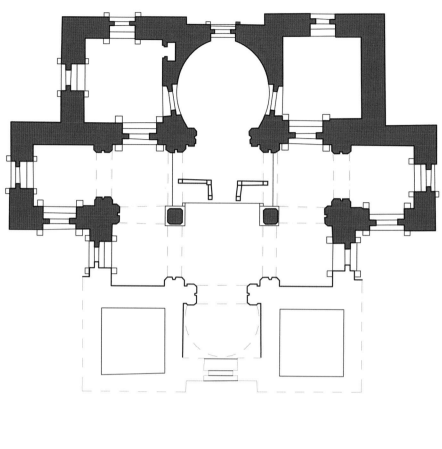

Figure 26.
Zarama Giyorgis,
reconstructed ground plan,
near Atsbi, Tigray, Ethiopia.
Plan by author and Binxin
Xie, redrawn and modified
after J. Gire in C. Lepage,
"L'église de Zaréma
(Éthiopie) découverte en
mai 1973 et son apport à
l'histoire de l'architecture
éthiopienne," *CRAI* 117.3
(1973): 429, fig. 9.

0m 3m 6m

N ◄

results have not been independently verified using AMS, the sample yielded a date of approximately 200–560, and when taken within a margin of error (± two centuries), shows at least some of the building dates to the Aksumite period (perhaps reconstituted spolia).[31] This church was badly damaged in the late 1990s when its transept arms were destroyed by the parish (presumably a demolition to make way for a new church), and visitation is rarely allowed. Few scholars have been permitted to enter since it was first surveyed in 1973.[32]

The church has a unique, semi-cruciform plan (partly the result of heavy remodeling prior to 1973, see below), and, also uniquely, is thought to have had a western apse over the narthex, with its own chancel, which clearly links the monument to other Mediterranean (and even Caucasian) late antique examples, and

31 C. Lepage, "Bilan des recherches sur l'art médiéval d'Éthiopie: Quelques résultats historiques," in *Proceedings of the Eighth International Conference of Ethiopian Studies, University of Addis Ababa, 1984*, ed. T. Beyene, 2 vols. (Addis Ababa, 1988–89), 2:48–50.

32 In the early 2000s it appears that Claude Lepage, with his then-collaborator Jacques Mercier, visited the church a second time, as did Michael Gervers independently. Since then, others, including myself, have gone with the intent to visit, but have been promptly turned away by the local parish. From the reports of Gervers and Lepage, the church was in perilous condition, and the parish even conveyed to Fr. Emmanuel Fritsch on a failed visit that they intended to tear it down. It is uncertain how much longer it will be standing.

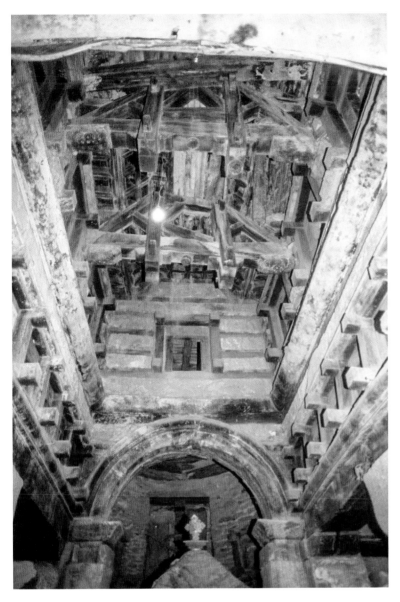

Figure 27.
Zarama Giyorgis, nave ceiling,
Tigray, Ethiopia. Photograph by
Michael Gervers, from Mazgaba
Seelat, http://ethiopia.deeds
.utoronto.ca/, MG-2002.022:033.

exemplifies the "international" style of the sixth-century Aksumites.[33] Though further study of the church was denied to Claude Lepage after 1973, he has suggested that the narthex was formerly flanked by side chambers, making the church in its original state an equilateral cruciform, a form that is highly evocative of Aksumite palaces (see Fig. 15).[34] Measuring some 13.5 by 8.5 meters, the building fabric is half-timbered; lacking the outwardly projecting beams characteristic of "Aksumite" architecture, it instead incorporates large ashlars to retain the rubble core.[35] Metal sutures tied the structure together, which, although looted prior to 1973, are still visible by rust stains in the plaster coat.[36] The church has three entrances to the west, one at each transept arm and one at the narthex. A small church, the two-bayed main vessel is flanked by aisles carried by monolithic piers with chamfered edges

33 Lepage and Mercier, *Les églises historiques*, 69; Lepage, "Bilan des recherches," 48. On dual-apsed churches, see N. Duval, *Les églises africaines à deux absides: Recherches archéologiques sur la liturgie chrétienne en Afrique du Nord*, 2 vols. (Paris, 1971–73).

34 See the comparison table of cruciform churches in C. Lepage, "L'église de Zaréma (Éthiopie) découverte en mai

1973 et son apport à l'histoire de l'architecture éthiopienne," *CRAI* 117.3 (1973): 416–54, at 449.

35 Lepage, "L'église de Zaréma," 424.

36 Lepage, "L'église de Zaréma," 425.

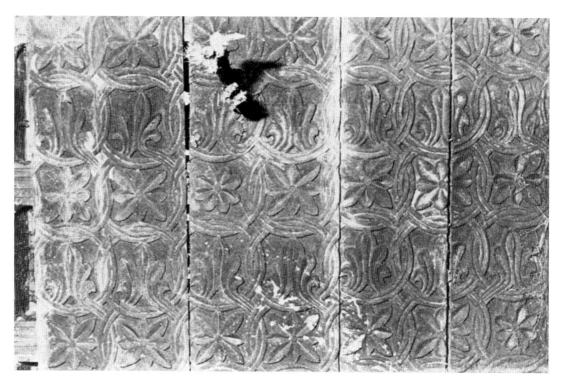

Figure 28.
Zarama Giyorgis, aisle
coffer, Tigray, Ethiopia.
Photograph from
C. Lepage, "L'église
de Zaréma (Éthiopie)
découverte en mai 1973
et son apport à l'histoire
de l'architecture
éthiopienne," *CRAI*
117.3 (1973): 437, fig. 1,
courtesy of Claude
Lepage and l'Académie
des Inscriptions et
Belles-Lettres.

and cushion capitals. The nave is crowned with a blind frieze pierced by exposed binders, from which the (likely twelfth-century) mansard roof with a flat apex springs (Fig. 27).[37] At the back of the church is a recumbent apse (formerly carrying a dome) over a low bema.

Much of the woodwork at Zarama is remarkable for its Byzantine appearance (Fig. 28). Pilaster brackets and aisle coffers are adorned with palmettes and crosses broadly similar to ornament from sixth-century Egypt, which, along with the roof of St. Catherine's Monastery on Mount Sinai, may be some of the only examples of early Byzantine wood still in situ.[38] Other

wood elements, however, such as the chancel, are most similar to examples of twelfth-century marquetry, and suggest a complex building chronology. Like Dabra Dammo, Zarama Giyorgis may actually be a twelfth-century reconstitution of an Aksumite foundation.

It may be helpful to conclude this section with the most problematic, yet potentially insightful, example of an Aksumite church, as depicted by an illustration in a fifth- to seventh-century illuminated gospel manuscript held in the monastery of Abba Garima (Abba Garimä; Fig. 29).[39] This full-page illumination reveals how Aksumite churches staged otherwise local

37 This type of frieze is often labeled Aksumite due to its similarities with those rendered on the stelae at Aksum.

38 Compare with the ornamental programs outlined in W. Lyster, "Artistic Working Practice and the Second-Phase Ornamental Program," in *The Red Monastery Church: Beauty and Asceticism in Upper Egypt*, ed. E. S. Bolman (New Haven, 2016), 97–118. Enda Cherqos WalWalo (Ǝnda Čerqos WalWalo), Monastery of St. Cyricus at Walwalo, a recent construction, has Aksumite spolia piers and carved brackets with the same interlace cross designs as those at Zarama. According to archeologist Tekle Hagos, there are some ancient foundations around the site as well as Aksumite pottery sherds: "Preliminary Result of the Archaeological Reconnaissance Carried out in S'aesie't S'ae'da Emba and Hawzen Districts, South Eastern Tigray, Ethiopia," *JES* 47 (2014): 95–119, at 104–6; G. Tesfaye, "Reconnaissance de trois églises antérieures à 1314," *JES* 12.2 (1974): 57–75, at 60–62.

See also Lepage, "Bilan des recherches," 49. On St. Catherine's roof, see L. Török, *Transfigurations of Hellenism: Aspects of Late Antique Art in Egypt, AD 250–700*, Probleme der Ägyptologie 23 (Leiden, 2005), 273–74.

39 On this architectural representation, see, most recently, Mercier, *Art of Ethiopia*, 38–41; J. Mercier, "Les deux types d'édicules associés aux Canons d'Eusèbe: Apport des Évangiles d'Abba Gärima (c. 450–650) à leur histoire et leurs symboliques byzantines et latines," *CahArch* 58 (2021): 29–54, at 29–35. See also J. S. McKenzie and F. Watson, *The Garima Gospels: Early Illuminated Gospel Books from Ethiopia* (Oxford, 2016), 121–44. Recent codicological work has revealed, however, that the illuminations, though themselves old, were probably inserted into the manuscript later; see S. Kim, "New Studies of the Structure and the Texts of Abba Garima Ethiopian Gospels," *Afriques* 13 (2022), https://doi.org/10.4000/afriques.3494.

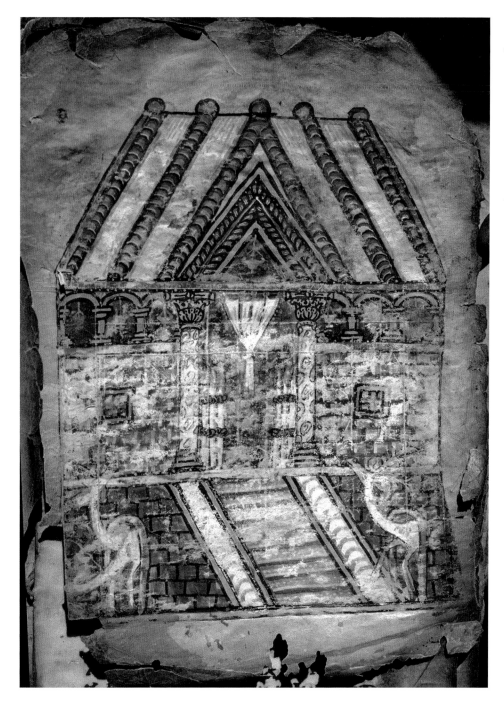

Figure 29.
Abba Garima II,
"Sanctuary of Light"
parchment folio,
Monastery of Abba
Garima, near Adwa,
Tigray, Ethiopia, ca.
450–650. Photograph by
Michael Gervers, from
Mazgaba Seelat, http://
ethiopia.deeds.utoronto
.ca/, MG-2000.036:011.

building fabrics with evocative and luxurious Byzantine forms. Though the ultimate subject of this image is debated (it is most recently thought to be an allegory of divine light), it depicts, in compressed perspective, a masonry structure, banded with two wood courses, atop a sloped platform. Indeed, this appears to be a highly stylized, Aksumite-era representation of a building, otherwise known only from archaeological foundations. Several unique features in the Garima illumination, such as an arcaded upper story, bread stamp-molded pediment, and fancy (perhaps faux Cipollino marble) spolia jamb columns, indicate that Aksumite churches were perhaps heavily embellished in their original state, thereby engaging in extensive artistic dialogue with their Byzantine contemporaries.

<div style="text-align:center">✠₊✠</div>

As shown in the above brief overview, churches from the Aksumite era, despite being thoroughly rooted in autochthonous palace designs, also incorporated many features from the Mediterranean, especially those produced in major urban areas (Aksum) and near the Red Sea coast (Adulis and Matara). In all cases, the building fabrics were local and half-timbered, though we often find the integration of prefabricated marble templon screens from Constantinople, which would continue to be imitated in wood into the later Middle Ages. In the sixth century, as a result of the Aksumite–Byzantine alliance, we find a wide use of Mediterranean forms, including dual apsed churches (as at Zarama; see Fig. 26) and aisled cruciform plans (Beta Giyorgis and Sanaa; see Fig. 22). However, this general efflorescence of churches in the late antique period sharply contrasts with the scarce architectural productions of the early Middle Ages. In contrast with the international empire of Aksum, we find in the post-Aksumite era a significant downsizing and privatization of worship, now territorially restricted to the eastern reaches of Tigray province.

Post-Aksumite Architecture, 700–1000

The reasons for and the exact timeline of the Aksumite collapse are unclear. Christian authority appears to have slowly contracted into east Tigray after the flooding of Adulis and the abandonment of urban settlements, with no clear break in terms of cultural and building practices.[40] While some evidence indicates that Byzantium served as a caretaker for Aksum in the seventh century, by the time of the Islamic conquests, the Byzantine Empire was in no condition to shore up an ally surrounded by hostile peoples, let alone one newly inaccessible by sea routes.[41]

Although there are few known ecclesiastical remains from the immediate post-Aksumite period, the paired micro-basilicas in the Degum Selassie (Dəgum Śəllase) complex (Fig. 30) appear to date from this ill-defined era, produced by "Aksumite" patrons immediately before or after the seventh-century collapse.[42] Unlike the great

Figure 30. Degum Selassie, North Church, ground plan, near Hawzen, Tigray, Ethiopia. Plan by author and Binxin Xie, redrawn and modified after C. Lepage, "Les monuments rupestres de Degum et les églises de vallée," *Documents pour servir à l'histoire des civilisations éthiopiennes* 2 (1971): unnumbered plate.

40 Aksumite titulature was even used in Tigray until the thirteenth century; S. B. Chernetsov, "Endärta," in *EAe* 2:297–98.

41 Gaudiello and Yule, *Mifsas Bahri*, 272. The tenth-century chronicler al-Ṭabarī wrote that during the Persian war of 602–628 CE, the Byzantine emperor Heraclius attempted to send a ship of treasures to Ethiopia hoping this would encourage them to fight against the Sasanians. Ironically, the Persians intercepted the ship before it got to Ethiopia; al-Ṭabarī, *Chronique de Abou Djafar ... Tabari, traduite sur la version persane d'Abou-'Ali-Mo'hammed Be'ami*, trans. M. H. Zotenberg, 4 vols. (Paris, 1867–74), 2:305.

42 F. Anfray, *Les anciens éthiopiens: Siècles d'histoire* (Paris, 1990), 179–85. Claude Lepage was the first to identify and document the complex, but considered the paired churches to be martyria; C. Lepage, "Les monuments chrétiens rupestres de Degum en Éthiopie (rapport préliminaire)," *CahArch* 22 (1972): 167–200. Lepage has further discussion of the monument in "L'église rupestre de Berakit," *AÉ* 9 (1972): 147–91.

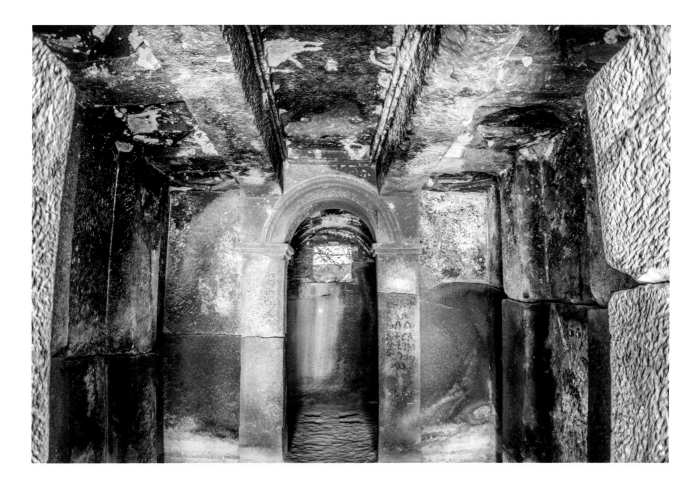

basilicas of late antiquity, the diminutive scale and rupestrian conception of Degum Selassie suggest both societal contraction and privatization of worship. Rock carving, after all, is the most expeditious and economical building practice in mountainous areas. The exceptionally small chapels may have been built only for infrequent, private use. Likely intended for commemorating the dead, the complex's rock construction appears directly tied to Aksumite funerary practice.[43]

My preliminary dating, based on that of Claude Lepage, rests on the basis of contextual pottery finds (dating to the late Aksumite period) as well as on the form and function of the church complex.[44] Both of Degum Selassie's basilicas consist of two antechambers preceding single naves (3.5 m square; Fig. 31), which end in sanctuaries flanked by side chambers. Pilaster strips and ceiling panels serve to divide each nave into simulated aisles, three bays in length. Although the nave is raised, the "aisles" are inscribed with imitation lantern ceilings, replete with bore holes in the center of each oblique void.[45] These holes, as well as those in the center of the ceiling, suggest that plaques of wood or bronze were fastened there.[46] This dependence on material inserts for architectural production in stone is, to my knowledge, singular, and indicates a general unfamiliarity with the rupestrian medium for creating churches, in sharp contrast to the skill that is shown at the apogee of rock carving that followed

43 J. Tipper, "The Tomb of the Brick Arches: Structure and Stratigraphy," in *Archaeology at Aksum, Ethiopia, 1993–7*, by D. W. Phillipson, 2 vols. (London, 2000), 1:31–57, 425–27.

44 H. de Roux, "Note sur des tessons céramiques de Degum (Tigré)," *AÉ* 10 (1976): 71–80; C. Lepage, "Les monuments rupestres de Degum et les églises de vallée," *Documents pour servir à l'histoire des civilisations éthiopiennes* 2 (1971): 61–72, at 69–70.

45 Lantern ceilings, hitherto used in Ethiopianist literature, is a descriptive term borrowed from wooden Indian architecture; they consist of angled boards imposed obliquely over one another in a successively narrow formation; D. Buxton, "The Rock-Hewn and Other Medieval Churches of Tigré Province, Ethiopia," *Archaeologia* 103 (1971): 33–100. at 73–76.

46 Lepage and Mercier, *Les églises historiques*, 51–52.

Figure 31.
Degum Selassie, North Church, nave view, Tigray, Ethiopia. Photograph by author.

Figure 32.
Degum Selassie,
round shaft,
southeast corner
of the apse,
Tigray, Ethiopia.
Photograph
by author.

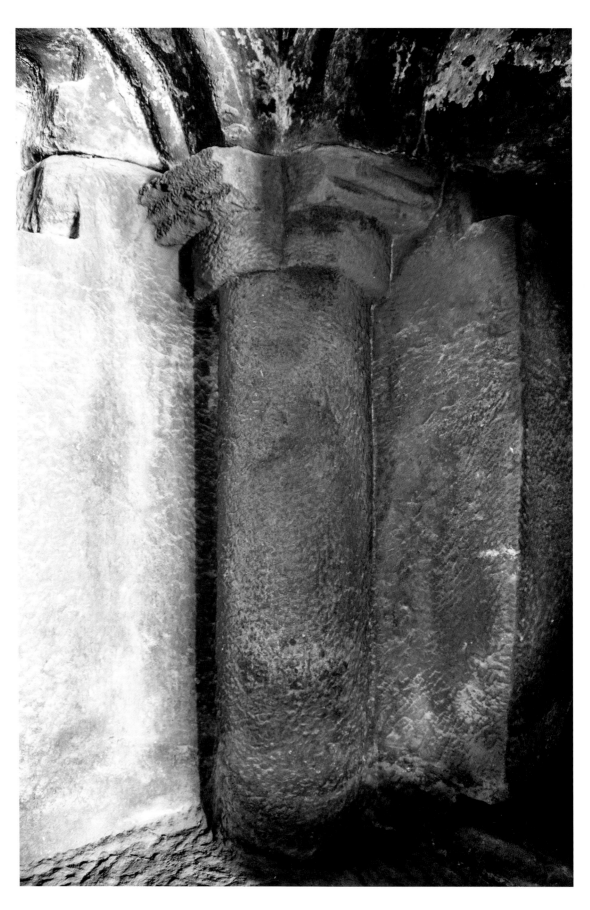

in the eleventh century.[47] I have also observed that the intrados of the arches defining the *mäqdäs* (altar chamber) are also deeply channeled, suggesting an original use of decorative wood.

At the north church, liturgical features are emphasized to the point of symbolism.[48] In front of the low bema of the sanctuary are tightly spaced square holes, laid out in the ∏-shaped templon configuration of early Christian churches, replete with parapet walls and a projecting solea (see Fig. 30). Large socles in the sanctuary and the south pastophorion indicate the placement of an altar and preparatory table, and signal the continued use of the prothesis rite among post-Aksumite Christians.[49] The sanctuary, which is uniquely framed by arcades of cylindrical shafts (Fig. 32), likewise appears as a sort of faux-ciborium, hitherto known only from Aksumite illuminations (Garimä I, fourth–seventh century; Fig. 33).[50] Perhaps the round pilasters were even intended to evoke the prestigious marble furnishings of the prior century.

Formally speaking, the twin churches at Degum Selassie also have a clear Aksumite precedent. The micro-basilicas (styled as if to evoke a three-aisled basilica) are similar to a twinned pair of three-aisled Aksumite churches eponymously named after the kings (reputedly) buried in their crypts: Gabra Masqal (Gäbrä Mäsqäl) and Kaleb (sixth century).[51] Moreover, the hewn font, located immediately east of the paired churches, is identical in both form and placement to those excavated from Aksumite sites, namely, Matara and Adulis (see Fig. 20).[52]

Figure 33. Abba Garima I, parchment folio, Monastery of Abba Garima, Tigray, Ethiopia, ca. 450–650. Photograph by Michael Gervers, from Mazgaba Seelat, http://ethiopia.deeds.utoronto.ca/, MG-2000.034:035.

47 See also Lepage and Mercier, *Les églises historiques*, 55.

48 The postholes of the chancel are too large and closely spaced to fit any templon slabs, a phenomenon broadly similar to the "liturgicality" of Cappadocian churches as defined by Robert Ousterhout, where liturgical features are overemphasized at the expense of useability; Ousterhout, *Visualizing Community*, 484–86.

49 Fritsch and Gervers, "Pastophoria and Altars," 13–14.

50 Lepage, "Les monuments rupestres," 64–65. See on the ciborium illumination in the Abba Garima gospels, Mercier, *Art of Ethiopia*, 37; McKenzie and Watson, *Garima Gospels*, 128–30.

51 On the tombs of Gabra Masqal and Kaleb, see D. W. Phillipson, *Archaeology at Aksum, Ethiopia, 1993–7* (London, 2000), 425–27; Phillipson, *Foundations of an African Civilisation*, 149–56. On the connection with Degum, see Lepage, "Les monuments rupestres," 70.

52 Muehlbauer, "Disappearance." Emmanuel Fritsch and Habtemichael Kidane have recently suggested that this font was

From the limited evidence that can be gleaned from the post-Aksumite foundation at Degum Selassie, we can see that Aksum's building traditions and select use of Mediterranean forms (i.e., cylindrical shafts, templon screen, cruciform

probably covered with a freestanding structure, though I have not found postholes or trench marks to suggest that this was the case; E. Fritsch and H. Kidane, "The Medieval Ethiopian Orthodox Church and Its Liturgy," in *A Companion to Medieval Ethiopia and Eritrea*, ed. S. Kelly (Leiden, 2020), 162–93, at 172.

piscina) continued, albeit at a highly reduced scale after the collapse of imperial patronage. Likely due to a general societal contraction and isolation, masons turned to the rock face for their church designs, a trend that will emerge as the main medium for ecclesiastic architecture in the succeeding centuries.

The Architecture of Ethiopia's "Second Christianization," 950–1150

In contrast to the few architectural foundations of the previous centuries, the early second millennium in Tigray was a time of architectural dynamism unseen since the Aksumite era. Indeed, it was during this time when the subjects of this monograph, Abreha wa-Atsbeha (see Fig. 3), Wuqro Cherqos (see Fig. 4), and Mika'el Amba (see Fig. 5), were commissioned, to which I also date several other churches, including Maryam Baraqit (Maryam Bäraqit), Yohannes Matmaq (Yoḥannəs Mäṭməq), and Hawzen Takla Haymanot (Ḥawzen Täklä Haymanot). Although the historical circumstances will be more fully discussed below (Chaps. 3 and 4), it appears that this resurgence in building activity was the result of profound political and economic changes in eleventh-century Ethiopia (more specifically, 1089–1094). Because the three cruciform churches of Abreha wa-Atsbeha, Wuqro Cherqos, and Mika'el Amba (and their exact dating) will be discussed at length later on, this section is limited to the other churches that date from this period.

Since the Fatimid caliphate had already established trading colonies in coastal Ethiopia, it compelled the Coptic church to use its episcopal ties to advance Egyptian trade and settlement in Tigray (1089 or 1090). I propose that this reintegrated the Christians of east Tigray into the Coptic papacy while providing the reigning elites with an overseas outlet for the sale of goods. By trading with the Fatimids, the post-Aksumite Tigrayan elite effectively resuscitated their ancient role as broker state in the established Indian Ocean trade network. Post-Aksumite state building followed, as the Coptic episcopal authority used the Christian elites as a pretext for aggressive territorial expansion. This trend culminated in the establishment of a Metropolitan center at Maryam Nazret in 1150 and the rise of the relatively centralized

Hatsani dynasty of the Zagwe, a rough timeline that Marie-Laure Derat has provocatively called "the second Christianization" of Ethiopia (a periodization hitherto used for the sixth century, per hagiographic tradition).[53]

In contrast with Aksumite churches from the early Christian period, those from the tenth and eleventh centuries are wholly rupestrian, and were established for a variety of functions; they comprise parish churches (Yohannes Matmaq, Maryam Baraqit, Hawzen Takla Haymanot), hybrid monastery/parish churches (Abreha wa-Atsbeha, Wuqro Cherqos, Mika'el Amba), and perhaps even an episcopal center (Abreha wa-Atsbeha). Moreover, the increased confidence in and normalization of hypogean architecture encouraged full-scale petrification of freestanding forms. In all cases, the later churches largely imitate the articulation of their Aksumite predecessors, deployed alongside select architectural and decorative features from the contemporary Islamic world (for those in the Tigrayan cruciform triad, see Chap. 3). Although the exact rituals to occur in these churches are debated, liturgical layouts are largely unchanged from late antiquity.[54] Low barriers, now made of wood, enclosed the bema and fronted the sanctuary. Side rooms, enlarged to house a preparatory table, flanked the apse, although its function may have now been the selection and washing of the sacramental bread (middle ordo) rather than strictly the prothesis.[55]

Two small, three-aisled basilicas, Hawzen Takla Haymanot and Maryam Baraqit, found in the vicinity of Hawzen, East Tigray—together commonly referred to as the "valley churches of the Hawzen plain" (a label that has hitherto also included Degum Selassie)—likely date to this transformative period.[56] Maryam Baraqit (Fig. 34) measures some 13 meters long, inset

53 M.-L. Derat, *L'énigme d'une dynastie sainte et usurpatrice dans le royaume chrétien d'Éthiopie du XIᵉ au XIIIᵉ siècle* (Turnhout, 2018), 92. See also the use of the word Hatsani in the land donations of the kings Tantawedem and Lalibela; ibid., 35, 149.

54 Cf. Fritsch and Kidane, "Medieval Ethiopian Orthodox Church," 175–76.

55 For the fullest overview of this liturgical development, see R. Mikhail, *The Presentation of the Lamb: The Prothesis and Preparatory Rites of the Coptic Liturgy*, Studies in Eastern Christian Liturgies 2 (Münster, 2020).

56 This term was first coined by Claude Lepage in his 1971 article "Les monuments rupestres." David Phillipson reframes

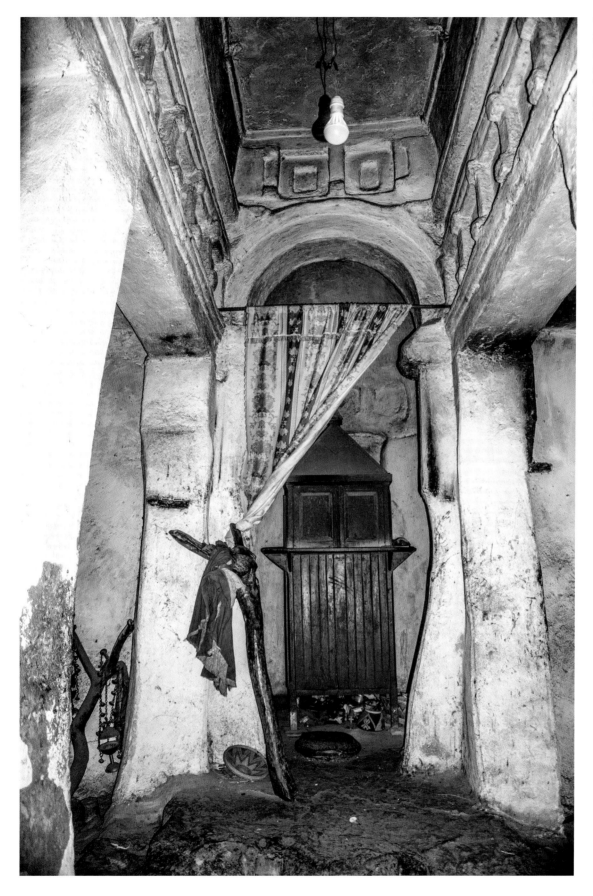

Figure 34.
Maryam Baraqit,
east elevation,
near Hawzen,
Tigray, Ethiopia.
Photograph
by author.

Figure 35.
Hawzen Takla
Haymanot, nave
elevation, Hawzen,
Tigray, Ethiopia.
Photograph by author.

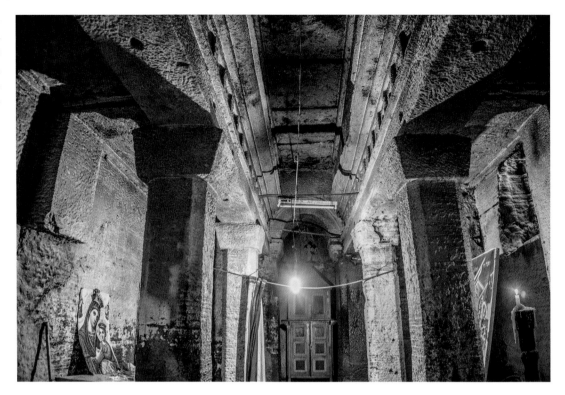

from two (recently reworked) rock-hewn vesti-bules. The main vessel is small, some 4.56 meters long, divided into aisles by pillars, with a pyrami-dal section centered on the nave elevation (nearly double the height of the aisles). The sanctuary is apsed, measuring some 1.5 meters long, preceded by a bema and triumphal arch, and flanked by, now immured, side chambers. The altar space is crowned with a cupola and lit on the east by a small square window. Immediately west of the triumphal arch is a low bema, marked with socles where the ∏-shaped chancel was fitted. Articulation is typically "Aksumite"—a blind frieze, akin to the wood examples at Zarama and Dabra Dammo, crowns the nave architrave and spans the semicircular drum of the apse cupola, while the nave ceiling is intersected by transverse lintels that are framed with a torus molding.[57]

Overall, articulation is idiosyncratic—engaged lintels on the aisles end in pilaster strips on the walls, independent of the freestanding supports.

Generally speaking, I regard Maryam Baraqit as unfinished (though the application of white paint and concrete to the entirety of the ves-sel makes archaeological study of it impossible). The two piers that "support" the nave ceiling are simple and square profiled, but without capi-tals. Moreover, a hole in the north wall suggests that the narrower, western part of the nave was intended to be aisled as well.

The Church of Takla Haymanot, located in Hawzen, is another small hypogean basilica, closely related to Maryam Baraqit. Hewn from a low sandstone outcrop, the church is named after the popular Ethiopian saint Takla Haymanot, who is alleged to have prayed in the anchoritic cell carved in the rock face immediately above the basilica.

Despite being cut from rock, Takla Haymanot incorporates an elaborate foundation that evokes stepped, Aksumite platforms. Although the basilica itself is off-limits to laypeople, it may be viewed at a distance from the vestibule.[58]

this designation as "funerary hypogea in the Hawzen plain"; see Phillipson, *Ancient Churches of Ethiopia*, 88–92.

57 Claude Lepage, who assembled mold profiles of the nave architrave at Maryam Baraqit, found close parallels with those made of Dabra Dammo's nave architrave in the 1940s. It may, therefore, date to the same general period as Dabra Dammo's hypothesized medieval restoration phase; see Lepage, "L'église rupestre," 156–57. For the mold profiles of Dabra Dammo, see Matthews, "Restoration of the Monastery Church," 195.

58 However, during a CNRS mission in the 1970s, Claude Lepage and Jean Gire were able to enlist the help of a priest, who

Worship now takes place in the main church, a large dressed rubble building that encloses the rupestrian chapel on three sides.[59] The medieval church measures 11 meters long, and consists of three aisles made of nine bays, each 2 meters square (Fig. 35). The nave is raised with a pyramidal section and flanked by chamfered piers and impost capitals. As at Baraqit, the sanctuary is entered via a floor raise (bema) and a triumphal arch, while the ceiling is crowned with a ribbed dome. The church is plainly decorated—the nave entablatures are adorned with a frieze of simple square frames, though holes along the architrave indicate that the nave at one time was likely also embellished with curtain rods. Severely bracketed quarter round moldings, which crown the architrave and fit snugly into the crown of the triumphal arch, suggest to me that the nave was also vaulted in its (hypothetical) first phase.

I conclude this section with a discussion of the impressive, yet rarely visited church of Yohannes Matmaq, carved into a hillside in the easternmost cliff escarpment in Tigray, less than an hour's drive from the Danakil Depression (ca. 30 km north of Atsbi). Established in a place of continuous habitation since the Aksumite period as well as an important stopover for salt caravans, this church is by far the largest rock-hewn creation in Tigray, measuring 24.3 meters end to end (Fig. 36). Its grandeur is likely due to its strategic location.[60] However, carved out of a porous sandstone, the basilica has been semi-abandoned for many years, as it has been slowly disintegrating on account of efflorescence on its lower walls. Unable to contact the regional Cultural and Tourism Bureau authorities, the local parish recently shored up the interior with daubed concrete (thereby preventing archaeological and iconographic study).[61] Nevertheless, the church's pastophoria, which were not "restored," are still collapsing. The floors are covered in heaps of powdered sandstone.

As at Hawzen Takla Haymanot and Maryam Baraqit, Yohannes Matmaq is rendered cave-like in the eastern face of a rock escarpment. The church, which is flanked by a hewn sacramental bread oven (betä ləḥəm), is a three-aisled basilica, colonnaded with three octagonal piers per side (Fig. 37), and with a narrow return aisle on the west. Entered through a timber portal, the scale of its interior is impressive—the nave is spatially massed to a height of 7 meters with an intercolumnar span of 4.6 meters, contrasting with a 4.2-meter height of the side aisles. Even its wood chancel was gargantuan: a surviving post maintained in storage stands at 2.5 meters (Fig. 38).

In its ground plan, Yohannes Matmaq closely resembles the excavated remains of Aksumite basilicas such as the church of Arbaetu Ensesa in Aksum and the "British Museum" cathedral at Adulis. Its axial nave ends in a partial apse conch atop a high, two-step bema, while great triumphal arches bookend the nave. Simple articulation serves to break up the interior; the return aisle ceiling is adorned with timber fittings, while the aisles are divided into bays with engaged lintels and pilaster strips. The nave (Fig. 39), flanked by simple entablatures, appears unfinished, though the ceiling is embellished with embedded wood beams.[62] The piers are unique among Ethiopian monuments; their purely octagonal sections and

is responsible for the measured plan presented in C. Lepage, "Entre Aksum et Lalibela: Les églises du sud-est du Tigray (IXᵉ–XIIᵉ s.) en Éthiopie," *CRAI* 150.1 (2006): 9–39, at 23; Claude Lepage, personal communication, November 2021.

59 Although now covered in decorative plaster, archival photos from 1936 illustrate that the rubble building is quite old, perhaps from the seventeenth or eighteenth centuries; A. Maugini, "Africa Orientale Italiana Vol. X Taclai Amanot–Adigrat–Asmara–Gondar–Bahardar," 1936.13/15, Archivio Istituto Agricolo Coloniale Italiano, Florence, Italy.

60 This is indicated by the presence of Aksumite pottery around the site, as recorded in Godet, "Répertoire des sites pré-axoumites et axoumites du Tigré," 48. During my visit (June 2018), I found large quantities of iron slag in the grounds around the church, which, if dated, may confirm such a settlement phase. Similar iron smelting sites have been documented in the vicinity of Wuqro as well; H. Berhe et al., "Preliminary Report on a Test Excavation at the Ancient Iron Smelting Site of Gud Baḥri (Wuqro, Tigray)," *AÉ* 33 (2021): 167–88. Claude Lepage also mentions a rupestrian necropolis dug into the rock face above the church, though I was unable to find this when I visited; Lepage and Mercier, *Les églises historiques*, 90.

61 According to an inscription seen by Lepage and Mercier, but now covered by whitewash, several of these paintings may be dated to 1294 CE. If accurate, this would provide a late thirteenth-century terminus ante quem for the church; see Lepage and Mercier, *Les églises historiques*, 91.

62 The north side incorporates a partial cyma and a setback molding, and the south entablature frames a void between a fillet molding and a severely projecting, quarter-round molding, perhaps indicating the one-time presence of a barrel vault.

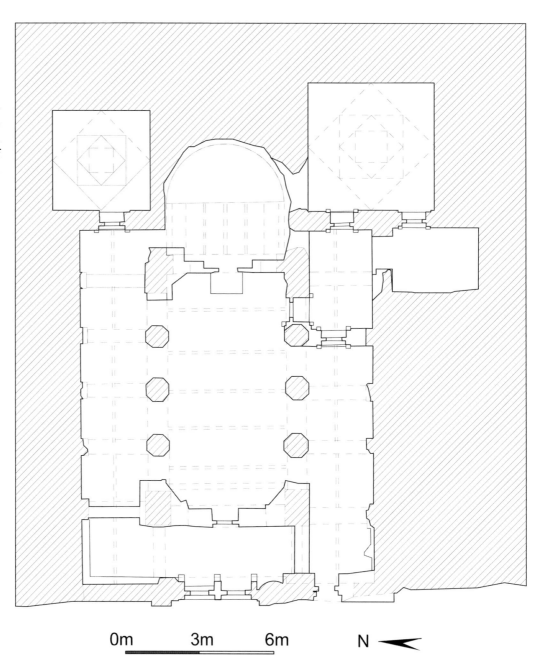

Figure 36.
Yohannes Matmaq,
measured ground plan,
Gazen, Tigray, Ethiopia.
Plan by author and Binxin
Xie, redrawn and modified
after that of Jean Gire, with
modifications by E. Fritsch
and P. Tiessé, courtesy of
Emmanuel Fritsch.

0m 3m 6m N

block capitals appear almost Pharaonic in conception (see Fig. 37).[63]

Like other churches from this early period, the apse in Yohannes Matmaq is flanked by side chambers crowned with lantern ceilings. As indicated by floor socles, the north chamber served as the prothesis, and could be entered from either a timber doorway on the north aisle or an irregular (now filled) portal in the sanctuary. The south chamber is a dedicated baptistery, mirroring Aksumite precedents at Yeha (Yəḥa), Enda Cherqos (Ǝnda Čerqos), and Adulis; though subsequently recarved, it may have originally resembled the cruciform type of font prevalent in late antiquity.[64]

63 This may be tied to Coptic engagements with the Pharaonic past; M. Cook, "Pharaonic History in Medieval Egypt," *Studia Islamica* 57 (1983): 67–103.

64 The "East Church" at Adulis, Enda Cherqos, and the ancient church at Yeha included baptismal fonts in their south

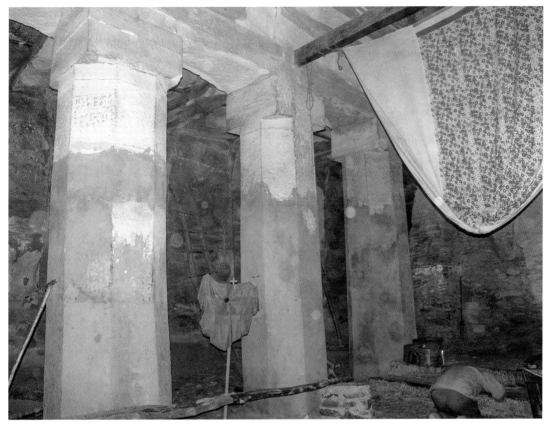

Figure 37.
Yohannes Matmaq, north
nave colonnade (pre-
restoration), viewed west
to east, Tigray, Ethiopia.
Photograph by Philippe
Sidot and Emmanuel
Fritsch, courtesy of
Emmanuel Fritsch.

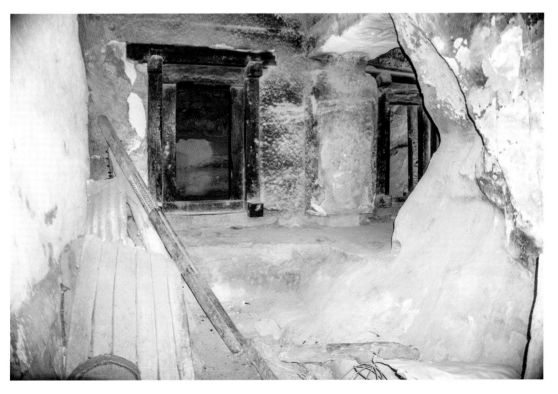

Figure 38.
Yohannes Matmaq, outer
rail post, stored in the
southeast baptistry
vestibule, Tigray, Ethiopia.
Photograph by author.

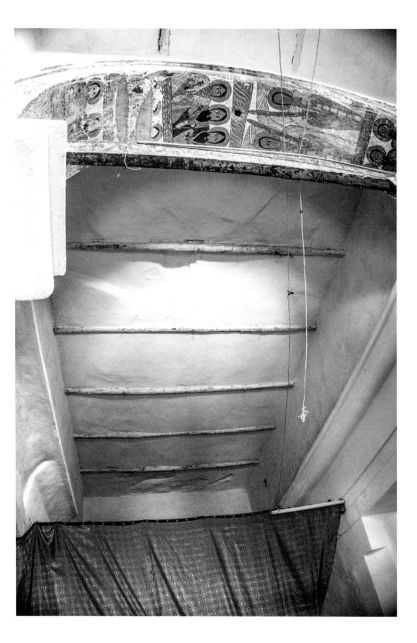

Figure 39.
Yohannes Matmaq, nave
ceiling, viewed west to
east, Tigray, Ethiopia.
Photograph by author.

The eleventh century was a watershed in the architectural history of Tigray. In response to the resurgence of Christian authority in the region, we find a marked increase in church production as well as a normalization of rock-carving as a medium. Compared with the diminutive monuments of the immediate post-Aksumite era, a general enlargement of church forms took place,

likely in order to accommodate a growth in parish communities following the reopening of episcopal channels. This would reach new heights in the next century under the centralized authority of the Zagwe dynasty and the founding of a new cathedral in south Tigray.

Early Zagwe Architecture in Tigray, 1100–1200

By the twelfth century, following the eleventh-century revival of political authority and overseas trade in Tigray, the Zagwe kings had emerged as the most powerful and centralized Christian

pastophoria; Muehlbauer, "Disappearance." Given the preservation of the old ordo in the layout of the east end of the church and the presence of a baptistery in the south pastophoria, it could be that the church is actually significantly earlier, perhaps even from the Aksumite period—an opinion held by Emmanuel Fritsch.

dynasty in the Horn of Africa. It was then that perhaps the most important medieval church in Ethiopia was constructed, the five-aisled Egyptian Metropolitan Cathedral of Maryam Nazret. A number of other churches were also built—Dabra Salam Mika'el (Däbrä Sälam Mika'el) and Cherqos Agabo (Čerqos Agäbo)—along with several that I believe to be reconstituted or restored in the twelfth century—Mika'el Amba, Yeha, likely Dabra Dammo, and Zarama Giyorgis. The likely impetus behind the Zagwe push to reconstruct and reconstitute earlier monuments was that the sovereigns considered themselves in a political continuum with the Aksumites, and even the Apocryphal Coptic Constantine.[65] The hypothesis that many of the earliest standing churches in northern Ethiopia and Eritrea (hitherto considered Aksumite) may be from the twelfth century suggests indeed that much of the Christianization ascribed to the Aksumites actually occurred much later. That said, the refurbishment of dilapidated buildings in Zagwe domains also occurred alongside violent Christianization. Muslims had settled in Tigray under Fatimid protection, but in a land grant of the first known Zagwe king, Tantawedem (Ṭänṭäwədəm, r. twelfth century?), is evidence of the forced removal of settled Muslims from Tigray.[66]

Architecturally speaking, twelfth-century Ethiopian churches testify to two consequential changes: the multiplication of altars and the introduction of iconographic mural painting. Multiple altars, developed first in the mother church in Egypt, were introduced to Ethiopia shortly thereafter, altering the use of preparatory rooms in some newly built churches.[67] This

liturgical practice had the benefit of allowing multiple consecrations, and thus requiring more sanctuaries (chapels) per church, thereby economizing patronage and accommodating a greater density of liturgical activity in a single church.[68] Churches in Ethiopia and Egypt were still occasionally outfitted with protheses until the late Middle Ages, but the churches associated with the episcopal center at Maryam Nazret were largely constructed with the newer liturgy in mind, especially to economize on large spaces.

It was also in the twelfth century that we see the first iconographic mural paintings in Ethiopian churches.[69] This consequential development was likely heralded by the establishment of a workshop at Maryam Nazret of either Egyptian or Egyptian-trained but local painters, as the first murals found in Ethiopian churches are stylistically and iconographically similar to those in Egypt at that time.[70] Contrary to the rock-hewn

65 Muehlbauer, "African 'Constantine.'"

66 M.-L. Derat, "L'affaire des mosquées: Interactions entre le vizirat fatimide, le patriarcat d'Alexandrie et les royaumes chrétiens d'Éthiopie et de Nubie à la fin du XIᵉ siècle," *Médiévales* 79 (2020): 15–36. See also N. Valieva, "King Ṭanṭawədəm's Land Charter: State of the Art and New Perspectives," https://horneast .hypotheses.org/files/2021/02/Valieva_King-Ṭanṭawədəms -land-charter-1.pdf. For the abandonment of the Fatimid settlement of Kwiḥa in East Tigray in the twelfth century, see J. Loiseau, "Retour à Bilet: Un cimetière musulman médiéval du Tigray oriental (*Inscriptiones Arabicae Aethiopiae* 1)," *BEO* 67 (2020/1): 59–96, esp. 71.

67 P. Grossmann, *Mittelalterliche Langhaus-Kuppelkirchen und Verwandte Typen in Oberägypten: Eine Studie zum Mittelalterlichen Kirchenbau in Ägypten*, ADAIK, Koptische Reihe 3 (Glückstadt, 1982), 222–24.

68 According to liturgist Arsenius Mikhail, it was only by the fifteenth century that the old ordo fell out of use entirely in Egypt, though evidence from Ethiopia suggests that it continued until significantly later; Mikhail, *Presentation of the Lamb*, 122–23. See also E. Fritsch, "The Order of the Mystery: An Ancient Catechesis Preserved in BnF Ethiopic Ms d'Abbadie 66–66bis (Fifteenth Century) with a Liturgical Commentary," in *Studies in Oriental Liturgy: Proceedings of the Fifth International Congress of the Society of Oriental Liturgy, New York, 10–15 June 2014*, ed. B. Groen et al., Eastern Christian Studies 28 (Leuven, 2019), 195–263. On the diversity of Coptic liturgical practices in the medieval period, see D. Atanassova, "The Primary Sources of Southern Egyptian Liturgy: Retrospect and Prospect," in *Rites and Rituals of the Christian East: Proceedings of the Fourth International Congress of the Society of Oriental Liturgy, Lebanon, 10–15 July 2012*, ed. B. Groen et al., Eastern Christian Studies 22 (Leuven, 2014), 47–96.

69 The Prophet Muḥammad's wife, Umm Ḥabība, who is alleged to have traveled to Aksum in the seventh century, described the interior of Aksum Tseyon as covered in mural paintings depicting saints. Regardless of the veracity of this account, it is likely that, if indeed covered in murals, these were executed by hired Byzantine craftsmen; G. R. D. King, "The Paintings of the Pre-Islamic Ka'ba," *Muqarnas* 21 (2004): 219–29, at 222.

70 For comparisons with Coptic iconography, see C. Lepage, "Première iconographie chrétienne de Palestine: Controverses anciennes et perspectives à la lumière des liturgies et monuments éthiopiens," *CRAI* 141.3 (1997): 739–82; C. Lepage, "Dieu et les quatre animaux célestes dans l'ancienne peinture éthiopienne," *Documents pour servir à l'histoire des civilisations éthiopiennes* 7 (1976): 67–112; Lepage, "Bilan des recherches," 51–54; C. Lepage, "Contribution de l'ancien art chrétien d'Éthiopie à la connaissance des autres arts chrétiens," *CRAI* 134.4 (1990): 799–822; E. Balicka-Witakowska, "Painting, IV: Monumental Painting," in *EAe* 4:97–99; Lepage and Mercier, *Les églises historiques*, 94–101. The presence and esteem of Egyptian painters

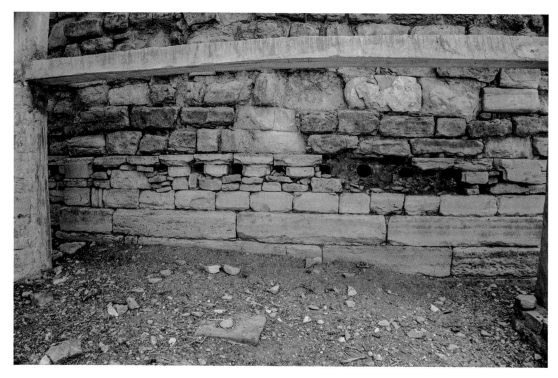

constructions of the previous century, twelfth-century Tigrayan churches tend to be fully or partly freestanding, a costly practice that must signify favorable economic conditions at the time.

Despite its current dilapidation, the old metropolitan center of medieval Ethiopia, the cathedral of Maryam Nazret, still stands (see Fig. 18) in the town of Addi Awona ('Addi Abunä; Ar. Wādī Abūnā), forty-four kilometers south of Mekelle (the capital of Tigray).[71] Today, the medieval church consists of four altar chambers

(out of an original five, measuring 3.5 m long) enclosed in a rubble retaining wall on the east side of a partly buried Aksumite platform (measuring ca. 23 by 30 meters and provisionally dated via a deposit of coins; Fig. 40).[72] These chambers are domed (Fig. 41), crowning octagonal drums, except for the center chamber, which is apsed. The chambers communicate via an eastern passage, and are constructed of small stone voussoirs suspended in mortar, all carried by angled timber boards, a construction style that is rooted in twelfth-century Egypt, but here executed in ashlars as opposed to mud brick. Large T-shaped piers encrusted by the rubble wall (see Fig. 18) suggest the placement of a triumphal arch, which would point to the church having been originally a great basilica. The Aksumite spolia piers now found exogenously around the ruins were likely redeployed as arcades in the original cathedral.[73]

Maryam Nazret is unique among Ethiopian monuments, not only because of its relatively secure date (now corroborated with carbon-14 and glass analysis), but also because of its wholly

in Ethiopia seem to have also inspired the iconography of later manuscript illuminations in the central highlands; see M. E. Heldman, "An Ethiopian Miniature of the Head of St. Mark: Egyptian Influence at the Monastery of St. Stephen, Hayq," in *Ethiopian Studies: Dedicated to Wolf Leslau on the Occasion of His Seventy-Fifth Birthday, November 14th, 1981*, ed. S. Segert and A. J. E. Bodrogligeti (Wiesbaden, 1983), 554–68.

71 M.-L. Derat et al., "Māryām Nāzrēt (Ethiopia): The Twelfth-Century Transformations of an Aksumite Site in Connection with an Egyptian Christian Community," *Cahiers d'études africaines* 239.3 (2020): 473–507; F.-X. Fauvelle et al., "Māryām Nāzrēt: Report to the Authority of Research and Conservation of the Cultural Heritage, Addis Ababa, Ethiopia, On Archaeological Works Conducted at the Site of Māryām Nāzrēt, Tigray in 2018" (Archaeological Report, Addis Ababa, 2019); M.-L. Derat et al., "Lalibela, la christianisation et le contrôle de l'Éthiopie centrale au tournant des 1er et 2e millénaires de notre ère: Recherches archéologiques et historiques entre Lasta et Tigré méridional (IXe–XIIIe siècles). Rapport sur les opérations 2020" (Paris, 2020).

72 Mordini, "Informazioni preliminari sui risultati delle mie ricerche in Etiopia dal 1939 al 1944," *RSE* 4 (1944): 145–54, at 150.

73 Fritsch and Kidane, "Medieval Ethiopian Orthodox Church," 175.

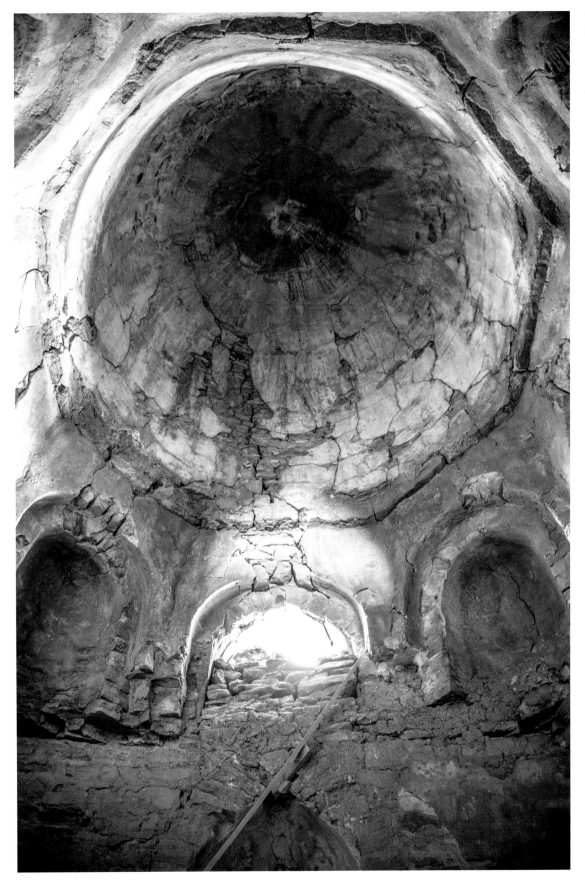

Figure 41.
Maryam Nazret,
southernmost
chamber, east wall
and dome, detail,
Tigray, Ethiopia.
Photograph
by author.

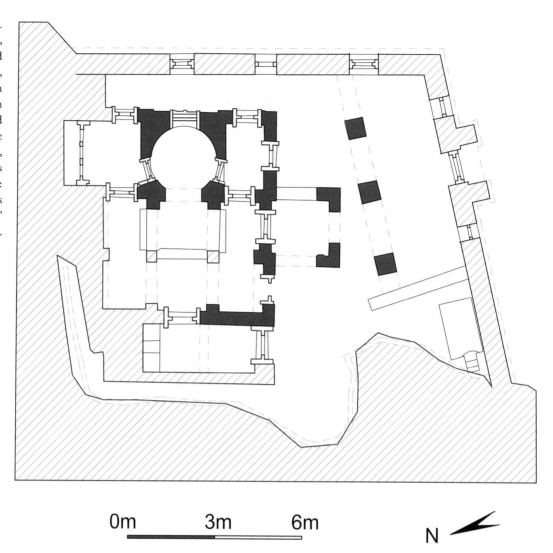

0m 3m 6m

N

Egyptian construction style and appropriation of an Aksumite platform.[74] While the deployment of five altars for this building was ultimately to accommodate the considerable clerical activity at such a center, the use of five aisles also referenced the metropolitan authority of the cathedral of Aksum as well as the architecture of Constantine the Great.[75] In the same vein, the reuse of an Aksumite platform for such a monument inscribed both Ethiopian-royal and Egyptian episcopal authority onto the material memory of late antiquity.

Although Maryam Nazret was the most important church established in the twelfth century, material evidence suggests that it was part of

a comprehensive push by the early Zagwe dynasty to reconsecrate Aksumite monuments. Along with the reconsecration of Maryam Nazret, I understand Mika'el Amba's reconsecration (see Fig. 6; to be discussed at length in Chap. 2) as part of this same effort; it resulted in the installation of three altars (and three chancels) in a church originally intended for the prothesis rite. Likewise, the probable reconsecration of the Almaqah temple at Yeha (800 BCE) as a five-aisled church appears to have occurred in this same campaign—its former triumphal arch bears the same marquetry style as those installed in Mika'el Amba.[76] I also contend that the Aksumite churches of Dabra Dammo (see Figs. 24, 25) and Zarama Giyorgis (see Figs. 26–28) were actually twelfth-century

74 Fauvelle et al., "Māryām Nāzrēt."

75 Muehlbauer, "African 'Constantine.'"

76 Muehlbauer, "African 'Constantine.'"

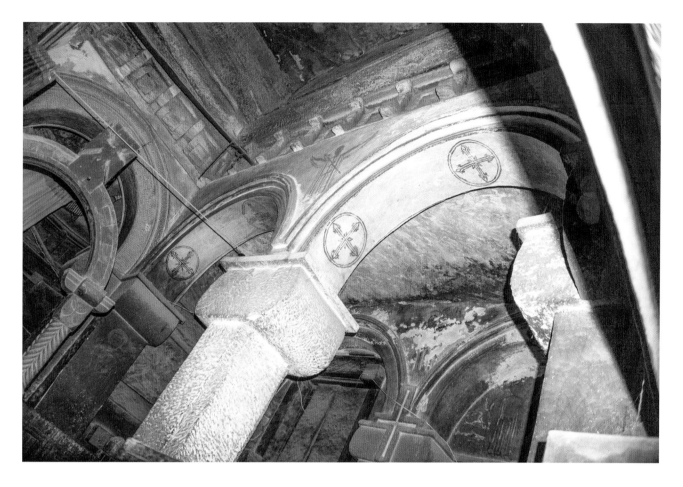

reconstructions, despite being established atop late antique foundations. Their decorative wood-work shares a strapwork marquetry style with the arches at Mika'el Amba and the converted temple at Yeha.[77]

Two small semi-freestanding churches near Atsbi, Dabra Salam Mika'el and Cherqos Agabo, also seem to date from the twelfth century.[78]

Located in close proximity to the Danakil salt flats, these churches testify to substantial ecclesiastic investment by the early Zagwe to turn the area into a major salt-trading hub.

Dabra Salam Mika'el (Fig. 42) is a small, three-aisled basilica occupying a narrow cave in a cliff face. Consisting of a fully hewn, arcaded nave with six bays (Fig. 43), its western portions are constructed of even courses of fine, half-timbered construction pierced by "monkey head" bosses. The back of the church is a semicircular

Figure 43.
Dabra Salam Mika'el, nave arcade and south aisle, Tigray, Ethiopia. Photograph by author.

77 A twelfth-century reconstitution of Dabra Dammo was already suggested by Derek Matthews and Antonio Mordini in their 1959 monograph on the church; Matthews and Mordini, "Monastery of Debra Damo," 31–39. Likewise, the lost church at Aramo may have been part of this same campaign; see A. Mordini, "La chiesa di Aramò (con considerazioni sulla datazione dei monumenti dell'arte religiosa Etiopica)," *RSE* 15 (1959): 39–54. See also the carved brackets and ceiling panels of the now lost, old church of Asmara in contemporary Eritrea; R. Sauter, "L'arc et les panneaux sculptés de la vieille église d'Asmara," *RSE* 23 (1967–68): 220–31.

78 E. Balicka-Witakowska, "Dabra Salam Mika'el," in *EAe* 2:37–39; Phillipson, *Ancient Churches of Ethiopia*, 68–73; Lepage, "Dieu et les quatre animaux célestes," 84–88; Lepage and Mercier, *Les églises historiques*, 94–103. Although I have not yet visited it personally, I might also add to this list the partially hewn, partially freestanding church of Tsada'aina Cherqos (Ṣada'aina Čerqos), also near Atsbi; see http://ethiopia .deeds.utoronto.ca/: MG-2005.019:019 – MG-2005.019:036; MG-2005.022:03 – MG-2005.022:036. For both churches, see the fine plans and elevations by Jean Gire, in C. Lepage, "Le premier art chretien d'Ethiopie," in *Les dossiers de l'archéologie* 8 (1975): 34–79, at 42–43, 58–59; Lepage, "Première iconographie chrétienne." Cherqos Agabo was radiocarbon dated in the early 1970s, which yielded an approximate date between the tenth and twelfth centuries, though the results are skewed toward the later date range (especially when factoring in cure times required for structural timber); Lepage, "Le premier art chretien d'Ethiopie," 44. See also M. Muehlbauer, "A Rock-Hewn Yəmrəḥannä Krəstos? An Investigation into Possible 'Northern' Zagʷe Churches near 'Addigrat, Təgray," *Aethiopica* 23 (2020): 31–56, at 35–36.

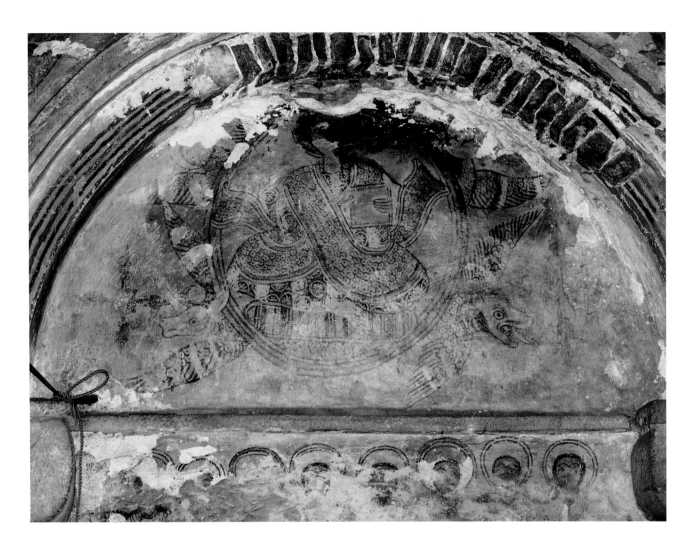

apse conch, preceded by a bema and (fully intact) chancel, and with chambers on each side that communicate directly with the altar and the main vessel. Although of exceptionally fine workmanship, Dabra Salam Mika'el is most celebrated for its extensive mural paintings, depicting among other things an elephant, angels, and a particularly "Islamic"-style representation of the Majestas Domini (Fig. 44).[79] Although more securely dated on the basis of the mural paintings' style, documentary evidence in the form of a land grant, housed in the cathedral of Aksum, indicates that the church dates from at least the early twelfth century.[80] Cherqos Agabo appears

79 As noted by Claude Lepage, Christ is seated cross-legged on a cushion like a Muslim ruler, and appears to be wearing "Islamic" dress, perhaps a caftan; Lepage, "Entre Aksum et Lalibela," 32. This may be fruitfully compared with the depiction of Roger II of Sicily in the muqarnas ceiling of the Cappella Palatina.

80 Lepage, "Dieu et les quatre animaux célestes," 87.

formally similar to Dabra Salam Mika'el, but is comparatively simple (Fig. 45)—only the south wall is hewn. Timber posts carry the flat architrave of the double piered nave, which is crowned with a coffered ceiling. The east end, which lacks a bema, is square, conforming fully to "Aksumite" half-timbered architecture. While likely built in the same campaign or system of patronage, its liturgical layout clearly reflects the old ordo, as the south pastophoria communicates with the sanctuary through an eastern passage.[81]

The twelfth century witnessed a profound centralization of Zagwe and Egyptian episcopal authority in Tigray. Although the eleventh century was a time of architectural efflorescence, the twelfth century was one of state building under known sovereigns, including the forced Christianization of Tigray and the establishment

81 Fritsch and Gervers, "Pastophoria and Altars," 39–40.

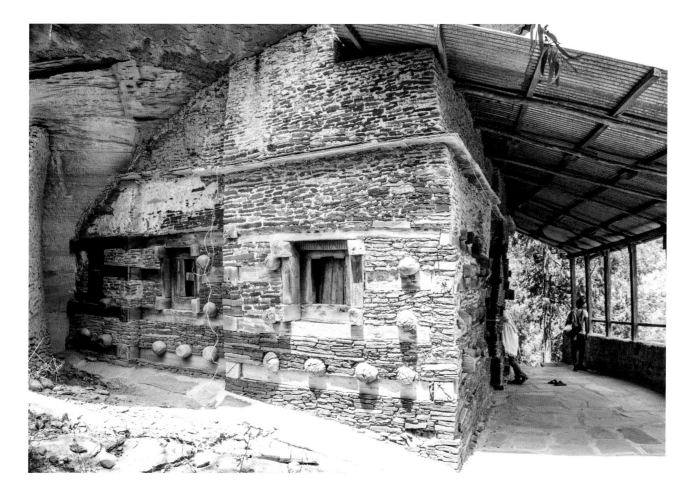

of a new episcopal center. Of crucial importance in the twelfth century was the introduction of iconographic murals into Ethiopia from Egypt, which became the main decorative schema in the following centuries. Though the Zagwe dynasty soon refocused its architectural efforts southward, we find a marked continuity of twelfth-century trends into the thirteenth century.

Tigrayan Churches during the Height of Zagwe Rule, 1200–1300

The thirteenth century is perhaps the period most associated with architectural dynamism in medieval Ethiopia, though not in Tigray.[82] It is easy to see why. The majority of the famed Lalibela church complex (see Fig. 10) was likely produced then, as was the remarkable freestanding

church of Yemrehanna Krestos.[83] Although it has been suggested that Lasta was the site of the Zagwe capital, new archaeological evidence suggests that royal investments there were due to the region's frontier status, recently conquered from a non-Christian foe.[84] Moreover, surviving land grants show that, even under King Lalibela, holdings were largely centered in Tigray and Eritrea instead of in Amhara.[85] Indeed, the Zagwe kings

Figure 45.
Cherqos Agabo, east elevation, Atsbi, Tigray, Ethiopia. Photograph by author.

82 See, however, C. Lepage and J. Mercier, "Évolution de l'architecture des églises éthiopiennes du XIIe au milieu du XVe siècle," *AÉ* 22 (2006): 9–43.

83 For a fuller discussion of the materials presented here, see Muehlbauer, "Rock-Hewn Yəmrəḥannä Krəstos?" For the thirteenth-century attribution of the church of Yəmrəḥannä Krəstos, see M. Gervers, "Churches Built in the Caves of Lasta (Wällo Province, Ethiopia): A Chronology," *Aethiopica* 17.1 (2014): 25–64. Cf. M. Gobezie Worku, "The Church of Yimrhane Kristos: An Archaeological Investigation" (PhD diss., Lund University, 2018).

84 M.-L. Derat et al., "The Rock-Cut Churches of Lalibela and the Cave Church of Washa Mika'el: Troglodytism and the Christianisation of the Ethiopian Highlands," *Antiquity* 95 (2021): 467–86. Cf. N. Finneran, "Built by Angels? Towards a Buildings Archaeology Context for the Rock-Hewn Medieval Churches of Ethiopia," *World Archaeology* 41.3 (2009): 415–29.

85 Derat, *L'énigme*, 133–45; M.-L. Derat, "Les donations du roi Lālibalā: Éléments pour une géographie du royaume

Figure 46.
Plan of Maryam
Qorqor, Garalta
Escarpment, Tigray,
Ethiopia. Plan by
author and Binxin Xie,
redrawn and modified
after C. Lepage and
J. Mercier, *Les églises
historiques du Tigray:
Art éthiopien / The
Ancient Churches of
Tigrai: Ethiopian Art*,
trans. S. Williams
and C. Wiener (Paris,
2005), 117.

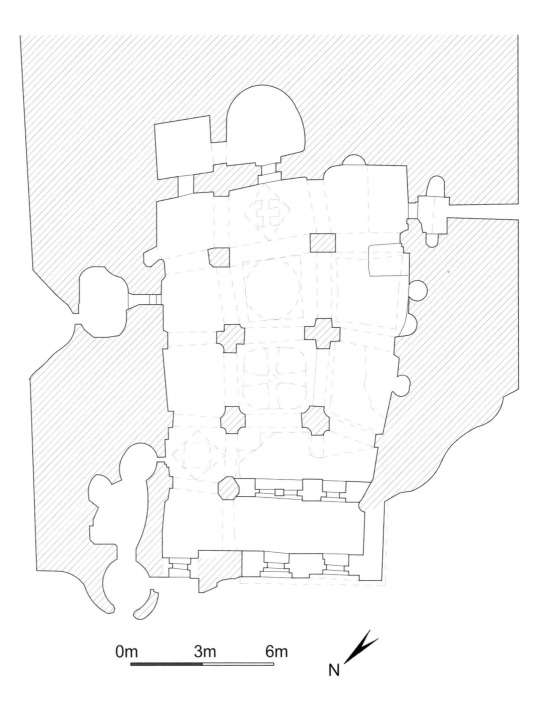

0m 3m 6m

N

seem to have remained a dynasty *in* and *of* Tigray; and the now ruined cathedrals of Maryam Nazret and Aksum Tseyon were their most important ecclesiastical centers.

In contrast with the parish churches of the early Middle Ages, those established in thirteenth-century Tigray are entirely monastic and rock hewn, located in seemingly isolated, inaccessible

places.[86] These establishments, which are called *gädäm* (ገዳም), "wilderness" in Geʿez, presage the great, isolated, monastic confederations of later

chrétien d'Éthiopie au tournant du XIIᵉ et du XIIIᵉ siècle," *AÉ* 25 (2010): 19–42.

86 Lepage and Mercier, *Les églises historiques*, 108–83. See also S. Klyuev, "The Rock-Hewn Churches of the Garalta Monasteries (Tigray, Ethiopia): The Comparative Analysis of Three Monuments of the Second Half of the 13th to the First Half of the 15th Centuries," in *Proceedings of the 2019 International Conference on Architecture: Heritage, Traditions and Innovations*, ed. I. Rumbal, Y. Zhang, and R. Green, Advances in Social Science, Education and Humanities Research 324 (Paris, 2019), 117–22.

medieval Ethiopia.[87] Monks there had, as some still do today, a semi-eremitic lifestyle, recalling the Egyptian desert fathers of late antiquity.[88] My discussion of churches from this period includes two monuments located on the border with Eritrea in modern-day Addigrat, Tigray—Maryam Qiat (Maryam Qiʻat) and Iyasus Gwahegot (Gʷaḫgot Iyäsus)—as well as Maryam Qorqor in the Garalta (Gärʻalta) mountain range near Hawzen. All are basilicas, outfitted with multiple sanctuaries and iconographic murals rendered in a mature Coptic style, not dissimilar to their illustrious contemporaries in Lasta.[89]

The monastery church of Maryam Qorqor, currently the subject of a major Franco-Ethiopian research project, is one of the best-known churches in Tigray.[90] Hewn into a sandstone massif, the monastery church, long associated with a famous abbot named Daniel (Danəʼel), sits at a perilous 400 meters above ground level.[91] The difficult ascent is repaid by the elaborate paintings in the interior, which make it an oft-visited church in tourist itineraries.[92] The building is near unparalleled in scale, measuring 18 meters end to end, and embodies an irregular, perhaps ultimately unfinished, form of a three-aisled basilica (Fig. 46). Spatial hierarchy is organized around the raised nave, though the ceilings are eclectic, a departure from freestanding architectural forms. The eastern bays of the nave are crowned with domes, perhaps mirroring practices established in lower Egypt,[93] which anticipate a triumphal arch and conched apse that is flanked by only one extra sanctuary on its north side. In anticipation of the high altar, the floor is raised with a bema, which was probably enclosed with a wooden templon screen.[94] Likely executed in multiple phases, the thirteenth-century paintings depict lollipop-headed figures in a localized Coptic style (captioned in Geʻez), broadly similar to the murals of the above-mentioned monastery of St. Antony (Fig. 47).[95] Despite Maryam Qorqor's physical isolation, the church's scale and extensive mural decoration underscore its status as a monastic center. The site

87 W. Leslau, *Comparative Dictionary of Geʻez* (Wiesbaden, 1987), 183. On the charismatic monastic leaders of late medieval Ethiopia, see S. Kaplan, *The Monastic Holy Man and the Christianization of Early Solomonic Ethiopia*, Studien zur Kulturkunde 73 (Wiesbaden, 1984).

88 G. Lusini, "The Ancient and Medieval History of Eritrean and Ethiopian Monasticism: An Outline," in Kelly, *Companion*, 194–216, at 196. On the late antique desert fathers, see D. Burton-Christie, *The Word in the Desert: Scripture and the Quest for Holiness in Early Christian Monasticism* (New York, 1993).

89 C. Bosc-Tiessé et al., "Peintures et sculptures à Lalibela: Matériaux, processus techniques et strates d'histoire," *Patrimoines* 16 (2021): 93–98; C. Lepage, "Les peintures murales de l'église *Betä Maryam* à Lalibäla, Éthiopie (rapport préliminaire)," *CRAI* 143.3 (1999): 901–67; G. Élias, C. Lepage, and J. Mercier, "Peintures murales du XIIᵉ siècle découvertes dans l'église Yemrehana Krestos en Éthiopie," *CRAI* 145.1 (2001): 311–34; E. Balicka-Witakowska and M. Gervers, "The Church of Yəmrəhannä Krəstos and Its Wall-Paintings: A Preliminary Report," *Africana Bulletin* 49 (2001): 9–47.

90 A large French team, including an architect, conservator, chemist, and art historian, has been working on the site since 2016; C. Bosc-Tiessé et al., "Qorqor Maryam: History, Materials and Techniques of Ethiopian Rock-Hewn Church Paintings" (presentation at Berhanou Abebe Library, French Center for Ethiopian Studies, Addis Ababa, Ethiopia, 2 May 2018), https://cfee.hypotheses.org/2605. On monastic iconography in the murals, see T. Tribe, "The Word in the Desert: The Wall-Paintings of Debra Maryam Korkor (Ger'alta, Tigray)," in *Ethiopia in Broader Perspective: Papers of the XIIIth International Conference of Ethiopian Studies, Kyoto, 12–17 December 1997*, ed. K. Fukui et al., 3 vols. (Kyoto, 1997), 3: 35–61. Compare the roughly contemporary murals of the monastery church of St. Antony in the eastern desert of Egypt; E. S. Bolman, "Theodore's Style, the Art of Christian Egypt, and Beyond," in *Monastic Visions: Wall Paintings in the Monastery of St. Antony at the Red Sea*, ed. E. S. Bolman (Cairo, 2002), 77–90; E. S. Bolman, "Theodore's Program in Context: Egypt and the Mediterranean Region," in ibid., 91–102.

91 Both the oratory adjacent to the church and the painted program are identified by inscription to this famous abbot, who, according to hagiographic tradition, is said to have lived in the late thirteenth century. However, given the multiphase nature of the painted program as well as the different paleographic styles used in the inscription, no conclusive dating or patronage can be attributed to the abbot Daniel; C. Bosc-Tiessé, "Le site rupestre de Qorqor (Garʻāltā, Éthiopie) entre littérature et peinture: Introduction à l'édition de la *Vie et des miracles de saint Daniel de Qorqor* et aux recherches en cours," *Afriques* (19 November 2014), http://journals.openedition.org/afriques/1486. On the hagiography of Abbot Daniel, see G. Colin, "Vie et miracles de Daniel de Qorqor: Introduction," *Afriques*, Sources (9 November 2014), http://journals.openedition.org/afriques/1487.

92 On the murals, see Lepage, "Dieu et les quatre animaux célestes," 88–91; Lepage, "Contribution de l'ancien art," 809–17, esp. fig. 6.

93 Grossmann, *Mittelalterliche Langhaus-Kuppelkirchen*, 158–61.

94 Only one post survives; E. Fritsch, "Liturgie et architecture ecclésiastique éthiopiennes," *JEChrSt* 64.1–2 (2012): 91–125, at 103–4. Because the floor was covered by a pavement, it is unclear what the original form of the screen was, though in all likelihood it was ∏-shaped as at Maryam Qiat and Iyasus Gwahegot.

95 Lepage and Mercier, *Les églises historiques*, 113–15; Lepage, "Contribution de l'ancien art," 809.

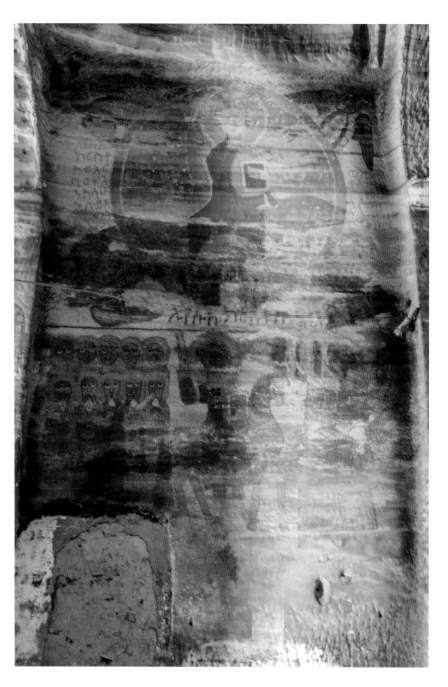

Figure 47.
Maryam Qorqor, north
wall, upper register (Christ
in majesty), lower register
(the entry into Jerusalem),
Tigray, Ethiopia.
Photograph by author.

continues to be used; a domed oratory attributed
to the abbot Daniel was carved adjacent to the
main building in the succeeding centuries, and is
now joined by a number of recent hermit cells.[96]

Hewn around the same time is the rarely vis-
ited monastery church of Maryam Qiat, near
Addigrat.[97] Like Maryam Qorqor, Maryam Qiat

is a three-aisled basilica; the main vessel measures
some 8.5 meters long and 7 meters wide, and is
entered through a pair of wooden doors said to be
of Egyptian import (Fig. 48).[98] Today it is a hall
church. All vaults stand at about 5.9–6.9 meters

96 Lepage and Mercier, *Les églises historiques*, 112–25.

97 The church is mentioned in Muehlbauer, "Rock-Hewn
Yəmrəḥannä Krəstos?," 40–41; Lepage and Mercier, *Les églises*

historiques, 126–29; R. Plant, *Architecture of the Tigre, Ethiopia*
(Worcester, UK, 1985), 188. Lepage and Mercier do not distin-
guish phases but also think that the church is from the same
general period as Maryam Qorqor.

98 Personal communication, parish priest at Maryam Qiat,
8 June 2018.

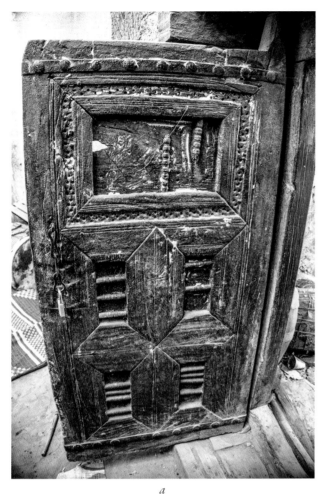

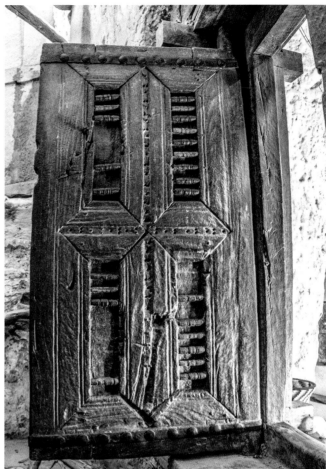

a *b*

in height (Fig. 49), though the ceilings were likely considerably lower when the church was first hewn, as indicated by the idiosyncratic flying chancel arch that anticipates the conched apse, itself flanked by an annex chapel.[99] Maryam Qiat's painted program is clearly multiphase.[100] Turquoise paintings partially cover up an earlier program of saints, painted in red, pink, and yellow, bearing the round heads and severe noses of Maryam Qorqor's (phase 1) murals. Though the floor height is consistent throughout the church, a fully extant templon screen (Fig. 49) stands before Maryam Qiat's sanctuary, lacking parapets but (formerly) fronted by a solea.[101]

My discussion of thirteenth-century Tigrayan architecture concludes with Iyasus Gwahegot, a remarkable, if isolated, monastery church located near Maryam Qiat in Addigrat.[102] A three-aisled, apsed basilica measuring 12.9 meters long, with three altars on its east end, Iyasus Gwahegot is peculiar in that it fully imitates, in its dimensions and articulation, a known freestanding model: the famous church of Yemrehanna Krestos in Lasta, some three hundred kilometers away (Fig. 50). An expressively designed hewn church, Gwahegot bears witness to the transfer of architecture (and masons) across the vast thirteenth-century Zagwe kingdom.[103]

Figure 48.
Maryam Qiat,
(a) north portal door,
(b) south portal door,
near Addigrat, Tigray,
Ethiopia. Photograph
by author.

99 There is suture, with a change of masons' hands above the dado, indicating a raised ceiling height; Muehlbauer, "Rock-Hewn Yəmrəḥannä Krəstos?," 40.

100 Muehlbauer, "Rock-Hewn Yəmrəḥannä Krəstos?," 40.

101 The former solea is indicated by vertical slots in the jamb posts. The presence of chancel screens in both Maryam Qiat and

Gwahegot challenges the argument made by Fritsch and Gervers that these screens were phased out in the thirteenth century.

102 The fullest publication on the monument is Muehlbauer, "Rock-Hewn Yəmrəḥannä Krəstos?"; for the church of Yemrehanna Krestos, see Gobezie Worku, "Church of Yimrhane Kristos."

103 Muehlbauer, "Rock-Hewn Yəmrəḥannä Krəstos?," 42.

Figure 49.
Maryam Qiat,
nave elevation,
Tigray, Ethiopia.
Photograph
by author.

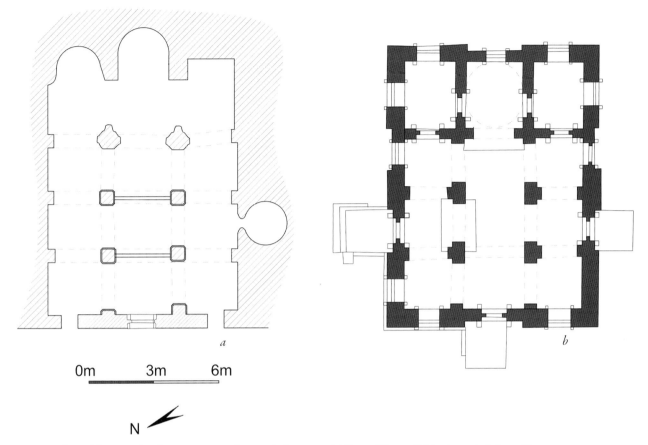

a

0m 3m 6m

N

Figure 50. Plans: (a) Iyasus Gwahegot, measured ground plan, near Addigrat, Tigray, Ethiopia, scaled alongside (b) Yemrehanna Krestos, ground plan, Lasta, Amhara region. Plans by (a) author and Binxin Xie, and (b) author and Binxin Xie, redrawn and modified after M. Gervers, "Churches Built in the Caves of Lasta (Wällo Province, Ethiopia): A Chronology," *Aethiopica* 17. 1 (2014): 58, fig. 1.

Carved into a rock escarpment overlooking a rich agricultural area, this monastery was likely a royal foundation, its precise architectural iconography a reflection of Zagwe authority in northern Tigray. Exhibiting a hewn saddleback roof (~6.85 m;[104] compare with the 6.7 meters of Yemrehanna Krestos), Iyasus Gwahegot even incorporates wooden roof trusses to reenact its freestanding prototype (Fig. 51).[105] The nave is carried by piered arcades with sculpted setback moldings that are spatially set against aisles that are 4.6 meters high (3.6 m high at Yemrehanna Krestos, a difference of ~19%).[106] Now whitewashed and with their lower portions covered by concrete, it is unknown whether the walls and pillars were originally painted.[107] The nave vault, however, is covered with strapwork ornament, which evokes the gables of Yemrehanna Krestos's roof, though in the characteristic pink

104 The mean height of the nave at Gwahegot is 6.85 meters. The hewn ceiling measures between 6.7 and 7 meters in height.

105 The wooden elements bear the exact same interlaced, cusped-cross design as is found on Yemrehanna Krestos's roof trusses, and it is possible that they were even painted by the same workshop. Although the trusses lack pendants at Gwahegot, there are gaps in the painted decoration that show where the pendants were intended to be applied (replete with nail holes), probably locally.

106 Though new carving at the east end later extended the church of Iyasus Gwahegot, the main vessels of Gwahegot and Yemrehanna Krestos have similar lengths, at 7.5 meters and 7.1 meters respectively, a difference of 40 centimeters, or ~5%. Moreover, the arches making up the arcades in each church closely match: 4.21–4.66 meters tall (+/< 10 cm) in Iyasus Gwahegot and nearly 4 meters tall in Yemrehanna Krestos, a difference of around 20 to 40 centimeters (~7%).

107 When Ruth Plant visited the church in the early 1970s, it was heavily blackened with soot and more or less disused; Plant, *Architecture of the Tigre*, 186.

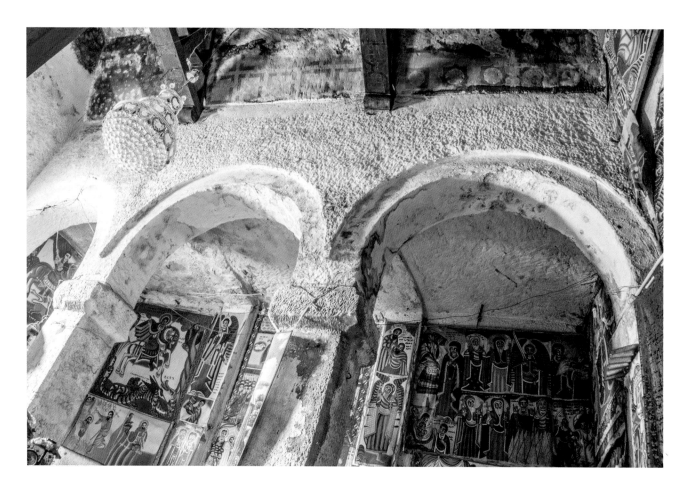

Figure 51.
Iyasus Gwahegot,
north nave arcade,
viewed south to north,
Tigray, Ethiopia.
Photograph by author.

and yellow hues of the murals at Maryam Qorqor and Qiat. As with earlier churches, the finely carved conched apse was preceded by a ∏-shaped templon screen, currently in storage.[108]

During the Zagwe dynasty's thirteenth-century apex, Tigray was a continued recipient of royal investment. The large, isolated monastic confederations that would become characteristic of the region's ecclesiastical sites in the following centuries had their start in this period, as did the increasingly imaginative use of the stone medium and the normalization of iconographic mural paintings. Although the Zagwe would be overthrown in the following century, these trends would reach an apex under the "Solomonic" dynasty, which succeeded the Zagwe in the central highlands.

Monastic Foundations under the "Solomonic" Dynasty, 1300–1500

Church production in Tigray during the fourteenth and fifteenth centuries was prolific and cannot be divorced from the political and economic changes of the era. The overthrow of the Zagwe dynasty in 1270 by Yekunno Amlak (Yəkunno Amlak), the first of a number of sovereigns who considered themselves heirs to the throne of Solomon (perhaps following Zagwe precedent), was pivotal.[109] The "Solomonic" kings were keen promoters of monasteries and religious institutions, and used Christianity as a pretext for wars against non-Christian neighbors in the south and east.[110] Stable relations with Egypt brought to Ethiopian scriptoria a regular

108 M. Muehlbauer, "From Stone to Dust: The Life of the Kufic Inscribed Frieze of Wuqro Cherqos in Tigray, Ethiopia," *Muqarnas* 38 (2021): 1–34, at 22.

109 M. E. Heldman and G. Haile, "Who Is Who in Ethiopia's Past, Part III: Founders of Ethiopia's Solomonic Dynasty," *NEAS* 9.1 (1987): 1–11.

110 M.-L. Derat, *Le domaine des rois éthiopiens (1270–1527): Espace, pouvoir et monachisme* (Paris, 2003), 160–98. See also Kaplan, *Monastic Holy Man.*

supply of Coptic Arabic texts, which formed the basis for much much Geʿez literature and liturgy.[111] The locus of Christian power was now in the central highlands of Ethiopia, especially in and around Lake Tana,[112] though Tigray was no backwater under this new regime.[113] The most important monastic confederations of late medieval Ethiopia (the Ewostathians and the Stephanites) were Tigrayan foundations,[114] and the cathedrals of Aksum Tseyon and Maryam Nazret continued to be the most important places for the demonstration of royal and episcopal authority (the former including coronation rites).[115] Even Tigrayan monasteries established in prior centuries were again lavished with gifts from or periodically restored under these southern monarchs.[116]

Following a trend already introduced in the previous century, churches from early "Solomonic" Tigray are almost entirely rock-hewn

monastic foundations.[117] Several of these monastery churches are also quite large, reflecting the wealth and esteem underlying their foundation. In many ways this could be considered the inverse of the situation in Byzantium, where adherence to the teachings of St. Basil of Caesarea may have inspired a contraction in scale for monastic foundations.[118]

Reflecting the increasingly visual demands of Ethiopian piety, after the introduction of icon worship, these monasteries showcase extensive murals, including icons whose frames are sculpted into the wall surfaces.[119] In contrast with the Copticizing iconography of the previous centuries, murals now bear witness to a mature, distinctly Ethiopian style that corresponds to the manuscript illuminations produced in their scriptoria.[120] Moreover, these churches are highly identifiable as well. Large, immovable altars and altar ciboria were then the norm in Egypt, and subsequently became localized in Tigray and Lasta in the form of the monolithic altar.[121] The wooden chancel was completely phased out, and replaced by sanctuary curtains or opaque masonry barriers evocative of Mamluk-era (1250–1517) Egyptian iconostases (ḥijāb screens).[122]

Many monastery churches in Tigray date between 1300 and 1500; my partial list is of buildings produced in toto as well as those that

111 A. Bausi, "Ethiopic Literary Production Related to the Christian Egyptian Culture," in *Coptic Society, Literature and Religion from Late Antiquity to Modern Times*, ed. P. Buzi, A. Camplani, and F. Contardi, Orientalia Lovaniensia Analecta 247, 2 vols. (Leuven, 2016), 1:503–71; A. Bausi, "Ethiopia and the Christian Ecumene: Cultural Transmission, Translation, and Reception," in Kelly, *Companion*, 217–51. For artistic transmission in this period, see M. E. Heldman, "Metropolitan Bishops as Agents of Artistic Interaction between Egypt and Ethiopia during the Thirteenth and Fourteenth Centuries," in *Interactions: Artistic Interchange between the Eastern and Western Worlds in the Medieval Period*, ed. C. Hourihane, The Index of Christian Art: Occasional Papers 9 (University Park, PA, 2007), 84–105.

112 C. Bosc-Tiessé, "L'histoire et l'art des églises du lac Ṭana," *AÉ* 16 (2000): 207–70.

113 The exact political situation in Tigray varied by sovereign and the degree to which it was governed by royal authority from the central highlands. On the political situation in late medieval and early modern Tigray, see D. Nosnitsin, "Təgre Mäkwännən," in *EAe* 4:900–902.

114 G. Haile, "Religious Controversies and the Growth of Ethiopic Literature in the Fourteenth and Fifteenth Centuries," *OC* 65 (1981): 102–36; G. Haile, "The Cause of the Ǝsṭifanosites: A Fundamentalist Sect in the Church of Ethiopia," *Paideuma* 29 (1983): 93–119; R. Beylot, "Le millénarisme, article de foi dans l'Église éthiopienne au XVᵉ siècle," *RSE* 25 (1972–1973): 31–43.

115 S. C. Munro-Hay, "The 'Coronation' of the Ethiopian Emperors at Axum," in *Studia Aethiopica: In Honour of Siegbert Uhlig on the Occasion of His 65th Birthday*, ed. V. Böll, D. Nosnitsin, T. Rave, W. Smidt, and E. Sokolinskaia (Wiesbaden, 2004), 177–201; S. C. Munro-Hay, *Ethiopia and Alexandria: The Metropolitan Episcopacy of Ethiopia*, Bibliotheca Nubica et Aethiopica 5, 9, 2 vols. (Warsaw, 1997–<2005>), 1:44.

116 Munro-Hay, "Saintly Shadows"; Tesfaye, "Reconnaissance de trois églises."

117 The archimandrite monastery church of the Stephanites, Gunda Gundo near Addigrat, is freestanding; see A. Mordini, "Il convento di Gunde Gundiè," *RSE* 12 (1953): 29–70.

118 A.-M. Talbot, "An Introduction to Byzantine Monasticism," *ICS* 12.2 (1987): 229–41, at 233–34.

119 On the development of icon worship in this period, see S. Kaplan, "Seeing Is Believing: The Power of Visual Culture in the Religious World of Aşe Zärʾa Yaʿeqob of Ethiopia (1434–1468)," *Journal of Religion in Africa* 32.4 (2002): 403–21. See also Mercier, *Art of Ethiopia*, 166–69.

120 Claude Lepage refers to this shift as the "fourth phase" of Ethiopian iconography; C. Lepage, "Histoire de l'ancienne peinture éthiopienne (Xᵉ–XVᵉ siècle): Résultats des missions de 1971 à 1977," *CRAI* 121.2 (1977): 325–76, at 352–56.

121 P. Grossmann, *Christliche Architektur in Ägypten* (Leiden, 2002), 127; S. Chauleur, "L'autel copte," *Les cahiers coptes* 9 (1955): 1–20, at 8. On monolithic altars in Ethiopia, see E. Fritsch, "The Altar in the Ethiopian Church: History, Forms and Meanings," in *Inquiries Into Eastern Christian Worship: Selected Papers of the Second International Congress of the Society of Oriental Liturgy, Rome, 17–21 September 2008*, ed. B. Groen, S. Hawkes-Teeples, and S. Alexopoulos, Eastern Christian Studies 12 (Leuven, 2012), 443–510, at 500–506.

122 Muehlbauer, "From Stone to Dust," 17–20; J. Mercier and C. Lepage, *Lalibela, Wonder of Ethiopia: The Monolithic Churches and Their Treasures* (London, 2012), 165.

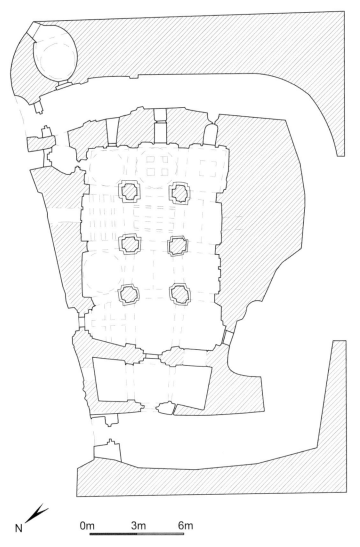

N

0m 3m 6m

Figure 52. Maryam Dabra Tseyon, measured ground plan, Garalta, Tigray, Ethiopia. Plan by author and Binxin Xie, redrawn and modified after C. Lepage and J. Mercier, *Les églises historiques du Tigray: Art éthiopien / The Ancient Churches of Tigrai: Ethiopian Art*, trans. S Williams and C. Wiener (Paris, 2005), 154.

Yoḥanni),[124] and Abuna Yemata Guh (Abunä Yəmʾata Gʷəḥ). In all cases, the monasteries were basilican, though spatial massing around the nave was largely abandoned in favor of contemporary Mamluk Egyptian-style, multidomed hall churches (so-called egg carton churches).[125] Moreover, buildings from this era exhibit extensive sculpted forms as well as imaginative articulation. Much is owed to developments in thirteenth-century Lasta. At sites like Lalibela (see Fig. 10), Gannata Maryam (Gännäta Maryam), and Washa Mikaʾel (Waša Mikaʾel), Zagwe and early Solomonic craftsmen sculpted veritable fantasies in stone, perhaps appropriated from the non-Christian troglodytes whose territory they conquered.[126]

Perhaps the greatest monument of late medieval Tigray is the monastery of Maryam Dabra Tseyon (Fig. 52), a semi-monolithic church hewn into the Garalta massif, somewhat adjacent to Maryam Qorqor (see Figs. 46, 47).[127] The monastery has long been attributed to Abuna Abraham (Abunä Abrəham), a canonized monastic leader and master mason, who is thought to have lived between 1350 and 1415.[128] It is unknown whether the archimandrite himself or an associated workshop carved out the church; the former's posthumous hagiography (*Gadla Abrəham*) dates the monument to the turn of the fifteenth century, which is corroborated by the church's painting style and use of (two) monolithic altars.[129] Measuring a monumental 19 meters long, Maryam Dabra Tseyon is a three-aisled basilica, partially detached from the rock face in the semi-monolithic manner of the central

were substantially reworked: Mikaʾel Amba (phase 3),[123] Wuqro Cherqos (phase 2), Maryam Dabra Tseyon (Maryam Däbrä Ṣəyon), Addi Qesho Medhane Alam (ʿAddi Qešo Mädḫane ʿAläm), Dabra Maar Giyorgis (Däbrä Mäʿar Giyorgis), Iyasus Tashi (ʾIyäsus Tašši), Abuna Gabra Masqal (Abunä Gäbrä Mäsqäl), Maryam Wuqro (Maryam Wəqro), Abba Yohanni (Abba

123 Mikaʾel Amba's easternmost chamber contains a hewn altar, which, with the decorative pendant in the apex, points to a third restoration phase in the fourteenth or fifteenth century.

124 J. Gnisci and M. Villa, "Evidence for the History of Early Solomonic Ethiopia from Tämben, Part II: Abba Yoḥanni Däbrä ʿAśa," *RSE* 3rd ser., 6 (2022): 97–128.

125 On this architectural form in Egypt, see Grossmann, *Mittelalterliche Langhaus-Kuppelkirchen*, 196–224; Grossmann, *Christliche Architektur in Ägypten*, 94–100.

126 Derat et al., "Rock-Cut Churches of Lalibela."

127 T. C. Tribe, "Holy Men in Ethiopia: The Wall Paintings in the Church of Abunä Abrəham Däbrä Sayon (Gär Alta, Təgray)," *Eastern Christian Art* 6 (2009): 7–37; Lepage and Mercier, *Les églises historiques*, 146–59; Plant, *Architecture of the Tigre*, 47–48; Phillipson, *Ancient Churches of Ethiopia*, 104–6.

128 G. Lusini, "Abraham of Däbrä Ṣəyon," in *EAe* 1:48.

129 R. Schneider, "Notes éthiopiennes," *JES* 16 (1983): 105–14, at 107.

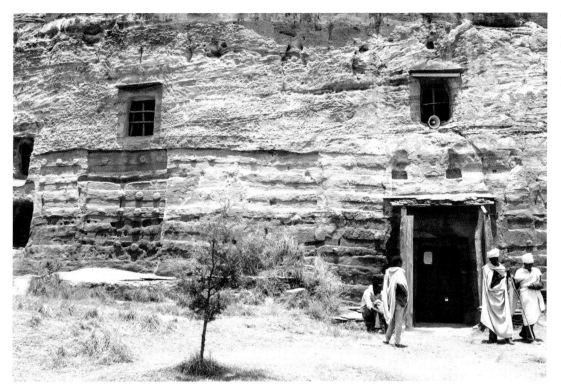

Figure 53.
Maryam Dabra
Tseyon, north facade,
Tigray, Ethiopia.
Photograph by
author.

highlands.[130] The north face of the church, from which the hypogeum was hewed, is expressive, sculpted as if to petrify the banded construction and exposed binders (monkey heads) of half-timbered freestanding churches (Fig. 53, compare Fig. 45). The basilica is flanked on the east by a domed oratory, the archimandrite's prayer room. The interior, which is entered through a transverse narthex, is eclectic: arcaded bays flanked by compound piers carry different types of ceilings, including faux gables, pendentive domes, true domes, and surbased vaults (Fig. 54).

Maryam Dabra Tseyon's grandeur largely derives from its painted program.[131] Practically every surface is covered with vibrant turquoise paintings on a white ground. Ornament is reserved for the vaults, while the walls, demarcated with a frieze of blind windows, bear figural murals. Lining the south wall and sanctuary, in particular, are registers of sculpted arches containing paintings of saints, a decorative schema that is unique to some fifteenth-century Tigrayan churches (Fig. 55).[132] Perhaps a hallmark of Abuna Abraham's workshop, these rupestrian icons may be fruitfully compared with the framed *proskynetaria* images of Palaiologan Greece,[133] as well as the (likely contemporary) sculpted effigies at Lalibela.[134] After all, by this time, Ethiopian ecclesiastic contacts with the Eastern Mediterranean

130 Maryam Dabra Tseyon was also one of the first churches in Tigray to be visited by a foreigner. Alberto Pollera, Italian anthropologist and colonial administrator in Eritrea, visited the monastery as early as 1924, though his photos are unpublished and are currently held in the archive of the Società Geografica Italiana in Rome. The church of Zoz Amba has a similar construction style to Maryam Dabra Tseyon; J. Mercier and C. Lepage, "Une église lalibelienne: Zoz Amba," *AÉ* 18 (2002): 149–54; Phillipson, *Ancient Churches of Ethiopia*, 106.

131 See the helpful key published in Tribe, "Holy Men in Ethiopia," 14. Ewa Balicka-Witakowska suggests that the murals are multiphased; E. Balicka-Witakowska, "Churches of Däbrä Ṣǝyon," in *EAe* 2:42–43.

132 Both the monastery church of Iyasus Tashi and Addi Qesho include these blind arcades; Plant, *Architecture of the Tigre*, 44–45, 135–36.

133 S. Kalopissi-Verti, "The Proskynetaria of the Templon and Narthex: Form, Imagery, Spatial Connections, and Reception," in *Thresholds of the Sacred: Architectural, Art Historical, Liturgical, and Theological Perspectives on Religious Screens, East and West*, ed. S. E. J. Gerstel (Washington, DC, 2006), 107–32.

134 For the sculptures at Lalibela, see Mercier and Lepage, *Lalibela*, 83, 111–15. In light of the presence of immovable altar tables adjacent to these sculptures, it is likely that they were hewn around the same time as Maryam Dabra Tseyon; M. Gervers, "The Rehabilitation of the Zaguë Kings and the Building of the Däbrä Sina–Golgotha–Sellassie Complex in Lalibäla," *Africana Bulletin* 51 (2003): 23–49, at 43–49.

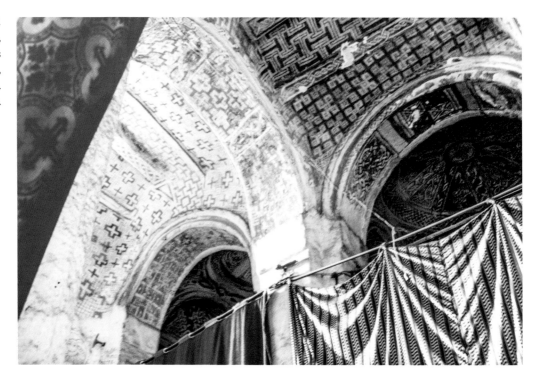

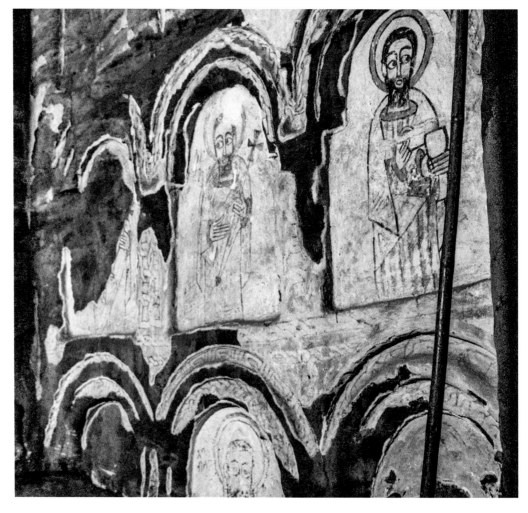

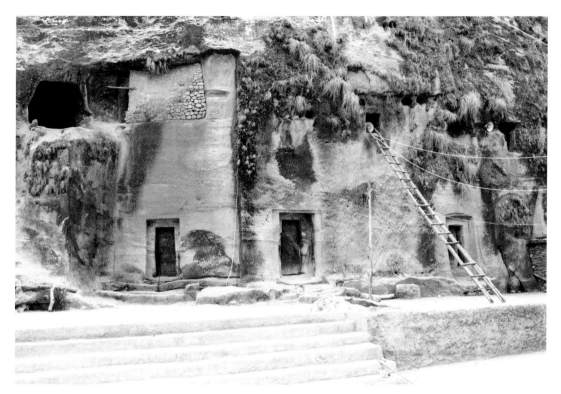

Figure 56.
Maryam Wuqro,
south facade, Nebelet,
Tigray, Ethiopia.
Photograph by author.

were stable, via Egyptian channels.[135] The strap-work ornament on the vaults tells another story—a workshop collaboration with Muslim counterparts from across the Red Sea.[136]

The church of Maryam Wuqro in Nebelet, located some sixteen kilometers northwest of Hawzen, is exceptional in many ways.[137] Located at ground level in a busy agricultural area, the placement and scale of the church suggest that it was intended for hybrid, monastic parish use

akin to the great cruciform churches of the eleventh century. The church itself is a large three-aisled basilica (21 m end to end), oriented west to east, though excavated transversally south to north into the cliff face (Fig. 56). As a result of the church's unique orientation and placement, the interior is extraordinarily well lit (for a rupestrian church), illuminated by three square apertures on the upper level.[138] Special attention is paid to the narthex, which is subdivided into bays by transverse piers and centered with a hanging double arch and a hewn throne on the western wall (Fig. 57). In contrast with the prevailing multidomed hall churches of the era, Maryam Wuqro exhibits extreme spatial massing along the nave, which is nearly double the height of the aisles (8.85 m / 5.5 m).[139] In addition to centering devotional focus in the main vessel, the high berth accommodated a gallery-like hypogeum above the narthex, which is only accessible from the outside. Long considered a dormitory area or a secondary church, a hagioscope (in direct view of the high altar) carved into the east wall of the chamber

135 M. Ambu, "Du texte à la communauté: Relations et échanges entre l'Égypte copte et les réseaux monastiques éthiopiens (XIIIᵉ–XVIᵉ siècle)" (PhD diss., Panthéon-Sorbonne University, 2022), 335–68.

136 B. Finster, "The Mosques of Wuṣāb Province in Yemen," *PSAS* 32 (2002): 233–45. See also C. Zanotti Eman, "The Harag of the Manuscripts of Gunda Gundi," in *Aspects of Ethiopian Art from Ancient Axum to the Twentieth Century*, ed. P. B. Henze (London, 1993), 68–72.

137 It is also one of the best studied churches in Tigray. The head of the ethnographic service in Italian East Africa published a monograph on the church already in 1939; A. Mordini, "La chiesa ipogea di Ucro (Amba Seneiti) nel Tigrai," *Gli Annali dell'Africa Italiana* 2.2 (1939): 519–26. See also E. Balicka-Witakowska, "Wəqro Maryam," in *EAe* 4:1181–82; Phillipson, *Ancient Churches of Ethiopia*, 101–4; Tigrai National Regional State Culture and Tourism Agency, *A Guide Book to Tigrai Tourist Attractions*, ed. V. Krebs (Mekelle, 2012), 69–72; Plant, *Architecture of the Tigre*, 76–79; Lepage and Mercier, *Les églises historiques*, 160–63.

138 Mordini, "La chiesa ipogea," 521.

139 Per Mordini's measurements: "La chiesa ipogea," 522.

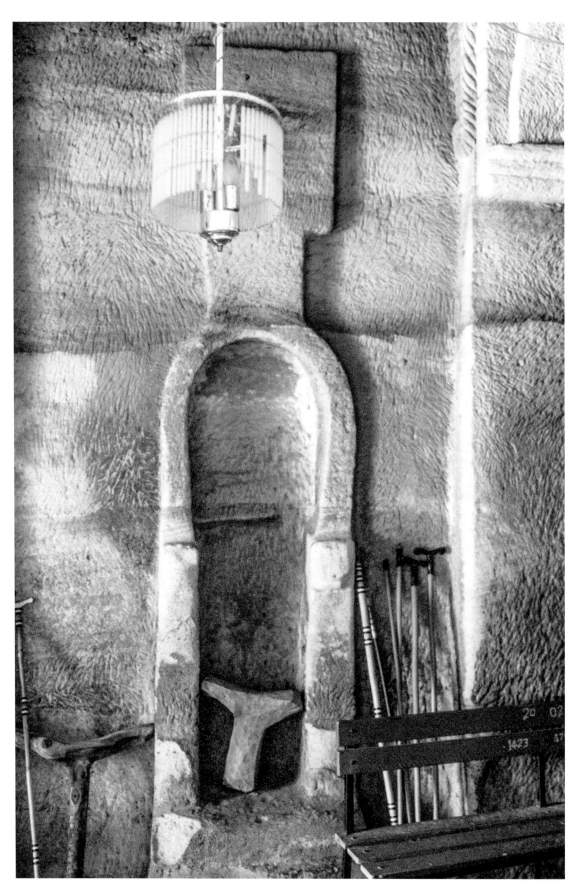

Figure 57.
Maryam Wuqro, throne in the narthex, Nebelet, Tigray, Ethiopia. Photograph by author.

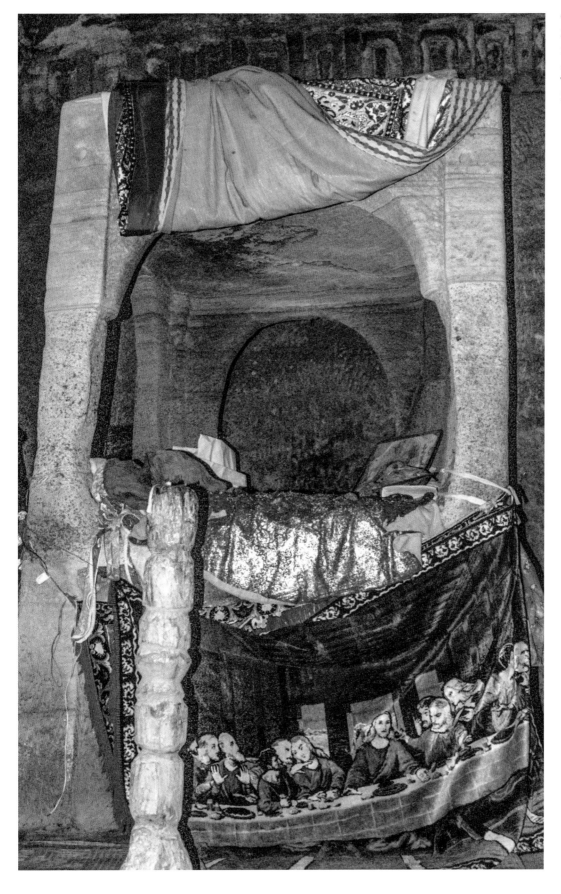

Figure 58.
Maryam Wuqro,
monolithic altar
ciborium, Nebelet,
Tigray, Ethiopia.
Photograph by author.

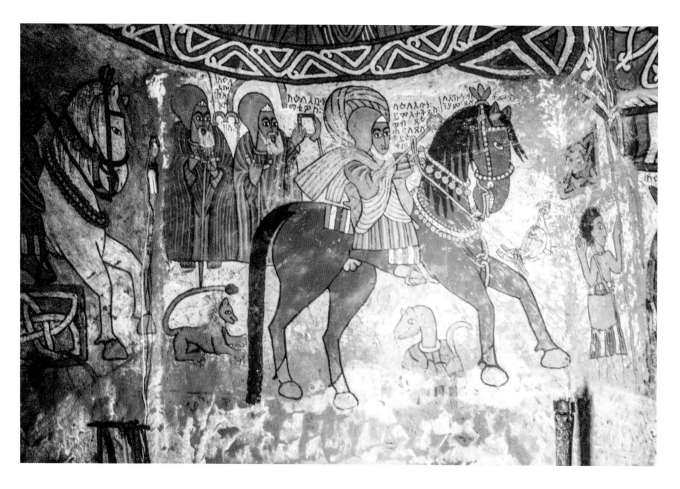

Figure 59.
Abuna Yemata, mural
painting showing
Saint Yemata on
horseback, Gaalta,
Tigray, Ethiopia.
Photograph
by author.

suggests to me a special anchoritic use, perhaps planned along with the throne underneath it.[140]

The nave itself is set atop a flat architrave crowned with a frieze of blind windows, carried by bracketed pillars. The vessel ends in a square apse containing a monolithic ciborium (Fig. 58, connected to a secondary altar chamber), surmounted by a ceiling and preceded by a three-step bema.[141] Each bay is crowned with eclectic ceilings sculpted in various configurations of crosses, domes, mini-domes, and coffers, each bearing hewn pendants.[142] Though the church generally lacks mural paintings, the southernmost dome

in the narthex bears traces of a strapwork diaper motif atop a register of arabesques, perhaps suggesting the presence of a more substantial decorative program in the past.[143] In contrast to Maryam Dabra Tseyon, the church's grandeur is derived from its expressive articulation.

This section concludes with a discussion of the oft-visited church of Abuna Yemata Guh in the Garalta escarpment near Hawzen. This small monastery church is extremely isolated, hewn into a vertical cliff face and accessible only through a narrow passageway (over a sheer drop of fifty meters) after an arduous climb.[144] A hall church of the Mamluk-era "egg carton" type,

140 Mordini, "La chiesa ipogea," 524. This was referred to as a "second church" when I visited it, though Mordini suggests it was originally a monk's cell. My identification of this feature as a hagioscope is based on those illustrated by Robert Ousterhout in his study of Byzantine Cappadocia, "Sightlines, Hagioscopes, and Church Planning in Byzantine Cappadocia," *AH* 39.5 (2016): 848–67.

141 Fritsch and Gervers, "Pastophoria and Altars," 37–38.

142 See the schematic plan of the vault types on the upper level; Mordini, "La chiesa ipogea," 525. Decorative pendants are consistent with freestanding constructions from the period, as

at Bethlehem in Gayint, Amhara, as well as in Mamluk Egyptian construction.

143 An inscription in Geʿez on the soffit of an arch near the painted decoration may be a complicating factor, however. Seemingly a request for divine intercession by a monk (during the year 1982 [1975 EC]), he may have also executed other painted work in the church.

144 Another "egg carton" church mentioned is Abba Yohanni; see M. Gervers and E. Balicka-Witakowska, "Abba Yohanni," in *EAe* 5:208–10.

Abuna Yemata consists of nine roughly hewn bays, divided by cruciform piers and crowned with pendentive domes. Lacking articulation and exhibiting continuous curved surfaces, the small, centralized interior is fully dematerialized through extensive murals on its walls and vaults. Containing, among other things, the first representation of those responsible for the "second Christianization" of Aksum, the legendary sixth-century Nine Saints, Abuna Yemata Guh is extraordinarily well preserved, modeling the, now fully fledged, Ethiopian iconographic painted style of the fifteenth century (Fig. 59).[145]

Despite a general refocus of royal authority toward the central highlands, Tigray maintained its preeminence as a Christian center long into the "Solomonic" era. The growth of monasticism was central, as was sustained royal patronage, even as Christian power had now shifted south. Although new liturgical and architectural forms were introduced from Egypt in this period, we also see the development of distinctly Ethiopian schools of mural painting as well as imaginative uses of architectural sculpture, to evoke and reimagine the built environment of Tigray.

A Living Tradition, 1500–Present

Tigrayan churches are not easily dated, as they are not immune to later alterations. Although so-called round churches became the preferred building type in the central highlands as of the fifteenth century, Tigrayan churches are still largely basilican.[146] Moreover, recent ethnographic work has highlighted a vibrant contemporary tradition of rock-cut architecture, presumably in

direct continuity with the Middle Ages. Since 2016, Michael Gervers has documented forty in-progress rock-hewn churches in Ethiopia.[147]

Generally speaking, the historic and continued practice of rock carving appears to have an economic basis. Rather than requiring the felling of timber or purchase of materials, hypogean churches only require payment for labor that is often done voluntarily on the promise of *bäräkät* (blessings). Though many "new" churches are roughly hewn and minimalistic in their conception, many are remarkable homages to their medieval predecessors.[148] For example, next to the aforementioned thirteenth-century church of Maryam Qorqor in Garalta, a hermit has been constructing a new rock-hewn church in honor of the same dedicatee.[149] Likewise, across a stream from the eleventh-century church of Hawzen Takla Haymanot, a team of artisans has been at work on a new church carved from the same sandstone escarpment.

Wholly new foundations of hewn churches are also commonplace. The parish church of Medhane Alam (Mädhane ꞌAläm), in the town of Warq Amba in the southeast of Tigray province, is in every sense a medieval church, but hewn in the present day.[150] Financed by a wealthy local,

145 Lepage and Mercier, *Les églises historiques*, 170–78; Plant, *Architecture of the Tigre*, 73–75. On the Nine Saints, see A. Brita, *I racconti tradizionali sulla «seconda cristianizzazione» dell'Etiopia: Il ciclo agiografico dei novi santi* (Naples, 2010).

146 On "round churches," see E. Fritsch, "The Origins and Meanings of the Ethiopian Circular Church: Fresh Explorations," in *Tomb and Temple: Re-Imagining the Sacred Buildings of Jerusalem*, ed. R. Griffith-Jones and E. Fernie, Boydell Studies in Medieval Art and Architecture 13 (Woodbridge, UK, 2018), 267–93. Because Tigrayans make up the overwhelming majority of Ethiopian immigrants in the United States, Ethiopian Orthodox churches in centers such as Washington, DC, and Los Angeles are largely basilicas, reflecting the architecture of their region; M. E. Heldman, "Creating Sacred Space: Orthodox Churches of the Ethiopian American Diaspora," *Diaspora: A Journal of Transnational Studies* 15.2–3 (2006): 285–302.

147 M. Gervers, "New Rock-Hewn Churches of Ethiopia," https://www.utsc.utoronto.ca/projects/ethiopic-churches/. This ambitious web project ("New Rock-Hewn Churches of Ethiopia" [2020]), includes a database searchable by region, interviews with the master masons, and excellent measured plans and elevations by architect Tarn Philipp. See also M. Gervers and T. Philipp, "The New Rock-Hewn Churches of Ethiopia: Continuity or Revival?" (paper given at ICES20, Mekelle University, Mekelle, Ethiopia, 1–5 October 2018). See also Phillipson, *Ancient Churches of Ethiopia*, 121.

148 Though not located in Tigray proper, perhaps the most exciting "new" church is the Ambager Complex (often called *Dagmawi* Lalibela or Lalibela Two), near to the eponymous site in Lasta. Carved in the round like its thirteenth-century prototype, master mason Gebremeskel Tesema planned the site in a wholly innovative way, with unique flourishes, including a monolithic map of Ethiopia's pre-1991 borders, and sculpted decorations throughout depicting varied subject matter such as antelopes, clay jugs, and incense burners; T. Philipp, "Ambager Complex (Dagmawi Lalibela)," https://www.utsc.utoronto.ca/projects/ethiopic-churches/ambager-complex-dagmawi-lalibela/ [2020].

149 T. Philipp, "Maryam Korkor (Gärꞌalta Region)," https://www.utsc.utoronto.ca/projects/ethiopic-churches/maryam-korkor/ [2020].

150 T. Philipp, "Medhane Alem Warq Amba (Tämben Region)," https://www.utsc.utoronto.ca/projects/ethiopic-churches/medhane-alem-warq/ [2020].

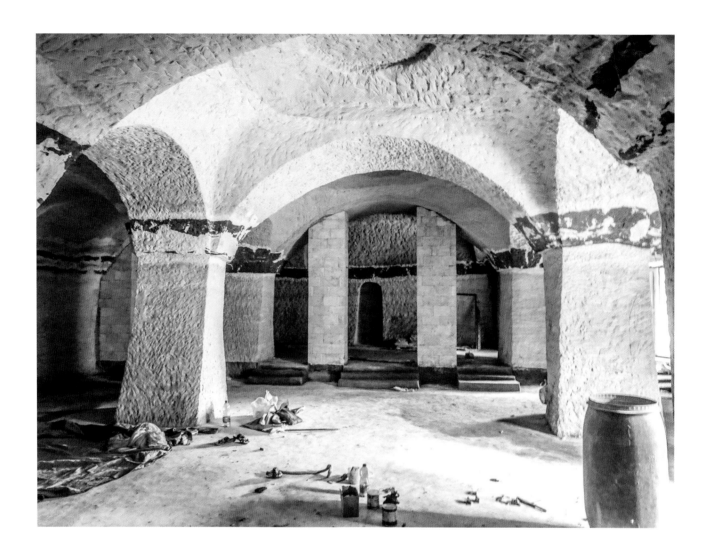

Figure 60.
Medhana Alam,
nave elevation,
Warq Amba,
Tigray, Ethiopia.
Photograph courtesy
of Michael Gervers.

like the donations recorded in medieval cartularies, Warq Amba Medhane Alam is a finely hewn, three aisled, multidomed hall church (Fig. 60) that resembles Abuna Yemata Guh stripped of its paint.

Though the ancient tradition of rock carving has served as a link with the past, for some it has also inspired entirely new developments. In the first decade of the twenty-first century, Gedey Berhan, a native of Hawzen and a veteran of the Eritrean war, began making a three-room rock-cut house (Fig. 61) adjacent to, and inspired by, the town's namesake church (Hawzen Takla Haymanot, eleventh century; see Fig. 35). Notwithstanding the modern accoutrements that Berhan made sure to include (including a rock-cut TV stand and armchair), his decision to live as a troglodyte is not rooted in any historical precedent after the Neolithic Revolution in

Tigray. Indeed, Berhan's rock-cut house is something of a local oddity in Hawzen, even attracting Ethiopian national news media.[151] His decision to make a hypogean house, though inspired by the past, represents a distinct, creative rupture in the history of Tigrayan architecture.

These divergent, contemporary uses of rupestrian architecture are brought up only to illustrate that in the postmedieval period, ancient building practices remain a living art form. In the present day, rock carving has inspired both faithful homages to as well as abrupt breaks with the past.

+₊+

151 *Ethiopian Couple Built Their Own Rock-Cut House in Hawzen, Tigray* (in Amharic), Documentary (News ET Zeno Oduu, 2016), https://youtu.be/AtexzOHKRbY.

The architectural history of Tigray is at once profoundly local and universal. While church architecture was indebted to local forms and building practices, it was also a vehicle for changing liturgies as well as stylistic trends, culminating in the widespread use of iconographic mural painting in response to icon worship. As elsewhere in the world, rock-hewn architecture was based on the local built environment, though after the thirteenth century, masons used the rock face to test the medium with profoundly imaginative articulation. The great cruciform churches of the eleventh century, the subjects of the following chapters, should be viewed against this architectural history. As I will illustrate, despite being thoroughly rooted in Aksumite architectural precedents, the church's biaxial conception and use of vaults were unprecedented design choices, especially when viewed against the overall trajectory of Tigrayan architecture outlined above.

Figure 61.
Rock-hewn house, exterior elevation, Hawzen, Tigray, Ethiopia. Photograph by author.

CHAPTER 2

CHURCHES IN THE MAKING

AS MENTIONED, IN THE ELEVENTH
century a revolution in rock-hewn architecture was staged in Tigray. The political, religious, and ideological motivations behind the construction of Abreha wa-Atsbeha, Wuqro Cherqos, and Mika'el Amba will be explored in the following chapter; here I provide the material evidence for this dating in the absence of textual records. In doing so, I establish the basis for my relative chronology, which considers all three churches to have been produced in short succession by a coherent patron and group of masons in the late eleventh century (most likely 1089–1094) with a terminus ante quem of 1150.

As I will show, Abreha wa-Atsbeha, the prototype, is an architectural experiment that was enabled by its specific geological setting. When copied onto different sandstone escarpments, as at Wuqro and Mika'el Amba, its cruciform shape was modified. At Wuqro it was effectively hewn in the shape of a basilica in order to better suit its geological setting, while at Mika'el Amba, the steadfast copying of Abreha wa-Atsbeha's form in a starkly different geological mass led to its initial abandonment. It was then modified around 1150 in a manner unrelated to Abreha wa-Atsbeha, into the functional and celebrated monastery church we know today.

As well as providing a millennial context for the churches, this complex building history shows that rock-hewn monuments, generally

speaking, should be conceived of as multiphase endeavors instead of single "great campaigns." In effect, even early medieval, well-preserved rupestrian churches must be considered as continuously "in the making," that is, changing in both their form and function in the centuries after their respective groundbreakings.

What's in a Name?

Abreha wa-Atsbeha, Wuqro Cherqos, and Mika'el Amba have long been identified as a distinct and tightly linked triad of buildings. Indeed, the churches differ from the region's basilicas by virtue of their specific architectural features. All are hewn in a semi-monolithic manner, externally cruciform as well as biaxial. Each church appears as an aisled cruciform, formed by an aisled nave intersecting with an aisled transept, and terminates in a conched apse. The churches are further distinguished by their vaulted cross arms and dramatic crossing spaces, which feature monumental sculpted crosses.

That said, they also defy easy typology. The churches are cruciform, yet aisled with the application of lateral bays, and axial (terminating in an apsed sanctuary), yet with space massed at the crossing and choir. Scholars have suggested various terms to classify them. The "Tigray Cross-in-Square," itself an explicit reference to centralized Middle Byzantine churches, is the

most common term, which we owe to David Buxton (1971) and David Phillipson (2009).[1] In French-language scholarship, the terms "semi-monolithic" and "cruciform" (the latter is my preference) are employed,[2] yet "cross-in-square" has remained the most popular, undoubtedly because of the accessibility of Phillipson's *Ancient Churches* and readers' relative familiarity with Byzantine architecture. However, as I will show here, the common use of this typology, following Phillipson in particular, is misleading, and in the process has spawned a number of ill-advised works comparing these churches to unrelated Byzantine buildings.[3]

The Byzantine cross-and-square church (alternatively, inscribed-cross church), which Tigrayan cruciform monuments have been classified as, is a small, stout, nine-bay building with a tripartite division of interior volume centered on a domed core. It is generally thought that the Middle Byzantine cross-in-square was developed to accommodate new devotional practices centered on private and monastic worship.[4] The diminished resources of the Byzantine Empire in the seventh century meant that producing massive basilicas with imperial largesse was difficult; smaller churches could be made more easily under private and monastic patronage. More of a modular structural system rather than a typology per se, the cross-and-square church plan was subject to great experimentation by Byzantine master masons, such as expansion in the case of

St. Sophia in Kiev and creative modifications as in the church of Nea Moni on Chios.[5]

The standard example of a Middle Byzantine building is the early tenth-century imperial church of Emperor Romanos (r. 919–944) in Constantinople, the Myrelaion (now Bodrum Camii; Fig. 62).[6] The Myrelaion's main vessel consists of a nine-bay core (*naos*) with four columns supporting a central dome at the highest point, braced on four sides with groin-vaulted cross arms, which are the second highest spaces, and then even lower vaults on the corner modules. The Myrelaion, which is some 15 meters long end to end, is small compared to Early Byzantine monuments, yet is consistent in size with most churches produced in the eastern Mediterranean after the ninth century.[7]

From this brief overview we can see that the Middle Byzantine "cross-in-square" church, in its most standard manifestation, does have several shared features with Abreha wa-Atsbeha, Mika'el Amba, and Wuqro Cherqos, mainly in terms of modular conception and spatial hierarchy. Abreha wa-Atsbeha, while overall cruciform in plan rather than square, is modular with a nine-bay core and tripartite spatial hierarchy (aside from the choir space) centered on the crossing (see Figs. 3, 4). The second level of spatial hierarchy is matched in both vaultedness and directionality in both Abreha wa-Atsbeha and the Myrelaion. Moreover, the engaged cross surmounting the central module is similar to creative expressions of domes found in Middle Byzantine Cappadocian churches.[8]

Although the two types share a modular conception and centralized spatial hierarchy, Tigrayan cruciform churches are ultimately quite different from the Byzantine cross-in-square, however. The

1 D. Buxton, "The Rock-Hewn and Other Medieval Churches of Tigré Province, Ethiopia," *Archaeologia* 103 (1971): 33–100, at 90–93; D. W. Phillipson, *Ancient Churches of Ethiopia: Fourth–Fourteenth Centuries* (New Haven, 2009), 92.

2 R. Sauter, "Où en est notre connaissance des églises rupestres d'Éthiopie," *AÉ* 5 (1963): 235–92, at 256–57; F. Anfray, "Des églises et des grottes rupestres," *AÉ* 13.1 (1985): 7–34; C. Lepage and J. Mercier, *Les églises historiques du Tigray: Art éthiopien / The Ancient Churches of Tigrai: Ethiopian Art*, trans. S. Williams and C. Wiener (Paris, 2005), 71–91.

3 See, for example, R. Higuchi, N. Shimizu, and H. Sugawara, "Some Topics towards a Better Understanding of Tigray's Cross-in-Square: A Wide-Ranging Comparison among Christian Cross-in-Square Churches" (paper presented at ICES20, Mekelle University, Mekelle, Ethiopia, 2 October 2018).

4 R. Ousterhout, *Eastern Medieval Architecture: The Building Traditions of Byzantium and Neighboring Lands*, Onassis Series in Hellenic Culture (New York, 2019), 303–34; R. Ousterhout, *Master Builders of Byzantium* (Princeton, 1999), 7–38.

5 Ousterhout, *Master Builders of Byzantium*, 86–127; R. Ousterhout, "Originality in Byzantine Architecture: The Case of Nea Moni," *JSAH* 51.1 (1992): 48–60.

6 C. L. Striker, *The Myrelaion (Bodrum Camii) in Istanbul* (Princeton, 1981).

7 Ousterhout, *Master Builders of Byzantium*, 25–33; C. Mango, "Approaches to Byzantine Architecture," *Muqarnas* 8 (1991): 40–44, at 41.

8 R. Ousterhout, *Visualizing Community: Art, Material Culture, and Settlement in Byzantine Cappadocia*, DOS 46, (Washington, DC, 2017), 45, 54, 58–59, 67, 157, 191, 199, 203; A. L. McMichael, "Rising above the Faithful: Monumental Ceiling Crosses in Byzantine Cappadocia" (PhD diss., CUNY Graduate Center, 2018).

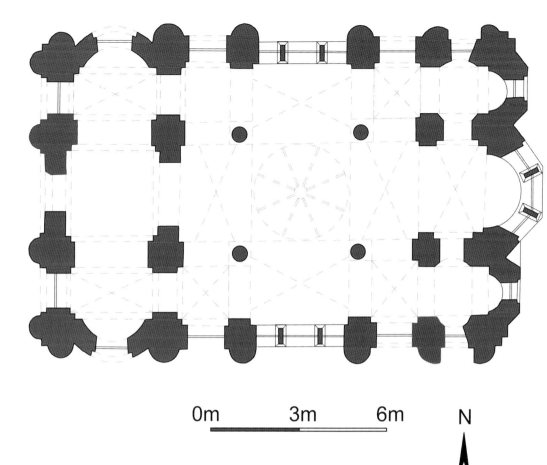

Figure 62.
Bodrum Camii
(Myrelaion),
measured ground
plan, Istanbul,
Turkey, 920.
Plan by author
and Binxin Xie,
redrawn and
modified from
R. Ousterhout,
*Eastern Medieval
Architecture: The
Building Traditions
of Byzantium and
Neighboring Lands*
(New York, 2019),
308, fig. 13.3.

0m 3m 6m N

biggest distinction is formal. Whereas Middle Byzantine cross-in-square churches are centralized and biaxial, they are also compact and rectangular. Tigrayan cruciform churches, despite their nine-bay core, are emphatically cruciform, with an exposed and clearly defined (if truncated) nave and transept. Moreover, in terms of scale, all three Tigrayan churches are monumental, a profound expression of renewed post-Aksumite power, whereas Middle Byzantine churches are intentionally small, marking a privatization of Orthodox worship.[9] And because these Tigrayan churches have only a superficial relationship with Middle Byzantium, this term is therefore a misnomer.[10]

9 But see the twelfth-century Pantokrator Monastery in Constantinople; S. Kotzabassi, ed., *The Pantokrator Monastery in Constantinople*, ByzArch 27 (Berlin, 2013).

10 Moreover, the broad application of this typology is problematic in the field of Byzantine architecture; Ousterhout, *Master Builders of Byzantium*, 25–33; Mango, "Approaches to Byzantine Architecture," 41.

Following prevailing French usage, primarily by Claude Lepage, I suggest that the churches be referred to as cruciform, but more particularly "Tigrayan cruciform," so as to distinguish these aisled examples from the single-aisle cruciform churches of the later central highlands (Beta Giyorgis at Lalibela, thirteenth century) and Zamaddo Maryam (Zämäddo Maryam, fifteenth century, for which, see the conclusion).

Abreha wa-Atsbeha

TOPONYM AND ENVIRONS

Abreha wa-Atsbeha (see Fig. 3) sits within an escarpment of red sandstone in the eponymous village of Abreha Atsbeha (Abrəha Aṣbəḥa) in eastern Tigray, Ethiopia, approximately fifteen kilometers from Wuqro (see Figs. 8, 63). Occasionally called Dabra Nagast (Däbrä Nägäśt, Monastery of the King) or, in hagiographic literature, Ayba Gamad (ʿAyba Gämad), the area was long regarded as a trading hub with the Red Sea

Figure 63.
Abreha wa-Atsbeha,
viewed from the market
square, Tigray, Ethiopia.
Photograph by author.

and the Danakil Depression near to the regional administrative capital Chalaqot (Čäläqot).[11] Abreha wa-Atsbeha's relative accessibility makes

11 J. Conder, *The Modern Traveller: A Popular Description, Geographical, Historical, and Topographical, of the Various Countries of the Globe*, vol. 5, *Egypt, Nubia, and Abyssinia*, 2 vols. (London, 1827), 2:357; C. Hutton, *The Tour of Africa: Containing a Concise Account of All the Countries [...] with the Manners and Customs of the Inhabitants*, 3 vols. (London, 1819–21), 2:9; C. Lepage, "L'église semi monolithique de Abrehä Asbehä: Monument clef de l'histoire de l'architecture éthiopienne," in *I molti volti dell'arte etiopica: Atti del IV Convegno internazionale di storia dell'arte etiopica, 24–27 settembre 1996, Trieste*, ed. A. L. Palmisano, S. Chojnacki, and A. Baghai (Bologna, 2010), 146. Ayba Gamad, a combination of the saint kings' maternal hometown and burial place (as per their hagiography), is found both in some hagiographic literature and also Italian colonial documentation. See S. Hummel, "The Disputed *Life* of the Saintly Ethiopian Kings ʾAbrəhā and ʾAṣbaḥa," *Scrinium* 16 (2016): 35–72, at 50–51; M. Muehlbauer, "An Italian Renaissance Face on a 'New Eritrea': The 1939 Restoration of the Church of Abreha wa-Atsbeha," *JSAH* 78.3 (2019): 312–26, at 312; C. Bosc-Tiessé, "Le site rupestre de Qorqor (Garʿāltā, Éthiopie) entre littérature et peinture. Introduction à l'édition de la *Vie et des miracles de saint Daniel de Qorqor* et aux recherches en cours," *Afrique*, Sources (19 November 2014), http://journals.openedition.org/afriques/1486.

it one of the most visited churches in the region.[12] Although many Tigrayans regard it as the second holiest church in Tigray, after the cathedral of Aksum Tseyon, due to its association with the eponymous saint kings, Abreha and Atsbeha,[13] it is likely that the church had another dedication when it was founded. None of the church's three altars is consecrated in the name of Saint Abreha or Saint Atsbeha.[14]

Like much of eastern Tigray, the ridge of hills from which Abreha wa-Atsbeha was hewn is made up of richly variegated red sandstone.[15]

12 Below and around the church are hundreds of rock-cut postholes, possibly showing the former placement of palisades or domestic architecture.

13 H. S. Almaho, *Tarik Negast Abreha wa-Atsbeha* (Mekelle, 2012).

14 The three altars are dedicated to Michael, Mary, and Gabriel, though the parish priest assured me in June 2018 that Abreha and Atsbeha were "mixed into" the dedication of *all* three altars.

15 A. Abay, G. Mebrahtu, and B. Konka, "Geological and Geomechanical Properties of Abraha-Atsibha and Wukro Rock-Hewn Churches and Its Surroundings, Tigray Region,

The site on which the church now sits is somewhat built up as a result of recent international and regional government investment in the parish and former monastery. Notable modern inclusions to the church grounds include a steel balustrade, a staircase, and a low wall made of local rubble.[16] North of the church, but within the monastic compound, is a brick two-story building, with a museum of the church's sacristy contents (established in 2017) on the upper level and a storeroom on the lower. Above the church to its northwest are some mixed-use buildings, livestock, and a cylindrical bell tower.

The church itself is surrounded by the parish's graveyard.[17] Burial sites carved into the rock face adjacent to the church are worth noting; perhaps these were hewn shortly after the foundation of the monastery. The south escarpment accommodates eight graves in total, of which two are indicated by a blind arcade and three are stacked on the extremity of the rock face. The north escarpment accommodates three discernable burial sites, one of which is signified by a blind arch. Pit burials also flank the north and south portals.[18]

FACADE AND NARTHEX

Abreha wa-Atsbeha is hewn as a semi-monolith, with part of the transept, nave, and narthex detached from the mother rock. Overall, there is very little external articulation at Abreha wa-Atsbeha aside from the timber-framed windows that light the transept arms (Fig. 64).[19] The south

transept incorporates two windows; the second window was added sometime prior to 1924 (per archival evidence; Fig. 65). It does not date from the groundbreaking, as indicated by its irregular fitting and slapdash use of rubble fill.[20] The north transept is lit by a single window.[21] In all cases, the window frames are recent; by 1924 the original timbers had vanished and the apertures had been filled in with rubble.

The facade is heavily disrupted by the Fascist Renaissance Revival-style outer porch (Fig. 66), constructed in 1939 under Italian imperial contract by Giuseppe Miari, the chief engineer of colonial Eritrea.[22] This followed at least two prior (Ethiopian) restoration works, the most invasive of which occurred in 1873 under Emperor Yohannes (Yoḥannes) IV (r. 1871–1889), as noted in a dedicatory inscription on the north doorjamb of the central portal. The original hewn narthex had collapsed by the early nineteenth century, likely from structural failure exacerbated by a fire (see below). Most recently, the narthex underwent comparatively limited restoration: the first project occurred between the 1950s and 1968, as documented in

Northern Ethiopia," *Momona Ethiopian Journal of Science* 9.2 (2017): 182–99.

16 According to the early traveler Henry Salt's companion, Nathaniel Pearce, the reigning lord Wolde Selassie (Śəllase) commissioned a paved walkway up to the church in the first decade of the nineteenth century; N. Pearce, *The Life and Adventures of Nathaniel Pearce, Written by Himself, during a Residence in Abyssinia from the Years 1810–1819, Together with Mr Coffin's Account of His First Visit to Gondar*, ed. J. J. Halls, 2 vols. (London, 1831), 2:44.

17 In 2017 I counted ninety-four graves around the church. The graves range from concrete podia with welded iron crosses on top, to the more customary pile of stones, occasionally capped with a vertically oriented slate, serving as a headstone.

18 These are illustrated in my plan of the church (see Fig. 3).

19 Set back some 10.5 meters from the first step of the Italianate porch is the south portal of the church, which is located on the transept. The present-day portal does not align at all with the 1.7-meter-wide aperture cut into the rock. While

the vertical posts fit snugly into the rock face, the rock is cleared around and above the posts with what appears to be the outline of a lunette or triangular pediment followed by a void, perhaps for a wood architrave. The church's north portal is similarly set back from the porch front. This follows the same basic shape as the south portal, and is inset into a 1.7-meter aperture, though the "lunette" capping it is smaller and skewed. Like the south portal, only the posts of the frame fit snugly into the rock aperture. The timber door, although likely wholly modern, is sutured with iron clamps—either Aksumite spolia or post-Aksumite spolia—that were forged in the centuries prior to its groundbreaking, perhaps from the recently discovered smelting workshop at Gud Bahri near Wuqro; H. Berhe et al., "Preliminary Report on a Test Excavation at the Ancient Iron Smelting Site of Gud Baḥri (Wuqro, Tigray)," *Annales d'Éthiopie* 33 (2021): 167–88 at 175.

20 The aperture in the rock into which the window frame is set is in the form of an irregular rectangle. Both the top and bottom of the rectangular aperture are slightly extended, likely in preparation for the insertion of a longer header and sill than that actually realized in the frames. While the frame is snugly inset, it is now supported on its sides with brick-and-mud fill.

21 Capping the window is a semicircular aperture that is somewhat symmetrical. This may signal that the church once had a decorative lunette, as on the south transept, or that a window expansion was once planned in more modern times, but not implemented.

22 Muehlbauer, "Italian Renaissance Face." During the Italian occupation of Ethiopia, Tigray was incorporated into the administrative region of Eritrea.

Figure 64. Abreha wa-Atsbeha, south transept elevation, Tigray, Ethiopia. Photograph by author.

Figure 65. Abreha wa-Atsbeha, south transept elevation, Tigray, Ethiopia, 1924. Photograph by Alberto Pollera, courtesy of the Archivio Fotografico, Società Geografica Italiana, Rome, Italy.

archival photos (Fig. 67), and the second, involving the application of concrete, occurred sometime between 2000 and 2007.[23]

The Renaissance-style facade (originally set back from the narthex and lacking a pediment, as per Fig. 67) is composed of plaster-faced flagstone (until 2005 it was painted green and yellow). The facade consists of a two-arch arcade atop five steps, sided with quoin blocks. Articulation is minimal. Three bands of stringcourses break up the central pillar and delineate an entablature above the arcade. Neorenaissance-style sculpted roundels further embellish the spandrels. Since 1968 the facade has been crowned with a cornice, pierced by keyhole windows containing a megaphone to project the liturgy for large events (including the festival of the two saint-kings that occurs annually in October as well as for funerals).[24]

The freestanding narthex, to which the Italianate porch is attached, had a low open gable roof prior to 1968. Underneath the roof were timber tie beams, inset in putlog holes on daub walls, which, after 2005, were reinforced with closely lodged timber joists (the same campaign that also covered the entire narthex in concrete). Inset within the porch at a depth of 1.7 meters is the main portal, which appears to date from Yohannes's intervention (1873–1874), if not before.

The freestanding narthex is a rectangular room measuring 6 by 3.2 meters, whitewashed, though built out of local rubble suspended in a daub matrix within timber frameworks.[25] The transition from the square foundation to the narrower interior portal was effected by interior

buttresses made of rubble, which carry timber lintels. Because of the heavily painted interior, it is difficult to tell the exact point of fracture where the original hewn narthex collapsed, though a meter-long section of the south rock wall remains at a sharp diagonal with the restored portion, hinting at a violent collapse.[26] There is no archival evidence in Ethiopia or Italy of the form of the hewn anteroom, but, having had the opportunity to remove the carpeting from the floor, I documented a residual plinth with a chamfered profile placed 70 centimeters from the west portal and 2.5 meters from the entrance into the main vessel.[27] If we assume this pier was centrally located, it may be that the hewn chamber had a 5-meter-long footprint in its original configuration.

THE MAIN VESSEL

Generally speaking, the church of Abreha wa-Atsbeha is remarkably regular for a hewn church. It is also quite large. Including the hypothetical 5-meter-long hewn narthex, the church would have been 23 meters end to end (the main vessel is 18 m long today). The transept is almost equal the length of the body, measuring 16.5 meters, north to south. Excluding the lateral bays of the transept and the western bays of the nave, the church appears to be based on a modular plan, centered on the 3-meter-square crossing space, which forms a 9 × 9 meter square core of nine bays. Making good use of the spatial constraints of the rock outcropping, three bays were added laterally to the western nave and the aisled transept, forming an overall cross shape. The southernmost three bays of the church measure around 2 × 3 meters, while those on the north are more irregular and measure from west to east approximately, 2 × 2 meters, 2 × 3 meters and 3 × 3 meters (see Figs. 2, 3). The church also has attempted bilateral symmetry, aside from the enlarged south chamber.

23 A terminus ante quem can also be found in the superb elevation drawings of Otto Dale ("The Rock-Hewn Churches of Tigre," *EO* 11.2 [1968]: 121–51, at 122).

24 As with most modern freestanding Tigrayan churches, there is a decorative fascia of toothed metal underneath the overhang and a star-shaped finial topping the apex of the roof, both of which probably date to no earlier than the mid-twentieth century.

25 George Annesley and Henry Salt, who visited the church at the turn of the nineteenth century, noted, "a thatched and two storied entrance, built in a style much resembling that of the Portuguese." Their description means that the original hewn narthex had collapsed prior to their visit, and was rebuilt, possibly in the seventeenth or eighteenth century, which would thereby explain the "Portuguese" construction (the Jesuits left a considerable legacy in the country after the seventeenth century); G. Annesley, *Voyages and Travels to India, Ceylon, the Red Sea, Abyssinia, and Egypt, in the Years 1802, 1803, 1804, 1805, and 1806*, 3 vols. (London, 1809), 3:27–29.

26 On the north side, most of the hewn wall remains below the dado level.

27 David Buxton suggested that the original narthex, while taking up the same footprint as the restored portion, had two laterally placed dividing piers. This is unlikely, especially since the other churches in Abreha wa-Atsbeha's formal group have single piers. Buxton was likely invoking the elaborate, two-pier narthex of the fourteenth-century church of Maryam Wuqro in Nebelet, Tigray; Buxton, "Rock-Hewn and Other Medieval Churches," 42, 46.

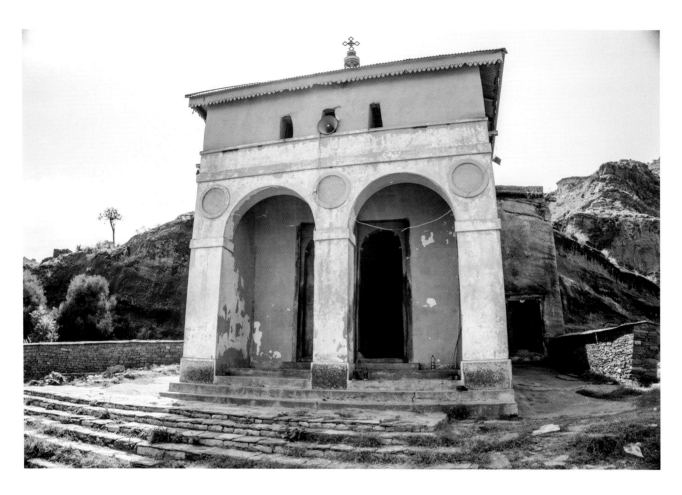

Figure 66.
Abreha wa-Atsbeha,
exochamber facade,
Tigray, Ethiopia.
Photograph by author.

Visible at the west end of the nave and the south wall is trauma from the collapse of the hewn narthex.[28] The nave entablature, especially in the architraves connecting the west bays to the wall, has fallen away in sheets, scaling along the sandstone grain (Fig. 68).[29] The western wall likely contained a decorative arch with a setback molding, matching the configuration at Wuqro Cherqos.

Freed from physical constraints that otherwise define freestanding structures, the walls of Abreha wa-Atsbeha's nave are neither straight nor symmetrical, but rather flare outward gradually from west to east. Though varying somewhat in their profiles, the piers are of a consistent 4-meter height. Moreover, a continuous frieze of blind "Aksumite" windows runs along the cross-shaped upper level of the main vessel, including the nave architrave (numbering nine on each side), the central bays of the transept (eleven on the north and nine on the south), and the apse conch.

From the west end of the main vessel to the crossing space, the nave measures approximately 5 meters long and 2 meters wide on the intercolumnar span. Dividing the nave into two bays are chamfered piers with octagonal plinths and stepped capitals. Although the nave is crowned with a flat ceiling, bisected by a transverse lintel, the eastern end preceding the crossing space includes a residual setback molding of a round arch (Fig. 68). This suggests that the nave was originally barrel vaulted and changed subsequently. Likewise, the nave frieze is crowned with a *cyma reversa*, perhaps recarved from a

28 The western bays of the south wall of the transept show significant structural damage as well in the form of a large diagonal crack, which was filled with rubble and wattle and daub infill. Particularly evident here is the massive internal buttress plastered onto the hewn engaged pilaster on the westernmost bay of the south wall, evidently to shore up the cracked wall, and the sizeable hole it created. The internal buttress, like the overall repair work, is composed of rubble and mud infill. Similarly, the south wall of the nave has a long diagonal crack and some bulgy portions on its lower half, signifying later bracing with this same vernacular infill.

29 I propose that when the narthex collapsed, it dragged down with it portions of the building that were carved from the same geological band of stone.

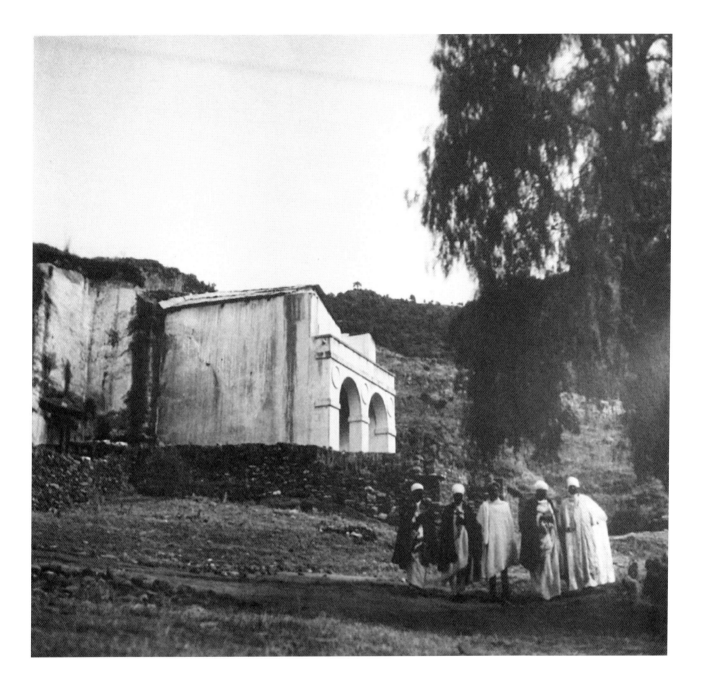

quarter-round molding (as are found on the transept arms and apse).

The ceiling rises to a height of 6.3 meters. Inset into the nave architraves above the pillars are square holes, possibly putlogs from the raising of the vault into a flat ceiling (since the masons could not sit on the unworked rock and spoils, as they presumably did with the other vaults), or rails for liturgical canopies. The aisles by contrast, measure 4.8 meters high in the north and 4.7 meters high in the south. The eastern aisles of the nave open up into the main vessel and serve

a dual purpose as lateral aisles for the transept (Fig. 69). Subtly L-shaped, the bays are defined by engaged pilasters and bracketed engaged lintels. Broadly indicative of the overall spatial program of the building, the aisle bays raise to heights roughly even with the western aisles: 4.8 meters high for the north aisle and 4.75 meters for the south.

Flanking the opening of the nave to the transept are the west bays of the lateral aisles, with heights of 4.8 meters on the south and 4.9 meters on the north, opened on the west

Figure 67.
Abreha wa-Atsbeha, facade viewed from the north, Tigray, Ethiopia, between 1939 and 1967. Archival photo from the National Museum Library, Authority for Research and Conservation of Cultural Heritage, Addis Ababa, courtesy of the Ethiopian Cultural Heritage Authority.

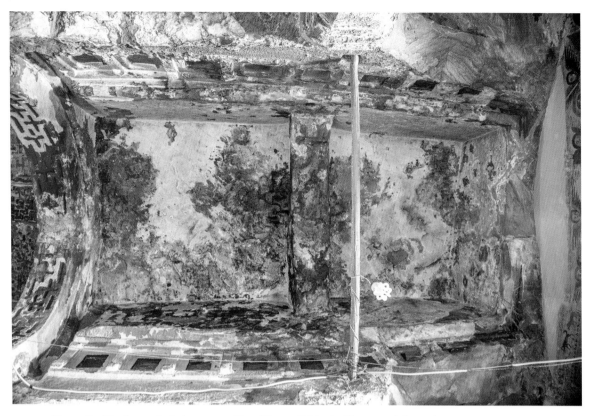

Figure 68. Abreha wa-Atsbeha, nave ceiling, Tigray, Ethiopia. Photograph by author.

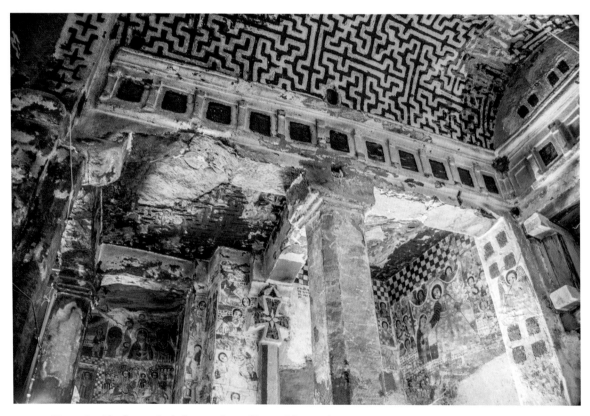

Figure 69. Abreha wa-Atsbeha, west lateral bays of the north transept, Tigray, Ethiopia. Photograph by author.

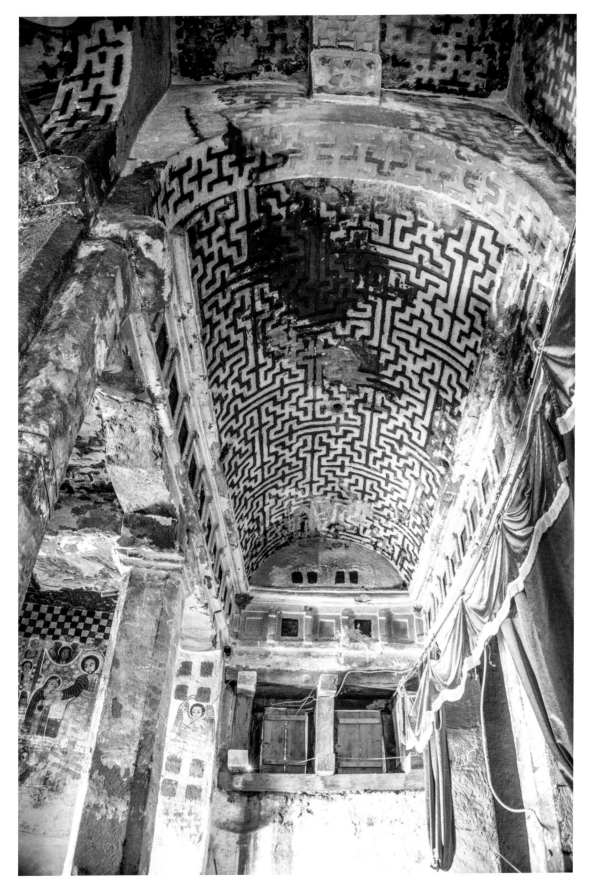

Figure 70.
Abreha
wa-Atsbeha,
north transept
vault, Tigray,
Ethiopia.
Photograph
by author.

Figure 71.
Abreha
wa-Atsbeha,
south transept
vault, Tigray,
Ethiopia.
Photograph
by author.

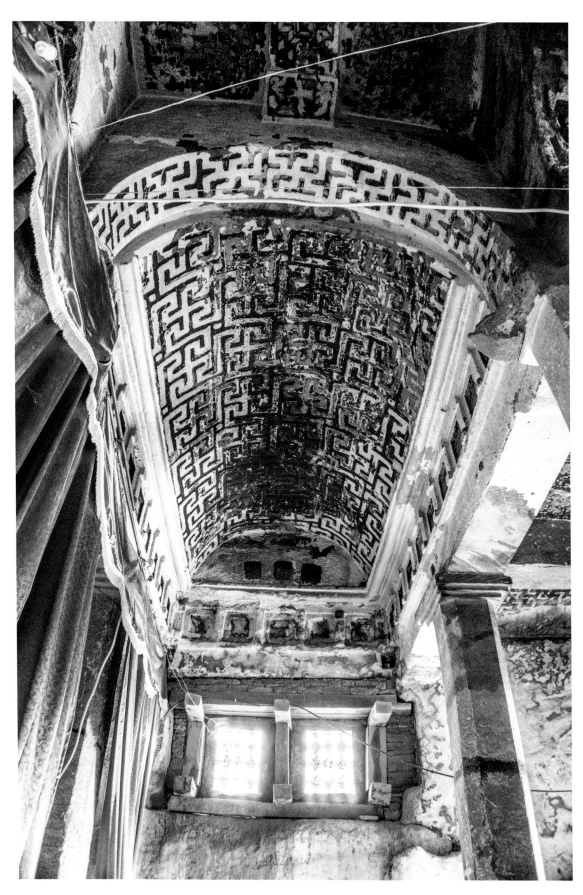

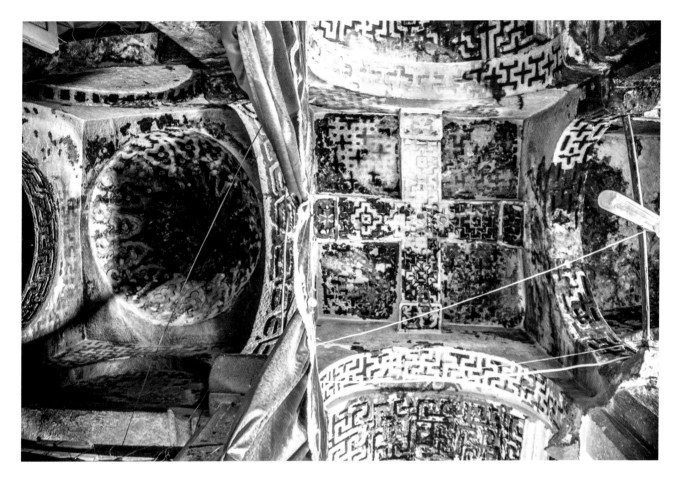

with portals.[30] Transverse piers carry the transept vaults. Quarter-round moldings crowning the blind frieze convert the flat architraves into barrel vaults. The transept has a roughly equal berth as the nave, measuring 6 meters on the north transept arm (Fig. 70) and 5.97 meters on the south (Fig. 71; the nave was also intended to have a 6-meter-high vault apex before it was raised by 30 cm as a flat ceiling). Supporting the vaults of the transept arms are laterally placed chamfered piers capped with stepped capitals (each with three steps) that, on the north side, have extra necking on top to adjust to the slightly higher ceiling. As on the nave architraves, holes pierce the transept's lateral colonnade, possibly for stabilizing timber tie beams, temporary scaffolds, or rails for liturgical canopies.

The crossing space (3 × 3 m) is carried by transverse arcades of chamfered cruciform piers,

resting on cruciform plinths and capped with cyma recta bracket capitals (see Fig. 2). The ceiling of the crossing space generally measures 7 meters, though the south side measures 7 centimeters lower. A Greek cross (Fig. 72), sculpted to a relief of 10 to 40 centimeters, resting on echinus brackets, is dramatically positioned in the center of the bay. The brackets are ornate, sculpted with Maltese crosses with small wings of split palmettes springing from the cross base.

East of the crossing is the domed choir (qeddest [qəddəst]; Figs. 72, 73) which is flanked on either side by lateral aisles. Here a low, hewn bench runs the length of the corner rooms and terminates at the entrance to the pastophoria (the low benches found elsewhere in the vessel are freestanding and recent, made of flagstones). Keeping with the overall spatial hierarchy exhibited in the church, the eastern lateral bays have a lower average ceiling height of 5.3 meters on the north and 5.15 meters on the south. The domed choir, however, is defined by a rise in ceiling height to an approximate 8 meters at its apex,

Figure 72.
Abreha wa-Atsbeha, crossing space and choir dome, Tigray, Ethiopia. Photograph by author.

30 Both the step leading to the doorway and the step into the interior of the transept are of recent manufacture and consist of mortared rubble topped with slabs.

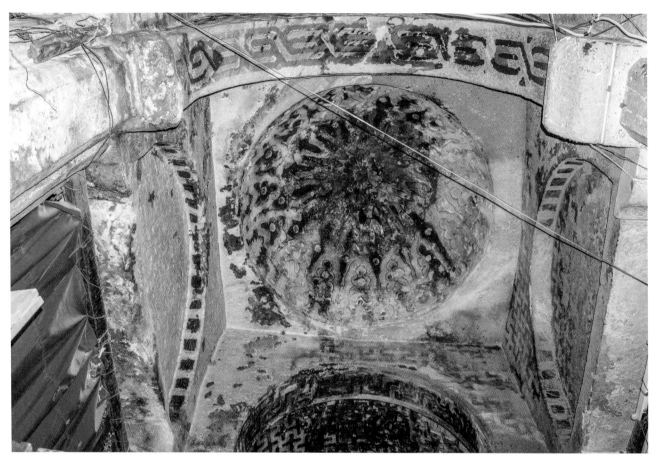

Figure 73. Abreha wa-Atsbeha, choir dome, viewed from the crossing, Tigray, Ethiopia. Photograph by author.

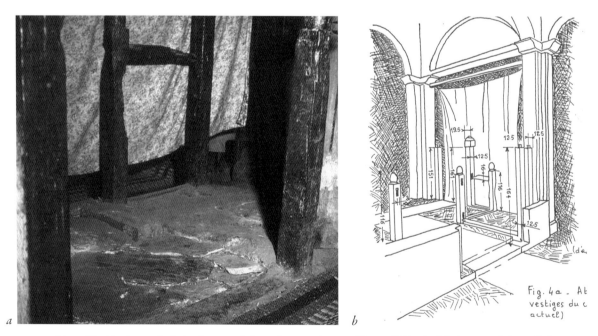

a

b

Figure 74. Abreha wa-Atsbeha, bema and chancel as seen in 1971, Tigray, Ethiopia: (a) photograph from C. Lepage,
"Entre Aksum et Lalibela: Les églises du sud-est du Tigray (IXᵉ–XIIᵉ s.) en Éthiopie," *CRAI* 150.1 (2006): 14, fig. 3;
and (b) drawing by Jean Gire, courtesy of Claude Lepage and l'Académie des Inscriptions et Belles-Lettres.

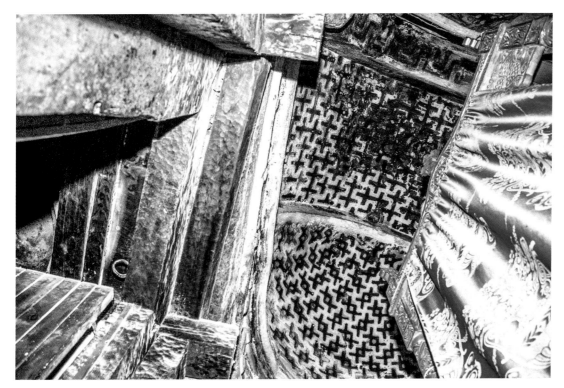

Figure 75.
Abreha wa-Atsbeha, barrel vault over the altar, Tigray, Ethiopia. Photograph by Michael Gervers, from Mazgaba Seelat, http://ethiopia.deeds.utoronto.ca/, MG-2007.115:013.

while the square space from which it springs is the same height as the crossing (7 m). The domed choir is flanked by blind diaphragm arches, presumably corresponding to the arcades of the crossing space.

The choir floor is raised with a bema, though it has been raised some 50 centimeters since it was first documented by Claude Lepage in 1971 (Fig. 74). The bema was framed with a ∏-shaped wooden chancel, of which only one post survives. The templon consisted of transennae (per trench marks recorded in 1971), set between posts measuring between 1.4 and 1.6 meters in height. Lateral parapets flanking the choir imposts were opened by way of an eastern passage.[31] Prominent holes above the brackets of the pilasters flanking

the east wall suggest that the choir was elaborately screened, perhaps veiled with liturgical canopies.

Between the domed choir and the conched apse is a barrel vault, crowned with a blind frieze that runs along the cross arms (Fig. 75).[32] Within the curve of the apse (Fig. 76) is a low single-step synthronon, the same height as the low bench found elsewhere in the church (Fig. 77). The easternmost point in the apse is pierced by a well-cut parabolic arch altar niche.

The apse is flanked by side chambers, which are entered either via the sanctuary or from the side aisles. On the aisle side, the chambers are entered through timber-framed portals (2 × 1 m) that are sided with viewing windows.[33] The south chamber, which is considerably larger, is raised with a rock-cut step, cut into the low bench that runs along the eastern wall.[34] This is

31 As seen in documentation from 1970, there seems to have been some sort of low parapet-like structure that connected the two rails of the chancel's west porch with the eastern piers of the crossing. This has since vanished, but I believe this to have been a choir (*khūrus*) screen, likely from the later Middle Ages, comparable to the former spolia ensemble installed in Wuqro Cherqos. The clearest photo of this was taken by Kebede Bogale and published in Lepage, "L'église semi monolithique," 146. On the khūrus screen at Wuqro Cherqos, see M. Muehlbauer, "From Stone to Dust: The Life of the Kufic Inscribed Frieze of Wuqro Cherqos in Tigray, Ethiopia," *Muqarnas* 38 (2021): 1–34.

32 Here the "windows" seem to preserve ocher infill as well.

33 The window (measuring 75 × 75 cm) is timber and composed of posts and lintels with engaged corner beams, all flush with the rock aperture. Inside there is an interior casing made of another layer of posts and lintels. The shutter is not original and is stylistically similar to the adjacent window tracery installed in the southeasternmost wall in the late twentieth century.

34 The timber doorframe is of the same type found elsewhere in the church and consists of a casing set inside a post-and-lintel frame with projecting corner beams. The door itself is modern,

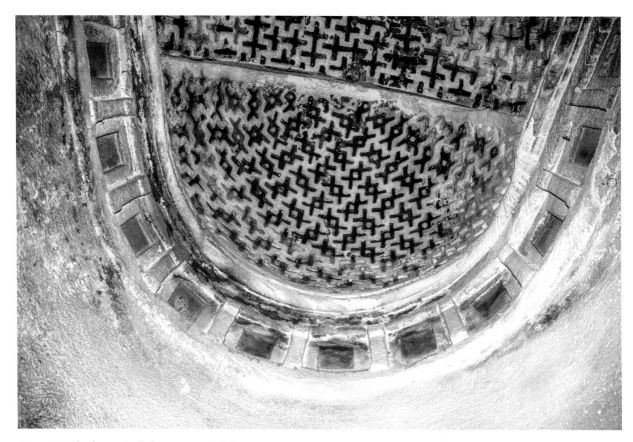

Figure 76. Abreha wa-Atsbeha, apse conch, Tigray,
Ethiopia. Photograph by Michael Gervers, from
Mazgaba Seelat, http://ethiopia.deeds.utoronto.ca/,
MG-2007.115:016.

Figure 77.
Abreha wa-Atsbeha, apse
synthronon and niche, Tigray,
Ethiopia. Photograph by Philippe
Sidot and Emmanuel Fritsch,
courtesy of Emmanuel Fritsch.

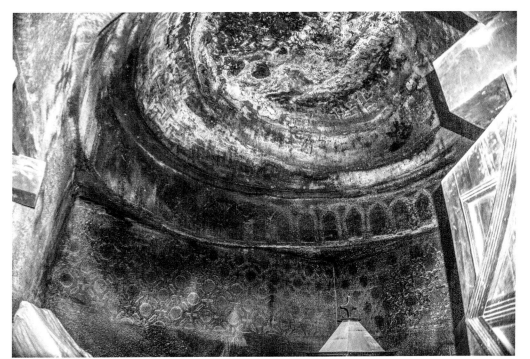

Figure 78.
Abreha wa-Atsbeha,
south pastophoria,
dome and drum
detail, Tigray,
Ethiopia. Photograph
by author.

Figure 79.
Abreha wa-Atsbeha,
north pastophoria,
Tigray, Ethiopia.
Photograph by author.

Figure 80.
Abreha wa-Atsbeha,
sculpted crosses, Tigray,
Ethiopia: (a) south
portal; (b) north portal.
Photographs by author.

a *b*

mirrored on the north, though the viewing window is smaller and the timber frames are slack within the rock aperture.

The eastern chambers at Abreha wa-Atsbeha are domed cubes. The south room is considerably enlarged, measuring approximately 6 × 6 meters (Fig. 78), though the cupola that surmounts it is segmental rather than hemispherical. Running the length of the drum is a blind arcade of linked pointed arches framed by fillet moldings. On the north wall is an ossuary containing the veiled remains of Abreha and Atsbeha, though a trench on the south wall suggests the placement at one time of a liturgical table. The north pastophorion is much smaller and comparatively simpler, measuring approximately

4 × 4 meters (Fig. 79). The room is crowned with a segmental dome which springs from a flat edge molding above the arcaded drum. Though the room appears generally unfinished, the east wall accommodates two niches, an unfinished bore, and an arched shelf.

Sculpted crosses flank the north and south transept portals. These crosses, set into a chamfered pilaster atop a circular base, are now largely subsumed into the (modern) rubble bench that runs along the west wall (Fig. 80). The crosses resemble a crux ansata (or ankh, the cross with a rounded top used in the Coptic church), and have equilateral flared cross arms on three sides and a rounded top. Each arm bears a stylized palmette. The round top is sculpted with curved indentations resembling a face. Atop the "head" of the crosses are two inward-facing tendril-like forms, perhaps affronted dolphins.

of the same manufacture as the newly applied window tracery on the transept windows.

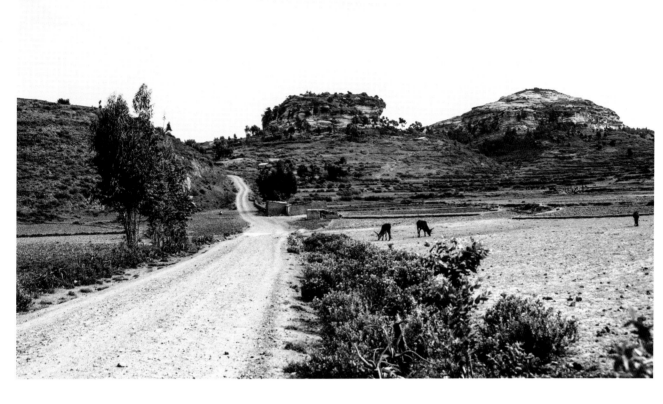

Mika'el Amba

ENVIRONS

The monastery of Mika'el Amba (see Fig. 5) is, unlike Abreha wa-Atsbeha, fully rural and relatively difficult to visit. Dedicated to the Archangel Michael (Mika'el) since at least the mid-twelfth century (per a dedicatory note in a gospel book outlined below), the monastery church is located immediately south of Atsbi, approximately forty kilometers east of Wuqro, and only a short distance away from the Danakil Depression.[35]

The church is hewn from a cylindrical plug of sandstone (hence amba, or mesa) some 3,500 meters above sea level (Fig. 81). The church is only accessible by way of a steep climb on the far

northern side of the mesa (in recent years an iron staircase has made access markedly easier than the previous wooden ladder). This butte contains an entire monastic complex, consisting of the namesake church as well as a monastery, a nunnery, and a "museum" (a small circular building containing the church's sacristy contents). Moreover, a circular foundation with a center kingpost hole (resembling a *tukul* or roundhouse) near the church, suggests once-extensive monastic dwellings around the site (Fig. 82).[36]

Two rock-cut cisterns, one to the church's immediate northeast and one to its immediate west, provide a source of "holy water," which services the parish community's baptismal and

Figure 81.
Mika'el Amba
Monastic Complex
viewed from
afar, Atsbi, Tigray,
Ethiopia. Photograph
by author.

35 In fact, due to the area's proximity to the Danakil Depression, and thereby the Red Sea coast, many young people from the area have been illegally immigrating to Saudi Arabia for work; as such, the area looked like a ghost town in June 2018. For this reason, too, it is also an important stop for the contemporary salt caravan trade.

36 This manifestation of the tukul house type is not found in the vernacular architecture of east Tigray and is more typical of Lasta province; I have located analogous architectural foundations around the Lalibela complex. This foundation may be evidence of collaboration with masons from the central highlands in Mika'el Amba's later phases; see the conclusion below. On this house type, see R. Partini, "Architetture autoctone nell'Africa Orientale Italiana: Le chiese monolitiche di Lalibela," *Architettura* 17.5 (1938): 261–70.

Figure 82.
Mika'el Amba,
tukul foundation,
immediately east
of the church,
Tigray, Ethiopia.
Photograph
by author.

exorcist needs.[37] Immediately east of the church is a cavern containing an ossuary said to contain the remains of esteemed monks.

The church grounds are entered through an iron gate within a rubble wall that surrounds the church compound. The hewn enclosure includes burial sites carved into the walls that may be of a considerable age.[38] The north side of the courtyard includes six oval tombs cut into the walls extending in a single, somewhat evenly spaced, course immediately west of the transept. These tombs do not have any architectonic detailing, though there is a setback above them. On the south courtyard wall there is a single oval grave dug into the stone. Mika'el Amba also has significant elements embedded in its courtyard structure. Chief among them are cisterns cut at the north and south ends of the transept, in addition to hewn chambers on the north and south courtyard walls immediately above the cisterns. To the immediate south of the main church is the Eucharistic bread oven,

and access by nonclergy is restricted (demarcated by a crude railing).

FACADE AND NARTHEX
As at Abreha wa-Atsbeha, Mika'el Amba manifests externally as a cruciform mass, with the narthex and transept forming the exposed cross arms. In the case of Mika'el Amba, however, an oval courtyard was hewn to detach the narthex and the western transept bays from the mother rock.

The facade perimeter is crowned with a concrete-faced rubble cornice, with a slate overhang that is pierced by drainage holes. The facade base is outfitted with a low, hewn bench that is 71–81 centimeters in height (Fig. 83). In front of Mika'el Amba's three portals are elaborate stepped plinths. The center platform is minimally raised with three steps and measures approximately 7 × 6 meters square. The transept platforms have single steps on the west side and measure approximately 5 × 4.5 meters square on the north, and 5 × 5 meters square on the south. Large postholes line the center plinth: three are placed equidistantly along the south edge and one is parallel to the easternmost hole on the north side (see Fig. 5). Prominent square putlog

37 The presence of a hewn step on the west cistern suggests that it was originally carved as a baptismal font.

38 To the courtyard's immediate south are a number of modern concrete podia serving as grave markers.

98 BASTIONS OF THE CROSS

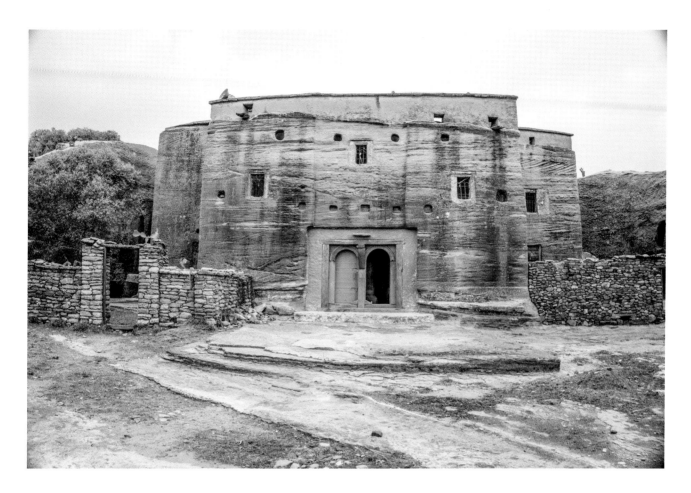

holes running diagonally across the top of the portal indicate some interaction with the holes in the plinth.[39] Perhaps these were socles that once retained a timber exo-chamber or scaffolding.[40]

Within the church enclosure, Mika'el Amba is further cloistered on its transept by rubble walls. On the north side of the church, the rubble wall begins at the northwest extremity of the narthex and extends some 2.5 meters west. A meter-long parapet encloses the area, extending all the way to the rock wall, which affords access through a timber-framed portal. A rubble wall also encloses

the south transept, though the stones used are less dressed and more densely lodged.[41]

The church of Mika'el Amba is entered through three portals. The center portal is roughly regular, measuring 3.6 meters wide and 2.5 meters tall; it is now painted pink but was formerly red, green, and yellow (Figs. 83, 84). It consists of a double door, centered within 50 centimeters of fill on its sides and header, and a matching concrete step. It was formerly filled with rubble, accommodating a single doorframe (Fig. 85). The double doors are now encased in round arches separated by pilasters (see Fig. 84), the result of a mid-2000s restoration that embellished the portal with pieces of the templon screen.[42] The door frames have been

Figure 83.
Mika'el
Amba, facade.
Photograph
by author.

39 The bottom row is closely aligned with the portal and consists of five evenly spaced, roughly square holes. Flanking the north and south facade window are also single square putlogs. The second row of holes is roughly parallel to the lower course and consists of four, wider spaced, square putlogs.

40 While local tradition attributes these holes to monks using them to soak beans, these could have been part of a timber exo-narthex that has since disappeared, such as the one Lepage proposed for Wuqro Cherqos; Lepage and Mercier, *Les églises historiques*, 87.

41 Since this area is also forbidden to laity, there would have been an early need for this partition. This wall consists of a low parapet that runs from the westernmost part of the narthex's south wall to the rock wall. It is broken up in the center with a simple square timber portal, but it is encased in approximately 30 centimeters of rubble.

42 Lepage and Mercier, *Les églises historiques*, 82.

Figure 84.
Mika'el Amba,
center portal,
chancel arch detail,
Tigray, Ethiopia.
Photograph
by author.

Figure 85.
Mika'el Amba, facade,
Tigray, Ethiopia, 1971.
Photograph courtesy of
Larry Workman.

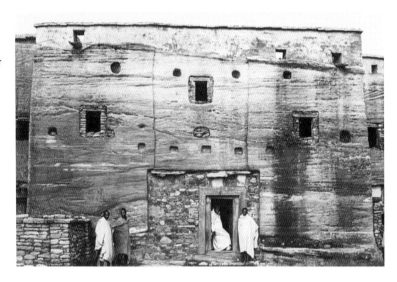

fitted with medieval chancel arches, while the trumeau was affixed with a wooden transennae slab. The north and south portals are also timber framed and sided with rubble, in an otherwise large, 2.5-meter-high and 2-meter-wide rectangular aperture; each is capped with windows.[43]

Crowning the center portal are three square windows that form a roughly pyramidal layout (see Fig. 83).[44] Both the north and south face of the

43 On the south transept, the aperture is approximately three times the size of the window contained within. In the past this was a double window, but the addition of new rubble infill

narrowed its fenestration considerably. A longitudinal notch, signaling that there was previously a mullion, is evident in the center of the header and sill.

44 These square apertures include a rubble interior frame— now faced with concrete—with wood lintels. While no other wood elements survive, we can assume they probably existed in the past.

Figure 86.
Mika'el Amba, north
transept viewed from
the north courtyard
overlay, Tigray, Ethiopia.
Photograph by author.

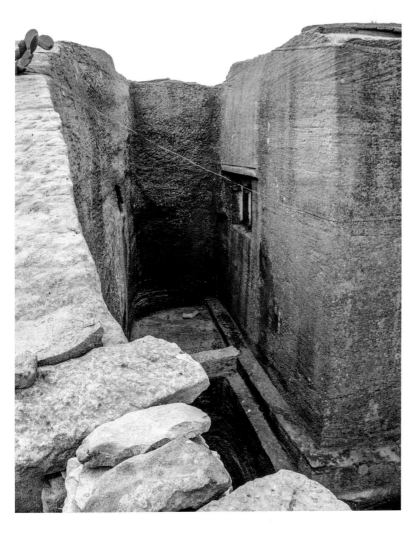

exposed narthex facade have square windows as
well, but these are now completely filled in with
rubble. The transept extremities are lighted by
large ~2.5-meter-wide timber windows on its
north (Fig. 86) and south ends.[45]

45 On the south transept, the frame consists of a wooden post
and lintel (of which only the header survives), with an inner cas-
ing that is three wooden boards thick, spanning the entire extent
of the wall aperture. On the north transept, the rock around
the aperture is slightly concave, possibly showing indecision
about where exactly the window would be hewn. Interesting
here, and likely evident on the south side as well, is an engaged
overhang, slightly longer than the aperture that was carved out
for the window. The overhang is articulated on its top with an
incised line.

 The narthex of Mika'el Amba is 3.6 meters
wide and 4 meters long (Fig. 87). The room is
centered with a chamfered dividing pier 6 meters
in height. The pier rests on a plinth and is capped
with a stepped capital, which forms the crux of a
sculpted ceiling cross. The cross lacks relief sculp-
ture, though its western arm merges seamlessly
with the crown fillet molding that surmounts the
ceiling and frames the west window. The relative
height of the narthex ceiling follows the south-
west incline of the mother rock, running 6 to
6.25 meters from west to east on the north and
5.9 to 6.13 meters west to east on the south. The
narthex east wall is pierced by heavily inclined,

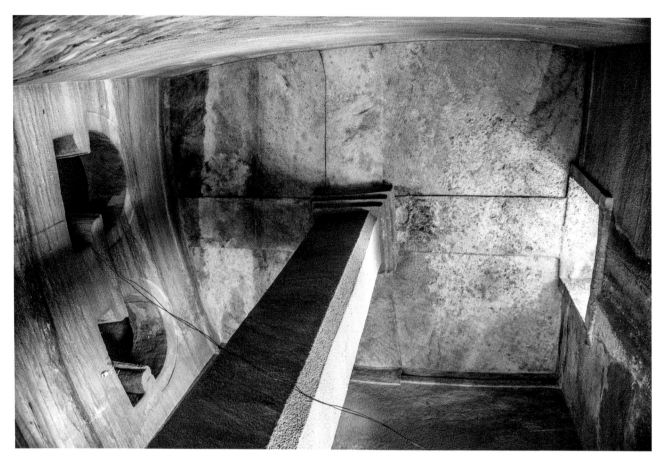

Figure 87. Mika'el Amba, narthex ceiling,
Tigray, Ethiopia. Photograph by author.

Figure 88.
Mika'el Amba, door to the nave, Tigray,
Ethiopia. Photograph by author.

arched apertures with recessed crowns and inward-
facing quarter-round moldings on the imposts.
On the base of the northeast narthex wall is a
hole that is excavated to an unknown depth, no
deeper than a meter or so.[46]

The main church is entered through a well-
fitted timber doorway, roughly 2 meters high and

46 Oral tradition among the monks assigns a second church
to this, but, having been able to go down there myself, it
appears to be a small tunnel of unknown use, perhaps originally
intended as a burial site. There is an even shallower hole in the
northeast corner of the northeast lateral aisle, probably also an
unfinished burial.

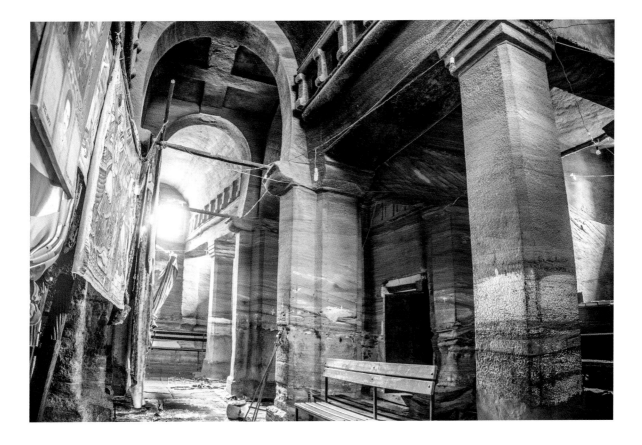

1 meter wide, set in the east wall of the narthex.[47] This portal contains a remarkable tenoned door, which appears to date from the Middle Ages (sharing a marquetry style with the triple chancel; Fig. 88).[48] Fully sculpted on its outward side with strapwork ornament, the door is made of two slabs of wood that were sutured together with iron staples secured through an attached mullion.[49] A wood stain in the center of the door suggests that it was originally secured by a lock rail.[50]

47 In its four corners are outwardly projecting crossbeams. The same configuration is seen on the nave-facing side of the portal.

48 Holes in the sill indicate that there was at least the option for a double door in the past. Perhaps these elements arrived pre-fabricated from a dedicated carpentry workshop.

49 The design is a type of channeled strapwork meander, made up of rendered straps incised with three lines. The mullion is adorned separately with the same channeled strapwork as the door. Running from top to bottom, the patterns employed are eclectic: a panel of diagonal chevrons running left to right, a Greek cross, diagonal chevrons running right to left, a single repeat of the door's meander, a stepped cross, and a Greek cross followed by a stepped cross again. There are also (modern) iron strips affixed as rails at the top and bottom of the door's face, bonded to the wood through iron staples.

50 Today, as a lock, a simple loop latch is hung to the far right of the door.

THE MAIN VESSEL

Mika'el Amba is exceptionally wide (Fig. 89): its main vessel is 20 meters long, whereas the transept measures just over 21 meters end to end. Excluding the narthex, the vessel measures only 15 meters long. The lay-inhabited portions (minus the choir and sanctuary) are even stubbier, some 7.5 meters long.

Mika'el Amba includes two side rooms flanking the narthex that communicate with the western transept bays. These rooms (Fig. 90), which are extremely uneven, are entered through arched portals with inward-facing quarter-round moldings. The dimensions of the rooms are roughly the same as the narthex, though they are considerably narrower, with floor levels that are higher (raised approximately 60 cm from those in the main vessel).[51] These chambers do provide further light penetration into the main vessel; each bay has windows on the west as well as on the south and north walls respectively.[52] Of some

51 These chambers are only partially worked, and the upper walls have partial recesses some 33 centimeters deep.

52 The side windows have since been filled.

Figure 89.
Mika'el Amba, south transept vault, Tigray, Ethiopia. Photograph by author.

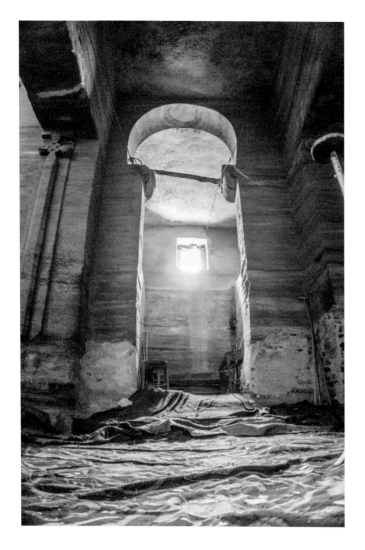

considerably in order to conform to a roughly consistent 9-bay core.[55]

The architectural detailing in Mika'el Amba is very similar to Abreha wa-Atsbeha. Bays are defined by engaged lintels and pilaster strips as well as chamfered piers (measuring a uniform 4 m tall) with stepped capitals and beveled plinths. All piers have capitals articulated with four steps, except for the support pier on the west side of the north transept, which has three steps. The crossing consists of a transverse arcade held up by large cruciform piers.

The nave is barrel vaulted (6 m high; Fig. 91), as are the central bays of the transept arms. The transept vault springs from a quarter-round molding on the north (Fig. 92) and west, and a sunken fillet molding on the south (see Fig. 89). The nave entablatures are surmounted by a frieze of blind windows (numbering five windows on the west end and four on each side) separated from the impost by a torus molding and crowned with a fillet molding.

The transept's transverse entablatures are articulated like the nave, though the moldings are uneven to allow a consistent vault spring from splayed and bowed support piers respectively.[56] The north transept vault measures 6.22 meters high and is considerably longer than the south, as evidenced by the eleven blind windows on each of its lateral entablatures (compared with nine per side on the south). The northernmost point in the transept is significantly unworked, however, and the blind windows sculpted from the lateral architrave sit above a massive chunk of unworked stone (Fig. 92). As such, the transept window is placed near the apex of the barrel vault

55 The nave bay measures 2 × 2 meters while the qeddest (choir) measures 2.5 × 3 meters. Both the middle bay of the northeast lateral aisle and the middle bay of the southwest lateral aisle measure nearly 5 meters wide and slightly longer than 2 meters long, while the middle bay on the southeast lateral aisle measures less than 2 meters square. Both the middle bay on the northwest lateral aisle, the choir bay, and the western lateral bays of the transept were hewn with roughly the same measurements as the crossing: ~3 × 3 meters. The southernmost and northernmost bays of the eastern lateral aisle are significantly shortened (resembling 2 × 2 m square modules).

56 The west architrave of the north transept and the east architrave of the south transept have severely bracketed quarter-round moldings. The eastern lateral entablature maintains a parallel molding, although it is considerably less engaged, reflecting the uneven placement of the support piers.

Figure 90.
Mika'el Amba,
south exochamber,
Tigray, Ethiopia.
Photograph
by author.

significance is a small Greek cross with flared ends rendered in sculpted relief on the upper wall of the north side chamber.[53]

Generally speaking, as at Abreha wa-Atsbeha, Mika'el Amba is composed of modules. The central module of the church consists of a 3-meter-square bay, which serves also as the church crossing. This space forms the crux of the 9-bay core of the main vessel, which measures roughly 10 meters wide and 9 meters long. The module in Mika'el Amba, however, is significantly lopsided, wider on its north side (nearly 4 m long) and narrow on the west (nearly 2 m wide).[54] As such, the measurements of Mika'el Amba's modules vary

53 The center of the cross is channeled, which is then outlined with a raised portion and further engaged through an incised outline.

54 The northwest crossing pier is skewed toward the west.

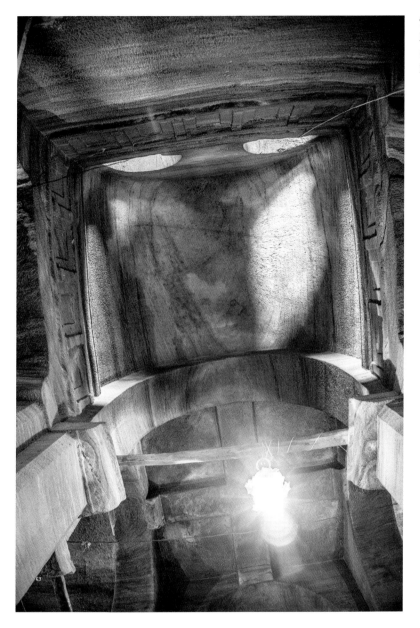

Figure 91.
Mika'el Amba, nave vault and
crossing, Tigray, Ethiopia.
Photograph by author.

and is retained by some 60 centimeters of rubble, suggesting this was a stop-gap measure to support the window frame on a partially worked wall.

The south transept arm (see Fig. 89) largely agrees with the layout of the north transept arm, although it is significantly shorter and has a slightly higher vault (6.42 m). As with the north transept, the south terminus appears unfinished as well. The south window, which is hewn into the apex of the barrel vault over an unworked rock surface, similarly interferes with the blind window frieze.

The central module is carried by round arches (between 5.72 and 5.9 m in height) that spring from the cyma brackets of its crossing piers (Fig. 92). In

contrast with Abreha wa-Atsbeha, the crossing has a lower berth than the transept vaults. The central cross is engaged from the ceiling by an average of 15 centimeters, although its eastern quadrants are 10 centimeters higher than its western ones. Curiously, though resting on echinus brackets, the engaged cross lacks a bracket at its western cross arm, likely due to interference from the height of the west crossing arch "supporting" it.

The heights of the eastern lateral bays are significantly lower than the vaults, with a berth of 4.6 to 4.8 meters (Fig. 93). The western bays have less divergent heights, measuring some 5.3 to 5.4 meters on the south and 5.73 to 5.67 meters on

Figure 92.
Mika'el Amba,
north transept,
Tigray, Ethiopia.
Photograph
by author.

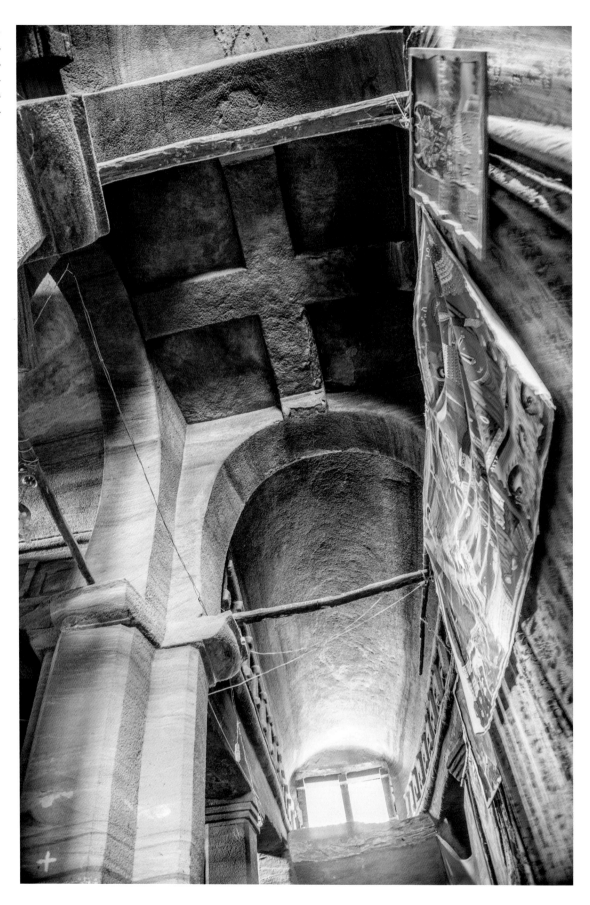

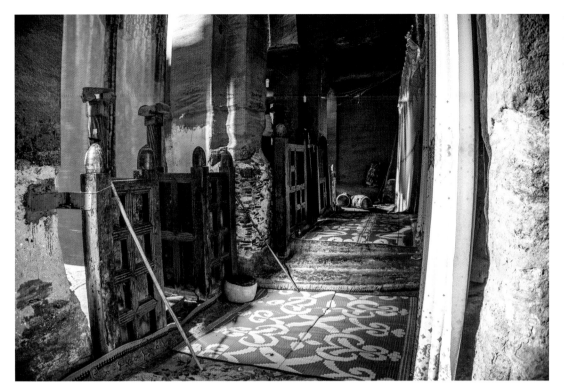

Figure 93.
Mika'el Amba,
eastern lateral aisle,
Tigray, Ethiopia.
Photograph by author.

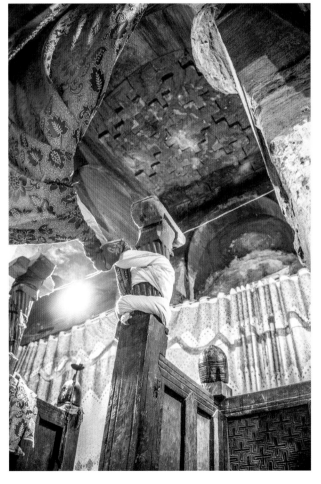

Figure 94.
Mika'el Amba, choir
viewed from the
chancel, Tigray,
Ethiopia. Photograph
by author.

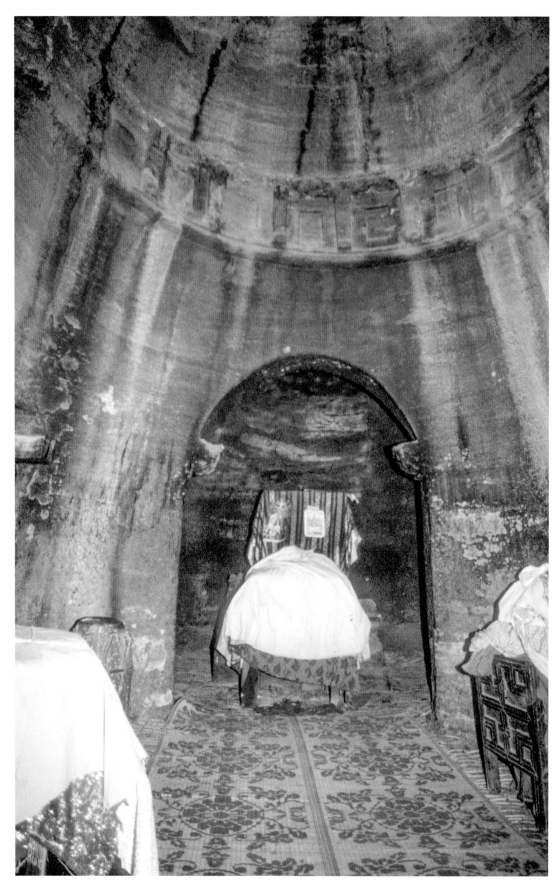

Figure 95.
Mika'el Amba,
apse, Tigray,
Ethiopia.
Photograph
by Michael
Gervers, from
Mazgaba Seelat,
MG-2005.023:030.

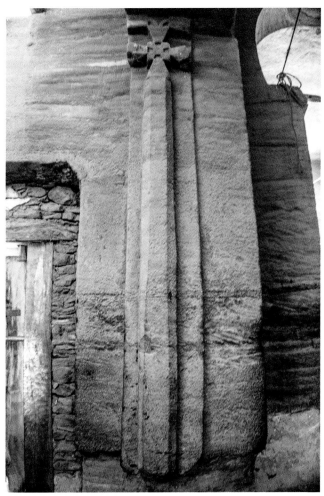

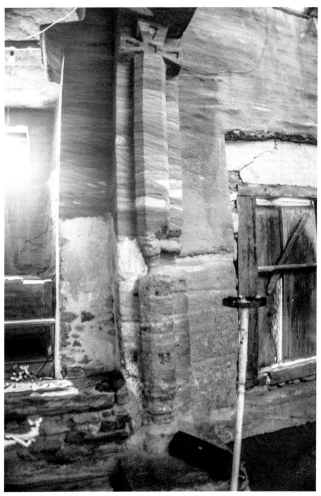

a *b*

the north.[57] On the northwesternmost bay, these ~75 centimeters of extra wall space accommodate faded murals (to be discussed below).

Immediately east of the crossing is the qeddest (choir which measures about the same height as the crossing and is caried by diaphragm arches). Lacking a dome, the sanctity of the space is instead demarcated by sculpted stepped crosses on the ceiling (Fig. 94). The choir and sanctuary are raised with a bema, some 70 centimeters high, with entry steps on its west and south. The apse is conched, and springs from a frieze of blind windows (Fig. 95). Dug into the main apse is a secondary (monolithic) altar, entered through a

wide-arched aperture with inward facing quarter-round moldings.

The apse is flanked by altar chambers of roughly equal size (4 × 4 m) that communicate with both the altar space and the lateral bays of the transept. From the apse, the door to the north pastophoria is entered through a timber framed portal, while the entry to the south chamber is hewn and partially collapsed.[58] The north pastophoria is entered on the west through a timber entryway made up of three layered frames.[59] Though the liturgical significance of this space precluded archaeological documentation of it, the wall separating it from the apse appears to be made

57 Suture marks are evident on the upper walls, which indicates that these bays were raised approximately 75 centimeters from their original height, leaving extremely engaged lintels that are not as well worked.

58 The north chamber door has a wide sill and header with projecting corner beams and an inner frame.

59 The innermost frame has an interior arch doorframe articulated at the crown and impost with roll moldings, with marquetry consistent with post-sixteenth-century constructions.

of whitewashed daub and rubble.[60] The south pastophoria is connected at its eastern wall with another chamber, which has narrower dimensions.

As at Abreha wa-Atsbeha, Mika'el Amba's transept portals are flanked by crosses sculpted atop chamfered pilasters and round bases (Fig. 96). The north cross is an unfinished flared-arm cross, with its top arm directly abutting the lintel above it. It is elaborately dished in low relief, with triangles incised on the cross arms, and a square on the axis. The south cross is also of a flared-arm type, but it has all four axes detached from the rock. This cross is crowned with sculpted horns, likely partially worked, affronted dolphins (as at Abreha wa-Atsbeha).[61]

Overall, Mika'el Amba is the best preserved and the least restored (in modern times) of the three monuments. Restoration work, by means of concrete and mud fill, is concentrated along the lowest course of the building, running from south to north. The south crossing piers in particular are heavily shored up above their bases. A band of crumbly sandstone on the south wall is the likely culprit (see below).

LITURGICAL FURNISHINGS

In front of both the main sanctuary and the side chambers at Mika'el Amba are three wood templon screens.[62] Aside from their remarkably good condition (except for the north chancel), the number of screens at Mika'el Amba is unique: no other church in Ethiopia has more than one.

The three chancels are scaled according to the span of the bay they inhabit (see Figs. 5, 93, 97); the north templon has about the same dimensions as the central screen, but is set astride the piers. The center chancel, despite inhabiting a smaller bay space, is set back from the pier and is thus the same size as the north, likely in order to accommodate the bema. The south chancel (see Fig. 97) is the smallest among the group and, like the north chancel, straddles the space between the piers, rather than being set behind them. The screens are all Π-shaped, with a protruding solea connected by adjoining duckboards. All three screens restrict access from west to east, but their lack of axial parapets means that a continuous eastern passage runs along the transverse choir.

Tall posts measuring 1.8 meters in height front the solea. These are carved in a serpentine manner on their upper portions and are crowned with bracket capitals.[63] Until recently, these carried the chancel arches, which are now nailed to the outer portal. The lower posts, which support the remainder of the chancel screen, are the same size as the parapet slabs and measure 1.5 meters tall.[64] The parapet slabs consist of posts and rails mitered together and fitted with sculpted transennae. Each wood element is adorned on its outward face with three grooves. When the elements are mitered together, they appear as continuous decorative grooves framing the templon coffers. In all cases, the transennae are sculpted with channeled strapwork ornament, which closely resembles the woodwork employed for those screens at Zarama Giyorgis, Dabra Salam

60 The western entry into the south pastophoria, by contrast, appears medieval. Snugly fit into its rock aperture with perhaps only 20 centimeters of slack above the header, the door consists of a simple post-and-lintel frame with projecting corner beams and two mitered interior frames within.

61 This cross is unfinished, as the dolphins are barely removed from the rock and there are two unworked chunks of stone that flank it.

62 In 2008 a British conservation team, funded by the UK-based Ethiopian Heritage Fund, set out to restore the chancels, and noted that the church was still in possession of all the pieces of the northernmost chancel. Among other things, this restoration provided metal shoes for the chancel posts to halt the degradation of the post sockets; Ethiopian Heritage Fund, "Mikael Amba," http://www.ethiopianheritagefund .org/current-project-4-mikael-amba-15. When I saw the church in 2017 and 2018, bits of the wood were being used as steps to approach the bema on the north, while other pieces were merely strewn around.

63 These are capped by bullet-shaped ball tops decorated with two rows of parallel-incised lines. The chancels are joined together through wedges and mitering. The inspiration for these serpentine posts can be neatly located in the Proconnesian marble spiral column fragments recovered from the port of Adulis; *Museo archeologico di Asmara: Itinerario descrittivo*, ed. L. Ricci, Collana di studi africani 7 (Rome, 1983), 9–10, 32 and pl. 3. D. Peacock, "Stone Artefacts from the Survey," in *The Ancient Red Sea Port of Adulis, Eritrea: Results of the Eritro-British Expedition, 2004–5*, ed. D. Peacock and L. Blue (Oxford, 2007), 115, 117.

64 See, for example, Marie-Anne Minart's schematic diagrams of the templon screen at the Egyptian Monastery of Bawit for information on mitering and marquetry; M.-A. Minart, "Étude d'une cloison d'église de la fin du premier millénaire conservée au musée du Louvre: Monastère de Baouît, Moyenne Égypte," *BIFAO* 116 (2016): 191–227, at 214, fig. 4.

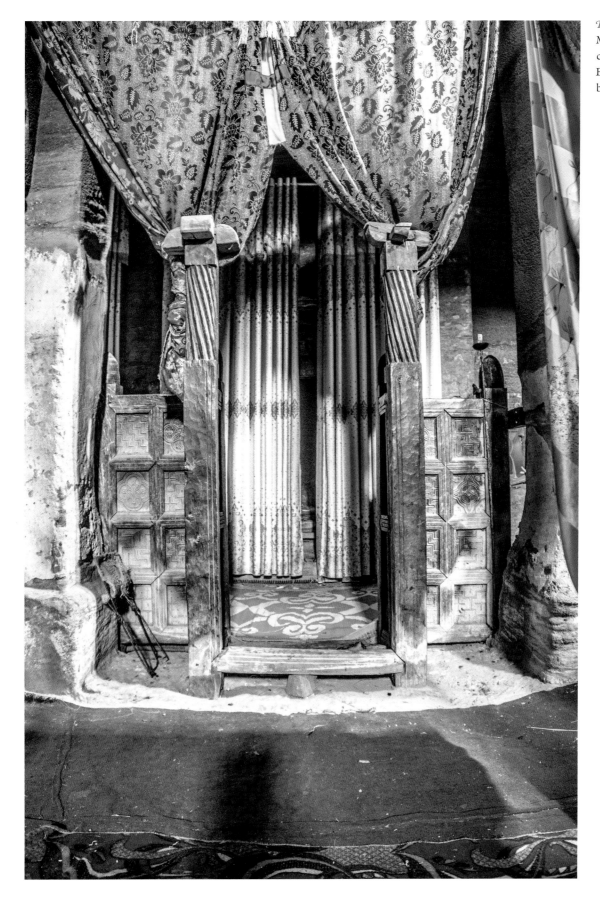

Figure 97.
Mika'el Amba, south
chancel, Tigray,
Ethiopia. Photograph
by author.

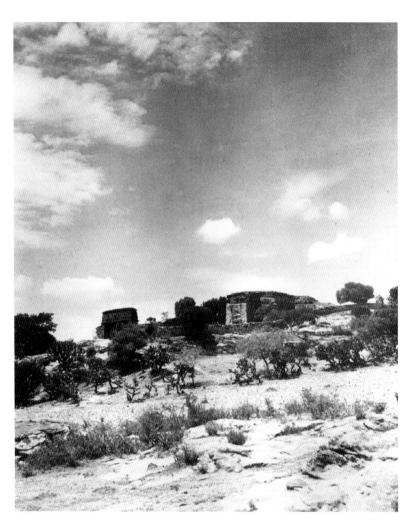

Figure 98.
Wuqro Cherqos Monastic
Complex, Wuqro, Tigray,
Ethiopia. Archival photo
from the National Museum
Library, Authority for
Research and Conservation
of Cultural Heritage,
Addis Ababa, courtesy of
the Ethiopian Cultural
Heritage Authority.

Mikaʾel, and Dabra Dammo (reused as ceiling coffers; see Fig. 25).[65]

The center chancel solea is paneled, with the mitered posts and rails forming four equal coffers. The two lateral portions of the center screen, like the porch, are divided into four quadrants, though the upper north and the lower south quadrants are further subdivided.

The south and north chancels bear slightly different configurations when compared with the central screen. Although the solea remains identical, the south and north screens have narrower lateral parapets consisting of eight framed coffers per side.

Wuqro Cherqos

TOPONYM AND ENVIRONS

Wuqro Cherqos (see Fig. 4), dedicated to the late Roman martyr St. Cyricus, is quite possibly the most urban rock-cut church in Ethiopia.[66] The eponymous church sits on the northeast end of Wuqro, off Ethiopia's major A2 highway (which runs from Addis Ababa to Asmara, Eritrea).

65 For a full inventory of the ornament on Mikaʾel Amba's chancel screens, see M. Muehlbauer, "'Bastions of the Cross': Medieval Rock-Cut Cruciform Churches of Tigray, Ethiopia" (PhD diss., Columbia University, 2020), 424–61.

66 On Cyricus's reception in Tigray, see V. Pisani, "*Passio* of St Cyricus (*Gädlä Qirqos*)* in North Ethiopia Elements of Devotion and of Manuscripts Tradition," in *Veneration of Saints in Christian Ethiopia: Proceedings of the International Workshop* Saints in Christian Ethiopia: Literary Sources and Veneration, *Hamburg, 28–29, 2012*, ed. D. Nosnitsin, Supplement to *Aethiopica* 3 (Wiesbaden, 2015), 161–99. David Buxton noted in 1949 that this was the only church that could be reached by an asphalt road; D. Buxton, *Travels in Ethiopia* (London, 1949), 131. Until recently, the town of Wuqro was known as Dangalo, presumably a historical name, though it has since been renamed after its famous monument (Wəqro is Təgrəñña for "rock-hewn church"); W. Smidt, "Dängolo," in *EAe* 2:87–88.

The town of Wuqro has long been known to foreigners, owing to its central placement (see Figs. 11, 12). The church's convenient access is not new[67]—it has always been easily reached by automobile or by foot from the town, without a steep climb to the church edifice.

Despite its urban location, the church maintains an active monastic community. Although photographs taken in the 1950s (Fig. 98) show the monastery as little more than a euphorbia grove, the compound of Wuqro Cherqos is now enlivened with several new buildings, including a square bell tower (immediately southeast of the church), a rubble balustrade around the church grounds, and a few mixed-use buildings to its southwest.[68] More recently, a local stone and concrete stepped podium was erected around the church, easing the slight upward approach. Immediately north is the parish cemetery.[69]

Of considerable age, possibly from the time of the church's groundbreaking, is an old hewn grave immediately southwest of the church, which is filled in with rubble, and another oval crevice to its immediate south, which may too have been a grave. On the church's northwest escarpment is a modern terraced plot of graves; the terrace walls, on which a number of euphorbia trees grow, are made of local rubble, faced in parts with concrete. This area is accessible from the church level via three steps.

FACADE AND NARTHEX

Wuqro Cherqos is hewn out of a low hill of sandstone that slopes from north to south. The perimeter of the natural rock from which it was carved may still be observed as a podium around the church (see Fig. 4). An approximately 3-meter-square cut-out from the southwest corner suggests that there was once a hewn cistern (since filled) carved from the same escarpment, akin to the basins flanking Mika'el Amba's transept arms.[70] The south slope of the hill is minimally worked (aside from a few rock-cut steps); only the rock wall that is flush with the transept is uniformly hewn. By contrast, the north side is heavily worked—the rock webbing was completely removed in order to detach the church from the mother rock, which now forms a courtyard area. Circumscribed by an enclosure wall since at least 1868,[71] this enclosure is inhabited by a *beta lehem* ("bread house," i.e., the bakery for the preparation of the sacramental bread; see Fig. 12), though the original oven may in fact be the sooty rock-hewn chamber on the eastern side of the church hill.

The main body of the church is cruciform and detached from the rock face on three sides (Fig. 99). Generally speaking, there is very little external articulation, though there is some slight simulated buttressing on the north and south faces, immediately west of the transept windows, possibly imitating the setbacks of freestanding basilicas (see conclusion). Archival photos (Fig. 100) illustrate that a rubble cornice once crowned the exposed rock;[72] it has since been replaced by a higher concrete wall.

The church is entered through three heavily restored portals. The center portal is a rock-cut aperture some 3.9 meters wide at the door level but narrower at the top, while the transept portals are considerably narrower (1.7 m). William Simpson's lithographs from 1868 indicate that the main portal contained a mid-bar timber door, set atop a single rock-hewn step set into a wooden frame, which was capped with a window.[73] Judging by the shape

67 W. Smidt, "Wəqro," in *EAe* 4:1180.

68 Some of these structures (sg. *hudmo*, a square semi-dressed rubble house) are likely early twentieth century. Another archival photo from the 1950s shows these same three structures to the west and southwest of the church precinct. However, these are absent in William Simpson's nineteenth-century watercolors; W. Simpson, "Abyssinian Church Architecture," in *Papers Read at the Royal Institute of British Architects: Session 1868–1869* (London, 1869), 234–46; W. Simpson, "Abyssinian Church Architecture: Part II, Rock-Cut Churches," *The Architectural Review* 4 (1898): 9–16.

69 It is rumored that several Italian soldiers are interred there. One notable grave is from an Ethiopian exchange student at the University of California, Davis, who perished in a car accident.

70 It could also be from an initial misestimation of the size of the narthex.

71 Simpson, "Abyssinian Church Architecture," 241.

72 See also a similar photograph taken by David Buxton in the late 1940s; Buxton, *Travels in Ethiopia*, pl. 71. Oral testimony from the older monks at the church confirm this restoration, as do Otto Dale's elevations, which provide a terminus ante quem of 1968; Dale, "Rock-Hewn Churches," 146. In photographs taken before 2006 by Emmanuel Fritsch and Philippe Sidot, the upper wall is composed of mortared rubble, with a cornice of uniform slabs. Since then, it has been faced with pinkish concrete that matches the sandstone.

73 Today, the center door is made of corrugated metal, adorned with wrought crosses and a glass lunette above it.

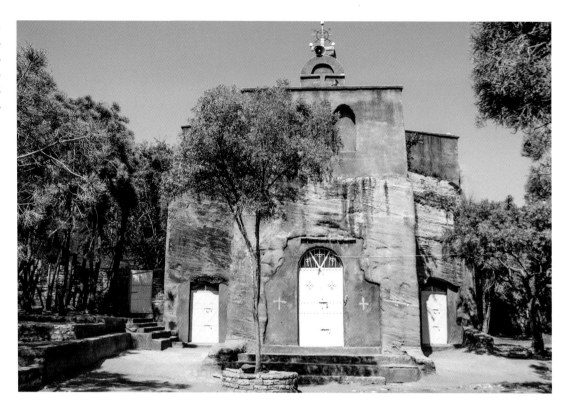

Figure 99.
Wuqro Cherqos,
facade, Tigray,
Ethiopia.
Photograph
by author.

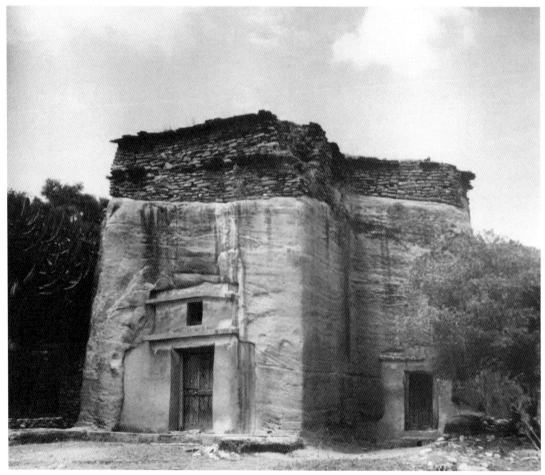

Figure 100.
Wuqro Cherqos,
facade, Tigray,
Ethiopia, pre-
1958. Archival
photo from the
National Museum
Library, Authority
for Research and
Conservation of
Cultural Heritage,
Addis Ababa,
courtesy of the
Ethiopian Cultural
Heritage Authority.

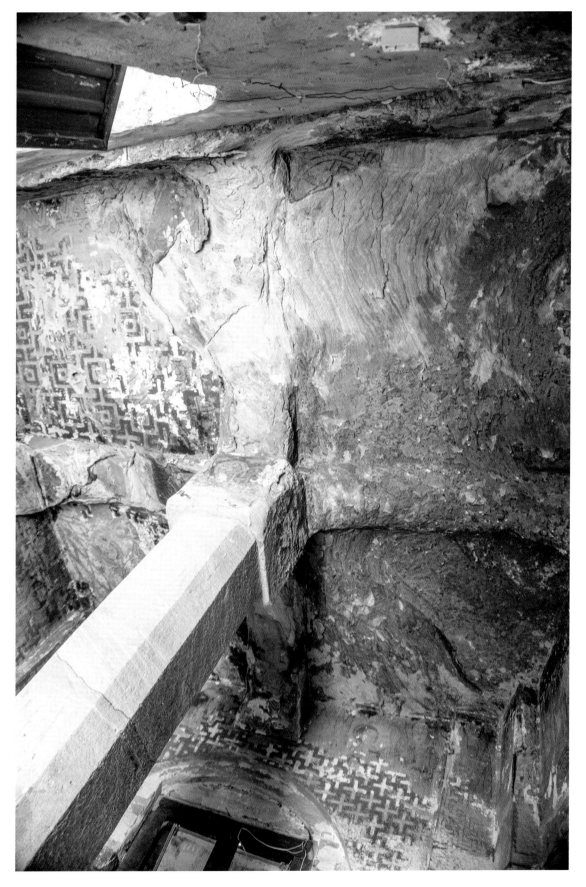

Figure 101.
Wuqro Cherqos,
narthex ceiling,
Tigray, Ethiopia.
Photograph
by author.

Figure 102.
Wuqro Cherqos,
narthex southwest
wall, Tigray, Ethiopia.
Photograph by author.

see Figs. 5, 99, 100).[75] Overall, this low wall corresponds to the present height of the doors, indicating that this was the original floor level of the church (perhaps of only the western bays) that was later worked down. Why the masons chose to give the church decorative low walls, either in the same campaign or after, is unclear, but I suggest it may have been from a late medieval restoration (see conclusion).[76] The transept arms are opened by windows measuring approximately 2 meters wide. These were formerly framed by timbers, recognizable by trench marks on the hewn surface.

The narthex is some 4 meters square with a chamfered pillar in the center (Fig. 101). The upright carries an echinus-bracketed cross that spans the entire ceiling.[77] The upper part of the west wall is sculpted with a blind arcade of six round arches with molded frames (Fig. 102).[78]

The corners of the eastern walls are engaged (resembling angle supports) and form a transition between the square room to the portal of the main church. The portal sits within a round arch separated from the wall surface by a setback molding. This arched configuration now accommodates the placement of two square windows and a timber door. Though scientific analysis has not yet been made, the framing timbers on the portal appear original, or at least from an early restoration.[79]

of the rock aperture, it is likely that the center portal had double doors in the Middle Ages.[74]

The center portal is framed by low, 3-meter-long, rock-cut walls on either side of the protruding narthex, matched by similar railings on the transept (north side: 1 m long, south side: 2.5 m;

74 The transept portals were also restored. Like the narthex portal, the apertures in the rock are wider than the space that today's single doors occupy (width of <1 m). The apertures around the doorframes are filled in with wattle and daub faced with concrete. In Simpson's 1868 watercolor, and in the aforementioned 1950s-era photos, the transept doors were of the simple timber plank-type, set into a wooden frame capped by a row of slates and surrounded by wattle and daub infill. Today, the doors are made of corrugated metal, painted white, and capped with glazed lunettes that are recessed in the rock aperture.

75 The north narthex balustrade is now encased in steps (post-2006), set atop original hewn steps. Where the final step fuses with the transept portal, there is a curious sculpted scroll molding, which cannot be explained.

76 Claude Lepage thought these low walls retained a timber exo-narthex; Lepage and Mercier, *Les églises historiques*, 87.

77 Although the narthex ceiling is damaged by seepage and scaling, the north cross arm still retains its original echinus bracketing.

78 It can be assumed that there were also two in the center, which, because of the overall deterioration of the rock wall, are no longer visible. In addition to the repainting of the narthex, these niches were, I believe, executed in the fifteenth century by Abuna Abraham, a Tigrayan archimandrite and master mason, who also completed the nearby church of Dabra Tseyon (see conclusion).

79 This header serves as the juncture with the door casing and spans the whole space of the rock aperture. The door case is nestled between two wooden jambs with projecting corner beams of which only the north jamb survives, the latter half replaced with concrete-faced mud infill. Within the casing is a modern interior frame with a hinged door. On its base, the door rests upon a modern concrete step, as the bottom has fallen away. The two square windows set in the tympanum are sided by dressed rubble to fill in the round aperture. Observable in the interior

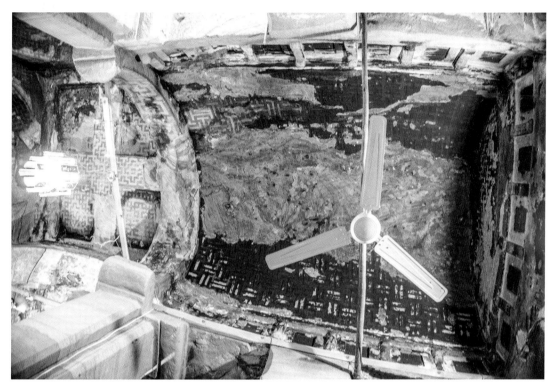

Figure 103.
Wuqro Cherqos,
nave vaults, Tigray,
Ethiopia. Photograph
by author.

THE MAIN VESSEL

The plan of Wuqro Cherqos is effectively basili-
can, with an interior layout that strongly refer-
ences an aisled cruciform church (see Fig. 4).
Wuqro Cherqos's relationship with Abreha
wa-Atsbeha is largely evidenced in its ground
plan, metrology, and elevation rather than its
form (strictly speaking). The nave, which is
three-aisled, has the same span as the transept:
approximately 11 meters. Excluding the nar-
thex, the church measures some 19 meters long
(~25 meters long including the narthex). The
transept is a referent, only indicated by the pres-
ence of lateral support piers. While these serve
a structural role in the transverse portions of
Abreha wa-Atsbeha and Mika'el Amba, they are
symbols in Wuqro Cherqos, as are the lateral
aisles that flank the transept fuse on the west end
of the church with the aisles of the nave. Despite
this, the narthex is only half as wide as the main
vessel, so that Wuqro Cherqos outwardly appears
cruciform. The height of both vault and ceiling

is dependent on the relative thickness of the rock
overlay, which is downward sloping.[80]

The church follows a modular spatial con-
figuration, ordered with bays that are defined
by piers, engaged lintels, and wall responds. The
three-meter-square crossing forms the core of
the 9 × 9-meter, nine-bay layout (consistent
with Abreha wa-Atsbeha and Mika'el Amba).
The three westernmost bays of the main ves-
sel are half-length: 1.5 meters long and 3 meters
wide. All piers in the church are of uniform
height—4 meters—and consist of chamfered
plinths with cushion capitals, except for the cross-
ing piers, which are cruciform and bracketed.[81]
All walls east of the western bays incorporate
a continuous 50-centimeter-high hewn bench
(aside from the choir and apse).

80 It is also important to keep in mind that there is a slate
floor, installed in the church in 2006, which is factored into my
measurements. Incidentally, this discrepancy further proves the
thoroughness of Gire and Schneider's mensuration, as my vault
measurements are 250 millimeters shorter than theirs, the exact
thickness of the slate.

81 The two western crossing piers lack brackets on their north
and south sides, respectively, and instead the engaged pilaster
merges with the aisle lintel.

of the window frames is a series of evenly spaced holes, which
probably supported a wood or even a metal grille in the past.

Figure 104.
Wuqro
Cherqos, west
end, Tigray,
Ethiopia.
Photograph
by author.

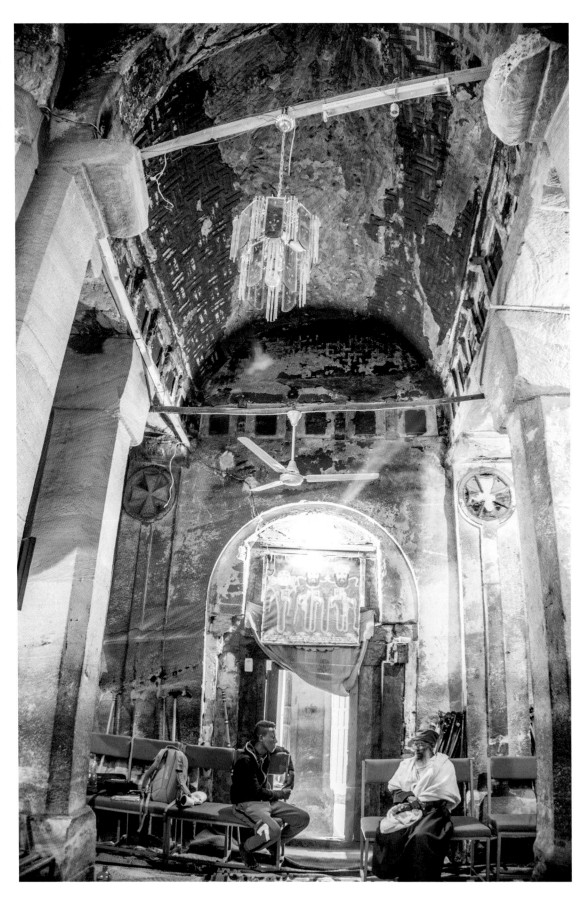

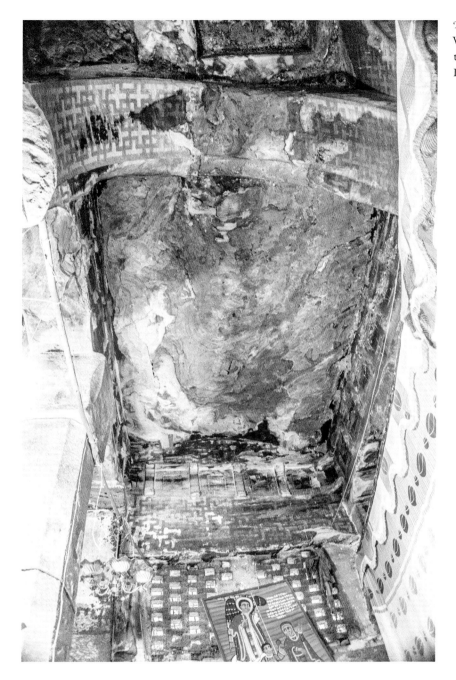

Figure 105.
Wuqro Cherqos, north
transept, Tigray, Ethiopia.
Photograph by author.

The nave is barrel vaulted, carried atop architraves that are adorned with a blind window frieze that lacks extra moldings (Fig. 103). While the narthex was designed to accommodate a low ceiling, with a relative height between 4.57 and 4.34 meters, the vaulted nave has an apex of 6 meters, springing from 4-meter-tall architraves (which resulted in an insufficiently thick rock overlay and water seepage). The west wall is flanked by two sculpted Maltese crosses set within roundels atop pilaster strips (Fig. 104).

Following the slope of the rock, the north aisle bays are slightly higher than those on the south (4.79–5.06 meters and 4.56–4.7 meters respectively). The dwarf transept arms of Wuqro Cherqos are also vaulted, springing from blind windows atop flat architraves that average 4.8 meters on the north transept and 4.5 meters on the south transept. The transept vaults are exceptionally low, resembling surbased rather than semi-circular arches, with apexes of 6 meters on the north (Fig. 105) and 5.6 meters

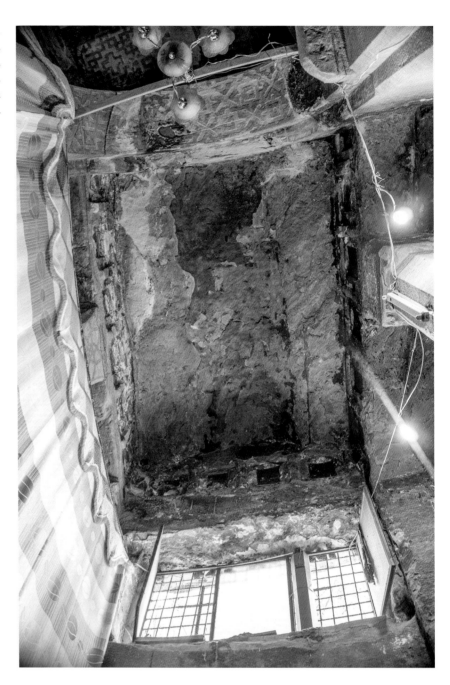

Figure 106.
Wuqro Cherqos,
south transept,
Tigray, Ethiopia.
Photograph
by author.

on the south (Fig. 106). In contrast to the rest of the church, the lateral aisles flanking the choir have vault heights that skew higher on the south end, measuring 5.25 meters on the north and 5.35 meters on the south.

While the walls are markedly parallel for a hewn construction, small deformations can be found in its internal layout. The southern half of the church is relatively narrow and low while the north transept bows eastward. This is particularly visible in the church articulation, as

the nave architrave has seven windows on the north side, but six on the south. As the north transept is some 30 centimeters longer, it accommodates six windows per architrave, while the south transept has five and a half windows per side (featuring curious half-windows). The nave piers are somewhat irregular, as are the lateral support piers, which bow south on the north arm and east on the south arm. These discrepancies are immediately clear in the crossing space (Fig. 107). Here the engaged ceiling cross was

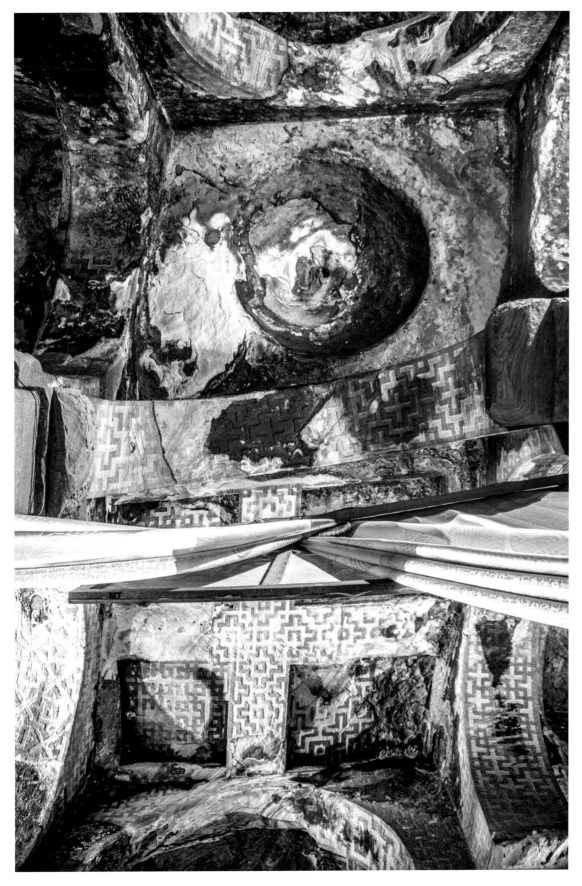

Figure 107.
Wuqro Cherqos,
choir dome
viewed from
the crossing,
Tigray, Ethiopia.
Photograph
by author.

Figure 108.
Wuqro Cherqos, pre-
2006 restoration
chancel holes, viewed
from the apse, Tigray,
Ethiopia. Photograph
by Philippe Sidot
and Emmanuel
Fritsch, courtesy of
Emmanuel Fritsch.

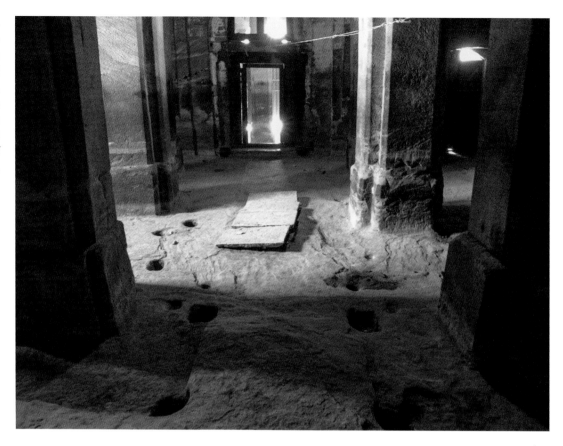

centered with an internal frame to accommodate the lopsided bay.

The crossing itself is caried by arches (between 5.48 and 5.18 meters high) and hewn to a depth of 5.56 to 5.71 meters. Immediately east of the crossing is the domed qeddest (with an apex of 6.19 meters ascending from a 5.61-meter flat ceiling), which is carried by round arches springing from brackets. This area was originally partitioned by a wood chancel and a low bema (now raised to 24 centimeters). Holes in the pavement indicate that the screen was a ∏-shaped templon, with a porch (Fig. 108) and lateral parapets. The church terminates on its east side in a semicircular apse conch (Fig. 109), separated from the wall by a torus molding and containing an arched altar niche. Square chambers communicating via doorways and viewing windows with the lateral aisles and apse flank the east ends of the church.[82] Although both rooms are adorned with engaged

crosses (Fig. 110) and lantern ceiling quadrants, they diverge in size. The south chamber is large (5.2 × 4.85 meters), presumably owing to a prothesis function, and contains a later burial site immured with daub on the east wall.[83] The north pastophoria measures 4.6 × 3.8 meters square with niches (40 cm wide) on the north and east.

Generally speaking, Wuqro Cherqos suffers from extensive fire damage and is covered with black soot. Seepage of water (only corrected in the 1950s or 1960s) along the nave and south aisles of the church has caused scaling (as

82 The south portal in the south chamber lacks frames, though there are signs indicating that it had extended lintels and sills.

83 William Simpson, who visited the church in 1868, was told that a burial had taken place there at an unknown date. Simpson attributes the other niches to "treasure hunters"; Simpson, "Abyssinian Church Architecture," 240. The measurements I am noting are from Emmanuel Fritsch's 2006 field notes, as I was unable to enter the rooms myself. The choir communicates with both the apse and the northeast lateral aisle through timber-framed doorways; the doorway in the aisle also has a timber viewing window. The doors are of a standard type, with extended lintels, sills, and projecting corner beams, set within a timber frame. In the case of the west-facing door, the timber lintel is considerably extended along the north wall and forms the sill of the viewing window. The viewing window is unique in that it has intersecting mullions with flared ends, forming a sort of flared cross shape in its resulting tracery.

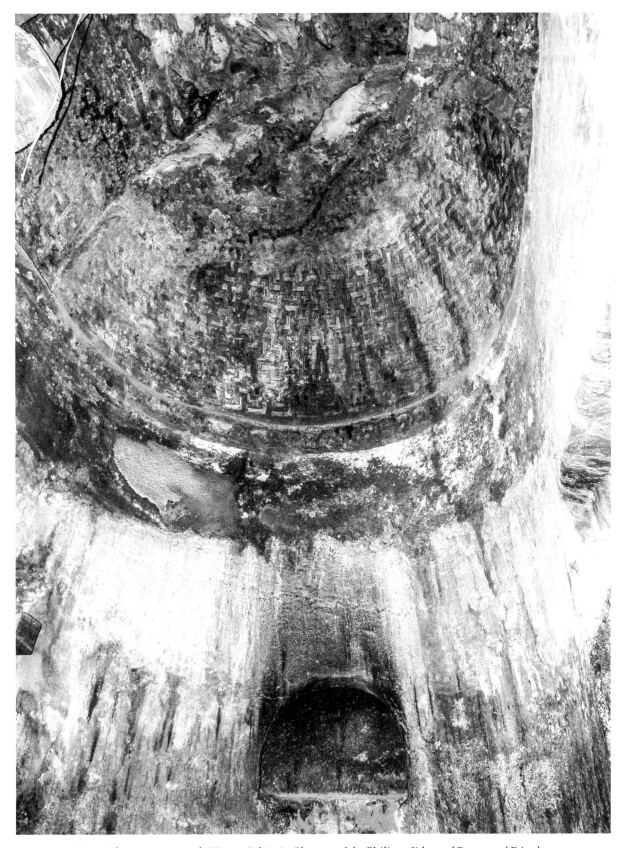

Figure 109. Wuqro Cherqos, apse conch, Tigray, Ethiopia. Photograph by Philippe Sidot and Emmanuel Fritsch, courtesy of Emmanuel Fritsch.

at Abreha wa-Atsbeha) on the ceiling and walls, making articulation and ornamentation in some parts of the church unreadable.[84]

The Problem of the Prototype

As I outlined earlier in the chapter, in addition to the unique typology that the Tigrayan cruciform churches share, they are more definitively linked by metrology. The measurements that govern the shape and volume of the churches are identical (3 × 3 × 4 meters spatial module). That said, even without metrology, scholars have long linked the three churches, considering Wuqro Cherqos and Mika'el Amba to be copies of Abreha wa-Atsbeha on the basis of the latter's "perfection."[85] My chronology however, establishes this relationship on the basis of surveying and stratigraphic sequencing.[86] As I will show, the hewing of Abreha wa-Atsbeha was uniquely suited to its geological location. When its form was copied, as at Wuqro and Atsbi, disjunctures between planning and execution led to abandonment (Mika'el Amba, Phase 1) and radical adjustment (Wuqro Cherqos, Phase 1). Mika'el Amba was left incomplete initially, and then later finished in a way that was not related to Abreha wa-Atsbeha's design. In the case of Wuqro Cherqos, Abreha wa-Atsbeha's plan was considerably narrowed and compressed to better accommodate its placement in a geologically different rock escarpment.

On the basis of liturgical planning, articulation (see Chap. 3), and limited carbon-14 dating, I suggest that the churches share a groundbreaking

in the second half of the eleventh century, with a terminus ante quem of 1150 when Mika'el Amba was "consecrated" (per documentary evidence). The following chronology serves as the basis for the subsequent discussion of the context and meaning behind the churches' unique architecture and decorative schemas (presented in Chaps. 3 and 4).

Carved into the western terminus of a mountain ridge, Abreha wa-Atsbeha is almost as much a product of its location as it is the ingenuity of its masons. Here there was space for a church of unparalleled scale and spatial volume. The church is rendered in a semi-monolithic manner out of what was probably a cubical or trapezoidal jag of the hill. The fact that the monolithic elements of the church are from a suitably workable outcropping can be found in the suture marks on the easternmost points of the exposed transept facade. The mountainside is somewhat set back, and where the church's semi-detached face is flush with the unworked hillside, there is a visible cleft running along the whole elevation of the structure, indicating where human intervention on the rock face ended. A survey of Abreha wa-Atsbeha's (heavily restored) rock overlay shows that systematic plotting or surveying was not used to plan the main vessel below it. Rather, the church was hewn entirely from west to east, top to bottom. Putlog holes along the transept facade as well as excavation-phase suture lines indicate that spoils were removed from the top down, with masons standing on the yet-unexcavated mountainside or on wooden scaffolding as is done today.[87] However, since the rock face was originally trapezoidal, the excavators likely only evened out the exterior portions of the church by removing the rock webbing between the transept arms and nave to create the even, cruciform shape (Fig. 64).[88]

In conceiving the church spatially from west to east rather than from the top down, masons maintained total control over the height and depth of the construction. Presumably, a test tunnel was made in order to carve out the central bay

84 Between the late 1950s and Otto Dale's 1969 elevation drawings of Wuqro Cherqos, Emperor Haile Selassie commissioned the filling-in of part of the roof with concrete in order to stop further seepage into the nave vault. According to oral testimony recorded by Ephrem Weldegiyorgis, this took place in 1958. For this, as well as an account of recent measures taken to control seepage, see E. T. Weldegiorgis et al., "Traditional Remedial Techniques and Current Conservation Challenges in the Rock-Hewn Churches of Tigray, Ethiopia: A Case Study on the Rock-Hewn Church of Wukro Cherkos, Wukro," *Journal of Architecture and Planning* 83.752 (2018): 2079–88, at 2083–86.

85 Playne, *St. George for Ethiopia*, 82, 187–88; Buxton, "Rock-Hewn and Other Medieval Churches," 42–43; Lepage and Mercier, *Les églises historiques*, 71–91; M. Di Salvo, *The Basilicas of Ethiopia: An Architectural History* (London, 2017), 85, 90.

86 For the importance of surveying and stratigraphic sequencing, see S. Murray, *Plotting Gothic* (Chicago, 2015), 129–30.

87 On the *chaîne opératoire* of hewn church construction, see T. Philipp, "Documenting Transformative Structures" (paper presented at ICES20, Mekelle University, Mekelle, Ethiopia, October 4, 2018).

88 Though the putlog holes may have been left from a later restoration.

module (H: 4 m, L: 3 m, W: 3 m), which thereby governed the overall shape and volume of the church. With the ample room afforded by the mountainside location, a spatial hierarchy governed the grandiose dimensions of the centralized, biaxial space (see Fig. 2), all based on a consistent 4-meter height (of the uprights). The lateral aisles rise to an average height of 5 meters while the nave and transept arms have vault heights of around 6 meters. The crossing space of the church rises to a 7-meter height (see Fig. 72), while the domed qeddest, at the location of the bema, is the highest point at 8 meters. Structural failure was for the most part avoided by maintaining a minimum thickness of stone for the overlay and plentiful internal supports. The vault heights follow the slight southern slope of the escarpment; they are on average 10 centimeters lower on the south. It is unclear what happened to the original anteroom, but traces of soot on the nave's west bays and the jagged suture mark, in addition to the uneven remains of the narthex, betray a violent collapse due to inadequate roof thickness exacerbated by a fire (see Fig. 68).[89]

The consistency of the measurements at Abreha wa-Atsbeha suggest that a coherent metrological system was employed. From what we know of Ethiopian units of measurement (documented from the seventeenth century on), cubits (sg. አመት, ʾəmat) are highly variable, customary units that are determined on an ad hoc basis based on parts of the body (arms, hands, and forearms).[90] Though generally difficult to ascertain because of the inherent irregularity and decentralization of these units, it may be inferred they were used in the hewing of these churches, if not the planning as well. Abreha wa-Atsbeha, however, is remarkably regular in its conception, with a consistent 3 × 3 × 4-meter core module guiding its equilateral cruciform shape. This suggests that these otherwise irregular customary measurements were standardized throughout its main building phase, with one set of forearms serving as ʾəmat and with a set number of said ʾəmat defining the intended space and volume. In this way, because Abreha wa-Atsbeha, Wuqro Cherqos, and Mikaʾel Amba share a core module, the same forearms (or consistent numbers of ʾəmat) must have supplied the shared measurements between all three churches. I therefore consider all three churches to have been cut out by a coherent group of masons, presumably under the same patron and in quick succession.[91]

If we understand Abreha wa-Atsbeha as the prototypical Tigrayan cruciform church (owing to its good execution and spatial use of the mother rock), then what was its terminus quo ante? Liturgical clues are of key importance here. As presented in Chapter 1, the presence of ∏-shaped templon screens and bemas in Tigrayan churches generally suggest dates prior to the fourteenth century (per the prevailing liturgy[ies] of the mother church in Egypt; see also Figs. 74, 108).[92] Moreover, within that liturgical timeframe, the enlarged side chambers at Abreha wa-Atsbeha and Wuqro Cherqos may be understood as pre-twelfth century (see Figs. 78, 110).[93] The large

89 The presence of sandstone scaling and soot in the western bays, in addition to rounded, melted edges on their architectural details, seem to indicate a large fire. Also visible in the western bays, as well as on the walls of the restored narthex, are the jagged remains from an associated collapse. While this fire was evidently not enough to bring down other portions of the church, the narthex was uniquely exposed to damage since it had a single pier holding up the ceiling. As a key load-bearing support, this element was more susceptible to disintegration under severe heat stress. This would have been exaggerated had there been engaged crossbeams on the ceiling, since elements in relief are more susceptible to sandstone scaling and fissures in high temperatures. The loss of the internal support pier, together with the severe shedding of the sandstone overlay, likely caused partial structural failure in the narthex ceiling and total collapse at the already stressed cleavage plane where it intersected with the inner portal to the nave. The minimal remains found there today were likely the result of a "clean up" in the centuries prior to 1806 in order to make room for the freestanding vestibule documented since Salt's nineteenth-century visit. On fire damage to sandstone, see M. Hajpál, "Changes in Sandstones of Historical Monuments Exposed to Fire or High Temperature," *Fire Technology* 38 (2002): 373–82.

90 R. Pankhurst, "A Preliminary History of Ethiopian Measures, Weights, and Values (Part 1)," *JES* 7.1 (1969): 31–54.

91 See, for example, the similar argument laid out for the thirteenth-century church of Iyasus Gwahegot, in M. Muehlbauer, "A Rock-Hewn Yəmrəhannä Krəstos? An Investigation into Possible 'Northern' Zagʷe Churches near ʿAddigrat, Təgray," *Aethiopica* 23 (2020): 31–56, at 40.

92 P. Grossmann, *Christliche Architektur in Ägypten* (Leiden, 2002), 98–100.

93 This is in contrast to the opinion of Fritsch and Kidane, who, in agreement with Claude Lepage, suggest they were martyria: "Answering the need for safe storage in the north—where practical niches are found—like the pastophoria of old, their likely primary funerary purpose explains cupolas and ornamentations while differences in size and ornamentation may be related to the different personalities buried there;" E. Fritsch

Figure 110.
Wuqro Cherqos,
south pastophoria
ceiling, Tigray,
Ethiopia. Photograph
by Philippe Sidot
and Emmanuel
Fritsch, courtesy of
Emmanuel Fritsch.

(and divergent) size of the south chambers in both churches, as well as their communication with the high altar, suggest to me that these were originally prothesis rooms, containing the oblation table (old ordo or prothesis rite) or bread selection table (middle ordo).[94] As discussed in Chapter 1, this was the prevailing liturgical layout of Aksumite-era churches, and their continued presence in Tigrayan cruciform churches points to a continued liturgical practice in the early Middle Ages. Although Claude Lepage is of the opinion that the chambers at Abreha wa-Atsbeha are sepulchers, and the entire building a cruciform martyrium (an identification reliant on the contemporary reliquary tradition of the saints Abreha and Atsbeha; see conclusion), the enshrinement of bodies in the south chamber appears to date from the seventeenth century at

the earliest.[95] That said, even if these chambers had indeed been used as sepulchers in medieval times, generally speaking, entombments in church protheses were a common occurrence (especially in Byzantium) and did not impact their ultimate, liturgical function.[96]

That said, the establishment of the cathedral at Maryam Nazret in the twelfth century appears to have been a turning point in the liturgy of medieval Tigray. Following the prevailing patriarchal norms of the mother church, multiple altars often replaced prothesis rooms in churches associated with episcopal authority (an

and H. Kidane, "The Medieval Ethiopian Orthodox Church and Its Liturgy," in *A Companion to Medieval Ethiopia and Eritrea*, ed. S. Kelly (Leiden, 2020), 162–93, at 176.

94 On this liturgical practice, see R. Mikhail, *The Presentation of the Lamb: The Prothesis and Preparatory Rites of the Coptic Liturgy*, Studies in Eastern Christian Liturgies 2 (Münster, 2020).

95 Lepage, "L'église semi monolithique," 148–52; J. Mercier and C. Lepage, *Lalibela, Wonder of Ethiopia: The Monolithic Churches and Their Treasures* (London, 2012), 69–70. The first mention of the cult of saints Abreha and Atsbeha seems to be from the seventeenth century; see H. M. Tegegne, "Dispute over Precedence and Protocol: Hagiography and Forgery in 19th-Century Ethiopia," *Afriques* 7 (2016), https://journals.openedition .org/afriques/1909.

96 G. Descoeudres, *Die Pastophorien im syro-byzantinischen Osten: Eine Untersuchung zu architektur und liturgiegeschichtlichen Problemen* (Wiesbaden, 1983), 41–44.

enduring liturgical modification).[97] Although later churches like Cherqos Agabo are proof that buildings could still be outfitted with prothesis rooms even after the introduction of an increase in altars, the diminutive church of Agabo was likely locally commissioned. As perceptively noted by liturgist Fr. Arsenius Mikhail, older liturgies in Egypt were often preserved and maintained in remote locales, long after official shifts in practice.[98] The grand conceptions of Tigrayan cruciform churches suggest to me that they were built with episcopal authority but immediately prior to the widespread, twelfth-century adoption of multiple altars in Ethiopia, on account of their enlarged and elaborate prothesis rooms.

Therefore, I suggest that Abreha wa-Atsbeha's early chancel layout, prothesis, and architectural style (to be fully reviewed in the next chapter) all suggest a groundbreaking in the second half of the eleventh century (specifically 1089–1094), a period that corresponds both with the reign of Badr al-Jamālī and the term of the presiding Egyptian metropolitan archbishop Severus (Sāwīrus). Although of limited applicability, carbon-14 dating on wood splinters from Abreha wa-Atsbeha's chancel screen (obtained by Claude Lepage in the 1970s) date to around the year 1000, which, in line with wood curing estimates, helps reinforce this provisional eleventh-century date.[99]

Mika'el Amba, located some fifty kilometers away from Abreha wa-Atsbeha, shares a number of characteristics with the latter in its plan and articulation, although its placement could not be more different. Mika'el Amba was carved into a flat-topped mesa (see Fig. 86) rather than a cliff-side, as were Abreha wa-Atsbeha (see Fig. 64) and Wuqro Cherqos (see Figs. 99, 100). I suggest that this made all the difference in its relative success and functionality as a church. In order to execute the plan and dimensions of Abreha wa-Atsbeha into a sloping hilltop, the semi-monolithic portions of Mika'el Amba were hewn through downward estimation, assisted by survey posts (Fig. 111).[100] Presumably, when the church was carved, these superficial holes provided a loose schematic with which to estimate the cruciform spatial division.

Masons at Mika'el Amba estimated the exterior proportions of Abreha wa-Atsbeha through downward plotting, and in doing so, expanded them considerably (compare Figs. 3 and 5). The exterior cruciform shape was made too broad at over 20 meters, while the protruding west end was left too stubby, leaving room only for a narthex sided by two huge buttresses of (then) unworked stone. In order to detach the west end of the church, a semi-circular courtyard was hewn, which in turn blocked light from entering the transept windows (see Fig. 86). Responding to these constraints, the masons truncated the nave into a single bay with a length and width of 2 meters (see Fig. 91). In addition, the north transept arm was left too long, so that there was a considerable discrepancy between the length of the vault and the support piers (see Fig. 92).

By defining the overall depth of the church by the semi-circular courtyard, the masons did not allow room for the radical spatial massing of Abreha wa-Atsbeha. Despite this, a change in chisel marks on the upper walls of the western bays and narthex indicate that these ceiling heights were originally 75 centimeters lower, in order to contrast with the vault heights of the transept (see Fig. 87), part of a tripartite spatial program in line with Abreha wa-Atsbeha (still observable in the eastern bays, see Fig. 93).[101]

However, even this was less pronounced, as the crossing space rises to an overall height that is lower than the transept vaults. This created difficulties

97 O. H. E. Burmester, "The Canons of Gabriel Ibn Turaik, LXX Patriarch of Alexandria (First Series)," *OCP* 1 (1935): 5–45; Mikhail, *Presentation of the Lamb*, 119–22; E. Fritsch, "The Preparation of the Gifts and the Pre-Anaphora in the Ethiopian Eucharistic Liturgy in around AD 1100," in *Rites and Rituals of the Christian East: Proceedings of the Fourth International Congress of the Society of Oriental Liturgy, Lebanon, 10–15 July 2012*, ed. B. Groen et al., Eastern Christian Studies 22 (Leuven, 2014), 100.

98 Á. T. Mihálykó and R. Mikhail, "A Prayer for the Preparation of the Priest and the First Prayer of the Morning in Sahidic Coptic (P. Ilves Copt. 8)," *OCP* 87.2 (2021): 353–70, at 368.

99 C. Lepage, "Bilan des recherches sur l'art médiéval d'Éthiopie: Quelques résultats historiques," in *Proceedings of the Eighth International Conference of Ethiopian Studies, University of Addis Ababa, 1984*, ed. T. Beyene, 2 vols. (Addis Ababa, 1988–89), 2:47–55, at 50.

100 Post holes on the rock overlay reflect the carving program undertaken underneath it, while the majority of socles line the cruciform mass of the exposed narthex and transept.

101 See also further documentation in Muehlbauer, "Bastions of the Cross," 119–35.

Figure 111.
Mika'el Amba,
survey post hole,
north courtyard
wall immediately
north of the north
transept arm, Tigray,
Ethiopia. Photograph
by author.

in the rendering of the monolithic cross over the crossing space, since the arches that surmount it interfered with its articulation (see Fig. 92). As a result, the cross, which rested on brackets, per the example provided by Abreha wa-Atsbeha (see Fig. 72), lacks an echinus on its west end, where the arch "supporting" it was not low enough. Furthermore, the choir space, typically the highest point in the church, was crowned with a flat ceiling instead of a dome so as not to compromise the sandstone overlay (see Fig. 94. However, stepped crosses in high relief, likely borrowed from luxury cloths, define the relative sanctity of the space in the absence of a dome; see Chap. 4).

Although it serves basic liturgical requirements, Mika'el Amba generally looks "unfinished."[102] The north and south ends of the transept remain unhewn (see Figs. 89, 92), while the sculpted crosses that flank the transept portals are only partly carved (see Fig. 96). The south transept facade is disrupted by an unworked mass of stone. The walls are undecorated and

lack the low relief sculpted ornament characteristic of Abreha wa-Atsbeha and Wuqro Cherqos. Moreover, interference between the transept windows and the blind frieze that runs along the aisled transept suggests that windows were an afterthought, so that the church was completely dark in its first phase (see Fig. 92).

Despite this troubled building history, the monastery church is quite light filled and well-functioning today. I believe this was the result of a *second* building campaign, which is partially attested to in a recopied note by the Coptic Metropolitan Michael as well as in liturgical evidence. The note is found in a seventeenth- or eighteenth-century gospel book kept in the treasury of Mika'el Amba:

In the name of the Father, the Son, and the Holy Spirit, one God. I, Mikā'ēl the sinner, a son of saint Abbā Enṭonyos [Ǝnṭonyos, MM] in the monastery of El'Arabeḥ which is on the shore of [the Sea] Eritrea [Red Sea, MM], and Abbā Maqāryos the archbishop of Alexandria appointed me pope of Ethiopia at the time of King Anbasā Wedem [Anbäsa Wǝdǝm, MM]. And by the good pleasure of God I have anointed seven kings

102 See the helpful articulation of this concept as applied to rock-cut architecture in V. Dehejia and P. Rockwell, *The Unfinished: Stone Carvers at Work on the Indian Subcontinent* (New Delhi, 2016), 59–61.

and consecrated 1,009 churches, and I have consecrated this monastery by the name of Saint Michael the archangel so that he may listen to my sorrow. And this matter took place in the Era of the Martyrs 866 [1149–1150, MM]. And by the good pleasure of God I have ordained 27,000 priests and I have made monks [or nuns] 5,000 [persons] and I have baptised 50,000 persons in the rivers and in the churches and I beg God that he may have compassion on me and hide my sins in his mercy and I have built 70 churches [as a whole, including] at Nāzrēt four at Ḍolā'et [Dolä'et, MM], and one at Norā. Out of them, 1 by the name of Mary and another next to her by the name of Michael and Gabriel, and 3 [by the names of the] 4 Animals and the 24 Heavenly Priests, 4 for the Infants whom Herod killed and 5 for the 12 Apostles. And with my means I have bought land for these churches, and let the one who steps on these churches and their lands be excommunicated from generation to generation, and let the altars condemn him before God, and all of you my male-slaves and my female-slaves, I have freed you from servitude for the sake of our Lord Jesus Christ and our Lady Mary the Mother of God, I Abbā Mikā'ēl, who consecrated her [i.e., the church of Mikā'ēl Ambā]. Remember me in your [pl.] prayer . . . [erasure of the last three lines].[103]

Though the authenticity of this note may be questioned, given its long history of being recopied, references to the Theodosian code and the specific mention of Macarius (r. 1102–1128), the Patriarch of Alexandria (who appointed him), provide a likely twelfth-century Egyptian context for the text. Moreover, while this statement was certainly made posthumously and aggrandized during its five centuries of recopying, the metropolitan may well have distributed many portable altars.[104] After all, Maryam Nazret, the aforementioned Egyptian cathedral, was founded then and its standing remains match buildings from twelfth-century Egypt (see Fig. 41). Indeed, the Metropolitan Michael seems to have undertaken this mass consecration as his final benefaction. Arabic accounts note that he was forced to move back to Egypt only a decade later, evidently due to Ethiopian displeasure with his senility in old age.[105]

Scholars such as Emmanuel Fritsch and Ewa Balicka-Witakowska have therefore ascribed the building of Mika'el Amba (and Abreha wa-Atsbeha and Wuqro Cherqos) to the twelfth century on the basis of this note, in conflict with the relative chronology presented thus far.[106] The hypothesis of a twelfth-century date is strengthened by faded paintings in the northwesternmost bay, depicting saints and the Majestas Domini (Fig. 112).[107] These are stylistically identical to early thirteenth-century mural paintings conserved at the Egyptian monastery of St. Anthony on the Red Sea (Fig. 113), the monastery with which the Metropolitan was affiliated, and a regular place

103 በስም፡ አብ፡ ወወልድ፡ ወመንፈስ፡ ቅዱስ፡ ፫አምላክ፡ አነ፡ ሚካኤል፡ ሃጥአ፡ ወልዱ፡ ለቅዱስ፡ አባ፡ እንጦንዮስ፡ በደብረ፡ አልአረብን፡ ዘዋእተ፡ ጸጋፈ፡ ኤርትራ፡ ወሓይመን፡ አባ፡ መቃርዮስ፡ ሊቀ፡ ጳጳሳት፡ ዘለ፡ እስክንድርያ፡ ጳጳስ፡ ዘኢትዮጵያ፡ በዘመነ፡ አንበሳ፡ ውእሙ፡ ንጉሥ፡ ወበሥምረተ፡ እግዚአብሔር፡ ቀዐስኩ፡ ፺ነገሥታተ፡ ወቀደስኩ፡ ፲፻፱ወፁአ በያተ፡ ክርስቲያናተ፡ ወቀደስኩዎ፡ ለዝተ፡ ገዳም፡ በስመ፡ ቅዱስ፡ ሚካኤል፡ ሊቀ፡ መላእክት፡ ከመ፡ ይስማዕ፡ ጋዜኖ፡ ወኮነ፡ ዝንቱ፡ ነገር፡ በዘመነ፡ ሰማዕታት፡ ፰፻፷፮ወፂ፡ ወበሥምረተ፡ እግዚአብሔር፡ ሤምኩ፡ ፳፸፻ወ፸፺ካህናት፡ ወአመንኮስኩ፡ ፶፻፩ወአጥመቁ፡ ፳፻ሰብአ፡ በአፍላጋት፡ ወበአብያት፡ ክርስቲያናተ፡ ወእስእለ፡ ላእግዚአብሔር፡ ከመ፡ ይምሐረኒ፡ ወይደምስስ፡ አበሳየ፡ በምሕረቱ፡ ወሐነጽኩ፡ ፸አብያተ፡ ክርስቲያናተ፡ በናዝሬተ፡ ፬ወ፬ላዕተ፡ ወ፩በኖራ፡ ወእምኔሆሙ፡ ፩በስመ፡ ለማርያም፡ ወካልአተ፡ በስመ፡ ሚካኤል፡ ወገብርኤል፡ ወ፫በአንስሳ፡ ወፀወየካህናት፡ ሰማይ፡ ወ፬ለሕፃናት፡ ዘቀተሎሙ፡ ሔሮድስ፡ ወፂ፡አፀ፡ወፀ፡ሐዋርያተ፡ ወተሣየጥኩ፡ በዋዳይ፡ ምድረ፡ ለእሎሙ፡ አብያተ፡ ክርስቲያናተ፡ ወእተጻዕደዞ፡ ለእሎሙ፡ አብያተ፡ ክርስቲያናተ፡ ወለአምድሮሙ፡ ውጉዝ፡ ለይኩን፡ ለትውልዶ፡ ትውልድ፡ ወይኩ፡ንን፯፡ ታ፡ታ፡ት፡ በቅድመ፡ እግዚአብሔር፡ ወኩሎሙ፡ አግብርተ፡ ወአዕማትየ፡ አገባዝክሙ፡ አምቅንየት፡ በእንተ፡ አግዚአነ፡ ኢየሱስ፡ ክርስ፡ ወአግዚእትነ፡ ማርያም፡ ወላዲተ፡አምላክ፡ አነ፡ አባ፡ ሚካኤል፡ ዘቀደስኩዎ፡ ዘክሩኒ፡ በጸሎ፡ትክሙ . . .

Gospel of Mika'el Ambā, fol. 102r–v. Translation from M.-L. Derat et al., "Māryām Nāzrēt (Ethiopia): The Twelfth-Century Transformations of an Aksumite Site in Connection with an Egyptian Christian Community," *Cahiers d'études africaines*

239.3 (2020): 473–507, at 483–84. See also the analysis of the note in M.-L. Derat, *L'énigme d'une dynastie sainte et usurpatrice dans le royaume chrétien d'Éthiopie du XI^e au XIII^e siècle* (Turnhout, 2018), 40–46.

104 E. Fritsch, "New Reflections on the Image of Late Antique and Medieval Ethiopian Liturgy," in *Liturgy's Imagined Past/s: Methodologies and Materials in the Writing of Liturgical History Today*, ed. T. Berger and B. D. Spinks (Collegeville, MN, 2016), 39–52, at 59.

105 P. M. Cobb, "Usāma Ibn Munqidh's *Lubāb al-Ādāb (The Kernels of Refinement)*: Autobiographical and Historical Excerpts," *Al-Masāq: Journal of the Medieval Mediterranean* 18.1 (2006): 67–78, at 69–70.

106 Fritsch, "New Reflections," 56–65; E. Balicka-Witakowska, "Mika'el Amba," in *EAe* 3:959–61; E. Balicka-Witakowska, "Sǝra Abrǝha wä-Aṣbǝḥa," in *EAe* 4:628–30.

107 C. Lepage, "Dieu et les quatre animaux célestes dans l'ancienne peinture éthiopienne," *Documents pour servir à l'histoire des civilisations éthiopiennes* 7 (1976): 67–112, at 91–92.

Figure 112. Mika'el Amba, painting detail, northwest wall, Tigray, Ethiopia. Photograph by author.

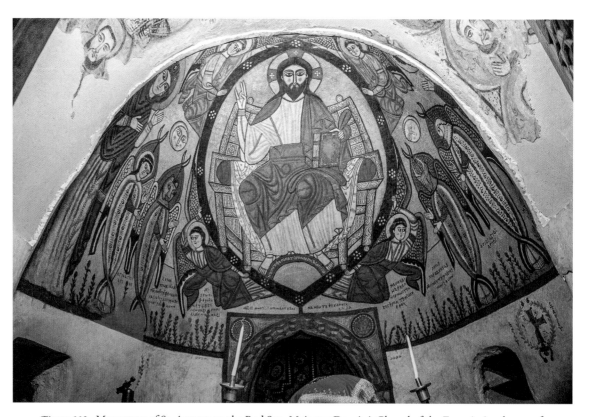

Figure 113. Monastery of St. Antony on the Red Sea, Majestas Domini, Chapel of the Four Animals, apse fresco, Eastern Desert, Egypt, early thirteenth century. Photograph by author.

of pilgrimage for Ethiopians.[108] Moreover, the equal size of the eastern rooms at Mikaʾel Amba and the triple chancel indicate that the church was designed with multiple altars in mind (see Fig. 93).[109] The coffered triple templon and narthex door at Mikaʾel Amba likewise bear a strong resemblance to contemporary Egyptian screens, such as the eleventh- or twelfth-century examples recovered from Bawit, suggesting an Egyptian episcopal role in the monastery's construction.[110]

Let us return again to this gospel book note. Unlike Michael's statement on Maryam Nazret, which he refers to having "built" (ሐነጸ, *ḥänäṣä*), Mikaʾel Amba is described as "consecrated," (ቀደሰ, *qädäsä*). This linguistic distinction is conspicuous and in light thereof I suggest that this "consecration" was a *second* building campaign, where Mikaʾel Amba was finished (and outfitted with a proper high altar). In fact, a portable altar in derelict condition, in the same marquetry style as Mikaʾel Amba's screen, is still stored in the apse of the church, perhaps the instrument with which this consecration occurred (see Fig. 95).

It was in this second campaign that the church was finished and adequately lighted. At this time the chambers flanking the narthex were still masses of unworked stone, left over from the first phase. However, it is likely that they were opened in the twelfth century (see Fig. 90). These chambers closely resemble those found in later churches in Lasta (perhaps a revival of Aksumite "palatial" designs), as at Beta Emmanuel (Betä ʿAmanuʾel; see Fig. 10) and Beta Maryam (Betä Maryam) (in the Lalibela church complex), as well as Soqota Masqala Krestos (Soqota Mäsqäla Krəstos, a church located between Amhara and Tigray; see Fig. 8).[111] In the context of Mikaʾel Amba,

we may understand them as happy accidents, as these chambers allowed an otherwise cramped, dark vessel to be lighted by the sun. The masons even seem to have left a mark here: a channeled carved cross with flared arms on the upper wall of the north chamber, in the same carved style as the triple chancel and narthex door.

A change in carving program, visible in the stone by a suture line, also illustrates that the western bay ceilings were raised 75 centimeters and west-facing windows were added, opening into the transept. The narthex ceiling was probably raised as well, thereby allowing a west window and two arched shaped apertures to light the main vessel. This recarving of the upper levels also explains the prominent putlog holes on the facade (see Fig. 83). Mikaʾel Amba's semi-monolithic portions were already sculpted by 1150, so in order to rework the upper levels, masons must have stood on scaffolds. Likewise, the anomalous three-stepped plinths around the portals were likely embellishments sculpted during this 1150 reconsecration.

As stated before, Abreha wa-Atsbeha and Wuqro Cherqos have enlarged south rooms (prothesis chambers), a defining trait of Aksumite and post-Aksumite churches. By contrast, Mikaʾel Amba features three, equally scaled sanctuaries preceded by three templon screens, indicating that the church was planned according to the new liturgy. However, rockfall in the south chamber as well as unworked stone surfaces in the north chamber suggest that when Mikaʾel Amba was first hewn, its side chambers were only minimally worked, with its prothesis left unhewn, perhaps due to perilous geological conditions. The triple sanctuaries in Mikaʾel Amba were likely hewn in this second, twelfth-century phase, alongside Maryam Nazret, by order of the Metropolitan Michael.

While the ∏-shaped chancel could be a signal of a shared date between the churches, Mikaʾel Amba's chancel, aside from its triplication, lacks axial parapets as at Abreha wa-Atsbeha and Wuqro Cherqos. Stylistically, the transennae slabs at Mikaʾel Amba also feature extensive strapwork and interlace (see Fig. 97), a marked departure from the linear carving styles in bas-relief on the walls and vaults of Abreha wa-Atsbeha and Wuqro Cherqos. Indeed, this channeled interlace is most similar

108 S. H. Griffith, "The Handwriting on the Wall: Graffiti in the Church of St Antony," in *Monastic Visions: Wall Paintings in the Monastery of St. Antony at the Red Sea*, ed. E. S. Bolman (New Haven, 2002), 185–94; M. el-Antony, J. Blid, and A. M. Butts, "An Early Ethiopic Manuscript Fragment (Twelfth–Thirteenth Century) from the Monastery of St Antony (Egypt)," *Aethiopica* 19 (2016): 27–51.

109 Fritsch, "New Reflections," 57, 65.

110 Minart, "Étude d'une cloison"; M.-A. Minart, "Étude d'un vantail de la fin du premier millénaire conservé au musée du Louvre, Monastère de Baouît, Moyenne Égypte," *BIFAO* 116 (2016): 229–72.

111 On the architecture of Soqota Masqala Krestos, see M. Gervers, "The Monolithic Church of Wuqro Mäsqäl Krəstos," *Africana Bulletin* 50 (2002): 99–113, at 100–108.

to the marquetry and relief carvings found in thirteenth-century churches in Lasta, such as at Beta Maryam and Yemrehanna Krestos. Traces of blue, yellow, and red pigment in the recesses of the chancel at Mika'el Amba suggest that the screen was once polychromed, strongly evoking the architectural revetments of Yemrehanna Krestos.[112] Other altar chambers excavated to the immediate east of the apse were executed later, in the fourteenth century, when immovable altars were standard (see Fig. 95).[113]

A substantial floor lowering seems to have been undertaken during Mika'el Amba's 1150 reconsecration. The 71- to 85-centimeter-high bench that runs alongside both the inner and outer walls is consistent with the roughly hewn pier plinths and multistepped bema, and implies that this was the height of the Phase 1 floor (see Fig. 83).[114] This is underscored by a consistent 70 centimeters of misfitting between the rock apertures and inset timber doorways. The inner door from the narthex to the main vessel is off by 20 centimeters instead of 70, and is likely evidence of the use of a slope for the west approach in the first phase (perhaps a ramp for spoil transport). Factoring in the lower height of the west bays and the higher floors from my proposed first phase, Mika'el Amba would have been excessively cramped and dark when it was first hewn, and was probably abandoned prior to its first-phase consecration.

Although the Metropolitan Michael's campaign to open the western bays and lower the floor resulted in the functional monastery we know today as Mika'el Amba, it was not without issue. As mentioned earlier, a soft chalky band of stone runs at a diagonal from south to north, which, among other things, compromised the

crossing piers (now shored up with daub infill; see Figs. 89, 90). This band, which is most visible on the lower wall of the south transept, may in fact have been noticed and avoided by the carvers in the first phase, which would explain the unworked south transept facade, overall cramped dimensions, and perhaps even the site's initial abandonment. Rockfall in the south chamber and the mud wall partitioning the north chamber illustrate that the eastern parts of the church are still riddled with geological hazards.

Mika'el Amba thus shows the pitfalls of architectural citation in rock-cut architecture. The mother rock could not support the spatial hierarchy, centralized spatial configuration, or unparalleled scale of Abreha wa-Atsbeha. That is why it was finished in a later building campaign that was independent of the prototypical design.

For this reason, I understand the "consecration" of Mika'el Amba, as recounted in the Metropolitan's note, to be a substantial restoration of an unfinished and problematic eleventh-century monument. As I proposed in Chapter 1, the early Zagwe were keenly interested in restoring and reconstituting older monuments, presumably as a symbolic appropriation of Aksumite authority. After all, the most important twelfth-century church, the cathedral of Maryam Nazret, was itself appropriated from an Aksumite structure (see Fig. 40).[115] Because Abreha wa-Atsbeha, Wuqro Cherqos, and Mika'el Amba were the largest and most experimental post-Aksumite architectural projects, it would make sense that later sovereigns would honor their predecessors through a transformative restoration work.

Along with Mika'el Amba, Wuqro Cherqos is also a casualty of architectural citation. Hewn west to east, as at Abreha wa-Atsbeha, here masons essentially truncated the cruciform plan in order to fit a lower and narrower rock escarpment (see Fig. 4), compressing the transept to a width of 11 meters, the same as the nave. Although the citation of its prototype is clear in the sculpting of the lateral support piers (in this case, spaced less than a meter apart), consistent

112 See Mazgaba Seelat, http://ethiopia.deeds.utoronto.ca/: EBW-2005.205:027, EBW-2005.205:029, EBW-2005.205:030, EBW-2005.205:031.

113 On this development, see E. Fritsch and M. Gervers, "*Pastophoria* and Altars: Interaction in Ethiopian Liturgy and Church Architecture," *Aethiopica* 10 (2007): 7–51, at 43–45.

114 A low floor raise is still visible on the southernmost transept bays, and might be a remnant of a band of harder stone that was left unworked, or the former placement of a laity chancel, as was the norm in Egypt in the fourteenth century; P. Grossmann, "Architectural Elements of Churches," in *The Coptic Encyclopedia*, ed. A. S. Atiya, 8 vols. (New York, 1991), 1:194–226, at 211–12.

115 M. Muehlbauer, "An African 'Constantine' in the Twelfth Century: The Architecture of the Early Zagwe Dynasty and Egyptian Episcopal Authority," *Gesta* 62.2 (2023): (forthcoming, 2023).

Table 2. Relative Chronology for Abreha wa-Atsbeha, Wuqro Cherqos, and Mika'el Amba

DATE RANGE	BUILDING PHASE
1000 to 1150 (most likely 1089–1094)	Abreha wa-Atsbeha is hewn, followed by Wuqro Cherqos (Phase 1) and Mika'el Amba (Phase 1) under royal (Hatsani) or Egyptian episcopal patronage, likely for monastic and parish use. Mika'el Amba (Phase 1) is left unfinished. Abreha wa-Atsbeha's nave vault is reworked into a flat ceiling sometime during its initial hewing.
1149/1150 (terminus ante quem)	Mika'el Amba (Phase 2) is substantially reworked and consecrated with three altars alongside Maryam Nazret under the Coptic Metropolitan Michael I.
1300 to 1500	Mika'el Amba (Phase 3) is outfitted with a secondary apse and monolithic altar.
1350 to 1415	Wuqro Cherqos (Phase 2) is substantially reworked by Abuna Abraham and outfitted with a khūrus and haykal screen (see conclusion). Reported as semi-abandoned in 1868.
Pre-1805	Collapse of Abreha wa-Atsbeha's narthex due to fire.
1873	Abreha wa-Atsbeha is restored under Emperor Yohannes IV (r. 1871–1889).
1939	Abreha wa-Atsbeha is restored by architect Giuseppe Miari during the Italian occupation (1936–1941).

pier height (4 meters), and the 3-meter-square crossing, the compressed transept renders the church ultimately basilican. Here the masons, careful not to disrupt the rock overlay, rendered the lateral vaults surbased instead of fully vaulted (see Figs. 105, 106).

Wuqro Cherqos's dependence on Abreha wa-Atsbeha as a prototype also led to issues in its functioning, despite its effective modification to fit into a narrow rock escarpment. This was due to a lack of adequate light penetration. Whereas Abreha wa-Atsbeha's wide transept and near-equilateral dimensions were conducive to light, Wuqro Cherqos's narrower shape was not. As at Mika'el Amba, the rock face, from which the north side of Wuqro Cherqos was detached, cast the north window in perpetual shadow (see Fig. 4). Since the monks compensated for this with torchlight, it resulted in a badly charred interior (see Fig. 103), and the open flames probably set fire on more than one occasion to the wooden chancel and the chancel veils, which consisted of both a ∏-shaped liturgical screen and also a laity chancel (see conclusion). When the church was visited by William Simpson in 1868, he noted in addition that the transept windows were intentionally blocked, so that

the church was completely dark.[116] Therefore, despite an otherwise successful modification into a geologically different space, in copying Abreha wa-Atsbeha, Wuqro Cherqos is also a "problem of the prototype."

Dating and Chronology

In conclusion, my relative chronology considers Abreha wa-Atsbeha the prototype, and Wuqro Cherqos and Mika'el Amba copies (see Table 2). Because of the shared volumetric dimensions between the three monuments (core module: \sim3 × 3 × 4 meters), and assuming a shared use of customary measurements based on forearms, I propose that the three churches were produced in short succession by the same workshop, under the same royal or episcopal patronage. Enlarged prothesis rooms at Abreha wa-Atsbeha and Wuqro Cherqos, along with unique architectural features (to be fully examined in the following chapter), suggest the use of an older liturgical format, so that the three churches were hewn prior to Mika'el Amba's 1150 "consecration" with three altars. That said, the terminus quo

116 Simpson, "Abyssinian Church Architecture," 240.

ante, established (albeit inconclusively) as the year 1000 on the basis of carbon-14 dating, thus adduces a 150-year period to be accounted for the groundbreaking of the three churches.

Within this timeframe, I situate the churches as products of the second half of the eleventh century, specifically between 1089 and 1094. This is on the basis of historical plausibility (political centralization and re-Christianization vis-à-vis relations with the Fatimid caliphate) as well as the use of architectonics that are unique to that era (vizierate-period Fatimid), such as vaults and domed cubes, and the overall large scale of the churches. In contrast to the isolated parishes of the post-Aksumite period (i.e., Degum Selassie), by the eleventh century the ascendant Hatsanis of East Tigray (Zagwe) required large (likely episcopal) monastic foundations to make permanent their revived Christian state and their attendant neo-Aksumite worldview. It was then, in the twilight years of Badr al-Jamālī's vizierate, that relations between the Hatsanis of Tigray and Fatimid Egypt reached their apex. Intense Fatimid involvement in the Red Sea trade provided Ethiopian Christians safe and uninterrupted passage to the Mediterranean as well as direct ties to the mother church (newly relocated to Cairo). Both the ecclesiastical affairs and economic lifeblood of post-Aksumite Tigray were for that brief window of time directly tied to Fatimid Egypt.

Indeed, it was in response to the economic, social, and political underpinnings of this Fatimid alliance that we also find the architecture of Mediterranean late antiquity explicitly revived

in their building fabrics. In the eleventh century Ethiopian pilgrims encountered Justinianic monuments anew via Fatimid mercantile networks, which they in turn localized in East Tigray. As these churches could not have been produced after 1150 for the reasons outlined above, their inclusion of Fatimid vizierate-era forms and large scale suggest that they must have been built in the late eleventh century when relations with Egypt were closest, but certainly prior to the eventual souring of relations and the Christian Tigrayan conquest of Fatimid trading settlements in the twelfth century.[117] Although these historical circumstances will be more fully addressed in the chapters to come, my relative chronology thus considers the period between 1089 and 1094 as the most likely for church construction within a larger, 150-year window between 1000 and 1150.

The biggest challenge facing the study of Ethiopia's early medieval past remains the lack of written sources. That said, as I have shown here, much can be revealed through the detailed study and surveying of ancient churches. Thus, by reconstructing the site stratigraphy and layered liturgical contexts, I have shown that all three monuments were produced in a single campaign, by the same workshop, in the late eleventh century, with a terminus ante quem of the mid-twelfth century. Mikaʾel Amba was heavily reconstructed in the twelfth century, however—an invasive and complicated restoration that explains its somewhat different conception.

117 Muehlbauer, "From Stone to Dust," 17.

CHAPTER 3

INVENTING LATE ANTIQUITY IN
MEDIEVAL ETHIOPIA

I N THIS CHAPTER I EVALUATE AND FULLY
explain the architecture of Tigrayan cruciform churches in light of their proposed shared late eleventh-century date (likely 1089–1094). As I will illustrate, these churches are unprecedented in the broader history of Ethiopian architecture. Their aisled cruciform conception and use of vaults directly referenced late antique architecture, refracted through the contemporary elite architecture of Tigray and the Fatimid caliphate.[1] Although aisled cruciform churches had been built by the Aksumites in late antiquity, I suggest that the form of Abreha wa-Atsbeha was directly inspired by standing Justinianic churches in the Mediterranean basin that were encountered anew by Tigrayan pilgrims in the eleventh century. The circumstances behind their production were directly tied to the foreign policies of the Fatimid caliphate, whose interest in the region enriched and legitimated the Christians of Tigray in what was then a largely non-Christian and Islamic realm. The eleventh-century Red Sea

was a Fatimid *mare nostrum*[2] in which Ethiopians traveled freely through Coptic monastic channels.

However, these churches were also a profoundly contemporary architectural statement. Barrel vaults and domed cubes, engineering feats popularized in Egypt during the reign of Badr al-Jamālī, were seamlessly incorporated into the late antique revival design of the Tigrayan cruciform churches. Deployed alongside their otherwise local building fabrics, vaults and domes provided their interiors with spectacular spatial massing evocative of Justinianic churches. Ultimately, I will suggest that these churches were an expression of a desire for ecumenism by post-Aksumite elites (early Zagwe Hatsani), which parallels contemporary developments in Byzantine and Western medieval architecture and society.

Egypt and Ethiopia in the Eleventh Century

In order to better contextualize the unique architecture of Abreha wa-Atsbeha, Wuqro Cherqos,

1 Claude Lepage has argued that the monuments were based on the freestanding church of Zarama Giyorgis. However, while Zarama is representative of an early cross-shaped church in Ethiopia, the biaxial layout created by the west apse and its applied single-bay transept arms, not to mention a lack of tripartite spatial hierarchy, makes it too dissimilar to be a prototype; C. Lepage and J. Mercier, *Les églises historiques du Tigray: Art éthiopien / The Ancient Churches of Tigrai: Ethiopian Art*, trans. S. Williams and C. Wiener (Paris, 2005), 71–81.

2 This was put best by the Fatimid jurist al-Quḍāʿī (d. 1062), who stated plainly that, "The sea of al-Qulzūm [i.e., the Red Sea] stands within the territory of Egypt." Translation from D. Bramoullé, "The Fatimids and the Red Sea (969–1171)," in *Navigated Spaces, Connected Places: Proceedings of the Red Sea Project V, Held at the University of Exeter, 16–19 September 2010*, ed. D. Agius et al., BAR International Series (Oxford, 2012), 127–36, at 127.

and Mika'el Amba, it is important to understand the political, economic, and religious circumstances behind their construction. Although as noted in Chapter 1, some sort of post-Aksumite Christian kingdom or chieftaincy appears to have survived in east Tigray, generally speaking, northern Ethiopia was a backwater after the collapse of Aksum. The "Ham inscription," one of only a handful of sources from the post-Aksumite period, gives some insight into this "post-Aksumite" society. The inscription, found in the eponymous town on the Eritrean border adjacent to Tigray, is a standard late antique epitaph, commemorating the death of a Christian female notable named Giho (Giḥo). Its import comes from its date, 23 December 974, written in archaizing Greek numerals, but long after Aksum's seventh-century dissolution.[3] It leads us to imagine that at this time, northern Ethiopia was home to an isolated "Rip Van Winkle," Christian, post-Aksumite polity ruled by one or more Hatsanis, whose worldview is otherwise visible in the architecture of Degum Selassie. Indeed, evidence from the thirteenth-century Coptic-Arabic *History of the Patriarchs of Alexandria* suggests that in the tenth century, Christians of Tigray were so disconnected from episcopal authority that they relied on Nubian intermediaries to forward urgent requests to Alexandria, itself an understudied political tie, which may also explain the inscription's use of Greek numerals.[4] Cultural dynamism in Ethiopia lay not in the Christian north, but to the south in Shoa (Šäwa) and Amhara, where a powerful non-Christian civilization, the so-called Shay culture, made sophisticated pottery and erected great megaliths.[5]

Global affairs would turn in post-Aksumite Tigray's favor in the eleventh century, however, albeit indirectly. The ruling power in Egypt, the Fatimid caliphate, which had hitherto centered its interests on the Mediterranean, was now turning its sights to the Red Sea and Indian Ocean, in order to reassert control over the maritime Silk Road, a strategy that historian David Bramoullé has coined the "Red Sea policy."[6] The Seljuk invasions of the Levant and Asia Minor had created an unbroken trade route between the Aegean Sea and the Persian Gulf, whereby overland traders could completely circumvent the Fatimids.[7]

In response, the Fatimids shored up their Red Sea possessions. In south Arabia, they propped up a puppet state under the Sulayhids, led by Queen Arwā bt. Aḥmad (r. 1067–1138).[8] On the African side of the Red Sea, they established entrepots on the Dahlak archipelago, immediately off the northern coast of the mainland horn, as well as in Kwiha (Kʷiḥa), Tigray.[9] The Fatimids also needed a stronger foothold in inland Tigray in order to control the Red Sea, but post-Aksumite

3 A. Bausi, "'Paleografia quale scienza dello spirito': Once More on the Gəʿəz Inscription of Ham (*RIÉ* no. 232)," in *Exploring Written Artefacts: Objects, Methods, and Concepts*, edited by J. B. Quenzer, 2 vols., Studies in Manuscript Cultures 25 (Berlin, 2021), 1:3–33. See, however, the mentioning of a zebra gifted by an Ethiopian queen to Yemen in the tenth century; M. el-Chennafi, "Mention nouvelle d'une 'reine éthiopienne' au IVᵉ s. de l'hégire/Xᵉ s. ap. J.-C," *AÉ* 10 (1976): 119–21.

4 J. Perruchon, "Notes pour l'histoire d'Éthiopie: Lettre adressée par le roi d'Ethiopie au roi Georges de Nubie sous le patriarcat de Philotée (981–1002 ou 1003)," *Revue sémitique d'épigraphie et d'histoire ancienne* 1 (1893): 71–79, 359–72. See also B. I. Beshir, "New Light on Nubian Fāṭimid Relations," *Arabica* 22.1 (1975): 15–24.

5 See A. Belay, "Megaliths, Landscapes, and Society in the Central Highlands of Ethiopia: An Archaeological Research"

(PhD diss., Université Toulouse–Jean Jaurès, 2020); F.-X. Fauvelle and B. Poissonnier, eds., *La culture Shay d'Éthiopie (Xᵉ–XIVᵉ siècles): Recherches archéologiques et historiques sur une élite païenne*, *AÉ* hors-série 3 (2017).

6 D. Bramoullé, *Les Fatimides et la mer (909–1171)*, Islamic History and Civilization 165 (Leiden, 2019), 584–87; A. Udovitch, "Merchants and Amirs: Government and Trade in Eleventh-Century Egypt," *Asian and African Studies* 22 (1988): 53–72.

7 B. Brentjes, "Karawanenwege durch Mittelasien," *AMIran* 25 (1992): 247–76; A. C. S. Peacock, *The Great Seljuk Empire*, Edinburgh History of the Islamic Empires (Edinburgh, 2015), 299–302.

8 On the Sulayhids, see Ḥ. al-Hamdānī, *al-Ṣulayḥiyyūn wa-l-ḥaraka al-fāṭimiyya fī al-Yaman (min sanat 268h ilā sanat 626h)* (Cairo, 1955). During the reign of Badr al-Jamālī, the Sulayhids sent Ismaili missionaries on a proselytizing mission (*daʿwa*) to India and Oman, presumably also in service of the maritime silk route; M. Brett, "Badr al-Ǧamālī and the Fatimid Renascence," in *Egypt and Syria in the Fatimid, Ayyubid and Mamluk Eras IV: Proceedings of the 9th and 10th International Colloquium Organized at the Katholieke Universiteit Leuven in May 2000 and May 2001*, ed. U. Vermeulen and J. van Steenbergen, Orientalia Lovaniensia Analecta 140 (Leuven, 2005), 61–78, at 72–73.

9 R. Basset, "Les inscriptions de l'île de Dahlak," *JA* 9.1 (1893): 77–111. The epigraphy of these graves largely match those found across the Red Sea in the Hejaz; see M. Schneider, "Points communs aux stèles funéraires musulmanes du Ḥiğāz et des îles Dahlak (Mer Rouge)," *Aula Orientalis* 19.1 (2001): 53–78. By the late twelfth century, graves on the Dahlak archipelago begin to show a Sunni religious character; E. van Donzel and R. E. Kon, "Dahlak Islands," in *EAe* 2:64–69, at 67.

Christians, who still governed at least some parts of the region at that time, presented an obstacle. Despite a general lack of communication with the mother church, Christians there were still legally under the episcopal see of Alexandria.[10] However, they were also hostile to Muslim authority and often refused customary tribute to the caliph.[11]

All of this changed under the reign of Fatimid vizier Badr al-Jamālī (d. 1094).[12] As part of a general push toward state centralization and economic domination of the India trade, in 1089 or 1090 Badr al-Jamālī forced the Coptic patriarch, Cyril II (r. 1078–1092), to move to Fustat from Alexandria, to be fully under the administrative reach of Cairo. In the interest of the Fatimid "Red Sea policy," the election of Archbishop Severus to Ethiopia hinged on promises that four mosques would be built for the Fatimid-aligned Muslim population of Tigray and that an annual tribute to Cairo from Ethiopia would be levied.[13] Official caliphal missionary doctrine also reflected this

latent interest in Ethiopia, as in the eleventh century the region was labeled *jazīrat al-ḥabash* (island of Abyssinia), a designation used for one of twelve official mission areas (*jazāʾir al-arḍ*).[14] After all, Mecca and Medina were the grand goal, and the Hejaz lay just across the Bab al-Mandab Strait from the Ethiopian highlands.[15] Although the Fatimid navy had regularly patrolled the Red Sea since 1073, by 1089, after the actions of Badr al-Jamālī, caliphal delegations now regularly entered the Tigrayan highlands.[16]

This was consequential for the religious demographics of east Tigray. Much as the establishment of cruciform churches were part of a momentous "second Christianization," the era was also one of Islamization. Although Muslims had settled in the region since the late tenth century (in Kwiha, near Mekelle, ca. fifty km from the subject churches), the density of cenotaphs from the late eleventh century indicates a period of intense Muslim settlement during the era of Badr al-Jamālī.[17] Moreover, as I have shown elsewhere, the material record suggests one or more Fatimid mosques were in the direct vicinity of Wuqro (perhaps even next to the church); from the fifteenth century to the turn of the second millennium, a spolia mihrab hood, formally and paleographically similar to those from eleventh-century Egypt and Yemen, was used as a *haykal* (sanctuary screen) in Wuqro Cherqos (Fig. 114,

10 S. Tadeschi and G. Haile, "Ethiopian Prelates (c.300–fl. Second Half of Eleventh Century)," in *The Coptic Encyclopedia*, ed. A. S. Atiya, 8 vols. (New York, 1991), 3:999–1003; S. Tadeschi, "Ethiopian Prelates (fl. Late Eleventh Century–fl. Mid-Fourteenth Century)," in *Coptic Encyclopedia*, 4:1005–44; I. Guidi, "Le liste dei metropoliti d'Abissinia," *Bessarione* 6 (1899): 2–16.

11 M.-L. Derat, "L'affaire des mosquées: Interactions entre le vizirat fatimide, le patriarcat d'Alexandrie et les royaumes chrétiens d'Éthiopie et de Nubie à la fin du XIᵉ siècle," *Médiévales* 79 (2020): 15–36, at 19.

12 Badr al-Jamālī, a military governor of enslaved Armenian descent, was responsible for the mid-eleventh-century revival of Fatimid authority in Egypt after protracted instability; see H. Halm, "Badr al-Ǧamālī: Wesir oder Militärdiktator?" in *Egypt and Syria in the Fatimid, Ayyubid and Mamluk Eras V: Proceedings of the 11th, 12th and 13th International Colloquium Organized at the Katholieke Universiteit Leuven in May 2002, 2003 and 2004*, ed. U. Vermeulen and K. D'hulster, Orientalia Lovaniensia Analecta 169 (Leuven, 2007), 121–27.

13 Derat, "L'affaire des mosquées"; S. Labib, "Cyril II," in *Coptic Encyclopedia*, 2:675–77; E. van Donzel, "Badr al-Jamālī, the Copts in Egypt and the Muslims in Ethiopia," in *Studies in Honour of Clifford Edmund Bosworth*, vol. 1, *Hunter of the East: Arabic and Semitic Studies*, ed. I. R. Netton (Leiden, 2000), 297–309. It was also in this period that Coptic liturgical and hagiographic literature began to be written in Arabic instead of Coptic; S. Rubenson, "Translating the Tradition: Some Remarks on the Arabization of the Patristic Heritage in Egypt," *Medieval Encounters* 2.1 (1996): 8–10. Among other things, this episode led to the suppression of polygamy among Ethiopian monarchs; see B. T. A. Evetts, ed. and trans., with A. J. Butler, *The Churches and Monasteries of Egypt and Some Neighbouring Countries, Attributed to Abû Ṣâliḥ, the Armenian* (Oxford, 1895), 290–91.

14 F. Daftary, "The Ismaili Daʿwa outside the Fatimid Dawla," in *L'Égypte fatimide: Son art et son histoire. Actes du colloque organisé à Paris les 28, 29 et 30 mai 1998*, ed. M. Barrucand (Paris, 1999), 29–43, at 37.

15 After 1069, Mecca and Medina were again under Abbasid religious sovereignty, making their restoration a major objective for the Fatimids; Bramoullé, "Fatimids and the Red Sea," 128–29; A. al-Maqrīzī, *Ittiʿāẓ al-ḥunafāʾ bi-akhbār al-aʾimma al-fāṭimiyyīn al-khulafāʾ*, ed. J. al-Shayyāl and M. Ḥ. M. Aḥmad, 3 vols. (Cairo, 1971), 2:303, 320–22.

16 As recorded in the Mamluk historian al-Maqrīzī's wide-reaching *Khiṭaṭ*; see B. I. Beshir, "The Fatimid Caliphate 386/996-487/1094" (PhD diss., University of London, School of Oriental and African Studies, 1970), 90.

17 J. Loiseau, "Retour à Bilet: Un cimetière musulman médiéval du Tigray oriental (*Inscriptiones Arabicae Aethiopiae 1*)," *BEO* 67 (2020): 59–96; J. Loiseau et al., "Bilet and the Wider World: New Insights into the Archaeology of Islam in Tigray," *Antiquity* 95 (2021): 508–29; A. Chekroun and B. Hirsch, "The Sultanates of Medieval Ethiopia," in *A Companion to Medieval Ethiopia and Eritrea*, ed. S. Kelly (Leiden, 2020), 86–112, at 91.

Figure 114.
Wuqro Cherqos,
triumphal arch,
Tigray, Ethiopia,
1868. Painting
from W. Simpson,
"Abyssinian Church
Architecture: Part II,
Rock-Cut Churches,"
*The Architectural
Review* 4 (1898): 15.

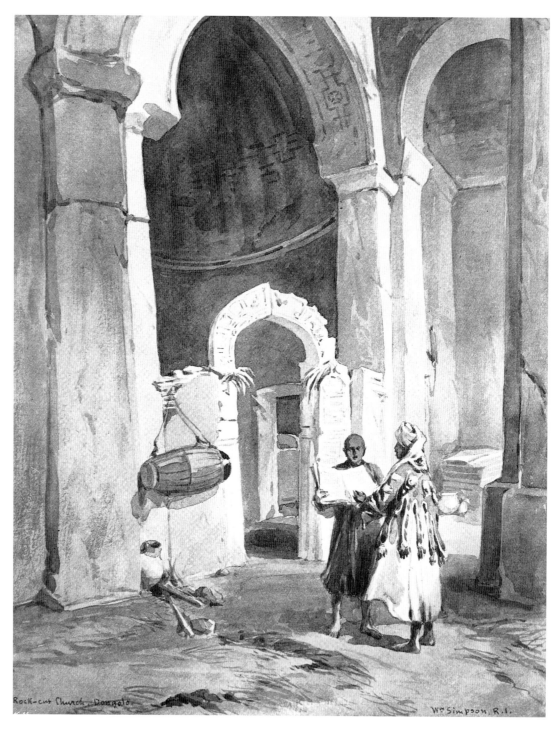

and see conclusion).[18] Fatimid settlement in Tigray was so conspicuous that by the twelfth century, during the decline and fall of the caliphate, the first known Zagwe king, Tantawedem,

forcibly expelled the now-unprotected Muslim residents of east Tigray (Ṣəraʿ).[19]

18 M. Muehlbauer, "From Stone to Dust: The Life of the Kufic Inscribed Frieze of Wuqro Cherqos in Tigray, Ethiopia," *Muqarnas* 38 (2021): 1–34.

19 M.-L. Derat, *L'énigme d'une dynastie sainte et usurpatrice dans le royaume chrétien d'Éthiopie du XIe au XIIIe siècle* (Turnhout, 2018), 30–40, 120–23, 261–271. See also the alternative translation proposed in N. Valieva, "King Ṭanṭawədəm's Land Charter: State of the Art and New Perspectives," https://horneast.hypotheses.org/1803 (open access). It seems that after

Suffice it to say, the late eleventh-century engagement between the globally oriented Fatimid caliphate and the isolated Christians of East Tigray was transformative. Ethiopian traders enriched themselves by selling civet musk, salt, pelts, and enslaved people to the Fatimids.[20] *Ḥabashī* Mamluks (enslaved Ethiopian soldiers) swelled the ranks of the eleventh-century Fatimid military, while the elites of Cairo dined on Ethiopian leather placemats.[21] For their part, Ethiopians now imported exotic cloths (and presumably spices) via Fatimid trading settlements, from South Asia and Egypt, to be used as canopies and curtains for their churches (see Chap. 4).

Although part of a broader play for power in the Red Sea, Fatimid investment in post-Aksumite Tigray was a boon for the Christians there, opening the African horn to increased episcopal contact and overseas trade opportunities.[22] Indeed, considered in the context of Eastern Mediterranean history, the Muslim and Christian Fatimid–Tigrayan alliance should be considered in tandem with, and similar to, the Fatimid–Byzantine alliance from the same general period.[23]

As reconstructed here briefly, the eleventh century in Tigray presented something of a reversal of fortune for the Christian sovereigns there. Indeed, Ethiopia's wealth, stability, and reforged connections with the wider world in the late eleventh century had not been seen there since late antiquity. I will suggest that this repositioning bode well for the reigning Hatsanis. After all, new Egyptian ecclesiastical authority was the pretext for the (often violent) Christianization of the region and the later founding of the Metropolitan Cathedral at Maryam Nazret (Chap. 1). In these favorable economic conditions, and with the episcopal support of the Fatimids in the late eleventh century, the Christian Hatsanis of east Tigray produced Abreha wa-Atsbeha, Wuqro Cherqos, and Mikaʾel Amba, the largest and most innovative churches in Tigray since the Aksumite period. Intriguingly, the circumstances of the late eleventh century almost precisely mirrored those of late antiquity—Christian Hatsanis were once again brokers in the India trade and well integrated with the Egyptian patriarchate; however, rather than the Byzantines, the Muslim Fatimids were now Tigray's post-Aksumite Mediterranean ally and trading partner.

Remaking Late Antiquity

Having identified Abreha wa-Atsbeha, Wuqro Cherqos, and Mikaʾel Amba as aisled cruciform rather than "cross-in-square," I begin my assessment of their architecture with reference to their Aksumite predecessors. Two, likely aisled cruciform churches, if only partially known, are thought to have been erected by the Aksumites: the sixth-century church at Beta Giyorgis hill and the cathedral of Sanaa (see Fig. 22, and Chap. 1). Localized from the most prestigious architecture of early Byzantium, this late antique architectural form consisted of a three-aisled nave intersecting with a three-aisled transept, staged with vaulted (in the case of Sanaa, timber for Beta Giyorgis) cross arms and pyramidal massing around a raised

the Fatimids, Muslim penetration into the Ethiopian highlands was based around the port of Zayla in contemporary Somaliland; see F.-X. Fauvelle and B. Hirsch, eds., *Espaces musulmans de la Corne de l'Afrique au Moyen Âge* (Addis Ababa, 2011), 27–74. As Fatimid trading communities in Tigray declined, we see reports of Zayla being used as a port. The famed cartographer Muḥammad al-Idrīsī of Norman Sicily (twelfth century) writes of vibrant markets in Zayla, reflecting a demand for Egyptian products in exchange for pelts and the enslaved; I. A. El-Adawi, "Egyptian Maritime Power in the Early Middle Ages: From the Arab Conquest of Egypt to the Fall of the Fatimids, 640–1171 A.D." (PhD diss., University of Liverpool, 1948), 284.

20 C. Lepage, "Entre Aksum et Lalibela: Les églises du sud-est du Tigray (IXᵉ–XIIᵉ s.) en Éthiopie," *CRAI* 150.1 (2006): 9–39, at 28–39. See also T. Tamrat, "Islam and Trade in Ethiopia c. 900–1332," in *Provisional Council for the Social Sciences in East Africa, 1st Annual Conference, University of Dar es Salaam, December 27th–31st, Proceedings,* 6 vols. (Dar es Salaam, 1970), 3:176–87. Up until the nineteenth century, the salt trade to Tigray was still entirely in the hands of itinerant Muslim traders; M. Abir, "Salt, Trade and Politics in Ethiopia in the 'Zämänä Mäsafent," *JES* 4.2 (1966): 1–10; W. Smidt, "Salt," in *EAe* 4:500.

21 A. Zouache, "Remarks on the Blacks in the Fatimid Army, Tenth–Twelfth Century CE," *NEAS* 19.1 (2019): 23–60; S. D. Goitein, *A Mediterranean Society: The Jewish Communities of the Arab World as Portrayed in the Documents of the Cairo Geniza,* vol. 4, *Daily Life* (Berkeley, 1983), 129.

22 On global trade in East Africa in this period, see D. Whitehouse, "Maritime Trade in the Gulf: The 11th and 12th Centuries," *World Archaeology* 14.3 (1983): 328–34, at 333–34.

23 K. E. F. Thomson, "Relations between the Fatimid and Byzantine Empires during the Reign of the Caliph al-Mustansir bi'llah, 1036–1094/427–487," *BMGS* 32.1 (2008): 50–62.

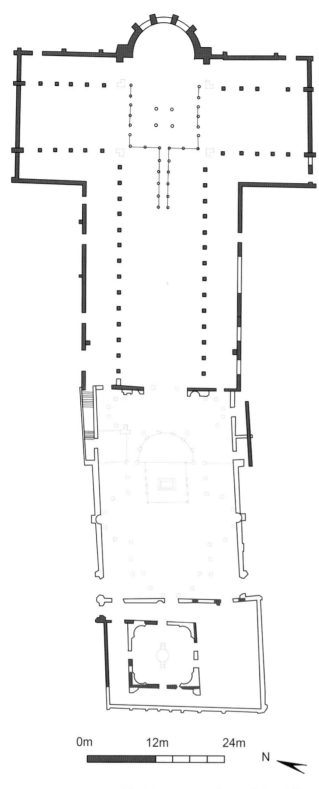

0m 12m 24m

N

Figure 115. Abu Mena, measured ground plan, fifth-to sixth-century phase, sixty kilometers west of Alexandria, Egypt. Plan by author and Binxin Xie, redrawn and modified after P. Grossmann, *Christliche Architektur in Ägypten* (Leiden, 2002), pl. 20.

core. By the eleventh century, however, these churches erected under Aksumite rule were no longer standing. The Sanaa cathedral had been destroyed and spoliated nearly half a millennium earlier, while Beta Giyorgis was already thoroughly buried by debris.

In Egypt, too, the great aisled cruciform churches of late antiquity had all but disappeared. The most famous (perhaps a forebear of those Aksumite aisled cruciform churches[24]) was the fifth- to sixth-century Great Basilica of Abu Mena (Abū Mīna, some sixty km southwest of Alexandria; Fig. 115). This church, which sat to the immediate east of the martyrium of its namesake (St. Menas), was one of the most important pilgrimage destinations in late antiquity.[25] With a main vessel measuring over 50 meters long, this T-shaped basilica incorporated a three-aisled nave, intersecting with an aisled transept of nearly equal length, and a conched apse, borne by arcades of fine spolia columns with lacy Corinthian capitals (scattered around the ruin today).[26] Although the actual church complex was derelict by the eighth century (and covered by the dunes of the Libyan desert by the eleventh), it remained a vital part of the medieval Coptic imaginary in the Fatimid period and beyond.[27] Indeed, this form was well localized in late antique Egypt. We find at the Justinianic cathedral at Pharan, in the Sinai, an aisled cruciform church that is especially close in ground plan to Abreha wa-Atsbeha: a roughly equilateral cross with reduced dimensions and a (four-)

24 B. Finster and J. Schmidt, "Die Kirche des Abraha in Ṣanʿāʾ," in *Arabia Felix: Beiträge zur Sprache und Kultur des vorislamischen Arabien. Festschrift für Walter W. Müller zum 60. Geburtstag*, ed. N. Nebes (Wiesbaden, 1994), 67–86, at 77.

25 St. Menas became a fixture of Ethiopia's later (post-fourteenth-century) hagiographic tradition; see C. M. Kauffmann, *Zur Ikonographie der Menas-Ampullen: Mit besonderer Berücksichtigung der Funde in der Menasstadt [. . .]* (Cairo, 1910), 30–55.

26 On the Great Basilica at Abu Mena (aisled transept phase), see P. Grossmann, *Christliche Architektur in Ägypten* (Leiden, 2002), 407–9. See also the original archaeological report by P. Grossmann et al., "Abū Mīna: Elfter vorläufiger Bericht. Kampagnen 1982 und 1983," *MDAIK* 40 (1984): 123–51.

27 P. Grossmann, *Abū Mīna*, vol. 1, *Die Gruftkirche und die Gruft* (Mainz, 1989), 16. The relics of St. Menas were transferred to Cairo in the fourteenth century, long after the complete abandonment of the late antique site; A. Khater, "La translation des reliques de Saint Ménas à son église au Caire," *BSAC* 16 (1962): 161–81.

aisled transept terminating in a conched apse.[28] However, this church, like Abu Mena, was buried by the sands (it was abandoned in the seventh century).[29] Indeed, by the eleventh century all standing points of reference for aisled-cruciform plan churches were located in Byzantium rather than Ethiopia and Egypt.

The reign of the Byzantine emperor Justinian (r. 527–565) was most associated with the development of vaulted and aisled cruciform-plan churches in the Byzantine heartlands.[30] The Justinianic church of the Holy Apostles in Constantinople is the most famous example, as it was the imperial mausoleum, oft cited in the architecture of its neighbors, as at San Marco in Venice (see Figs. 1, 116). Although demolished in 1461, scholars have reconstructed that it was a nearly equilateral cruciform, with a slightly longer nave. The entire structure was aisled, with the central bays of the main vessel and transept twice the scale of the side units. The church had a modular spatial configuration, with domical vaults on the nave and transept, though centered with a dome-on-drum in the crossing space.[31] The sixth-century church of St. John at Ephesus, erected above the resting place of the eponymous apostle, is of similar conception, but located in coastal Asia Minor. Like the Church of the Holy Apostles in Constantinople, it was also an oft-visited pilgrimage destination in the eleventh century and after. An aisled cruciform construction, the church of St. John was centered on an elaborate dome in the crossing, but with pendentive domes on the cross arms and nave.[32] Unlike the church of the Holy Apostles, the church of St. John terminated in a semicircular apse conch, ringed by a synthronon.[33]

Aisled cruciform churches were once a common sight in the Eastern Mediterranean. In Cyprus, where Ethiopian traders have been documented from at least the twelfth century onward, we find remains of a seventh-century pilgrimage church (and martyrium) that closely resembles that of St. John at Ephesus.[34] The

28 Grossmann, *Christliche Architektur in Ägypten*, 483–85; P. Grossmann, *Die antike Stadt Pharan: Ein archäologischer Führer* (Cairo, 1998); P. Grossmann, "Excavations in Firan–Sinai in the Years from 2000 to 2005," *BZ* 106.2 (2013): 679–80. The fifth-century cathedral of Hermopolis Magna, another pilgrimage center, was also a three-aisled basilica with aisled transept, but its ends were rounded, making it an ambulatory as well. This church was in ruins by the eleventh century, according to historical accounts; Grossmann, *Christliche Architektur in Ägypten*, 441–43; A. J. B. Wace, A. H. S. Megaw, and T. C. Skeat, *Hermopolis Magna, Ashmunein: The Ptolemaic Sanctuary and the Basilica* (Alexandria, 1959), 21–22.

29 Grossmann, *Christliche Architektur in Ägypten*, 155–65. In Nubia, immediately west of Ethiopia, several cathedrals were produced with somewhat cruciform conceptions, as at Faras and Dongola. Despite being five-aisled basilicas, in both cases the churches have applied transepts. However, at Dongola the transept consists of apsed single-bays (*exedrae*), perhaps indicating that it also had a lateral devotional use; P. M. Gartkiewicz, *The Cathedral in Old Dongola and Its Antecedents* (Warsaw, 1990); W. Godlewski, *Pachoras: The Cathedrals of Aetios, Paulos and Petros. The Architecture* (Warsaw, 2006); P. Grossmann, *Mittelalterliche Langhaus-Kuppelkirchen und verwandte Typen in Oberägypten: Eine Studie zum mittelalterlichen Kirchenbau in Ägypten*, ADAIK, Koptische Reihe 3 (Glückstadt, 1982), 183–94. That said, another Nubian church at Old Dongola, the church of Raphael, which stood from the eighth century to the fourteenth century, has a plan somewhat similar to the aforementioned cathedral of Pharan, albeit significantly truncated, with its cross arms reduced to cylindrical pilasters. Although formally grouped with the applied-transept-type cathedrals found in Nubia, I see this form as a fruitful alternative point of reference for the Tigrayan cruciform plan church. On the aforementioned church of Raphael, see W. Godlewski, "The Church of Archangel Raphael (SWN.B.V)," in *Dongola 2015–2016: Fieldwork, Conservation and Site Management*, ed. W. Godlewski, D. Dzierzbicka, and A. Łajtar, PCMA Excavation Series 5 (Warsaw, 2018), 115–31.

30 H. Buchwald, "The First Byzantine Architectural Style: Evolution or Revolution?," *JÖB* 32.5 (1982): 33–46.

31 Some of the various reconstruction proposals include N. Karydis, "Justinian's Church of the Holy Apostles: A New Reconstruction Proposal," in *The Holy Apostles: A Lost Monument, a Forgotten Project, and the Presentness of the Past*, ed. M. Mullett and R. G. Ousterhout (Washington, DC, 2020), 99–130; R. Krautheimer, "A Note on Justinian's Church of the Holy Apostles in Constantinople," in *Mélanges Eugène Tisserant*, 7 vols. (Vatican City, 1964), 2:265–70; K. Dark and F. Özgümüş, "New Evidence for the Byzantine Church of the Holy Apostles from Fatih Camii, Istanbul," *Oxford Journal of Archaeology* 21.4 (2002): 393–413.

32 A. Thiel, *Die Johanneskirche in Ephesos*, Spätantike–Frühes Christentum–Byzanz 6 (Wiesbaden, 2005), 9–65; H. Buchwald, "Western Asia Minor as a Generator of Architectural Forms in the Byzantine Period, Provincial Back-Wash or Dynamic Center of Production?" *JÖB* 34 (1984): 199–234.

33 Thiel, *Die Johanneskirche in Ephesos*, 37.

34 E. Procopiou, "L'architecture chrétienne dans la région d'Amathonte à l'époque byzantine (IVᵉ–XIIᵉ siècles): Recherches archéologiques 1991–2012," trans. P. Xydas, *Cahiers du Centre d'études chypriotes* 43 (2013): 253–74; E. Procopiou, "New Evidence for the Early Byzantine Ecclesiastical Architecture of Cyprus," in *Church Building in Cyprus (Fourth to Seventh Centuries): A Mirror of Intercultural Contacts in the Eastern Mediterranean*, ed. M. Horster, D. Nicolaou, and S. Rogge, Schriften des Instituts für interdisziplinäre Zypern-Studien 12 (Münster, 2018), 73–98. For Ethiopians on Cyprus, see E. Cerulli, *Etiopi in Palestina: Storia della comunità etiopica*

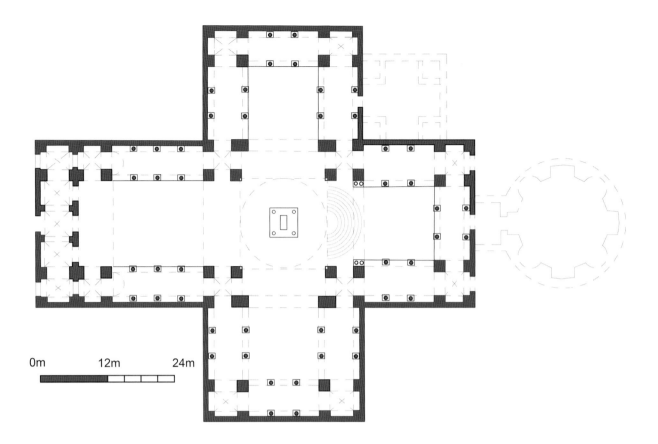

0m 12m 24m

Figure 116.
Church of the
Holy Apostles,
hypothetical ground
plan, Constantinople,
Turkey, sixth century.
Plan by author and
Binxin Xie, redrawn
and modified after
N. Karydis, "Justinian's
Church of the Holy
Apostles: A New
Reconstruction
Proposal," in *The
Holy Apostles: A
Lost Monument, a
Forgotten Project, and
the Presentness of the
Past*, ed. M. Mullett
and R. G. Ousterhout
(Washington, DC,
2020), fig. 7.15.

Church of Panagia Ekatontapiliani on the island of Paros, like the church of the Holy Apostles in Constantinople, and the church of St. John in Ephesus, was an aisled cruciform built at approximately the same time, though it remains fully standing today, a unique, if underappreciated window into Justinian's architectural productions.[35] Although it was not built with an integral martyrium, it became in the later Middle Ages a well-known pilgrimage destination, specifically for the veneration of Mary, its popularity in part due to its island location—a port of cabotage between the Levant and Constantinople.[36] The church is a 43-meter-long cruciform basilica; its

nave and transept are framed by an intersecting aisle system well suited to pilgrim ambulation.[37] The church is centered around a dramatic dome on pendentives on the crossing, and braced on its cross arms by barrel vaults borne by galleried aisles (Fig. 117). With its severe, pyramidal massing of space around the domed core, the church is ultimately axial, terminating in a conched east end, which is surmounted by a synthronon.

Tigray was well integrated in the Mediterranean world and its religious destinations from the eleventh century on, primarily via Egypt by means of pilgrimage and trade. At this time, Ethiopians resided in the Egyptian littoral, not far from the ruins of Abu Mena, having established a monastery in Wadi Natrun (Wādī al-Naṭrūn) on the Nile Delta.[38] Traces of parchment also attest to Ethiopian presence at St. Catherine's Monastery on Mount Sinai from at least the twelfth century,

di Gerusalemme, 2 vols., Collezione Scientifica e Documentaria 12 (Rome, 1943), 1:31–37.

35 For a reappraisal of this monument's Justinianic phasing, see M. Muehlbauer, "Problems in Justinianic Architecture: The Sixth-Century Gallery Arcades of the Panagia Ekatontapiliani (Katapoliani) in Paros," forthcoming.

36 The island seems to have undergone a demographic revival in the tenth and eleventh centuries, possibly a byproduct of increased pilgrimage; A. K. Vionis, "The Thirteenth–Sixteenth-Century *Kastro* of Kephalos: A Contribution to the Archaeological Study of Medieval Paros and the Cyclades," *BSA* 101 (2006): 459–92, at 463.

37 R. Ousterhout, *Eastern Medieval Architecture: The Building Traditions of Byzantium and Neighboring Lands*, Onassis Series in Hellenic Culture (New York, 2019), 228–30; F. W. Hasluck and H. H. Jewell, *The Church of Our Lady of the Hundred Gates (Panagia Hekatontapyliani) in Paros* (London, 1920), 29–53.

38 Evetts, *Churches and Monasteries of Egypt*, 87.

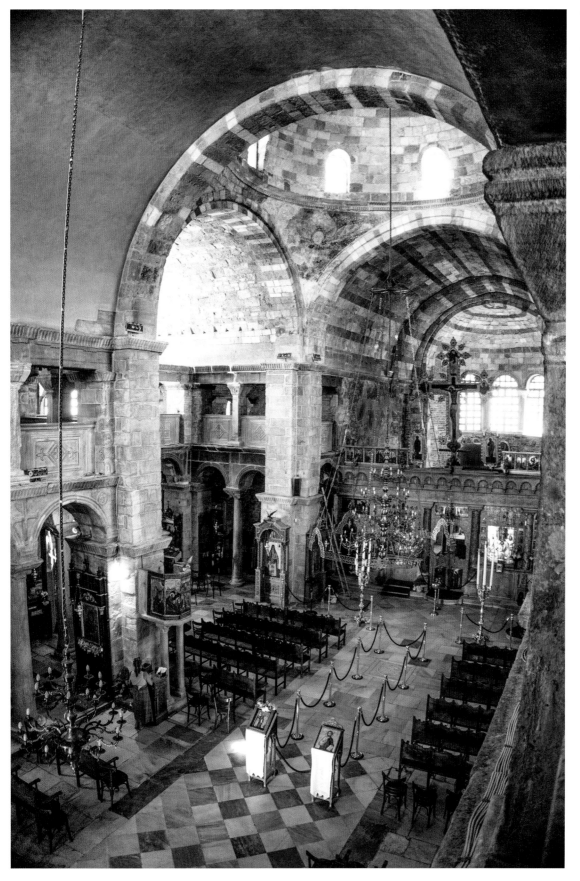

Figure 117.
Panagia
Ekatontapiliani,
Great Church,
interior elevation
viewed from the
gallery, Parikia,
Paros, Cycladic
Islands, Greece,
sixth century.
Photograph
by author.

and presumably from there, they visited other far-flung destinations in the eastern Mediterranean.[39] As with other pilgrims and traders along the Red Sea, Ethiopians would make cabotage northward, perhaps departing east Tigray via the Dahlak and traveling to the ports of Quseir [al-Quṣayr] or Aydhab, on the Egyptian Red Sea coast. From there, pilgrims or merchants would join caravans inward to Nilotic entrepots, namely Qus [Qūṣ], the capital of Upper Egypt, but also Aswan, and from there depart for lower Egypt and the Mediterranean.[40] By the eleventh century, these Ethiopian pilgrims were on well-trodden networks; we find Ethiopic pilgrims' graffiti in trafficked monasteries such as the White and Red Monasteries in Upper Egypt.[41]

Justinian, the Byzantine emperor who was closest to Aksum, was an admired figure into the medieval period and the pilgrimage churches associated with him likely carried ecumenical undertones.[42] The great basilica of Abu Mena

continued to be venerated, even as it sat in ruin—it was the subject of literary fantasies in the eleventh century still.[43] The aisled cruciform churches that stayed standing were not built in Ethiopia or the Eastern Mediterranean for nearly half a millennium.[44] In Byzantium, these large basilicas were a casualty of imperial contraction and private, monastic patronage. Their wide vault spans were still the products of Roman engineering, and relied on expensive timber formwork rather than the narrower pitched brick vaults (corbeled) characteristic of Middle Byzantium.[45] As such, when visited in the later Middle Ages, these great, ancient monuments were seen as testaments to the glory of Justinian's Byzantium, and a source of awe and inspiration.[46] For Ethiopian pilgrims, these aisled cruciform churches likely carried extra meaning as well, since they also reflected the architecture of Aksum's sixth-century zenith, perhaps still retained in the cultural memory of these post-Aksumite Christian sovereigns. Indeed, this revivalist impulse was mirrored in their texts. In the twelfth century we find conspicuous recopying of late antique Byzantine texts in Zagwe scriptoria.[47]

39 S. Kelly, "Medieval Ethiopian Diasporas," in Kelly, *Companion*, 424–52, at 428 n. 12. In the sixth century, however, Aksumites regularly visited St. Catherine's monastery en route to the Levant; see É. Puech, "Une inscription éthiopienne ancienne au Sinaï (Wadi Hajjaj)," *RB* 87.4 (1980): 597–601.

40 El-Adawi, "Egyptian Maritime Power," 21–22; L. Guo, "Arabic Documents from the Red Sea Port of Quseir in the Seventh/Thirteenth Century, Part 2: Shipping Notes and Account Records," *JNES* 60.2 (2001): 81–116, at 92–94. See also J.-C. Garcin, *Un centre musulman de la Haute-Égypte médiévale: Qûs* (Cairo, 1976), 37–180, esp. 76–126.

41 The Ethiopian pilgrims' graffiti at the White Monastery is dated to either 1038 or 1114; O. Meinardus, "Ethiopian Monks in Egypt," in *EAe* 2:243–45, at 243; M.-L. Derat, "Before the Solomonids: Crisis, Renaissance and the Emergence of the Zagʷe Dynasty (Seventh–Thirteenth Centuries)," in Kelly, *Companion*, 31–56, at 39; O. F. A. Meinardus, "Ecclesiastica Aethiopica in Aegypto," *JES* 3.1 (1965): 23–35, at 31; M. Ambu, "Du texte à la communauté: Relations et échanges entre l'Égypte copte et les réseaux monastiques éthiopiens (XIIIᵉ–XVIᵉ siècle)" (PhD diss., Panthéon-Sorbonne University, 2022), 343–44. At the Red Monastery, I located two extremely fragmentary Ethiopic inscriptions on the northeast wall of the nave, one of which appears to be an invocation. However, these inscriptions are likely of a later date than the inscription located at the White Monastery. See also the Ethiopic graffiti in the Monastery of St. Anthony; S. H. Griffith, "The Handwriting on the Wall: Graffiti in the Church of St. Antony," in *Monastic Visions: Wall Paintings in the Monastery of St. Antony at the Red Sea*, ed. E. S. Bolman (New Haven, 2002), 185–94.

42 The thirteenth-century (perhaps earlier) Ethiopian national text "The Glory of Kings," which was written at the Metropolitan scriptorium at Maryam Nazret, includes a bizarre apocalyptic, certainly adapted from an earlier text, wherein "Justinios" (a conflation of Justin I and Justinian) and an unnamed Aksumite

emperor meet in Jerusalem and split the world in half, ushering in the end of days; C. Bezold, *Kebra Nagast: Die Herrlichkeit der Könige. Nach den Handschriften in Berlin, London, Oxford und Paris* (Munich, 1905), 170–72. On this text and its genre, see I. Shahîd, "The Kebra Nagast in the Light of Recent Research," *Le Muséon* 89 (1976): 133–78; G. W. Bowersock, "Helena's Bridle, Ethiopian Christianity, and Syriac Apocalyptic," *StP* 45 (2010): 211–20; F. J. Martinez, "The King of Rūm and the King of Ethiopia in Medieval Apocalyptic Texts from Egypt," in *Coptic Studies: Acts of the Third International Congress of Coptic Studies*, ed. W. Godlewski (Warsaw, 1990), 247–59.

43 Grossmann, *Abū Mīna*, 16.

44 See, however, T. Papacostas, "The Medieval Progeny of the Holy Apostles: Trails of Architectural Imitation across the Mediterranean," in *The Byzantine World*, ed. P. Stephenson (New York, 2010), 386–405.

45 N. Karydis, "The Vaults of St. John the Theologian at Ephesos: Visualizing Justinian's Church," *JSAH* 71.4 (2012): 524–51, at 549.

46 N. D. Karydis, *Early Byzantine Vaulted Construction in Churches of the Western Coastal Plains and River Valleys of Asia Minor* (Oxford, 2011), 8. See also A. W. Carr, "Pilgrimage to Constantinople," in *The Cambridge Companion to Constantinople*, ed. S. Bassett (Cambridge, 2022), 310–23.

47 A. Bausi et al., "The *Aksumite Collection* or Codex Σ (*Sinodos of Qafrǝyā*, MS C3-IV-71/C3-IV-73, EthioSPaRe UM-039): Codicological and Palaeographical Observations. With a Note on Material Analysis of Inks," *COMst Bulletin* 6.2 (2020): 127–71. See also G. Haile, "A Fragment of the Late Aksumite or Early Zagʷe Period on the Commentary on the Gospel of Matthew," *Aethiopica* 24 (2021): 223–32.

Most telling of a deliberate archaizing and "Byzantinizing" at Abreha wa-Atsbeha is the presence of a synthronon in the apse (see Fig. 77). Synthronoi, the tiered benches where the clergy would sit (Fig. 118), akin to modern stands, were common in the churches of late antiquity, but fell out of use in both Byzantium and Egypt by the High Middle Ages, as did other forms of dado-level benches (in the singular, often called *maṣṭaba* in late antique Egyptian churches) in the aisles.[48] More importantly, since no examples of a synthronon have been located in Aksumite churches, it seems that such a liturgical furnishing was unprecedented when hewn at Abreha wa-Atsbeha.[49] However, the synthronon that surmounts the apse at Abreha wa-Atsbeha is a single step, far too low and narrow to actually act as a bench for the clergy. I therefore regard it as a symbol: a direct, anachronistic, and "exotic" reference to late antique Byzantine architecture, otherwise evidenced only in the church's aisled cruciform conception.

It may be that Abreha wa-Atsbeha (and its copies) were created in order to reproduce the architecture of Mediterranean late antiquity in post-Aksumite Tigray. Tigrayan masons

Figure 118.
Hagia Irene,
Synthronon, Istanbul,
Turkey, sixth century,
rebuilt in the eighth
or ninth century.
Photograph by author.

48 Grossmann, *Christliche Architektur in Ägypten*, 189–92; M. Altripp, "Beobachtungen zu Synthronoi und Kathedren in byzantinischen Kirchen Griechenlands," *BCH* 124.1 (2000): 377–412, at 405. The Pantokrator Monastery complex in Constantinople, the twelfth-century burial place of the Komnenian monarchs, includes in the South Church one of the only examples of a synthronon in Middle Byzantium; see A. H. S. Megaw, "Notes on Recent Work of the Byzantine Institute in Istanbul," *DOP* 17 (1963): 333–71, at 340 and figs. D and F. This, too, was a deliberate archaizing, in my opinion, found in the architectural constructions of the Komenian dynasty. That said, Nubian churches continued to be built with synthronoi into the later Middle Ages; A. Obłuski, *The Monasteries and Monks of Nubia*, trans. D. Dzierzbicka, *Journal of Juristic Papyrology* Supplement 36 (Warsaw, 2019), 160.

49 One church in Adulis, unofficially excavated in the late nineteenth century, incorporated marble spolia from Byzantium into its east end and is thought to have possibly had a single-step marble synthronon. However, there is little evidence to suggest that this was the case, and if this church had a synthronon, its Proconnesian marble manufacture would preclude a local origin, pointing instead to sixth-century Byzantium, perhaps even a Justinianic "Church kit," as recovered from Marzamemi; C. Giostra and S. Massa, "Dal Mediterraneo al Mar Rosso: La cristianizzazione della città-porto di Adulis e la diffusione di modelli e manufatti bizantini," *Hortus Artium Medievalium* 22 (2016): 92–109, at 107–8. After Abreha wa-Atsbeha we find single-step synthronoi in two locations: the late thirteenth-century church of Gannata Maryam (Gännäta Maryam) in Lasta, near Lalibela, and the fourteenth-century church of Arbaetu Enesa (Arbaʿətu Ǝnsəsa) in Tigray.

creatively localized these forms into rupestrian space by truncating the cross arms and adapting the tripartite, pyramidal, massing of space according to the relative thickness of the rock overlay. Such an unprecedented and archaizing program of building served to elevate the burgeoning post-Aksumite Christian state and evinced the ecumenical desires of the sovereigns and religious authorities there. In recreating this late antique church type in their own image, the Tigrayan Hatsanis made a profound statement that at once reclaimed the legacy of Aksum's sixth-century zenith and the ecumenism of Justinian the Great.

It is unknown what the original use was for Abreha wa-Atsbeha, though the presence of a synthronon may suggest episcopal use (a bishop's

throne?). Moreover, the aisled transept and overall large scale suggest that the building was planned to host a large, clerical audience, replete with an ambulatory for organized processions. Indeed, both St. John in Ephesus and the church of the Holy Apostles (as well as its eleventh-century revival as San Marco, Venice) used aisled transepts for this function, propelling visitors and parishioners around the cross arms.[50] The aisle system, along with the synthronon, may indicate that Abreha wa-Atsbeha was a metropolitan cathedral (prior to the 1150 establishment of Maryam Nazret). Perhaps the archbishop Severus even considered this new aisled cruciform church as a reincarnation of a long-lost Egyptian monument like Abu Mena. Because the nearby churches of Wuqro Cherqos and Mika'el Amba also embodied this unique form (but lacked a synthronon), it suggests that these were episcopal satellite monasteries or hermitages, which corresponded with major settlement areas, fiefdoms, or strategic trade routes.

Vaults and Domed Cubes: A Rock-Cut Revolution?

The radical conception of Abreha wa-Atsbeha is embodied both in its cruciform ground plan and the pyramidal massing of space in its interior. Like the Tigrayan adaptation of the aisled cruciform, this use of vaults to create cruciform spatial massing is, I suggest, further citation and creative reinterpretation of Justinianic architecture. Rather than relying on Aksumite precedent—or, strictly speaking, late antique Mediterranean precedent—I propose that the use of vaults was grounded in the architecture of the then-contemporary Fatimid caliphate, especially the elite buildings from the vizierate era (age of Badr al-Jamālī). The boldness of this design choice should not be understated, as the architectonics behind rock-hewn vaults may have been deemed hazardous initially. After all, Abreha wa-Atsbeha's

nave vault (see Fig. 68) was seemingly reworked into a flat ceiling shortly after it was hewn, likely in response to initial rock fall.[51]

Alongside the aisled cruciform conception, three tiers of spatial hierarchy are employed at Abreha wa-Atsbeha, centered on the crossing (7 m) and choir (qeddest, 8 m), braced with vaulted cross arms (6 m) and flat aisle units (5 m). Especially when viewed from the lateral aisles (see Fig. 2), the vault system that is formed at the upper levels provides a dramatic frame for the engaged cross surmounting the crossing (see Fig. 72). This use of vaults and spatial massing was not replicated in Ethiopia until some centuries later (see conclusion). Moreover, as discussed in Chapter 1, Ethiopian basilicas generally follow either a hall format (post-thirteenth century) or a two-point pyramidal profile centered on the nave elevation (see Figs. 34, 35).

Barrel vaults in Ethiopia are rare, found only in rock-cut constructions; the first instances are Abreha wa-Atsbeha, Wuqro Cherqos, and Mika'el Amba, followed by several of the Lalibela churches in the thirteenth century. In the Aksumite period, vaulting was occasionally deployed in the context of elite funerary architecture, but in all cases it was engineered with brick voussoirs in a matrix of lime mortar.[52] As brick and mortar are

50 G. Forsyth Jr., "The Transept of Old St. Peter's at Rome," in *Late Classical and Mediaeval Studies in Honor of Albert Mathias Friend, Jr.*, ed. K. Weitzmann (Princeton, 1955), 56–70; E. Hadjitryphonos, "The Pilgrimage Monument as Space in the Eastern Mediterranean," in *Routes of Faith in the Medieval Mediterranean: History, Monuments, People, Pilgrimage Perspectives. Proceedings of an International Symposium, Thessalonike 7–10/11/2007*, ed. E. Hadjitryphonos (Thessaloniki, 2008), 31–48.

51 As illustrated in the engineering of modern tunnels, hewn barrel vaults have increased compression strength compared with other excavated spaces. The form of the round arch, when executed in a space with adequate overlay and wall thickness, evenly distributes the lateral and vertical load into the mother rock, functioning in a manner akin to buttresses. However, when hewn vaults are begun, the initial rounded bore created is structurally unstable and must be fully hewn into a half circle at a quick pace (called "stand-up time") before fissures and rock fall ruin the structure. Carvers unfamiliar with the architectonics of hewn barrel vaults may have inferred that, because initial rock fall occurred during stand-up time, its form compromised the structural stability of the rock overlay. Abreha wa-Atsbeha's nave ceiling, hewn east to west after the crossing module was spatially defined, probably caused some popping and peeling of the outer sandstone layer in the initial boring, which led to an abrupt change in the vault design. By contrast, the transept, which has an overall thicker rock overlay, may have been of as much concern for the masons, who were now more familiar with the architectonics of hewn vaults. On this engineering principle, see E. H. King, "Rock Tunnels," in *Tunnel Engineering Handbook*, ed. J. O. Bickel, T. R. Kuesel, and E. H. King, 2nd ed. (New York, 1996), 122–52, at 123–24.

52 J.-F. Breton, *Les bâtisseurs des deux rives de la mer Rouge / Builders across the Red Sea*, AÉ hors-série 5 (Paris, 2015), 61, 260–61.

not vernacular building techniques in the region, we can assume that their use in Aksumite times was the work of hired craftsmen from Yemen or Byzantium.[53] Indeed, already in the first decade of the twentieth century, members of the Deutsche Aksum expedition considered Wuqro Cherqos an anomaly due to its barrel-vaulted nave.[54] Moreover, although Aksumite churches are only confirmed at their foundations, they were in all likelihood timber-roofed as well, aside from the well-known Cathedral of Sanaa (see Fig. 22) whose mosaicked vaults were the likely work of Byzantine *mechanikoi* (engineers).[55]

In the fourteenth and fifteenth centuries we find the occasional use of freestanding wooden barrel vaults (Fig. 119) in the architecture of the central highlands (Bethlehem in Gayint, Zammadu Maryam, and Welie). However, medieval Ethiopians took care to distinguish these wooden vaults from true vaults, calling them *ʿaqd* (ዐቅድ) beams bound together rather than "vaults" (*qāmāra* [ቀመረ], after the Greek, καμάρα).[56] Engineered with timber beams and transverse wooden arches rather than centering or mortar, these wood vaults were not an architectural

revolution but rather an elaboration on existing carpentry practices.[57]

In the context of the aisled cruciform plan, the vaulted cross arms and flat aisle units at Abreha wa-Atsbeha formally evoke the spatial massing of sixth-century Byzantine precedents (see Figs. 2, 117).[58] The aforementioned sixth-century church of St. John in Ephesus and Panagia Ekatontapiliani are examples of this—aisled cruciform churches defined spatially through a vaulted nave, apse, and transept with a tall dome in the crossing and a pyramidal section relative to the aisle system.[59] At Abreha wa-Atsbeha, the crossing was embellished with a monolithic cross that also functioned alongside the barrel vaults to create a sort of heavenly space on the upper level (see Fig. 2).[60] This use of spatial massing dovetails well with conceptions of the heavens in the late antique Mediterranean (Fig. 120). The sixth-century traveling monk Cosmas Indicopleustes described heaven's relationship to earth as a barrel vault over a room:

The table was all around wreathed with a waved molding symbolic of the sea, which is

53 Breton, *Les bâtisseurs*, 60, 228. The "tomb of the brick arches" at the necropolis in Aksum, despite its mud and granite construction, includes the only extant barrel vault in Ethiopia, albeit a miniscule one set underneath a monolithic lintel; see D. W. Phillipson, *Ancient Churches of Ethiopia: Fourth–Fourteenth Centuries* (New Haven, 2009), 17; S. C. Munro-Hay, "Horse-Shoe Arches in Ancient Ethiopia," *RSE* 33 (1989): 157–61, at 159–60. There is a small brick structure of unknown use in Aksum, which had a chamber measuring some 4 meters long, and a vaulted hearth or oven in the "Dungur Palace," also in Aksum; F. Anfray, "L'archéologie d'Axoum en 1972," *Paideuma: Mitteilungen zur Kulturkunde* 18 (1972): 60–78, at 65; F. Anfray, *Le site de Dongour: Axoum, Ethiopie: Recherches archéologiques*, Archaeology as History 3 (Hamburg, 2012), 23. The last example is a single brick arch in the so-called "tomb of the false door" in the necropolis at Aksum; Munro-Hay, "Horse-Shoe Arches," 159–60; Breton, *Les bâtisseurs*, 61. Mortar is also used in the church of Maryam Nazret and the associated area around Addi Awona, presumably due to the presence or lasting impact of Egyptian artisans there from the mid-twelfth century on.

54 D. Krencker, ed., *Deutsche Aksum-Expedition*, vol. 2, *Ältere Denkmäler nordabessiniens* (Berlin, 1913), 181.

55 Though the dome appears to have been made of wood, and constructed in an Aksumite manner; for which, see Finster and Schmidt, "Die Kirche des Abraha," 77.

56 W. Leslau, *Comparative Dictionary of Geʿez* (Wiesbaden, 1987), 66, 432.

57 For Welie, see J. Mercier and C. Lepage, *Lalibela, Wonder of Ethiopia: The Monolithic Churches and Their Treasures* (London, 2012), 28, 33, 70, 84, 89, 98, 102. Identical trussed timber vaults are found in the Hanging Church in Cairo. For the Byzantine practice of centering through mortar instead of formwork, see R. Ousterhout, *Master Builders of Byzantium* (Princeton, 1999), 216–33. In the British Isles, formwork was sometimes made without timber, using wicker or soft stone instead; M. Thurlby, "The Use of Tufa Webbing and Wattle Centering in English Vaults down to 1340," in *Villard's Legacy: Studies in Medieval Technology, Science and Art in Memory of Jean Gimpel*, ed. M.-T. Zenner, AVISTA Studies in the History of Medieval Technology, Science and Art 2 (Aldershot, UK, 2004), 157–74. An early attempt at a freestanding barrel vault prior to the fourteenth century might be seen at the monastery of Dabra Dammo, which had a gambrel roof set atop several transverse wooden round arches, signaling that perhaps this was intended to evoke a freestanding, timber barrel vault.

58 Buchwald, "Western Asia Minor," 209–15; O. Demus, *Byzantine Mosaic Decoration: Aspects of Monumental Art in Byzantium* (London, 1948); L. Theis, *Flankenräume im mittelbyzantinischen Kirchenbau: Zur Befundsicherung, Rekonstruktion und Bedeutung einer verschwundenen architektonischen Form in Konstantinopel* (Wiesbaden, 2005), 168–80.

59 Karydis, *Early Byzantine Vaulted Construction*, 69–105; C. Foss, "Pilgrimage in Medieval Asia Minor," *DOP* 56 (2002): 129–51.

60 See David Buxton's diagram of Abreha wa-Atsbeha's "upper levels" in his "The Rock-Hewn and Other Medieval Churches of Tigré Province, Ethiopia," *Archaeologia* 103 (1971): 33–100, at 43, fig. 6.

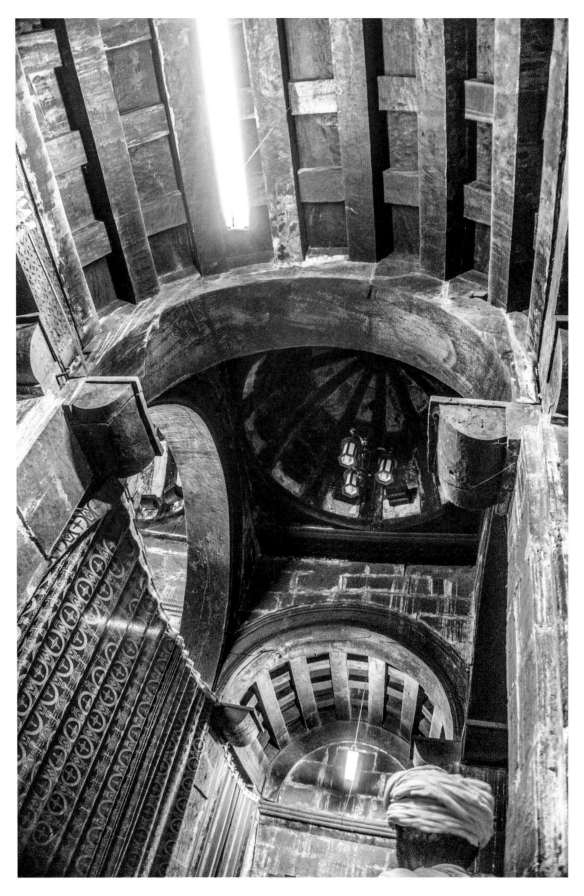

Figure 119.
Bethlehem, barrel-
vaulted cross arms
and crossing dome,
viewed north to south,
Gayint, Ethiopia.
Photograph by author.

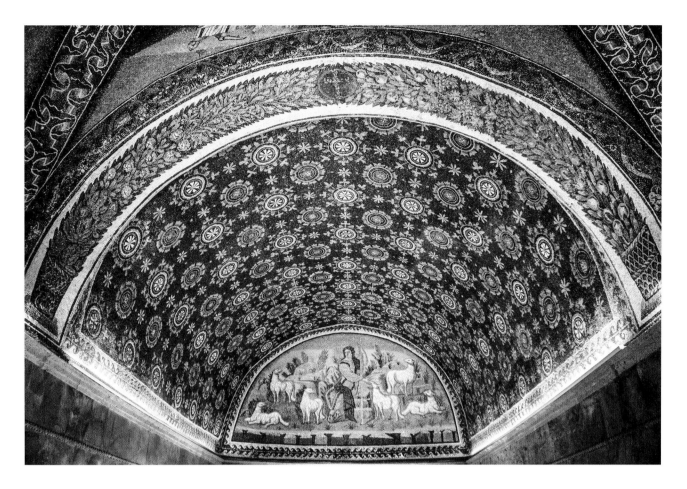

called the ocean, and all around this again was a border of a palm's breadth emblematic of the earth beyond the ocean, where lies paradise away in the east, and where also the extremities of the first heaven, which is like a vaulted chamber (καμαροειδοῦς), are everywhere supported on the extremities of the earth.[61]

In Ethiopia, too, we find analogous conceptions of heaven as a domed or vaulted enclosure. This is a trope of later hagiographies, though Antiochene conceptions of a heavenly dome may have also governed the plans of royal encampments.[62] The trope was applied to literary descriptions of ecclesiastical architecture as well: the chancel arches at the lost cathedral of Aksum Tseyon were referred to as *qästä dämäna* (ቀስተ : ደመን) or "rainbows."[63]

As much as barrel vaults recalled the architecture of Justinian's Byzantium, in the context of the late eleventh century they were also an innovation associated with (Fatimid) caliphal productions under the vizier Badr al-Jamālī. Builders had long used vaults in Egypt, but these were executed in the uncomplicated and lightweight medium of mud brick and in a vernacular catenary system (so-called Nubian vaults),

Figure 120. Mausoleum of Galla Placidia, north vault, Ravenna, Italy, fifth century. Photograph by author.

61 Cosmas Indicopleustes, *The Christian Topography* 3:52: Πέριξ δὲ τῆς τραπέζης κύκλῳ κυμάτιον στρεπτὸν σημαῖνον τὴν θάλασσαν, τὸν λεγόμενον Ὠκεανόν, εἶτα καὶ πέριξ τούτου πάλιν κύκλῳ στεφάνην παλαιστοῦ σημαίνουσαν τὴν πέραν γῆν, ἔνθα ἐστὶ καὶ ὁ παράδεισος κατὰ ἀνατολάς, ἔνθα καὶ τὰ ἄκρα τοῦ οὐρανοῦ τοῦ πρώτου τοῦ καμαροειδοῦς τοῖς ἄκροις τῆς γῆς πάντοθεν ἐπερείδεται; cited in S. Faller, "The World According to Cosmas Indicopleustes: Concepts and Illustrations of an Alexandrine Merchant and Monk," *Transcultural Studies* 2.1 (2011): 193–232, at 209.

62 M. K. Gebru, "Liturgical Cosmology: The Theological and Sacramental Dimensions of Creation in the Ethiopian Liturgy" (PhD diss., University of St. Michael's College, Toronto, 2012), 190; A. P. Lagopoulos and M.-G. L. Stylianoudi, "The Symbolism of Space in Ethiopia," *Aethiopica* 4 (2001): 55–95.

63 Mercier and Lepage, *Lalibela*, 91. See also Leslau, *Comparative Dictionary of Ge'ez*, 134; A. Bausi, "Un indice del *Liber Aksumae*," *Aethiopica* 9 (2006): 102–46, at 134.

Figure 121.
Bab al-Nasr
(Gate of Victory),
walls of Cairo,
Cairo, Egypt,
1087. Photograph
by author.

which required no formwork.[64] Since the Nile basin lacks forests, centering with precious timber was wasteful and opulent.[65] Much changed under Badr al-Jamālī, however, and centered ashlar "true vaults" became emblems of the Fatimid vizierate. The new walls of Cairo presented this ideological shift. Drawing inspiration from Byzantine fortification walls, the vizier had Cairo's mud-brick walls knocked down and replaced by multistoried ashlar gates, engineered with centered barrel and groin vaults (Fig. 121).[66]

Erected by hired Armenian architects, the walls of Cairo were a symbol of Badr al-Jamālī's resurgent caliphate, an "imperial" engineering feat that recalled the fourth-century Theodosian land walls of Constantinople.[67]

64 Grossmann, *Mittelalterliche Langhaus-Kuppelkirchen*, 239–43. See also P. Vitti, "Brick Vaulting without Centering in the Mediterranean from Antiquity to the Middle Ages," in *History of Construction Cultures: Proceedings of the 7th International Congress on Construction History (7ICCH 2021), July 12–16, 2021, Lisbon, Portugal*, ed. J. Mascarenhas-Mateus and A. P. Pires, 2 vols. (London, 2021), 1:119–25.

65 On the difficulties of erecting centered barrel vaults in premodern times, see S. M. Holzer, "How to Build a (Brick) Barrel Vault," in Mascarenhas-Mateus and Pires, *History of Construction Cultures*, 1:757–64.

66 S. Pradines, "Identity and Architecture: The Fāṭimid Walls in Cairo," in *Earthen Architecture in Muslim Cultures:*

Historical and Anthropological Perspectives, ed. S. Pradines, Arts and Archaeology of the Islamic World 10 (Leiden, 2018), 104–45, at 129–35. On the "classical revival" in the Fatimid period, see O. Grabar, "Imperial and Urban Art in Islam: The Subject-Matter of Fatimid Art," in O. Grabar, *Early Islamic Art, 650–1100*, vol. 1, *Constructing the Study of Islamic Art* (Aldershot, UK, 2005), 173–90, https://www.archnet.org/publications/4980; E. J. Grube, "Studies in the Survival and Continuity of Pre-Muslim Traditions in Egyptian Islamic Art," *JARCE* 1 (1962): 75–97; R. Ettinghausen, "Early Realism in Islamic Art," in *Studi orientalistici in onore di Giorgio Levi Della Vida*, 2 vols. (Rome, 1956), 1:250–73. For architecture, see M. Barrucand, "Remarks on the Iconography of the Medieval Capitals of Cairo: Form and Emplacement," in *The Iconography of Islamic Art: Studies in Honour of Robert Hillenbrand*, ed. B. O'Kane (Edinburgh, 2005), 23–44; J. M. Bloom, *Arts of the City Victorious: Islamic Art and Architecture in Fatimid North Africa and Egypt* (New Haven, 2007), 129–55.

67 T. Allen, *A Classical Revival in Islamic Architecture* (Wiesbaden, 1986), 29–35. On the Theodosian walls of Constantinople, see N. Asutay-Effenberger, *Die Landmauer von*

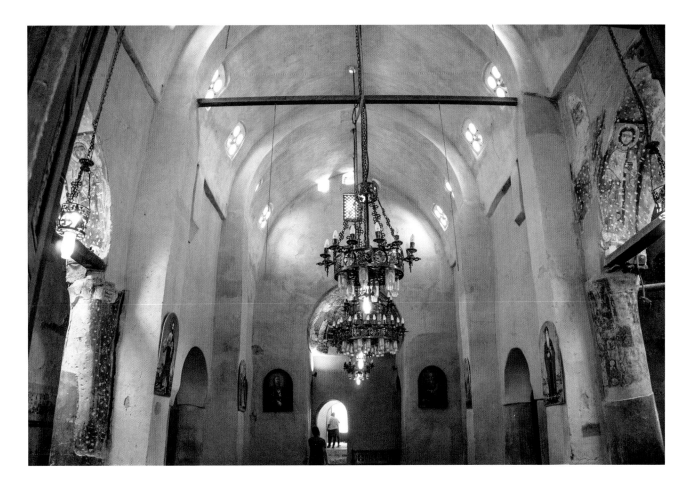

The Coptic church was not immune to caliphal architectural trends either. As with mosques and fortifications produced under Badr al-Jamālī, the Copts also integrated vaults and domes into their churches at that time (Fig. 122).[68] The monastery church of Deir al-Surian (Dayr al-Suryān) in Wadi Natrun, is a good example of this.[69] This church, which stood near to known Ethiopian hermitages in the Nile Delta, was extensively recast in the Fatimid period.[70] Established atop a building fabric from the early eighth century, the church was outfitted in the tenth and eleventh centuries with elaborately fenestrated domes (in the contemporary "Islamic" manner) over its sanctuary (haykal; Fig. 123) and choir (khūrus), each screened with inlaid wood iconostases, or hijab screens.[71] Slightly later, in the early thirteenth century, the monastery church was crowned with elaborate vaults to enhance the pyramidal division of space (see Fig. 122).[72] The nave arcade was later crowned with a barrel vault that was segmented by

Figure 122.
Deir al-Surian, nave and west end, Wadi Natrun, Egypt, early thirteenth and eighteenth centuries (?). Photograph by author.

Konstantinopel-İstanbul: Historisch-topographische und baugeschichtliche Untersuchungen, Millennium-Studien 18 (Berlin, 2007), 13–117.

68 This Fatimid-era trend took different paths in Egypt, ultimately according to geography. In Lower Egypt, basilicas were crowned with barrel vaults. In Upper Egypt, basilicas utilized domes, usually over both the choir and altar, which developed into the so-called egg-carton churches of late medieval Egypt: hall churches with multiple domed bays. On this parallel development, see Grossmann, *Mittelalterliche Langhaus-Kuppelkirchen*, 1–137.

69 See also the poorly preserved, likely late eleventh-century church of St. Menas in Fustat (Old Cairo); Grossmann, *Mittelalterliche Langhaus-Kuppelkirchen*, 13–16.

70 Grossmann, *Christliche Architektur in Ägypten*, 501–3; P. Grossmann and A. Cody, "Dayr al-Suryan," in *Coptic Encyclopedia*, 3:876–81.

71 P. Grossmann, "Neue Beobachtungen zur al-ʿAḏrāʾ-kirche von Dair as-Suryân," *Nubian Letters* 19 (1993): 1–8, https://medievalsaiproject.files.wordpress.com/2013/09/nubian-letters-19.pdf; Grossmann, *Mittelalterliche Langhaus-Kuppelkirchen*, 112–20.

72 K. Innemée, "The Church of the Holy Virgin in Deir al-Surian: New Insights in Its Architecture," *BSAC*, forthcoming. I thank Karel Innemée for sharing his important article with me prior to publication.

Figure 123.
Deir al-Surian,
sanctuary dome,
Wadi Natrun,
Egypt, tenth to
eleventh century.
Photograph
by author.

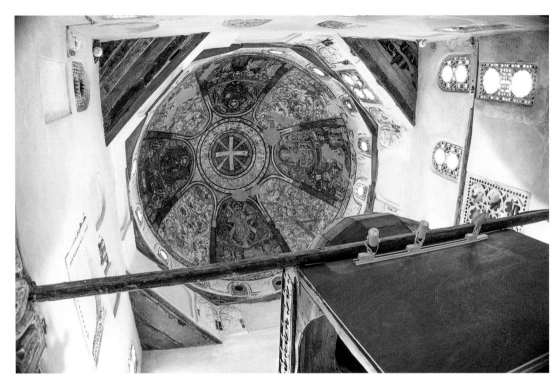

transverse arches and pilaster responds to contrast with the (now) groin-vaulted aisles.

The Shiʿi Fatimid vizier Badr al-Jamālī, himself formerly enslaved (*mamlūk*) of Christian Armenian extraction, is thought to have explicitly chosen monastic prototypes for his final resting place.[73] We find in the architecture of his *mashhad* (funerary mosque, eponymously called Juyushi [al-Juyūshī]) from 1085, overlooking Cairo, a centered masonry structure that is both axial and muscular—not unlike contemporary Christian basilicas. Unlike the wide hypostyle mosques typical of Fatimid Cairo, we find at the Juyushi Mosque a tight, six-bay, groin-vaulted core that anticipates an elaborately fenestrated, domed qibla wall, a spatial conception that closely resembles the elaborate khūrus of contemporary monasteries in Wadi Natrun.[74]

As at Deir al-Surian, and to a lesser extent the Juyushi Mosque, we find at Abreha wa-Atsbeha a direct borrowing of Fatimid vaulting practices in service of the liturgy—in this case, the domed side chambers (see Figs. 78, 79).[75] Although domes are typically used to express the sanctuary space in Tigrayan churches (both hewn and freestanding), in all cases they are timber and ribbed with a framework, carried by angled boards instead of a tambour (in the manner of a lantern ceiling; see Fig. 73, cf. Fig. 41).[76] In Fatimid architecture, however, domes (sg. *qubba*) were elaborately transitioned with multiple courses of well-fenestrated octagonal drums (zones of transition) atop square bases, a layout known as the domed cube (found at the aforementioned monastery church, Fig. 123, as well as the Egyptian cathedral at Maryam Nazret, see Fig. 41), which is used in elite

73 B. Finster, "On Masjid al-Juyushi on the Muqattam," *Archéologie islamique* 10 (2000): 65–78. Others have posited that it was built as a disguised watchtower, or a regular, if atypical mosque; see respectively F. Shāfeʿī, "The Mashhad al-Juyūshī (Archaeological Notes and Studies)," in *Studies in Islamic Art and Architecture in Honour of Professor K. A. C. Creswell* (London, 1965), 237–52; Y. Rāġib, "Un oratoire fatimide au sommet du Muqaṭṭam," *Studia Islamica* 65 (1987): 51–67.

74 See, in particular, the old church of Mary at Deir al-Baramus [Dayr al-Barāmūs]; Grossmann, *Mittelalterliche Langhaus-Kuppelkirchen*, 122–23.

75 During this period, the Byzantine Empire also borrowed architectural terminology from Islamic lands because of its prestigious connotations; A. Walker, "Middle Byzantine Aesthetics and the Incomparability of Islamic Art: The Architectural Ekphraseis of Nikolaos Mesarites," *Muqarnas* 27 (2010): 79–101.

76 A comparison of the churches presented in Chapter 1 shows that almost all feature these domes over the choir/sanctuary. Maryam Nazret is the exception, though it was built by Egyptians.

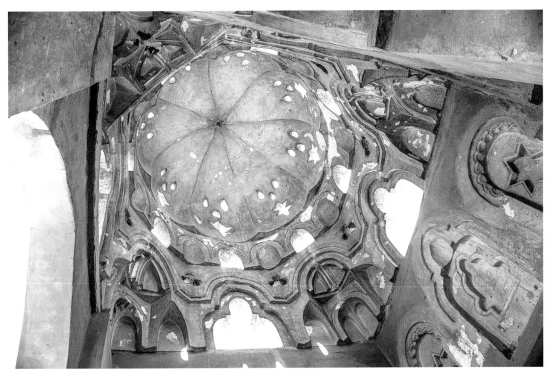

Figure 124.
Qus tomb
tower, pumpkin
dome, al-ʿAmri
mosque, Qus,
Egypt, Fatimid.
Photograph
by author.

mosques, churches, and tomb towers alike.[77] Although the choir dome petrifies a Tigrayan structural system (see Fig. 73), the side chambers at Abreha wa-Atsbeha (see Figs. 78, 79) are Fatimid domed cubes. Each room is transformed into a segmented dome by a drum arcaded with pointed arches. Unlike in the mud-brick towers of Egypt, the hewn chambers at Abreha wa-Atsbeha do not require structural support. The pastophoria at Abreha wa-Atsbeha incorporate transitional zones that are elongated and flattened to cover the full circumferences of the square rooms, while the dome apexes are surbased so as not to compromise the rock overlay. Without a need for light diffusion or structural support, the arcaded transitional zone is reduced to shallow strapwork akin to the low-relief decorations that cover the dado walls (see Fig. 78). Although referential, the fenestration implied by the decorative arcades may have carried Fatimid symbolism: diffused light was the light of God in Ismaili contexts, a metaphor otherwise well illustrated

with the presence of star-shaped apertures in the Fatimid-era tomb tower in Qus (Fig. 124).[78] Considered in the Christian context of a prothesis chamber, the implied openwork drum suggests that the sacraments were symbolically bathed in divine light. That said, the conception of these rooms as domed cubes may not have been strictly based on the built environment. The linked arches that surmount the "zone of transition" in the south chamber of Abreha wa-Atsbeha are deeply ornamental, perhaps adapted from the schematic designs of soft furnishings brought from Fatimid Cairo to East Tigray. Indeed, a luxurious eleventh-century coffer slab in the Islamic Museum of Cairo (Fig. 125) bears this same linked-cross design in the service of

77 L. ʿA. Ibrāhīm, "The Transitional Zones of Domes in Cairene Architecture," *Kunst des Orients* 10.1/2 (1975): 5–23; Grossmann, *Mittelalterliche Langhaus-Kuppelkirchen*, 259–73. For Fatimid tomb towers, see ʿA.-R. M. ʿAbd al-Tawab, *Stèles islamiques de la nécropole d'Assouan* (Cairo, 1977).

78 C. Williams, "The Cult of ʿAlid Saints in the Fatimid Monuments of Cairo, Part II: The Mausolea," *Muqarnas* 3 (1985): 39–60; M. B. Khan, "*Chirāgh-i Rōshan*: Prophetic Light in the Ismāʿīlī Tradition," *Islamic Studies* 52.3–4 (2013): 327–56. For the cubical mausoleum at Qus, see Ḥ. ʿAbd al-Wahhāb, "Dome Decorations by Means of Pierced Openings," in *Studies [. . .] in Honour of Professor K. A. C. Creswell*, 95–104; C. Añorve-Tschirgi and O. Seif, "Fatimid Frontiers: The Mausoleum of Qus as a Case Study," in *The International Conference on Heritage of Naqada and Qus Region: Monastery of the Archangel Michael, Naqada, Egypt, 22–28 January 2007*, ed. H. Hanna, 2 vols. (Cairo, 2007), 1:149–60.

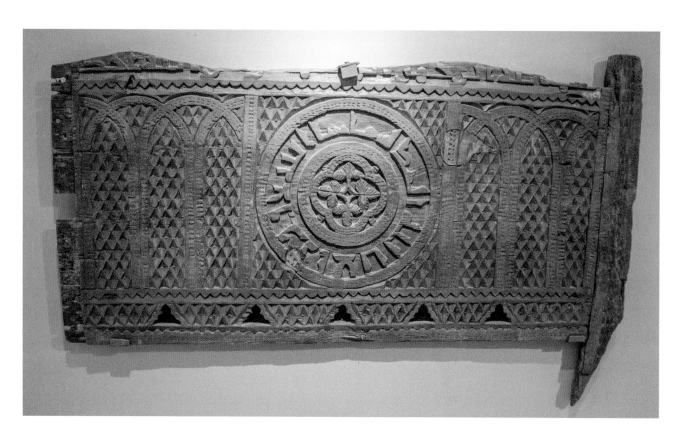

Figure 125.
Fatimid wood
panel, wood, Cairo,
Egypt, ca. 1000.
Museum of Islamic
Art, Cairo, inv. no.
9929. Photograph
by author; courtesy
of the Museum of
Islamic Art.

an abstracted dome.[79] In this way, Abreha wa-Atsbeha, as a possible episcopal center, may have incorporated Fatimid-style domes and barrel vaults as an expression of contemporary Egyptian ecclesiastical prestige, to complement and enhance the sixth-century revivalism otherwise found in its cruciform, vaulted, conception.

The use of vaults and domed cubes in the conception of Abreha wa-Atsbeha was motivated by complex and multifarious factors. Although the great cruciform churches of Justinian's Byzantium were engineered with vaulted cross arms and dramatic pyramidal spatial massing (see Fig. 117), barrel vaults and domed cubes also bore revolutionary connotations in the contemporary (eleventh-century) Fatimid caliphate. Because Tigrayan hypogea were typically indebted to freestanding forms, the decision to incorporate barrel vaults should not be understated. The use of vaults in the service of biaxial, tripartite

spatial hierarchy was a singular occurrence, an architectural revolution that embellished and underscored the late antique revival style of these great churches.

"Aksumite" Architecture

Tigrayan cruciform churches are wholly local endeavors. Apart from the vaults and domed cubes (in the pastophoria of Abreha wa-Atsbeha), most of the architectural forms that we find petrified in stone are easily located elsewhere in the built environment of Tigray. This should come as no surprise. As was shown in Chapter 1, from the earliest adoption of Christianity by the Aksumites on, church architecture was consistently expressed through a local idiom. A dramatic example is the twelfth-century fabric of Cherqos Agabo (see Fig. 45), a mirror image of the half-timbered coursing and setbacks sculpted on fourth-century Aksumite stelae (see Fig. 9) constructed nearly a millennium earlier.[80]

Niall Finneran and David Phillipson have taken pains to establish the roots of post-

79 E. Pauty, *Catalogue général du Musée arabe du Caire: Les bois sculptés jusqu'à l'époque ayyoubide* (Cairo, 1931), 64–65. This fragment was likely from a casket, akin to the roughly contemporary example outlined in A.-F. al-ʿUsh, "Les bois de l'ancien mausolée de Khālid ibn al-Walīd a Ḥimṣ," *Ars orientalis* 5 (1963): 111–39.

80 Phillipson, *Ancient Churches of Ethiopia*, 71.

Aksumite architecture in the antique past.[81] Both scholars regard the medieval use of local architectural forms as a politically motivated campaign of survival or revival.[82] For the Tigrayan cruciform churches in particular, one finds Aksumite precedent in nearly every facet of their design. The frieze of blind windows that crown each architrave, a ubiquitous motif in Tigrayan architecture, is easily discovered in the false windows and doors of Aksum's funerary monuments (see Fig. 9, perhaps ultimately drawn from a classical vocabulary of metopes).[83] Cyma moldings and chamfered piers are rendered faithfully from the many Aksumite ruins that dot the Tigrayan highlands.[84] Various types of capitals used in the three churches (bracket, cushion, and stepped) mirror those recovered from sixth-century ruins such as Maryam Nazret (see Fig. 18) and Mifsas Bahri.[85] Lantern ceilings (as found in Wuqro Cherqos; see Fig. 110) replicate freestanding examples, such as those that once crowned Zarama Giyorgis's exedra, while the choir domes spring from flat oblique planes, as at Dabra Dammo.[86] The ceiling crosses above the crossing appear rooted in the crossed "lintels" crowning the sanctuary at the seventh-century (north) church of Degum

Selassie. Even the cruciform compound piers that carry the crossing are part of the Aksumite record: pier sections identical to those employed in Abreha wa-Atsbeha, Wuqro Cherqos, and Mika'el Amba were found at an Aksumite outpost in the Danakil Depression by Italian surveyors in 1909 (Fig. 126).[87]

However, the sheer ubiquity of Aksumite forms in the architecture of medieval Tigray also resists a teleological reading.[88] One should note that the "Aksumite"-style church neighboring the temple at Yeha (half-timbered and adorned with monkey head bosses) was built in 1948.[89] Robert Coates-Stephens wrote on the "conservatism" of early medieval church architecture in Rome that patrons there were likely motivated by the venerable presences of past monuments rather than the staging of distinct "renaissances,"[90] and by the same token medieval Tigray remained in the perpetual shadow of the ancient world.[91] The dilapidated ruins (as at Aksum; see Fig. 9) and reconstituted spolia in and around medieval settlements, as at Maryam Nazret (see Fig. 18) and Ura Masqal (Ura Mäsqäl), were constant wellsprings for architectural inspiration and veneration.[92] Thus, rather than local building

81 Phillipson, *Ancient Churches of Ethiopia*, 92–98, 183–91.

82 N. Finneran, *The Archaeology of Ethiopia* (Abingdon, UK, 2007), 214–15, 224; D. W. Phillipson, "The Aksumite Roots of Medieval Ethiopia," *Azania: Archaeological Research in Africa* 39.1 (2004): 77–89. See also J. Tromp, "Aksumite Architecture and Church Building in the Ethiopian Highlands," *Eastern Christian Art* 4 (2007): 49–75.

83 E. Fritsch, "Twin Pillars: An Epistemological Note in Church Archaeology," *AÉ* 25 (2010): 103–11, at 105–7. See also B. Playne, "Notices brèves: Suggestions on the Origin of the 'False Doors' of the Axumite Stelae," *AÉ* 6 (1965): 279–80.

84 See the mold profiles recorded from Aksumite sites, in Krencker, *Deutsche Aksum-Expedition*, 101–6.

85 M. Gaudiello and P. A. Yule, eds., *Mifsas Baḥri: A Late Aksumite Frontier Community in the Mountains of Southern Tigray. Survey, Excavation and Analysis, 2013–16*, BAR International Series 2839 (Oxford, 2017), 236–44; M.-L. Derat et al., "Māryām Nāzrēt (Ethiopia): The Twelfth Century Transformations of an Aksumite Site in Connection with an Egyptian Christian Community," *Cahiers d'études africaines* 239.3 (2020): 473–507, at 476.

86 C. Lepage, "L'église de Zaréma (Éthiopie) découverte en mai 1973 et son apport à l'histoire de l'architecture éthiopienne," *CRAI* 117.3 (1973): 416–54, at 432; D. Matthews and A. Mordini, "The Monastery of Debra Damo, Ethiopia," *Archaeologia* 97 (1959): 1–58, at 44. See also T. von Lüpke, *Deutsche Aksum-Expedition*, vol. 3, *Profan- und Kultbauten nordabessiniens, aus älterer und neuerer Zeit* (Berlin, 1913), 16.

87 The publication of the mission did not include photographs of the ruins, however; A. M. Tancredi, "Nel Piano del Sale," *Bollettino della Società geografica italiana* 12 (1911): 57–84, 150–78.

88 See Fritsch, "Twin Pillars." A similar argument is made in regard to Gothic architecture in M. Trachtenberg, "Desedimenting Time: Gothic Column/Paradigm Shifter," *RES: Anthropology and Aesthetics* 40 (2001): 5–28.

89 Phillipson, *Ancient Churches of Ethiopia*, 37.

90 R. Coates-Stephens, "Dark Age Architecture in Rome," *Papers of the BSR* 65 (1997): 177–232. See also D. Kinney, "Rome in the Twelfth Century: *Urbs fracta* and *renovatio*," *Gesta* 45.2 (2006): 199–220.

91 Moreover, it is also unclear which state structures post-Aksumite Tigrayans saw in these ancient ruins. Although conveniently called an empire by scholars (including the present author), it is unclear whether ancient Aksum was a coherent state or a collection of affiliated cities.

92 A huge number of Aksumite remains can still be viewed in the open air, just as medieval Tigrayans saw them. See, for example, the sites recorded in E. Godet, "Répertoire des sites pré-axoumites et axoumites du Tigré (Ethiopie)," *Abbay* 8 (1977): 19–58; E. Godet, "Répertoire des sites pré-axoumites et axoumites d'Éthiopie du Nord, II partie: Érythrée," *Abbay* 11 (1980–82): 73–113; F. Anfray, "Nouveaux sites antiques," *JES* 11.2 (1973): 13–27; J. Leclant and A. Miquel, "Reconnaissances dans l'Agamé: Goulo-Makeda et Sabéa (octobre 1955 et avril 1956)," *AÉ* 3 (1959): 107–29. See also for sites further afield, W. G. C. Smidt, "Ein

Figure 126.
Unidentified Aksumite
cruciform drum pillar,
Dancallia, Eritrea,
1909. Photograph by
Alfonso Tancredi,
courtesy of the Archivio
fotografico della Società
Geografica Italiana.

practices perpetuating an Aksumite architectural iconography, I suggest that these near ubiquitous forms should be understood as a broad reflection of elite building practice, shared by the region's prestigious monuments from antiquity to the present day.

Form and Function

Given the unique, biaxial conceptions of Tigrayan cruciform churches, it may be asked what, if anything, of their architecture and articulation was explicitly liturgical. After all, sermons can be given anywhere, and to administer the Eucharist, all that is needed is an altar, liturgical implements, a priest, and a celebrant.[93]

Broadly speaking, if we are to understand Tigrayan cruciform churches in terms of liturgy, aside from the return aisle, bema, and eastern passage behind the chancel, very little is explicitly necessary for the rituals performed within them.[94] Moreover, the presence of extensive fire damage in the interiors of both Abreha wa-Atsbeha (see Fig. 68) and Wuqro Cherqos (see Fig. 103) might indicate that light penetration was not adequate for worship and parishioners relied on torches

wenig erforschter aksumitischer Platz in Däbrä Gärgiš, ʾAddi Daʾəro, Təgray," *Aethiopica* 10 (2007): 106–14.

93 V. Marinis, *Architecture and Ritual in the Churches of Constantinople: Ninth to Fifteenth Centuries* (New York, 2013), 7–8.

94 Instances of liturgy changing to fit large spaces, rather than the other way around, are well documented outside of Ethiopia in the Gothic churches of Noyon and Beauvais in addition to the Hagia Sophia. See R. J. Mainstone, *Hagia Sophia: Architecture, Structure, and Liturgy of Justinian's Great Church* (New York, 1988), 230; Marinis, *Architecture and Ritual*, 10–11; A. Tallon, "Acoustics at the Intersection of Architecture and Music: The *Caveau Phonocamptique* of Noyon Cathedral," *JSAH* 75.3 (2016): 263–80; A. Tallon, "The Play of Daniel in the Cathedral of Beauvais," in *Resounding Images: Medieval Intersections of Art, Music, and Sound*, ed. S. Boynton and D. J. Reilly (Turnhout, 2015), 205–20.

for light. Although Claude Lepage has suggested that the wide, biaxial configuration of Abreha wa-Atsbeha was to fit monastic congregations, while true, that only accounts for its size, which the aforementioned church of Yohannes Matmaq (see Fig. 36) surpasses with its otherwise longitudinal, basilican layout.[95] That said, the aisle system that runs along the nave and transept in both Abreha wa-Atsbeha and Mika'el Amba (Wuqro Cherqos is narrowed into a basilica, see Chap. 2) likely accounts for specific ritual use, with the transverse passage serving as both a pilgrim's ambulatory and a monastic processional space.

Aside from their cruciform shape, the churches exhibit a wide range of sculpted crosses, from the elaborate hewn crosses surmounting the crossing to the sculpted staff crosses rendered on the transept portals, all of which may have been planned for liturgical purposes. The sculptures that flank the transept portals are unique to Tigrayan cruciform churches; they look like petrified staff (processional) crosses. These sculptures are precisely rendered, perhaps copied from metalwork prototypes used within them. Abreha wa-Atsbeha's crosses (see Fig. 80) are the most elaborate and can be easily found in historical precedent. The rounded tops evoke the ankh or *crux ansata* of the Coptic church, and details that suggest human faces recall early medieval Egyptian decorative arts (as with the "Cross of Esna" held at the Metropolitan Museum of Art; Fig. 127). This Coptic connection is underscored by the fine sculpting of palmettes on the cross arms, which, in addition to the affronted dolphins on the crown, tie these sculptures to the classical vocabulary of the Mediterranean world, albeit refracted through the decorative arts of Christians in Alexandria and Fustat as well as in upper Egyptian monastic centers like those at Sohag (Fig. 128).[96] Although similar crosses were intended for Mika'el Amba in its first phase (see Fig. 96), these were left unfinished.

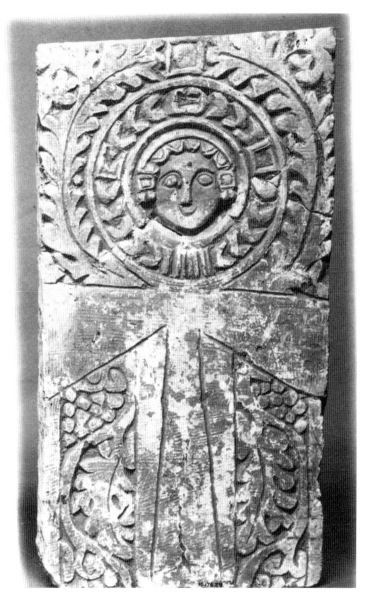

Figure 127. Funerary stele with ankh (looped cross) featuring a human face at the center, sixth or seventh century, attributed to Egypt, Akhmim. Metropolitan Museum of Art, New York, inv. no. 10.176.29, Rogers Fund 1910. Courtesy of the Metropolitan Museu of Art.

The recarved north cross from the church's second phase appears drawn from a local processional cross from the twelfth century or later.[97] The simpler inscribed Maltese crosses at Wuqro Cherqos (see Fig. 104), like the crux ansata at

95 Lepage and Mercier, *Les églises historiques*, 73, 79.

96 H. Maguire, "Epigrams, Art, and the "Macedonian Renaissance," *DOP* 48 (1994): 105–15; D. Bénazeth, *L'art du métal au début de l'ère chrétienne* (Paris, 1992), 64, 79, 81, 83, 109, 111–13, 143–48, 156–57, 169; *L'Art copte en Égypte: 2000 ans de christianisme* (Paris, 2000), 135; G. Gabra and M. Eaton-Krauss, *The Treasures of Coptic Art: In the Coptic Museum and Churches of Old Cairo* (Cairo, 2007), 32, 45. For Coptic crosses more broadly, see L. Del Francia Barocas, "L'immagine della croce nell'egitto cristiano," *RSO* new ser., 85.1–4 (2012): 165–211.

97 These may have been added during later interventions at the site, as similar processional crosses are attributes of the sculpted saints in Beta Golgotha in the Lalibela complex. See also J. Mercier, *Art of Ethiopia: From the Origins to the Golden Century* (Paris, 2021), 68–70.

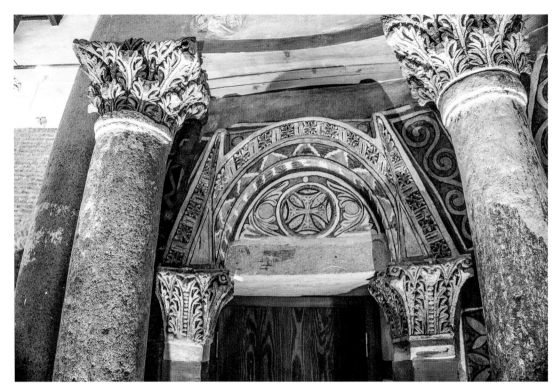

Figure 128. Red Monastery, pediment detail, east face, west portal of the north conch, Sohag, Egypt, sixth century. Photograph by author.

Abreha wa-Atsbeha, are clearly Egyptianizing and can be matched with period-specific examples of Coptic metalwork *in extenso*.[98] In all cases, these crosses served a dual function. Whereas their form was that of petrified, episcopal Egyptian iconography, these sculpted crosses functioned as if continuously lofted. Placed adjacent to thresholds, these crosses may have been hewn to automatically bless entrants to the church (the center portal was likely reserved for clergy).[99] Likewise, the sculpted brackets on Abreha wa-Atsbeha's ceiling

cross appear to stem from Egyptian decorative arts. Adorned with crosses atop split palmettes, this motif appears borrowed, precisely, from a Coptic portable object: its decorative repertoire is easily located in soft furnishings, such as the tenth-century chancel at the monastery of Deir al-Surian in Wadi Natrun (Fig. 129), as well as architectural sculpture, such as the rendered pediments in the sixth-century Red Monastery triconch in Sohag, Upper Egypt.[100]

The engaged ceiling crosses above the crossing spaces of Tigrayan cruciform churches are also liturgically charged. As well as supplying the apex of pyramidal massing in the church (see Figs. 2, 72), these crosses also signal the entry to the choir where the sacraments were distributed to laypeople in the medieval Coptic liturgy (still a practice in the present day);[101] the divine liturgy

98 Bénazeth, *L'art du métal*, 178. Inscribed Maltese crosses are also found in the ornamental program of the Red Monastery; see W. Lyster, "Preliminary Catalog of Designs and Motifs in the Red Monastery Church Sohag, Egypt" (3rd ed.) (unpubl., Egyptian Antiquities Conservation Project American Research Center in Egypt, [2010]), 68. I thank William Lyster for allowing me to see his manuscript. Several bronze Maltese crosses were recovered from both the site of Yeha in Tigray and nearby tombs; J. Doresse, "Les premiers monuments chrétiens de l'Éthiopie et l'église archaïque de Yéha," *NT* 1.3 (1956): 209–24, at 219 and pl. II; F. Anfray, "Une campagne de fouilles à Yěḥā (février–mars 1960)," *AÉ* 5 (1963): 171–232, at 189 and pl. CLII.

99 Claude Lepage refers to them as "consecration crosses" functioning as an apotropaic protection against demons entering the church; Lepage and Mercier, *Les églises historiques*, 81. As in other Orthodox contexts, processional crosses still serve as a priestly attribute during processions as well as for blessings in large gatherings; J. A. Cotsonis, *Byzantine Figural Processional Crosses*, Dumbarton Oaks Byzantine Collection Publications 10

(Washington, DC, 1994), 8–39. For the earliest known processional cross in Tigray, see Mercier, *Art of Ethiopia*, 49–51.

100 Lyster, "Preliminary Catalog," 70–71. A similar motif appears on later staff crosses from the central highlands; Mercier, *Art of Ethiopia*, 62–74. See also later Ethiopian crosses with this iconography in Mercier and Lepage, *Lalibela*, 133.

101 R. Mikhail, *The Presentation of the Lamb: The Prothesis and Preparatory Rites of the Coptic Liturgy*, Studies in Eastern Christian Liturgies 2 (Münster, 2020), 374–75.

158 BASTIONS OF THE CROSS

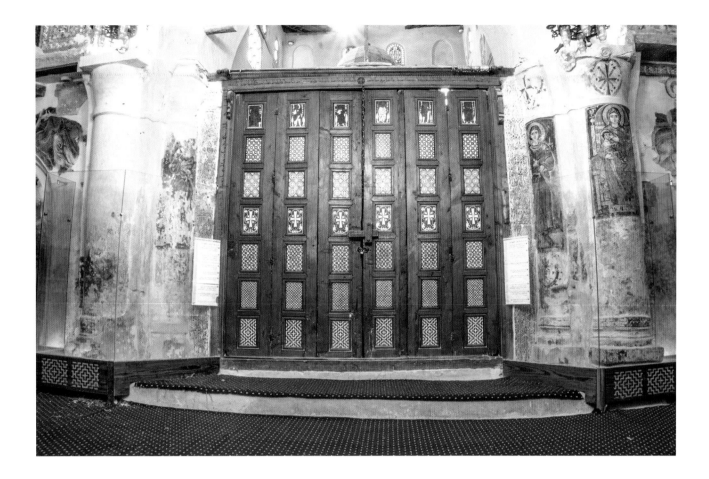

occurred therefore under the sign of the cross.[102] As every holy liturgy is a consecration, the ceiling crosses are, in the context of the Eucharistic celebration, a reenactment of Constantine's fourth-century vision and conversion (especially for the Good Friday "Veneration of the Cross").[103] For that same reason, the ceiling crosses that top the narthexes of Wuqro Cherqos and Mika'el Amba (probably Abreha wa-Atsbeha as well) also mirror the crossing. This relationship was metaphorical

as well as formal: the crossing is the threshold to the sanctuary, just as the narthex is the threshold to the church.[104] In the case of Wuqro Cherqos, this relationship is explicit—several ornamental patterns on the crossing are consistent in form and placement with the narthex (see Figs. 101, 107).[105] As liturgical thresholds (prothesis), Wuqro Cherqos's side rooms, which are topped by ceiling crosses (see Fig. 110) that parallel both the crossing and narthex, also fit this paradigm.

The sculpted cross was also self-referential. The crossing bay presents the church in microcosm: this consistent square module (3 × 3 with a depth of 4 m) is both sculpted with a relief cross and serves as the crux of a cross-shaped church.

102 On Cappadocian ceiling crosses and their symbolism, see A. L. McMichael, "Rising above the Faithful: Monumental Ceiling Crosses in Byzantine Cappadocia" (PhD diss., CUNY Graduate Center, 2018), 83–135.

103 Despite originating in Jerusalem, the ritual of the "Veneration of the Cross" became part of the Byzantine rite around the tenth century, and was likely used in Coptic, and by proxy Ethiopian, liturgy shortly after. See R. Mikhail, "Prostrating, Processing, and Burying: The Human Body and Its Participation in the Coptic Tradition for Great Friday," in *Le corps humain dans la liturgie: 65e Semaine d'études liturgiques, Paris, Institut Saint-Serge, 2–5 juillet 2018*, ed. A. Lossky, G. Sekulovski, and T. Pott (Münster, 2019), 179–91, at 182–83. For the Byzantine ritual, see R. Bornert, "La célébration de la sainte croix dans le rite byzantin," *La Maison-Dieu* 75 (1963): 92–108.

104 This architectural mode of citation is common elsewhere in the eastern Christian world. See N. Stankovic, "At the Threshold of the Heavens: The Narthex and Adjacent Spaces in Middle Byzantine Churches of Mount Athos (10th–11th Centuries): Architecture, Function, and Meaning" (PhD diss., Princeton University, 2018), esp. 459–62; Marinis, *Architecture and Ritual*, esp. 64–99.

105 Muehlbauer, "'Bastions of the Cross,'" 386, 398–402.

Figure 129. Deir al-Surian, wooden sanctuary screen, Wadi Natrun, Egypt, early tenth century. Photograph by author.

The crossing was also where the two axes of the church were planned and hewn, which, with my relative chronology in mind, bears ecumenical as well as apocalyptic connotations. The seventh-century Syriac apocalypse of Pseudo-Methodius (likely localized into Ethiopia in medieval times) envisions the end of the world as an equilateral ceiling cross that grows to encompass the "ends of the earth."[106]

That said, notwithstanding the near millennium that has passed since these churches were first hewn, they still remain operational for regular parish use and, in the case of Mika'el Amba and Wuqro Cherqos, the monastic typicon. Their comparatively large size can hold a good number of parishioners, while the hewn dado-benches make them accessible to elderly and disabled congregants (other congregants must stand). In Abreha wa-Atsbeha and Mika'el Amba, where there is a pronounced transept, the parish priests use the lateral aisles as a circuit to bless congregants with processional crosses or gospel books.

The Global Year 1000

Tigrayan cruciform churches were products of their time. As I have shown here, Ethiopia's late eleventh century was not a Dark Age but rather a forgotten watershed in the architectural history of Eastern Christianity. The immense resources marshaled to hew Abreha wa-Atsbeha, Wuqro Cherqos, and Mika'el Amba had not been seen in the region since the heady days of the sixth century. This circumstance was embraced by the elites of post-Aksumite Tigray, who chose to present their millennial resurgence through the lens of their old "golden age." This ideology was not defined by continuing to replicate local elite architectural forms (hitherto called "Aksumite"), but to borrow architectural iconography from a long-vanished Byzantium, which were then hewn

according to contemporary elite architectural vocabularies of Tigray and Fatimid Egypt.

Indeed, when considered from a global perspective, we find remarkable parallels to Tigrayan cruciform churches in the millennial architecture produced elsewhere, that is, an analogous, ideologically motivated recasting of sixth-century architectural forms through local fabrics and contemporary architectonics in Byzantium and Western Europe. The aforementioned Justinianic-style rendition of the church of San Marco in Venice (see Fig. 1), from 1063, is just one example, albeit one that is particularly evocative and roughly contemporary: an act of desire for ecumenism by a burgeoning polity on the edge of empire, staged in the contemporary manner, yet ultimately indebted to sixth-century Byzantium for its architectural iconography. Indeed, the Byzantines themselves, the direct heirs to Justinian, also looked inward toward the sixth century in that period. Justinian the Great was a source of inspiration for the reigning Komnenian dynasty (r. 1081–1185), whose Byzantine Empire was on the brink of collapse after the Seljuk victory at Manzikert in 1071.[107] Imperial building projects focused on reviving and reinventing architectural forms associated with Justinian, in this case the cross-domed basilica. This building type, also characterized by the multiphase church of Hagia Irene (Justinianic, rebuilt in the eighth or ninth century) in Constantinople,[108] was revived in twelfth-century Constantinople (Kalenderhane Camii or Theotokos Kyriotissa; Fig. 130) as well as in its Thracian hinterlands (as at Enez Fatih Camii).[109] Both architecturally epitomized the sixth century with their three-aisled, apsed

106 "[The] kingdom established from the seed of the Ethiopian maiden has acquired the great and awesome wood of the honorable and life-giving cross fixed in the midst of the earth … the cross by which … the ends of the earth are circumscribed according to breadth." B. Garstad, ed. and trans., *Apocalypse of Pseudo-Methodius: An Alexandrian World Chronicle* (Cambridge, MA, 2012), 31–33. For an indication that this text was copied and circulated in Ethiopia in the Middle Ages, via Egyptian channels, see Bowersock, "Helena's Bridle"; Martinez, "King of Rūm."

107 R. Macrides and P. Magdalino, "The Fourth Kingdom and the Rhetoric of Hellenism," in *The Perception of the Past in Twelfth-Century Europe*, ed. P. Magdalino (London, 1992), 117–56, at 121; G. Prinzing, "Entstehung und Rezeption der Justiniana-Prima-Theorie im Mittelalter," *BBulg* 5 (1978): 269–87. On the battle of Manzikert, see A. Friendly, *The Dreadful Day: The Battle of Manzikert 1071* (London, 1981).

108 Ousterhout, *Eastern Medieval Architecture*, 251–52; U. Peschlow, *Die Irenenkirche in Istanbul: Untersuchungen zur Architektur*, Istanbuler Mitteilungen 18 (Tübingen, 1977).

109 R. Ousterhout, "The Byzantine Church at Enez: Problems in Twelfth-Century Architecture," *JÖB* 35 (1985): 261–80; C. L. Striker and Y. Doğan Kuban, eds., *Kalenderhane in Istanbul: The Buildings, Their History, Architecture and Decoration. Final Reports on the Archaeological Exploration and Restoration of Kalenderhane Camii 1966–1978* (Mainz, 1997).

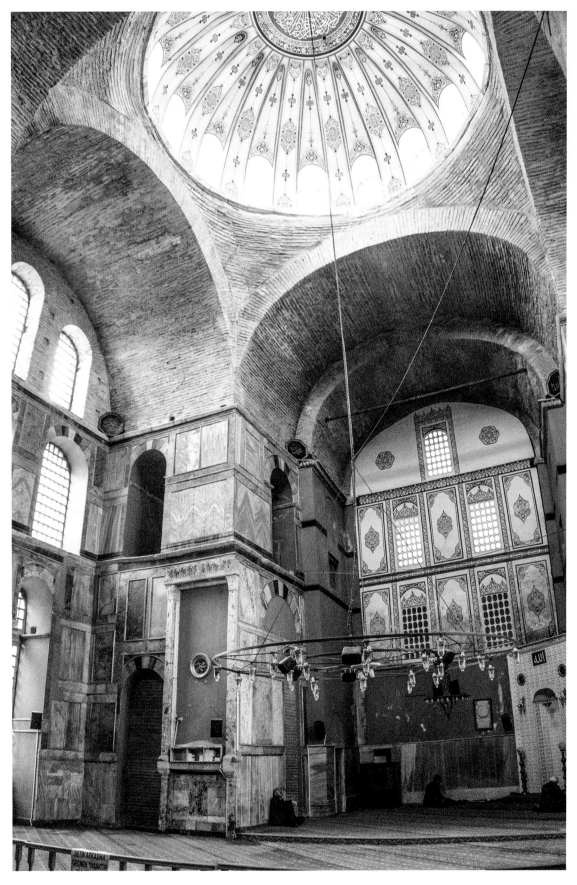

Figure 130.
Kalenderhane
Camii (Theotokos
Kyriotissa[?]),
Istanbul,
Turkey, late
twelfth century.
Photograph
by author.

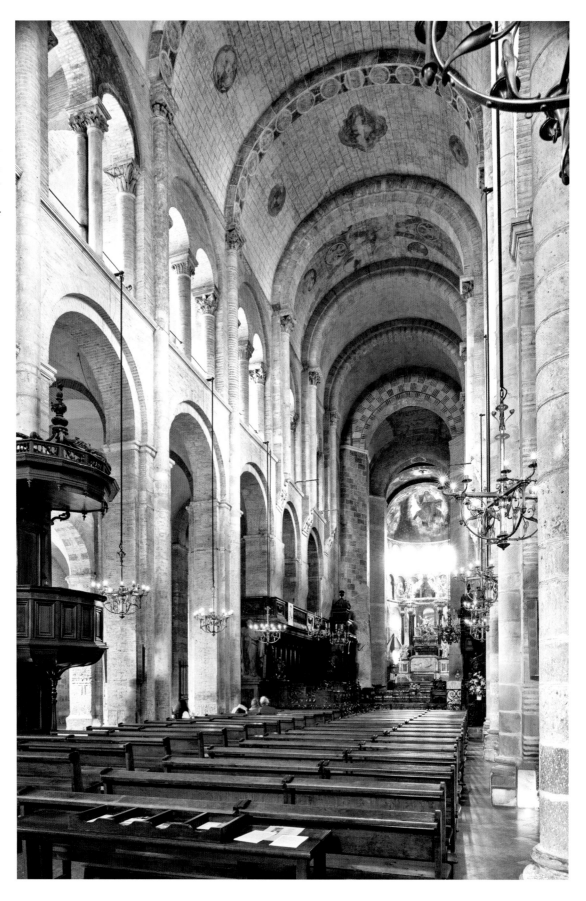

halls on the ground floor and domed upper levels braced with vaulted cross arms. Yet, like San Marco and Abreha wa-Atsbeha, these buildings were equally the product of their millennial time and place. Rather than reviving alternating courses of stone and brick, which were typical of late antique Constantinople, these churches were built with then-contemporary Middle Byzantine recessed brickwork (bricks sunk into thick mortar beds).[110]

In Northern Europe around the turn of the first millennium, Justinian's Byzantium was also looked to for inspiration. Post-Roman Gaul presented a similar situation to East Tigray in that its Christian society was left somewhat fractured, isolated, and impoverished after late antiquity.[111] The eleventh century was a watershed there too, as the growth of monastic institutions and a demographic revival inspired the patronage of more elaborate, and permanent, architectural forms.[112] As in the contemporaneous Fatimid caliphate, the "Romanesque" churches of Western Europe were differentiated by their use of centered vaults and ashlar masonry (as opposed to wood and daub). Although these sturdy structures conveyed a spirit of *Romanitas*[113] (broadly speaking), their form and articulation often communicated sixth-century Byzantium more specifically.[114] Well known in this regard is the early twelfth-century aisled cruciform church of Saint-Front, in Périgueux (Aquitaine, France), a Romanesque rendition of a Justinianic aisled cruciform church (in this case the Holy Apostles, refracted through Venice), using local building materials (limestone ashlars) and a "proto-gothic" structural system.[115] Other churches, such as those

established *en route* to Santiago de Compostela (St. James in Compostela) in northwest Spain also presented variations on the aisled cruciform type (as at Saint-Sernin, Toulouse; Fig. 131), while the new medium of portal sculpture presented, often explicitly, revived Imperial Roman iconography.[116]

Suffice it to say that millennial introspection, particularly recalling the architecture of Justinian the Great, took place in parallel circumstances around the year 1000. Even the Seljuks, who were heirs to a great Iranian architectural tradition, were drawn into this discourse. They, too, looked to Mediterranean late antiquity in order to contextualize their triumphs over the Byzantines in Anatolia, such that we find in Rum Seljuk (1077–1308) architecture the conspicuous display of spoliated Byzantine Greek epigraphy on their mosques and fortifications as well as prominent refurbishments of dilapidated Romano-Byzantine infrastructure.[117] Although Venice and post-Aksumite Tigray present the closest parallel in terms of their ideological and economic underpinnings, the appreciation and reinvention of sixth-century architecture across transforming societies may be deemed characteristic of the "global" eleventh century. Indeed, in post-Aksumite Tigray and Western Europe, the existing conditions were especially analogous. Strong local building traditions, the lack of geographical proximity to Byzantium, and the consistent availability of prestigious architectural forms from the Islamic world (Egypt and al-Andalus[118] respectively) are the likely explanations for making the redeployment of sixth-century forms in Tigray and Western Europe an introspective and autochthonous, yet fully hybrid endeavor.

110 Ousterhout, "Byzantine Church at Enez," 263.

111 N. Gauthier, "From the Ancient City to the Medieval Town: Continuity and Change in the Early Middle Ages," in *The World of Gregory of Tours*, ed. K. Mitchell and I. Wood (Leiden, 2002), 47–66.

112 R. Landes, "The White Mantle of Churches: Millennial Dynamics and the Written and Architectural Record," in *The White Mantle of Churches: Architecture, Liturgy, and Art around the Millennium*, ed. N. Hiscock, International Medieval Research 10 (Turnhout, 2003), 249–64.

113 L. Seidel, "Rethinking 'Romanesque'; Re-engaging Roman[z]," *Gesta* 45.2 (2006): 109–23.

114 F. de Verneilh-Puyraseau, *L'architecture byzantine en France: Saint-Front de Périgueux et les églises à coupoles de l'Aquitaine* (Paris, 1851).

115 Papacostas, "Medieval Progeny," 389–95; C. Andrault-Schmitt, "A Western Interpretation of an Oriental Scheme: The

Domed Churches in Romanesque Aquitaine," in *Romanesque and the Mediterranean: Patterns of Exchange across the Latin, Greek and Islamic Worlds c. 1000 to c. 1250*, ed. R. M. Bacile and J. McNeill (London, 2015), 225–40.

116 L. Seidel, *Songs of Glory: The Romanesque Facades of Aquitaine* (Chicago, 1981). On archaizing articulation, see C. E. Armi, "Parts and Words in Romanesque Architecture," *Gesta* 54.2 (2015): 127–41.

117 S. Redford, "The Seljuqs of Rum and the Antique," *Muqarnas* 10 (1993): 148–56; S. Redford, "The Water of Life, the Vanity of Mortal Existence and a Penalty of 2,500 Denarii: Thoughts on the Reuse of Classical and Byzantine Remains in Seljuk Cities," in *Cities as Palimpsests? Responses to Antiquity in Eastern Mediterranean Urbanism*, ed. E. K. Fowden et al. (Oxford, 2021), 85–102.

118 See P. Draper, "Islam and the West: The Early Use of the Pointed Arch Revisited," *Architectural History* 48 (2005): 1–20.

CHAPTER 4

MEDIEVAL ETHIOPIA IN
THE INDIAN OCEAN WORLD SYSTEM

ADORNING THE INTERIORS OF THE churches of Abreha wa-Atsbeha and Wuqro Cherqos are distinctive ornamental patterns, widely (and rightly) understood as "Islamicate"[1] by scholars, due to their clear parallels with Abbasid- and Seljuk-era ornament.[2] However, I suggest that these designs present far more than just ornamentation, but are rather a conspicuous display of designs drawn from luxury textile imports, which had material and devotional primacy in Ethiopia as liturgical screens and coverings in the Middle Ages.[3] These motifs *do* bear a strong similarity to the architectural revetments (*ḥazār-bāf*, "woven" brickwork) found in contemporaneous Seljuk monuments in Iran. But these are distant regions, and as such did not engage in any sustained contact. Nevertheless, this comparison is instructive, in that both societies valued textile imports, and ultimately borrowed architectural ornament from the same sources. Textile imports from South Asia, in particular, were widely available in both Iran and Tigray as luxury goods. In early medieval Tigray, Indian cloth patterns were a means by which sanctity could be projected onto the rock surface, transforming these hewn structures into great liturgical canopies. In all cases, patterns were rendered with ocher paint and bas-relief, the latter of which is most visible when photographed in high contrast.

These textiles entered the Tigrayan highlands through the mercantile channels of the Fatimid caliphate, which formed the link with the western Indian Ocean world. Documentation from Cairo illustrates that these luxury goods were widely available in Ethiopia during the vizierate of Badr al-Jamālī. The nature of this circulation

1 I refer here to the concept of secular "Islamicate" civilization, rather than the strictly religious label of "Islamic," as first outlined in M. G. S. Hodgson, *The Venture of Islam*, vol. 1, *The Classical Age of Islam* (Chicago, 1974).

2 C. Lepage, "L'église semi monolithique de Abrehä Asbehä: Monument clef de l'histoire de l'architecture éthiopienne," in *I molti volti dell'arte etiopica: Atti del IV Convegno internazionale di storia dell'arte etiopica, 24–27 settembre 1996, Trieste*, ed. A. L. Palmisano, S. Chojnacki, and A. Baghai (Bologna, 2010), 145–63, at 158–59; C. Lepage and J. Mercier, *Les églises historiques du Tigray: Art éthiopien / The Ancient Churches of Tigrai: Ethiopian Art*, trans. S. Williams and C. Wiener (Paris, 2005), 80–81; C. Lepage, "Entre Aksum et Lalibela: Les églises du sudest du Tigray (IXᵉ–XIIᵉ s.) en Éthiopie," *CRAI* 150.1 (2006): 9–39, at 28–39.

3 On Seljuk ornament, see E. Ettinghausen, "Woven in Stone and Brick: Decorative Programs in Seljuk and Post-Seljuk Architecture and Their Symbolic Value," in *Turkish Art: 10th International Congress of Turkish Art, Geneva, 17–23 September 1995. Proceedings*, ed. F. Déroche et al. (Geneva, 1999), 315–25.

On Abbasid ornament, see M. D. Saba, "A Restricted Gaze: The Ornament of the Main Caliphal Palace of Samarra," *Muqarnas* 32 (2015): 155–95. See also G. Necipoğlu, *The Topkapı Scroll: Geometry and Ornament in Islamic Architecture* (Santa Monica, CA, 1995), 91–109.

of cloths was dynamic, representing in microcosm the confluence of the Mediterranean and Indian Ocean trade networks. The circulation of goods in and out of Ethiopia suggests that it remained engaged in long-distance contact and participated in the same material exchanges, conspicuous consumption, and transmaterial uses of textiles as the rest of the medieval world.[4] That this mechanism of exchange was due to good relations with the Fatimid caliphate contrasts sharply with older historiography, which regards early medieval Ethiopia as isolated *because* of Islamic expansion in the Red Sea.[5] Moreover, because iconographic mural painting was introduced to Ethiopia in the twelfth century at the earliest, textile-derived ornament appears to have had devotional primacy in the early Middle Ages.[6]

Ethiopia and the Maritime Silk Road

In antiquity, Ethiopia's north, located strategically across the Bab al-Mandab Strait, was a choke point for Roman trade with India and China (see Fig. 8).[7] Spices, incense, ivory and all types of Eastern goods made their way to the Mediterranean through this key artery, but by far the most valued commodity was silk.[8] The Byzantine Empire under Justinian relied on Aksum so as to bypass high Persian tariffs on the overland silk route.[9] Francisco Alvares, a Portuguese chaplain sent to Ethiopia in 1515, remarked with wonder at the vast quantities of silk covering church interiors in Tigray.[10] Around the same time, in the chronicle of the destructive campaigns of Aḥmad ibn Ibrāhīm, the ruler of the adjacent Adal sultanate, which fought a war against "Solomonic" Ethiopia from 1529 to 1543, silks from Byzantium, India, and Egypt were remarked upon as churches were devastated.[11] Today, mass manufactured silk textiles, largely imported from Greece, cover anything and everything in church space. They are ubiquitously hung as chancel screens, and occasionally are tacked onto piers and over windows.

Generally speaking, the contemporary picture of medieval churches is skewed, in part due to the loss of liturgical ephemera.[12] The cluttered spaces of contemporary Ethiopian churches are, in a way, a window through time. Historically, textile screens and other soft furnishings were as integral to churches as their architectural fabrics. Texts such as the *Liber Pontificalis* illustrate that

4 For textile-derived ornament in Byzantine architecture, see E. D. Maguire, "Curtains at the Threshold: How They Hung and How They Performed," *DOP* 73 (2019): 217–44; A. Gonosová, "The Formation and Sources of Early Byzantine Floral Semis and Floral Diaper Patterns Reexamined," *DOP* 41 (1987): 227–37; H. C. Evans, "The Original Mosaic Decoration of Hagia Sophia," in *Mosaics of Anatolia*, ed. G. Sözen (Istanbul, 2011), 221–32. For the medieval West, see J. Tripps, "Von der Kathedrale zu Reims bis zum Baptisterium von Florenz: Funde zum Behängen mittelalterlicher Kirchenfassaden mit Textilen," in *Die gebrauchte Kirche: Symposium und Vortragsreihe anlässlich des Jubiläums der Hochaltarweihe der Stadtkirche Unserer Lieben Frau in Friedberg (Hessen) 1306–2006*, ed. N. Nußbaum (Stuttgart, 2010), 83–89; J. Osborne, "Textiles and Their Painted Imitations in Early Medieval Rome," *Papers of the BSR* 60 (1992): 309–51.

5 It may be useful to quote Edward Gibbon here for his comments on seventh-century Aksum: "Encompassed on all sides by the enemies of their religion the Æthiopians slept near a thousand years, forgetful of the world, by whom they were forgotten"; E. Gibbon, *The History of the Decline and Fall of the Roman Empire*, 4 vols. (Philadelphia, 1887), 4:135.

6 C. Bosc-Tiessé, "Christian Visual Culture in Medieval Ethiopia: Overview, Trends and Issues," in *A Companion to Medieval Ethiopia and Eritrea*, ed. S. Kelly (Leiden, 2020), 322–64, at 341–42.

7 R. K. Pedersen, "The Byzantine-Aksumite Period Shipwreck at Black Assarca Island, Eritrea," *Azania: Archaeological Research in Africa* 43.1 (2008): 77–94.

8 S. C. Munro-Hay, *Aksum: An African Civilization of Late Antiquity* (Edinburgh, 1991), 166–80.

9 According to Procopius, "The Ethiopians, by purchasing silk from India and selling it to the Romans [Byzantines, MM], would themselves gain much money while causing the Romans to profit in only one way, namely, that they would no longer be forced to pay over their money to the enemy [the Sasanians, MM]"; Prokopios, *The Wars of Justinian*, trans. H. B. Dewing, rev. A. Kaldellis (Indianapolis, 2014), 53 (book 1.19:9).

10 F. Alvares, *The Prester John of the Indies: A True Relation of the Lands of the Prester John, Being the Narrative of the Portuguese Embassy to Ethiopia in 1520*, rev. trans. and ed. C. F. Beckingham and G. W. B. Huntingford, 2 vols. (Cambridge, 1961), 1:75, 89, 125, 283.

11 ʿArab Faqīh, *Futūḥ Ḥabaša: The Conquest of Abyssinia (16th Century)*, trans. P. L. Stenhouse, annot. R. Pankhurst (Hollywood, 2003), 144, 152–53, 165–67, 183–86, 190–92, 201, 210–11, 222, 247–52.

12 See, for example, J. Bony, *French Gothic Architecture of the 12th and 13th Centuries* (Berkeley, 1983). Bony faults rare survivals of soft furnishings and the choir screen for "destroying the interior unity" of the cathedral. See also W. Sauerländer, "Mod Gothic," *The New York Review of Books*, 8 November 1984.

from the Constantinian beginnings of organized Christianity onward, liturgical textiles were incorporated into architecture and used liberally as soft furnishings, whether as intercolumnar screens, chancel veils, altar cloths, or wall hangings.[13] Already in the fourth century, a Spanish pilgrim to Jerusalem noted how the most important donations to the church of the Holy Sepulcher were textiles, for both their material value and liturgical function.[14]

Ethiopian writings dating from the fourteenth century onward, however, engage with textiles only as metaphors, in Christian tropes such as a saint being clothed with light or robes of gold.[15] As such, despite the textiles' historical importance and prominence, their import and function in medieval Ethiopia are significantly understated.[16] Although the lack of ancient textiles in churches is ascribed to the aforementioned sixteenth-century invasion, the prevailing idea of "newer is better" for devotional objects in

monasteries as well as the extensive use of lighting by torches are more likely.[17]

The most extensive account of the use and kinds of textiles that were hung in churches in Tigray is found in the early sixteenth-century reports of Francisco Alvares, written almost half a millennium after the subject churches were built. As mentioned, he repeatedly remarked with wonder at the vast quantities of silks covering church interiors in Tigray, providing the earliest full account of cloth hangings as architectural adornment. About one monastery, Alvares wrote, "In the center are curtains from end to end; and there are other curtains before the side doors, from wall to wall. They are curtains of silk: the entrance through these curtains is in three places, they are open in the middle, and they reach one to another, also they can be entered close to the walls."[18] Here we may draw several clues from the description of its liturgical arrangement. Conspicuously, Alvares noted the two-part curtain of Ethiopian chancels, as is found today, in contrast to the single curtain of other Miaphysite churches, such as the Coptic and Syrian, but similar to those found in Byzantium and the medieval

13 J. W. Stephenson, "Veiling the Late Roman House," *Textile History* 45 (2014): 3–31, at 6–10; P. Grossmann, "Late Antique Architecture in Egypt: Evidence of Textile Decoration," in *Clothing the House: Furnishing Textiles of the 1st Millennium AD from Egypt and Neighbouring Countries. Proceedings of the 5th Conference of the Research Group "Textiles from the Nile Valley,"* Antwerp, 6–7 October 2007, ed. A. De Moor and C. Fluck (Tielt, Belgium, 2009), 19–35.

14 A. Guillou, "Rome, centre transit des produits du luxe d'Orient au Haut Moyen Âge," *Zograf* 10 (1979): 17–21.

15 This is a reference to the transfiguration of Christ referenced in three of the four gospels (Matthew 17:2, Mark 9:3, and Luke 9:29), and is a trope repeated endlessly in various saints' lives.

16 For clerical dress, see E. Hammerschmidt, "The Liturgical Vestments of the Ethiopian Church: A Tentative Survey," in *Proceedings of the Third International Conference of Ethiopian Studies, Addis Ababa, 1966*, ed. R. K. P. Pankhurst, 3 vols. (Addis Ababa, 1969–70), 2:151–56; J. Gnisci, "Ecclesiastic Dress in Medieval Ethiopia: Preliminary Remarks on the Visual Evidence," in *The Hidden Life of Textiles in the Medieval and Early Modern Mediterranean: Contexts and Cross-Cultural Encounters in the Islamic, Latinate and Eastern Christian Worlds*, ed. N. Vryzidis (Turnhout, 2020), 231–56. For wall hangings, see M. H. Henze, "Studies of Imported Textiles in Ethiopia," *JES* 40.1–2 (2007): 65–82; M. Gervers, "The Tablet–Woven Hangings of Tigre, Ethiopia: From History to Symmetry," *Burlington Magazine* 146 (2004): 588–601; M. H. Henze, "Unique Textiles of Tigray," *ITYOPIS, Northeast African Journal of Social Sciences and Humanities* Extra Issue 2 (2016): 137–47.

17 On the alleged mass destruction of Christian material culture in the sixteenth century, see A. J. Davis, "The Sixteenth Century Jihād in Ethiopia and the Impact on Its Culture (Part One)," *Journal of the Historical Society of Nigeria* 2.4 (1963): 567–92; A. J. Davis, "The Sixteenth Century Jihād in Ethiopia and the Impact on Its Culture, Part II: Implicit Factors behind the Movement," *Journal of the Historical Society of Nigeria* 3.1 (1964): 113–28.

18 "[T]em tres portas assi como estam as nossas: hũa principal, & duas trauessas. A cobertura da ygreja e feu cercuito: he de palha braua que dura vida domẽs: o corpo da ygreja he feito de naues muy bem feitas, & feus arcos muy bem çarados: tudo pareçe como aboboda: tem oussya & cruzeiro, & no cruzeiro estam cortinas de cabo a cabo. E outras cortinas está diante das portas trauessas tambem de parede a parede: & fão cortinas de seda. A seruītia destas cortinas he per tres lugares .s. são abertas pello meyo: comtudo chegua hũa aa outra: & assi se seruē per iũto das paredes": F. Alvares, *Verdadeira informação das terras do Preste João das Indias*, new ed. (Lisbon, 1889), 10; English translation in Alvares, *Prester John of the Indies*, 1:75. On the monastery, see G. Lusini, "Dābrā Bizan," in *EAe* 2:15–17; A. Andemichael, "The Monastery of Debre Bizen," in *Proceedings of a Workshop on Aspects of Eritrean History: 20–21 September 2005, Asmara*, ed. T. Melake, Cultural Assets Rehabilitation Project (Asmara, 2007), 28–40.

West.[19] There may be firm iconographic evidence for this practice in Ethiopia from late antiquity—the illuminated "Garima Gospels," which date to this early period, display a two-curtain configuration rendered on the fantastical tholos (altar ciborium) found in its canon table illuminations (see Fig. 33).[20]

On a visit to the (fourteenth-century?) chapel of the Tigrayan monastery of Dabra Bizan (Däbrä Bizän, "Monastery of Byzantium," now located immediately across the border in Eritrea), Alvares also described axial curtains around the sanctuary, also a contemporary practice, which keep the altar and choir space veiled on all sides. He went on to describe the liturgy during feast days: "[The monastery of Dabra Bizan was] all covered in with brocades and velvets of Mec[c]a, all long pieces, sewn one to another in order that they might shelter the whole circuit. They made a very beautiful procession through this canopied circuit; all wore cloaks of the same stuffs, brocades, and velvets of Mec[c]a."[21]

In the past, curtains were not restricted to the altar and choir space but were hung over vaults and ceilings through which monks, dressed in the same materials, would move in a procession across the silken space. The neatly carved holes lining the cross-arm architraves at Abreha wa-Atsbeha on both the nave (see Fig. 68) and transept arms (see Figs. 69, 71), may have held rails for canopies, perhaps in the service of later liturgical developments (lay chancels). Alvares is precise when discussing the textiles' origins, stating they were imports from "Mecca," i.e., the Muslim realm. While some of the silks and velvets mentioned were likely recent purchases at the time,

facilitated during a period of great relations under Emperor Zara Yaqob (Zärʾa Yaʿəqob, r. 1434–1468) with Mamluk Egypt, both textual evidence and physical survivals show that this practice and importation was long lived.[22]

Known remnants of Egyptian textiles from early periods in Ethiopia (Fig. 132) survive exclusively from the hilltop monastery of Dabra Dammo (see Figs. 23, 24, 25), where they were hidden by the monks.[23] These were first identified by Antonio Mordini, who assisted with the church's stabilization during the Italian occupation of Ethiopia in 1937 and again in the late 1940s (after the restoration of the Ethiopian Empire).[24] The textiles from Dabra Dammo have since been sold—in two groups, according to Mordini, based on their placement in the church. Among other things, these cloths include the only tiraz textiles (ṭirāz; cloths inscribed in Arabic, usually with links to caliphal authority) recovered from a nonfunerary context.[25]

19 E. Fritsch, "Mägaräğa," in *EAe* 3:630–31; P. Speck, "Die Ἐνδυτή: Literarische Quellen zur Bekleidung des Altars in der byzantinischen Kirche," *JÖB* 15 (1966): 323–75.

20 There is also a biblical precedent for this: "At that moment the curtain of the temple was torn in two from top to bottom. The earth shook, the rocks split" (Matthew 27:51 [NIV]).

21 "E este descuberto estava emtã todo cuberto de brocados & brocadilhos & veludos de meca, tudo pecas de côprido cosidas huas com outras pera que abrãgessem a todo curcuito. Fezerão per este circuito assi toldado muy fremosa procissão, todos com capas dos mesmos panos, .s. brocados brocadilhos & veludos de meca mal feitos como acima dito he"; Alvares, *Verdadeira informação*, 15. English translation in Alvares, *Prester John of the Indies*, 1:89.

22 In 1443 the Mamluk sultan Jaqmaq (r. 1438–1453) sent to Emperor Zara Yaqob, "2 golden saddles, gold-brocaded textiles, wool and wool garments of two different types, 200 pieces of fabric, 2 bottles of fine oil (*al-zayt al-tayyib*), probably balsam, and interestingly, a rock crystal ewer carved in the shape of a cock in a gold setting (*muzayyak*) along with other things," D. Behrens-Abouseif, *Practising Diplomacy in the Mamluk Sultanate: Gifts and Material Culture in the Medieval Islamic World* (London, 2014), 51. See also J. Loiseau, "The Ḥaṭī and the Sultan: Letters and Embassies from Abyssinia to the Mamluk Court," in *Mamluk Cairo, a Crossroads for Embassies: Studies on Diplomacy and Diplomatics*, ed. F. Bauden and M. Dekkiche (Leiden, 2019), 638–57.

23 Sergew Hable Selassie, without any citation lamentably, noted that the Abba Pantalewon (Abba Ṗänṭälewon) monastery near Aksum held similar textiles; S. Hable Selassie, *Ancient and Medieval Ethiopian History to 1270* (Addis Ababa, 1972), 206. The Dabra Dammo silks may have been donations from Emperor Zara Yaqob in the fifteenth century; see S. C. Munro-Hay, "Saintly Shadows," in *Afrika's Horn: Akten der Esten Internationalen Littmann-Konferenz*, ed. W. Raunig and S. Wenig, Meroitica 22 (Wiesbaden, 2005), 137–68, at 156.

24 D. Matthews and A. Mordini, "The Monastery of Debra Damo, Ethiopia," *Archaeologia* 97 (1959): 1–58. See also A. Bausi, "'Däbrä Dammo,' Not 'Däbrä Damo,'" *Géolinguistique* 20 (2020), http://journals.openedition.org/geolinguistique/1918.

25 J. A. Sokoly, "Between Life and Death: The Funerary Context of Ṭirāz Textiles," in *Riggisberger Berichte* 5 (1997): 71–78. The Dabra Dammo tiraz fragments may, however, have been stripped from a dead pilgrim or dignitary brought to the monastery to be buried.

Figure 132. Islamic textile scraps from the sacristy of Dabra Dammo, now in Doha, Qatar: (a) linen with silk tapestry; (b) wool and linen tape; (c) linen with tapestry; (d) linen with silk embroidery Abbasid/Tulunid tiraz; (e) linen with tapestry; (f) linen with silk embroidery Abbasid/Tulunid tiraz; (g) linen with silk embroidery Abbasid/Tulunid tiraz; (h) linen with silk embroidery Abbasid/Tulunid tiraz. Photographs from D. Matthews and A. Mordini, "The Monastery of Debra Damo, Ethiopia," *Archaeologia* 97 (1959): pl. XV, courtesy of the Society of Antiquaries, London.

One set of cloths had been kept in a cubby-hole underneath the church loft; these are largely dated to the early Islamic centuries. Mordini sent them for tests and cleaning in Asmara (1944), where they were comprehensively documented.[26] Sometime in the succeeding years, they made their way onto the art market, perhaps by Mordini himself, and were ultimately sold (in 2008) to the Museum of Islamic Art in Doha, Qatar, where they are housed today.[27]

The second set is less well known, but consists of cloths from a similar time frame from Egypt. According to Mordini, these were larger and better preserved, owing to their having been safeguarded in the church sacristy—they were formerly used as vestments in the church.[28] At least one was a curtain, as is indicated by its monumental scale (2.5 m long) and the presence of woven suspension rings.[29]

The earliest confirmed example, though hard to date or know its provenance given its standard heraldic iconography, is a linen and wool variant of a Byzantine, Sasanian, or even early Islamic animal silk from the sixth or seventh century (Fig. 132b). Composed of a vegetal frame diaper, the repeat pattern incorporates outward-facing lions surmounting the Tree of Life. This textile

is part of a standard luxury repertoire in late antiquity.[30] As such, it was probably a remnant of the sacristy's contents from when the monastery was founded, or shortly thereafter, when trade between Ethiopia and the Byzantine Empire was well established. These early Islamic textiles included several linens with tiraz bands inscribed with the names of Abbasid caliphs, datable to the late ninth to mid-tenth century. They were likely brought from Alexandria by official delegations or esteemed pilgrims, or were perhaps regifted in the late eleventh century by caliphal delegates, such as the aforementioned 1089 delegation.[31]

There is also a fragment of another wall hanging, but unlike the earlier curtain, this one instead dates to the Fatimid period, which is unlike much of what survives today from Egypt (Fig. 132a).[32] This textile is likely representative of an esteemed commission by an official in the church of Alexandria, or a wealthy Coptic

26 A. Mordini, "I tessili medioevali del convento di Dabra Dāmo," in *Atti del Convegno internazionale di studi Etiopici (Roma 2–4 aprile 1959)*, Problemi Attuali di Scienza e di Cultura, Quaderno 48 (Rome, 1960), 229–48, at 229–33.

27 At the Historians of Islamic Art Conference at Yale University in 2018, Jochen Sokoly kindly notified me that the cloths were "still alive."

28 There were more, but Mordini reports that a monk from Dabra Dammo (a stand-in for Mordini himself?) took several with him on pilgrimage to donate to the Church of the Holy Sepulcher in 1939. Having run out of funds in Cairo, however, the monk allegedly sold his ex-votos to the Egyptian antiquities dealer Maurice Nahman, and they were then sold at auction in Paris to a private collector—in whose collection Mordini was later able to find several; Mordini, "I tessili medioevali," 233–35. On Nahman and his dealing habits, see E. D. Williams, "'Into the Hands of a Well-Known Antiquary of Cairo': The Assiut Treasure and the Making of an Archaeological Hoard," *West 86th: A Journal of Decorative Arts, Design History, and Material Culture* 21.2 (2014): 251–72.

29 Mordini, "I tessili medioevali," 235. For comparanda, see the hangings catalogued in G. Bühl, "Textiles | Architecture | Space," in *Woven Interiors: Furnishing Early Medieval Egypt*, by G. Bühl, S. B. Krody, and E. D. Williams (Washington, DC, 2019), 15–33.

30 D. Thompson, "The Evolution of Two Traditional Coptic Tape Patterns: Further Observations on the Classification of Coptic Textiles," *JARCE* 23 (1986): 145–56. See various examples in A. Muthesius, *Byzantine Silk Weaving: AD 400 to AD 1200*, ed. E. Kislinger and J. Koder (Vienna, 1997). The best overview of the historiography of Byzantine textiles is M. M. Fulghum, "Under Wraps: Byzantine Textiles as Major and Minor Arts," *Studies in the Decorative Arts* 9.1 (2001–2): 13–33.

31 See E. Kühnel, *Catalogue of Dated Tiraz Fabrics: Umayyad, Abbasid, Fatimid* (Washington, DC, 1952); L. W. Mackie, *Symbols of Power: Luxury Textiles from Islamic Lands, 7th–21st Century* (Cleveland, 2015), 86–104. Ernst Kühnel records one inscription as being from the Abbasid caliph al-Mutawakkil (r. 847–861); see Mordini, "I tessili medioevali," 236. Jochen Sokoly notes others: "One is inscribed in the name of the Abbasid caliph al-Muʿtamid (256–279/870–892) . . . one in Muktafi's (289–295/902–908) [name] . . . and two in al-Muttaqi's (329–333/940–944)"; J. A. Sokoly, "*Ṭirāz* Textiles from Egypt: Production, Administration and Uses of *Ṭirāz* Textiles from Egypt under the Umayyad, ʿAbbāsid and Fāṭimid Dynasties" (PhD diss., University of Oxford, 2002), 20. I thank the author for kindly sharing his unpublished dissertation with me, and for suggesting a "regifting." See also F.-X. Fauvelle, *The Golden Rhinoceros: Histories of the African Middle Ages*, trans. T. Tice (Princeton, 2018), 94–99.

32 Matthews and Mordini, "Monastery of Debra Damo," 58; A. Mordini, "Tre Tiraz abbasidi provenienti dal convento di Dabra Dammò," *Il Bollettino dell'Istituto di studi etiopici* 2 (1957): 33–38; A. Mordini, "Un tissu musulman du Moyen Âge provenant du couvent de Dabra Dāmmò (Tigrai, Éthiopie)," *AÉ* 2.1 (1957): 75–79; Mordini, "I tessili medioevali."

pilgrim, rather than a Muslim dignitary.[33] The linen and silk fabric contains figural imagery, reminiscent of Christian Egyptian textiles in late antiquity, juxtaposed with otherwise standard Fatimid ornaments and a tiraz band.[34]

Other textile fragments found in the church include standard Fatimid luxury cloths (Fig. 132c, e) with tiraz bands rendered in tapestry alternating with registers of geometric patterns or striped linens and joined with embroidered linen backing, presumably also sent through these same commercial channels or esteemed delegations. These textiles are also contextualized by way of a number of Arabic-inscribed gold and silver coins from the seventh to ninth century that were also found in the church grounds (now presumed missing).[35]

The Red Sea Textile Trade in Geniza Documents

As corroborated by documents in the Cairo Geniza (storehouse of the synagogue of Fustat and the largest repository of Fatimid-era written sources), during the eleventh century Fatimid merchants facilitated the trade of textiles into northern Ethiopia from centers in Yemen, Egypt, and India.[36] Silk was the most valuable commodity that could be traded, and the fact that it was lightweight and easily portable helped make it particularly convenient for the Fatimids to cover trade deficits with India over spices with it— merchants traveling to India would periodically stop over at ports (including the Dahlak islands) along the Red Sea to sell these textiles. In the process, they would pick up extra cash for large spice purchases in Yemen or India. After returning from India, merchants would then sell more durable cotton textiles to these same entrepôts.[37]

Physical evidence of these Egyptian and Indian silk and cotton cloths, which the Fatimids were known to trade, have largely come down to us from an ancient trash heap in old Cairo (Fustat), which was raided by antiquities traders in the nineteenth century.[38] Scraps were also

33 Most weavers were Copts. For medieval Egyptian textiles, see Y. Lev, "Tinnis: An Industrial Medieval Town," in *L'Égypte fatimide: Son art et son histoire. Actes du colloque organisé à Paris les 28, 29 et 30 mai 1998*, ed. M. Barrucand (Paris, 1999), 83–96; E. J. Grube, "Studies in the Survival and Continuity of Pre-Muslim Traditions in Egyptian Islamic Art," *JARCE* 1 (1962): 75–97.

34 A. Stauffer, *Textiles of Late Antiquity* (New York, 1995); T. K. Thomas, ed., *Designing Identity: The Power of Textiles in Late Antiquity* (New York and Princeton, 2016).

35 It is possible that these coins are housed at the Accademia dei Lincei in Rome; when I visited, I was told that they were being catalogued and I was not allowed to see them. For more on the coin discovery, see Matthews and Mordini, "Monastery of Debra Damo," 50–51, 53; Hable Selassie, *Ancient and Medieval Ethiopian History*, 206. There were also a number of third-century coins from the Kushan Kingdom in northwest India; R. Göbl, "Der Kušānische Goldmünzschatz von Debra Damo (Äthiopien) 1940 (Vima Kadphises bis Vāsudeva I)," *Central Asiatic Journal* 14 (1970): 241–52; A. Mordini, "Gold Kushāna Coins in the Convent of Dabra Dammo," *Journal of the Numismatic Society of India* 29.2 (1967): 19–25 (Eng. trans. of A. Mordini, "Gli aurei Kushāna del convento di Dabro Dāmmo: Un'idizio sui rapporti commerciali fra l'India e l'Etiopia nei primi secoli dell'era volgare," in *Atti del Convegno internazionale di studi Etiopici, Roma 2–4 aprile 1959*, Problemi Attuali di Scienza e di Cultura, Quaderno 48 [Rome, 1960], 249–54). See, most recently, S. Whitfield, *Silk, Slaves, and Stupas: Material Culture of the Silk Road* (Oakland, CA, 2018), 57–80.

36 As the largest single repository of medieval documents— fragments of paper and parchment written in Hebrew script as well as in vernacular Judeo-Arabic—the Cairo Geniza has been intensely studied since its discovery by Solomon Schechter at the turn of the twentieth century. The repository, which includes everything from legal documents to religious texts to horoscopes, and much more, has been invaluable for the writing of premodern social history. For an overview of the historiography of Geniza scholarship, see M. Rustow, *The Lost Archive: Traces of a Caliphate in a Cairo Synagogue* (Princeton, 2020), 31–49; M. R. Cohen, "Geniza for Islamicists, Islamic Geniza, and the 'New Cairo Geniza,'" *Harvard Middle Eastern and Islamic Review* 7 (2006): 129–45. For the eleventh century more specifically, see J. L. Goldberg, *Trade and Institutions in the Medieval Mediterranean: The Geniza Merchants and Their Business World* (New York, 2012).

37 A. L. Udovitch, "Fatimid Cairo: Crossroads of World Trade—From Spain to India," in Barrucand, *L'Égypte fatimide*, 681–91; R. E. Margariti, *Aden and the Indian Ocean Trade: 150 Years in the Life of a Medieval Arabian Port* (Chapel Hill, 2007); Goldberg, *Trade and Institutions*; R. Chakravarti, "Nakhudas and Nauvittakas: Ship-Owning Merchants in the West Coast of India (c. AD 1000–1500)," *Journal of the Economic and Social History of the Orient* 43.1 (2000): 34–64. For trade with India, see also S. D. Goitein and M. Friedman, *India Traders of the Middle Ages: Documents from the Cairo Geniza 'India Book'* (Leiden, 2008), 121–67.

38 These textile scraps are spread among museums and private collections around the world. As textile curator at Ashmolean Museum, Oxford, Ruth Barnes has studied them most thoroughly, producing several collection-specific volumes: R. Barnes, *Indian Block-Printed Textiles in Egypt: The Newberry*

excavated in-situ in the "Sheikh's house," the storehouse of the thirteenth-century port of Quseir al-Qadim (Quṣayr al-Qadīm; Myos Hormos) along the Red Sea coast.[39]

Of these commodities, Indian block-printed textiles, produced in Gujarat on the west coast of India, were traded the most. S. D. Goitein, the renowned social historian who worked on Fatimid-era mercantile communities from study of the Cairo Geniza fragments, wrote:

A textile constantly mentioned as a main export from India to the West, and especially from the north-Indian province of Nahrawāra-Gujerāt, requires some attention. It was named *miḥbas* (more commonly occurring in the plural *maḥābis*), which might be translated as wrapper. It was traded in scores, consisting of twenty complete or half thawbs, a word usually denoting the robe worn by everyone, male or female, but also the piece of material needed for a robe. The mahabis were also used for the manufacture of pillows; red and black are mentioned as their colors, and their average price, approximately 1 Adenese, or ⅓ Egyptian dinar, makes it more than likely that they were made of cotton, the most important of Indian textiles.[40]

Thus, for the Fatimid world, their popularity was due to their being relatively inexpensive and durable. These cloths were pervasive in Egyptian

Collection in the Ashmolean Museum, 2 vols. (Oxford, 1997); R. Barnes, *Indian Block-Printed Cotton Fragments in the Kelsey Museum, University of Michigan* (Ann Arbor, 1993); R. Barnes, "Indian Cotton for Cairo: The Royal Ontario Museum's Gujarati Textiles and the Early Western Indian Ocean Trade," *Textile History* 48.1 (2017): 15–30. See also R. Pfister, *Les toiles imprimées de Fostat et l'Hindoustan* (Paris, 1938).

39 G. M. Vogelsang-Eastwood, *Resist Dyed Textiles from Quseir al-Qadim, Egypt* (Paris, 1990); K. S. Burke and D. Whitcomb, "Quṣeir al-Qadīm in the Thirteenth Century: A Community and Its Textiles," *Ars orientalis* 34 (2004): 82–97; D. S. Whitcomb and J. H. Johnson, *Quseir al-Qadim 1978: Preliminary Report* (Cairo, 1979). For recent excavation reports of the site, see D. Peacock and L. Blue, eds., *Myos Hormos–Quseir al-Qadim: Roman and Islamic Ports on the Red Sea*, 2 vols. (Oxford, 2006–11).

40 S. D. Goitein, *A Mediterranean Society: The Jewish Communities of the Arab World as Portrayed in the Documents of the Cairo Geniza*, vol. 4, *Daily Life* (Berkeley, 1983), 171.

conservative designs[42]—stepped crosses, rosettes, linked circles, grids, and diapers being most common, rendered in combinations of white and red (lac) (Figs. 133, 134), white and blue (indigo), and red, blue, and white.[43]

Proposed Trade Routes into Ethiopia in the Tenth and Eleventh Centuries

After arriving at African Red Sea ports such as Quseir al-Qadim, Aydhab, Sawakin (Sawākin), and the Dahlak, the cargo would be portaged by caravan inland to centers in Egypt (Qus and Aswan), Nubia (Qasr Ibrim and Gebel Adda [Jabal ʿAdda]), and Tigray.[44] Gravestones in Kwiha, the Dahlak, and in Qus in Upper Egypt indicate that individuals in the eleventh century traveled between the three locales frequently, trading between Ethiopia and Egypt (see Fig. 8).[45]

While we lack rich textual documentation on Quseir al-Qadim, inscribed tombstones fully index the various settlement phases on the Dahlak islands. Here we find imported goods from as far afield as China, with notable finds

Figure 134. Red and white textile fragment, cotton, resist dyed, textile fragment, 33.5 × 18 cm, Gujarati, recovered from Fustat, Egypt, tenth to fifteenth century. Ashmolean Museum, Oxford, inv. no. EA1990.405. Photograph © Ashmolean Museum, University of Oxford.

homes—and presumably, places of worship as well—as cushion covers, curtains, and clothing. Through the resist-dye process, patterns were made with wax stamped on cotton cloth. The wax would subsequently block the patterns in the cloth from the dye. This allowed artisans to make complex, multicolored compositions without expensive and labor-intensive embroidery or tapestry.[41] Dating from the eighth to eighteenth century, these textiles are notable for their

41 Barnes, *Indian Block-Printed Textiles*, 2:52–60; T. K. Thomas, *Textiles from Medieval Egypt, A.D. 300–1300* (Pittsburgh, 1990), 56.

42 A few have been carbon-14 tested, placing them in a broad range from the second half of the tenth century up to the fifteenth century; Barnes, "Indian Cotton for Cairo," 24.

43 Trousseaux lists from the Cairo Geniza do not distinguish between textiles that are silk or cotton, though it is generally assumed that textiles mentioned in these lists were silk. From aggregated data collected from the documents, preferred colors seem to be white, blue, red, "black" (made by dark indigo dye), and green; Goitein, *Mediterranean Society*, 4:173–75; S. D. Goitein, "Three Trousseaux of Jewish Brides from the Fatimid Period," *AJS Review* 2 (1977): 77–110. Surviving cotton textiles are for the most part blue and white; J. Guy, *Woven Cargoes: Indian Textiles in the East* (London, 1998), 51.

44 J.-C. Garcin, *Un centre musulman de la Haute-Égypte médiévale: Qūṣ* (Cairo, 1976), 76–126; Vogelsang-Eastwood, *Resist Dyed Textiles*, 7; E. Crowfoot, *Qasr Ibrim: The Textiles from the Cathedral Cemetery*, Excavation Memoir 96 (London, 2011). F.-X. Fauvelle-Aymar and B. Hirsch, "Muslim Historical Spaces in Ethiopia and the Horn of Africa: A Reassessment," *NEAS* 11.1 (2004): 25–53, at 40; Y. F. Hasan, "Some Aspects of the Arab Slave Trade from the Sudan 7th–19th Century," *Sudan Notes and Records* 58 (1977): 85–106, at 89–90.

45 J. Loiseau et al., "Bilet and the Wider World: New Insights into the Archaeology of Islam in Tigray," *Antiquity* 95 (2021): 508–29; J. Loiseau, "Retour à Bilet: Un cimetière musulman médiéval du Tigray oriental (*Inscriptiones Arabicae Aethiopiae* 1)," *BEO* 67 (2020): 59–96; M. Schneider, *Stèles funéraires musulmanes des îles Dahlak (Mer rouge)*, 2 vols. (Cairo, 1983), 1:29.

such as porcelain and Abbasid sgraffito rough-ware sherds, have testified to imported goods from as far afield as China.[46] As discussed in the previous chapter, documents from the Cairo Geniza point to a thriving textile trade between Egypt and the Dahlak archipelago in the eleventh century. A remarkable Geniza document records court proceedings between two former business partners in Cairo. The plaintiff, Joseph la-Lebdi, stated that he traded copious amounts of exotic textiles as well as resin (*storax*) to Dahlak markets, noting that cloth brought especially high prices there.[47] These high prices likely reflected inland Tigrayan demand, and it is almost certain that at least some entered the highlands through this north–south axis of Islamic settlements and the mercantile channels guaranteed to Badr al-Jamālī by Pope Cyril II and enforced by Archbishop Severus.[48] The availability of Ethiopian (*ḥabashī*) products in Egypt likewise suggests a robust reciprocal exchange system between Tigrayan middlemen and the Fatimid caliphate.[49] Several of these traders may have been from the Yamami family (originally hailing from al-Yamama in inland Arabia), whose funerary stelae are divided between the

Dahlak archipelago and Kwiha (with dates spanning nearly the entire Fatimid period).[50]

Already in the thirteenth century, we find in Rasulid-dynasty documentation reports of Yemeni merchants selling mahabis or indigo-dyed cottons to coastal Ethiopian communities (then based at the port of Zayla), in exchange for civet and enslaved people (presumably continuing Fatimid practice on Dahlak and in Tigray).[51] These cloths were held in high esteem on the littoral; by the seventeenth century, Indian cloths were given as diplomatic gifts to Portuguese missionaries by Muslim elites in the Danakil Depression.[52]

That said, cotton cloths were also inherently utilitarian, according to Geniza documentation. In contrast, the treasury cloths at Dabra Dammo, and the hangings discussed by Francisco Alvares and Aḥmad ibn Ibrāhīm, are exclusively silk (or with silk embroidered elements). Aḥmad ibn Ibrāhīm's scribe even wrote of one church hung with "curtains the like of which no one—Arab or non-Arab—had ever seen: they were valued at one-hundred ounces of gold," and "a chasuble that belonged to king Eskender."[53] Neither writer can be considered wholly neutral—Alvares wanted to promote Ethiopia as a wealthy Christian ally of the Portuguese crown, while Aḥmad ibn Ibrāhīm's scribe wanted to cultivate the conquest narrative as a herculean effort against a wealthy infidel state. We may infer that these churches were hung with a diversity of cloth types, including silks and cottons from South Asia and Egypt. Moreover, both hanging types shared a decorative repertoire; cotton was the poor man's silk, and export cottons

46 T. Insoll, *The Archaeology of Islam in Sub-Saharan Africa* (Cambridge, 2003), 36–86.

47 E. A. Lambourn, *Abraham's Luggage: A Social Life of Things in the Indian Ocean World* (Cambridge, 2018), 97; R. E. Margariti, "Thieves or Sultans? Dahlak and the Rulers and Merchants of Indian Ocean Port Cities, 11th–13th Centuries AD," in *Connected Hinterlands: Proceedings of Red Sea Project IB Held at the University of Southampton, September 2008*, ed. L. Blue et al., BAR International Series 2052 (Oxford, 2009), 155–63, at 159; S. D. Goitein, "From the Mediterranean to India: Documents on the Trade to India, South Arabia, and East Africa from the Eleventh and Twelfth Centuries," *Speculum* 29.2 (1954): 181–97, at 193.

48 D. Bramoullé, *Les Fatimides et la mer (909–1171)*, Islamic History and Civilization 165 (Leiden, 2019), 555–65.

49 The Fatimid governor of the Dahlak islands delivered "one thousand slave girls" of Nubian and Ethiopian extraction to the ruler of Yemen in 977; Hasan, "Some Aspects," 89–90; Lambourn, *Abraham's Luggage*, 124; R. Margariti, "An Ocean of Islands: Islands, Insularity, and Historiography of the Indian Ocean," in *The Sea: Thalassography and Historiography*, ed. P. N. Miller (Ann Arbor, 2013), 198–229, at 215–16. See also the synthesis provided in A. Wion, "Medieval Ethiopian Economies: Subsistence, Global Trade and the Administration of Wealth," in Kelly, *Companion*, 395–424, at 415–21.

50 The patriarch from whom the family tree originates was a certain Ḥafṣ ibn ʿUmar al-Yamāmī (d. 972), buried in Bilet, Kwiha. See Loiseau, "Retour à Bilet," 78–80; M. Schneider, "Des Yamāmī dans l'Enderta (Tigre)," *Le Muséon* 122.1–2 (2009): 131–48.

51 É. Vallet, *L'Arabie marchande: État et commerce sous les sultans rasūlides du Yémen (626–858/1229–1454)*, Bibliothèque historique des pays d'Islam 1 (Paris, 2010), 413–15.

52 Ibn Faḍl Allah al-ʿOmarī, *Masālik el absar fi mamālik el amsar*, vol. 1, *L'Afrique, moins l'Égypte*, trans. [M.] Gaudefroy-Demombynes (Paris, 1927), 25; D. M. Lockhart, trans., *The Itinerário of Jerónimo Lobo* (London, 1984), 124.

53 ʿArab Faqīh, *Futūḥ al-Ḥabaša*, 185, 210. This reference to Eskender may be a reference to either the third-century BCE Macedonian king Alexander the Great (Iskandar) or the recent Ethiopian king Alexander (Eskender), who reigned 1478–1494. It might also be a conflation of the two Alexanders.

were often modeled on silk prototypes.[54] It is also likely that cloth hangings were alternated according to the liturgical calendar.[55]

Architectural Ornament and Indian Ocean Cloths

The low-relief and painted decorations on Wuqro Cherqos and Abreha wa-Atsbeha today represent the most extensive and varied repertoires of architectural ornament in Ethiopia prior to the thirteenth century.[56] As I have shown in the preceding pages, in the context of the eleventh century these designs may be best understood as part of both a vibrant international textile trade and devotional use specific to northern Ethiopia. Much as Tigray supplied civet musk, salt, and enslaved people to the Fatimids, exotic cloths made up the majority of goods sent reciprocally, per Geniza documents. Used as chancel veils, altar cloths, and intercolumnar screens, these imported hangings were instrumental for devotion and popular piety. Considering the quantity of South Asian cloths that ultimately made it to Cairo (or were found buried at Red Sea ports), I suggest that the decorative schemas at Abreha wa-Atsbeha and Wuqro Cherqos were rooted in these luxury imports. In this way, Tigrayan cruciform churches correlate with how textile patterns were used in better-known Seljuk monuments from the same period (Fig. 135).[57] Tigray's eleventh-century reentry into world trade was coterminous with Seljuk domination of the overland silk route, which bore similar effects for each

broker-state;[58] in both post-Aksumite Tigray and Seljuk Iran we find analogous uses of textile ornament deployed alongside elite architecture. Whereas the Seljuks are thought to have used textile motifs as a means of evoking their nomadic origins in otherwise immovable buildings,[59] in the case of Tigray, Indian cloths served a devotional and liturgical role, and their replication in

Figure 135. Masjid-i Tārākhāna, minaret detail, Damghan, Iran, eleventh century. Photograph by Baroness Marie-Thérèse Ullens de Schooten, courtesy of Special Collections, Fine Arts Library, Harvard University.

54 Vogelsang-Eastwood, *Resist Dyed Textiles*, 4–5.

55 R. Mikhail, *The Presentation of the Lamb: The Prothesis and Preparatory Rites of the Coptic Liturgy*, Studies in Eastern Christian Liturgies 2 (Münster, 2020), 130–32.

56 For all of the ornamental patterns in the churches, see the appendix in M. Muehlbauer, "'Bastions of the Cross': Medieval Rock-Cut Cruciform Churches of Tigray, Ethiopia" (PhD diss., Columbia University, 2020), 344–461. The church of Yemrehanna Krestos in Lasta from the thirteenth century is by far the largest repository of architectural ornament in Ethiopia from the medieval period. See M. Gervers, "The West Portal Ceiling Paintings in the Zagwe Church of Yəmrəḥannä Krəstos," in *Studies in Ethiopian Languages, Literature, and History: Festschrift for Getatchew Haile, Presented by His Friends and Colleagues*, ed. A. C. McCollum (Wiesbaden, 2017), 35–64.

57 C. Bier, "Art and *Mithāl*: Reading Geometry as Visual Commentary," *Iranian Studies* 41.4 (2008): 491–509.

58 J. M. Rogers, "The 11th Century: A Turning Point in the Architecture of the Mashriq?," in *Islamic Civilisation, 950–1150: A Colloquium Published under the Auspices of the Near Eastern History Group, Oxford, the Near East Center, University of Pennsylvania*, ed. D. S. Richards, Papers in Islamic History 3 (Oxford, 1973), 211–49.

59 Ettinghausen, "Woven in Stone and Brick," 315–16.

bas-relief figuratively petrified these festive, ultimately ephemeral, cloths. The ultimate effect of this architectural ornament is dazzling: structure is effectively dissolved through repeat patterns. Inside Abreha wa-Atsbeha and Wuqro Cherqos one might even mistake the hewn vaults for textile canopies (Fig. 136), an illusion that was likely further dramatized when the interiors were hung with physical Indian cloths, whose designs were mirrored on the building surfaces.

Wuqro Cherqos's ornament was the result of at least two phases of painting (see conclusion), whereas Abreha wa-Atsbeha's ornament is largely original to the eleventh century (Mika'el Amba was left unfinished). Although the ornament could have been executed long after the churches were hewn, many cloth patterns are period-specific, coupled with the fact that surface embellishment was considered integral for places of worship.[60] One witnesses this logic with the early medieval church of Zarama Giyorgis. Here coffers and brackets were made of heavily sculpted prefabricated components; ornament and structure were deployed at one and the same time (see Fig. 28). Likewise, at the Church of Mary (Betä Maryam, late twelfth/early thirteenth century) at the Lalibela complex, scientific tests on the murals suggest that it was painted immediately after it was hewn.[61] Thus, for hewn architecture as well, surface decoration appears to have been requisite. In Ethiopia, as elsewhere in the medieval world, only after surface decoration was applied could a church be deemed fully "finished."

The ornamental programs at Abreha wa-Atsbeha and Wuqro Cherqos are entirely rendered through bas-relief and ocher infill. These reliefs, perceptibly termed *faux-stucs* (pseudo stucco) by Claude Lepage, defy easy comparison.[62] Small chisel marks suggest that the reliefs were made with iron tools, struck at sixty-degree angles—though the depths are uneven and the portions that are carved in relief are idiosyncratic (which can be seen with photo manipulation software such as Adobe Photoshop or Lightroom).[63] Some panels are almost entirely painted rather than relief carved, which also contributed to their degradation under heat stress and seepage.

Although the ornament of Abreha wa-Atsbeha is executed in a monochromatic reddish brown directly onto the rock surface, Beatrice Playne alleged that she saw a remnant of gold leaf in the transept vault, after having been told that the patterns inscribed there were originally gilded.[64] A gilded interior at Abreha wa-Atsbeha is not inconceivable. The unprecedented recent discovery at Lalibela of the presence of gold leaf on later relief sculpture has upended a number of scholarly assumptions,[65] and, as ocher is typically the ground on which icons were often gilded, this observation by Playne, in light of the evidence from Lalibela, should not be discounted.[66]

Generally speaking, the majority of the reliefs at Wuqro Cherqos and Abreha wa-Atsbeha are geometric and linear, consisting of various combinations of fretwork and meanders. Most of these patterns are uncircumscribed, that is, the designs are not fitted to their architectural space, but repeat indefinitely, in the manner of loom-spun cloth.[67] Variations in these motifs are the result of chiral symmetry: replication according to reflection and rotation (Fig. 137).[68] Each cross arm at

60 R. Ousterhout, "The Holy Space: Architecture and the Liturgy," in *Heaven on Earth: Art and the Church in Byzantium*, ed. L. Safran (University Park, PA, 1998), 81–120. See, however, D. W. Phillipson, *Ancient Churches of Ethiopia: Fourth–Fourteenth Centuries* (New Haven, 2009), 188–89.

61 C. Bosc-Tiessé et al., "Peintures et sculptures à Lalibela: Matériaux, processus techniques et strates d'histoire," *Patrimoines* 16 (2021): 93–98, at 95.

62 Lepage, "Entre Aksum et Lalibela," 28–29. Earlier, Beatrice Playne referred to this ornament as "stucco"; B. Playne, *St. George for Ethiopia* (London, 1954), 73.

63 It is likely that this inconsistent carving depth was one of the main reasons for the ornament's erosion in the centuries that followed.

64 Playne, *St. George for Ethiopia*, 81.

65 Bosc-Tiessé et al., "Peintures et sculptures," 96–98. On the use of gold leaf in manuscript illumination, see the near-singular, early fifteenth-century illuminated miracles of Mary, in J. Mercier, *Art of Ethiopia: From the Origins to the Golden Century* (Paris, 2021), 132–39.

66 G. R. Parpulov, I. V. Dolgikh, and P. Cowe, "A Byzantine Text on the Technique of Icon Painting," *DOP* 64 (2010): 201–16, at 206.

67 M. Di Salvo, *Crosses of Ethiopia: The Sign of Faith. Evolution and Form* (Milan, 2006), 93–95; M. Di Salvo, "Serial Geometric Decorations in the Ancient Ethiopian Basilicas," *RSE* 3rd ser. 3 (2019): 65–86.

68 C. Bier, "Elements of Plane Symmetry in Oriental Carpets," *Textile Museum Journal* 31 (1992): 53–70. See also similar

Figure 136.
Abreha wa-Atsbeha,
transept vaults,
Tigray, Ethiopia.
Photograph
by author.

Figure 137.
Schematic of uncircumscribed crosses in Abreha wa-Atsbeha, Tigray, Ethiopia. Drawing by and courtesy of Mario Di Salvo.

Abreha wa-Atsbeha is ornamented with a repeat tetraskelion meander (see Figs. 70, 71, 75), as are the crossing spandrels (see Fig. 72).[69] Because in each case the crosses are rotated to a different degree, the resulting geometric ornament appears markedly different.[70] Bound by the laws of symmetry, yet freed from the spatial constraints of their architectural setting, these linear designs serve to break up the rock surface and dematerialize the vaults. This form of meander ornament is clearly based in the art of weaving,[71] which helps explain its formal similarities with Seljuk revetments (*ḥazār-bāf*) constructed on the opposite end of the Indian Ocean world. As suggested by Carol Bier, in the tenth-century Indian Ocean, the textile arts underwent something of a geometric revolution, a result of mathematic correspondence between Indian and Abbasid spheres, which were then applied, on a monumental scale, to elite architectural spaces.[72] This textile aesthetic spread widely—on the opposite side of the Indian Ocean, masons in Java, Indonesia, utilized

motifs from Gujarati cottons and Abbasid silks to outfit their Hindu temples.[73]

From this same Indian Ocean context, geometric textiles came to both Tigray (via Kwiha and the Dahlak) and Seljuk Iran (via Siraf, Hormus, or Nishapur) in the eleventh century, and in both cases cloth forms were deployed in the service of innovative architecture. Whereas in Iran, cloth-like brickwork was a means of petrifying the luxurious cloths of the royal encampment,[74] in Tigray, the Ethiopian cubit (*ʾəmat*) used to hew the churches was connected to cloth measuring, which reinforces the intersection of architecture and textile use.[75] The masons adorned vaults and walls as if weaving patterns on a loom. These hewn churches were conceived as canopies of cloth, reflecting their liturgical use. Indeed, in Ethiopic, "to veil" (as in textiles) and "to cleave or enclose (space)" is the same, መግዛዝ (*mägzäz*).[76]

Wuqro Cherqos's vaults are also adorned with meanders, which, as in the sanctuary, mirror those

ornamental patterns on Fatimid buildings; K. A. C. Creswell, *The Muslim Architecture of Egypt,* vol. 1, *Ikhshids and Fāṭimids, 939–1171 A.D.* (Oxford, 1952), pls. 29d, 37c, 65d.

69 This is true of Wuqro Cherqos as well.

70 A. J. Lee, "Islamic Star Patterns," *Muqarnas* 4 (1987): 182–97.

71 Ettinghausen, "Woven in Stone and Brick," 316–17.

72 C. Bier, "Patterns in Time and Space: Technologies of Transfer and the Cultural Transmission of Mathematical Knowledge across the Indian Ocean," *Ars orientalis* 34 (2004): 172–94, at 189; Necipoğlu, *Topkapı Scroll,* 99.

73 M.-L. Totton, "Cosmopolitan Tastes and Indigenous Designs: Virtual Cloth in a Javanese *candi,*" in *Textiles in Indian Ocean Societies,* ed. R. Barnes (London, 2005), 105–26; Guy, *Woven Cargoes,* 55–63.

74 A. Patel, *Iran to India: The Shansabānīs of Afghanistan, c. 1145–1190 CE* (Edinburgh, 2021), 139–40.

75 R. Pankhurst, "A Preliminary History of Ethiopian Measures, Weights, and Values (Part 1)," *JES* 7.1 (1969): 31–54, at 33–36.

76 W. Leslau, *Comparative Dictionary of Geʿez* (Wiesbaden, 1987), 73, 212.

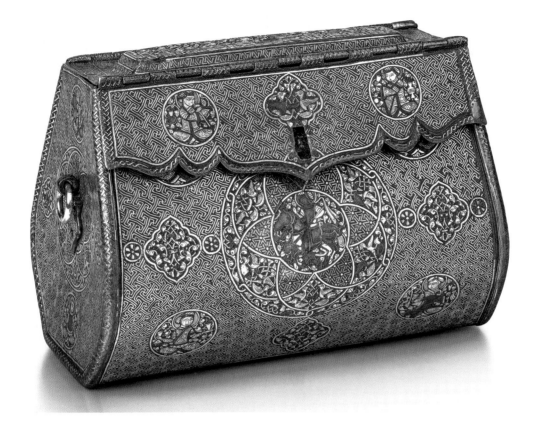

Figure 138.
The Courtauld
Handbag, brass alloy
with silver inlay, 21 cm
× 15.2 cm, Mosul, Iraq,
fourteenth century.
Courtauld Gallery,
London, inv. no. 1966.
GP.209. Photograph
© The Courtauld /
Samuel Courtauld
Trust, Courtauld
Gallery, London /
Bridgeman Images.

at Abreha wa-Atsbeha. Wuqro Cherqos's nave vault, however, is inscribed with a more specific triskelion, that of a T-fret meander (also found in the southwest and northwest aisle bays at Abreha wa-Atsbeha; see Figs. 103, 104). Though ultimately derived from the same cruciform pattern used on the vaulted cross arms of Abreha wa-Atsbeha, this motif may suggest a transfer from the Far East via a textile intermediary.[77] Generally thought to have originated in China, the T-fret is an ornamental program commonly inscribed on bronze basins in Mosul and in Seljuk brickwork (Fig. 138).[78] Though it is most likely that this motif was brought into Tigray from Islamic portable objects, such as textiles or metalwork, it may have come in the form of Chinese cloths as well. From as early as the tenth century, Chinese silks, then known for their lively geometric imagery, were regularly sold (at a premium) in the Persian Gulf, and from there, they presumably made their way into Tigray through the aforementioned Fatimid mercantile channels.[79]

That said, nearly all the motifs inscribed on the church surfaces have direct textile parallels in Gujarati cloths and medieval Egyptian samplers.[80] Of these cloth-based forms, several are specific to their architectural placement. A diaper motif,

77 There is evidence that there was trade in Chinese textiles in the Indian Ocean and Red Sea regions before the Mongol conquests of the thirteenth century. As reported in Geniza documents, the Persian merchant Abū al-Qāsim Rāmisht purchased a silk cloth from China to serve as a new cover (*kiswa*) for the Kaaba in Mecca in 1137–1138; S. M. Stern, "Rāmisht of Sīrāf, a Merchant Millionaire of the Twelfth Century," *JRAS* 99.1 (1967): 10–14.

78 T. Anninos, "Tibetan Leather Boxes," *Arts of Asia* 30.1 (2000): 101–17.

79 Abū Dulaf (mid-tenth century), as quoted in al-Thaʿālibī a century later, wrote of seeing Chinese silks with "shapes depicted on them which only appear in certain lights"; B. D. Averbuch, "From Siraf to Sumatra: Seafaring and Spices in the Islamicate Indo-Pacific, Ninth–Eleventh Centuries C.E." (PhD diss., Harvard University, 2013), 52.

80 Such samplers, a unique window into the minds of weavers in medieval Cairo, are linen swatches with a number of repeat patterns on them to provide inspiration for woven textile compositions; M. Ellis, *Embroideries and Samplers from Islamic Egypt* (Oxford, 2001).

Figure 139. Abreha wa-Atsbeha, north lateral aisle, Tigray, Ethiopia. Photograph by author.

Figure 140.
Textile fragment with
diamond shapes and
quatrefoils, cotton,
resist dyed, 20.5 cm
× 16 cm, Gujarati,
recovered from Fustat,
Egypt, tenth to fifteenth
century. Ashmolean
Museum, Oxford,
inv. no. EA1990.505.
Photograph © Ashmolean
Museum, University
of Oxford.

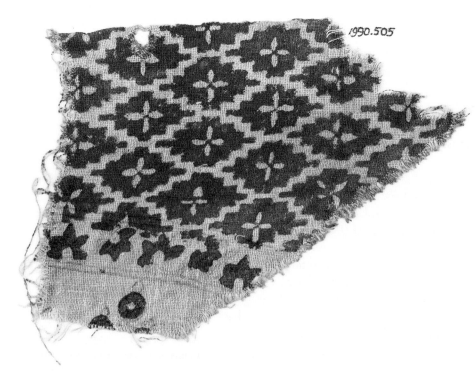

Figure 141.
Stepped cross textile, cotton, resist dyed, 36 cm × 19.02 cm, Gujarati, recovered from Fustat, Egypt, seventeenth or eighteenth century (?). Textile Museum, Washington, DC, inv. no. 6.254, acquired by George Hewitt Myers in 1951. Photograph courtesy of the Textile Museum, Washington, DC.

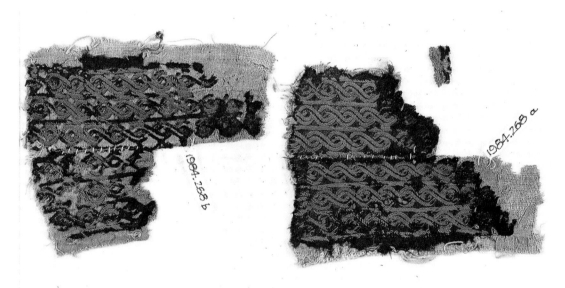

Figure 142.
Interlace braid motif, embroidered silk with linen backing, 13 cm × 9.5 cm, recovered from Fustat, Egypt, tenth to fifteenth century. Ashmolean Museum, Oxford, inv. no. EA1984.268.a. Photograph © Ashmolean Museum, University of Oxford.

consisting of intersecting diamonds, anticipates the entry to the north pastophoria at Abreha wa-Atsbeha (Figs. 139, 140). Likewise, in the elaborate domed south chamber (prothesis; see Fig. 78), the walls are inscribed with hexagons and crosses on the east wall (Fig. 141) and alternating eight-petaled rosettes and stars on the south wall (see Fig. 134), all motifs adapted from South Asian cotton repertoires. The chancel arch soffit (see Fig. 73), in anticipation of the choir dome, bears an elaborate braided motif, perhaps adapted as well from embroidered interlace (Fig. 142).

In this way, some ornaments even suggest a shared function with their cloth counterparts.

A particular example is the stepped cross motif, which in Gujarati and Egyptian cloths is usually a transitional design, framing more elaborate patterns or defining borders (see Fig. 133). One of the aforementioned Egyptian textile hangings sold from the sacristy of Dabra Dammo to Maurice Nahman in 1939 incorporates a stepped cross border to separate two sets of floral motifs.[81]

81 Mordini, "I tessili medioevali," 239 and fig. F; Barnes, *Indian Block-Printed Textiles*, 2:80–84, esp. Percy Newberry Collection EA1990.522, EA1990.313, EA1990.498, EA1990.499, EA1990.500, EA1990.1018, and EA1990.1019.

Figure 143.
Qubba Imām al-Dūr,
bastion detail, near
Samarra, Iraq, 1063
(destroyed 2014).
Photograph from the
Yasser Tabbaa Archive,
courtesy of the Aga
Khan Documentation
Center, MIT Libraries,
Cambridge, MA.

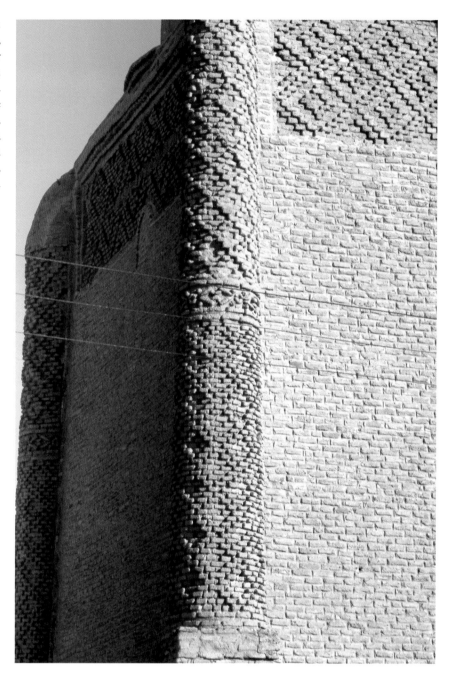

Stepped crosses are used in the same way at Wuqro Cherqos and Abreha wa-Atsbeha. At the engaged pilaster in the northeast lateral aisle of Abreha wa-Atsbeha (see Fig. 139), stepped crosses serve to transition and frame two individual panels of a cross-in-square motif, while in the crossing spaces of Wuqro Cherqos (see Fig. 107) and Abreha wa-Atsbeha (see Fig. 72), the stepped cross (carved in especially deep relief) serves a dramatic function, differentiating the engaged ceiling cross from the flat surface that carries it. It is no

surprise that when the carvers at Mika'el Amba felt that a choir dome might compromise the rock overlay, they decided to replace it with relief-carved stepped crosses (see Fig. 94): the only panel of ornament in the otherwise bare church.

The transmaterial form and function of the stepped cross motif-as-frame had a global reach. The roughly contemporary Seljuk tomb of Imam al-Dur near Samarra, Iraq (1085; Fig. 143), was framed with bastions revetted with brickwork bearing this stepped cross motif in order to frame

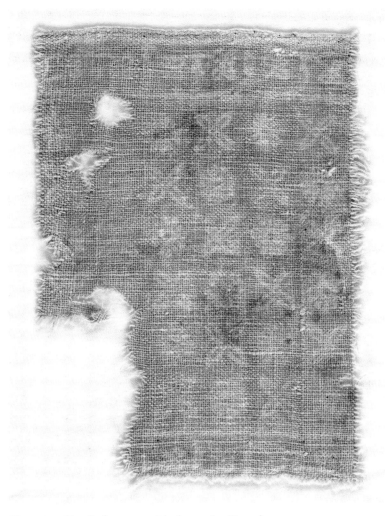

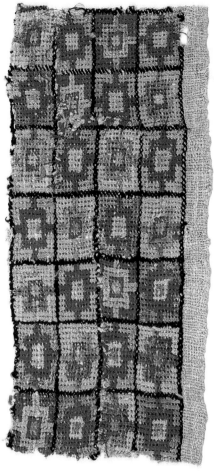

Figure 144. Textile fragment with alternating Xs and rosettes, cotton, 10.99 cm × 15.05 cm, Gujarati, recovered from Fustat, Egypt, tenth to fifteenth century. Textile Museum, Washington, DC, inv. no. 6.306, acquired by George Hewitt Myers in 1954. Photograph courtesy of the Textile Museum, Washington, DC.

Figure 145. Textile with "checkerboard" pattern, embroidered linen, 26 cm × 12 cm, recovered from Fustat, Egypt, tenth to fifteenth century. Ashmolean Museum, Oxford, inv. no. EA1993.316. Photograph © Ashmolean Museum, University of Oxford.

the wall surfaces.[82] It is likely that this framing motif ultimately derived from similar Gujarati cloths, in this case imported to Mesopotamia via the Persian Gulf (in parallel to the import of cloths into Tigray via the Red Sea).

In this same way, a number of imposts and spandrels at Wuqro Cherqos (most visible at the

north crossing arch; see Fig. 107) bear a repeat pattern of alternating X shapes and eight-armed rosettes, which, like the stepped-cross motif, is a transitional ornament in textiles, here rendered, as if directly, from cotton hangings (Fig. 144). Ornament is even used to underscore liturgical relationships: a repeat pattern of square lozenges and Greek crosses is executed in exact detail on both the narthex ceiling and crossing (Fig. 145, and see Figs. 101, 107).

On the other hand, the pattern on the apse conch of Abreha wa-Atsbeha (see Fig. 76) and probably the west wall of Wuqro Cherqos as well (see Fig. 104) suggest another origin: Armenian

82 T. Leisten, *Architektur für Tote: Bestattung in architektonischem Kontext in den Kernländern der islamischen Welt zwischen 3./9. und 6./12. Jahrhundert*, Materialien zur iranischen Archäologie 4 (Berlin, 1998), 159–60. See also F. B. Flood, *Objects of Translation: Material Culture and Medieval "Hindu-Muslim" Encounter* (Princeton, 2009), 235.

Figure 146.
Zavareh Jami Mosque
(Masjid-i Jāmiʿ-i Zavārah),
herringbone brickwork,
west iwan interior, Zavareh
(near Isfahan), Iran, twelfth
century. Photograph by Alka
Patel, courtesy of Artstor.

Figure 147.
Monastery church
of St. Macarius, "old
door" immured in
the central haykal
screen, wood, Wadi
Natrun, Egypt,
tenth to twelfth
century. Photograph
by author.

liturgical cloths. This complex herringbone pattern (composed of splayed double crosses), though commonly featured in Seljuk architecture from the period (Fig. 146), is widely considered an Armenian textile development (Iran and Asia Minor border historical—and contemporary— Armenia).[83] Despite a lack of connection between the Caucasus and Tigray via the India trade, the presence of Armenian cloths in eleventh-century Ethiopia is actually unsurprising. During the rule of Badr al-Jamālī (himself of Armenian origin), the immigration of Armenians to Egypt was encouraged, and for a time many settled in Egypt under the protection afforded by caliphal authority.[84] It was through these mercantile or

83 Ellis, *Embroideries and Samplers*, 10; Ettinghausen, "Woven in Stone and Brick."

84 J. den Heijer, "Considérations sur les communautés chrétiennes en Égypte fatimide: L'État et l'Église sous le vizirat de Badr al-Jamālī (1074–1094)," in Barrucand, *L'Egypte fatimide*,

workshop channels that this type of herringbone likely made it to Ethiopia in the form of Armenian liturgical cloths. That several cenotaphs on the Dahlak islands have a *nisba* (Arabic origin marker, akin to a surname) from the Caucasus and historical Armenia (Harran, Tiflis, and Bastam) does suggest that the cloths arrived directly via Armenian traders on the Ethiopian littoral;[85] alternatively, or as well, this translation of Armenian cloth patterns may have occurred through Egyptian intermediaries. The same pattern is inscribed on the old door of the monastery church of St. Macarius in Wadi Natrun (tenth to twelfth century; Fig. 147).[86]

Perhaps the most compelling, and liturgically significant, stone cloth pattern is the eccentric foliate motif carved into the choir dome at Abreha wa-Atsbeha (see Fig. 73).[87] Largely rendered through strapwork, this design is complex, though not explicitly geometric in nature (Fig. 148). The base of the dome is surmounted by sixteen leaves, serrated with nine teeth alternating with an equal number of interlaced loops. The strapwork is drawn out from the loop, in one direction as an angle above the serrated leaf, and the other strip as one half of a lobed arch over the aforementioned angle. The two intersecting interlaces then form a cusped arch, in which small disks were cut out between the cusps. The interlaced strapwork loops again toward the apex to form a diamond shape, flanked on either side by discs. Further interlacing forms a dart at the apex, preceding an eighteen-petaled rosette at the summit.

A parallel to this precise and complex design may be made to the so-called stylized tree motif in Indian resist-dyed cottons (Fig. 149, and their hypothetical silk prototypes), recovered from Fustat.[88] Although rendered with elaborate

interlacing, when taken as a whole, the cupola decoration evokes compressed foliage, like a flower bud or a terminal crown of a date palm, endemic to the Red Sea littoral.[89] When considered in the context of the highly ornamented vaults, the rendering of paradisiacal vegetal patterns near the sanctuary is fitting. In this case, the foliate decoration in the choir dome was Edenic, a metaphor for the heavenly Jerusalem and the four rivers of paradise that flowed from it. Already in the tenth century we find at the Egyptian monastery church of Deir al-Surian in Wadi Natrun, elaborate Abbasid-style stuccowork vinescrolls defining the liturgical significance of the choir and sanctuary (khūrus and haykal), presumably for their paradisiacal associations (Fig. 150).[90] In the case of Tigray, this leafy imagery was drawn from textile sources and therefore also embodied the festive functions of the chancel veil.

Nor was the liturgical use of the textile-derived "stylized tree motif" limited to Tigray. In Fatimid Cairo we find a variant of this same design on a wooden altar ciborium (currently held in the Coptic Museum in Cairo, no. 1171; Fig. 151) recovered from the Hanging Church (*al-Kanīsa al-muʿallaqa*) in Fustat.[91] Specific to the

569–78; M. N. Swanson, *The Coptic Papacy in Islamic Egypt (641–1517)* (Cairo, 2010), 63.

85 Schneider, *Stèles funéraires*, 1:33, 326, 334–36, 338–39.

86 A. Jeudy, "Le mobilier liturgique en bois au Moyen Âge: Interactions et identité de la communauté copte du Xᵉ au XIVᵉ siècle" (PhD diss., Panthéon-Sorbonne University, 2006), 87–91, pl. 11a.

87 Lepage and Mercier connect this decoration to foliation found in Egyptian and Syrian dome programs (lamentably without examples): *Les églises historiques*, 79–80.

88 Examples of this pattern shared by the dome include Percy Newberry Collection EA1990.601, EA1990.603, EA1990.608,

EA1990.614, EA1990.617, EA1990.625, EA1990.635, EA1990.916, EA1990.935, EA1990.936, EA1990.941, EA1990.943, and EA1990.966.

89 On the Edenic symbolism of the date palm in medieval Arabia, see S. Bandyopadhyay, "Conflation of Celestial and Physical Topographies in the Omani Decorated *miḥrāb*," *PSAS* 40 (2010): 99–110.

90 See M. Immerzeel, "A Play of Light and Shadow: The Stuccoes of Dayr al-Suryan and Their Historical Context," in *Christianity and Monasticism in Wadi al-Natrun: Essays from the 2002 International Symposium of the Saint Mark Foundation and the Saint Shenouda the Archimandrite Coptic Society*, ed. M. S. A. Mikhail and M. Moussa (Cairo, 2009), 246–71. For the medieval West, see also the eucharistic symbolism of vine scrolls, in M. S. Doquang, *The Lithic Garden: Nature and the Transformation of the Medieval Church* (New York, 2018), 116–124.

91 J. Auber de Lapierre and A. Jeudy, *Catalogue général du Musée copte du Caire: Objets en bois 1*, Bibliothèque d'études coptes 26 (Cairo, 2018), 126–31; Jeudy, "Le mobilier liturgique," 205–7; A. Jeudy, "Icônes et ciboria: Relation entre les ateliers coptes de peinture d'icônes et l'iconographie du mobilier liturgique en bois," *Eastern Christian Art* 1 (2004): 67–88, at 83; C. J. Lamm, "Fatimid Woodwork, Its Style and Chronology," *BIE* 18 (1935): 59–91, at 64; E. S. Bolman, "Veiling Sanctity in Christian Egypt: Visual and Spatial Solutions," in *Thresholds*

Figure 148. Abreha wa-Atsbeha, dome ornament, Tigray, Ethiopia. Drawn by author.

Figure 149. Textile fragment with arches and stylized plants (stylized tree), cotton, resist dyed, 18.5 cm × 17 cm, Gujarati, recovered from Fustat, Egypt, tenth to fifteenth century. Ashmolean Museum, Oxford, inv. no. EA1990.916. Photograph © Ashmolean Museum, University of Oxford.

Figure 150.
Deir al-Surian,
apse stucco detail,
Wadi Natrun,
Egypt. Photograph
by author.

vizierate of Badr al-Jamālī, this liturgical canopy was adorned contemporaneously with the dome decoration at Abreha wa-Atsbeha, and functioned in the same way. Located in the choir, both structures were originally shrouded, veiled with Indian cloths. This motif's special use was not limited to Christian settings: we find in Sulayhidera (Fatimid vassal) mosques in Yemen, mihrab hoods ornamented with similar foliate patterns.[92]

Could the widespread use of this motif in devotional contexts in the late eleventh century suggest a coherent "Fatimid" Indian Ocean style?

Freestanding chancels, which functioned alongside hung curtains to conceal and reveal sacred space, were likewise ordered according to textile ornament. After all, both wood and silk screens act as hijab—or liturgical—curtains.[93] Although extant Tigrayan transennae slabs date to the twelfth century, or shortly thereafter as in the case of Mika'el Amba (see Fig. 97), in all cases form follows function, i.e., the same logic undergirds textile patterns and wall surfaces.[94] On wooden chancel arches we even note the use of precise textile logic: stepped crosses are reserved for the soffits (see Fig. 84), which thereby function as transitional zones or borders within the church. This was certainly the case in Egypt as well, where we find Fatimidera screens adorned to evoke cloth hijabs. The

of the Sacred: Architectural, Art Historical, Liturgical, and Theological Perspectives on Religious Screens, East and West, ed. S. E. J. Gerstel (Washington, DC, 2006), 73–104, at 95; M. G. Parani, *Reconstructing the Reality of Images: Byzantine Material Culture and Religious Iconography (11th–15th Centuries)*, The Medieval Mediterranean 41 (Leiden, 2003), 179–85. See Textile Museum Collection Number 6.304 for a direct parallel. For a broad history of altar ciboria in the Byzantine Empire, see J. Bogdanović, *The Framing of Sacred Space: The Canopy and the Byzantine Church* (New York, 2017).

92 B. Finster, "Survey islamischer Bau- und Kunstdenkmäler im Yemen: Erster vorläufiger Bericht," in *Archäologische Berichte aus dem Yemen*, vol. 1, ed. J. Schmidt (Mainz, 1981), 223–71, at pls. 104, 105a. The mechanism of translation between architecture and ornament is well documented in Yemen; see R. Barnes, "The Painted Ceiling of the 'Amiriya: An Influence from Indian Textiles?," in *The 'Amiriya in Rada': The History and Restoration of a Sixteenth-Century Madrasa in the Yemen*, ed. S. al-Radi, Oxford Studies in Islamic Art 13 (Oxford, 1997), 139–48; Bier, "Patterns in Time and Space."

93 P. Grossmann, "Architectural Elements of Churches," in *The Coptic Encyclopedia*, ed. A. S. Atiya, 8 vols. (New York, 1991), 1:194–226, at 211–12; S. McNally, "Transformations of Ecclesiastical Space: Churches in the Area of Akhmīm," *BASP* 35.1–2 (1998): 79–95, at 92–95.

94 For the full typology of Mika'el Amba's transennae ornament, see Muehlbauer, "'Bastions of the Cross,'" 424–61.

Figure 151.
Wooden ciborium from the Hanging Church, eleventh to twelfth century. Coptic Museum, Cairo, inv. no. 1171. Photograph by author; courtesy of the Coptic Museum.

well-preserved wood-and-ivory chancel from Deir al-Surian includes panels of stepped crosses, meanders, diapers, and roundels,[95] all ultimately derived from these same Indian Ocean cloth forms (see Fig. 127).

While modern art historiography widely considers ornament as a hallmark of Islamic visual culture (viz., the term "arabesque"[96]), the idea that artisans translated ornamental forms between

95 Jeudy, "Le mobilier liturgique," 75–87.

96 F. B. Flood, "The Flaw in the Carpet: Disjunctive Continuities and Riegl's Arabesque," in *Histories of Ornament: From*

cloths and monumental buildings in the Christian medieval contexts is not new. It is also known that luxury textiles' material hierarchy over other media transcended geography.[97] However, while silk had enormous diplomatic and economic powers, it also had a critical socio-aesthetic function within the church. Here textiles, and thereby textile-derived motifs, were mostly associated with windows, chancels, screens, and lattices.[98] The presence of such patterns on later Ethiopian processional crosses[99] testifies to the potentially revelatory role ornament played in the liturgy, especially when torches were the light source.

This translation of motifs into architectural space was likely for a liturgical end, as textiles and their ornaments were a means to articulate the liminal. In imitating textiles' materiality as a lattice screen or lifted veil, textile-derived repeat patterns were a sumptuous window and liturgical threshold, where the immaterial is made material and vice versa. Much as veils can conceal, once lifted, they also reveal.[100] In their original state, the paralleling of rendered and physical veils at Abreha wa-Atsbeha and Wuqro Cherqos likely also agitated the space, making the physical church interior appear haptic and diaphanous.[101]

The revelatory contexts of chancel veils also bore biblical connotations. In the New Testament's "Epistle to the Hebrews," Christ is likened to the temple veil in the administering of the Eucharistic gifts: "Since we have confidence to enter the Most Holy Place by the blood of Jesus, by a new and living way opened for us through the curtain, that is, his body."[102]

The Coptic Anaphora of St. Mary, a eucharistic prayer composed by Cyriacus of Behnesa and translated from Arabic into Geʿez (or authored in Geʿez by Giyorgis of Sagla [Sägla]) sometime in the late fourteenth or early fifteenth century, similarly likens God to the chancel curtain: "Oh Virgin, when there abode in your womb the fire of the godhead, whose face is fire, whose clothes are fire, whose covering is fire, how did it not burn you? . . . when I think of this [the miraculous conception, MM] my mind likes to soar and ascend secretly and draw back the curtains of the hiding-places of the living one [God, MM]."[103]

Although narrowed to a specific time period and to an even more specific liturgical setting within eleventh-century Ethiopia, these interactions between textile and architecture should not be understood in isolation. Since Lisa Golombek's 1984 publication "The Draped Universe of Islam," it has been known that, in Islamicate contexts, textiles not only covered the bodies of people but ubiquitously and conspicuously adorned buildings as well.[104] This practice was thus shared among the Seljuks and post-Aksumite Tigrayans, both of whom clothed their monuments

Global to Local, ed. G. Necipoğlu and A. Payne (Princeton, 2016), 82–93.

97 For global overviews of Silk Road history, see X. Liu, *The Silk Road in World History* (New York, 2010). For Byzantium, see F. E. Schlosser, "Weaving a Precious Web: The Use of Textiles in Diplomacy," *BSl* 63 (2005): 45–52; A. M. Muthesius, "Silk, Power and Diplomacy in Byzantium," in *Textiles in Daily Life: Proceedings of the Third Biennial Symposium of the Textile Society of America, September 24–26, 1992* (Columbia, PA, 1992), 99–110, https://digitalcommons.unl.edu/cgi/viewcontent.cgi?article=1579&context=tsaconf.

98 See the recent edited volume on chancel veils, L.-J. Bord, V. Debiais, and É. Palazzo, eds., *Le rideau, le voile et le dévoilement: Du Proche-Orient ancien à l'Occident médiéval* (Paris, 2019).

99 M. E. Heldman, "Creating Religious Art: The Status of Artisans in Highland Christian Ethiopia," *Aethiopica* 1 (1998): 131–47, at 144, 146–47.

100 The iconography of the choir screen as a liturgical bridge appears in the Deesis programs of sixth-century Byzantine chancels; L. Nees, "The Iconographic Program of Decorated Chancel Barriers in the Pre-Iconoclastic Period," *ZKuntsg* 46.1 (1983): 15–26.

101 As in Spain, see P. Blessing, "Weaving on the Wall: Architecture and Textiles at the Monastery of Las Huelgas in Burgos," *Studies in Iconography* 40 (2019): 137–82, at 170.

102 Hebrews 10:19–20 (NIV).

103 Anaphora of St. Mary, vv 80–85, trans. M. Daoud and M. Hazen, *The Liturgy of the Ethiopian Orthodox Church* (Cairo, 1959), 79 (translation slightly modified). Verena Böll dates the translation of this text to the reign of Dawit I (1382–1412); V. Böll, *"Unsere Herrin Maria": Die traditionelle äthiopische Exegese der Marienanaphora des Cyriacus von Behnesa* (Wiesbaden, 1998), 16. Getatchew Haile has recently proposed that this text was composed in Geʿez but ascribed to Cyriacus; see G. Haile, *Ethiopian Studies in Honour of Amha Asfaw* (New York, 2017), 36.

104 L. Golombek, "The Draped Universe of Islam," in *Content and Context of Visual Arts in the Islamic World: Papers from a Colloquium in Memory of Richard Ettinghausen, Institute of Fine Arts, New York University, 2–4 April 1980, Planned and Organized by Carol Manson Bier*, ed. P. P. Soucek (University Park, PA, 1988), 29–49.

in physical and transmaterial veils: the spoils of world trade.

The Fatimids conceived their entire worldview in terms of textiles. Al-Maqrīzī, the fourteenth-century Mamluk historian, noted that the tenth-century caliph al-Muʿizz commissioned a world map made of silk, centered on Mecca, to be hung in his mausoleum. He described it as:

A piece of fine blue silk . . . with gold lettering and with various pieces of silk stitched on . . . On it were pictured the parts of the earth with all the cities and mountains, seas and rivers, a reproduction of geography; Mecca and Medina were plotted on it, and below it was written: 'Completed at the command of al-Muʿizz li-Dīn Allāh, out of longing for the sanctuary of God, and in order to make known the places of the Messenger of God, in the year 353 [964 CE].[105]

For the Fatimids, textiles were not simply their economic lifeblood; they were also how the empire envisaged itself in this world and the next. It is thus no surprise that in eleventh-century Ethiopia, esteemed commissions such as Abreha wa-Atsbeha and Wuqro Cherqos, two of the largest and most architecturally innovative churches in Tigray, would be adorned with luxurious cloth imports as well as low relief ornament drawn from textiles. These hangings and their painted representations had a dual function—both liturgical use (screening the altar space) and as signifiers of material wealth. Considering their Fatimid context as well, it may even be that these cloths conveyed the sought-for ecumenism otherwise conveyed in the churches' "Justinianic"-aisled cruciform conceptions. That these patterns were inscribed on vaulted cross arms underscored their ecumenical connotations: the vault of heaven was a canopy of cloth.

105 Translation from S. Jiwa, *Towards a Shiʿi Mediterranean Empire: Fatimid Egypt and the Founding of Cairo. The Reign of the Imam-Caliph al-Muʿizz from Taqī al-Dīn Aḥmad b. ʿAlī*

al-Maqrīzī's Ittiʿāz. al-Ḥunafāʾ bi-akhbār al-aʾimma al-fāṭimiyyīn al-khulafāʾ (New York, 2009), 28.

A LOCAL LEGACY

ALTHOUGH SCARCELY KNOWN OUTSIDE of Ethiopia, Abreha wa-Atsbeha, Wuqro Cherqos, and Mika'el Amba are innovative monuments that could and should be considered representative of one of the great architectural movements of the Middle Ages. Indeed, when considered alongside better-known marvels in the contemporary (late eleventh-century) Mediterranean, we find remarkable parallels. Late antique revival architecture, staged with innovative technology and presented in a local idiom, defined elite architecture in the global year 1000, whether Romanesque (see Fig. 131), Komnenian Byzantine (see Fig. 130), Fatimid (see Figs. 121, 123), or Venetian (see Fig. 1). In the case of Abreha wa-Atsbeha (see Fig. 2) and its allied churches, the legacy of late antiquity was reinvented through a particularly multifaceted lens. Local building fabrics were staged with vaulted cross arms and tripartite spatial massing, while Indian ocean cloth patterns served to embellish the space and challenge the rupestrian medium. Tigrayan cruciform churches advertised post-Aksumite Christianity as a burgeoning world power, on the brink of total hegemony and expansion while engaged in extensive dialogue with their erstwhile ally and benefactor, Fatimid Egypt.

Reflecting on their current and historical use, it is likely that Abreha wa-Atsbeha, Wuqro Cherqos, and Mika'el Amba were founded as monasteries in the late eleventh century, during

the apex of Fatimid involvement there (1089–1094). Owing to their accessible location and large scale, these monuments were plausibly also built as parish churches, reflecting their use today, and, in the case of Abreha wa-Atsbeha, served an episcopal function (synthronon as bishop's throne). Although monastic patronage for the three churches cannot be discounted outright, the unprecedented use of textile ornament and vaulting alongside explicitly elite architectural forms suggests an ideological motive: royal and/or episcopal input.

As discussed in the preceding chapter, the availability of imported textiles in the region were a late eleventh-century circumstance, owing to Tigray's recent reentry into Indian Ocean trade. These cloths were luxury goods, and their ornament was deployed alongside vaults (then associated with the Fatimid vizier Badr al-Jamālī and the Byzantine Empire) as identifiers of extreme prestige, cosmopolitanism, and perhaps even empire (by virtue of the Fatimid example). With the cruciform plan, adapted from the architecture of Justinian's Byzantium, it appears that those who commissioned the triad were invoking the (political) legacy of Aksum at its sixth-century zenith as well as the ecumenism of a past alliance with Byzantium. As the early Zagwe kings were the likely heirs of an Aksumite polity (an east Tigrayan client or chieftaincy?), such monumental architectural projects would fit naturally into

their worldview. The discovery in the land grants of later Zagwe kings Tantawedem and Lalibela of conspicuous references to the cross as a legitimator of their sovereignty[1] suggests that the establishment of these great cruciform churches in an otherwise non-Christian and Islamic domain were as much a political statement as they were religious foundations.

The extent to which Tigrayan cruciform churches should be valorized in the canon of Eastern Christian architecture and art history more broadly is an open question. Although the current North American framework of the "Global Middle Ages" has encouraged the field to look outward, especially to oft-neglected Africa, eclectic nonspecialist overviews often lack nuance and consultation of local literature.[2] At the same time, the siloing of Ethiopian art in specialist publications has often prevented fruitful exchanges with other fields, namely, within Eastern Christian studies. This is especially the case for Coptology, where ignorance of Ethiopia's Christianity, like that of Nubia, is to the detriment of its overall study, if not the historical record itself. Moreover, although I comfortably call the Christian heritage of Ethiopia's northern province Tigray "medieval," this also brings its own disciplinary and methodological baggage, especially in non-Western contexts.[3] For example, the "Shay culture" group, a pagan civilization that coexisted with the "medieval" Tigrayan post-Aksumite subjects of this book, is better studied in an Africanist context, but, when taken alone, important reciprocal connections may be overlooked.[4]

Although Byzantine architecture is inherently unwieldy and difficult to define,[5] it is a promising way forward for the validation of Tigrayan cruciform churches (to which this publication by Dumbarton Oaks Press can attest).[6] Recently, Robert Ousterhout's textbook, *Eastern Medieval Architecture*, gracefully incorporated Ethiopian monuments by virtue of its decentralized regional framework.[7] That said, although Ousterhout's survey is something of a successor to Richard Krautheimer's classic *Early Christian and Byzantine Architecture* (first published in 1965), the respective authors' geographic focus (the Eastern Mediterranean, ca. 300–1453) has remained static, much like the field itself.[8]

Although Tigrayan cruciform churches remain almost unknown to Byzantinists, we might model their future inclusion and study in an Eastern Christian context after that of early medieval Armenia. Like post-Aksumite Tigray, Armenia was historically a broker state, an economic position that was reflected in its architecture—as part of global architectural discourse as well as local idioms.[9] Christina Maranci has

1 M.-L. Derat, *L'énigme d'une dynastie sainte et usurpatrice dans le royaume chrétien d'Éthiopie du XIᵉ au XIIIᵉ siècle* (Turnhout, 2018), 115–16.

2 B. Cheng, "A Camel's Pace: A Cautionary Global," *The Medieval Globe* 3.2 (2017): 11–34, at 17.

3 See the critique offered in S. Wolde, "The Profile of Writings on Ethiopian Medieval Christian Art," in *Proceedings of the Eighth International Conference of Ethiopian Studies, University of Addis Ababa, 1984*, ed. T. Beyene, 2 vols. (Addis Ababa, 1988–89), 2:165–71.

4 F.-X. Fauvelle and B. Poissonnier, "The Shay Culture of Ethiopia (Tenth to Fourteenth Century AD): 'Pagans' in the Time of Christians and Muslims," *African Archaeological Review* 33.1 (2016): 61–74, at 62–63.

5 C. L. Striker, "Richard Krautheimer and the Study of Early Christian and Byzantine Architecture," in *In memoriam Richard Krautheimer: Relazioni della giornata di studi, Roma, 20 febbraio 1995, Palazzo dei Conservatori, Sala dell'Ercole*, ed. J.-M. Kliemann (Rome, 1996), 27–40, at 36. See also R. Ousterhout, "An Apologia for Byzantine Architecture," *Gesta* 35.1 (1996): 21–33.

6 That said, in France, the study of Christian Ethiopian art has long been studied under a "Byzantine" rubric. Claude Lepage mentored a generation of Byzantine art historians (including Athanasious Semoglou, Ioanna Lagou, and Anestis Vasilakeris) at the Sorbonne.

7 R. Ousterhout, *Eastern Medieval Architecture: The Building Traditions of Byzantium and Neighboring Lands*, Onassis Series in Hellenic Culture (New York, 2019), xix, 295–97.

8 Ousterhout's contributions are mainly temporal and thematic, giving equal weight to secular as well as Middle and Late Byzantine architecture, and largely abandoning typological classification in favor of a regional framework. Richard Krautheimer however, should be commended for his prescient, "global" approach. See, for example, his discussions of Nubian churches and their relationship to Byzantine monuments in R. Krautheimer, *Early Christian and Byzantine Architecture* (New Haven, 1992), 304–8. Although not a textbook, we find in Sebastian Ristow's definitive corpus of early Christian baptisteries the seamless incorporation of Aksumite piscina; S. Ristow, *Frühchristliche Baptisterien*, JbAC Eg. Bd. 27 (Münster, 1998).

9 Early medieval Armenia sat between the great powers of Sasanian Iran (later the Abbasid caliphate) and Byzantium. On this, see C. Maranci, *Vigilant Powers: Three Churches of Early Medieval Armenia* (Turnhout, 2015).

suggested that the power of Armenian churches may lie in their "frontier" status, and thereby their ability to destabilize canonical constructs.[10] I have shown in this monograph how Tigrayan cruciform churches lie geographically and conceptually on multiple frontiers of study (e.g., Byzantine, African, Islamic, and South Asian art histories), and thus, like those Armenian monuments, Tigrayan cruciform churches could serve as a foil, destabilizing the geographic and cultural canon of Byzantine architecture.

The periphery serves as more than just a destabilizing force, however. Maranci has also shown that the seventh-century tetraconch church of Zuartʿnocʿ in Armenia was constructed just as Byzantine Emperor Heraclius restored Constantine's Church of the Holy Sepulcher in Jerusalem in 630.[11] Rather than a distant echo of a "canonical" building, the architecture of Zuartʿnocʿ was, in fact, a profound appropriation of sacred architectural iconography across western Asia. Much as Maranci concludes that Zuartʿnocʿ and the Umayyad Dome of the Rock are equal members of the same, seventh-century lineage of sacred rotundae,[12] so, too, do I suggest that Abreha wa-Atsbeha and San Marco are distant relatives. Constructed on opposite ends of the eastern Mediterranean world, they nevertheless share an aisled cruciform conception and "Byzantine" use of spatial massing that is ultimately drawn from the same sixth-century Justinianic sources (real or imagined).

However geographically, culturally, and canonically removed from one another, these medieval monuments share an ideological use of architectural iconography that transcends the physical and temporal realms. The close study of geographically "peripheral" monuments, such as Abreha wa-Atsbeha and Zuartʿnocʿ, does not just productively destabilize, it also serves to inform the "center" (and vice versa) without assuming outdated processes of cultural diffusion and "influence." By bridging disciplinary divides I hope that my study of Tigrayan churches will encourage open dialogue and collaboration

between disparate geographies and historiographies outside the confines of the Byzantine canon, much as Maranci has done for Armenia.

The Cult of Saints Abreha and Atsbeha

Within Ethiopia, Tigrayan cruciform churches are influential and undergird a significant local legacy. This is apparent in Ethiopia's later architectural history *and* in its contemporary religious landscape. Abreha wa-Atsbeha, in particular, has become the locus of a cult of saints, that of the fourth-century brother-kings Abreha and Atsbeha.[13] Although probably loosely based on Aksumite precedent (Abreha is the name of the sixth-century Aksumite governor of South Arabia, and Atsbeha is derived from ʾƎllä ʾAṣbəḥa [Ἐλεσβόας], the throne name of the sixth-century Aksumite emperor Kaleb), their hagiography was recorded sometime in the nineteenth century.[14] In contemporary Tigray it is believed that the twin kings hewed hundreds of churches there (according to some, *every* hypogea), all connected by secret passageways in the mountains. Perhaps this story conflates the Aksumite apex (sixth century) and Christianization (fourth century) with the eleventh-century revival of post-Aksumite Christian authority in east Tigray?[15]

The church of Abreha wa-Atsbeha is now the alleged resting place of these kings, and a veiled ossuary in the south chamber is said to contain their remains. The church is undoubtedly one of Tigray's most important monuments, in large part due to this recent reliquary tradition.[16] The monument was chosen among many for a costly and conspicuous restoration during the Italian

10 C. Maranci, "Locating Armenia," *Medieval Encounters* 17 (2011): 147–66.

11 Maranci, *Vigilant Powers*, 144–46.

12 Maranci, *Vigilant Powers*, 182–84.

13 S. C. Munro-Hay, "Abreha and Asbaha," in *EAe* 1:45–46.

14 P. Marrassini, "Il *Gadla Abreha waAṣbeḥa*: Indicazioni preliminari," *Warszawskie Studia Teologiczne* 12.2 (1999): 159–79; S. Hummel, "The Disputed *Life* of the Saintly Ethiopian Kings ʾAbrəhā and ʾAṣbəḥa," *Scrinium* 16 (2016): 35–72; H. M. Tegegne, "Dispute over Precedence and Protocol: Hagiography and Forgery in 19th-Century Ethiopia," *Afriques* 7 (2016), http://journals.openedition.org/afriques/1909.

15 Much as Marie-Laure Derat has suggested that the early Zagwe period was the actual "second Christianization," although traditionally attributed to the sixth century in hagiographic literature.

16 H. S. Almaho, *Tarik Negast Abreha wa-Atsbeha* (Mekelle, 2012).

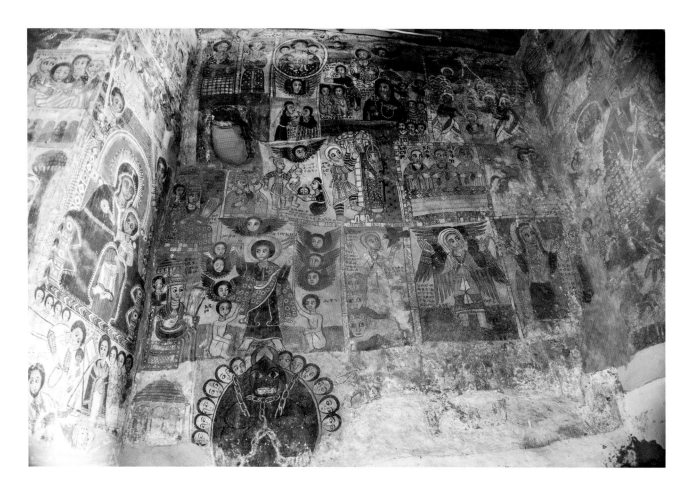

Figure 152.
Abreha wa-Atsbeha,
narthex south wall,
Tigray, Ethiopia. On
the middle register
in the center we
see the twin kings
distributing blessed
wine. Photograph
by author.

occupation owing to its regional importance.[17] As with other reliquary traditions, these remains are associated with miracles. Beatrice Playne has alleged that their bodies leaked fluid, which was collected as a holy salve and distributed in ampullae, which, if true, closely mirrors late antique Levantine practice.[18] Although their hagiography does not mention holy fluid, it records that the saintly incorruptness of Abreha and Atsbeha meant that their hair continued to grow after death, which the current parish priest himself witnessed in 2018.[19] A story told to me when I visited elaborates on this: In medieval times it was said that a blind king from Arabia made a pilgrimage to the church, skeptical of this miracle; when he prayed to the saint kings, however, his sight was restored, and he was able to gaze upon their still growing hair.[20] This is just one of many miracles associated with the saints Abreha and Atsbeha. Paintings commissioned for the narthex in the late nineteenth century depict the twin kings in a Christlike manner healing the sick with blessed wine (Fig. 152).[21]

The fame of these saints in contemporary Tigray as well as their legacy as builders have led to a special history of the cruciform plan there. The twin kings are said to have hewed Abreha wa-Atsbeha as their last monument (their sepulcher), and Mika'el Amba and Wuqro Cherqos

17 M. Muehlbauer, "An Italian Renaissance Face on a 'New Eritrea': The 1939 Restoration of the Church of Abreha Wa-Atsbeha," *JSAH* 78.3 (2019): 312–26.

18 B. Playne, *St. George for Ethiopia* (London, 1954), 82. On the late antique practice, see J. Raby, "In Vitro Veritas: Glass Pilgrim Vessels from 7th-Century Jerusalem," in *Bayt al-Maqdis*, vol. 2, *Jerusalem and Early Islam*, ed. J. Johns (Oxford, 1992), 113–90. However, it may be that Playne's observation was a misinterpretation of the "holy water" column seen by Henry Salt; see G. Annesley, *Voyages and Travels to India, Ceylon, the Red Sea, Abyssinia, and Egypt, in the Years 1802, 1803, 1804, 1805, and 1806*, 3 vols. (London, 1809), 3:27–29.

19 Hummel, "Disputed *Life*," 51.

20 Personal communication, parish priest, Abreha wa-Atsbeha, 18 June 2018.

21 Muehlbauer, "Italian Renaissance Face," 319.

just prior. Another story, recorded by Wolbert Smidt in the vicinity of Wuqro, places the three churches' origins in biblical times. Immediately after Christ's crucifixion, a zebu horn beaker (*wanča*) was placed under his feet, and it filled with the blood that dripped from his wounds. After it was filled, it was carried up to heaven by an angel and poured out, with three droplets becoming the three "identical" churches of Mika'el Amba, Wuqro Cherqos, and Abreha wa-Atsbeha.[22]

Beyond contributing to a contemporary social history of the region, these modern accounts highlight a significant postmedieval legacy of these churches. The fact that they were restored and modified multiple times in the premodern period underscores their significance. As places of pilgrimage, or through the mechanism of restoration, various attributes of these monuments were invoked in the later medieval architecture of Tigray and Amhara regions.

Architectural Echoes

The influence of the Tigrayan cruciform church was felt in the architecture of Ethiopia already during the thirteenth and fourteenth centuries. Despite having emerged in Tigray, the Zagwe dynasty, especially under King Lalibela (r. 1204–1225?), soon refocused their architectural energy toward the frontier, in and around Lasta.[23] Although the Lalibela church complex, the aforementioned group of eleven monolithic churches, was initially established as a non-Christian troglodytic and hypogean settlement, it was heavily built up as an ecclesiastical site from the thirteenth century on.[24] These later

Zagwe monuments in many ways echo the earlier churches in the north. This is unsurprising since the dynasty was in all likelihood of Tigrayan origin and, as of the twelfth century, controlled the lands containing Abreha wa-Atsbeha, Wuqro Cherqos, and Mika'el Amba.[25] The Hatsanis, who had commissioned the Tigrayan cruciform churches in the eleventh century, were probably the dynastic predecessors of King Lalibela.

Although the thirteenth-century monuments in the church complex are somewhat unprecedented in their wholly monolithic conception and expressive uses of articulation and sculpture, they may also be understood as an extension of the building practices of the prior centuries (see Fig. 10). As mentioned in Chapters 1 and 3, generally speaking, Tigrayan cruciform churches were the first vaulted monuments after antiquity. This form was then rarely used in the centuries after, and therefore these arched ceilings are a striking characteristic of the thirteenth-century churches at Lalibela.[26] Four of the eleven churches (roughly corresponding with King Lalibela's input on the site) were hewn as basilicas with vaulted naves (Fig. 153). In each case, space was dramatically massed around the central aisle. Vaults were segmented with transverse arches and pilaster responds on the springing.[27] Although more heavily articulated than those at Abreha wa-Atsbeha, the form and practice of vaulting was the result of architectural experimentation in the eleventh century (see Chap. 3). In keeping with the use in the complex of iconographic mural paintings and colored glass, barrel vaults likely carried the same Fatimid connotations of the previous century—a point of fact made clear with the known involvement of Egyptian ecclesiastics at the site.[28]

22 This oral history was passed on to me by Wolbert Smidt in June 2018. It was recorded as part of a wider oral history component of a DFG-Projekt at the Friedrich-Schiller-Universität Jena entitled "Kulturelle Kontakte zwischen Südarabien und Äthiopien: Rekonstruktion des antiken Kulturraums von Yeha (Tigray/Äthiopien)."

23 Derat, *L'énigme*, 168.

24 M.-L. Derat et al., "The Rock-Cut Churches of Lalibela and the Cave Church of Washa Mika'el: Troglodytism and the Christianisation of the Ethiopian Highlands," *Antiquity* 95 (2021): 467–86; C. Bosc-Tiessé et al., "The Lalibela Rock Hewn Site and Its Landscape (Ethiopia): An Archaeological Analysis," *Journal of African Archaeology* 12.2 (2014): 141–64; F.-X. Fauvelle-Aymar et al., "Rock-Cut Stratigraphy: Sequencing the Lalibela Churches," *Antiquity* 84 (2010): 1135–50; M. Gervers,

"The Rehabilitation of the Zagüe Kings and the Building of the Däbrä Sina–Golgotha–Sellassie Complex in Lalibäla," *Africana Bulletin* 51 (2003): 23–49.

25 Derat, *L'énigme*, 133–45, 261–71.

26 Although described as vaulted, the unfinished Tigrayan church of Maryam Hitsewto (Maryam Hṣ'ǝwto) has a faux gable roof, like Iyasus Gwahegot, and not a vault; R. Plant, *Architecture of the Tigre, Ethiopia* (Worcester, UK, 1985), 159–60.

27 J. Mercier and C. Lepage, *Lalibela, Wonder of Ethiopia: The Monolithic Churches and Their Treasures* (London, 2012), 76–81.

28 C. Lepage, "Un métropolite égyptien bâtisseur à Lalibäla (Éthiopie) entre 1205 et 1210," *CRAI* 146.1 (2002): 141–74;

Figure 153.
Beta Emmanuel,
nave vault,
Lalibela, Lasta,
Amhara, Ethiopia.
Photograph
by author.

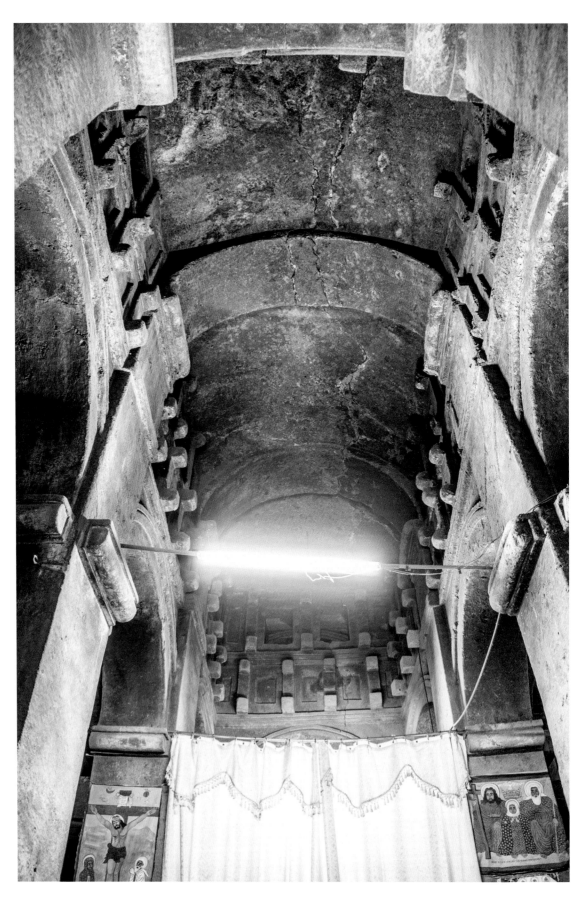

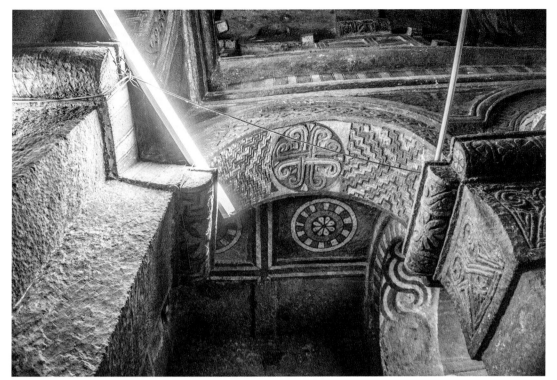

Figure 154.
Beta Maryam,
south arcade
spandrel, Lalibela,
Lasta, Amhara,
Ethiopia.
Photograph
by author.

However, even more than the vaults employed on the cross arms of Tigrayan cruciform churches, the ceilings at Lalibela incorporated a pseudo-Romanesque alternation of support, mirroring with impressive fidelity those used in some Egyptian monastery churches (e.g., the roughly contemporary vaults at Deir al-Surian; see Fig. 122).[29] Moreover, in a manner superseding the earlier churches of Tigray, we find "Aksumite" architectural elements steadfastly rendered in stone (see Fig. 9).[30] Forms such as blind windows with protruding joins as well as chamfered pillars and torus moldings were hewn in a wrought, heavily sculpted, and ultimately imaginative manner.[31] When looked at in the context of Tigrayan church architecture, the thirteenth-century churches at Lalibela represent a continuation and elaboration of elite trends that were already established in the architecture of Tigrayan cruciform churches, that is, the deployment of Aksumite articulation[32] alongside contemporary Egyptian architectonics.[33] As an example, the low relief sculptures that line the soffits of Beta Maryam's nave arcade (Fig. 154) are stepped crosses, a form and technique that are ultimately adapted from the same "textile logic" employed in Tigrayan cruciform churches as well as in the marquetry of twelfth-century screens (see Fig. 84).[34]

To this end, the church of St. George (Betä Giyorgis) in Lalibela may be more directly linked with Tigrayan cruciform churches. Although hewn prior to the fourteenth century, it still remains unclear, due to its good state of preservation and unique articulation, whether its foundation was during the reign of King Lalibela or his

C. Lepage, "Les peintures murales de l'église *Betä Maryam* à Lalibäla, Éthiopie (rapport préliminaire)," *CRAI* 143.3 (1999): 901–67.

29 On the recent archaeological redating of these vaults, see K. Innemée, "The Church of the Holy Virgin in Deir al-Surian: New Insights in Its Architecture," *BSAC*, forthcoming.

30 D. W. Phillipson, *Ancient Churches of Ethiopia: Fourth–Fourteenth Centuries* (New Haven, 2009), 181.

31 M. Di Salvo, *The Basilicas of Ethiopia: An Architectural History* (London, 2017), 124.

32 C. Lepage, "Entre Aksum et Lalibela: Les églises du sud-est du Tigray (IXᵉ–XIIᵉ s.) en Éthiopie," *CRAI* 150.1 (2006): 9–39, at 24.

33 M. Muehlbauer, "Architectural Hybridity at the Lalibela Church Complex," in *Proceedings of the 18th Annual Marco Institute Symposium* (Turnhout, forthcoming).

34 See also the use of meanders on one of the thirteenth-century "Lalibela crosses" that were likely cast alongside the hewing of the churches; J. Mercier, *Art of Ethiopia: From the Origins to the Golden Century* (Paris, 2021), 62–63.

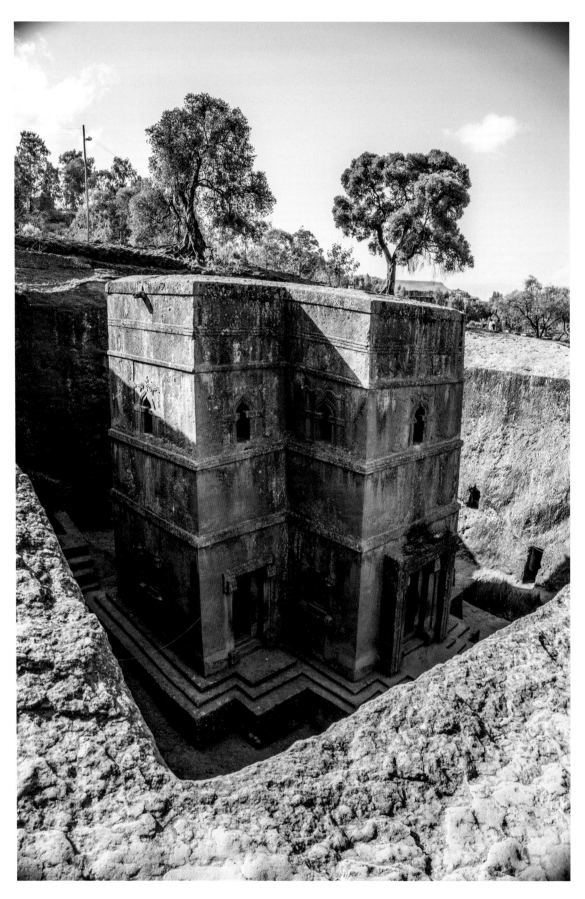

successors.[35] Isolated from the other churches in the complex, Beta Giyorgis is located on the far west of the plateau and is cruciform in shape: a single-aisle bisected by a transept of roughly equal dimensions. Like the majority of thirteenth-century churches in the complex, it is carved from the mother rock in a wholly monolithic manner (in-the-round) with four sides fully exposed (Fig. 155). Hewn from a slightly harder volcanic stratum, and linked with well-functioning outflow channels (for rainwater), Beta Giyorgis is somewhat impervious to weathering, allowing it to stand unprotected still today. The church has a dramatic profile. This cruciform monument, which sits atop an elaborate stepped platform, has sheer walls that are 11 meters high. Stringcourses break up the severe rock mass into registers, ordering the building into discrete levels. The clerestory is pierced by ogee-arch window apertures styled with elaborate split palmettes, while blind "Aksumite"-styled windows define the ground floor. The rock overlay at Beta Giyorgis, which fully follows the slope of the rock massif from which it was hewn, is elaborately carved, with layered Greek crosses and drainage spouts. The church is entered through three portals on its west end, including entrances on the western cross arm (framed by an elaborate channeled torus molding) and the transept. Compared to earlier Tigrayan cruciform churches, Beta Giyorgis is also small, measuring some 11 meters long (the same dimensions as the elevation) and 13 meters wide, with thick load-bearing walls. The equilateral cruciform church has a modular interior composed of five, roughly 2.5-meter-square bays. The nave, bisected by two single bay exedrae, leads to a square apse atop a stepped bema, which is surmounted by a dome inscribed with a cross. The cross-arm ceilings (Fig. 156) are sculpted with nonbracketed monolithic Greek crosses, while the crossing is surmounted by a low springing,

surbased barrel vault (inclined, likely to not compromise the rock overlay, as at Wuqro Cherqos).

Notwithstanding that this church plan is simpler than the aisled cruciform churches of Tigray, the form and articulation of its vaults present a clear parallel with those northern monuments. Compared to the upper levels of Tigrayan cruciform churches (see Figs. 2, 134), which have vaulted cross arms and a monumental cross in the crossing, we find that the carvers at Beta Giyorgis effectively inverted the articulation. As these earlier churches were the only cruciform monuments in Ethiopia at that time, it is likely that Beta Giyorgis was creatively adapted from esteemed Tigrayan prototypes.

The connection between these monuments goes beyond formal parallels, however. Per my relative chronology, Mika'el Amba was reconsecrated in 1150 under the aegis of the Zagwe court—a rededication by King Lalibela's predecessor(s)[36]—and as such, it was then likely reified as a dynastic monument. Meanwhile, the architecture of the Lalibela church complex was, generally speaking, loaded with architectural iconography. We find Levantine parallels in the topography of the site as well as metropolitan associations embedded in the conception of the five-aisled church of Medhane Alam (Mädḫane ʿAläm, Savior of the World).[37] That the form and articulation of the recently consecrated church of Mika'el Amba would be creatively invoked at the church of Beta Giyorgis is therefore unsurprising in the context of Lalibela, an ideologically charged locale.

That is not to say that the influence of Tigrayan cruciform churches on Lalibela was one-sided. We find at Mika'el Amba expressive architectural features, including a stepped courtyard (see Fig. 83), arched windows in the narthex (see Fig. 87), and exo-chambers flanking the

35 M. Muehlbauer, "Church of Saint George at Lalibela," in *World Architecture and Society: From Stonehenge to One World Trade Center*, ed. P. L. Bonfitto, 2 vols. (Santa Barbara, CA, 2022), 377–82; Phillipson, *Ancient Churches of Ethiopia*, 179. See, however, the carbon-14 dates measured by Mengistu Gobezie on the wood box contained in the church; M. Gobezie Worku, "The Church of Yimrhane Kristos: An Archaeological Investigation" (PhD diss., Lund University, 2018), 79–80. The monks at Mika'el Amba also consider Lalibela Beta Giyorgis a copy of Mika'el Amba.

36 Derat, *L'énigme*, 181.

37 For architectural citations in the Lalibela complex, see M. E. Heldman, "Architectural Symbolism, Sacred Geography and the Ethiopian Church," *Journal of Religion in Africa* 22.3 (1992): 222–41. For a critique of this hypothesis, see Mercier and Lepage, *Lalibela*, 267–75. See also the sober synthesis provided in Derat, *L'énigme*, 182–90. For metropolitan architectural iconography, see M. Muehlbauer, "An African 'Constantine' in the Twelfth Century: The Architecture of the Early Zagwe Dynasty and Egyptian Episcopal Authority," *Gesta* 62.2 (forthcoming, 2023); Derat, *L'énigme*, 180.

Figure 156.
Beta Giyorgis,
nave and north
transept ceiling,
Lalibela, Lasta,
Amhara, Ethiopia.
Photograph
by author.

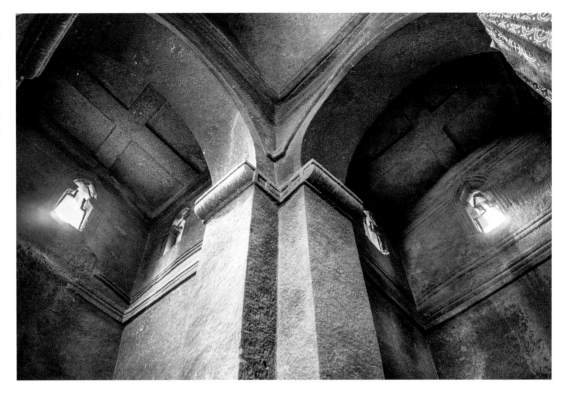

narthex (see Fig. 90) that cannot be explained by Tigrayan example alone. These forms are actually characteristic of the thirteenth-century churches at Lalibela, including at Beta Giyorgis, and were likely added to Mika'el Amba in the twelfth century or later (at least one other restoration was responsible for the monolithic altar in the eastern apse). The presence of a "Lasta-style" tukul foundation (see Fig. 82) adjacent to Mika'el Amba even suggests that Christians from the area of Lalibela once resided at the monastery. We might imagine that Mika'el Amba and Beta Giyorgis were part of extensive cross-pollination and citation between the architecture of the central highlands and Tigray during the Zagwe and early "Solomonic" periods (thirteenth to fourteenth century). The late medieval freestanding church, Zamaddo Maryam (fifteenth century?) may have stemmed from this discourse as well. An equilateral cruciform like Beta Giyorgis, its nave and crossing are crowned by a trussed timber vault, perhaps in further citation of Lalibela and of proxy Tigrayan cruciform churches.[38]

We find later evocations of Abreha wa-Atsbeha, Wuqro Cherqos, and Mika'el Amba elsewhere in the central highlands, namely, at the church of Bethlehem, immediately south of Lalibela. Somewhat securely dated to the late fourteenth century (from a dedicatory note contained in a gospel book in the church of Medhane Alam in Lalibela), the church of Bethlehem was commissioned by Dal Mangesha (Däl Mängəśha), the daughter of monarch Dawit I (r. 1382–1412), who is otherwise most famous for introducing the cult of the true cross to Ethiopia.[39]

38 Zammadu Maryam was entered once by Irmgard Bidder in the 1950s. The outside was later viewed by Michael Gervers, Zara Theisen, and Claude Lepage. See Di Salvo, *Basilicas of*

Ethiopia, 128–34; I. Bidder, *Lalibela: The Monolithic Churches of Ethiopia* (New York, 1959), 39, 132.

39 For the aforementioned note, see M. Schneider, "Deux actes de donation en arabe," *AÉ* 8 (1970): 79–87, at 82–83. For the church, see C. Bosc-Tiessé, "Christian Visual Culture in Medieval Ethiopia: Overview, Trends and Issues," in *A Companion to Medieval Ethiopia and Eritrea*, ed. S. Kelly (Leiden, 2020), 322–64, at 336–37; C. Bosc-Tiessé, "Beta Lehem, Church in Amhara," in *EAe* 1:560; G. Gerster, *Churches in Rock: Early Christian Art in Ethiopia*, trans. R. Hosking (New York, 1970), 137–40; T. Pakenham, *The Mountains of Rasselas: An Ethiopian Adventure* (New York, 1959), 110–38; Phillipson, *Ancient Churches of Ethiopia*, 82–85. The cult of the true cross in Ethiopia is connected to the gifting of a reliquary from Venice to Dawit I; see A. Caquot, "Aperçu préliminaire sur le *Maṣḥafa Ṭēfut* de Gechen Amba," *AÉ* 1 (1955): 89–108; M. E. Heldman, "St. Luke as Painter: Post-Byzantine Icons in Early-Sixteenth-Century Ethiopia," *Gesta* 44.2 (2005): 125–48, at 140.

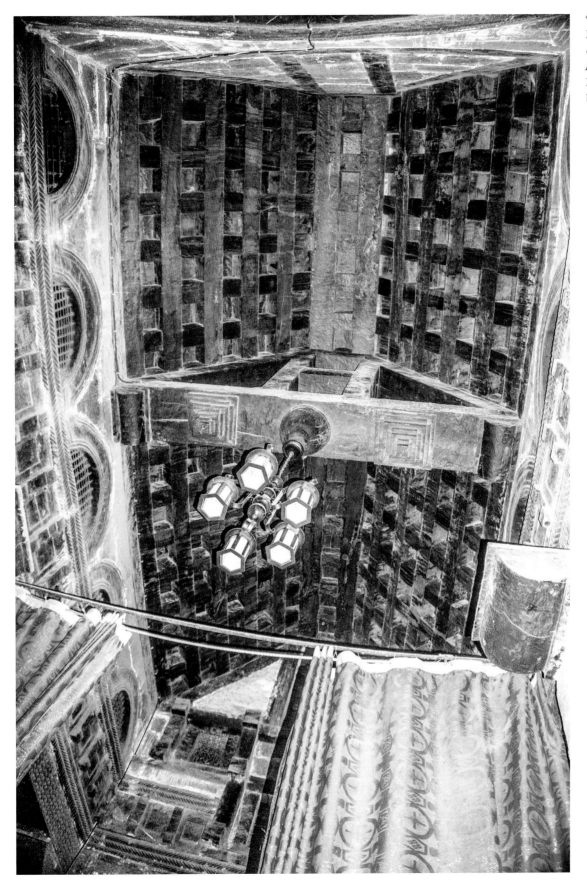

Figure 157.
Bethlehem, nave
ceiling, Gayint,
Amhara, Ethiopia.
Photograph
by author.

This freestanding, three-aisled basilica, measures some 12 meters long and 8 meters wide; it is obscured by a large conical roof, formerly of thatch but now corrugated metal. Located half a day's drive from Lalibela, Bethlehem is attached to a school for cantors (sg. *däbtära*) and is seldom visited by foreigners or Ethiopians alike; the deterioration of the dirt road leading there and the generally suspicious resident clergy are not particularly encouraging.[40]

The building fabric of Bethlehem presents a marked departure from historical precedent. Wholly built of well-cut ashlars rather than half-timbering, Bethlehem is one of the few freestanding buildings that remains from the early "Solomonic" period in Amhara and Shoa (see Chap. 1).[41] Although of stone construction, the upper levels are timber, and the nave is crowned with a saddleback roof (Fig. 157). The aisles are eclectically framed, the western bays have wood crossbeams joined together, so as to form ceiling crosses, and the pastophoria are topped by lantern ceilings. As at Maryam Qorqor (see Fig. 46), both the crossing and sanctuary are domed. The main similarity with Tigrayan cruciform churches, however, is found in the aisle bays preceding the sanctuary. Here trussed timber barrel vaults flank the central dome, in the service of spatialized hierarchy with the church crossing (see Fig. 119). Within the context of Bethlehem's overall basilican conception, the vaulted arms resemble the dwarf transept at Wuqro Cherqos. As noted in Chapter 3, barrel vaults, when used, were typically restricted to the nave, and Bethlehem is the only church outside of Tigrayan cruciform churches to have a vaulted "transept."[42] There is a case to be made for shared architectural iconography. Tigray was loosely governed from the central highlands during this period, and the Solomonic kings were eager to appropriate symbols of Zagwe authority, including aspects of the Lalibela complex and even descent

from the biblical King Solomon.[43] It may be that Bethlehem's dwarf transept was intended to legitimate the monument, and thereby the royal productions of this new dynasty, through citation of an esteemed eleventh-century church. That said, this design choice may have also reflected the architecture of the actual Church of the Nativity in Bethlehem, which was a basilica with a transept (T-shaped rather than cruciform).[44] After all, this fourteenth- or fifteenth-century church was built at a time when Ethiopians already had long-standing contact with the Levant, Egypt, and the eastern Mediterranean.[45]

Wuqro Cherqos and Abuna Abraham

The clearest impact of Tigrayan cruciform churches on later architecture was felt during the career of Abuna Abraham (or the workshop associated with him, 1350–1415?). As I will show, the material record indicates that this master mason heavily reworked the church of Wuqro Cherqos alongside the hewing of his masterpiece, Maryam Dabra Tseyon. Signs of his workshop's impact on the ancient church abound. Sculpted parabolic arch frames, akin to those lining the north wall and sanctuary at Maryam Dabra Tseyon (see Fig. 55), are found on the upper west wall of the narthex at Wuqro Cherqos (see Fig. 102). Although thoroughly degraded by seepage and soot, we might imagine that full-length icons of saints were painted on them. Figural decoration in polychrome paint atop a white ground, depicting the four seraphim carrying a strapwork star (thought to be the throne of God) as well as unnamed saints[46] in the distinctly Ethiopian style of Dabra Tseyon, can be found atop earlier geometric reliefs in the narthex (see Fig. 101). Occupying the eastern ceiling, these fire angels are surrounded by arabesques of strapwork, in a

40 I, too, was refused entry, until Fikru Woldegiyorgis mentioned that since I could read Ge'ez, I was a *däbtära*, and therefore belonged there. I was then given a manuscript page to recite. Remarking on my stilted speech and poor accent, I was told, jokingly, that I was "almost a deacon."

41 Bosc-Tiessé, "Christian Visual Culture," 336–41.

42 Phillipson, *Ancient Churches of Ethiopia*, 85.

43 Derat, *L'énigme*, 200–213.

44 For the church of the nativity in Bethlehem, see M. Bacci, *The Mystic Cave: A History of the Nativity Church at Bethlehem*, Convivia 1 (Brno, 2017).

45 On King Dawit and his relations with the Mediterranean, see most recently V. Krebs, *Medieval Ethiopian Kingship, Craft, and Diplomacy with Latin Europe* (Cham, Switzerland, 2021), 17–59.

46 Mercier and Lepage, *Lalibela*, 196–97; Bosc-Tiessé, "Christian Visual Culture," 342.

Figure 158.
Wuqro Cherqos,
southeast lateral
support pier,
capital detail,
Tigray, Ethiopia.
Photograph
by author.

style markedly different from Wuqro Cherqos's geometric carvings but similar to the murals of Maryam Dabra Tseyon (see Figs. 54, 55). Elsewhere in the narthex and in the main vessel, this fourteenth- or fifteenth-century workshop repainted the original geometric ornament, in all cases without carving reliefs and with varying fidelity to the eleventh-century originals. We can distinguish the hand of the Abuna from the earlier ornaments by his use of black highlights, which serve as borderlines for ocher straps, and *X*s in the interstices of triskelia. Occasionally, as on the southwest wall, these later interventions are invasive. Here Abuna Abraham's workshop appears to have contrived a circumscribed cross-in-square pattern that alternates with ovals, which is not based in textile precedent. Moreover, on the south transept we also find traces of black-outlined Maltese crosses fitted into the blind window frieze (see Fig. 105).

Worth mentioning in this regard is a curious interlace rosette painted in the Abuna's style on the lateral support pier preceding the prothesis (Fig. 158). This decoration resembles the emblem (*tughrā*) of the Rasulid dynasty of Yemen (1229–1454), a client kingdom of Mamluk Egypt. In addition to this dynasty having sent a number of

metalwork dishes to Ethiopia for use as patens, the Abuna's workshop was in stylistic dialogue with Rasulid muralists.[47] At the threshold to the southeast chamber, this blazon, lifted from precious metalwork, may have signaled this area's liturgical significance.[48] On the other hand, this emblem may have also been connected to the now-departed Zagwe dynasty. A similar symbol is embossed into the metal cover of a twelfth-century gospel book that belonged to king Tantawedem.[49] The fact that fourteenth-century

47 On the relations between the Rasulid dynasty and Ethiopia in this period, see T. Baba, "Notes on Migration between Yemen and Northeast Africa during the 13–15th Centuries," in *From Mountain to Mountain: Exchange between Yemen and Ethiopia, Medieval to Modern*, ed. A. Regourd and N. Um, *Chroniques du manuscrit au Yémen*, n.s. 1 (2017–18): 69–86. The Mamluk historian al-Maqrīzī also wrote on relations between the two sides of the Red Sea in the late Middle Ages, especially as it pertained to the trade in enslaved people, see F.-C. Muth, "A Globe-trotter from Maghrib in al-Maqrīzī's Booklet on Ethiopia: A Footnote from Some Arabic Sources," *Afrique et histoire* 4 (2005): 123–31.

48 On the symbolism of the rosette, see N. Sadek, "Rasūlid Women: Power and Patronage," *PSAS* 19 (1989): 121–36. Several of these dishes have been noted in Ethiopian treasury collections; M. Muehlbauer, "From Stone to Dust: The Life of the Kufic Inscribed Frieze of Wuqro Cherqos in Tigray, Ethiopia," *Muqarnas* 38 (2021): 1–34, at 31 n. 96.

49 C. Lepage and J. Mercier, *Les églises historiques du Tigray: Art éthiopien / The Ancient Churches of Tigrai: Ethiopian Art,*

Tigray was still governed by lords carrying the post-Aksumite and Zagwe title "Hatsani" suggests that this emblem, and thereby the restoration more broadly, was perhaps ideological and dynastic in nature.[50]

Abuna Abraham's work on the church seems to have followed a great conflagration and it appears as though new liturgical furnishings were added to replace lost equipment. Although postholes record that there was once a ∏-shaped templon to screen off the sanctuary (see Fig. 108), this was likely made of wood; it would have easily caught fire, especially since, in all likelihood, it was located beneath curtains.

Until the late 1990s, two wall-like rubble screens—one for the crossing and one for the apse—were used in Wuqro Cherqos.[51] William Simpson, who documented the church in 1868, found that the eastern screen was made of Islamic spolia: likely a mihrab hood (see Fig. 114).[52] These now-vanished liturgical furnishings were architectonic screens, made of fancy revetments from an abandoned Fatimid Friday mosque (see Figs. 12, 13, 114).[53] As mentioned earlier, in the Coptic church khūrus and haykal screens were adopted piecemeal into Ethiopian settings in the thirteenth and fourteenth centuries and were the norm by the late Middle Ages. It is likely that when Abuna Abraham rededicated Wuqro Cherqos, he also updated the liturgical layout. Evenly spaced postholes that run along the south wall of the church, from the eastern lateral aisle to the westernmost aisle, suggest that these were curtain posts for an intercolumnar screen, much like the laity chancels of the Coptic church under the Mamluks.[54] Indeed, William Simpson noted that in 1868, the edifice was liturgically "divided into three [individual] churches," each inhabiting a single nave corresponding to the dedications of

the altars.[55] Even today, we find an axial screen of curtains running down the south nave piers, in living continuation with this late medieval practice.

Abuna Abraham's workshop appears to have reworked Wuqro Cherqos building fabric as well. Expressive elements in rock-cut architecture were a post-Lalibelan phenomenon. Decorative low walls that now frame Wuqro Cherqos's west courtyard are likely later additions (see Fig. 99), as are the vertical trenches executed on the north and south facades. In both cases, the work appears to imitate the setbacks of freestanding monuments and closely matches the faux half-timbered facade of Maryam Dabra Tseyon (see Fig. 53).

This is not to say that the Abuna's work on Wuqro Cherqos was one-sided. I suggest that the older Wuqro Cherqos influenced, in turn, his major monument, Maryam Dabra Tseyon, where we find processional crosses, Maltese-styled and inscribed as at Wuqro Cherqos (see Fig. 104), carved on the east piers preceding the sanctuary (Fig. 159). Placed on a liturgical threshold, and sculpted in clear imitation of Wuqro Cherqos, these hewn crosses, a direct borrowing from the Tigrayan cruciform churches of the eleventh century, are anachronistic in their new setting. Although the murals at Maryam Dabra Tseyon are painted in the characteristic strap-work of the era, we also find creative adaptations of the eleventh-century textile ornament of Wuqro Cherqos. The transverse faux-saddleback roof preceding the main sanctuary at Maryam Dabra Tseyon is blanketed with T-fret patterns (see Fig. 54), adapted from the Wuqro Cherqos nave (see Fig. 103), while the north and central sanctuary domes are partitioned by arches bearing stepped crosses, an architectural logic drawn from Indian cloths. The ribbed sanctuary dome may even reference the (now lost) ornamental program at Wuqro Cherqos's dome. Knotwork crosses alternate with elaborate strapwork darts that may be fruitfully compared with Abreha wa-Atsbeha's dome ornament (see Figs. 73, 148).

Suffice it to say that Tigrayan cruciform churches were continuous wellsprings of architectural inspiration in the later Middle Ages. From

trans. S. Williams and C. Wiener (Paris, 2005), 87. For the metal book cover, see Derat, *L'énigme*, 38–40, fig. 4.

50 Derat, *L'énigme*, 35.

51 Muehlbauer, "From Stone to Dust."

52 W. Simpson, "Abyssinian Church Architecture: Part II, Rock-Cut Churches," *The Architectural Review* 4 (1898): 9–16.

53 Muehlbauer, "From Stone to Dust."

54 E. Fritsch, "St Cyricus Church at Weqro, East Tegray: A Complete Description and Interpretation of Its Salient Architectonics" (paper presented at ICES20, Mekelle University, Mekelle, Ethiopia, 5 October 2018).

55 W. Simpson, "Abyssinian Church Architecture," in *Papers Read at the Royal Institute of British Architects: Session 1868–69* (London, 1869), 234–46, at 241.

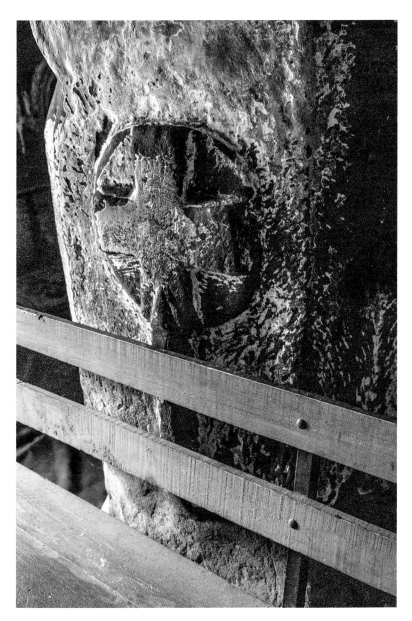

Figure 159.
Maryam Dabra Tseyon,
hewn processional cross,
northeast pier, Tigray,
Ethiopia. Photograph
by author.

Lalibela to Maryam Dabra Tseyon we find architectural echoes, including both elaborate homages and creative inversions. Although Tigrayan cruciform churches were revolutionary monuments when hewn, perhaps their most significant impact was their continued architectural influence in Ethiopia in the centuries that followed.

"Bastions of the Cross"

The work of an architectural historian is, ultimately, that of an underpaid detective. Working in the absence of scientific dating and archaeological soundings, I have to the best of my

abilities sought to explain when, why, and how these churches were hewn. I am humbled, however, to think of my ultimate audience. This is an academic book, and those who will read it will be like-minded researchers, educators, and students. However, taken broadly, my lens is also parochial.[56] Although I have advanced a late eleventh-century date for the three churches

56 On alternate approaches to archaeological practice, using oral histories as elsewhere in Africa, see P. Lane, "Possibilities for a Postcolonial Archaeology in Sub-Saharan Africa: Indigenous and Usable Pasts," *World Archaeology* 43.1 (2011): 7–25; P. R. Schmidt and J. R. Walz, "Re-Representing African Pasts through Historical Archaeology," *American Antiquity* 72.1 (2007): 53–70.

of Abreha wa-Atsbeha, Wuqro Cherqos, and Mika'el Amba, for the people whose lives these monuments are deeply a part of, they are far more ancient and far more charged. It is fitting therefore to end my text by returning to a passage in the hagiography of saints Abreha and Atsbeha. This history is far more familiar to those who toil in the semi-arid lands of East Tigray, the monks who pray at these monuments daily, the parishioners who receive the sacraments under the crossing, and those who request funerary rites in these esteemed churches, despite living great distances away.

For the pious of Tigray, the churches of Abreha wa-Atsbeha, Wuqro Cherqos, and Mika'el Amba were established by the Aksumite saint-kings Abreha and Atsbeha in the fourth century. Although no explicit mention is made in their hagiography of these three churches, the twin kings are described as establishing *Ḥaṣara Mäsqäl* (ሐጸረ ፡ መስቀል), "Bastions of the Cross," in their campaign to Christianize the landscape.[57]

This phrase *Ḥaṣara Mäsqäl* (ሐጸረ ፡ መስቀል), is evocative. *Ḥaṣara* (ሐጸረ), the possessive singular of bastion or fortress, brings to mind adjectives associated with defense and protection.[58] *Mäsqäl* (መስቀል) means the cross points of the instrument of Christ's crucifixion, and thereby Christianity itself. The fact that this hagiography described the instruments of Tigray's Christianization in such specific terms seems to imply that the bastions described are actually rock-hewn churches. As instruments of Christianity, rock-cut churches are naturally fortified and immovable, and also embedded into the landscape: literal bastions of the cross. For the people who use these monuments the most, these ancient churches are far more than places of worship—they are material testaments to Christianity's ancient presence in the land.

Whether taken literally or figuratively, the churches of Abreha wa-Atsbeha, Wuqro Cherqos, and Mika'el Amba are "bastions of the cross" to the people of Tigray. This is not only because they are material testaments to the work of these saint-kings, but also because their rupestrian, cruciform conception dovetails with this hagiographic label. Hewn into the jagged ambas of East Tigray, these churches present the landscape's materialization of their faith: "Bastions of the Cross."

57 Marrassini, "Il *Gadla Abreha Wa Aṣbeḥa*," 169.

58 W. Leslau, *Comparative Dictionary of Ge'ez* (Wiesbaden, 1987), 247, 509–10.

ABBREVIATIONS

ADAIK	Abhandlungen des Deutschen Archäologischen Instituts, Abteilung Kairo
AH	*Art History*
AJA	*American Journal of Archaeology*
AMIran	*Archaeologische Mitteilungen aus Iran*
AÉ	*Annales d'Éthiopie*
ArtB	*Art Bulletin*
BAR	British Archaeological Reports
BASP	*Bulletin of the American Society of Papyrologists*
BBulg	*Byzantinobulgarica*
BCH	*Bulletin de correspondance hellénique*
BEO	*Bulletin d'études orientales de l'Institut français de Damas*
BIE	*Bulletin de l'Institut d'Égypte*
BIFAO	*Bulletin de l'Institut français d'archéologie orientale*
BMGS	*Byzantine and Modern Greek Studies*
BO	*Bibliotheca orientalis*
BSA	*The Annual of the British School at Athens*
BSAC	*Bulletin de la Société d'Archéologie Copte*
BSl	*Byzantinoslavica*
ByzArch	Byzantinisches Archiv
BZ	*Byzantinische Zeitschrift*
CahArch	*Cahiers archéologiques*
CNRS, Traveaux de la RCP	*CNRS, Traveaux de la Recherche Coopérative sur Programme*
COMst Bulletin	*Comparative Oriental Manuscript Studies Bulletin*
CRAI	*Comptes rendus des séances de l'Académie des Inscriptions et Belles-Lettres*
DOS	Dumbarton Oaks Studies
EAe	*Encyclopaedia Aethiopica*, ed. S Uhlig. 5 vols. Wiesbaden, 2005–14
EO	*Ethiopia Observer*
ICMA	International Center of Medieval Art
ICS	*Illinois Classical Studies*
IJMES	*International Journal of Middle East Studies*
JA	*Journal asiatique*
JARCE	*Journal of the American Research Center in Egypt*
JbAC	*Jahrbuch für Antike und Christentum*

JEChrSt	Journal of Early Christian Studies
JES	Journal of Ethiopian Studies
JNES	Journal of Near Eastern Studies
JÖB	Jahrbuch der Österreichischen Byzantinistik
JRA	Journal of Roman Archaeology
JRAS	Journal of the Royal Asiatic Society
JSAH	Journal of the Society of Architectural Historians
MDAIK	Mitteilungen des Deutschen Archäologischen Instituts für Ägyptische Altertumskunde, Abteilung Kairo
NEAS	Northeast African Studies
NT	Novum Testamentum
OrChr	Oriens christianus
OCP	Orientalia christiana periodica
Papers of the BSR	Papers of the British School at Rome
PNAS	Proceedings of the National Academy of Sciences
PSAS	Proceedings of the Seminar for Arabian Studies
RACr	Rivista di archeologia cristiana
RB	Revue biblique
RRAL	Rendiconti della R. Accademia dei Lincei. Classe di scienze morali storiche e filologiche
RSE	Rassegna di studi etiopici
RSO	Rivista degli studi orientali
StP	Studia patristica
ZDMG	Zeitschrift der Deutschen Morgenländischen Gesellschaft
ZKuntsg	Zeitschrift für Kuntsgeschichte

Abay, A., G. Mebrahtu, and B. Konka. "Geological and Geomechanical Properties of Abraha-Atsibha and Wukro Rock-Hewn Churches and Its Surroundings, Tigray Region, Northern Ethiopia." *Momona Ethiopian Journal of Science* 9.2 (2017): 182–99.

ʿAbd alTawab, ʿA.-R. M. *Stèles islamiques de la nécropole d'Assouan*. Cairo, 1977.

ʿAbd al-Wahhāb, Ḥ. "Dome Decorations by Means of Pierced Openings." In *Studies in Islamic Art and Architecture in Honour of Professor K. A. C. Creswell*, 95–104. Cairo, 1965.

Abiodun, R. *Yoruba Art and Language: Seeking the African in African Art*. New York, 2014.

Abir, M. "Salt, Trade and Politics in Ethiopia in the 'Zämänä Mäsafent.'" *JES* 4.2 (1966): 1–10.

Abrha Abay, H. "Ethiopia's War in Tigray Risks Wiping out Centuries of the World's History." *The Conversation* (blog), March 29, 2022. https://theconversation.com/ethiopias-war-in-tigray-risks-wiping-out-centuries-of-the-worlds-history-179829

———. "Tigray's Ancient Rock-Hewn Churches Are under Threat: Why It Matters." *The Conversation* (blog), May 3, 2022. https://theconversation.com/tigrays-ancient-rock-hewn-churches-are-under-threat-why-it-matters-182026?

Abul-Haggag, Y. *A Contribution to the Physiography of Northern Ethiopia*. London, 1961.

Alehegne, M. *The Ethiopian Commentary on the Book of Genesis: Critical Edition and Translation*. Äthiopistische Forschungen 73. Wiesbaden, 2011.

Allen, T. *A Classical Revival in Islamic Architecture*. Wiesbaden, 1986.

Almaho, H. S. *Tarik Negast Abreha wa-Atsbeha*. Mekelle, 2012.

Altheim, F., and R. Stiehl. "Chronologie der altäthiopischen kirchlichen Kunst." *Klio* 53 (1971): 361–68.

Altripp, M. "Beobachtungen zu Synthronoi und Kathedren in byzantinischen Kirchen Griechenlands." *BCH* 124.1 (2000): 377–412.

Alvares, F. *The Prester John of the Indies: A True Relation of the Lands of the Prester John, Being the Narrative of the Portuguese Embassy to Ethiopia in 1520*, rev. translation and edited by C. F. Beckingham and G. W. B. Huntingford. 2 vols. Cambridge, 1961.

———. *Verdadeira informação das terras do Preste João das Indias*. New ed. Lisbon, 1889.

Ambu, M. "Du texte à la communauté: Relations et échanges entre l'Égypte copte et les réseaux monastiques éthiopiens (XIIIᵉ–XVIᵉ siècle)." PhD diss., Panthéon-Sorbonne University, 2022.

An, K.-S. *An Ethiopian Reading of the Bible: Biblical Interpretation of the Ethiopian Orthodox Tewahido Church*. Eugene, 2016.

Ancel, S., and D. Nosnitsin. "On the History of the Library of Mäqdäla: New Findings." *Aethiopica* 17 (2014): 90–95.

Andemichael, A. "The Monastery of Debre Bizen." In *Proceedings of a Workshop on Aspects of Eritrean History: 20–21 September 2005, Asmara*, edited by T. Melake, 28–40. Cultural Assets Rehabilitation Project. Asmara, 2007.

Andrault-Schmitt, C. "A Western Interpretation of an Oriental Scheme: The Domed Churches in Romanesque Aquitaine." In *Romanesque and the Mediterranean: Patterns of Exchange across the Latin, Greek and Islamic Worlds c. 1000 to c. 1250*, edited by R. M. Bacile and J. McNeill, 225–40. London, 2015.

Anfray, F. *Les anciens éthiopiens: Siècles d'histoire*. Paris, 1990.

———. "L'archéologie d'Axoum en 1972." *Paideuma: Mitteilungen zur Kulturkunde* 18 (1972): 60–78.

———. "Une campagne de fouilles à Yĕḥā (février–mars 1960)." *AÉ* 5 (1963): 171–232.

———. "Deux villes axoumites: Adoulis et Matara." In *Atti del IV Congresso Internazionale di Studi Etiopici*, 1:745–65. 2 vols. Rome, 1974.

———. "Des églises et des grottes rupestres." *AÉ* 13.1 (1985): 7–34.

———. "Maṭarā." *Annales d'Éthiopie* 7 (1967): 33–88.

———. "Matara: The Archaeological Investigation of a City of Ancient Eritrea." *P@lethnology* 4 (2012): 11–48.

———. "Le Musée archéologique d'Asmara." *RSE* 21 (1965): 5–15.

———. "Notes archéologiques." *AÉ* 8 (1970): 31–56.

———. "Nouveaux sites antiques." *JES* 11.2 (1973): 13–27.

———. *Le site de Dongour: Axoum, Ethiopie. Recherches archéologiques*. Archaeology as History 3. Hamburg, 2012.

Annesley, G. *Voyages and Travels to India, Ceylon, the Red Sea, Abyssinia, and Egypt, in the Years 1802, 1803, 1804, 1805, and 1806*. 3 vols. London, 1809.

Anninos, T. "Tibetan Leather Boxes." *Arts of Asia* 30.1 (2000): 101–17.

Añorve-Tschirgi, C., and O. Seif. "Fatimid Frontiers: The Mausoleum of Qus as a Case Study." In *The International Conference on Heritage of Naqada and Qus Region: Monastery of the Archangel Michael, Naqada, Egypt, 22–28 January 2007*, edited by H. Hanna, 1:149–60. 2 vols. Cairo, 2007.

el-Antony, M., J. Blid, and A. M. Butts. "An Early Ethiopic Manuscript Fragment (Twelfth–Thirteenth Century) from the Monastery of St. Antony (Egypt)." *Aethiopica* 19 (2016): 27–51.

ʿArab Faqīh, S. *Futūḥ al-Ḥabaša: The Conquest of Abyssinia (16th Century)*. Translated by P. L. Stenhouse, annotated by R. Pankhurst. Hollywood, 2003.

Armi, C. E. "Parts and Words in Romanesque Architecture." *Gesta* 54.2 (2015): 127–41.

L'Art copte en Égypte: 2000 ans de christianisme. Paris, 2000.

Asutay-Effenberger, N. *Die Landmauer von Konstantinopel-İstanbul: Historisch-topographische und baugeschichtliche Untersuchungen*. Millennium-Studien 18. Berlin, 2007.

Atanassova, D. "The Primary Sources of Southern Egyptian Liturgy: Retrospect and Prospect." In *Rites and Rituals of the Christian East: Proceedings of the Fourth International Congress of the Society of Oriental Liturgy, Lebanon, 10–15 July 2012*, edited by B. Groen, D. Galadza, N. Glibetic, and G. Radle, 47–96. Eastern Christian Studies 22. Leuven, 2014.

Auber de Lapierre, J., and A. Jeudy. *Catalogue général du Musée copte du Caire: Objets en bois 1*. Bibliothèque d'études coptes 26. Cairo, 2018.

Averbuch, B. D. "From Siraf to Sumatra: Seafaring and Spices in the Islamicate Indo-Pacific, Ninth–Eleventh Centuries C.E." PhD diss., Harvard University, 2013.

Ayenachew, D. *Selomonawyan: A History of the Political Administration of Ethiopia (1270–1529)*. Addis Ababa, 2021.

al-Azraqī, Abū al-Walīd. *Akhbār Makka wa-mā jāʾa fīhā min al-āthār*, edited by ʿA. ʿA. Ibn Duhaysh. 2 vols. Mecca, 2003.

Baba, T. "Notes on Migration between Yemen and Northeast Africa during the 13–15th Centuries." In *From Mountain to Mountain: Exchange between Yemen and Ethiopia, Medieval to Modern*, ed. A. Regourd and N. Um. *Chroniques du manuscrit au Yémen*, n.s. 1 (2017–18): 69–86.

Bacci, M. *The Mystic Cave: A History of the Nativity Church at Bethlehem*. Convivia 1. Brno, 2017.

Bāfaqīh, M. ʿA. *L'unification du Yémen antique: La lutte entre Sabaʾ, Ḥimyar et le Ḥaḍramawt du Iᵉʳ au IIIᵉᵐᵉ siècle de l'ère chrétienne*. Paris, 1990.

Bauer, T. *Warum es kein islamisches Mittelalter gab: Das Erbe der Antike und der Orient* (Munich, 2018).

Balicka-Witakowska, E. "Churches of Däbrä Ṣəyon." In *EAe* 2:42–43.

———. "Dabra Salam Mikaʾel." In *EAe* 2:37–39.

———. "Mikaʾel Amba." In *EAe* 3:959–61.

———. "Painting, IV: Monumental Painting." In *EAe* 4:97–99.

———. "Sära Abrəha wä-Aṣbəḥa." In *EAe* 4:628–30.

———. "Wəqro Maryam." In *EAe* 4:1181–82.

Balicka-Witakowska, E., and M. Gervers. "The Church of Yəmrəhannä Krəstos and Its Wall-Paintings: A Preliminary Report." *Africana Bulletin* 49 (2001): 9–47.

Bandyopadhyay, S. "Conflation of Celestial and Physical Topographies in the Omani Decorated *miḥrāb*." *PSAS* 40 (2010): 99–110.

Barberi, F., S. Borsi, G. Ferrara, G. Marinelli, R. Santacroce, H. Tazieff, and J. Varet. "Evolution of the Danakil Depression (Afar, Ethiopia) in Light of Radiometric Age Determinations." *Journal of Geology* 80.6 (1972): 720–29.

Bard, K. A., M. Coltorti, M. C. DiBlasi, F. Dramis, and R. Fattovich. "The Environmental History of Tigray (Northern Ethiopia) in the Middle and Late Holocene: A Preliminary Outline." *African Archaeological Review* 17.2 (2000): 65–86.

Barnes, R. *Indian Block-Printed Cotton Fragments in the Kelsey Museum, University of Michigan*. Ann Arbor, 1993.

———. *Indian Block-Printed Textiles in Egypt. The Newberry Collection in the Ashmolean Museum*. 2 vols. Oxford, 1997.

———. "Indian Cotton for Cairo: The Royal Ontario Museum's Gujarati Textiles and the Early Western Indian Ocean Trade." *Textile History* 48.1 (2017): 15–30.

———. "The Painted Ceiling of the ʿAmiriya: An Influence from Indian Textiles?" In *The ʿAmiriya in Radaʿ: The History and Restoration of a Sixteenth-Century Madrasa in the Yemen*, edited by S. al-Radi, 139–48. Oxford Studies in Islamic Art 13. Oxford, 1997.

Barrucand, M. "Remarks on the Iconography of the Medieval Capitals of Cairo: Form and Emplacement." In *The Iconography of Islamic Art: Studies in Honour of Robert Hillenbrand*, edited by B. O'Kane, 23–44. Edinburgh, 2005.

Barry, F. "*Disiecta Membra*: Ranieri Zeno, the Imitation of Constantinople, the *Spolia* Style, and Justice at San Marco." In *San Marco, Byzantium, and the Myths of Venice*, edited by H. Maguire and R. S. Nelson, 7–62. Washington, DC, 2010.

Basset, R. "Les inscriptions de l'île de Dahlak." *JA* 9.1 (1893): 77–111.

Bausi, A. "'Däbrä Dammo', Not 'Däbrä Damo.'" *Géolinguistique* 20 (2020). http://journals.openedition.org/geolinguistique/1918.

———. "Ethiopia and the Christian Ecumene: Cultural Transmission, Translation, and Reception." In *A Companion to Medieval Ethiopia and Eritrea*, edited by S. Kelly, 217–51. Leiden, 2020.

———. "Ethiopic Literary Production Related to the Christian Egyptian Culture." In *Coptic Society,*

Literature and Religion from Late Antiquity to Modern Times: Proceedings of the Tenth International Congress of Coptic Studies, Rome, September 17th–22th, 2012, and Plenary Reports of the Ninth International Congress of Coptic Studies, Cairo, September 15th–19th, 2008, edited by P. Buzi, A. Camplani, and F. Contardi, 503–71. Orientalia Lovaniensia Analecta 247. Leuven, 2016.

———. "'Paleografia quale scienza dello spirito': Once More on the Gəʿəz Inscription of Ham (*RIÉ* no. 232)." In *Exploring Written Artefacts: Objects, Methods, and Concepts*, edited by J. B. Quenzer, 1:3–33. 2 vols. Studies in Manuscript Cultures 25. Berlin, 2021.

———. "The Enigma of a Medieval Ethiopian Dynasty of Saints and Usurpers." *Orientalistische Literaturzeitung* 113.6 (2018): 439–47.

———. "Un indice del *Liber Aksumae*." *Aethiopica* 9 (2006): 102–46.

Bausi, A., A. Brita, M. di Bella, D. Nosnitsin, N. Sarris, and I. Rabin. "The *Aksumite Collection* or Codex Σ (*Sinodos of Qafrəyā*, MS C$_3$-IV-71/C$_3$-IV-73, EthioSPaRe UM-039): Codicological and Palaeographical Observations. With a Note on Material Analysis of Inks." *COMst Bulletin* 6.2 (2020): 127–71.

Bausi, A., M. J. Harrower, and I. A. Dumitru. "The Gəʿəz Inscriptions from Beta Samāʿti (Beta Samati)." *BO* 77.1 (2020): 34–56.

Baxandall, M. *Patterns of Intention: On the Historical Explanation of Pictures*. New Haven, 1985.

Behrens-Abouseif, D. *Practising Diplomacy in the Mamluk Sultanate: Gifts and Material Culture in the Medieval Islamic World*. London, 2014.

Bekerie, A. "Ethiopica: Some Historical Reflections on the Origin of the Word Ethiopia." *International Journal of Ethiopian Studies* 1.2 (2004): 110–21.

Belados, A., and T. Tribe. "The World Heritage Site of Lalibela and Environs: Current Situation." *ICMA News* (Spring 2022): 25–26, https://www.medievalart.org/pastnewsletters.

Belay, A. "Megaliths, Landscapes, and Society in the Central Highlands of Ethiopia: An Archaeological Research." PhD diss., Université Toulouse–Jean Jaurès, 2020.

Belcher, W. L. *Abyssinia's Samuel Johnson: Ethiopian Thought in the Making of an English Author*. New York, 2012.

Bénazeth, D. *L'art du métal au début de l'ère chrétienne*. Paris, 1992.

Berger, A. *Life and Works of Saint Gregentios, Archbishop of Taphar: Introduction, Critical Edition and Translation*. Berlin, 2006.

Berhe, H., M. Haftu, S. Abrha, D. Haileyesus, A. Bekerie, G. Teklu, S. Fiqadu, and A. Kiros. "Preliminary Report on a Test Excavation at the Ancient Iron Smelting Site of Gud Baḥri (Wuqro, Tigray)." *AÉ* 33 (2021): 167–88.

Bernand, É., A. J. Drewes, and R. Schneider. *Recueil des inscriptions de l'Éthiopie des périodes pré-axoumite et axoumite*. 3 vols. in 4. Paris and Wiesbaden, 1991–2019.

Beshir, B. I. "The Fatimid Caliphate 386/996–487/1094." PhD diss., University of London, School of Oriental and African Studies, 1970.

———. "New Light on Nubian Fāṭimid Relations." *Arabica* 22.1 (1975): 15–24.

Beylot, R. "Le millénarisme, article de foi dans l'Église éthiopienne, au XVᵉ siècle." *RSE* 25 (1971–1972): 31–43.

Bezold, C. *Kebra Nagast: Die Herrlichkeit der Könige. Nach den Handschriften in Berlin, London, Oxford und Paris*. Munich, 1905.

Bidder, I. *Lalibela: The Monolithic Churches of Ethiopia*. New York, 1959.

Bier, C. "Art and *Mithāl*: Reading Geometry as Visual Commentary." *Iranian Studies* 41.4 (2008): 491–509.

———. "Elements of Plane Symmetry in Oriental Carpets." *Textile Museum Journal* 31 (1992): 53–70.

———. "Patterns in Time and Space: Technologies of Transfer and the Cultural Transmission of Mathematical Knowledge across the Indian Ocean." *Ars orientalis* 34 (2004): 172–94.

Billi, P. *Landscapes and Landforms of Ethiopia*. Dordrecht, 2015.

Blessing, P. "Weaving on the Wall: Architecture and Textiles at the Monastery of Las Huelgas in Burgos." *Studies in Iconography* 40 (2019): 137–82.

Bloom, J. M. *Arts of the City Victorious: Islamic Art and Architecture in Fatimid North Africa and Egypt*. New Haven, 2007.

Bogdanović, J. *The Framing of Sacred Space: The Canopy and the Byzantine Church*. New York, 2017.

Böll, V. *"Unsere Herrin Maria": Die traditionelle äthiopische Exegese der Marienanaphora des Cyriacus von Behnesa*. Wiesbaden, 1998.

Bolman, E. S., ed. *Monastic Visions: Wall Paintings in the Monastery of St. Antony at the Red Sea*. Cairo, 2002.

———. "Theodore's Program in Context: Egypt and the Mediterranean Region." In *Monastic Visions: Wall Paintings in the Monastery of St. Antony at the Red Sea*, edited by E. S. Bolman, 91–102. Cairo, 2002.

———. "Theodore's Style, the Art of Christian Egypt, and Beyond." In *Monastic Visions: Wall Paintings in the Monastery of St. Antony at the Red Sea*, edited by E. S. Bolman, 77–90. Cairo, 2002.

———. "Veiling Sanctity in Christian Egypt: Visual and Spatial Solutions." In *Thresholds of the Sacred: Architectural, Art Historical, Liturgical, and Theological Perspectives on Religious Screens, East and West*, edited by S. E. J. Gerstel, 73–104. Washington, DC, 2006.

Bony, J. *French Gothic Architecture of the 12th and 13th Centuries*. Berkeley, 1983.

Bord, L.-J., V. Debiais, and É. Palazzo, eds. *Le rideau, le voile et le dévoilement: Du Proche-Orient ancien à l'Occident médiéval*. Paris, 2019.

Bornert, R. "La célébration de la sainte croix dans le rite byzantin." *La Maison-Dieu* 75 (1963): 92–108.

Bosc-Tiessé, C. "Beta Lehem, Church in Amhara." In *EAe* 1:560.

———. "Christian Visual Culture in Medieval Ethiopia: Overview, Trends and Issues." In *A Companion to Medieval Ethiopia and Eritrea*, edited by S. Kelly, 322–64. Leiden, 2020.

———. "Ethiopian Manuscripts in Old Regime France and the Collection of the French National Library." *RSE* 6 (2022): 153–94.

———. "L'histoire et l'art des églises du lac Ṭana." *AÉ* 16 (2000): 207–70.

———. "Le site rupestre de Qorqor (Garʿāltā, Éthiopie) entre littérature et peinture: Introduction à l'édition de la *Vie et des miracles de saint Daniel de Qorqor* et aux recherches en cours." *Afrique*, Sources (19 November 2014). http://journals.openedition.org/afriques/1486.

C. Bosc-Tiessé and Derat, M.-L., eds. *Lalibela: Site rupestre chrétien d'Éthiopie*. Toulouse, 2019.

———. "Lalibela, un site rupestre dans la longue durée: Histoire, archéologie et patrimonialisation." In *Patrimoine mondial de l'UNESCO: Enjeux et opportunités*, 77–115. Paris, 2019.

C. Bosc-Tiessé, M.-L. Derat, L. Bruxelles, F.-X. Fauvelle, Y. Gleize, and R. Mensan. "The Lalibela Rock Hewn Site and Its Landscape (Ethiopia): An Archaeological Analysis. *Journal of African Archaeology* 12.2 (2014): 141–64.

Bosc-Tiessé, C., S. Mirabaud, J.-D. Metz, F. Guéna, A. Fabijanec, and D. Burlot. "Qorqor Maryam: History, Materials and Techniques of Ethiopian Rock-Hewn Church Paintings." Presentation at Berhanou Abebe Library, French Center for Ethiopian Studies, Addis Ababa, Ethiopia, 2 May 2018, https://cfee.hypotheses.org/2605.

Bosc-Tiessé, C., S. Mirabaud, D. Morana-Burlot, A. Gaillard, and C. Maugaret-Guiné. "Peintures et sculptures à Lalibela: Matériaux, processus techniques et strates d'histoire." *Patrimoines* 16 (2021): 93–98.

Bouderbala, S. "Al-Ḥabasha in Miṣr and the End of the World: Early Islamic Egyptian Apocalypse Narratives Related to Abyssinia." *NEAS* 19.1 (2019): 9–22.

Bowersock, G. W. "Helena's Bridle, Ethiopian Christianity, and Syriac Apocalyptic." *StP* 45 (2010): 211–20.

———. *The Throne of Adulis: Red Sea Wars on the Eve of Islam*. New York, 2013.

Brakmann, H. *Τὸ παρὰ τοῖς βαρβάροις ἔργον θεῖον: Die Einwurzelung der Kirche im spätantiken Reich von Aksum*. Bonn, 1994.

Bramoullé, D. *Les Fatimides et la mer (909–1171)*. Islamic History and Civilization 165. Leiden, 2019.

———. "The Fatimids and the Red Sea (969–1171)." In *Navigated Spaces, Connected Places: Proceedings of the Red Sea Project V, Held at the University of Exeter, 16–19 September 2010*, edited by D. A. Agius, J. P. Cooper, A. Trakadas, and C. Zazzaro, 127–36. BAR International Series. Oxford, 2012.

Brentjes, B. "Karawanenwege durch Mittelasien." *AMIran* 25 (1992): 247-76.

Breton, J.-F. *Les bâtisseurs des deux rives de la mer Rouge / Builders across the Red Sea*. AÉ hors-série 5. Paris, 2015.

Brett, M. "Badr al-Ǧamālī and the Fatimid Renascence." In *Egypt and Syria in the Fatimid, Ayyubid and Mamluk Eras IV: Proceedings of the 9th and 10th International Colloquium Organized at the Katholieke Universiteit Leuven in May 2000 and May 2001*, ed. U. Vermeulen and J. van Steenbergen, 61–78. Orientalia Lovaniensia Analecta 140. Leuven, 2005.

Brita, A. *I racconti tradizionali sulla «seconda cristianizzazione» dell'Etiopia: Il ciclo agiografico dei novi santi*. Naples, 2010.

Buchwald, H. "The First Byzantine Architectural Style: Evolution or Revolution?" *JÖB* 32.5 (1982): 33–46.

———. "Western Asia Minor as a Generator of Architectural forms in the Byzantine Period, Provincial Back-Wash or Dynamic Center of Production?" *JÖB* 34 (1984): 199–234.

Bühl, G. "Textiles | Architecture | Space." In *Woven Interiors: Furnishing Early Medieval Egypt*, by G. Bühl, S. B. Krody, and E. D. Williams, 15–33. Washington, DC, 2019.

Burke, K. S., and D. Whitcomb. "Quṣeir al-Qadīm in the Thirteenth Century: A Community and Its Textiles." *Ars orientalis* 34 (2004): 82–97.

Burmester, O. H. E. "The Canons of Gabriel Ibn Turaik, LXX Patriarch of Alexandria (First Series)." *OCP* 1 (1935): 5–45.

Burton-Christie, D. *The Word in the Desert: Scripture and the Quest for Holiness in Early Christian Monasticism*. New York, 1993.

Butzer, K. W. "Rise and Fall of Axum, Ethiopia: A Geo-Archaeological Interpretation." *American Antiquity* 46.3 (1981): 471–95.

Butzer, K. W., and G. H. Endfield. "Critical Perspectives on Historical Collapse." *PNAS* 109.10 (2012): 3628–31.

Buxton, D. R. *The Abyssinians*. New York: Praeger, 1970.

———. "The Christian Antiquities of Northern Ethiopia." *Archaeologia* 92 (1947): 1–42.

———. "Ethiopian Medieval Architecture: The Present State of Studies." *Journal of Semitic Studies* 9.1 (1964): 239–44.

———. "The Rock-Hewn and Other Medieval Churches of Tigré Province, Ethiopia." *Archaeologia* 103 (1971): 33–100.

———. *Travels in Ethiopia*. London, 1949.

Buxton, D., and D. Matthews. "The Reconstruction of Vanished Aksumite Buildings." *RSE* 25 (1971–72): 53–77.

Büyükkolancı, M. "Zwei neugefundene Bauten der Johannes-Kirche von Ephesos: Baptisterium und Skeuophylakion." In A. Thiel, *Die Johanneskirche in Ephesos*, 66–84. Spätantike–Frühes Christentum–Byzanz 6. Wiesbaden, 2005.

Caquot, A. "Aperçu préliminaire sur le *Maṣḥafa Ṭēfut* de Gechen Amba." *AÉ* 1 (1955): 89–108.

Carr, A. W. "Pilgrimage to Constantinople." In *The Cambridge Companion to Constantinople*, edited by S. Bassett, 310–23. Cambridge, 2022.

Castiglia, G. "Between Aksum and Byzantium: The Rise of Early Christianity in the Horn of Africa. Sources and New Archaeological Data." *Vetera Christianorum* 57 (2020): 85–105.

———. "La cristianizzazione di Adulis (Eritrea) e del regno Aksumita: Nuovi dati dal Corno d'Africa d'etá tardo antica." *Rendiconti della Pontificia Accademia di Archeologia* 91 (2020): 91–127.

Castiglia, G., P. Pergola, M. Ciliberti, B. Maletić, M. Pola, and O. Larentis. "For an Archaeology of Religious Identity in Adulis (Eritrea) and the Horn of Africa: Sources, Architecture, and Recent Archaeological Excavations." *Journal of African Archaeology* 19 (2021): 25–56.

Caulk, R. *"Between the Jaws of Hyenas": A Diplomatic History of Ethiopia, 1876–1896*, ed. B. Zewde. Wiesbaden, 2002.

Cerulli, E. *Etiopi in Palestina: Storia della communità etiopica di Gerusalemme.* Vol. 1. 2 vols. Collezione Scientifica e Documentaria 12. Rome, 1943.

Chakravarti, R. "Nakhudas and Nauvittakas: Ship-Owning Merchants in the West Coast of India (c. AD 1000–1500)." *Journal of the Economic and Social History of the Orient* 43.1 (2000): 34–64.

Chauleur, S. "L'autel copte." *Les cahiers coptes* 9 (1955): 1–20.

Chekroun, A., and B. Hirsch. "The Sultanates of Medieval Ethiopia." In *A Companion to Medieval Ethiopia and Eritrea*, edited by S. Kelly, 86–112. Leiden, 2020.

Cheng, B. "A Camel's Pace: A Cautionary Global." *The Medieval Globe* 3.2 (2017): 11–34.

el-Chennafi, M. "Mention nouvelle d'une 'reine éthiopienne' au IVᵉ s. de l'hégire/Xᵉ s. ap. J.-C." *AÉ* 10 (1976): 119–21.

Chernetsov, S. B. *Efiopskaia feodal'naia monarkhiia v XIII–XVI vv.* Moscow, 1982.

———. *Efiopskaia feodal'naia monarkhiia v XVII veke.* Moscow, 1990.

———. "Endärta." In *EAe* 2:297–98.

Coates-Stephens, R. "Dark Age Architecture in Rome." *Papers of the BSR* 65 (1997): 177–232.

Cobb, P. M. "Usāma Ibn Munqidh's *Lubāb al-Ādāb (The Kernels of Refinement)*: Autobiographical and Historical Excerpts." *Al-Masāq: Journal of the Medieval Mediterranean* 18.1 (2006): 67–78.

Cohen, M. R. "Geniza for Islamicists, Islamic Geniza, and the 'New Cairo Geniza.'" *Harvard Middle Eastern and Islamic Review* 7 (2006): 129–45.

Colin, G. "Vie et miracles de Daniel de Qorqor: Introduction." *Afriques*, Sources (19 November 2014). http://journals.openedition.org/afriques/1487.

Conder, J. *The Modern Traveller: A Popular Description, Geographical, Historical, and Topographical, of the Various Countries of the Globe*, vol. 5, *Egypt, Nubia, and Abyssinia.* 2 vols. London, 1827.

Conti Rossini, C. "Appunti sulla lingua awiyā del Denghelà." *Giornale della Società Asiatica Italiana* 18 (1905): 103–94.

———. "Documenti per l'archeologia eritrea nella bassa Valle dei Barca." *RRAL*, ser. 5, 12.4 (1903): 139–50.

Cook, M. "Pharaonic History in Medieval Egypt." *Studia Islamica* 57 (1983): 67–103.

Cotsonis, J. A. *Byzantine Figural Processional Crosses.* Dumbarton Oaks Byzantine Collection Publications 10. Washington, DC, 1994.

Creswell, K. A. C. *The Muslim Architecture of Egypt*, vol. 1, *Ikhshids and Fātimids.* Oxford, 1952.

Crowfoot, E. *Qasr Ibrim: The Textiles from the Cathedral Cemetery.* Excavation Memoir 96. London, 2011.

Crummey, D. *Land and Society in the Christian Kingdom of Ethiopia: From the Thirteenth to the Twentieth Century.* Urbana, IL, 2000.

Daftary, F. "The Ismaili *Da'wa* outside the Fatimid *Dawla*." In *L'Égypte fatimide: Son art et son histoire. Actes du colloque organisé à Paris les 28, 29 et 30 mai 1998*, edited by M. Barrucand, 29–43. Paris, 1999.

Dale, O. "The Rock-Hewn Churches of Tigre." *EO* 11.2 (1968): 121–57.

Dale, T. "Cultural Hybridity in Medieval Venice: Reinventing the East at San Marco after the Fourth Crusade." In *San Marco, Byzantium, and the Myths of Venice*, edited by H. Maguire and R. S. Nelson, 151–91. Washington, DC, 2010.

D'Andrea, A. C., A. Manzo, M. J. Harrower, and A. L. Hawkins. "The Pre-Aksumite and Aksumite Settlement of NE Tigrai, Ethiopia." *Journal of Field Archaeology* 33.2 (2008): 151–76.

Daoud, M., and M. Hazen, trs. *The Liturgy of the Ethiopian Orthodox Church.* Cairo, 1959.

Dark, K., and F. Özgümüş. "New Evidence for the Byzantine Church of the Holy Apostles from Fatih Camii, Istanbul." *Oxford Journal of Archaeology* 21.4 (2002): 393–413.

Darles, C. "Typologie des sanctuaires de l'Arabie du Sud antique: Tentative pour une nouvelle classification." *PSAS* 44 (2014): 121–38.

Darley, R. "Seen from across the Sea: India in the Byzantine Worldview." In *Global Byzantium: Papers from the Fiftieth Spring Symposium of Byzantine Studies*, edited by L. Brubaker, R. Darley, and D. Reynolds, 9–38. Abingdon, UK, 2022.

Daum, W. "Abraha's Cathedral: Change and Continuity of a Sacred Place." In *South Arabian Long-Distance Trade in Antiquity: "Out of Arabia"*, edited by G. Hatke and R. Ruzicka, 245–59. Newcastle upon Tyne, 2021.

———. "Ṣanʿāʾ: The Origins of Abrahah's Cathedral and the Great Mosque. A Water Sanctuary of the Old Arabian Religion." *PSAS* 48 (2018): 67–74.

Davis, A. J. "The Sixteenth Century Jihād in Ethiopia and the Impact on Its Culture (Part One)." *Journal of the Historical Society of Nigeria* 2.4 (1963): 567–92.

———. "The Sixteenth Century Jihād in Ethiopia and the Impact on Its Culture, Part II: Implicit Factors behind the Movement." *Journal of the Historical Society of Nigeria* 3.1 (1964): 113–28.

De Contenson, H. "Les fouilles à Axoum en 1958.—Rapport préliminaire." *AnnEth* 5 (1963): 3–40.

Dehejia, V., and P. Rockwell. *The Unfinished: Stone Carvers at Work on the Indian Subcontinent.* New Delhi, 2016.

Del Francia Barocas, L. "L'immagine della croce nell'egitto cristiano." *RSO* new ser., 85.1–4 (2012): 165–211.

Demus, O. *Byzantine Mosaic Decoration: Aspects of Monumental Art in Byzantium.* London, 1948.

———. *The Mosaics of San Marco in Venice.* 2 vols. in 4. Chicago, 1984.

Dennert, M., and S. Westphalen. "Säulen aus Konstantinopel - ein Schiffsfund im antiken Hafen von Amrit." *Damaszener Mitteilungen* 14 (2004): 183–95.

Derat, M.-L. "L'affaire des mosquées: Interactions entre le vizirat fatimide, le patriarcat d'Alexandrie et les royaumes chrétiens d'Éthiopie et de Nubie à la fin du XIᵉ siècle." *Médiévales* 79 (2020): 15–36.

———. "Les archives Roger Schneider (1917–2002) au centre Walda Masqal (Institute of Ethiopian Studies, Addis Abeba)." *AÉ* 26 (2011): 291–302.

———. "Before the Solomonids: Crisis, Renaissance and the Emergence of the Zagᵂe Dynasty (Seventh–Thirteenth Centuries)." In *A Companion to Medieval Ethiopia and Eritrea*, edited by S. Kelly, 31–56. Leiden, 2020.

———. *Le domaine des rois éthiopiens (1270–1527): Espace, pouvoir et monachisme.* Paris, 2003.

———. "Les donations du roi Lālibalā: Éléments pour une géographie du royaume chrétien d'Éthiopie au tournant du XIIᵉ et du XIIIᵉ siècle." *AÉ* 25 (2010): 19–42.

———. *L'énigme d'une dynastie sainte et usurpatrice dans le royaume chrétien d'Éthiopie du XIe au XIIIe siècle.* Turnhout, 2018.

Derat, M.-L., C. Bosc-Tiessé, A. Garric, R. Mensan, F.-X. Fauvelle, Y. Gleize, and A.-L. Goujon. "The Rock-Cut Churches of Lalibela and the Cave Church of Washa Mika'el: Troglodytism and the Christianisation of the Ethiopian Highlands." *Antiquity* 95 (2021): 467–86.

Derat, M.-L., F.-X. Fauvelle, R. Mensan, Y. Gleize, H. Berhe, M. Muehlbauer, A. Lamesa, and G. Gebreegziabher. "Lalibela, la christianisation et le contrôle de l'Éthiopie centrale au tournant des 1ᵉʳ et 2ᵉ millénaires de notre ère: Recherches archéologiques et historiques entre Lasta et Tigré méridional (IXᵉ–XIIIᵉ siècles)." Rapport sur les opérations 2020. Paris, 2020.

Derat, M.-L., E. Fritsch, C. Bosc-Tiessé, A. Garric, R. Mensan, F.-X. Fauvelle, and H. Berhe. "Māryām Nāzrēt (Ethiopia): The Twelfth-Century Transformations of an Aksumite Site in Connection with an Egyptian Christian Community." *Cahiers d'études africaines* 239.3 (2020): 473–507.

Descoeudres, G. *Die Pastophorien im syro-byzantinischen Osten: Eine Untersuchung zu architektur- und liturgiegeschichtlichen Problemen.* Wiesbaden, 1983.

Di Salvo, M. *The Basilicas of Ethiopia: An Architectural History.* London, 2017.

———. *Crosses of Ethiopia: The Sign of Faith. Evolution and Form.* Milan, 2006.

———. "Serial Geometric Decorations in the Ancient Ethiopian Basilicas." *RSE* 3rd ser. 3 (2019): 65–86.

Dietrich, H. T., trans. *Arriani alexandrini periplus maris erythraei.* Dresden, 1849.

van Donzel, E. "Badr al-Jamālī, the Copts in Egypt and the Muslims in Ethiopia." In *Studies in Honour of Clifford Edmund Bosworth*, vol. 1, *Hunter of the East: Arabic and Semitic Studies*, edited by I. R. Netton, 297–309. Leiden, 2000.

van Donzel, E., and R. E. Kon. "Dahlak Islands." In *EAe* 2:64–69.

Doquang, M. S. *The Lithic Garden: Nature and the Transformation of the Medieval Church.* New York, 2018.

Dore, G. "Carlo Conti Rossini in Eritrea tra ricerca scientifica e prassi coloniale (1899–1903)." In *Linguistic, Oriental and Ethiopian Studies in Memory of Paolo Marrassini*, edited by A. Bausi, A. Gori, and G. Lusini, 321–42. Wiesbaden, 2014.

Doresse, J. *L'empire du Prêtre-Jean.* 2 vols. Paris, 1957.

———. "Nouvelles recherches sur les relations entre l'Égypte copte et l'Éthiopie: XIIᵉ–XIIIᵉ siècles." *CRAI* 114.3 (1970): 557–66.

———. "Les premiers monuments chrétiens de l'Éthiopie et l'église archaïque de Yéha." *NT* 1.3 (1956): 209–24.

Draper, P. "Islam and the West: The Early Use of the Pointed Arch Revisited." *Architectural History* 48 (2005): 1–20.

Duval, N. *Les églises africaines à deux absides: Recherches archéologiques sur la liturgie chrétienne en Afrique du Nord.* 2 vols. Paris, 1971–73.

———. "Les installations liturgiques dans les églises paléochrétiennes." *Hortus Artium Medievalium* 5 (1999): 7–30.

El-Adawi, I. A. "Egyptian Maritime Power in the Early Middle Ages: From the Arab Conquest of Egypt to the Fall of the Fatimids, 640–1171 A.D." PhD diss., University of Liverpool, 1948.

Élias, G., C. Lepage, and J. Mercier. "Peintures murales du XIIᵉ siècle découvertes dans l'église Yemrehana Krestos en Éthiopie." *CRAI* 145.1 (2001): 311–34.

Ellis, M. *Embroideries and Samplers from Islamic Egypt.* Oxford, 2001.

Erlich, H. "Identity and Church: Ethiopian–Egyptian Dialogue, 1924–59." *IJMES* 32.1 (2000): 23–46.

Ettinghausen, E. "Woven in Stone and Brick: Decorative Programs in Seljuk and Post-Seljuk Architecture and Their Symbolic Value." In *Turkish Art: 10th International Congress of Turkish Art, Geneva, 17–23 September 1995. Proceedings*, edited by F. Déroche et al., 315–25. Geneva, 1999.

Ettinghausen, R. "Early Realism in Islamic Art." In *Studi orientalistici in onore di Giorgio Levi Della Vida*, 1:250–73. 2 vols. Rome, 1956.

Evangelatou, M. *A Contextual Reading of Ethiopian Crosses Through Form and Ritual: Kaleidoscopes of Meaning.* Gorgias Eastern Christian Studies 49. Piscataway, NJ, 2018.

Evans, H. C. "The Original Mosaic Decoration of Hagia Sophia." In *Mosaics of Anatolia*, edited by G. Sözen, 221–32. Istanbul, 2011.

Evetts, B. T. A, ed. and trans., with A. J. Butler. *The Churches and Monasteries of Egypt and Some Neighbouring Countries, Attributed to Abû Ṣâliḥ, the Armenian.* Oxford, 1895.

Fabricius, B., ed. *Arriani Alexandrini periplus maris erythraei.* Dresden, 1849.

Falla Castelfranchi, M. Βαπτιστήρια: *intorno ai più noti battisteri dell'Oriente.* Quaderni dell'Istituto di Archeologia e Storia Antica 1. Rome, 1980.

Faller, S. "The World According to Cosmas Indicopleustes: Concepts and Illustrations of an Alexandrian Merchant and Monk." *Transcultural Studies* 2.1 (2011): 193–232.

Fattovich, R. "Aksum and the Habashat: State and Ethnicity in Ancient Northern Ethiopia and Eritrea," 1–24. Working Papers in African Studies 228. Boston, 2000.

Fattovich, R., K. A. Bard, L. Petrassi, and P. Visano. *The Aksum Archaeological Area: A Preliminary Assessment.* Naples, 2000.

Fauvelle, F.-X. *The Golden Rhinoceros: Histories of the African Middle Ages*, translated by T. Tice. Princeton, 2018.

Fauvelle-Aymar, F.-X., and B. Hirsch. "Muslim Historical Spaces in Ethiopia and the Horn of Africa: A Reassessment." *NEASt* 11.1 (2004): 25–53.

———, eds. *Espaces musulmans de la Corne de l'Afrique au Moyen Âge.* Addis Ababa, 2011.

Fauvelle, F.-X., and B. Poissonnier, eds. *La culture Shay d'Éthiopie (Xᵉ–XIVᵉ siècles): Recherches archéologiques et historiques sur une élite païenne.* AE hors-série 3 (2012).

———. "The Shay Culture of Ethiopia (Tenth to Fourteenth Century AD): 'Pagans' in the Time of Christians and Muslims." *African Archaeological Review* 33.1 (2016): 61–74.

Fauvelle-Aymar, F.-X., L. Bruxelles, R. Mensan, C. Bosc-Tiessé, M.-L. Derat, and E. Fritsch. "Rock-Cut Stratigraphy: Sequencing the Lalibela Churches." *Antiquity* 84 (2010): 1135–50.

Fauvelle, F.-X., M.-L. Derat, R. Mensan, and A. Garric. "Māryām Nāzrēt: Report to the Authority of Research and Conservation of the Cultural Heritage, Addis Ababa, Ethiopia, On Archaeological Works Conducted at the Site of Māryām Nāzrēt, Tigray in 2018." Archaeological Report. Addis Ababa, 2019.

Finneran, N. *The Archaeology of Ethiopia.* Abdington, UK, 2007.

———. "Built by Angels? Towards a Buildings Archaeology Context for the Rock-Hewn Medieval Churches of Ethiopia." *World Archaeology* 41.3 (2009): 415–29.

Finster, B. "The Mosques of Wuṣāb Province in Yemen." *PSAS* 32 (2002): 233–45.

———. "The Material Culture of Pre- and Early Islamic Arabia." In *A Companion to Islamic Art and Architecture*, edited by F. B. Flood and G. Necipoğlu, 1:61–88. 2 vols. Hoboken, NJ, 2017.

———. "On Masjid al-Juyushi on the Muqattam." *Archéologie islamique* 10 (2000): 65–78.

———. "Survey islamischer Bau- und Kunstdenkmäler im Yemen: Erster vorläufiger Bericht." In *Archäologische Berichte aus dem Yemen*, vol. 1, edited by J. Schmidt, 223–75. Mainz, 1981.

———. "Zu einigen Spolien in der Freitagsmoschee von Ṣanʿāʾ [sic]." *ZDMG*, Suppl. 4 (1980): 492–500, https://menadoc.bibliothek.uni-halle.de/dmg/periodical/pageview/127288.

Finster, B., and J. Schmidt. "Die Kirche des Abraha in Ṣanʿāʾ." In *Arabia Felix: Beiträge zur Sprache und Kultur des vorislamischen Arabien. Festschrift Walter W. Müller zum 60. Geburtstag*, edited by N. Nebes, 67–86. Wiesbaden, 1994.

Flood, F. B. "The Flaw in the Carpet: Disjunctive Continuities and Riegl's Arabesque." In *Histories of Ornament: From Global to Local*, edited by G. Necipoğlu and A. Payne, 82–93. Princeton, 2016.

———. *Objects of Translation: Material Culture and Medieval "Hindu-Muslim" Encounter.* Princeton, 2009.

Forsyth Jr., G. "The Transept of Old St. Peter's at Rome." In *Late Classical and Mediaeval Studies in Honor of Albert Mathias Friend, Jr.*, edited by K. Weitzmann, 56–70. Princeton, 1955.

Foss, C. "Pilgrimage in Medieval Asia Minor." *DOP* 56 (2002): 129–51.

Friendly, A. *The Dreadful Day: The Battle of Manzikert 1071.* London, 1981.

Fritsch, E. "The Altar in the Ethiopian Church: History, Forms and Meanings." In *Inquiries into Eastern Christian Worship: Selected Papers of the Second International Congress of the Society of Oriental Liturgy, Rome, 17–21 September 2008*, edited by B. Groen, S. Hawkes-Teeples, and S. Alexopoulos, 443–510. Eastern Christian Studies 12. Leuven, 2012.

———. "The Churches of Lalibäla (Ethiopia): Witnesses of Liturgical Changes." *Bollettino della Badia greca di Grottaferrata* 3.5 (2008): 69–112.

———. "Liturgie et architecture ecclésiastique éthiopiennes." *Journal of Eastern Christian Studies* 64.1–2 (2012): 91–125.

———. "Mägaräga." In *EAe* 3:630–31.

———. "New Reflections on the Image of Late Antique and Medieval Ethiopian Liturgy." In *Liturgy's Imagined Past/s: Methodologies and Materials in the Writing of Liturgical History Today*, edited by T. Berger and B. D. Spinks, 39–92. Collegeville, MN, 2016.

———. "The Order of the Mystery: An Ancient Catechesis Preserved in BnF Ethiopic Ms d'Abbadie 66-66bis (Fifteenth Century) with a Liturgical Commentary." In *Studies in Oriental Liturgy:*

Proceedings of the Fifth International Congress of the Society of Oriental Liturgy, New York, 10–15 June 2014, edited by B. Groen, D. Galadza, N. Glibetic, and G. Radle, 195–263. Eastern Christian Studies 28. Leuven, 2019.

———. "The Origins and Meanings of the Ethiopian Circular Church: Fresh Explorations." In *Tomb and Temple: Re-Imagining the Sacred Buildings of Jerusalem*, edited by R. Griffith-Jones and E. Fernie, 267–93. Boydell Studies in Medieval Art and Architecture 13. Woodbridge, UK, 2018.

———. "The Preparation of the Gifts and the Pre-Anaphora in the Ethiopian Eucharistic Liturgy in around AD 1100." In *Rites and Rituals of the Christian East: Proceedings of the Fourth International Congress of the Society of Oriental Liturgy, Lebanon, 10–15 July 2012*, edited by B. Groen, D. Galadza, N. Glibetic, and G. Radle, 97–152. Eastern Christian Studies 22. Leuven, 2014.

———. Review of D. W. Phillipson, *Ancient Churches of Ethiopia: Fourth–Fourteenth Centuries*, *AÉ* 25 (2010): 307–17.

———. "St. Cyricus Church at Weqro, East Tegray: A Complete Description and Interpretation of Its Salient Architectonics." Paper presented at ICES20, Mekelle University, Mekelle, Ethiopia, 5 October 2018.

———. "Twin Pillars: An Epistemological Note in Church Archaeology." *AÉ* 25 (2010): 103–11.

Fritsch, E., and M. Gervers. "*Pastophoria* and Altars: Interaction in Ethiopian Liturgy and Church Architecture." *Aethiopica* 10 (2007): 7–51.

Fritsch, E., and H. Kidane. "The Medieval Ethiopian Orthodox Church and Its Liturgy." In *A Companion to Medieval Ethiopia and Eritrea*, edited by S. Kelly, 162–93. Leiden, 2020.

Fulghum, M. M. "Under Wraps: Byzantine Textiles as Major and Minor Arts," *Studies in the Decorative Arts* 9.1 (2001–2): 13–33.

Gabra, G., ed. *Coptic Civilization: Two Thousand Years of Christianity in Egypt*. Cairo, 2014.

Gabra, G., and M. Eaton-Krauss. *The Treasures of Coptic Art: In the Coptic Museum and Churches of Old Cairo*. Cairo, 2007.

Garcin, J.-C. *Un centre musulman de la Haute-Égypte médiévale: Qūṣ*. Cairo, 1976.

Garstad, B., ed and trans. *Apocalypse of Pseudo-Methodius: An Alexandrian World Chronicle*. Cambridge, MA, 2012.

Gartkiewicz, P. M. *The Cathedral in Old Dongola and Its Antecedents*. Warsaw, 1990.

Gaudiello, M., and P. A. Yule, eds. *Mifsas Baḥri: A Late Aksumite Frontier Community in the Mountains of Southern Tigray. Survey, Excavation and Analysis, 2013–16*. BAR International Series 2839. Oxford, 2017.

Gauthier, N. "From the Ancient City to the Medieval Town: Continuity and Change in the Early Middle Ages." In *The World of Gregory of Tours*, edited by K. Mitchell and I. Wood, 47–66. Leiden, 2002.

Gebre Selasse, Y. "Plague as a Possible Factor for the Decline and Collapse of the Aksumite Empire: A New Interpretation." *ITYOPIS, Northeast African Journal of Social Sciences and Humanities* 1 (2011): 36–61.

Gebru, M. K. "Liturgical Cosmology: The Theological and Sacramental Dimensions of Creation in the Ethiopian Liturgy." PhD diss., University of St. Michael's College, Toronto, 2012.

Gerster, G. *Churches in Rock: Early Christian Art in Ethiopia*. Translated by R. Hosking. New York, 1970.

Gervers, M. "Churches Built in the Caves of Lasta (Wällo Province, Ethiopia): A Chronology." *Aethiopica* 17.1 (2014): 25–64.

———. "The Mediterranean Context of the Rock-Cut Churches of Ethiopia." In *Proceedings of the Eighth International Conference of Ethiopian Studies, University of Addis Ababa, 1984*, edited by T. Beyene, 1:171–83. 2 vols. Addis Ababa, 1988–89.

———. "The Monolithic Church of Wuqro Mäsqäl Krəstos." *Africana Bulletin* 50 (2002): 99–113.

———. "New Rock-Hewn Churches of Ethiopia." Database. New Rock-Hewn Churches of Ethiopia, 2020. https://www.utsc.utoronto.ca/projects/ethiopic -churches/.

———. "The Rehabilitation of the Zaguë Kings and the Building of the Däbrä Sina–Golgotha–Sellassie Complex in Lalibäla." *Africana Bulletin* 51 (2003): 23–49.

———. "The Tablet–Woven Hangings of Tigre, Ethiopia: From History to Symmetry." *The Burlington Magazine* 146 (2004): 588–601.

———. "The West Portal Ceiling Paintings in the Zagwe Church of Yəmrəḥannä Krəstos." In *Studies in Ethiopian Languages, Literature, and History: Festschrift for Getatchew Haile, Presented by His Friends and Colleagues*, edited by A. C. McCollum, 35–64. Wiesbaden, 2017.

Gervers, M., and E. Balicka-Witakowska. "Abba Yoḥanni." In *EAe* 5:208–10. Wiesbaden, 2014.

Gervers, M., and E. Fritsch. "Rock-Hewn Churches and Churches-in-Caves." In *EAe*, edited by S. Uhlig, 4:400–404. Wiesbaden, 2010.

Gervers, M. and T. Philipp. "The New Rock-Hewn Churches of Ethiopia: Continuity or Revival?" Paper given at ICES20, Mekelle University, Mekelle, Ethiopia, 1–5 October 2018.

Gibbon, E. *The History of the Decline and Fall of the Roman Empire*. 4 vols. Philadelphia, 1887.

Giorgis, E. W. *Modernist Art in Ethiopia*. New African Histories. Athens, OH, 2019.

Giostra, C. "La diffusione del Cristianesimo lungo il Mar Rosso alla luce dell'archeologia: La città-porto di Adulis e il regno di Aksum." *RACr* 93 (2017): 249–313.

Giostra, C., and S. Massa. "Dal Mediterraneo al Mar Rosso: La cristianizzazione della città-porto di Adulis e la diffusione di modelli e manufatti bizantini." *Hortus Artium Medievalium* 22 (2016): 92–109.

Gire, J., and R. Schneider. "Etude des églises rupestres du Tigré: Premiers résultats de la mission 1970." *Abbay* 1 (1970): 73–79.

Gnisci, J. "A Contextual Reading of Ethiopian Crosses through Form and Ritual." *Aethiopica* 23 (2020): 256–68.

———. "Constructing Kingship in Early Solomonic Ethiopia: The David and Solomon Portraits in the Juel-Jensen Psalter." *ArtB* 102.4 (2020): 7–36.

———. "Ecclesiastic Dress in Medieval Ethiopia: Preliminary Remarks on the Visual Evidence." In *The Hidden Life of Textiles in the Medieval and Early Modern Mediterranean: Contexts and Cross-Cultural Encounters in the Islamic, Latinate and Eastern Christian Worlds*, edited by N. Vryzidis, 231–56. Turnhout, 2020.

Gnisci, J., and M. Villa. "Evidence for the History of Early Solomonic Ethiopia from Tämben, Part II: Abba Yoḥanni Däbrä ʾAśa." *RSE* ser. 3, 6 (2022): 97–128.

Gobezie Worku, M. "The Church of Yimrhane Kristos: An Archaeological Investigation." PhD diss. Lund University, 2018.

Göbl, R. "Der Kušānische Goldmünzschatz von Debra Damo (Äthiopien) 1940 (Vima Kadphises bis Vāsudeva I)." *Central Asiatic Journal* 14 (1970): 241–52.

Godet, E. "Répertoire des sites pré-axoumites et axoumites d'Éthiopie du Nord, II partie: Érythrée." *Abbay* 11 (1980–82): 73–113.

———. "Répertoire des sites pré-axoumites et axoumites du Tigré (Ethiopie)." *Abbay* 8 (1977): 19–58.

Godlewski, W. "The Church of Archangel Raphael (SWN.B.V)." In *Dongola 2015–2016: Fieldwork, Conservation and Site Management*, edited by W. Godlewski, D. Dzierzbicka, and A. Łajtar, 115–31. PCMA Excavation Series 5. Warsaw, 2018.

———. *Pachoras: The Cathedrals of Aetios, Paulos and Petros. The Architecture*. Warsaw, 2006.

Goitein, S. D. "From the Mediterranean to India: Documents on the Trade to India, South Arabia, and East Africa from the Eleventh and Twelfth Centuries." *Speculum* 29.2 (1954): 181–97.

———. *A Mediterranean Society: The Jewish Communities of the Arab World as Portrayed in the Documents of the Cairo Geniza*, vol. 4, *Daily Life*. Berkeley, 1983.

———. "Three Trousseaux of Jewish Brides from the Fatimid Period." *AJS Review* 2 (1977): 77–110.

Goitein, S. D., and M. Friedman. *India Traders of the Middle Ages: Documents from the Cairo Geniza 'India Book.'* Leiden, 2008.

Goldberg, J. L. *Trade and Institutions in the Medieval Mediterranean: The Geniza Merchants and Their Business World*. New York, 2012.

Golombek, L. "The Draped Universe of Islam." In *Content and Context of Visual Arts in the Islamic World: Papers from a Colloquium in Memory of Richard Ettinghausen, Institute of Fine Arts, New York University, 2–4 April 1980, planned and organized by Carol Manson Bier*, edited by P. P. Soucek, 29–49. University Park, PA, 1988.

Gonosová, A. "The Formation and Sources of Early Byzantine Floral Semis and Floral Diaper Patterns Reexamined." *DOP* 41 (1987): 227–37.

Grabar, O. "Imperial and Urban Art in Islam: The Subject-Matter of Fatimid Art." In O. Grabar, *Early Islamic Art, 650–1100*, vol. 1, *Constructing the Study of Islamic Art*, 173–90. Aldershot, UK, 2005. https://www.archnet.org/publications/4980.

Griffith, S. H. "The Handwriting on the Wall: Graffiti in the Church of St. Antony." In *Monastic Visions: Wall Paintings in the Monastery of St. Antony at the Red Sea*, edited by E. S. Bolman, 185–94. New Haven, 2002.

Groom, N. *Frankincense and Myrrh: A Study of the Arabian Incense Trade*. London, 1981.

Grossmann, P. *Abū Mīna*, vol. 1, *Die Gruftkirche und die Gruft*. Mainz, 1989.

———. "Architectural Elements of Churches." In *The Coptic Encyclopedia*, edited by A. S. Atiya, 1:194–226. 8 vols. New York, 1991.

———. *Christliche Architektur in Ägypten*. Leiden, 2002.

———. *Die antike Stadt Pharan: Ein archäologischer Führer*. Cairo, 1998.

———. "Excavations in Firan–Sinai in the Years from 2000 to 2005." *BZ* 106.2 (2013): 645–82.

———. "Late Antique Architecture in Egypt: Evidence of Textile Decoration." In *Clothing the House: Furnishing Textiles of the 1st Millennium AD from Egypt and Neighbouring Countries. Proceedings of the 5th Conference of the Research Group "Textiles from the Nile Valley," Antwerp, 6–7 October 2007*, edited by A. De Moor and C. Fluck, 19–35. Tielt, Belgium, 2009.

———. *Mittelalterliche Langhaus-Kuppelkirchen und verwandte Typen in Oberägypten: Eine Studie zum Mittelalterlichen Kirchenbau in Ägypten*. ADAIK, Koptische Reihe 3. Glückstadt, 1982.

———. "Neue Beobachtungen zur al-ʿAdrâ-kirche von Dair as-Suryân." *Nubian Letters* 19 (1993): 1–8. https://medievalsaiproject.files.wordpress.com/2013/09/nubian-letters-19.pdf.

Grossmann, P., and A. Cody. "Dayr Al-Suryan." In *The Coptic Encyclopedia*, edited by A. S. Atiya, 3:876–81. 8 vols. New York, 1991.

Grossmann, P., J. Kościuk, G. Severin, and H.-G. Severin. "Abū Mīna: Elfter vorläufiger Bericht. Kampagnen 1982 und 1983." *MDAIK* 40 (1984): 123–51.

Grube, E. J. "Studies in the Survival and Continuity of Pre-Muslim Traditions in Egyptian Islamic Art." *JARCE* 1 (1962): 75–97.

Gui, I., N. Duval, and J.-P. Caillet. *Basiliques chrétiennes d'Afrique du Nord (inventaire et typologie)*, Vol. 1: *Inventaire de l'Algérie*. Série Antiquité 129. Paris, 1992.

Guida dell'Africa Orientale Italiana. Milan, 1939.

Guidetti, M. "The Byzantine Heritage in the *Dār al-Islām*: Churches and Mosques in al-Ruha between the Sixth and Twelfth Centuries." *Muqarnas* 26 (2009): 1–36.

Guidi, I. "Le liste dei metropoliti d'Abissinia." *Bessarione* 6 (1899): 2–16.

Guillou, A. "Rome, centre transit des produits du luxe d'Orient au Haut Moyen Âge." *Zograf* 10 (1979): 17–21.

Guindeuil, T. "Alimentation, cuisine et ordre social dans le royaume d'Éthiopie (XIIe–XIXe siècle)." PhD diss., Sorbonne University–Paris 1, 2012.

———. "What Do Christians (Not) Eat: Food Taboos and the Ethiopian Christian Community (13th-18th Centuries)." *AÉ* 29 (2014): 59–82.

Guo, L. "Arabic Documents from the Red Sea Port of Quseir in the Seventh/Thirteenth Century, Part 2: Shipping Notes and Account Records." *JNES* 60.2 (2001): 81–116.

Guy, J. *Woven Cargoes: Indian Textiles in the East.* London, 1998.

Hable Selassie, S. *Ancient and Medieval Ethiopian History to 1270.* Addis Ababa, 1972.

———. "The Problem of Gudit." *JES* 10.1 (1972): 113–24.

Hadjitryphonos, E. "The Pilgrimage Monument as Space in the Eastern Mediterranean." In *Routes of Faith in the Medieval Mediterranean: History, Monuments, People, Pilgrimage Perspectives. Proceedings from an International Symposium, Thessalonike 7–10/11/2007,* edited by E. Hadjitryphonos, 31–48. Thessaloniki, 2008.

Hagos, Tekle. "Archaeological excavations at the church of Arbaetu Ensesa Aksum, Ethiopia, 2006–2007." *AnnEth* 26 (2011): 79–98.

———. "Preliminary Result of the Archaeological Reconnaissance Carried Out in S'aesie't S'ae'da Emba and Hawzen Districts, South Eastern Tigray, Ethiopia." *JES* 47 (2014): 95–119.

Hagos, Tsegray. "Breathtaking Rock-Hewn Churches in Eastern Tigray." *The Ethiopian Herald.* 16 February 2018, sec. Technology. https://web.archive.org/web/20180706001143/http://www.ethpress.gov.et/herald/index.php/technology/item/10942-breath taking-rock-hewn-churches-in-eastern-tigray.

Hahn, W. "Symbols of Pagan and Christian Worship on Aksumite Coins: Remarks to the History of Religions in Ethiopia as Documented by Its Coinage." *Nubica et Aethiopica* 4/5 (1999): 431–54.

Hahn, W., and R. Keck. *Münzgeschichte der Aksumitenkönige in der Spätantike.* Veröffentlichungen des Instituts für Numismatik und Geldgeschichte der Universität Wien 21. Vienna, 2020.

Haile, G. "The Cause of the Ǝsṭifanosites: A Fundamentalist Sect in the Church of Ethiopia." *Paideuma* 29 (1983): 93–119.

———. *Ethiopian Studies in Honour of Amha Asfaw.* New York, 2017.

———. "A Fragment of the Late Aksumite or Early Zagʷe Period on the Commentary on the Gospel of Matthew." *Aethiopica* 24 (2021): 223–32.

———. "In Memoriam Taddesse Tamrat (1935–2013)." *Aethiopica* 16 (2013): 212–19.

———. "Religious Controversies and the Growth of Ethiopic Literature in the Fourteenth and Fifteenth Centuries." *OC* 65 (1981): 102–36.

Hajpál, M. "Changes in Sandstones of Historical Monuments Exposed to Fire or High Temperature." *Fire Technology* 38 (2002): 373–82.

Halm, H. "Badr al-Ǧamālī: Wesir oder Militärdiktator?" In *Egypt and Syria in the Fatimid, Ayyubid and Mamluk Eras V: Proceedings of the 11th, 12th and 13th International Colloqium Organized at the Katholieke Universiteit Leuven in May 2002, 2003 and 2004,* edited by U. Vermeulen and K. D'hulster, 121–27. Orientalia Lovaniensia Analecta 169. Leuven, 2007.

———. *Kalifen und Assassinen: Ägypten und der Vordere Orient zur Zeit der ersten Kreuzzüge 1074–1171.* Munich, 2014.

Hamdānī, Ḥ. *Al-Ṣulayḥiyyūn wa-l-Ḥaraka al-fāṭimiyya fī al-Yaman.* Cairo, 1955.

Hamilakis, Y. *The Nation and Its Ruins: Antiquity, Archaeology, and National Imagination in Greece.* New York, 2007.

Hammerschmidt, E. "The Liturgical Vestments of the Ethiopian Church: A Tentative Survey." In *Proceedings of the Third International Conference of Ethiopian Studies, Addis Ababa, 1966,* ed. R. K. P. Pankhurst, 2:151–56. 3 vols. Addis Ababa, 1969–70.

Harrower, M. J., I. A. Dumitru, C. Perlingieri, S. Nathan, K. Zerue, J. L. Lamont, A. Bausi, et al. "Beta Samati: Discovery and Excavation of an Aksumite Town." *Antiquity* 93.372 (2019): 1534–52.

Hasan, Y. F. "Some Aspects of the Arab Slave Trade from the Sudan 7th–19th Century." *Sudan Notes and Records* 58 (1977): 85–106.

Hasluck, F. W., and H. H. Jewell. *The Church of Our Lady of the Hundred Gates (Panagia Hekatontapyliani) in Paros.* London, 1920.

Hatke, G. *Aksum and Nubia: Warfare, Commerce, and Political Fictions in Ancient Northeast Africa.* New York, 2013.

Heijer, J. den. "Considérations sur les communautés chrétiennes en Égypte fatimide: l'État et l'Église sous le vizirat de Badr al-Jamālī (1074–1094)." In *L'Égypte fatimide: Son art et son histoire,* edited by M. Barrucand, 569–78. Paris, 1999.

Heldman, M. E. "Architectural Symbolism, Sacred Geography and the Ethiopian Church." *Journal of Religion in Africa* 22.3 (1992): 222–41.

———. "Creating Religious Art: The Status of Artisans in Highland Christian Ethiopia." *Aethiopica* 1 (1998): 131–47.

———. "Creating Sacred Space: Orthodox Churches of the Ethiopian American Diaspora." *Diaspora: A Journal of Transnational Studies* 15.2–3 (2006): 285–302.

———. "Early Byzantine Sculptural Fragments from Adulis." In *Études éthiopennes: Actes de la Xe conférence internationale des études éthiopiennes, Paris, 24–28 août, 1988,* edited by C. Lepage, 239–52. Paris, 1994.

———. "An Ethiopian Miniature of the Head of St. Mark: Egyptian Influence at the Monastery of St. Stephen, Hayq." In *Ethiopian Studies: Dedicated to Wolf Leslau on the Occasion of His Seventy-Fifth Birthday. November 14th, 1981,* edited by S. Segert and A. J. E. Bodrogligeti, 554–68. Wiesbaden, 1983.

———. "Metropolitan Bishops as Agents of Artistic Interaction between Egypt and Ethiopia during the Thirteenth and Fourteenth Centuries." In *Interactions: Artistic Interchange between the Eastern and Western Worlds in the Medieval Period*, edited by C. Hourihane, 84–105. Index of Christian Art Occasional Papers 9. University Park, PA, 2007.

———. "St. Luke as Painter: Post-Byzantine Icons in Early-Sixteenth-Century Ethiopia." *Gesta* 44.2 (2005): 125–48.

Heldman, M. E., and G. Haile. "Who Is Who in Ethiopia's Past, Part III: Founders of Ethiopia's Solomonic Dynasty." *NEAS* 9.1 (1987): 1–11.

Henze, M. H. "Studies of Imported Textiles in Ethiopia." *JES* 40.1–2 (2007): 65–82.

———. "Unique Textiles of Tigray." *ITYOPIS, Northeast African Journal of Social Sciences and Humanities* Extra Issue II (2016): 137–47.

Higuchi, R., N. Shimizu, and H. Sugawara. "Some Topics towards a Better Understanding of Tigray's Cross-in-Square: A Wide-Ranging Comparison among Christian Cross-in-Square Churches." Paper presented at ICES20, Mekelle University, Mekelle, Ethiopia, 2 October 2018.

Hirsch, B., and F.-X. Fauvelle-Aymar. "Aksum après Aksum: Royauté, archéologie et herméneutique chrétienne de Ménélik II (r. 1865–1913) à Zärʾa Yaʿqob (r. 1434–1468)." *AÉ* 17 (2001): 59–109.

Hodgson, M. G. S. *The Venture of Islam*, vol. 1, *The Classical Age of Islam*. Chicago, 1974.

Holzer, S. M. "How to Build a (Brick) Barrel Vault." In *History of Construction Cultures: Proceedings of the 7th International Congress on Construction History (7ICCH 2021), July 12–16, 2021, Lisbon, Portugal*, edited by J. Mascarenhas-Mateus and A. P. Pires, 1:757–64. 2 vols. London, 2021.

Hummel, S. "The Disputed *Life* of the Saintly Ethiopian Kings ʾAbrəhā and ʾAṣbəḥa." *Scrinium* 16 (2016): 35–72.

Hutton, C. *The Tour of Africa: Containing a Concise Account of All the Countries [. . .] with the Manners and Customs of the Inhabitants*. 3 vols. London, 1819–21.

Ibrāhīm, L. ʿA. "The Transitional Zones of Domes in Cairene Architecture." *Kunst des Orients* 10.1/2 (1975): 5–23.

Immerzeel, M. "A Play of Light and Shadow: The Stuccoes of Dayr al-Suryan and Their Historical Context." In *Christianity and Monasticism in Wadi al-Natrun: Essays from the 2002 International Symposium of the Saint Mark Foundation and the Saint Shenouda the Archimandrite Coptic Society*, edited by M. S. A. Mikhail and M. Moussa, 246–71. Cairo, 2009.

Innemée, K. "The Church of the Holy Virgin in Deir Al-Surian: New Insights in Its Architecture." *BSAC*, forthcoming.

Insoll, T. *The Archaeology of Islam in Sub-Saharan Africa*. Cambridge, 2003.

Isenberg, C. W., and J. L. Krapf. *Journals of the Rev. Messrs. Isenberg and Krapf, Missionaries of the Church Missionary Society: Detailing Their Proceedings in the Kingdom of Shoa, and Journeys in Other Parts of Abyssinia, in the Years 1839, 1840, 1841, and 1842.* London, 1843.

Jacoby, D. "Venetian Commercial Expansion in the Eastern Mediterranean, 8th–11th Centuries." In *Byzantine Trade, 4th–12th Centuries: The Archaeology of Local, Regional and International Exchange. Papers of the Thirty-Eighth Spring Symposium of Byzantine Studies, St. John's College, University of Oxford, March 2004*, edited by M. M. Mango, 371–91. Farnham, UK, 2009.

Jäger, O. A., and I. Pearce. *Antiquities of North Ethiopia: A Guide*. 2nd ed. Stuttgart, 1974.

Jakobielski, S. *Pachoras: The Wall Painting from the Cathedrals of Aetios, Paulos and Petros*. Warsaw, 2017.

Jeudy, A. "Icônes et ciboria: Relation entre les ateliers coptes de peinture d'icônes et l'iconographie du mobilier liturgique en bois." *Eastern Christian Art* 1 (2004): 67–88.

———. "Le mobilier liturgique en bois au Moyen Âge: Interactions et identité de la communauté copte du Xᵉ au XIVᵉ siècle." PhD diss., Panthéon-Sorbonne University, 2006.

Jiwa, S. *Towards a Shiʾi Mediterranean Empire: Fatimid Egypt and the Founding of Cairo. The Reign of the Imam-Caliph al-Muʿizz from Taqī al-Dīn Aḥmad b. ʿAlī al-Maqrīzī's Ittiʿāẓ al-Ḥunafāʾ bi-akhbār al-aʾimma al-fāṭimiyyīn al-khulafāʾ*. New York, 2009.

Johnson, M. J. "Architecture of Empire." In *The Cambridge Companion to the Age of Constantine*, edited by N. Lenski, 278–97. New York, 2005.

Joseph, T. "Introduction générale aux églises monolithes du Tigrai." In *Proceedings of the Third International Conference of Ethiopian Studies, Addis Ababa 1966*, 1:83–98. 2 vols. Addis Ababa, 1969.

Josief, T. *Betigrie Teklay Gezat Yemigenyu Bewqer Yeteseru Abyate Kerstyanat*. Addis Ababa, 1970.

Juel-Jensen, B., and G. Rowell, eds. *Rock-Hewn Churches of Eastern Tigray: An Account of the Oxford University Expedition to Ethiopia, 1974*. Oxford, 1975.

Kalopissi-Verti, S. "The Proskynetaria of the Templon and Narthex: Form, Imagery, Spatial Connections, and Reception." In *Thresholds of the Sacred: Architectural, Art Historical, Liturgical, and Theological Perspectives on Religious Screens, East and West*, edited by S. E. J. Gerstel, 107–32. Washington, DC, 2006.

Kaplan, S. *The Monastic Holy Man and the Christianization of Early Solomonic Ethiopia*. Studien zur Kulturkunde 73. Wiesbaden, 1984.

———. "The Periodization of Ethiopian History: Reflections, Questions, and Some Modest Suggestions." *History in Africa*, forthcoming.

———. "Seeing Is Believing: The Power of Visual Culture in the Religious World of Aşe Zärʾa Yaʿeqob of Ethiopia (1434–1468)." *Journal of Religion in Africa* 32.4 (2002): 403–21.

Karydis, N. D. *Early Byzantine Vaulted Construction in Churches of the Western Coastal Plains and River Valleys of Asia Minor*. Oxford, 2011.

———. "Justinian's Church of the Holy Apostles: A New Reconstruction Proposal." In *The Holy Apostles: A Lost Monument, a Forgotten Project, and the Presentness of the Past*, edited by M. Mullett and R. G. Ousterhout, 99–130. Washington, DC, 2020.

———. "The Vaults of St. John the Theologian at Ephesos: Visualizing Justinian's Church." *JSAH* 71.4 (2012): 524–51.

Kauffmann, C. M. *Zur Ikonographie der Menas-Ampullen: Mit besonderer Berücksichtigung der Funde in der Menasstadt nebst einem einführenden Kapitel über die neuentdeckten nubischen und aethiopischen Menastexte*. Cairo, 1910.

Kebede, M. "Eurocentrism and Ethiopian Historiography: Deconstructing Semitization." *International Journal of Ethiopian Studies* 1.1 (2003): 1–19.

Keller, E. J. "Drought, War, and the Politics of Famine in Ethiopia and Eritrea." *Journal of Modern African Studies* 30.4 (1992): 609–24.

Kelly, S., ed. *A Companion to Medieval Ethiopia and Eritrea*. Leiden, 2020.

———. "Medieval Ethiopian Diasporas." In *A Companion to Medieval Ethiopia and Eritrea*, edited by S. Kelly, 424–52. Leiden, 2020.

Khan, M. B. "*Chirāgh-i Rōshan*: Prophetic Light in the Ismāʿīlī Tradition." *Islamic Studies* 52.3–4 (2013): 327–56.

Khater, A. "La translation des reliques de Saint Ménas à son église au Caire." *BSAC* 16 (1962): 161–81.

Kim, S. "New Studies of the Structure and the Texts of Abba Garima Ethiopian Gospels," *Afriques* 13 (2022), https://doi.org/10.4000/afriques.3494.

King, E. H. "Rock Tunnels." In *Tunnel Engineering Handbook*, edited by J. O. Bickel, T. R. Kuesel, and E. H. King, 122–52. 2nd ed. New York, 1996.

King, G. R. D. "The Paintings of the Pre-Islamic Kaʿba." *Muqarnas* 21 (2004): 219–29.

Kinney, D. "Rome in the Twelfth Century: *Urbs fracta* and *renovatio*." *Gesta* 45.2 (2006): 199–220.

Klein, H. A. "Refashioning Byzantium in Venice, ca. 1200–1400." In *San Marco, Byzantium, and the Myths of Venice*, edited by H. Maguire and R. S. Nelson, 193–226. Washington, DC, 2010.

Klyuev, S. "The Rock-Hewn Churches of the Garalta Monasteries (Tigray, Ethiopia): The Comparative Analysis of Three Monuments of the Second Half of the 13th to the First Half of the 15th Centuries." In *Proceedings of the 2019 International Conference on Architecture: Heritage, Traditions and Innovations*, edited by I. Rumbal, Y. Zhang, and R. Green, 117–22. Advances in Social Science, Education and Humanities Research 324. Paris, 2019.

Kobishchanov, I. M. *Axum*, translated by J. W. Michels. University Park, PA, 1979.

Kotzabassi, S., ed. *The Pantokrator Monastery in Constantinople*. ByzArch 27. Berlin, 2013.

Krautheimer, R. "A Note on Justinian's Church of the Holy Apostles in Constantinople." In *Mélanges Eugène Tisserant*, 2:265–70. 7 vols. Vatican City, 1964.

———. *Early Christian and Byzantine Architecture*. New Haven, 1992.

Krebs, V. *Medieval Ethiopian Kingship, Craft, and Diplomacy with Latin Europe*. Cham, Switzerland, 2021.

Krencker, D., ed. *Deutsche Aksum-Expedition*, vol. 2, *Ältere Denkmäler nordabessiniens*. Berlin, 1913.

Kropp, M. "La corne orientale de l'Afrique chez les géographes arabes." *Bulletin des études africaines* 17–18 (1992): 161–97.

Kühnel, E. *Catalogue of Dated Tiraz Fabrics: Umayyad, Abbasid, Fatimid*. Washington, DC, 1952.

Labib, S. "Cyril II." In *The Coptic Encyclopedia*, edited by A. S. Atiya, 2:675–77. 8 vols. New York, 1991.

Lagopoulos, A. P., and M.-G. L. Stylianoudi. "The Symbolism of Space in Ethiopia." *Aethiopica* 4 (2001): 55–95.

Lambourn, E. A. *Abraham's Luggage: A Social Life of Things in the Indian Ocean World*. Cambridge, 2018.

Lamm, C. J. "Fatimid Woodwork, Its Style and Chronology." *BIE* 18 (1935): 59–91.

Landes, R. "The White Mantle of Churches: Millennial Dynamics and the Written and Architectural Record." In *The White Mantle of Churches: Architecture, Liturgy, and Art around the Millennium*, edited by N. Hiscock, 249–64. International Medieval Research 10. Turnhout, 2003.

Lane, P. "Possibilities for a Postcolonial Archaeology in Sub-Saharan Africa: Indigenous and Usable Pasts." *World Archaeology* 43.1 (2011): 7–25.

Leal, B. "The Abbasid Mosaic Tradition and the Great Mosque of Damascus." *Muqarnas* 37 (2020): 29–62.

J. Leclant, and A. Miquel. "Reconnaissances dans l'Agamé: Goulo-Makeda et Sabéa (octobre 1955 et avril 1956)." *AÉ* 3 (1959): 107–29.

Lee, A. J. "Islamic Star Patterns." *Muqarnas* 4 (1987): 182–97.

Lefebvre, T. *Voyage en Abyssinie exécuté pendant les années 1839, 1840, 1841, 1842, 1843*. 6 vols. Paris, 1845–51.

Leidwanger, J. "New Investigations of the 6th-C. A.D. 'Church Wreck' at Marzamemi, Sicily." *JRA* 31 (2018): 339–56.

Leidwanger, J, E. S. Greene, and A. Donnelly. "The Sixth-Century CE Shipwreck at Marzamemi." *AJA* 125.2 (2021): 283–317.

Leisten, T. *Architektur für Tote: Bestattung in architektonischem Kontext in den Kernländern der islamischen*

Welt zwischen 3./9. und 6./12. Jahrhundert. Materialien zur iranischen Archäologie 4. Berlin, 1998.

Lepage, C. "Bilan des recherches sur l'art médiéval d'Éthiopie: Quelques résultats historiques." In *Proceedings of the Eighth International Conference of Ethiopian Studies, University of Addis Ababa, 1984,* edited by T. Beyene, 2:47–55. 2 vols. Addis Ababa, 1988–89.

———. "Contribution de l'ancien art chrétien d'Éthiopie à la connaissance des autres arts chrétiens." *CRAI* 134.4 (1990): 799–822.

———. "Dieu et les quatre animaux célestes dans l'ancienne peinture éthiopienne." *Documents pour servir à l'histoire des civilisations éthiopiennes* 7 (1976): 67–112.

———. "L'église de Zaréma (Éthiopie) découverte en mai 1973 et son apport à l'histoire de l'architecture éthiopienne." *CRAI* 117.3 (1973): 416–54.

———. "L'église rupestre de Berakit." *AÉ* 9 (1972): 147–91.

———. "L'église semi monolithique de Abrehä Asbehä: Monument clef de l'histoire de l'architecture éthiopienne." In *I molti volti dell'arte etiopica: Atti del IV Convegno internazionale di storia dell'arte etiopica, 24–27 settembre 1996, Trieste,* edited by A. L. Palmisano, S. Chojnacki, and A. Baghai, 145–63. Bologna, 2010.

———. "Entre Aksum et Lalibela: Les églises du sud-est du Tigray (IX^e–XII^e s.) en Éthiopie." *CRAI* 150.1 (2006): 9–39.

———. "Histoire de l'ancienne peinture éthiopienne (X^e–XV^e siècle): Résultats des missions de 1971 à 1977." *CRAI* 121.2 (1977): 325–76.

———. "Les monuments chrétiens rupestres de Degum en Éthiopie (rapport préliminaire)." *CahArch* 22 (1972): 167–200.

———. "Les monuments rupestres de Degum et les églises de vallée." *Documents pour servir à l'histoire des civilisations éthiopiennes* 2 (1971): 61–72.

———. "L'ornementation végétale fantastique et le pseudo-réalisme dans la peinture byzantine." *CahArch* 19 (1969): 191–211.

———. "Une origine possible des églises monolithiques de l'Éthiopie ancienne." *Comptes rendus des séances de l'Académie des Inscriptions et Belles-Lettres* 141.1 (1997): 199–212.

———. "Les ornements peints de l'église de Visoko Decani: Description et analyse des motifs recherches sur l'histoire et l'origine des ornements." PhD diss., University of Nancy, 1967.

———. "Les peintures murales de l'église *Betä Maryam* à Lalibäla, Éthiopie (rapport préliminaire)." *CRAI* 143.3 (1999): 901–67.

———. "Le premier art chrétien d'Ethiopie." *Les dossiers de l'archéologie* 8 (1975): 34–79.

———. "Première iconographie chrétienne de Palestine: Controverses anciennes et perspectives à la lumière des liturgies et monuments éthiopiens." *CRAI* 141.3 (1997): 739–82.

———. "Premières recherches sur les installations liturgiques des anciennes églises d'Éthiopie (X^e–XV^e siècles)." *CNRS Travaux de la RCP* 230 (1972): 77–114.

———. "Un métropolite égyptien bâtisseur à Lalibäla (Éthiopie) entre 1205 et 1210." *CRAI* 146.1 (2002): 141–74.

Lepage, C., and J. Mercier. *Les églises historiques du Tigray: Art éthiopien / The Ancient Churches of Tigrai: Ethiopian Art,* translated by S. Williams and C. Wiener. Paris, 2005.

———. "Évolution de l'architecture des églises éthiopiennes du XII^e au milieu du XV^e siècle." *AÉ* 22 (2006): 9–43.

———. *Lalibela: Capitale de l'art monolithe d'Ethiopie.* Paris, 2013.

Leslau, W. *Comparative Dictionary of Ge'ez.* Wiesbaden, 1987.

Lev, Y. "Tinnis: An Industrial Medieval Town." In *L'Égypte fatimide: Son art et son histoire. Actes du colloque organisé à Paris les 28, 29 et 30 mai 1998,* edited by M. Barrucand, 83–96. Paris, 1999.

Levin, A. "Haile Selassie's Imperial Modernity: Expatriate Architects and the Shaping of Addis Ababa." *JSAH* 75.4 (2016): 447–68.

Lewis, H. S. "Anthropology In Ethiopia, 1950s–2016: A Participant's View." In *Seeking Out Wise Old Men: Six Decades of Ethiopian Studies at the Frobenius Institute Revisited,* edited by S. Dinslage and S. Thubauville, 27–46. Studien zur Kulturkunde 131. Berlin, 2017.

Libanos, T. B. "Däbrä Damo." In *EAe,* edited by S. Uhlig, 2:17–20. Wiesbaden, 2005.

Lindahl, B. *Architectural History of Ethiopia in Pictures.* Addis Ababa, 1970.

Littmann, E., et al. *Deutsche Aksum-Expedition.* 4 vols. Berlin, 1913.

Liu, X. *The Silk Road in World History.* New York, 2010.

Lockhart, D. M., trans. *The ltinerário of Jerónimo Lobo.* London, 1984.

Loiseau, J. "The Ḥaṭī and the Sultan: Letters and Embassies from Abyssinia to the Mamluk Court." In *Mamluk Cairo, a Crossroads for Embassies: Studies on Diplomacy and Diplomatics,* edited by F. Bauden and M. Dekkiche, 638–57. Leiden, 2019.

———. "Retour à Bilet: Un cimetière musulman médiéval du Tigray oriental (*Inscriptiones Arabicae Aethiopiae* 1)." *BEO* 67 (2020): 59–96.

Loiseau, J., S. Dorso, Y. Gleize, D. Ollivier, D. Ayenachew, H. Berhe, A. Chekroun, and B. Hirsch. "Bilet and the Wider World: New Insights into the Archaeology of Islam in Tigray." *Antiquity* 95 (2021): 508–29.

von Lüpke, T. *Deutsche Aksum-Expedition,* vol. 3, *Profan- und Kultbauten Nordabessiniens aus älterer und neuerer Zeit.* Berlin, 1913.

Lusini, G. "Abrəham of Däbrä Ṣəyon." In *EAe* 1:48.

———. "The Ancient and Medieval History of Eritrean and Ethiopian Monasticism: An Outline." In *A Companion to Medieval Ethiopia and Eritrea,* edited by S. Kelly, 194–216. Leiden, 2020.

———. "Christians and Moslems in Eastern Tigray up to the XIV C." *Studi maghrebini* 25 (1993–1997): 245–52.

———. "Däbrä Bizan." In *EAe* 2:15–17.

Lyster, W. "Artistic Working Practice and the Second-Phase Ornamental Program." In *The Red Monastery Church: Beauty and Asceticism in Upper Egypt*, edited by E. S. Bolman, 97–118. New Haven, 2016.

———. "Preliminary Catalog of Designs and Motifs in the Red Monastery Church Sohag, Egypt." 3rd ed. unpubl., Egyptian Antiquities Conservation Project American Research Center in Egypt, [2010].

Mackie, G. "Abstract and Vegetal Design in the San Zeno Chapel, Rome: The Ornamental Setting of an Early Medieval Funerary Programme." *Papers of the BSR* 63 (1995): 159–82.

Mackie, L. W. *Symbols of Power: Luxury Textiles from Islamic Lands, 7th–21st Century*. Cleveland, 2015.

Macrides, R., and P. Magdalino. "The Fourth Kingdom and the Rhetoric of Hellenism." In *The Perception of the Past in Twelfth-Century Europe*, edited by P. Magdalino, 117–56. London, 1992.

Maguire, E. D. "Curtains at the Threshold: How They Hung and How They Performed." *DOP* 73 (2019): 217–44.

Maguire, H. "Epigrams, Art, and the "Macedonian Renaissance." *DOP* 48 (1994): 105–15.

Mainstone, R. J. *Hagia Sophia: Architecture, Structure, and Liturgy of Justinian's Great Church*. New York, 1988.

Mallette, K. *European Modernity and the Arab Mediterranean: Toward a New Philology and a Counter-Orientalism*. Philadelphia, 2010.

Mango, C. "Approaches to Byzantine Architecture." *Muqarnas* 8 (1991): 40–44.

Manzo, A. Review of David W. Phillipson, *Ancient Churches of Ethiopia*. *RSE* 4 (2012): 275–83.

al-Maqrīzī, A. b. ʿAlī. *Ittiʿāz al-hunafāʾ bi-akhbār al-aʾimma al-fāṭimiyyīn al-khulafāʾ*, edited by J. al-Shayyāl and M. Ḥ. M. Aḥmad. 3 vols. Cairo, 1971.

Maranci, C. "Locating Armenia." *Medieval Encounters* 17 (2011): 147–66.

———. *Vigilant Powers: Three Churches of Early Medieval Armenia*. Turnhout, 2015.

Margariti, R. E. *Aden and the Indian Ocean Trade: 150 Years in the Life of a Medieval Arabian Port*. Chapel Hill, 2007.

———. "An Ocean of Islands: Islands, Insularity, and Historiography of the Indian Ocean." In *The Sea: Thalassography and Historiography*, edited by P. N. Miller, 198–229. Ann Arbor, 2013.

———. "Thieves or Sultans? Dahlak and the Rulers and Merchants of Indian Ocean Port Cities, 11th–13th Centuries AD." In *Connected Hinterlands: Proceedings of Red Sea Project IV Held at the University of Southampton, September 2008*, edited by L. Blue, J. Cooper, R. Thomas, and J. Whitewright, 155–63. BAR International Series 2052. Oxford, 2009.

Marinis, V. *Architecture and Ritual in the Churches of Constantinople: Ninth to Fifteenth Centuries*. New York, 2013.

Marrassini, P. "Il *Gadla Abreha waAṣbeḥa*: Indicazioni preliminari." *Warszawskie Studia Teologiczne* 12.2 (1999): 159–79.

———. "Some Considerations on the Problem of the 'Syriac Influences' on Aksumite Ethiopia." *JES* 23 (1990): 35–46.

Martinez, F. J. "The King of Rūm and the King of Ethiopia in Medieval Apocalyptic Texts from Egypt." In *Coptic Studies: Acts of the Third International Congress of Coptic Studies*, edited by W. Godlewski, 247–59. Warsaw, 1990.

Massa, S. "La prima chiesa di Adulis: Le origini della cristianità nel Corno d'Africa alla luce delle testimonianze archeologiche." *RACr* 93 (2017): 411–55.

Mathews, T. F. "An Early Roman Chancel Arrangement and Its liturgical Functions." *RACr* 38 (1962): 73–95.

Matthews, D. H. "The Restoration of the Monastery Church of Debra Damo, Ethiopia." *Antiquity* 23.92 (1949): 188–200.

Matthews, D., and A. Mordini. "The Monastery of Debra Damo, Ethiopia." *Archaeologia* 97 (1959): 1–58.

Maugini, A. "Africa Orientale Italiana Vol. X Taclai Amanot–Adigrat–Asmara–Gondar– Bahardar." 1936.13/15. Archivio Istituto Agricolo Coloniale Italiano, Florence, Italy.

McCrindle, J. M., trans. *The Christian Topography of Cosmas Indicopleustes*. Repr. New York, 2010.

McKenzie, J. S., and F. Watson. *The Garima Gospels: Early Illuminated Gospel Books from Ethiopia*. Oxford, 2016.

McMichael, A. L. "Rising above the Faithful: Monumental Ceiling Crosses in Byzantine Cappadocia." PhD diss., CUNY Graduate Center, 2018.

McNally, S. "Transformations of Ecclesiastical Space: Churches in the Area of Akhmīm." *BASP* 35.1–2 (1998): 79–95.

Megaw, A. H. S. "Notes on Recent Work of the Byzantine Institute in Istanbul." *DOP* 17 (1963): 333–71.

Meinardus, O. F. A. "Ecclesiastica Aethiopica in Aegypto." *JES* 3.1 (1965): 23–35.

———. "Ethiopian Monks in Egypt." In *EAe* 2:243–45.

Mercier, J. *Art of Ethiopia: From the Origins to the Golden Century*. Paris, 2021.

———. "Les deux types d'édicules associés aux Canons d'Eusèbe: Apport des Évangiles d'Abba Gärima (c. 450–650) à leur histoire et leurs symboliques byzantines et latines." *CahArch* 58 (2021): 29–54.

Mercier, J., and C. Lepage. *Lalibela, Wonder of Ethiopia: The Monolithic Churches and Their Treasures*. London, 2012.

———. "Une église lalibelienne: Zoz Amba." *AÉ* 18 (2002): 149–54.

Mihálykó, Á. T., and R. Mikhail. "A Prayer for the Preparation of the Priest and the First Prayer of the Morning in Sahidic Coptic (P.Ilves Copt. 8)." *OCP* 87.2 (2021): 353–70.

Mikhail, R. "Prostrating, Processing, and Burying: The Human Body and Its Participation in the Coptic Tradition for Great Friday." In *Le corps humain dans la liturgie: 65e Semaine d'études liturgiques, Paris, Institut Saint-Serge, 2–5 juillet 2018*, edited by A. Lossky, G. Sekulovski, and T. Pott, 179–91. Münster, 2019.

———. *The Presentation of the Lamb: The Prothesis and Preparatory Rites of the Coptic Liturgy*. Studies in Eastern Christian Liturgies 2. Münster, 2020.

Milas, S. *Sharing the Nile: Egypt, Ethiopia and the Geo-Politics of Water*. London, 2013.

Minart, M.-A. "Étude d'un vantail de la fin du premier millénaire conservé au musée du Louvre, Monastère de Baouît, Moyenne Égypte." *BIFAO* 116 (2016): 229–72.

———. "Étude d'une cloison d'église de la fin du premier millénaire conservée au musée du Louvre. Monastère de Baouît, Moyenne Égypte." *BIFAO* 116 (2016): 191–227.

Monti della Corte, A. A. *I castelli di Gondar*. Rome, 1938.

———. *Lalibelà, le chiese ipogee e monolitiche e gli altri monumenti medievali del Lasta*. Rome, 1940.

Mordini, A. "L'architecture religieuse chrétienne dans l'Éthiopie du Moyen Age: Un programme de recherches." *Cahiers d'études africaines* 2.5 (1961): 166–71.

———. "Gli aurei Kushāna del convento di Dabro Dāmmo: Un'idizio sui rapporti commerciali fra l'India e l'Etiopia nei primi secoli dell'era volgare." In *Atti del Convegno internazionale di studi Etiopici, Roma 2–4 aprile 1959*, 249–54. Problemi Attuali di Scienza e di Cultura, Quaderno 48. Rome, 1960.

———. "Gold Kushāna Coins in the Convent of Dabra Dammo." *Journal of the Numismatic Society of India* 29.2 (1967): 19–25.

———. "Il convento di Gunde Gundiè." *RSE* 12 (1953): 29–70.

———. "Il soffitto del secondo vestibolo dell'Endā Abuna Aragāwi in Dabra Dāmmó," *RSE* 6.1 (1947): 29–35.

———. "I tessili medioevali del convento di Dabra Dāmo." In *Atti del Convegno internazionale di studi Etiopici (Roma 2–4 aprile 1959)*, 229–48. Problemi Attuali di Scienza e di Cultura, Quaderno 48. Rome, 1960.

———. "Informazioni preliminari sui risultati delle mie ricerche in Etiopia dal 1939 al 1944." *RSE* 4 (1944): 145–54.

———. "La chiesa di Aramò (con considerazioni sulla datazione dei monumenti dell'arte religiosa Etiopica)." *RSE* 15 (1959): 39–54.

———. "La chiesa ipogea di Ucro (Amba Seneiti) nel Tigrai." *Gli Annali dell'Africa Italiana* 2.2 (1939): 519–26.

———. "Letters to Carlo Conti Rossini from Asmara." 14 April, 18 April, and 10 May 1940. Carlo Conti Rossini Archivio (Busta 10), Accademia dei Lincei, Rome.

———. "Stato attuale delle ricerche etnografiche (cultura materiale) nell'A.O.I." In *Atti del terzo Congresso di studi coloniali, Firenze–Roma, 12–17 aprile 1937–XV*, vol. 6, *V. sezione: Etnografica-filologica-sociologica*, 149–59. Centro di studi coloniali, Istituto coloniale fascista. 9 vols. Florence, 1937.

———. "Tre Tiraz abbasidi provenienti dal convento di Dabro Dammò." *Il Bollettino dell'Istituto di studi etiopici* 2 (1957): 33–38.

———. "Un tissu musulman du Moyen Âge provenant du couvent de Dabra Dāmmò." *AnnEth* 2.1 (1957): 75–79.

———. "Uno sconosciuto capolavoro dell'arte etiopica: Il soffitto di Dabra Dammò." *Antichità viva: Rassegna d'Arte* 1.8 (1962): 29–35.

Mubangizi, O. "Dr. Abiy Ahmed's Ethiopia: Anatomy of an African Enigmatic Polity." *Pambazuka News*, 15 May 2018. https://www.pambazuka.org/node/99007.

Muehlbauer, M. "An African 'Constantine' in the Twelfth Century: The Architecture of the Early Zagwe Dynasty and Egyptian Episcopal Authority." *Gesta* 62.2 (forthcoming, 2023).

———. "Architectural Hybridity at the Lalibela Church Complex." In *Proceedings of the 18th Annual Marco Institute Symposium*. Turnhout, Forthcoming.

———. "'Bastions of the Cross': Medieval Rock-Cut Cruciform Churches of Tigray, Ethiopia." PhD diss., Columbia University, 2020.

———. "Church of Saint George at Lalibela." In *World Architecture and Society: From Stonehenge to One World Trade Center*, edited by P. L. Bonfitto, 2:377–82. 2 vols. Santa Barbara, CA, 2022.

———. "The Disappearance of the Ethiopian Baptismal Font." In *Baptême et baptistères: Regards croisés sur l'initiation chrétienne entre antiquité tardive et Moyen Âge. Actes du colloque international d'études, Sorbonne Université, Paris, 12–13 novembre 2020*, edited by B. Caseau, V. Michel, and L. Orlandi, 92–107. Biblioteca di Archeologia e Storia dell'Arte 1. Milan, 2023.

———. "From Stone to Dust: The Life of the Kufic Inscribed Frieze of Wuqro Cherqos in Tigray, Ethiopia." *Muqarnas* 38 (2021): 1–34.

———. "An Italian Renaissance Face on a 'New Eritrea': The 1939 Restoration of the Church of Abreha wa-Atsbeha." *JSAH* 78.3 (2019): 312–26.

———. "A Rock-Hewn Yəmrəḥannä Krəstos? An Investigation into Possible 'Northern' Zagʷe Churches near ʿAddigrat, Təgray." *Aethiopica* 23 (2020): 31–56.

———. "Problems in Justinianic Architecture: The Sixth-Century Gallery Arcades of the Panagia Ekatontapiliani in Paros." Forthcoming.

Munro-Hay, S. C. "Abreha and Asbaha." In *Eae* 1:45–46.

———. *Aksum: An African Civilization of Late Antiquity*. Edinburgh, 1991.

———. "The British Museum Excavations at Adulis, 1868." *Antiquaries Journal* 69 (1989): 43–52.

———. "The 'Coronation' of the Ethiopian Emperors at Aksum." In *Studia Aethiopica: In Honour of Siegbert Uhlig on the Occasion of His 65th Birthday*, edited by V. Böll et al., 177–201. Wiesbaden, 2004.

———. *Ethiopia and Alexandria: The Metropolitan Episcopacy of Ethiopia*. Vol. 1. Bibliotheca Nubica et Aethiopica 5. Warsaw, 1997.

———. "The Foreign Trade of the Aksumite Port of Adulis." *Azania: Archaeological Research in Africa* 17.1 (1982): 107–25.

———. "Horse-Shoe Arches in Ancient Ethiopia." *RSE* 33 (1989): 157–61.

———. "Saintly Shadows." In *Afrikas Horn: Akten der Ersten Internationalen Littmann-Konferenz*, edited by W. Raunig and S. Wenig, 137–68. Meroitica 22. Wiesbaden, 2005.

Murray, S. *Plotting Gothic*. Chicago, 2015.

Museo archeologico di Asmara: Itinerario descrittivo, ed. L. Ricci. Collana di studi africani 7. Rome: [Istituto italo-africano], 1983.

Muth, F.-C. "A Globe-trotter from Maghrib in al-Maqrīzī's Booklet on Ethiopia: A Footnote from Some Arabic Sources." *Afrique et histoire* 4 (2005): 123–31.

Muthesius, A. M. *Byzantine Silk Weaving: AD 400 to AD 1200*, ed. E. Kislinger and J. Koder. Vienna, 1997.

———. "Silk, Power and Diplomacy in Byzantium." In *Textiles in Daily Life: Proceedings of the Third Biennial Symposium of the Textile Society of America, September 24–26, 1992*, 99–110. Columbia, PA, 1992. https://digitalcommons.unl.edu/cgi/viewcontent.cgi?article=1579&context=tsaconf.

Necipoğlu, G. *The Topkapı Scroll: Geometry and Ornament in Islamic Architecture*. Santa Monica, CA, 1995.

Nees, L. "The Iconographic Program of Decorated Chancel Barriers in the Pre-Iconoclastic Period." *ZKuntsg* 46.1 (1983): 15–26.

Nosnitsin, D. "Tǝgre Mäkwännǝn." In *EAe* 4:900–902.

Nünnerich-Asmus, A. *Basilika und Portikus: Die Architektur der Säulenhallen als Ausdruck gewandelter Urbanität in später Republik und früher Kaiserzeit*. Arbeiten zur Archäologie 13. Cologne, 1994.

Oba-Smidt, C. *The Oral Chronicle of the Boorana in Southern Ethiopia: Modes of Construction and Preservation of History among People without Writing*. Translated by R. Prior and J. Watt. Northeast African History, Orality and Heritage 4. Zurich, 2016.

Obłuski, A. *The Monasteries and Monks of Nubia*, translated by D. Dzierzbicka. Journal of Juristic Papyrology Supplement 36. Warsaw, 2019.

al-ʿOmarī, Ibn Fadl Allah. *Masālik el absar fi mamālik el amsar*, vol. 1, *L'Afrique, moins l'Égypte*. Translated by [M.] Gaudefroy-Demombynes. Paris, 1927.

Osborne, J. "Textiles and Their Painted Imitations in Early Medieval Rome." *Papers of the BSR* 60 (1992): 309–51.

Ousterhout, R. G. "An Apologia for Byzantine Architecture." *Gesta* 35.1 (1996): 21–33.

———. "The Byzantine Church at Enez: Problems in Twelfth-Century Architecture." *JÖB* 35 (1985): 261–80.

———. *Eastern Medieval Architecture: The Building Traditions of Byzantium and Neighboring Lands*. Onassis Series in Hellenic Culture. New York, 2019.

———. "The Holy Space: Architecture and the Liturgy." In *Heaven on Earth: Art and the Church in Byzantium*, edited by L. Safran, 81–120. University Park, PA, 1998.

———. *Master Builders of Byzantium*. Princeton, 1999.

———. "Originality in Byzantine Architecture: The Case of Nea Moni." *JSAH* 51.1 (1992): 48–60.

———. "Sightlines, Hagioscopes, and Church Planning in Byzantine Cappadocia." *AH* 39.5 (2016): 848–67.

———. *Visualizing Community: Art, Material Culture, and Settlement in Byzantine Cappadocia*. DOS 46. Washington, DC, 2017.

Pakenham, T. *The Mountains of Rasselas: An Ethiopian Adventure*. New York, 1959.

Pankhurst, R. "A Preliminary History of Ethiopian Measures, Weights, and Values (Part 1)." *JES* 7.1 (1969): 31–54.

———. "Caves in Ethiopian History, with a Survey of Cave Sites in the Environs of Addis Ababa." *EO* 16 (1973): 15–34.

Papacostas, T. "The Medieval Progeny of the Holy Apostles: Trails of Architectural Imitation across the Mediterranean." In *The Byzantine World*, edited by P. Stephenson, 386–405. New York, 2010.

Parani, M. G. *Reconstructing the Reality of Images: Byzantine Material Culture and Religious Iconography (11th–15th Centuries)*. The Medieval Mediterranean 41. Leiden, 2003.

Parpulov, G. R., I. V. Dolgikh, and P. Cowe. "A Byzantine Text on the Technique of Icon Painting." *DOP* 64 (2010): 201–16.

Partini, R. "Architetture autoctone nell'Africa Orientale Italiana: La chiese monolitiche di Lalibelà." *Architettura* 17.5 (1938): 261–70.

Patel, A. *Iran to India: The Shansabānīs of Afghanistan, c. 1145–1190 CE* Edinburgh, 2021.

Pauty, E. *Catalogue général du Musée arabe du Caire: Les bois sculptés jusqu'à l'époque ayyoubide*. Cairo, 1931.

Peacock, A. C. S. *The Great Seljuk Empire*. Edinburgh History of the Islamic Empires. Edinburgh, 2015.

Peacock, D. "Stone Artefacts from the Survey." In *The Ancient Red Sea Port of Adulis, Eritrea: Results of the Eritro-British Expedition, 2004–5*, edited by D. Peacock and L. Blue, 109–24. Oxford, 2007.

Peacock, D, and L. Blue, eds. *Myos Hormos–Quseir al-Qadim: Roman and Islamic Ports on the Red Sea*. 2 vols. Oxford, 2006–11.

Pearce, I. "Pearce's Pilgrimage to the Rock-Hewn Churches of Tigre." *EO* 11.2 (1968): 77–120.

Pearce, N. *The Life and Adventures of Nathaniel Pearce, Written by Himself, during a Residence in Abyssinia*

from the Years 1810–1819, Together with Mr Coffin's Account of His First Visit to Gondar, ed. J. J. Halls. 2 vols. London, 1831.

Pedersen, R. K. "The Byzantine-Aksumite Period Shipwreck at Black Assarca Island, Eritrea." *Azania: Archaeological Research in Africa* 43.1 (2008): 77–94.

Perruchon, J. "Notes pour l'histoire d'Éthiopie: Lettre adressée par le roi d'Ethiopie au roi Georges de Nubie sous le patriarcat de Philotée (981–1002 ou 1003)." *Revue sémitique d'épigraphie et d'histoire ancienne* 1 (1893): 71–79, 359–72.

Peschlow, U. *Die Irenenkirche in Istanbul: Untersuchungen zur Architektur.* Istanbuler Mitteilungen 18. Tübingen, 1977.

Pfister, R. *Les toiles imprimées de Fostat et l'Hindoustan.* Paris, 1938.

Phillipp, T. "Ambager Complex (Dagmawi Lalibela)." Database. New Rock-Hewn Churches of Ethiopia, 2020. https://www.utsc.utoronto.ca/projects /ethiopic-churches/ambager-complex-dagmawi -lalibela/.

———. "Documenting Transformative Structures." Paper presented at ICES20, Mekelle University, Mekelle, Ethiopia, 4 October 2018.

———. "Maryam Korkor (Gärʿalta Region)." Database. New Rock-Hewn Churches of Ethiopia, 2020. https://www.utsc.utoronto.ca/projects/ ethiopic-churches/maryam-korkor/.

———. "Medhane Alem Warq Amba (Tämben Region)." Database. New Rock-Hewn Churches of Ethiopia, 2020. https://www.utsc.utoronto.ca/projects/ ethiopic-churches/medhane-alem-warq/.

Phillipson, D. W. "Aksum: An African Civilisation in Its World Contexts," *Proceedings of the British Academy* 111 (2001): 23–59.

———. "The Aksumite Roots of Medieval Ethiopia." *Azania: Archaeological Research in Africa* 39.1 (2004): 77–89.

———. *Ancient Churches of Ethiopia: Fourth–Fourteenth Centuries.* New Haven, 2009.

———. *Archaeology at Aksum, Ethiopia, 1993–7.* 2 vols. London, 2000.

———. "Changing Settlement Patterns in Northern Ethiopia: An Archaeological Survey Evaluated." *Azania: Archaeological Research in Africa* 43 (2008): 133–45.

———. *Foundations of an African Civilisation: Aksum and the Northern Horn, 1000 BC–AD 1300.* Woodbridge, UK, 2012.

———, ed. *The Monuments of Aksum: An Illustrated Account.* Addis Ababa, 1997.

Pincus, D. "Venice and the Two Romes: Byzantium and Rome as a Double Heritage in Venetian Cultural Politics." *Artibus et Historiae* 13.26 (1992): 101–14.

Piovanelli, P. "Reconstructing the Social and Cultural History of the Aksumite Kingdom: Some Methodological Reflections." In *Inside and Out: Interactions between Rome and the Peoples on the Arabian and Egyptian Frontiers in Late Antiquity*, edited by J. H. F. Dijkstra and G. Fisher, 331–52. Leuven, 2014.

Pisani, V. "*Passio* of St. Cyricus (*Gädlä Qirqos*)* in North Ethiopia Elements of Devotion and of Manuscripts Tradition." In *Veneration of Saints in Christian Ethiopia: Proceedings of the International Workshop Saints in Christian Ethiopia: Literary Sources and Veneration, Hamburg, 28–29, 2012*, edited by D. Nosnitsin, 161–99. Supplement to *Aethiopica* 3. Wiesbaden, 2015.

Plant, R. *Architecture of the Tigre, Ethiopia.* Worcester, UK, 1985.

———. "Notes on 17 Newly-Discovered Rock-Hewn Churches of Tigre." *EO* 16.1 (1973): 36–53.

———. "Rock-Hewn Churches of the Tigre Province (with Additional Churches by David Buxton)." *EO* 13.3 (1970): 157–268.

Playne, B. "Notices brèves: Suggestions on the Origin of the 'False Doors' of the Axumite Stelae." *AÉ* 6 (1965): 279–80.

———. *St. George for Ethiopia.* London, 1954.

Poissonnier, B. "The Giant Stelae of Aksum in the Light of the 1999 Excavations." *P@lethnology* 4 (2012): 49–86.

Popper, W. *The Cairo Nilometer: Studies in Ibn Taghrî Birdî's Chronicles of Egypt.* Berkeley, 1951.

Pradines, S. "Identity and Architecture: The Fāṭimid Walls in Cairo." In *Earthen Architecture in Muslim Cultures: Historical and Anthropological Perspectives*, edited by S. Pradines, 104–45. Arts and Archaeology of the Islamic World 10. Leiden, 2018.

Prinzing, G. "Entstehung und Rezeption der Justiniana-Prima-Theorie im Mittelalter." *BBulg* 5 (1978): 269–87.

Procopiou, E. "L'architecture chrétienne dans la région d'Amathonte à l'époque byzantine (IVᵉ–XIIᵉ siècles). Recherches archéologiques 1991–2012," translated by P. Xydas, 253–74. *Cahiers du Centre d'études Chypriotes* 43 (2013).

———. "New Evidence for the Early Byzantine Ecclesiastical Architecture of Cyprus." In *Church Building in Cyprus (Fourth to Seventh Centuries): A Mirror of Intercultural Contacts in the Eastern Mediterranean*, edited by M. Horster, D. Nicolaou, and S. Rogge, 73–98. Schriften des Instituts für interdisziplinäre Zypern-Studien 12. Münster, 2018.

Prokopios. *The Wars of Justinian.* Translated by H. B. Dewing, revised by A. Kaldellis. Indianapolis, 2014.

Puech, É. "Une inscription éthiopienne ancienne au Sinaï (Wadi Hajjaj)." *RB* 87.4 (1980): 597–601.

Rabasa-Díaz, E., A. González-Uriel, I.-J. Gil-Crespo, and A. Sanjurjo Álvarez. "Geographic and Chronological Extent of Brick Vaults by Slices." In *History of Construction Cultures: Proceedings of the 7th International Congress on Construction History (7ICCH 2021), July 12–16, 2021, Lisbon, Portugal*, vol. 1, edited by J. Mascarenhas-Mateus and A. P. Pires, 126–33. London, 2021.

Raby, J. "In Vitro Veritas: Glass Pilgrim Vessels from 7th–Century Jerusalem." In *Bayt al-Maqdis*, vol. 2, *Jerusalem and Early Islam*, edited by J. Johns, 113–90. 2 vols. Oxford, 1992.

Rāġib, Y. "Un oratoire fatimide au sommet du Muqaṭṭam." *Studia Islamica* 65 (1987): 51–67.

Redford, S. "The Seljuqs of Rum and the Antique." *Muqarnas* 10 (1993): 148–56.

———. "The Water of Life, the Vanity of Mortal Existence and a Penalty of 2,500 Denarii: Thoughts on the Reuse of Classical and Byzantine Remains in Seljuk Cities." In *Cities as Palimpsests? Responses to Antiquity in Eastern Mediterranean Urbanism*, edited by E. K. Fowden, S. Çağaptay, E. Zychowicz-Coghill, and L. Blanke, 85–102. Oxford, 2021.

Ricci, L., and R. Fattovich. "Scavi archeologici nella zona di Aksum. B. Bieta Giyorgis." *RSE* 31 (1987): 123–97.

Ristow, S. *Frühchristliche Baptisterien. JbAC* Eg. Bd. 27. Münster, 1998.

Robin, C. J. "La Grande Église d'Abraha à Ṣanʿāʾ: Quelques remarques sur son emplacement, ses dimensions et sa date." In *Interrelations between the Peoples of the Near East and Byzantium in Pre-Islamic Times*, edited by V. Christides, 105–29. Semitica Antiqua 3. Cordoba, 2015.

Robin, C. J., and A. de Maigret. "Le Grand Temple de Yéha (Tigray, Éthiopie), après la première campagne de fouilles de la Mission française (1998)." *CRAI* 142.3 (1998): 737–98.

Rogers, J. M. "The 11th Century: A Turning Point in the Architecture of the Mashriq?" In *Islamic Civilisation, 950–1150: A Colloquium Published under the Auspices of the Near Eastern History Group, Oxford, the Near East Center, University of Pennsylvania*, edited by D. S. Richards, 211–49. Papers in Islamic History 3. Oxford, 1973.

Roux, H. de. "Note sur des tessons céramiques de Degum (Tigré)." *AÉ* 10 (1976): 71–80.

Rubenson, S. *The Survival of Ethiopian Independence*. London, 1976.

———. "Translating the Tradition: Some Remarks on the Arabization of the Patristic Heritage in Egypt." *Medieval Encounters* 2.1 (1996): 4–14.

Rustow, M. *The Lost Archive: Traces of a Caliphate in a Cairo Synagogue*. Princeton, 2020.

Saba, M. D. "A Restricted Gaze: The Ornament of the Main Caliphal Palace of Samarra." *Muqarnas* 32 (2015): 155–95.

Sadek, N. "Rasūlid Women: Power and Patronage." *PSAS* 19 (1989): 121–36.

Salt, H. *A Voyage to Abyssinia, and Travels into the Interior of That Country, Executed under the Orders of the British Government, in the Years 1809 and 1810; in Which Are Included, an Account of the Portugese Settlements on the East Coast of Africa, Visited in the Course of the Voyage; and a Concise Narrative of Late Events in Arabia Felix. And Some Particulars Respecting the Aboriginal African Tribes, Extending from Mosambique to the Borders of Egypt; Together with Vocabularies of Their Respective Languages*. London, 1814.

Salvatore, M., and J. De Lorenzi. "An Ethiopian Scholar in Tridentine Rome: Täsfa Ṣeyon and the Birth of Orientalism." *Itinerario* 45.1 (2021): 17–46.

Sauerländer, W. "Mod Gothic." *The New York Review of Books*, November 8, 1984.

Sauter, R. "L'arc et les panneaux sculptés de la vieille église d'Asmara." *RSE* 23 (1967–68): 220–31.

———. "Églises rupestres au Tigré." *AÉ* 10 (1976): 157–75.

———. "Où en est notre connaissance des églises rupestres d'Éthiopie." *AÉ* 5 (1963): 235–92.

Saxcé, A. de. "Trade and Cross-Cultural Contacts in Sri Lanka and South India during Late Antiquity (6th-10th Centuries)." *Heritage: Journal of Multidisciplinary Studies in Archaeology* 4 (2016): 121–59.

Schlosser, F. E. "Weaving a Precious Web: The Use of Textiles in Diplomacy." *BSl* 63 (2005): 45–52.

Schmidt, P. R., and J. R. Walz. "Re-Representing African Pasts through Historical Archaeology." *American Antiquity* 72.1 (2007): 53–70.

Schneider, M. "Des Yamāmī dans l'Enderta (Tigre)." *Le Muséon* 122.1–2 (2009): 131–48.

———. "Deux actes de donation en arabe." *AÉ* 8 (1970): 79–87.

———. "Points communs aux stèles funéraires musulmanes du Ḥiğāz et des îles Dahlak (Mer Rouge)." *Aula orientalis* 19.1 (2001): 53–78.

———. *Stèles funéraires musulmanes des îles Dahlak (Mer rouge)*. 2 vols. Cairo, 1983.

Schneider, P. *L'Éthiopie et l'Inde: Interférences et confusions aux extrémités du monde antique (VIIIe siècle avant J.-C.–VIe siècle après J.-C.)*. Collection de l'École française de Rome 335. Rome, 2004.

Schneider, R. "Notes éthiopiennes." *JES* 16 (1983): 105–14.

Schoff, W. H., trans. *The Periplus of The Erythraean Sea: Travel and Trade in the Indian Ocean by a Merchant of the First Century*. New York, 1912.

Seidel, L. "Rethinking 'Romanesque'; Re-engaging Roman[z]." *Gesta* 45.2 (2006): 109–23.

———. *Songs of Glory: The Romanesque Façades of Aquitaine*. Chicago, 1981.

Sernicola, L., and L. Phillipson. "Aksum's Regional Trade: New Evidence from Archaeological Survey." *Azania: Archaeological Research in Africa* 46.2 (2011): 190–204.

Shāfeʿī, F. "The Mashad al-Juyūshī (Archaeological Notes and Studies)." In *Studies in Islamic Art and Architecture in Honour of Professor K. A. C. Creswell*, 237–52. London, 1965.

Shahîd, I. "The Kebra Nagast in the Light of Recent Research." *Le Muséon* 89 (1976): 133–78.

Sicilia, F. *I manoscritti etiopici di Antonio Mordini alla Biblioteca Palatina*. Genoa, 1995.

Silverman, R. A., ed. *Ethiopia: Traditions of Creativity*. East Lansing, MI, 1999.

Simpson, W. "Abyssinian Church Architecture." In *Papers Read at the Royal Institute of British Architects: Session 1868–69*, 234–46. London, 1869.

———. "Abyssinian Church Architecture: Part II, Rock-Cut Churches." *The Architectural Review* 4 (1898): 9–16.

———. "An Artist's Jottings in Abyssinia." *Good Words* 9 (1868): 605–13.

———. *The Autobiography of William Simpson, R. I. (Crimean Simpson)*, edited by G. Eyre-Todd. London, 1903.

Smidt, W. G. C. "Dängolo." In *EAe* 2:87–88.

———. "Ein wenig erforschter aksumitischer Platz in Däbrä Gärgiš, ʿAddi Daʾəro, Təgray." *Aethiopica* 10 (2007): 106–14.

———. "Ethnohistorische Feldforschung Tigray DFG-Projekt Yeha, Kurzreport der Feldforschungsphase II: Februar / Mai-Juni 2018, Zusammenfassung der Ergebnisse ʾOrale Historiographie.'" Friedrich-Schiller-Universität Jena–DFG-Projekt "Kulturelle Kontakte zwischen Südarabien und Äthiopien: Rekonstruktion des antiken Kulturraums von Yeha (Tigray/Äthiopien)." Mekelle, 2018.

———. "Salt." In *EAe* 4:500–503.

———. "Wəqro." In *EAe*, edited by S. Uhlig, 4:1180–81. Wiesbaden, 2010.

Sodini, J.-P. "Le commerce des marbres à l'époque proto-byzantine." In *Hommes et richesses dans l'Empire byzantin*, 1: 163–86. 2 vols. Paris, 1989.

Sokoly, J. A. "Between Life and Death: The Funerary Context of Ṭirāz Textiles." In *Riggisberger Berichte* 5 (1997): 71–78.

———. "Ṭirāz Textiles from Egypt: Production, Administration and Uses of Ṭirāz Textiles from Egypt under the Umayyad, ʿAbbāsid and Fāṭimid Dynasties." PhD diss., University of Oxford, 2002.

———. "Towards a Model of Early Islamic Textile Institutions in Egypt." In *Riggisberger Berichte, 5*, 115–22. Bern, 1997.

Sorenson, J. "History and Identity in the Horn of Africa." *Dialectical Anthropology* 17.3 (1992): 227–52.

Speck, P. "Die Ἐνδυτή: Literarische Quellen zur Bekleidung des Altars in der byzantinischen Kirche." *JÖB* 15 (1966): 323–75.

Stalley, R. Review of R. Plant, *Architecture of the Tigre, Ethiopia. NEAS* 10.1 (1988): 99–101.

Stankovic, N. "At the Threshold of the Heavens: The Narthex and Adjacent Spaces in Middle Byzantine Churches of Mount Athos (10th–11th Centuries): Architecture, Function, and Meaning." PhD diss., Princeton University, 2018.

Stauffer, A. *Textiles of Late Antiquity*. New York, 1995.

Stephenson, J. W. "Veiling the Late Roman House." *Textile History* 45 (2014): 3–31.

Stern, S. M. "Rāmisht of Sīrāf, a Merchant Millionaire of the Twelfth Century." *JRAS* 99.1 (1967): 10–14.

Strauch, I. *Foreign Sailors on Socotra: The Inscriptions and Drawings from the Cave Hoq*. Bremen, 2012.

Strauch, I., and M. D. Bukharin. "Indian Inscriptions from the Cave Ḥōq on Suquṭrā (Yemen)." *Annali: Università degli studi di Napoli "L'Orientale"* 64 (2004): 121–38.

Striker, C. L. "Richard Krautheimer and the Study of Early Christian and Byzantine Architecture." In *In memoriam Richard Krautheimer: Relazioni della giornata di studi, Roma, 20 febbraio 1995, Palazzo dei Conservatori, Sala dell'Ercole*, edited by J.-M. Kliemann, 27–40. Rome, 1996.

———. *The Myrelaion (Bodrum Camii) in Istanbul*. Princeton, 1981.

Striker, C. L., and Y. Doğan Kuban, eds. *Kalenderhane in Istanbul: The Buildings, Their History, Architecture and Decoration. Final Reports on the Archaeological Exploration and Restoration at Kalenderhane Camii 1966–1978*. Mainz, 1997.

Swanson, M. N. *The Coptic Papacy in Islamic Egypt (641–1517)*. Cairo, 2010.

Swift, E., and A. Alwis. "The Role of Late Antique Art in Early Christian Worship: A Reconsideration of the Iconography of the 'Starry Sky' in the 'Mausoleum' of Galla Placidia." *Papers of the BSR* 78 (2010): 193–217, 352–54.

al-Ṭabarī. *Chronique de Abou Djafar . . . Tabari, traduite sur la version persane d'Abou-ʿAli-Moʿhammed Belʿami*, translated by M. H. Zotenberg. 4 vols. Paris, 1867–74.

Tadeschi, S. "Ethiopian Prelates (fl. Late Eleventh Century–fl. Mid-Fourteenth Century)." In *The Coptic Encyclopedia*, ed. A. S. Atiya, 4:1005–44. 8 vols. New York, 1991.

Tadeschi, S., and G. Haile. "Ethiopian Prelates (c.300–fl. Second Half of Eleventh Century)." In *The Coptic Encyclopedia*, ed. A. S. Atiya, 3:999–1003. 8 vols. New York, 1991.

Tafla, B. "Production of Historical Works in Ethiopia and Eritrea: Some Notes on the State of Recent Publications 1991–97." *Aethiopica* 1 (1998): 176–206.

Taft, R. F., and S. Parenti. *Il Grande Ingresso: Edizione italiana rivista, ampliata e aggiornata*. Analekta kryptopherrēs 10. Grottaferrata, Italy, 2014.

Talbot, A.-M. "An Introduction to Byzantine Monasticism." *ICS* 12.2 (1987): 229–41.

Tallon, A. "Acoustics at the Intersection of Architecture and Music: The *Caveau Phonocamptique* of Noyon Cathedral." *JSAH* 75.3 (2016): 263–80.

———. "The Play of Daniel in the Cathedral of Beauvais." In *Resounding Images: Medieval Intersections of Art, Music, and Sound*, edited by S. Boynton and D. J. Reilly, 205–20. Turnhout, 2015.

Tamrat, T. *Church and State in Ethiopia 1270–1527*. Oxford, 1972.

———. "Islam and Trade in Ethiopia c. 900–1332." In *Provisional Council for the Social Sciences in East Africa, 1st Annual Conference, Dar Es Salaam, December 27th–31st, Proceedings*, 3:176–87. 6 vols. Dar es Salaam, 1970.

Tancredi, A. M. "Nel Piano del Sale." *Bollettino della Societa geografica italiana* 12 (1911): 57–84, 150–78.

Tegegne, H. M. "Dispute over Precedence and Protocol: Hagiography and Forgery in 19th-Century Ethiopia." *Afriques* 7 (2016). https://journals.openedition.org/afriques/1909.

Tesfaye, G. "Reconnaissance de trois églises antérieures à 1314." *JES* 12.2 (1974): 57–75.

Theis, L. *Flankenräume im mittelbyzantinischen Kirchenbau: Zur Befundsicherung, Rekonstruktion und Bedeutung einer verschwundenen architektonischen Form in Konstantinopel.* Wiesbaden, 2005.

Thiel, A. *Die Johanneskirche in Ephesos.* Spätantike–Frühes Christentum–Byzanz 6. Wiesbaden, 2005.

Thiessen, Z. *Yemrehannä Krestos Church: Documenting Cultural Heritage in Ethiopia.* Stockholm, 2010.

Thomas, T. K., ed. *Designing Identity: The Power of Textiles in Late Antiquity.* New York and Princeton, 2016.

———. *Textiles from Medieval Egypt, A.D. 300–1300.* Pittsburgh, 1990.

Thompson, D. "The Evolution of Two Traditional Coptic Tape Patterns: Further Observations on the Classification of Coptic Textiles." *JARCE* 23 (1986): 145–56.

Thomson, K. E. F. "Relations between the Fatimid and Byzantine Empires during the Reign of the Caliph al-Mustansir bi'llah, 1036–1094/427–487." *BMGS* 32.1 (2008): 50–62.

Thurlby, M. "The Use of Tufa Webbing and Wattle Centering in English Vaults down to 1340." In *Villard's Legacy: Studies in Medieval Technology, Science and Art in Memory of Jean Gimpel*, edited by M.-T. Zenner, 157–74. AVISTA Studies in the History of Medieval Technology, Science and Art Series 2. Aldershot, UK, 2004.

Tibebe, E., and T. W. Giorgis. "The Ethiopian Orthodox Church: Theology, Doctrines, Traditions, and Practices." In *The Routledge Handbook of African Theology*, edited by E. K. Bongmba, 265–79. London, 2020.

Tigrai National Regional State Culture and Tourism Agency. *A Guide Book to Tigrai Tourist Attractions.* Edited by V. Krebs. Mekelle, 2012.

Tipper, J. "The Tomb of the Brick Arches: Structure and Stratigraphy." In *Archaeology at Aksum, Ethiopia, 1993–7*, by D. W. Phillipson, 1:31–57, 425–27. 2 vols. London, 2000.

Török, L. *Transfigurations of Hellenism: Aspects of Late Antique Art in Egypt, AD 250–700.* Probleme der Ägyptologie 23. Leiden, 2005.

Totton, M.-L. "Cosmopolitan Tastes and Indigenous Designs: Virtual Cloth in a Javanese *candi*." In *Textiles in Indian Ocean Societies*, edited by R. Barnes, 105–26. London, 2005.

Trachtenberg, M. "Desedimenting Time: Gothic Column/Paradigm Shifter." *RES: Anthropology and Aesthetics* 40 (2001): 5–28.

Tribe, T. C. "Holy Men in Ethiopia: The Wall Paintings in the Church of Abunä Abrəham Däbrä Sayon (Gär Alta, Təgray)." *Eastern Christian Art* 6 (2009): 7–37.

———. "The Word in the Desert: The Wall-Paintings of Debra Maryam Korkor (Ger'alta, Tigray)." In *Ethiopia in Broader Perspective: Papers of the XIIIth International Conference of Ethiopian Studies, Kyoto, 12–17 December 1997*, edited by K. Fukui, E. Kurimoto, and M. Shigeta, 3:35–61. 3 vols. Kyoto, 1997.

Tripps, J. "Von der Kathedrale zu Reims bis zum Baptisterium von Florenz: Funde zum Behängen mittelalterlicher Kirchenfassaden mit Textilen." In *Die gebrauchte Kirche: Symposium und Vortragsreihe anlässlich des Jubiläums der Hochaltarweihe der Stadtkirche Unserer Lieben Frau in Friedberg (Hessen) 1306–2006*, edited by N. Nußbaum, 83–89. Stuttgart, 2010.

Tromp, J. "Aksumite Architecture and Church Building in the Ethiopian Highlands." *Eastern Christian Art* 4 (2007): 49–75.

Udovitch, A. L. "Fatimid Cairo: Crossroads of World Trade—From Spain to India." In *L'Égypte Ffatimide: Son art et son histoire. Actes du colloque organiséà Paris les 28, 29 et 30 mai 1998*, edited by M. Barrucand, 681–91. Paris, 1999.

———. "Merchants and Amirs: Government and Trade in Eleventh-Century Egypt." *Asian and African Studies* 22 (1988): 53–72.

Uhlig, S. "Ethiopian Studies." In *EAe*, edited by S. Uhlig, 2:433–38. Wiesbaden, 2005.

United Nations. "OCHA Ethiopia Situation Report." Situation Report. New York: United Nations Office for the Coordination of Humanitarian Affairs, July 22, 2022.

al-'Ush, A.-F. "Les bois de l'ancien mausolée de Khālid ibn al-Walīd à Ḥimṣ." *Ars orientalis* 5 (1963): 111–39.

Valieva, N. "King Ṭanṭawədəm's Land Charter: State of the Art and New Perspectives." https://horneast.hypotheses.org/1803.

Vallet, É. *L'Arabie marchande: État et commerce sous les sultans rasūlides du Yémen (626–858/1229–1454).* Bibliothèque historique des pays d'Islam 1. Paris, 2010.

Varisco, D. M. "Making 'Medieval' Islam Meaningful." *Medieval Encounters* 13 (2007): 385–412.

de Verneilh-Puyraseau, F. *L'architecture byzantine en France: Saint-Front de Périgueux et les églises à coupoles de l'Aquitaine.* Paris, 1851.

Vionis, A. K. "The Thirteenth–Sixteenth-Century *Kastro* of Kephalos: A Contribution to the Archaeological Study of Medieval Paros and the Cyclades." *BSA* 101 (2006): 459–92.

Vitti, P. "Brick Vaulting without Centering in the Mediterranean from Antiquity to the Middle Ages." In *History of Construction Cultures: Proceedings of the 7th International Congress on Construction History (7ICCH 2021), July 12–16, 2021, Lisbon, Portugal*, edited by J. Mascarenhas-Mateus and A. P. Pires, 1:119–25. 2 vols. London, 2021.

Vogelsang-Eastwood, G. M. *Resist Dyed Textiles from Quseir al-Qadim, Egypt.* Paris, 1990.

Volpe, M. L. "An Annotated Bibliography of Ethiopian Literature in Russian." *RSE* 32 (1988): 171–93.

Wace, A. J. B., A. H. S. Megaw, and T. C. Skeat. *Hermopolis Magna, Ashmunein: The Ptolemaic Sanctuary and the Basilica*. Alexandria, 1959.

Walker, A. "Globalism." *Studies in Iconography* 33 (2012): 183–96.

———. "Middle Byzantine Aesthetics and the Incomparability of Islamic Art: The Architectural Ekphraseis of Nikolaos Mesarites." *Muqarnas* 27 (2010): 79–101.

Weldegiorgis, E. T., R. Miayke, S. Kaku, and T. Ozawa. "Traditional Remedial Techniques and Current Conservation Challenges in the Rock-Hewn Churches of Tigray, Ethiopia: A Case Study on the Rock-Hewn Church of Wukro Cherkos, Wukro." *Journal of Architecture and Planning* 83.752 (2018): 2079–88.

Wendowski, M., and H. Ziegert. "Aksum at the Transition to Christianity." *AÉ* 19 (2003): 215–30.

Whitcomb, D. S., and J. H. Johnson. *Quseir al-Qadim 1978: Preliminary Report*. Cairo, 1979.

Whitehouse, D. "Maritime Trade in the Gulf: The 11th and 12th Centuries." *World Archaeology* 14.3 (1983): 328–34.

Whitfield, S. *Silk, Slaves, and Stupas: Material Culture of the Silk Road*. Oakland, CA, 2018.

Williams, C. "The Cult of ʿAlid Saints in the Fatimid Monuments of Cairo, Part II: The Mausolea." *Muqarnas* 3 (1985): 39–60.

Williams, E. D. "'Into the Hands of a Well-Known Antiquary of Cairo': The Assiut Treasure and the Making of an Archaeological Hoard." *West 86th: A Journal of Decorative Arts, Design History, and Material Culture* 21.2 (2014): 251–72.

Wion, A. "Medieval Ethiopian Economies: Subsistence, Global Trade and the Administration of Wealth." In *A Companion to Medieval Ethiopia and Eritrea*, edited by S. Kelly, 394–424. Leiden, 2020.

Wolde, S. "The Profile of Writings on Ethiopian Medieval Christian Art." In *Proceedings of the Eighth International Conference of Ethiopian Studies, University of Addis Ababa, 1984*, edited by T. Beyene, 2:165–71. 2 vols. Addis Ababa, 1988–89.

Woldekiros, H. S. "The Route Most Traveled: The Afar Salt Trail, North Ethiopia." *Chungara: Revista de Antropoligía Chilena* 51.1 (2019): 95–110.

Wolf, P., and U. Nowotnick. "The Almaqah Temple of Meqaber Gaʿewa near Wuqro (Tigray, Ethiopia)." *PSAS* 40 (2009): 367–80.

Yates, B. J. "Ethnicity as a Hindrance for Understanding Ethiopian History: An Argument Against an Ethnic Late Nineteenth Century." *History in Africa* 44 (2017): 101–31.

Zanotti Eman, C. "The Harag of the Manuscripts of Gunda Gundi." In *Aspects of Ethiopian Art from Ancient Axum to the Twentieth Century*, edited by P. B. Henze, 68–72. London, 1993.

Zena, A. G. "Archaeology, Politics and Nationalism in Nineteenth- and Early Twentieth-Century Ethiopia: The Use of Archaeology to Consolidate Monarchical Power." *Azania: Archaeological Research in Africa* 53.3 (2018): 398–416.

Zervos, A. *L'empire d'Éthiopie: Le miroir de l'Éthiopie moderne, 1906–1936*. Alexandria, 1936.

Zewde, B. "A Century of Ethiopian Historiography." *JES* 33.2 (2000): 1–26.

Zouache, A. "Remarks on the Blacks in the Fatimid Army, Tenth–Twelfth Century CE." *NEAS* 19.1 (2019): 23–60.

GENERAL INDEX

Page numbers in *italics* indicate illustrations.

Abba Garima mss. *See* Garima Gospels
Abba Pantalewon (Abba P̣änṭälewon) monastery, Aksum, 168n23
Abba Salāma (Frumentius), 12n30
Abba Yohanni (Abba Yoḥanni), 68, 74n144
Abiy Ahmed, 9–10
Abreha (saint-king), 35, 82, 85, 96, 126, 193–95, *194*, 206
Abreha wa-Atsbeha (Abrəha wa-Aṣbəḥa), 81–96; Abreha and Atsbeha, cult of, 82, 85, 96, 193–95, *194*; Aksumite references at, 154–56; alternate names for, 81, 82n11; as architectural experiment and prototype, 79, 124–33, *133*; bema, 91–93, *92*, *93*, 125, 146, 185, *186*; chancel/ chancel screen, 18, *92*, 127, 181; construction method at, 124–25, *133*; cross relief sculptures, *91*, *96*, 157–58, *159*; dedications, 82; domed cubes, use of, 93, *95*, *95*–96, 152–54; facade, 83–85, *84*, *86*, *87*; fire damage, 83, 125, *133*, 156; Greek cross relief sculpture, *91*, *96*; ground plans, *5*, *22*; historical background, 3–4, 46, 135–39; as hybrid monastery/parish church, 46, 160, 191; as cathedral, 46, 145–46, 154, 191; Indian Ocean textiles and ornamentation program of, 4, 26, 175–81, *177*, *178*, *180*, 182, 183, 185, *186*, 187, 189, *190*; interior views, *3*, 85–86, *88–96*, *177*, *180*, *186*, *194*; Maryam Dabra Tseyon and, 204; Mika'el Amba compared, 79, 97, 98, 104, 105, 110; monolithic elements of, 124; narthex, 83, 85, 86, *194*; original purpose/use of, 145–46, 154, 157, 191; painted decorations, *88–94*, *177*, *180*, *186*, *194*; pastophoria, 91, *95*, 96, 153, 154, 181; Pharan, Egypt, Justinianic cathedral, compared, 140; processional space at, 146, 157; prothesis, 126–27, 131, *133*, 181; restoration work and modern inclusions, 83–85, *86*, *87*, 91n30, 193–94; San Marco, Venice, compared, 1–4, *2*, *3*, 163, 193; sanctuary, 93, *93*, *94*; scholarly studies of, 18, 20n76, 21, 23, 24n99; synthronon at, 93, *94*, 145–46, 191; templon screen, *92*, 93; toponym and environs, 81–83, *82*; typology of, 79–81; vault system at, 146–54; Wuqro Cherqos compared, 79, 86, 117, 124
Abū al-Qāsim Rāmisht, 179n77
Abū Dulaf, 179n79
Abu Mena (Abū Mīna), *140*, 140–41, 142, 144, 146
Abuna Abraham (Abunä Abrəham), 68, 69, 116n78, *133*, 202–5, *203*, *205*
Abuna Gabra Masqal (Abunä Gäbrä Mäsqäl), 68
Abuna Yemata Guh (Abunä Yəm'ata Gwəḥ), 68, *74*, 74–75, *76*
Abyssinia, as term, 9, 10
Addi Qesho Medhane Alam ('Addi Qešo Mädḥane 'Aläm), 68, 69n132

Adulis: "British Museum" cathedral, 30, 49; Byzantine spolia and synthronon, church with, 145n49; East Church, *32*, 34, 45, 50–52n64
Aethiopica (journal), 17
Agula Cherqos (Agula' Čerqos), 29–30, *30*
Aḥmad ibn Ibrāhīm "Grañ" (Adal sultan), 166, 174
Aksum: Abba Pantalewon (Abba P̣änṭälewon) monastery, 168n23; Arbaetu Ensesa (Arba'ətu Ǝnsəsa), church of, 30, 49; barrel vaults in, 147n53; Beta Giyorgis (Betä Giyorgis) hill church, 34, 35, 139–40; Dungur "palace," *28*, 142n53; Umm Ḥabība (wife of Prophet Muhammad), in, 53n69
Aksum Stele Park, monoliths of, 11–12, *13*, 154
Aksum Tseyon (Aksum Ṣəyon or St. Mary of Zion; cathedral of Aksum), 25n110, 34, 53n69, 60, 67, 82, 149
Aksumite Empire. *See also under* medieval architecture in Tigray: Byzantium, contact with, 4, 12, 42; collapse of, 13, 42, 136; churches of, 27–42; conversion of emperors of, 12; cruciform churches of, 139–40; cruciform drum pillar from period of, 155, *156*; history of, 11–13; later churches referencing architecture of, 45, 46, 48, 144, 154–56, *156*; "palaces," *28*, 28–29, 36, 39; Zagwe belief in continuum with, 53
"Aksumite" friezes, *91*, 93, 104, 109, *119*, 155
Alexandria, patriarchate of, 12, 25, 46, 56, 58–59, 128, 129, 136, 137, 139
Altars: ciboria, 45, 67, *73*, 74, 168, 185, 187n91, *188*; monolithic, 67, *73*, 109; multiplication of, 53, 56, 126–27, 131, *133*; portable, 129, 131
Alvares, Francisco, 18, 166, 167–68, 174
Ambager Complex (*Dagmawi* Lalibela or Lalibela Two), 75n148
al-'Amri mosque, Qus, Egypt, mausoleum at, 153, *153*
Anaphora of St. Mary, 189
Anastasius (Byzantine emperor), 12
Anbasa Wedem (Anbäsa Wədəm), 128
Anchoritic monasticism, 48, 74
Ancient Churches of Ethiopia (Phillipson), 24, 80
Andemta (Andəmta), 16
Anfray, Francis, 21n77
Annales d'Ethiopie (journal), 17
Annesley, George, 18, 85n25
Aramo, lost church of, 57n77
Arbaetu Enesa (Arba'ətu Ǝnsəsa), monastery church of, 145n49
Arbaetu Ensesa (Arba'ətu Ǝnsəsa), church of, Aksum, 30, 49
Armenia: Badr al-Jamālī's origins in, 137n12, 152, 184; Egypt, medieval Armenian immigration to, 184–85; liturgical cloths from, 183–85, *184*; modeling Ethiopian

architectural history after, 192–93; Zuart'noc', church of, 193

Arwā bt. Aḥmad (Sulayhid queen), 136

Asmara, lost church at, 57n77

Atsbeha (saint-king), 82, 85, 96, 126, 193–95, *194*, 206

Ayba Gamad ('Ayba Gämad), 81, 82n11. *See also* Abreha wa-Atsbeha

Aydhab, 144, 173

al-Azraqī, 'Abd al-Walīd, 35

Bab al-Nasr, Cairo, *150*

Badr al-Jamālī (vizier), 127, 134, 135, 136n8, 137, 146, 149–52, 165, 174, 184, 187

Balicka-Witakowska, Ewa, 129

baptismal fonts: Aksumite, 30, 50–52n64; at Mika'el Amba, 97–98; post-Aksumite, 45, 50

Barnes, Ruth, 171–72n38

barrel vaulting: architectural echoes and influences of rock-cut cruciform churches within Ethiopia, 195, *196*, 199, 202; at Hawzen Takla Haymanot (hypothetical), 49; revival architecture, rock-cut cruciform churches as, 135, 146–51, *148–51*; in rock-cut cruciform churches, 86, *93*, 104, *105*, 119, 133; at Yohannes Matmaq (hypothetical), 49n62

Basil of Caesarea, 67

basilicas: Christian adaptation of Roman form of, 28; development of Aksumite churches beyond, 34; Ethiopian Orthodox churches in US as, 75n146; majority of medieval Tigrayan churches as, 27, 75; Wuqro Cherqos as, 79, 157

"Bastions of the Cross" (Ḥaṣara Mäsqäl), 206

Bawit monastery, Egypt, 110n64, 131

Beauvais, France, church of, 156n94

bema: at Abreha wa-Atsbeha, *92*, 93; in Aksumite churches, 40; at Beta Giyorgis, 199; dating and, 23, 125; liturgical functionality of, 156; at Mika'el Amba, 109, 110, 132; in post-Aksumite churches, 45, 46, 48, 49; in "Solomonic"-era churches, 74; at Wuqro Cherqos, 122; in Zagwe churches, 58, 61

Berhan, Gedey, 76

Berhe, Hiluf, xi

Beta Emmanuel (Beta 'Amanu'el), Lalibela church complex, *14*, 131, *196*

Beta Giyorgis (Betä Giyorgis), Lalibela church complex, 81, 197–200, *198, 200*

Beta Giyorgis (Betä Giyorgis) hill, Aksum, church at, 34, 35, 139–40

Beta Maryam (Betä Maryam), Lalibela church complex, 131, 132, 176, *197*

Beta Samati (Betä Semati), 29–30

Bethlehem in Gayint, 147, *148*, 200–202, *201*

Bier, Carol, 178

blind arcades, 69, *70*, 116, 202

blind windows, 86, 104, 109, *119*, 155

Bodrum Camii (Myrelaion), Constantinople, 80, *81*

Bony, Jean, 166n12

bracket capitals, 74, 91, 105, 110, *111*, 117, 122, 155, *156*

Bramoullé, David, 136

bread ovens (beta laḥəm), sacramental, 49, 98, 113

"British Museum" cathedral, Adulis, 30, 49

Buxton, David, 21–22, 36n28, 80, 85n27, 112n66, 113n72

Byzantium. *See also* Constantinople: Abba Garima II manuscript, Byzantine forms in, *41*; Aksumite contact with, 4, 12, 42; barrel vaulting by craftsmen from, 147;

Cappadocian churches, 27, 45n48, 80; cross-in-square (inscribed-cross) church, Middle Byzantine, 80–81, *81*; Deesis programs of Byzantine chancels, *189n100*; "influence," of, 24–25; integration of Ethiopian and Byzantine studies, 16, 21, 192; Komnenians, Justinianic architectural revival under, 160, 191; late antiquity of, rock-cut churches intentionally harkening back to, 4, 6, 26 (*See also* revival architecture, rock-cut churches as); Manzikert, battle of (1071), 160; Maritime Silk Road and, 166; San Marco (St. Mark's), Venice, and, 1–4; scholarly comparisons of rock-cut churches to architecture of, 18; Zarama Giyorgis, Byzantine appearance of woodwork at, 40

Cairo. *See also* Fustat: Bab al-Nasr (Gate of Victory), *150*; Coptic patriarchate moved to Fustat, 137; Juyushi (al-Juyūshī; funerary mosque of Badr al-Jamālī), 152; linked-cross design on Fatimid wood panel from, 153–54, *154*; walls of, 150, *150*

Cairo Geniza, 171–73, 173n43, 174, 175, 179n77

Cappadocian churches, 27, 45n48, 80

Carini, Domenico, 1

Centre national de la recherche scientifique (CNRS)., 23, 48–49n58

Cerulli, Enrico, 16

chancels/chancel screens: at Abreha wa-Atsbeha, 18, 91–93, *92–93*, 125, 127, 146, 181, 185, *186*; Aksumite, 32–34, *33*, 38, 40, 42; dating and, 23; Egyptian comparisons with, 110, 131; Deesis programs of Byzantine chancels, *189n100*; at Dabra Dammo, 155; Deir al-Surian, Wadi Natrun, Egypt, 158, *159*, 185, 188; engaged ceiling crosses signaling entry into, 158; Indian Ocean textiles, architectural versions of, 187–89; as liminal/revelatory space, 189; khūrus and Haykal screens, 93n31, *133*, 151, 152, 185, 204; liturgical bridges, iconography of choir screens as, 189n100; at Mika'el Amba, *100*, 103, 104n55, *107*, 109, 110–12, *111*, 128, 131–32, 187; phase-out of wooden chancels, 67; Π-shaped, 45, 48, 61n94, 66, 93, 110, 122, 125, 131, 133, 204; post-Aksumite, 48, 49; late medieval screens, 67, 137, 204; textiles used for, 67, 167, 168, 175; wooden chancel at Abreha wa-Atsbeha, documentation of, 18; at Wuqro Cherqos, 120, *121–22*, 122, 133; under Zagwe rule, 56, 58, 63

Cherqos Agabo (Čerqos Agäbo), 53, 57, 58, *59*, 127, 154

Chinese silks. *See* Indian Ocean textiles

chiral symmetry, 176

Christianity in Tigray and Ethiopia. *See also* "second Christianization": active places of worship, rock-cut cruciform churches as, 6; Aksumite emperors, conversion of, 12; Coptic church, historic link to, 12, 24, 25; distinct form of Miaphysite Orthodox Christianity, 7, 10; ecumenical connotations of Justinianic church architecture, 3, 144, 145, 160, 190; in Zagwe period, 15

Church Missionary Society, 18

Church of the Nativity, Bethlehem, 202

ciboria, 45, 67, *73*, 74, 168, 185, 187n91, *188*

civet musk, trade in, 4, 139, 174, 175

civil war (2020–2022), xi, 1

Coates-Stephens, Robert, 155

colonialism, race, and "influence," 24–25

Communist revolution (1974), 15, 17, 23

A Companion to Medieval Ethiopia and Eritrea (ed. S. Kelly), 17n64

conched apses, 30, 58, 61, 63, 66, 93, *94, 108,* 109, 122, *123, 130,* 140–41, 145, *145,* 183

Constantine I (Roman emperor), 25n110, 28, 34, 53, 56, 159, 193

Constantinople: Ethiopian pilgrims in, 5, 144; Fourth Crusade, sack of (1204), 3; Hagia Irene, *145,* 160; Hagia Sophia, 156n94; Holy Apostles, Church of the, 1–3, 141, *142,* 163; Myrelaion (Bodrum Camii), 80, *81;* Pantokrator monastic complex, 145n48; templon screens imported from, 32–34, *33,* 42, 110n63; Theodosian land walls of, 150; Theotokos Kyriotissa (Kalenderhane Camii), 160, *161*

Conti Rossini, Carlo, 16

Coptic church: Alexandria, patriarchate of, 12, 25, 46, 56, 58–59, 128, 129, 136, 137, 139; Anaphora of St. Mary, 189; Arabic texts from, importation of, 67; *crux ansata* (ankh) used by, 96, 157; Fatimid architectural innovations, use of, *151,* 151–52, *152;* under Fatimid Egypt, 46, 137; Fustat, patriarchate moved to, 137; historic link of Ethiopian Orthodoxy to, 12, 24, 25; "influence," 25; khūrus and haykal screens, Ethiopian adoption of, 204; liturgical clues to dating of Tigray churches and, 125; mural painting, introduction of, 53; Pharaonic past, engagement with, 50n63; scholarly studies of rock-cut churches and, 24; Zagwe dynasty recognized by, 15

Corinthian capitals: at Abu Mena, Egypt, 140; Aksumite imitations of, 30, *31*

Cosmas Indicopleustes, 11n24, 147–49

Courtauld Handbag, *179*

COVID-19 pandemic, in Ethiopia, xi

Cross of Esna, *157*

cross relief sculptures: Abreha wa-Atsbeha, *91,* 96, *96,* 157–58, 159; form and function of, 157–60; at Lalibela church complex, *197,* 199; Mika'el Amba, 101, 103n49, *104,* 105, *106, 109,* 110, 128, 157, 159, 182; processional crosses at Maryam Dabra Tseyon referencing, 204, *205;* Wuqro Cherqos, *118,* 119, 157–58, 159

crosses, processional, 96, *96, 109,* 110, *118,* 119, 157–58, 189, 204, *205*

cross-in-square churches: Middle Byzantine cross-in-square (inscribed-cross) churches, 80–81, *81;* as typological term, 79–81, 139

cruciform churches. *See also* rock-cut cruciform churches of Tigray: Aksumite, 34–35, 139–40; Justinianic, 141–44, *142, 143;* Egypt, late antique cruciform churches of, *140,* 140–41; as political statement, 192; as typological term, 79–81, 139

cruciform drum pillar, Aksumite, 155, *156*

crux ansata (ankh), 96, 157

cubits, Ethiopian use of, 125, 178

cyma molding, 49n62, 155

cyma reversa, 86–87

Cyprus, seventh-century pilgrimage church and martyrium on, 141

Cyricus (saint and martyr), 112

Cyril II (pope), 174

Dabra Bizan (Däbrä Bizän), 168

Dabra Dammo (Däbrä Dammo) monastery, 35–36; choir dome at, 155; Eucharistic preparation, subsidiary space for, 32; ground plan, *36;* Maryam Baraqit compared,

48; Mika'el Amba compared, 112; modern restoration of, 21, 35, 36n27; monolithic pillars, 36, *37;* narthex ceiling, 36, *37;* problems in dating of, 35, 36n28; reconstitution/restoration in twelfth century, 53, 56–57; textiles surviving from, 168–71, *169,* 174, 181; timber barrel vault, early attempt at, 147n57; Zarama Giyorgis compared, 40

Dabra Maar Giyorgis (Däbrä Mä'ar Giyorgis), 68

Dabra Nagast (Däbrä Nägäśt, Monastery of the King), 81. *See also* Abreha wa-Atsbeha

Dabra Salam Mika'el (Däbrä Sälam Mika'el), 53, *57,* 57–58, *58,* 110–12

däbtära (school for cantors), 202

Dagmawi Lalibela (Lalibela Two; Ambager Complex), 75n148

Dahlak archipelago, 15, 136, 144, 171, 173, 174, 178, 185

Dal Mangesha (Dal Mangaśha), 200

Dale, Otto, 33, 85n23, 113n72

Danakil Depression, 7, 8, 11, 49, 82, 97, 155, 174

Danakil salt flats and salt trade, 11, 13n36, 49, 57, 139, 175

Daniel (Dana'el; abbot), 61, 62

Dawit I (Ethiopian ruler), 200

Degum Selassie (Dagum Śəllase) complex, *42–44,* 42–45, 46, 134, 136, 155

Deir al-Surian (Dayr al-Suryān), Wadi Natrun, Egypt, *151,* 151–52, *152,* 158, *159,* 185, *187,* 188, 197

Derat, Marie-Laure, xi, xii, 15

Deutsche Aksum-Expedition (1906), 16, 147

Di Salvo, Mario, xii, 24

diaper motif, 74, 170, 173, 179–81, 188

diffused light, as light of God, 153

Dome of the Rock, Jerusalem, 193

domed cubes, *95,* 96, 134, 135, *152,* 152–54, *153*

Doresse, Jean, 21

dual-apsed churches, *See also* Zarama Giyorgis, 38–39, 42

Dungur "palace," Aksum, *28,* 142n53

East Church, Adulis, *32,* 34, 45, 50–52n64

Eastern Medieval Architecture (Ousterhout), 192

echinus brackets, *91,* 105, 116, 128

ecumenical connotations of Justinianic church architecture, 3, 144, 145, 160, 190

"egg carton" churches, 68, 74

Egypt. *See also* Coptic church; Fatimid Egypt; Mamluk Egypt; *specific towns, cities, and buildings*: late antique cruciform churches of, *140,* 140–41; mural painters from or trained in, 53; samplers from, 179; "Solomonic" dynasty's relations with, 66–67; textile imports from, 168–71, *169,* 179, 181; wooden doors imported from, 62, *63;* Zarama Giyorgis, ornamentation of, 40

Enda Cherqos WalWalo (Ǝnda Čerqos WalWalo; Monastery of St. Cyricus at Walwalo), 40n38

Enez Fatih Camii, Thrace, 160–63

enslaved people: Badr al-Jamāli's origins as enslaved Armenian, 137n12, 152; Frumentius and conversion of Ethiopia, 12n30; Mamluks taken from, 139; trade in, 4, 139, 174, 175, 203n47

Ephesus, church of St. John at, 30, 141, 146, 147

Eskender (Alexander the Great/Ethiopian king), 174

Ethiopia. *See* Tigray and Ethiopia

Ethiopian Heritage Fund, 110n62

Ewostathians, 67

Ezana (Aksumite emperor), 12

facades. *See specific churches*

Fascist Italy, 16–17, 18, 20–21, 60n130, 71n137, 82n11, 168; restoration of Abreha wa-Atsbeha by, 83–85, *86,* 193–94

Fatimid Egypt, 4, 135–39; architectural style of, 6, 36; Coptic church under, 46, 137; dating of rock-cut cruciform churches and, 134; innovative architectural adaptations from, 146–54; Justinianic monuments encountered by Ethiopian pilgrims under, 134, 135; Muslim settlement in Tigray under protection of, 53, 137–38; Red Sea as *mare nostrum* for, 135, 136–37; resuscitation of Indian Ocean trade under, 46, 134, 139, 165–66, 179; "second Christianization" of Ethiopia and, 46, 134, 139; textiles, world-view conceived in terms of, 190; textiles from, *169,* 170–71; trade with Ethiopia, 139; Zagwe aligned with, 6

Fauvelle, Francois-Xavier, xi

faux-stucs (pseudo stucco), 176

Finneran, Niall, 24, 154–55

foliate motifs, 35, 185–87, *186–88*

Fourth Crusade, sack of Constantinople in (1204), 3

Fritsch, Emmanuel, xii, 23–24, 38n32, 63n101, 113n72, 122n83, 125–26n93, 129

Froebenius, Leo, 25n104

Frumentius (Abba Salāma), 12n30

Fustat: Hanging Church, 147n57, 185, *188;* patriarchate moved to, 137; trash heap, textile fragments from, 171–72, *172, 173, 180, 181, 183, 186*

Gabra Masqal (Gäbrä Mäsqäl) and Kaleb, churches/tombs of, 45

gädäm, 60–61

Gadla Abrɘham, 68

Galla Placidia, mausoleum of, Ravenna, 35, *149*

Gunda Gundo, 67n117

Gannata Maryam (Gännäta Maryam), 68, 145n49

Garima Gospels: Abba Garima I manuscript, *45;* Abba Garima II manuscript, 40–41, *41;* representations of liturgical curtains in, *45,* 168

Geniza, Cairo, documentation of Red Sea textile trade, 171, 173n43, 174, 179n77

Gerster, George, 22

Gervers, Michael, xii, 23, 38n32, 63n101, 75

Gibbon, Edward, 166n5

Giho (Giḥo; Christian female notable), 136

Gire, Jean, 23, 48–49n58

Giyorgis of Sagla (Sägla), 189

Gleize, Yves, xi

global year 1000, 160–63, 191

"The Glory of Kings" (Kɘbrä nägäst; thirteenth-century text), 144n42

Goitein, S. D. (Shelomo Dov Goitein), 172

gold leaf, use of, 176

Golombeck, Lisa, 189

Grabar, André, 23

Greek Cross reliefs. *See* cross relief sculptures

Gud Bahri smelting workshop, 83n19

Gujarati textiles, *172, 173,* 178, 179, *180–81,* 181, *183, 186*

Habesha people, 9–10

Hable Selasse, Sergew, 16, 168n23

Hagia Irene, Constantinople, *145,* 160

Hagia Sophia, Constantinople, 156n94

hagioscopes, 71–74

Hagos, Tekle, 40n38

Hahn, Wolfgang, 12

Haile, Getatchew, 16

Haile Selassie (Ḥaylä Śɘllase; emperor), 9, 17, 22, 23, 35

half-timbering, 28, *29,* 35, 36, 39, 42, 58, *59,* 154, 155

Ham inscription, 136

Hanging Church, Fustat, 147n57, 185, *188*

Haṣara Mäsqäl ("Bastions of the Cross"), 206

Hatsani Daniel (Ḥaṣani Danʾɘl) inscription, 13–15

Hatsani (Ḥaṣani; Zagwe titulature), 4, 13–15, 46, 134, 135, 136, 139, 145, 195, 204

Hawzen Takla Haymanot (Ḥawzen Täklä Haymanot), 46, *48,* 48–49, 75, 76

Haykal screens, *133,* 137–38, *138,* 151, 158, *159, 184,* 185, 187–88, 204

heaven: as domed or vaulted enclosure (Antiochene cosmography), 147–49; vegetal patterns, paradisaical, 185, *186–88*

Heldman, Marilyn, 22

Heraclius (Byzantine emperor), 42n41, 193

Hermopolis Magna, cathedral of, 141n28

Himyar and Himyarites, 12, 35

History of the Patriarchs of Alexandria, 136

Holy Apostles, Constantinople, 1–3, 141, *142,* 163

Holy Sepulcher, Jerusalem, 167, 170n28, 193

hudmo (square rubble house), 113n68

hypogean architecture, 5, 7, 27, 46, 48, 69, 75–76, 193, 195. *See also* rock-cut cruciform churches of Tigray

icons and icon worship, 67, 202

Indian Ocean textiles, 4, 5, 26, 165–90; architectural ornament based on, *175,* 175–90, *177–84, 186–88;* Armenian liturgical cloths, 183–85, *184;* bas-relief and ocher infill, textiles represented by, 176; Cairo Geniza documentation of Red Sea textile trade, 171, 173n43, 174, 179n77; Egypt, textile imports from, 168–71, *169,* 179, 181; Fustat trash heap, textile fragments from, 171–72, *172, 173, 180, 181, 183, 186;* liminal/revelatory space, used to define, 189; liturgical importance of, 87, 166–68, 175, 189; Maritime Silk Road, 26, 136, 166; Maryam Dabra Tseyon and, 204; proposed trade routes into Ethiopia, 173–74; resuscitation of Indian Ocean trade under Fatimid influence, 46, 134, 139, 165–66, 179; Seljuk buildings and, 26, *175,* 178, *182,* 182–83, *184,* 189–90; "Sheikh's house," Quseir al-Qadim, textile scraps from, 172; silk versus cotton, 174–75; trading hub, Abreha wa-Atsbeha as, 81–82

"influence," race, and colonialism, 24–25

inscribed-cross church. *See* cross-in-square churches

interlace, 40n38, 65n105, 131–32, *181,* 185, 203

International Conference of Ethiopian Studies, 18

Iran. *See* Seljuks

iron smelting, 49n60, 83n19

Islam: collapse of Aksum and, 42; in Ethiopia, 15, 53, 137–38; Fatimid mission area, Ethiopia as, 137; textiles, Islamic, Ethiopian use of, 168–71, *169*

Islamic architectural and decorative motifs: Majestas Domini, "Islamic"-style representation of, *58;* in rock-cut churches of Tigray, 46, 165; in San Marco, Venice, 4n7; T-fret, Ethiopian importation of decorative arts with, 179, *179 See also* Fatimid Egypt

Istanbul. *See* Constantinople

Italy, occupation of Ethiopia by (1936–941), 16–17, 83, 193–94

ivory trade, 11, 34, 106, 166

Iyasus Gwahegot (Gwaḫgot Iyäsus), 61, 61n94, 63–66, *65, 66,* 125n91
Iyasus Tashi ('Iyäsus Tašši), 68, 69n132

Jäger, Otto, 33
Jaqmaq (Mamluk sultan), 168n22
Java, Indonesia, textile motifs used as architectural ornament in, 178
Jerusalem: Dome of the Rock, 193; Holy Sepulcher, 167, 170n28, 193
Jesuit-Portuguese construction, 85n25
Joseph la-Lebdi (Egyptian Trader), 174
Journal of Ethiopian Studies, 17
Justinian I the Great (Byzantine emperor), 4, 34, 35, 141, 142, 144, 145, 160, 163, 166
Justinianic churches: eleventh-century revival of, 160–63, 191; Hagia Irene, *145,* 160; Hagia Sophia, 156n94; Holy Apostles, Church of the, 1–3, 141, *142,* 163; Paros, cathedral of Panagia Ekatontapiliani, 142, *143,* 147, Pharan, Egypt, cathedral of, 140; Sanaa, cathedral (al-Qalīs) in, *34,* 35, 139–40, 147; rock-cut churches intentionally harkening back to, 4, 6, 26, 134, 135, 141–46, 154, 191 (*See also* revival architecture, rock-cut churches as)
Juyushi (al-Juyūshī; funerary mosque [mashad] of Badr al-Jamālī), Cairo, 152

Kaaba, 35, 179n79
Kaleb and Gabra Masqal (Gäbrä Mäsqäl), churches/ tombs of, 45
Kalenderhane Camii (Theotokos Kyriotissa), Constantinople, 160–63, *161*
Kebede, Dawit, xiii, 5
khūrus screens, 93n31, *133,* 151, 152, 185, 204
Kidane, Habtemichael, 125–26n93
Komnenian Byzantium, Justinianic architectural revival under, 160, 191
Krautheimer, Richard, 192n8
Kwiha (Kwiḥa), 136–37, 173, 174, 178

Lalibela (Lalibäla; Zagwe king), 59, 192, 195, 197, 199
Lalibela (Lalibäla) church complex, *14,* 59, 68, 69, 81, 97n36, 131, 132, 146, 176, 195–200, *198, 200,* 202, 205. *See also specific churches*
"Lalibela crosses," 197n34
Lalibela Two (*Dagmawi* Lalibela; Ambager Complex), 75n148
lantern ceilings, 43, 50, 155
late antiquity, rock-cut churches intentionally harkening back to, 4, 6, 26, 134, 135, 139–46, 154, 191. *See also See also* Aksumite Empire, Justinianic churches, revival architecture, rock-cut churches as
Lefebvre, Théophile, 18, *19*
Lepage, Claude: Byzantine and Ethiopian studies, incorporation of, 192n6; on cross relief sculptures, 158n99; on *faux-stucs* (pseudo stucco), 176; on foliate motifs, 185n87; on medieval architecture in Tigray and Ethiopia, 36, 38n32, 39, 42n42, 43, 46n56, 48–49n58, 49nn60–61, 67n120; on rock-cut cruciform churches of Tigray, 81, 93, 116n76, 125n93, 126, 127, 157; scholarship of, 23, 24; on Zarama Giyorgis as basis for rock-cut cruciform churches, 135n1
Liber Pontificalis, 166
liminal/revelatory spaces, 153, 189

liturgy: active places of worship, rock-cut cruciform churches of Tigray as, 6, 160; altars, multiplication of, 53, 56, 126–27, 131, 133; changing to fit ecclesiastical spaces, 156n94; choir screens as liturgical bridges, iconography of, 189n100; dating criteria based on, xii, 5, 23, 24, 125–27, 133; functionality of rock-cut cruciform churches for purposes of, 156–60; furnishings, liturgical, 25; khūrus and haykal screens, Ethiopian adoption of, 204; layout of churches and, 23, 32, 45, 46; liminal/revelatory spaces in context of, 153, 189; middle ordo, 46, 126; Mika'el Amba, liturgical furnishings at, 110–12, *111;* old ordo, 32, 52n64, 53n68, 58, 126; processions and processional spaces, 146, 157, 158n99; prothesis rite, 32, 45, 56 (*See also* prothesis); rails for liturgical canopies, 87, 168; rededication of Wuqro Cherqos and updating of liturgical layout, 204; textiles, importance of, 87, 166–68, 175, 189 (*See also* Indian Ocean textiles); Veneration of the Cross ritual, 159
local legacy of rock-cut churches, 26, 191–206; Abreha and Atsbeha, cult of, 193–95; Abuna Abraham, career of, 202–5; architectural echoes and influences within Ethiopia, 195–202, 204–5; modern continuation of rock-cut architectural tradition, 75–76; peripheries, appropriate study of, 191–93
locust plague (2020), xi

Macarius (patriarch of Alexandria), 128, 129
maḫābis (sing. *miḫbas*), 172–73, 174
Majestas Domini, *58,* 129, *130*
Maltese Cross reliefs. *See* cross relief sculptures
Mamluk Egypt: architectural style from, 67, 68, 74; Rasulid dynasty of Yemen as client kingdom of, 203; textile imports from, 168
Mamluks, Ethiopians serving as, 139
Manzikert, battle of (1071), 160
Maqdala (Mäqdäla) expedition (1868), 16, 17, 18, 18n74
al-Maqrīzī, 190
Maranci, Christina, 192–93
Maritime Silk Road, 26, 136, 166
martyria, 42n42, 125n93, 126, 140, 141, 142
Maryam Baraqit (Maryam Bäraqit), 46–48, *47,* 49
Maryam Dabra Tseyon (Maryam Däbrä Ṣəyon), *68–70,* 68–71, 74, 116n78, 202, 204–5, *205*
Maryam Hitsewto (Maryam Ḥṣ'əwto), 195n26
Maryam Nazret, 54–56; in Addi Awona ('Addi Abunä, Wädī Abūnä), 54; Aksumite spolia piers and Aksumite style at, *31,* 54, 132, 155; dating, 54, 129; domed chambers, 54, *55;* domed cube, use of, 54, *55,* 152; early Zagwe rule, (re)construction under, 53, 56; excavations, xi; foundations on Aksumite platform, *54,* 56; ground plan, *56;* liturgical change and, 126; as Metropolitan center, 46, 53, 54, 60; Michael (Coptic metropolitan) on, 131; Mika'el Amba compared, 131; mortar used at, 147n53; mural workshop at, 53; under "Solomonic" dynasty, 67
Maryam Qiat (Maryam Qi'at), 61, 61n94, 62–63, *63, 64*
Maryam Qorqor, *60,* 61–62, *62,* 63, 68, 75, 202
Maryam Wuqro (Maryam Wəqro), 68, *71,* 71–74, *72, 73,* 85n27
Masjid-i Tārākhāna, Damghan, Iran, *175*
maṣṭaba, 145
Matara (Mäṭära), basilica at, 30, 32, 45
Matthews, Derek, 21, 35, 36n27, 57n77
meanders, 103n49, 176, 178–79, 188, 197n34

Medhane Alam (Mädḫane ʿAläm; Savior of the World), Lalibela, 75–76, *76, 199, 200
Medhin Joseph, Tewalde, 18, 21
medieval architecture in Tigray, 25, 27–77. *See also* basilicas; *specific buildings*
 Aksumite early Christian churches (300–700), 27–42; archaeological foundations, 27–35; in illuminated manuscripts, 40–41, *41*; later churches referencing architecture of, 45, 46, 48, 49; standing churches, 35–40
 in illuminated manuscripts, 40–41, *41, 45*
 modern continuation of tradition (1500–present), 75–76, *76, 77*
 "palaces," Aksumite, *28,* 28–29, 36, 39
 post-Aksumite (700–1000), 42–46
 "second Christianization," architecture of (950–1100), 46–52, 137
 "Solomonic" dynasty, monastic foundations under (1300–1500), 66–75
 Zagwe architecture: early Zagwe period (1100–1200), 52–59, 132; height of Zagwe rule (1200–1300), 59–66
 "medieval," use of, in Ethiopian history, 4n9, 192
Mediterranean world, trade and pilgrimage routes into, 144, 166
Menas (saint), 140
Menelik (Mənilək) II (emperor), 8, 16
Mercier, Jacques, 36, 38n32, 49n61, 185n87
metrological system used in Tigray and Ethiopia, *See Also* cubits, Ethiopian use of; 125, 178
Miari, Giuseppe, 83, *133*
Michael I (Coptic metropolitan), 128–29, 131, 132, *133*
middle ordo, 46, 126
Mifsas Bahri, 155
Mikaʾel Amba, 97–112; Abreha and Atsbeha, cult of, 195; Abreha wa-Atsbeha as prototype for, 79, 124–33, *133*; Abreha wa-Atsbeha compared, 97, 98, 104, 105, 110; Aksumite references at, 155; bema, 109, 110, 132; chancel/chancel screen, *100,* 103, 104n55, *107,* 109, 110–12, *111,* 128, 131–32, 187; construction methods at, 127–29, *128, 133;* courtyard, 98, *101,* 127, 199; cross relief sculptures, 101, 103n49, *104,* 105, *106, 109,* 110, 128, 157, 159, 182; Dabra Dammo compared, 36; dedication to Archangel Michael (Mikaʾel), 97, 128; environs and monastic complex, *97,* 97–98, *98;* facade, 98–101, *99–101;* ground plan, *7;* historical background, 4; as hybrid monastery/parish church, 46, 160, 191; initial abandonment of, 79, 124, *133;* interior, 103–10, *103–10;* Lalibela church complex and, 199–200; liturgical furnishings at, 110–12, *111,* 131; marquetry of door, *102,* 103; marquetry of portable altar, 131; Maryam Nazret compared, 131; modern restoration work on, 99, *100,* 110; monolithic elements at, 131; narthex, 98, 101–3, *102,* 131, 132, 199–200; original purpose/use of, 146; painted decorations, 109, 129, *130;* pastophoria, 109–10; portals, 98, *99,* 99–100, *100;* processional space at, 157; prothesis, originally intended to have, 53, 131; restoration in twelfth century, 53, 56, 57, 79, 124, 128–32, *133, 134,* 199; sanctuary, 103, 110, 131; scholarly studies of, 18–20, 21, 23; "Solomonic" dynasty reworking of, 68; templons/templon screens, 99, 110–12, *111,* 131; typology of, 79–81; vault system at, 146; Wuqro Cherqos compared, 113, 117, 133
Mikhail, Arsenius (formerly Ramez Mikhail), 53n68, 127

Minart, Marie-Anne, 110n64
modular architecture: of Middle Byzantine churches, 80; of Myrelaion, Constantinople, 80; revival architecture and, 141, 146n51, 159; of Tigrayan cruciform churches, 5, 80, 85, 104, 105, 117, 124–25, 132, 199
monasteries. *See also specific monasteries by name*: hybrid monastery/parish churches, 46, 71, 160, 191; under "Solomonic" dynasty, 66–75; under Zagwe dynasty, 59–66.
monkey head bosses, 57–59, *69,* 155
monolithic altars, 67, *73,* 109
monolithic elements at Abreha wa-Atsbeha, 124
monolithic elements at Mikaʾel Amba, 131
monolithic elements at Wuqro Cherqos, 113–14, 204
monolithic piers and pillars, Aksumite, 30, *31,* 36, 40n38
monolithic stele, Aksum Stele Park, 11–12, *13,* 154
Monti della Corte, Alessandro Augusto, 16
Mordini, Antonio, 16, 17n55, 20–21, 57n77, 74n140, 168, 170
Mount Sinai, St. Catherine's Monastery at, 40, 142–44
Muḥammad al-Idrīsī, 139n19
multiple altars, 53, 56, 126–27, 131, *133*
murals. *See* painted decorations
Muslims. *See* Islam
al-Muʿizz (Fatimid caliph), world map of, 190
Myos Hormos. *See* Quseir al-Qadim
Myrelaion (Bodrum Camii), Constantinople, 80, *81*

Nahman, Maurice, 170n28, 181
narthex: at Abreha wa-Atsbeha, 83, 85, 86, 194; Dabra Dammo monastery, narthex ceiling, 36, *37;* at Maryam Wuqro, 71, *72;* at Mikaʾel Amba, 98, 101–3, *102,* 131, 132, 199–200; at Wuqro Cherqos, *115–16,* 116, 117, 159
Nea Moni, Chios, 80
Nine Saints, 75
Northeast African Studies (journal), 17
Noyon, France, church of, 156n94
Nubia, cathedrals and churches of, 141n29, 145n48
Nubian vaults, 149

Old Cairo. *See* Fustat
old ordo, 32, 52n64, 53n68, 58, 126 *See Also* prothesis rite
oral history in Ethiopia, 16n50, 195n22, 205n56
oratories, 61n91, 62, 69
orientalists and orientalism, 16
Orthodox Christianity in Tigray and Ethiopia. *See* Christianity in Tigray and Ethiopia
Ossuaries, *95,* 96, 98, 198
Ousterhout, Robert, 45n48, 74n140, 192

painted decorations: at Abreha wa-Atsbeha, *88–94, 194;* gold leaf, use of, 176; Indian Ocean textiles, architectural ornament based on, *175,* 175–90, *177–84, 186–88;* introduction of mural painting into Ethiopia, 53–54, 166; at Maryam Dabra Tseyon, 203; at Mikaʾel Amba, 109, 129, *130;* under "Solomonic" dynasty, 67, 69–71, *70, 74,* 75; at Wuqro Cherqos, *115, 117, 118, 121,* 202–3; under Zagwe dynasty, 53–54, 58, 59, 61, *62,* 63, *64, 66*
"palaces," Aksumite, *28,* 28–29, 36, 39
Panagia Ekatontapiliani, Paros, 142, *143,* 147
Pantokrator monastic complex, Constantinople, 145n48
pastophoria: at Abreha wa-Atsbeha, 91, *95,* 96, 153, 154, 181; Aksumite, 30, 50–52n64; at Mikaʾel Amba,

109–10; funerary purpose of, 122, 125n93, 126; post-Aksumite, 45, 49; at Wuqro Cherqos, 122, *126*

Pearce, Ivy, 22

Pearce, Nathaniel, 83n16

periodization of Ethiopian history, 4n9, 12, *12*

Persia and Persians, 12, 42n41, 166

Pharan, Egypt, Justinianic cathedral at, 140–41

Phillipson, David, 23, 24, 25n110, 46–48n56, 80, 154–55

pilgrims and pilgrimage networks, 5, 6, 131, 134, 135, 140–44, 157

Π-shaped templons/chancels, 45, 48, 61n94, 66, 93, 110, 122, 125, 131, 133, 204

Plant, Ruth, 22, 65n107

Playne, Beatrice, 18–20, 23, 176, 194

Pollera, Alberto, 69n130

Portuguese-Jesuit construction, 85n25

prestige architecture: in Aksumite society, 29; rock-cut churches, Hatsani production of, 4, 6, 134, 136, 139, 145, 160

processional crosses, 96, *96, 109,* 110, *118,* 119, 157–58n89, 204, *205*

processions and processional spaces, 146, 157, 158n99

Proconnesian marble, 32, *33,* 110n63, 145n49

Procopius, 166n9

prothesis chamber: at Abreha wa-Atsbeha, 126–27, 131, 133, 181; at Cherqos Agabo, 127; continuing construction of, after change in ordo, 53, 127; diffused light, liturgical significance of, 153; Mika'el Amba originally intended to have, 53, 131; at Wuqro Cherqos, 122, 126–27, 131, 133, 159, 203; at Yohannes Matmaq, 50

prothesis rite, 32, 45, 56 *See also* Old Ordo

Pseudo-Methodius, Syriac apocalypse of, 160

qeddest. See choirs/choir screens

quarter-round moldings, 49n62, 87, 91, 102, 103, 104

Qubba Imām al-Dūr, Samarra, Iraq, *182,* 182–83

al-Quḍā'ī (jurist), 135n2

Qus (Qūṣ), 144, 153, 173

Quseir al-Qadīm (Quṣayr al-Qadīm; Myos Hormos): proposed trade routes into Ethiopia from, 144, 173; "Sheikh's house," textile scraps from, *172*

race, colonialism, and "influence," 24–25

Rassegna di studi etiopici (journal), 17

Rasulid dynasty of Yemen, emblem of, 203

recumbent apse, 40

Red Monastery, Sohag, Upper Egypt, 40n38, 144, 157, *158*

Red Sea: Aksumite international trade via, 11; Cairo Geniza documentation of textile trade via, 171, 173n43, 174, 179n77; as Fatimid *mare nostrum,* 135, 136–37; isolation of Ethiopia attributed to Islamic expansion in, 166; Mediterranean world, trade and pilgrimage routes into, 144, 166; proposed trade routes into Ethiopia from, 173–74; St. Antony on the Red Sea, monastery of, 61, 61n90, 129–31, *130,* 144n41

reliquaries/reliquary tradition, 3n6, 126, 193–94, 200n39

revelatory/liminal spaces, 153, 189

revival architecture, rock-cut churches as, 26, 135–63, 191–92; Aksumite Empire, later churches referencing architecture of, 45, 46, 48, 144, 154–56, *156;* ecumenical connotations, 3, 144, 145, 160, 190; Egypt and Ethiopia in eleventh century and, 135–39; global parallels, 160–63, 191; innovative and contemporary elements, 135, 146–54; Justinianic cruciform churches

and, 4, 6, 26, 134, 135, 141–46, 154, 191; late antiquity, intentionally harkening back to, 4, 6, 26, 134, 135, 139–46, 154, 191; liturgical functionality and, 156–60; texts, revivalist impulse in, 144

Ristow, Sebastian, 192n7

rock-cut cruciform churches of Tigray, 79–134. *See also* Abreha wa-Atsbeha; Mika'el Amba; Wuqro Cherqos; as active places of worship, 6, 160, 206; dating of, 6, 23, 24, 25–26, 46, 79, 124, 125–27, 129–31, *133,* 133–34; defining Tigray and Ethiopia, 7–10, *8–10;* as Ḥaṣara Mäsqäl ("Bastions of the Cross"), 206; as hybrid monastery/parish churches, 46, 160, 191; Indian Ocean textiles and decoration of, 4, 5, 26, 165–90 (*See also* Indian Ocean textiles); liturgical functionality of, 156–60 (*See also* liturgy); local afterlife of, 26, 191–206 (*See also* local afterlife of rock-cut churches); martyria/funerary chambers in, 125–26; metrological system used for, 125, 178; as multiphase endeavors, 79; number of, 7, 18; pre-Christian origins of rock cutting, theories about, 20n77, 68; as prestige architecture produced by local elites, 4, 6, 134, 136, 139, 145, 160; prototype, Abreha wa-Atsbeha as, 79, 124–33, *133;* research conditions, 5–6; as revival architecture, 26, 135–63, 191–92 (*See also* revival architecture, rock-cut churches as); scholarship on, 15–24, 69n130; significance of, 4–5; typology of, 6, 21–22, 21n77, 79–81, 139; Venice/San Marco compared, 1–4, *2, 3,* 163, 193

Romanesque churches of Western Europe, 163, 191

Romanos (Byzantine emperor), 80

round churches, 75

Rum Seljuk, 163

saddleback roof, 65, *201, 202,* 204

St. Antony on the Red Sea, monastery of, 61, 61n90, 129–31, *130,* 144n41

St. Catherine's Monastery, Mount Sinai, 40, 142–44

St. James in Compostela (Santiago de Compostela), Spain, 163

St. John, Ephesus, 30, 141, 146, 147

St. Macarius, monastery church of, Wadi Natrun, Egypt, *184,* 185

St. Mark's, Venice. *See* San Marco

St. Mary of Zion (Aksum Tseyon/Aksum Ṣəyon; cathedral of Aksum), 25n110, 34, 53n69, 60, 67, 82, 149

St. Sernin, Toulouse, France, *162,* 163

St. Sophia, Kiev, 80

Saint-Front, Périgueux, Aquitaine, France, 163

Salt, Henry, 18, *22,* 83n16, 85n25, 194n18

salt trade and Danakil salt flats, 11, 13n36, 49, 57, 139, 175

San Marco (St. Mark's), Venice: Abreha wa-Atsbeha compared, 1–4, *2, 3,* 163, 193; Holy Apostles in Constantinople and, 1–3, 141, 163; Islamic architectural motifs, use of, 4n7; late antiquity, harkening back to, 160, 163

Sanaa, cathedral of (al-Qalīs), *34,* 35, 139–40, 147

Sanaa, Great Mosque of, 35

sanctuaries. *See also* bema, conched apse: at Abreha wa-Atsbeha, 93; at Degum Selassie, 155; Deir al-Surian, Wadi Natrun, Egypt, 151, *152,* 185; engaged ceiling crosses signaling entry into, 159; haykal screens, *133,* 137–38, *138,* 151, *184,* 185, 204; at Mika'el Amba, 103, 110, 131; post-Aksumite, 43, 45, 46, 48, 49, 50; textiles, use of, 168; at Wuqro Cherqos, 178, 204

"Sanctuary of Light" folio, Abba Garima II manuscript, 40–41, *41*

Santiago de Compostela (St. James in Compostela), Spain, 163

Sauter, Roger, 20

Sawakin (Sawākin), 173

Schechter, Solomon, 171n36

Schneider, Roger, 23

"second Christianization": architecture of (950–1100), 46–52, 137; Fatimid influence on Ethiopia and, 46, 134, 139; historiographic reasons for dating of rock-cut cruciform churches and, 134; "Nine Saints" responsible for, 75

Seljuks: Indian Ocean textiles and buildings of, 26, *175, 178, 182,* 182–83, *184,* 189–90; invasions of Levant and Asia Minor, 136; Islamicate ornament associated with, 165; late antiquity, revival of architectural style of, 163; Manzikert, battle of (1071), 160; Masjid-i Tārākhāna, Damghan, Iran, *175;* Qubba Imām al-Dūr, Samarra, Iraq, *182,* 182–83; T-fret, use of, *179;* Zavareh Jami Mosque (Masjid-i Jāmiʿ-i Zavārah), Iran, *184*

"semi-monolithic," as typological term, 80

setback molding, 49n52, 86, 116

Severus (Sāwīrus; archbishop), 127, 137, 146, 174

Shay culture, 136

"Sheikh's house," Quseir al-Qadim, textile scraps from, 172

Sidot, Philippe, 113n72

Silk Road, Maritime, *See also* Indian Ocean textiles; 26, 136, 166

Simpson, William, 18, *20, 21,* 24, 113, 113n68, 122n83, 133, 204

slaves and slavery. *See* enslaved people

Smidt, Wolbert, xiii, 195

solea, *See also* chancel/chancel screen, 32, 45, 63, 110, 112

"Solomonic" dynasty in Ethiopia, 15, 66–75, 166, 200, 202. *See also under* medieval architecture in Tigray

Soqota Masqala Krestos (Soqota Mäsqälä Krəstos), 131

spatial massing, 49, 68, 71, 127, 135, 146–47, 154, 191, 193

spolia, 3, *31,* 35, 36, 40n38, 41, 83n19, 137, *138,* 146n49, 155, 163, 204

St. *See specific entries at* Saint

Stalley, Roger, 1n1

Stephanites, *See also* Gunda Gundo, 67

stepped cross motif, 103n49, 109, 128, *172,* 173, *181,* 181–83, *182,* 187–88, 191, 204

strapwork ornament, 36, *37,* 57, 65, 71, 74, 103, 110, *111,* 131, 153, 185, *186,* 202, 204

stylized tree motif, 185–87, *186–88*

Sulayhids, 136, 187

sunken fillet molding, 104

surbased vaults, 69, 119, *119–20,* 133, 153, 199, *200*

synthronon (pl. synthronoi), 93, *94, 145,* 145–46, 191

Syriac apocalypse of Pseudo-Methodius, 160

Syria-Palestine: Church of the Nativity, Bethlehem, 202; Dome of the Rock, Jerusalem, 193; Ethiopian relations with, 12n31; Holy Sepulcher, Jerusalem, 167, 170n28, 193

al-Ṭabarī, 42n41

Tamrat, Taddesse, 16

Tantawedem (Ṭanṭawədəm; Zagwe king), 53, 138, 192, 203

Taʾaka Maryam, 29

templons/templon screens, *See also* chancels/chancel screens: at Abreha wa-Atsbeha, *92,* 93; Constantinople,

importation from, 32–34, *33,* 42, 110n63; dating and, 125; early Christian, 23, 45; at Mikaʾel Amba, 99, 110–12, *111,* 131; Π-shaped, 45, 48, 61n94, 66, 93, 110, 122, 125, 131, 133, 204; post-Aksumite, 45; at Wuqro Cherqos, 122, 204; under Zagwe rule, 61, 63, 66

Tesema, Gebremeskel (Tigrayan mason), 75n148

Tewodros II (Theodore; emperor), 16, 18

textiles. *See* Indian Ocean textiles

T-fret, *179*

Theodosian code, 129

Theotokos Kyriotissa (Kalenderhane Camii), Constantinople, 160–63, *161*

thrones, hewn, *See also* synthronon 71, *72, 74*

Tigray and Ethiopia. *See also* Christianity in Tigray and Ethiopia; rock-cut cruciform churches of Tigray; *specific cities, towns, and buildings:* civil war (2020–2022), xi, 1; Communist revolution (1974) in, 15, 17, 23; defining, 7–10, *8–10;* in eleventh century, 135–39; as Fatimid mission area, 137; history of, 11–15, *12;* Islam in, 15, 53, 137–38; Italian occupation of (1936–941), 16–17, 83; languages of, 9, 12; maps, *8, 10;* medieval architecture of, 25, 27–77 (*See also* medieval architecture in Tigray); periodization of Ethiopian history, 4n9, 12; scholarship and Ethiopian studies, 10, 15–24, 192; terminology for, 8–9, *10;* Venetian Republic compared to post-Aksumite polity in, 1

Tigray Cultural and Tourism Bureau, Mekelle (Mäqälä), xiii, 5, 49

tiraz (ṭirāz) textiles, 168, *169,* 170, 171

trade. *See also* Indian Ocean textiles: in civet musk, 4, 139, 174, *175;* Danakil salt flats and salt trade, 11, 13n36, 49, 57, 139, 175; between Fatimids and Ethiopians, 139; ivory trade, 11, 34, 106, 166; Mediterranean world, trade routes into, 11–12, 144; proposed trade routes into Ethiopia, 173–74; Red Sea as Fatimid *mare nostrum,* 135, 136–37; resuscitation of Indian Ocean trade under Fatimids, 46, 134, 139, 165–66, 179; in enslaved people, 4, 139, 174, 175, 203n47

transennae, *See also* chancels/chancel screens 93, 100, 110, 131, 187

triumphal arches, 36, 48, 49, 54, 56, 61, *92, 107, 121, 138*

true cross, cult of, 200

Tsadaʾaina Cherqos (Ṣadaʾaina Čerqos), 57n77

tukul or roundhouse, 97, *98,* 200

Umm Ḥabība (wife of Prophet Muhammad), in Aksum, 53n69

Ura Masqal (Ura Mäsqäl), 155

"valley churches of the Hawzen plain," 46, *See also* "second Christianization": architecture of (950–1100)

Veneration of the Cross ritual, 159

Venetian Republic. *See also* San Marco: Justinianic/late antique style, revival of, 1–3, 163; post-Aksumite Tigray compared, 1–4; true cross relic in Ethiopia gifted from, 200n39

Wadi Natrun (Wādī al-Naṭrun), Egypt: Deir al-Surian (Dayr al-Suryān), *151,* 151–52, *152,* 158, *159,* 185, *187,* 188, 197; Ethiopian monastery at, 142; St. Macarius, monastery church of, *184,* 185

Washa Mikaʾel (Waša Mikaʾel), 68

Welie, church of, 147

White Monastery, Upper Egypt, 144

Wolde, Seyoum, 25n104

Wolde Selassie (Śəllase), 83n16

Woldegiyorgis, Fikru, xiii, 202n40

Worku, Mengistu Gobezie, 23, 24

Wuqro Cherqos (Wəqro Čerqos), 112–24; Abreha and Atsbeha, cult of, 195; Abreha wa-Atsbeha as prototype for, 124–33, *133*; Abreha wa-Atsbeha compared, 79, 86, 117, 124; Abuna Abraham at, 116n78, *133*, 202–5, *203*; Aksumite references at, 155; as basilica, 79, 157; bema, 122; chancel/chancel screen, *122*, 133; choir/choir screen, 120, *121*, 122; construction method at, 132–33, *133*; courtyard, 113, 204; cross relief sculptures, *118*, 119, 157–58, *159*; dedication to St. Cyricus, 112; 113–16, *114*; fire damage, 122, 133, 156, 204; ground plans, *6*, *20*; historical background, 4; as hybrid monastery/parish church, 46, 160, 191; Indian Ocean textiles and ornamentation program of, 26, 175, 176, 178–81, 178n69, 182, 183, 189, 190; interior, *117–23*, 117–24; liturgical layout, updating of, 204; Mika'el Amba compared, 113, 117, 133; mosque(s) in vicinity of, 137; narthex, *115–16*, 116, 117, 159; original purpose/use of, 146; painted decorations, *115, 117, 118, 121*, 202–3; pastophoria, 122, *126*; portals, 113–16; prothesis, 122, 126–27, 131, 133, 159, 203; radical adjustment of form at, 79, 124, *133*; restoration work at, 113, 116; sanctuary, 178, 204; scholarly studies of, 18, *19–21*, 20n76, 21, *22*, 23, 24; "Solomonic-era" reworking of, 68; spolia mihrab hood used as *haykal* in, 137–38, *138*, 204; templons/templon screens, 122, 204; toponym, environs, and monastic complex, *112*, 112–13; typology of, 79–81; vault system at, 146, 147; viewing window, 133n83

Yamami family, 174

Yeha (Yəha), 50, 53, 56, 57, 155

Yekunno Amlak (Yəkunno Amlak; Solomonic ruler), 66

Yemen: barrel vaulting by craftsmen from, 147; cave of Hoq, inscriptions from India traders in, 11n24; Himyar and Himyarites, 12, 35; Indian Ocean textile trade and, 171, 174; mihrab hoods from, 137, 187; Rasulid dynasty, emblem of, 203; Sanaa, cathedral of (al-Qalīs), *34, 35*, 139–40, 147; Sanaa, Great Mosque of, 35; translation between architecture and ornament in, 187n92; Sulayhids from, 136, 187; zebra gifted by Ethiopian queen to, 136n3

Yemrehanna Krestos (Yəmrəhannä Krəstos), 24, 59, 63 *65*, 132, 175n56

Yohannes (Yoḥannes) IV (emperor), 83, *133*

Yohannes Matmaq (Yoḥannəs Mäṭməq), 46, 49–50, *50–52*

Zagwe dynasty, 15, 46, 132, 135, 144, 191–92, 195, 199, 200, 202. *See also under* medieval architecture in Tigray

Zamaddo Maryam (Zämäddo Maryam), 81, 147, 200

Zara Yaqob (Zär'a Ya'əqob; emperor), 168, 168nn22–23

Zarama Giyorgis (Zärema Giyorgis), 36–40, *38–40*, 42, 48, 53, 56–57, 110, 135n1, 155, 176

Zavareh Jami Mosque (Masjid-i Jāmi'-i Zavārah), Iran, *184*

Zayla, as port, 139n19

zebra gifted to Yemen by Ethiopian queen, 136n3

Zoz Amba, 69n130

Zuart'noc', Armenia, 193